IX

THE FRICK COLLECTION

DRAWINGS, PRINTS & LATER ACQUISITIONS

Edited by

JOSEPH FOCARINO

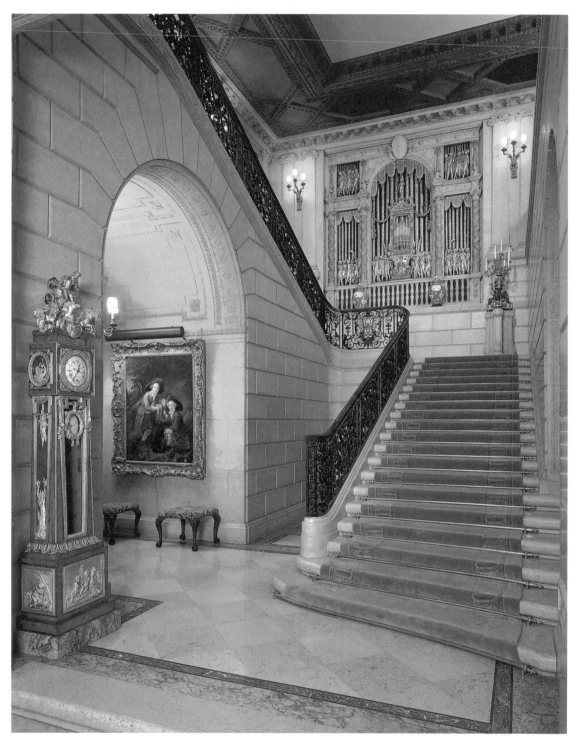

STAIRCASE · THE FRICK COLLECTION

THE FRICK COLLECTION

AN ILLUSTRATED CATALOGUE

IX

DRAWINGS
PRINTS, AND LATER
ACQUISITIONS

THE FRICK COLLECTION

DISTRIBUTED BY PRINCETON UNIVERSITY PRESS

2003

PUBLISHED IN 2003 BY THE FRICK COLLECTION
I EAST 70TH STREET, NEW YORK, NEW YORK 10021
PUBLISHED SIMULTANEOUSLY IN
THE UNITED KINGDOM BY THE FRICK
COLLECTION

LIBRARY OF CONGRESS
CONTROL NUMBER: 68–57985
ISBN: 0–691–03836–8
DISTRIBUTED BY PRINCETON UNIVERSITY PRESS
PRINCETON, NEW JERSEY, AND
OXFORD, ENGLAND

THE PHOTOGRAPHS
REPRODUCED IN VOLUME IX ARE PRINCIPALLY THE
WORK OF RICHARD DI LIBERTO, STAFF PHOTOGRA-
PHER, AND OF PREVIOUS STAFF PHOTOGRAPHERS
FRANCIS BEATON AND PETER O'SULLIVAN. THE
FRONTISPIECE PHOTOGRAPH IS BY
JOHN BIGELOW TAYLOR

PRINTED IN ITALY
BY THE STAMPERIA VALDONEGA, VERONA

In Memory of

BERNICE F. DAVIDSON

RESEARCH CURATOR AT

THE FRICK COLLECTION FROM

1965 UNTIL 1997

DRAWINGS

Fifteenth through Nineteenth Centuries

BERNICE F. DAVIDSON · SUSAN GRACE GALASSI

EDGAR MUNHALL

PRINTS

Sixteenth through Nineteenth Centuries

DAVID P. BECKER

LATER ACQUISITIONS & PREVIOUSLY UNCATALOGUED WORKS

Paintings, Sculpture & Decorative Art · Fifteenth through Nineteenth Centuries

CHARISSA BREMER DAVID · BERNICE F. DAVIDSON

SUSAN GRACE GALASSI · MARGARET IACONO

WOLFRAM KOEPPE · HOLGER MÖHLMANN · EDGAR MUNHALL

JOHN POPE-HENNESSY

ORLANDO ROCK · SOPHIE SCHLÖNDORFF

ASHLEY THOMAS

CONTENTS

DRAWINGS

PRINTS

English Reproductive Portrait Prints

LATER ACQUISITIONS
AND PREVIOUSLY UNCATALOGUED
WORKS

Paintings

Sculpture

Decorative Art

INDICES

FOREWORD

THE informative and perceptive Preface that follows these brief comments was originally prepared before his retirement in 1997 by Charles Ryskamp, my predecessor. Since then, several notable events have occurred that are worthy of mention here.

The foremost of these took place in 1999, when the holdings of The Frick Collection were substantially expanded by the bequest of twenty-five clocks and fourteen watches from the estate of the celebrated New York collector Winthrop Kellogg Edey. A selection of thirteen clocks and eight watches from that group was catalogued and displayed here in 2001, and it is hoped that an expanded catalogue of the entire collection will appear at a future date.

Another major development has been the cleaning and hanging of the two Don Quixote tapestries bequeathed to the Collection by Childs Frick, son of the founder, in 1965. These pieces, which were recorded in the French royal collection in 1775, had not been seen by the public for many decades. They were conserved at the Cathedral of St. John the Divine in Manhattan and were put on display in our Music Room in 2001.

Also in 2001, the Collection received title to two small but quite amazing Constable cloud studies bequeathed by Henrietta E. S. Lockwood in memory of her father and mother, Ellery Sedgwick and Mabel Cabot Sedgwick. These were duly put on display in the Garden Court, where they have been admired by countless visitors.

A small but highly effective development has been the reframing of the charming Liotard *Trompe l'Oeil* that was given to the Collection in 1997. This effort was generously underwritten by Eugene V. Thaw.

Of course the Collection grows continually, in ways both small and large, obvious or subtle. No catalogue of a developing institution can ever hope to be definitive. But in the nine-volume quarto *Catalogue* of which this represents the final tome, we have done our best to bring to the public all the most useful information that has been available to us.

Clearly, many hands were instrumental in these results. I should like to express my deep gratitude to all of the scholars who have made these volumes possible, and

above all to the staff of The Frick Collection and the Frick Art Reference Library. The late Bernice Davidson, who long served as Research Curator, and after her Edgar Munhall, Curator Emeritus, have been largely responsible for the oversight of this volume. In bringing it to print, I am also grateful to Robert Goldsmith, Deputy Director for Administration, and to Colin B. Bailey, the Chief Curator. Joseph Focarino, Editor of the series since its inception, has produced this final publication with consummate care, as always. Most of the photographs are by our photographer, Richard di Liberto. I am most thankful to all of these, and to the Trustees and Fellows of The Frick Collection, and to our many supporters.

<div align="right">

SAMUEL SACHS II
Director, The Frick Collection

</div>

PREFACE

THIS final volume in the current series of catalogues raisonnés of The Frick Collection has always been planned for descriptions of drawings and prints. In the years since 1968, however, when the first two volumes were published, the additions to the collections of paintings and sculpture have been so significant that the present work can also be taken as a necessary supplement to the first four volumes, which covered those areas. The paintings in Volume IX are divided between early works of the fifteenth century and those of the eighteenth and nineteenth centuries (with as well two fine pastel portraits by Greuze).

In recent years, the Collection was given an early eighteenth-century marble bust by Coysevox to complement the two bronzes by or attributed to him that it long has owned. The rest of the sculpture recently acquired relates to the principal concentration of The Frick Collection on Renaissance bronzes, together with a few marble portrait busts of major importance from that period. Two of these acquisitions, those by Severo da Ravenna and Bernini, must be among the most copied Italian sculptures of the sixteenth and seventeenth centuries. In the present volume are descriptions of acquisitions of sculptures from Verrocchio and Laurana to Bernini and Algardi, each of them adding remarkably not only to the collections of the Frick, but also to those of New York and of the United States in general.

Drawings have never been considered paramount among the various categories of art that constitute The Frick Collection. Drawings evidently did not strongly attract Henry Clay Frick, who seems to have felt a greater appreciation for prints, which he bought more perceptively than drawings, though in limited quantities and areas. Some of his best acquisitions of drawings were made early in his career and were not left to the Collection at his death in 1919. Notable among these were the ten drawings and pastels by Jean-François Millet, bought between 1897 and 1908, which remained at his Pittsburgh residence, Clayton, and are now in The Helen Clay Frick Foundation at Clayton. Pastels and watercolors appealed to Mr. Frick more than monochrome drawings. Of the ten drawings he bequeathed to the Collection, half were in color.

The earliest purchases among those drawings left to the Collection were made on October 11, 1913, when the Fricks' New York residence was under construction.

Possibly because of the cost of that enterprise, Mr. Frick had for many months curbed his eager acquisitive instincts. On that October day, he bought three drawings by Gainsborough (one of them in color) and three by Rembrandt (in addition to two paintings by Guardi). All six drawings were acquired through Knoedler and had come from the J. P. Heseltine collection in London. In 1915 he added to these works three pastels by Whistler, and in the following year a pastel portrait by Daniel Gardner.

In 1913, the collecting of drawings in America was still in its infancy. It seems extraordinary that the first groups of drawings in the United States were gathered for the extreme corners of the country: for Maine (those at Bowdoin College, bequeathed by James Bowdoin III in 1811) and California (by James Edwin Crocker, bought in Germany and Austria in 1869–71 and given to the art gallery he established in Sacramento). The Cornelius Vanderbilt gift to the Metropolitan Museum of Art in 1880 was the foundation of the collection there. It was not until 1910, when Pierpont Morgan bought the Fairfax Murray drawings now in the Morgan Library, that this country had a classic collection of European Old Master drawings of all schools.

For many years after Mr. Frick's death, the Trustees acquired nothing in the field of drawings. Then in 1936, while his daughter, Helen Clay Frick, was Chairman of the Committee on Art Acquisitions, the Trustees purchased seven drawings from the great Oppenheimer sale in London. It is difficult to know what motivated them, but they—and Mr. Frick a quarter of a century earlier when the Heseltine drawings were sold—may have been stimulated to buy because of the excitement created by a very important collection being sold, much like institutions and private collectors in the last few decades when drawings from the Ellesmere, Chatsworth, or Holkham collections were put up at auction. The remaining dozen drawings in this volume, which were subsequently acquired or given, were added because each was in some way related to a work of art in the Collection. This general objective has guided the Trustees' policy for the acquisition of graphic art—prints as well as drawings—over the past quarter century.

The roster of names associated with the small group of drawings in The Frick Collection is remarkable—Pisanello, Titian, Altdorfer, Rubens, Rembrandt, Claude, Fragonard, Boucher, Greuze, Gainsborough, Goya, Ingres, Corot, Whistler. But the prints are clearly of finer quality. In 1915, the year after he moved into his new home on Fifth Avenue, Mr. Frick purchased two great impressions of

Rembrandt etchings, and after that the complete edition of Whistler's Venetian Set of 1880, as well as the first state of Dürer's celebrated *Adam and Eve*.

The following year Mr. Frick bought two more Dürer engravings, two of the etched portraits by Van Dyck, two works by Meryon, and nine by Rembrandt. In 1917 he added twelve of Meryon's etchings of Paris. Many of these prints are outstanding, but for the most part it is among the works of Rembrandt that one finds impressions that are truly distinguished.

It is only fitting to quote here from the foreword by Edwin DeT. Bechtel to Volume IV, 1951, of the first (folio) catalogue of The Frick Collection:

> Mr. Frick's greatest interest was in Rembrandt, whose paintings meant more to him than the work of any other artist; and he understood his distinction as an etcher. A few years before his death, Mr. Frick, when he was asked whose talents he would most have wished to possess if fate had given him his choice, replied, "Rembrandt's." Thus, it is not surprising to find that Mr. Frick's last purchases as well as his first selections of prints were Rembrandts. … A pendant to his overwhelming representation of the Crucifixion is Rembrandt's largest etching, "Christ Presented to the People." … This etching was on Mr. Frick's desk at the time of his death.
>
> The total number of prints and drawings in The Frick Collection is, of course, small; for it was late in his life when Mr. Frick began to purchase engravings, etchings, and drawings for his Collection. Obviously he was not interested in acquiring or possessing a systematic collection of the works of any engraver or etcher or the prints of any special period. What Mr. Frick bought was not intended to fill portfolios. He took pleasure in his selections of prints and drawings; he wished to see them; they were framed and found places on the walls of his home.

The additions to the collections since the first volumes of the present quarto catalogue were published reveal the names of a number of donors; without their gifts of works of art and of money none of these would have been possible. Notable among these generous supporters of The Frick Collection have been Helen Clay Frick and John D. Rockefeller, Jr., who were both original Trustees. Among later donors, we should especially note Arthemise Redpath and Mr. and Mrs. Eugene V. Thaw. The Thaws are, quite properly, celebrated collectors. Mrs. Redpath, however, is not, and her bequest to The Frick Collection deserves particular mention here. A substantial portion of that money formed the beginning of an endowment for the Frick Art Reference Library. Other parts enabled the Collection to buy a painting by Watteau and a bronze plaque by Algardi.

Mrs. Redpath was born on Broadway in New York about 1906. Her mother, Arthemise Bouligny Baldwin, was from a well-known French family in New Orleans. Her father, William Ottman, was from a wealthy family of German extraction. They met in New Orleans during Mardi Gras, and after they married they moved to New York, where Mr. Ottman was a businessman. Mrs. Ottman died during the birth of Arthemise, her only child; after her father remarried, young Arthemise was brought up by him and her stepmother in a large house in the Nineties on the East Side of New York. She was educated at the Spence School and in Florence. In Italy she came into her own, and Florence, Italy, and art became passions for the rest of her life, as did Romanesque architecture. In her twenties, she married Albert Redpath, an investment banker, and they bought a house at 40 East Sixty-seventh Street, three blocks from The Frick Collection, where they resided for the rest of their lives. (Mrs. Redpath died in 1989.) They lived there in a restrained, elegant, intellectual way with furniture, porcelain, silver, and books of excellent quality, but not of exceptional importance. Nearly every summer they traveled to Europe for two months. From what we can learn now, the portrait of their lives might have been sketched by Henry James or Edith Wharton.

It is not known when Mrs. Redpath's interest in the Frick began, but it is said that for many years she visited it nearly every day. She became a familiar figure to the guards, and eventually she purchased an annual pass to the Collection. She especially loved the Library, which reminded her of her own home, and the Garden Court. Her last years, after her husband's death in 1985, were difficult. She became confined to a wheelchair, but she continued to come to the Frick with her nurse. Her decision to leave almost all of her estate to the Frick was a complete surprise to the Collection, as well as to her closest friends. Although previously unknown to us, she will always be remembered here with deep affection.

As a "house museum," The Frick Collection possesses, through Mr. Frick's original donation, family gifts, and assorted purchases over the years, a certain number of objects that can only be considered house furnishings, of family interest, or that were bought for temporary use in exhibitions. These are not included in Volume IX. On Miss Frick's death in 1984, another group of objects that had long been in the Frick Art Reference Library as her possessions joined the institution's collective inventory. A few of these—the paintings by Guardi and five of the mezzotints, for instance—merit inclusion in this volume, as they had been acquired originally by Mr. Frick and are of significance. A number of others are not. Finally, several works

of art which were omitted from previous volumes of this quarto catalogue (notably some tapestries and a Tuscan dresser or credenza of about 1600) are included here.

In this last volume of the catalogue, no attempt has been made to correct attributions concerning paintings and sculpture that appeared in the earlier volumes. The most recent scholarship, as well as the location of objects shown in the Collection, is given in the *Guide to Works of Art on Exhibition*, which is revised annually. Each of these nine volumes reflects the fluidity of scholarship; this is especially the case in this last one. Not only has the authorship of celebrated paintings in The Frick Collection traditionally given to van Eyck, Rembrandt, and La Tour frequently been debated, but other works less well known have also often been discussed. All of its publications reflect the continuing revaluation of the works of art in The Frick Collection.

A draft of this Preface was written when I retired from the Directorship of The Frick Collection (including the Frick Art Reference Library). During my official years and in the five years that have followed them, it has been the greatest pleasure to work with the staff there. I am happy as well to express my deep gratitude to all of the scholars who have made this series of volumes possible. The Collection and Library remain, as they were originally established, centers of learning as well as places for enjoyment, for appreciation of beauty, and oases of serenity and contemplation.

<div align="right">CHARLES RYSKAMP</div>

EXPLANATORY NOTE

A FEW remarks may be useful regarding the methods of presentation within each entry of this catalogue.

ORDER OF ENTRIES: Within each division of the catalogue, entries are arranged chronologically by the artists' birth-dates. An exception is made in the case of the English reproductive portrait prints, which, due to their dual authorship (painter and printmaker), are arranged instead according to their dates of execution. Where an artist is represented by more than one work, an attempt has been made to present those entries chronologically.

ARTISTS' BIOGRAPHIES: In the case of Rembrandt and Whistler, who are represented in this volume by both drawings and prints, and of Corot, who appears as both draftsman and painter, separate biographical notes emphasize the aspects of each artist's career there under consideration. Further biographical information on them and on other artists discussed here can be found in Volumes I through IV of the present catalogue.

TITLES: The titles of all works belonging to The Frick Collection are given here in English, with place-names retained in French for the Meryon prints. In the case of the English reproductive prints, new titles have been created for the purposes of this catalogue that incorporate the names of both the printmaker and the painter whose original work has been reproduced, again reflecting their dual authorship.

SIGNATURES: All genuine artist's signatures and original inscriptions—including, in the case of prints, all signatures and most inscriptions made within the plate itself—are reproduced, except where they appear more than once in the same group (as in the Whistler set of prints) and in the few instances where signatures are illegible in photograph.

DIMENSIONS: In listing dimensions, the following abbreviations are employed: H. indicates height; W. indicates width, which is used here as interchangeable with length; and D. indicates depth or diameter. Measurements given for prints are of the plate area or, if the sheet has been trimmed within the platemark, of the extant sheet.

REFERENCES & STATES: For the prints, references include the most prominent catalogues raisonnés of the printmaker's work, indicating the state of the Frick impression and the total number of recorded states.

MARKS & INSCRIPTONS FOR WORKS ON PAPER: Included here are watermarks, if any, and inscriptions entered by persons other than the artist. Collectors' marks do not appear under this heading; if they are recorded in F. Lugt, *Les Marques de collections de dessins & d'estampes*, Amsterdam, 1921, and *Supplément*, The Hague, 1956, the Lugt numbers are mentioned under *Collections*. Unless a watermark is specified, it can be assumed either that the sheet is without one or that its mount prevents inspection.

DESCRIPTIONS: In all descriptions, left and right refer to the spectator's left and right. For three-dimensional objects, these references are given in relation to the front of the piece.

CONDITION: The condition reports included in this catalogue are necessarily condensed; far more complete records of many of the works, with photographs of various stages in the process of restoration, are available for study to qualified specialists.

EXHIBITIONS & COLLECTIONS: References to exhibitions and provenance are taken for the most part from purchase records and inventories and from the folio *Illustrated Catalogue of the Works of Art in the Collection of Henry Clay Frick* (Pittsburgh and New York, I–IX, 1949–56). The titles of exhibitions usually are given in abbreviated form. Where a year appears in parentheses after a collector's name, it indicates a date when the work is known to have been in that person's possession, but not necessarily the date of its acquisition.

FRICK PROVENANCE: A number of the works catalogued here have a date of purchase during the lifetime of Henry Clay Frick and a subsequent date of entry into The Frick Collection. In such cases, the objects were purchased by Mr. Frick, inherited by members of his family, and finally given to the Collection by an inheritor.

BIBLIOGRAPHICAL REFERENCES: As a rule, bibliographical citations are given in full the first time they appear in each entry and in abbreviated form thereafter within that entry. An exception is made in the case of the Meryon and Whistler sets

of prints, where publications that are most frequently cited are given in full form at the end of the artist's biography and in shortened form within the individual entries that follow.

ADDITIONAL REFERENCES: These are selective, not comprehensive. In general, the listings include standard catalogues or monographs, and commentaries or analyses that contribute to an understanding of the work of art.

CATALOGUE AUTHORS: Each entry is signed with its author's initials, as follows:

D. P. B.	David P. Becker	H. M.	Holger Möhlmann
C. B. D.	Charissa Bremer David	E. M.	Edgar Munhall
B. F. D.	Bernice F. Davidson	J. P.-H.	John Pope-Hennessy
S. G. G.	Susan Grace Galassi	O. R.	Orlando Rock
M. I.	Margaret Iacono	S. S.	Sophie Schlöndorff
W. K.	Wolfram Koeppe	A. T.	Ashley Thomas

DRAWINGS

ANTONIO PISANELLO

Recorded 1395 – d. 1455

Antonio di Puccio Pisano, called Pisanello, was born in Pisa. He led an itinerant and diversified career, successfully finding employment as painter and medalist in centers spanning Italy from Naples to Venice. He worked for the Este and Gonzaga families at Ferrara and Mantua and is documented in Rome and Milan, but some of his most important works were executed in Verona, home of his mother's family. For an artist of his early date and peripatetic activity, an unusually large number of his drawings have survived, possibly because their superlative quality was always recognized and prized by collectors, but also because originally many were preserved in sketchbooks. More than four hundred drawings are attributed to Pisanello and his followers, of which perhaps a quarter may be from his own hand. These crisp, lively sketches range widely in subject, recording portraits, scenes from daily life, animals, birds, and architecture, as well as designs for works of art.

STUDIES OF MEN HANGING (36.3.54)

Pen and brown ink, over traces of black chalk underdrawing, 10⅝₁₆ × 7 in. (26.2 × 17.8 cm).

INSCRIPTION: In chalk on recto at bottom left: *63*.

DESCRIPTION: Two men hang from ropes tied about their necks. Their hands are bound behind them. Their bowl-cropped hair is straight. The man at left, seen from the rear, wears a short surcoat bloused at the waist and fitted tightly over the hips. From beneath it emerge the collar and sleeves of a shirt. His long hose, worn over drawers, have soles, probably of leather. The hose on his right leg has slipped down almost to the knee and sags in loose folds. The hose on his left leg is suspended from the coat at the side but is detached at the back, where it hangs folded below the but-tock. The second man, seen in profile at right, is clad in a similar costume but without a shirt, and his close-fitting doublet has tight sleeves. His upper arms are bound with a rope that passes across his back. The hose on his right leg appears to cling smoothly to the leg and to be tied to the doublet at his hip. The hose on the left leg droops in folds beneath the buttock. At the bottom of the sheet are larger-scale studies of the legs of two hanging men. The legs at left are viewed from the rear in a position almost identical to that of the complete figure drawn above them. However, the hose on the right leg has only begun to slip down the leg, forming a broad open cuff at the top, below which, at the thigh, appears a tear in the material. The legs at right are in profile, like the figure above, but in

3

a slightly different position, and the hose on the right leg sags in deep folds from hip to knee.

CONDITION: The drawing, which had been laid down, was removed from its backing in 1973. Near the middle of the left margin is a narrow repair about 1¾ in. long. The paper is slightly foxed.

THESE studies of hanged men are complexly related to two other drawings of the same figures and to a fresco painted by Pisanello above the entrance arch of the Cappella Pellegrini in S. Anastasia, Verona.[1] The fresco depicts in terms of courtly pageantry an event from the legend of St. George, said to have occurred in Libya, where the saint converted the citizens of Silene to Christianity by saving them from a dragon that terrorized the city. In the foreground of the fresco, the saint departs to slay the dragon, thus to spare its next designated victim, the daughter of the king of Silene. This princess stands in elegant profile to the right. On a hill in the background is a city with two men hanging from a gallows outside its walls. The fresco is generally agreed to have been painted after 1433, when Pisanello returned to Verona from Rome, and probably before 1438, when he was in Ferrara, though dates as late as the 1440s have been proposed. Archives refer to a sculptor, Michele da Firenze, working in the Pellegrini chapel between 1436 and 1439, a plausible period for Pisanello's activity there. However, his paintings in the chapel are not documented.

A great number of drawings for the fresco have survived, but only four are related to the gallows and their dangling burden; considering this scanty evidence, any attempts to establish a sequence of the drawings or to reconstruct how Pisanello developed the motif risk fabricating a fiction.[2] The four drawings vary greatly in purpose and in style. One, a slight sketch of the gallows alone, appears on the verso of a drawing in the Louvre for the *Vision of St. Eustace*.[3] The other three drawings examine the bodies, clothing, and decaying condition of the corpses. A study in the British Museum (No. 1895–9–15–441) includes six figures of hanging men, two at the center of the sheet in a bloated state of decomposition.[4] Along the top is a row of four smaller, less grisly studies of hanging men showing—rather schematically—views from the front, rear, and both sides. The second and fourth of these figures (a profile and a rear view) relate closely to the Frick figures, but all four appear to be copied from, or perhaps traced over, sketches by the artist.[5] For a drawing in the National Gallery of Scotland, Edinburgh (D 722), a studio assistant assumed the pose of the hanged man seen from the rear.[6] Although the man's

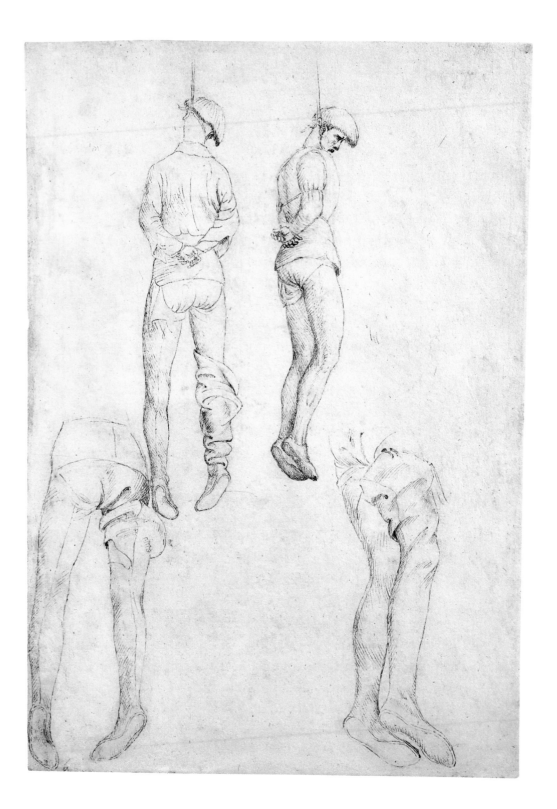

lower legs are not drawn, it is clear from the position of his head and the thrust of his hips that he is standing, not hanging. The placement of his bound hands comes closer to the fresco than the other studies.

Of the three drawings that include figures, those on the Frick sheet most nearly resemble the painted version, though the relation in scale and the spacing between the two figures, apparently not yet considered in the drawing, was developed more suavely and tautly in the fresco. The figure at upper left on the Frick sheet was repeated with few changes in the painting. The somewhat stiff, flattened treatment of folds in his right sleeve and leg resembles the schematic style of the figures in the British Museum drawing. The alternative design for this man's hose sketched below was rejected for the fresco. But in the study of legs at lower right, the leg with voluminous, sagging hose was incorporated into the final painted version in preference to the simpler, close-fitting hose of the full figure above.

The bloated figures of the British Museum drawing seem to have been observed directly from the cadavers, while the figures at the top of that sheet suggest a far less immediate experience. The Frick hanged men appear to be drawn from life (or death), but the alternative treatments of the legs introduce a more complex and puzzling note of deliberation to the studies. It is difficult to judge to what degree their sequence resulted from changes in the observed subject over time and what derived from developments in the artist's ideas about the design of the motif.

More than thirty drawings have been associated with the fresco, obviously a small fraction of the total made in designing the figures, heads, animals, birds, and buildings that fill the painted surface with such richness of invention. The skill and vital energy of these studies render the depiction of a corpse as captivating as the sketch of a hound. Baxandall, quoting Aristotle (*Poetics*, 1448b, 10–12), made the point neatly: "Things which in themselves we view with distress we enjoy contemplating when they are represented with very great accuracy—the forms of the lowest animals, for instance, and also of dead bodies."[7]

The subject was not peculiar to Pisanello. Hanging men are found in works by earlier painters—for example Giotto's *Last Judgment* in the Cappella degli Scrovegni, Padua—and as background details in compositions by later artists perhaps influenced by Pisanello, such as Uccello and Jacopo Bellini.[8] And before the Frick and British Museum drawings were identified as by Pisanello, they were attributed to Castagno, based on Vasari's description of Castagno's painting of the hanged conspirators in the Pazzi rebellion.[9] Each of these depictions of punishment and

6

death may be intended to convey a lesson. Cordelier has suggested that by positioning the hanging men in the S. Anastasia fresco directly above the ermine-wrapped figure of the king of Silene, Pisanello intended to point a moral about the ultimate sovereignty of Death.[10]

<div style="text-align: right">B. F. D.</div>

EXHIBITED: London, Royal Academy, Italian Drawings, 1930, No. 19, lent by Henry Oppenheimer. Paris, Bibliothèque Nationale, L'Oeuvre de Pisanello, 1932, No. 128, lent by Henry Oppenheimer. Verona, Museo di Castelvecchio, Pisanello, 1996, No. 42.

COLLECTIONS: Marquess of Lansdowne.[11] His sale, March 25, 1920, Sotheby's, Lot 15, bought by Oppenheimer. Henry Oppenheimer, London. His sale, July 10–14, 1936, Christie's, Lot 145. Frick, 1936.

NOTES

1. For the history and dating of the fresco and an extensive bibliography on the subject, see the catalogue of the Verona exhibition *Pisanello*, ed. P. Marini, Milan, 1996, pp. 232ff.

2. The attempt made by B. Degenhart, A. Schmitt, *et al.*, in *Pisanello und Bono da Ferrara*, Munich, 1995, pp. 132ff., is not convincing. The most recent publications discussing the four drawings related to the hanged men are cited in entries by D. Cordelier for the above-mentioned Verona catalogue (Nos. 40–43, pp. 264ff.; see No. 42 for the Frick drawing) and in the catalogue of an exhibition held earlier at the Louvre (to which the Frick drawing was not lent), *Pisanello: Le Peintre aux sept vertus*, Paris, 1996, Nos. 151, 152, pp. 244–46, No. 194, pp. 301–02.

3. Louvre Pisanello catalogue, No. 194; Verona catalogue, No. 40.

4. A. E. Popham and P. Pouncey, *Italian Drawings … in the British Museum: The Fourteenth and Fifteenth Centuries*, London, 1950, p. 134, No. 220.

5. M. Fossi Todorow, *I disegni del Pisanello e della sua cerchia*, Florence, 1966, p. 63. Pisanello's workshop practices and the use of copies from model books drawn by studio apprentices have complicated the attribution of drawings to the artist. See J. Woods-Marsden, "Preparatory Drawings for Frescoes in the Early Quattrocento: The Practice of Pisanello," *Drawings Defined*, pref. K. Oberhuber, New York, 1987, pp. 49–62.

6. K. Andrews, *National Gallery of Scotland: Catalogue of Italian Drawings*, Cambridge, 1968, I, p. 96, No. D 722.

7. M. Baxandall, "Guarino, Pisanello and Manuel Chrysoloras," *Journal of the Warburg and Courtauld Institutes*, XXVII, 1965, p. 190.

8. See W. Paatz, "Una Natività di Paolo Uccello e alcune considerazioni sull'arte del Maestro," *Rivista d'Arte*, XVI, 1934, p. 127. In the background of Uccello's *Nativity* in S. Martino alla Scala, Florence, is a hanging man, and another can be seen in a drawing by Jacopo Bellini in the Louvre (No. RF 1506).

9. The Frick drawing was first recognized as a study by Pisanello for S. Anastasia by G. F.

Hill, in "Gallow-Studies by Pisanello," *Burlington Magazine*, XXXVI, 1920, p. 306. C. Dodgson ("Ein Studienblatt des Vittore Pisano zu dem Fresko in S. Anastasia su Verona," *Jahrbuch der Königlich Preussischen Kunstsammlungen*, XV, 1894, pp. 259–60) first identified the British Museum study.

10. In the 1996 Louvre catalogue, p. 244.

11. A. Vallance, "Auctions," *Burlington Magazine*, XXXVI, 1920, p. 154.

ADDITIONAL REFERENCES

R. Chiarelli, "Note Pisanelliane," *Antichità viva*, XI, No. 2, 1972, pp. 11, 16, 24.

B. Degenhart, *Antonio Pisanello*, Vienna, 1941, pp. 37, 68, No. 67.

B. Degenhart, "Zu Pisanellos Wandbild in S. Anastasia in Verona," *Zeitschrift für Kunstwissenschaft*, V, 1951, pp. 29ff.

E. Sindona, *Pisanello*, Paris, 1962, pp. 121, 131.

J. Woods-Marsden, *The Gonzaga of Mantua and Pisanello's Arthurian Frescoes*, Princeton, 1988, pp. 38, 196, note 57.

SWABIAN

Late Fifteenth Century

VIRGIN AND CHILD (36.3.58)

Pen and black ink, heightened by brush with white, yellow, red, and pink gouache, on dark greenish-blue prepared paper, 8⁷/₁₆ × 5¾ in. (21.5 × 14.6 cm).

INSCRIPTION: In black ink at bottom center: *92*.

DESCRIPTION: The Virgin is seated on a bench in the foreground of a narrow room. With her left arm she supports the Christ Child lying across her lap. He reaches for an apple which she holds in her right hand, just beyond his grasp. The outlines and shadows of the drawing are executed in black ink. The hair of both mother and child is tinted with yellow, their flesh tones are heightened with pink and touches of red. A slightly deeper pink, with small dabs of red, colors the apple. The folds of the Virgin's robe are highlighted with white, as are the architectural details of the room—the windows, the pilasters, and the doorway at right. The ridge-ribs of the low tunnel vaults, the bench, and the book lying on it are heightened in yellow. Whites and yellows gleam with the effect of silver and gold against the black shadows and pervading twilight blue of the prepared ground.

CONDITION: The paper is worn, particularly in the lower half, and has some holes and numerous small tears. A large, irregularly-shaped, cloudy stain at top, extending more than halfway down the three arched windows, appears to have been caused by mold or moisture; the drawing has been retouched throughout this area. The drawing was treated in 1980, when it was taken from its wood pulp support and cleaned of old tape and adhesives. Because its removal would have been hazardous, the paper backing was left intact.

THE drawing was first attributed to the Swabian artist Bernhard Strigel (1460/61–1528) by Parker when it was in the Oppenheimer collection,[1] but a number of drawings once believed to be by Strigel are now doubted, including the Frick *Virgin and Child*. The attribution was accepted by Otto, though with apparent strain since she found the style to be strongly retrospective.[2] Rettich thought the draftsman was earlier than Strigel, and Frankish rather than Swabian.[3] Koreny placed him in Swabia, about 1470–80.[4] Andersson,[5] Falk,[6] Hendrix,[7] and Mielke[8] suggested that he came from Swabia, in the vicinity of Ulm, and was active in the late years of the fifteenth century. Falk has assembled a group of drawings, not all by the same hand, which he believes to be Swabian and which employ a similar

unusual technique of rose and sometimes yellow tints and white heightening on a green or blue-green ground.[9]

Apart from works by a small number of major figures, such as Schongauer, little is certain about German drawings of the fifteenth century. Few can be associated with signed or dated paintings or sculpture, and the graphic production of many artists has never been identified. One such artist is Friedrich Herlin, who was born about 1425/30, perhaps in Ulm, and died in 1500 in Nördlingen,[10] only some forty miles north of Ulm. Certain features of his paintings suggest a link with the present work. Herlin's interior scenes, like the Frick drawing, are set in constricted spaces that recede sharply toward a near background. A number of his interiors are roofed with an odd construction of serial tunnel or trough vaults, such as are seen in the Frick drawing but are rarely found in other fifteenth-century paintings or drawings.[11] The motif of the Virgin and Child seated on a broad, benchlike throne is also repeated in Herlin's work, most notably in the 1459 altar for the Gottesack-erkirche, Nördlingen. However, without stronger evidence and with no drawings attributed to him, one can only surmise that the draftsman responsible for the *Virgin and Child* was at least familiar with Herlin's works in Nördlingen.

At the bottom of the drawing, the number *92* is inscribed in black ink in what appears to be a fifteenth-century hand. Two other drawings by Strigel or his circle bear similar numbers at bottom center. One in the British Museum of the *Holy Family* (No. 1854–6–28–22) has *91* written on the recto and *90* on the verso, which is a fragmentary sketch of a *Standing Virgin and Child*. The other, *Death and the Beggar* in the Ashmolean Museum, Oxford (Parker 344), is marked with the number *24*. These numbers cannot represent dates, since it is highly unlikely that a date would be written using the last two digits alone, or that a single sheet would be dated with one year on the recto and another on the verso, or that the Oxford drawing dates from as late as 1524. It seems more plausible that the drawings once belonged to a large fifteenth-century collection, possibly an artist's studio, and were numbered in sequence. No doubt more numbered drawings, and perhaps prints, will emerge, but obviously a great many have been lost.

Whoever the artist may be, the Frick example of his draftsmanship is of high quality, delicately drawn, with great sweetness and naturalism. The tender scene of a mother and her child is imbued with deeper significance by the inclusion of objects conveying messages designed to remind the viewer that the Virgin was not an ordinary mortal but the mother of the Savior and the embodiment of the Church.

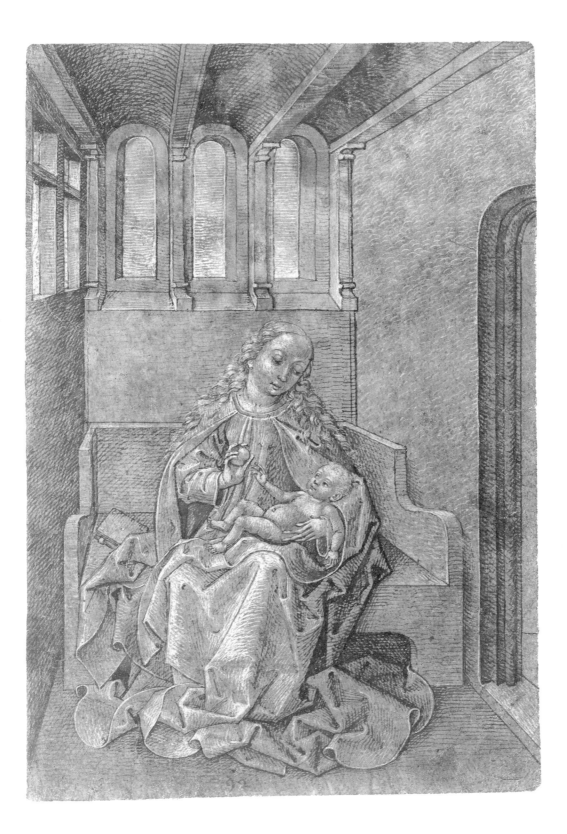

The simple bench is also her throne. The three windows behind her recall the Trinity, and the window to the left, facing Christ, assumes the form of the Cross. The apple the Virgin seems so tentatively to proffer her son is the fruit of Salvation.

<div align="right">B. F. D.</div>

COLLECTIONS: Henry Oppenheimer, London, 1926.[12] His sale, July 10–14, 1936, Christie's, Lot 405. Frick, 1936.

NOTES

1. K. T. Parker, "Bernhard Strigel," *Old Master Drawings*, VII, 1932, pp. 27–28. Parker reported that Oppenheimer acquired the drawing in 1926.

2. G. Otto, *Bernhard Strigel*, Munich, 1964, pp. 19, 107.

3. E. Rettich, "Bernhard Strigels Handzeichnungen," *Kunstgeschichtliche Studien für Kurt Bauch*, Berlin, 1967, pp. 110, 113.

4. Fritz Koreny, orally, April 18, 1997.

5. Christiane Andersson, orally, May 10, 1984.

6. T. Falk, "Baldungs jugendliches Selbstbildnis: Fragen zur Herkunft seines Stils," *Zeitschrift für Schweizerische Archäologie und Kunstgeschichte*, XXXV, 1978, p. 219.

7. Lee Hendrix, orally, August 26, 1994. In a later letter (March 21, 1997), Hendrix felt more positive about an attribution to Strigel, adding that "at the least … the drawing is Swabian and from his orbit."

8. Hans Mielke, orally, March 21, 1986.

9. *Op. cit.*

10. A. Stange, *Kritisches Verzeichnis der deutschen Tafelbilder vor Dürer*, Munich, 1970, II, p. 224.

11. This type of vaulting, constructed of wattle and daub resting on wooden beams, was naturally highly perishable and was probably more common in domestic buildings than in grander public architecture. Apart from several paintings by Herlin, the author has found only about a half-dozen examples depicting such vaults, most of them in drawings or manuscripts and most of them Flemish. Closest to the Frick drawing, in a number of ways, is one in the Louvre (No. 20.669) of a *Virgin with Saints and Donor*, believed to be a copy after the Master of Flémalle. According to Luc Devliegher (orally, 1994), such vaults were not employed at Bruges but were common in Brabant, an opinion confirmed by A. Bergmans, Bestuur Monumenten, Brussels (letter of December 7, 1994).

12. See note 1, above.

ALBRECHT ALTDORFER

Probably 1480s – 1538

Neither the date nor the place of Altdorfer's birth is known. He became a citizen of Regensburg in 1505 and spent the rest of his life in that port city on the Danube, where he prospered and was assigned important civic and diplomatic responsibilities. Painter, architect, and illuminator, Altdorfer was also a prolific draftsman and printmaker, whose vibrant, expressive style imbues his varied subjects with an air of fantasy.

MERCENARY FOOT SOLDIER (36.3.56)

Dated, at upper right: *1512.* Pen and black ink, heightened with white gouache applied with brush, on paper prepared with brown wash, 5¹³⁄₁₆ × 4¹⁄₁₆ in. (14.6 × 10.2 cm).

INSCRIPTIONS: On verso, in different hands and media: *Altdorfer*; *f 13*; *Kat. no. 24*; *Auct. Klinkosch, Wien / April 1889*; *A. Altdorfer*; and *4*.

DESCRIPTION: The soldier, viewed from the back, charges forward on a diagonal toward the left rear. His right hand, held by his side, grasps a sword. In his left, which is hidden by his body, he carries a lance. He wears a slashed doublet over a shirt, breeches with long lappets hanging before the knees, and close-fitting hose. What appears to be the plume of a hat froths over his right shoulder. Tufts of grass spring from the hillock beneath his feet. Traces of pen lines at the upper right corner suggest that the drawing may once have included a tree at right.

CONDITION: The drawing has been cut down on all sides. A few damaged spots, notably in the upper and lower left corners and 1 in. above the lower left corner, have been filled. A glue stain is visible at the lower right margin. Two diagonal lines crossing the upper right corner may indicate old creases. There are minor surface abrasions. In 1981 the drawing was removed from its backing and cleaned of glue and tape. Where weakened, the paper was reinforced with Japanese tissue.

THE sheet is dated 1512, a vintage year in Altdorfer's oeuvre for such small, finished drawings on a prepared ground, usually dark in color and most often, as here, a rich shade of brown. Against this enveloping background, the swift, free calligraphy of black and white lines delineates or merely suggests forms, as though they were picked out in a glimmer of moonlight, while their substance is swallowed by the dark ground, making figure and landscape seem almost transparent. This air of fantasy is heightened by Altdorfer's love of idiosyncratic types and costumes and per-

verse choice of postures, with the figure often viewed from the rear, as in the present drawing and in two others of the same period: the British Museum's *St. Christopher Carrying the Christ Child*, also dated 1512,[1] and the Berlin *Samson Battling the Lion*.[2] Neither the Frick drawing nor most of the others of its type can be identified as studies for paintings or prints. They seem instead to be intended as discrete works of art which by their nature allowed great freedom of invention.

The subject of the Landsknecht—the mercenary soldier with his ragged dandyism, the puffs and plumes, the dangling lappets and slashed breeches of his costume—was dear to many artists. Altdorfer often portrayed these independent ruffians, singly and in groups, in prints as well as drawings. The fierce energy of the Frick example is expressed in every quick, wispy stroke of the pen.

Altdorfer was a contemporary of Dürer, Holbein, Grünewald, Cranach, and other notable artists, all strong individualists, widely diverse in style. He must have known their work and also the graphic work of Italian artists, whose prints were documented in his collection. But his own personality seems virtually untouched by others, so consistent and sharply defined were his tastes.

<div align="right">B. F. D.</div>

COLLECTIONS: Josef C. Ritter von Klinkosch, Vienna. His sale, April 15, 1889, Wawra, Vienna, Lot 24. Adalbert Freiherr von Lanna, Prague (on verso Lugt 2773, with *5* written above).[3] Henry Oppenheimer, London. His sale, July 10–14, 1936, Christie's, Lot 350. Frick, 1936.

NOTES

1. F. Winzinger, *Albrecht Altdorfer: Zeichnungen*, Munich, 1952, pl. 38. The Frick drawing is No. 41 of the catalogue.
2. *Idem*, pl. 34.

3. J. Schönbrunner and J. Meder, *Handzeichnungen alter Meister aus der Albertina und anderen Sammlungen*, Vienna, 1896–1906, X, pl. 1091 (as in the collection of "A. v. Lanna, Prag").

ADDITIONAL REFERENCES

H. L. Becker, *Die Zeichnungen Albrecht Altdorfers*, Munich, 1938, No. 76, p. 29.

K. Oettinger, *Altdorferstudien*, Nuremberg, 1959, p. 51.

H. Tietze, *Albrecht Altdorfer*, Leipzig, 1923, p. 86.

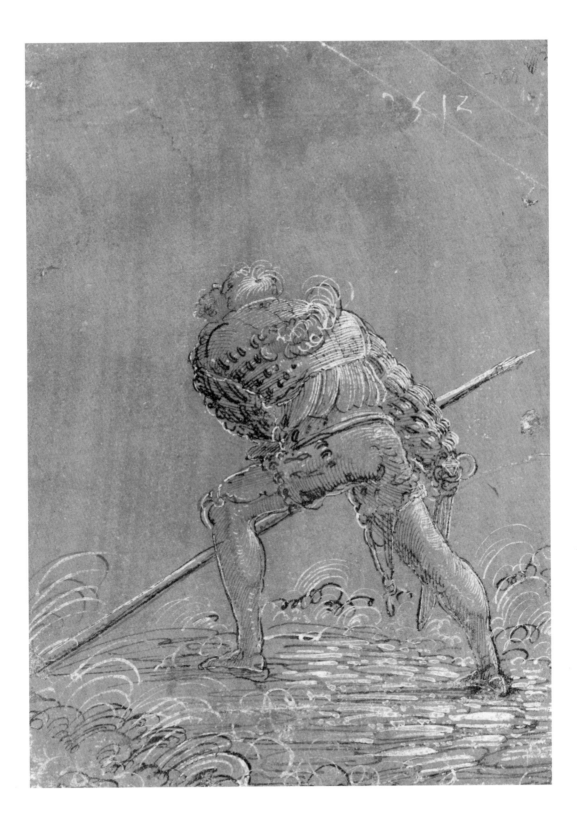

Style of

NIKLAUS MANUEL DEUTSCH

c. 1484–1530

Poet and statesman as well as artist, Niklaus Manuel—who adopted the surname of Deutsch—was a citizen of Berne. He probably received his training there, though he is known to have traveled in Italy. In addition to paintings and drawings, he produced prints and designs for stained glass. His works were imitated by a number of followers, including his son Hans Rudolf Manuel.

A LADY ON HORSEBACK AND A FOOT SOLDIER (36.3.57)

Dated, above the lady's head: *1522*. Pen with black ink, white gouache applied with brush, black ink border, on gray-green prepared paper, 12⅝ × 8⅝ in. (32.1 × 21.9 cm).

MARK & INSCRIPTIONS: Unidentified mark on verso, upper right corner: flower in purplish ink. Inscribed on verso: *12* in red chalk, upper right corner; *469* in ink, upper right corner; *Andi / Hs Burgmair / aus d. Saml. d. Auditeur / Würtemberg / in Danzig* in pencil, lower right; and, below that, two rows of vertical parallel pen marks, six (*c.* ¼ in. high) and ten (*c.* ½ in. high) lines each.

DESCRIPTION: A foot soldier, followed by a woman on horseback, marches toward the left over pebbled ground. He wears an extravagantly plumed hat, a doublet with deeply slashed sleeves, and half-hose—that on the right leg

striped—with scalloped, beribboned cuffs. With his right hand he supports the staff of a billowing standard, and with his left he grasps a scabbard hung from his waist. The lady, riding sidesaddle with her back to the spectator, wears a dress with wide-yoked collar, banded puffed sleeves, and a plumed hat that frames her profile. In her left hand she holds the horse's reins.

CONDITION: The drawing has several repaired areas, notably a vertical tear at upper left, running down through the white portion of the banner, which has been retouched. All four corners have been replaced. There are several marks of horizontal creases and minor staining throughout. In 1981, old hinges, tape, and adhesives, which were causing the paper to contract, were removed.

AN old attribution to Hans Burgkmair inscribed on the back of the drawing is considerably less plausible than its late nineteenth-century attribution to Niklaus Manuel Deutsch.[1] Yet none of the leading experts consulted in recent years believes

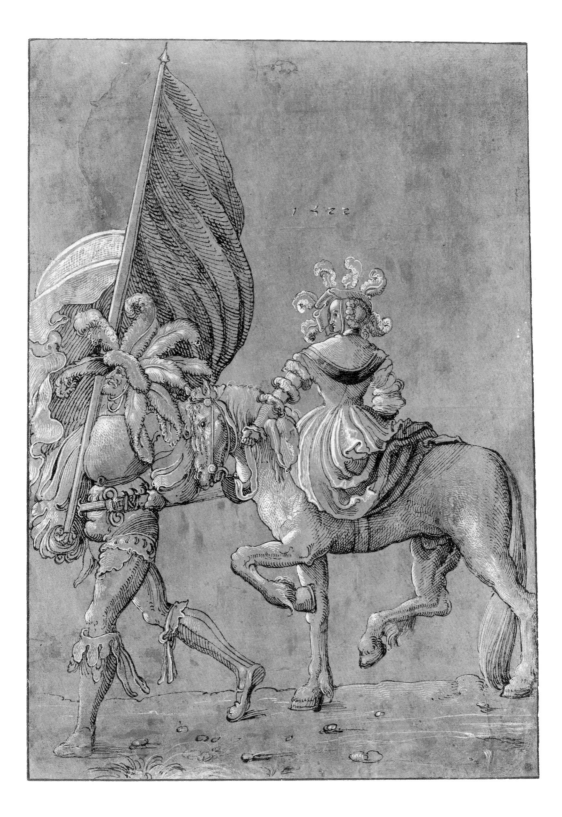

the drawing to be by Niklaus Manuel, and some even wonder whether the artist responsible was Swiss.

Von Tavel is one who not only doubts the attribution to Niklaus Manuel but also questions a Swiss identity.[2] Others skeptical of the attribution include: Falk;[3] Koreny, who sees some Danube School influence;[4] Mielke, who suggested that the drawing might originate from the school of Niklaus Manuel;[5] Andersson, who felt that it could be a copy or adaptation of a drawing by Niklaus Manuel;[6] and Hendrix, who believes it to be a copy, imitation, or pastiche of the period, but more likely by a German than a Swiss artist.[7]

The somewhat wooden aspect of the drawing and the stiff, inanimate character of the pen lines, which convey little of the sprightly modishness of the promenading pair, do hint at a copyist's mentality, as do certain awkward passages. Perhaps the most disturbing of these are various spatial incongruities, such as that presented by the soldier's sword, which though placed far forward over his left hip seems at the same time to pass behind the horse. Other portions of the drawing are strangely flat, notably the lady's skirt and the horse's belly and haunch.

The motif of the foot soldier with a woman on horseback appears elsewhere in German graphic art of the period—for example, in an engraving by Dürer (Bartsch 82) and a drawing by Altdorfer.[8] Niklaus Manuel often drew elaborately costumed women and soldiers, similar to the couple in the present drawing, but he seems to have avoided the portrayal of horses, even in his paintings, offering only occasional fragmentary views of them.

<div align="right">B. F. D.</div>

COLLECTIONS: Divisionsauditeur Würtemberg, Danzig. Karl Eduard von Liphart. His sale, April 26, 1898, Boerner, Leipzig, Lot 254, as Deutsch. Eugène Rodrigues, Paris (Lugt 897, bottom right). His sale, July 12–13, 1921, Muller, Amsterdam, Lot 22. Henry Oppenheimer, London. His sale, July 10–14, 1936, Christie's, Lot 395. Frick, 1936.

NOTES

1. In the von Liphart sale (see *Collections*).
2. Hans Christoph von Tavel, letter of December 1, 1987.
3. Tilman Falk, letter of January 8, 1988.
4. Fritz Koreny, orally, April 18, 1997.
5. Hans Mielke, letter of March 21, 1986.
6. Christiane Andersson, orally, May 15, 1984.
7. Lee Hendrix, orally, July 23, 1993.
8. The Altdorfer drawing is known through a copy in the Kupferstichkabinett, Berlin (KdZ 82).

ADDITIONAL REFERENCES

W. Hugelshofer, *Swiss Drawings of the XV. and XVI. Century*, London,
1928, p. 32, No. 21, pl. 21.

Société de reproduction des dessins de maîtres, Paris, 1912, IV (unnum-
bered plate).

L. Stumm, *Niklaus Manuel Deutsch*, Berne, 1925, p. 96, No. 117.

TIZIANO VECELLIO (TITIAN)

1477/90–1576

A Venetian painter, Titian was more renowned for his color and brushwork than for his skills in the graphic arts. He did, however, make prints and also a few drawings—remarkably few for so long a career. Because of the scarcity of drawings that can be firmly documented and because many derivations and imitations were produced, especially of his landscapes, both during his lifetime and after, attributions to him are seldom undisputed.

LANDSCAPE WITH A SATYR (36.3.55)

Pen and brown ink, 7⁷⁄₁₆ × 8⅛ in. (18.9 × 20.6 cm).

DESCRIPTION: A satyr sits on the ground, a vase beside him, and looks to his right, toward an approaching goat whose head and forefoot appear at the left margin. A rock outcropping and tree stump fill the foreground to the right. In the distance, beyond an undulant terrain, is a small town in which are visible a tower gate, houses with steeply pitched roofs, and smoke rising from behind walls at right. A solitary tree grows on the bank of a lake or river which curves before the town, and a jagged mountain rises beyond the far shore.

CONDITION: The drawing is lightly foxed. On the satyr's right shoulder is the trace of what appears to be an added patch of gray chalk. The truncated figure of the goat at left indicates that this margin at least has been cropped. In 1980 a secondary support was removed from the verso, but the first laid paper backing was left in place.

THE *Landscape with a Satyr* is a puzzling drawing. The subject itself is enigmatic and provocative, made more mysterious by a loss of unknown extent at left (see *Condition*). One cannot feel certain that a simple pastoral scene (of the sort so favored in the Veneto) was intended, or whether perhaps the artist meant to convey some layer of moralizing meaning within the classical subject, as Roman poetry on pastoral themes often did.

Not only the subject but also the attribution and date of the drawing are moot issues and, like the subject, remain matters of individual judgment, problems not

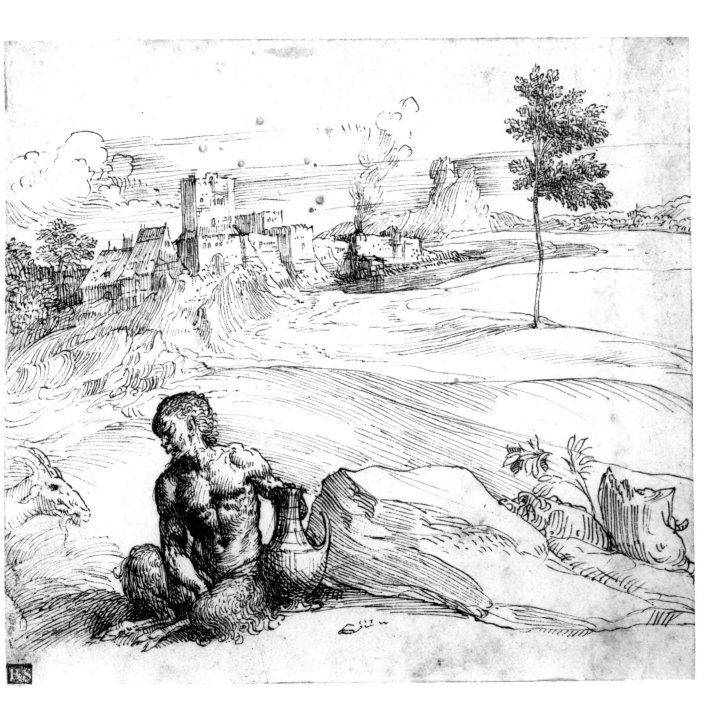

capable of resolution until some form of external evidence is discovered to support one theory or another. Among opinions published since 1920, more scholars have accepted the drawing as a work by Titian than have doubted the attribution. Those in favor include: Hind (1921, without great conviction),[1] Ames (1963),[2] Rearick (1976, 1977),[3] Oberhuber (1976, 1978),[4] Pignatti (1979),[5] Shaw (1980),[6] Saccomani (1982),[7] and Wiel (1988, 1989).[8] Those who questioned the attribution include: Popham (1931, school of Titian but not Domenico Campagnola),[9] Tietze and Tietze-Conrat (1944, circle of Titian but not Campagnola),[10] Rosand (1981, more likely Campagnola than Titian),[11] and Wethey (1987, "Titian (?) and workshop, or Domenico Campagnola").[12] All of the opinions provided orally have been negative: Sydney Freedberg (1974, Venetian or Paduan, but not attributable), John Gere (1974, Venetian or Paduan, nearer to early Campagnola than Titian), Peter Dreyer (1988, not Titian), and Charles Hope (1989, closer to Campagnola than Titian). Opinions about the date of the drawing also diverge, with most authors arguing for an early period, about 1510 to 1515, while others place it in the 1530s.[13]

Those endorsing an early date generally compare the drawing to two others they consider early works by Titian: the *Two Satyrs with an Astrological Disk* from the Baer collection and the *Castle on a Hill* in the British Museum (No. 1895–9–15–832). However, neither of these drawings is more firmly attributed or dated than the Frick *Landscape with a Satyr*. And though the three resemble each other superficially in the subjects represented and through their common graphic language rooted in the Veneto, stylistically they differ quite sharply. When the present landscape is studied side by side with the coarser, much more vigorous Baer drawing, one can at best conclude that if the two are by the same hand, they cannot be close in date. The British Museum sketch appears to have been composed by an artist with yet another vision of landscape, one with a far greater sense of coherence, sweep, and space, though it is conceivable that the staccato, additive, flattening organization of the Frick landscape has been exaggerated by the cropped condition of the sheet.

As Hope has sagely remarked: "There exists not a single drawing with Titian's handwriting on it and only a few which can with any degree of confidence be considered as preparatory designs for his paintings or prints. As a result the study of his drawings is a connoisseur's paradise, where attributions are often based on little more than hunches that are made all the more unreliable by our relative ignorance of other North Italian draughtsmen of the period."[14]

It is conceivable nevertheless that a clue extracted from within the drawing itself might eventually lead to some promising paths, for it seems that the artist may have been left-handed. The dominant movement of the composition from upper left to lower right and the prevailing slant of the longer pen strokes in the same direction suggest this possibility. A number of drawings by or attributed to Domenico Campagnola exhibit a similar tendency, though it is less pronounced in those works. Perhaps a pattern will one day emerge that will bring greater clarity to the study of Venetian drawings and will help to sort out Titian's works from those of his contemporaries and imitators.

<div align="right">B. F. D.</div>

EXHIBITED: London, Messers. Woodburn's Gallery, One Hundred Original Drawings by Albert Dürer and Titian Veccelli, Collected by Sir Thomas Lawrence, May 1836, No. 79. London, Burlington Fine Arts Club, The Venetian School: Pictures by Titian and his Contemporaries, 1914, No. 59, lent by Henry Oppenheimer. London, Royal Academy, Italian Drawings, 1930, No. 271, lent by Henry Oppenheimer.

COLLECTIONS: Paul Sandby, London (Lugt 2112, recto, bottom left). Sir Joshua Reynolds. Sir Thomas Lawrence. Samuel Woodburn, 1835.[15] His sale, May 1836, Lot 79. William Esdaile, 1836.[16] His sale, June 30, 1840, Christie's, Lot 87. Andrew James.[17] Miss James. Her sale, June 27, 1891, Christie's, Lot 253. John Postle Heseltine, London. P. and D. Colnaghi, 1912.[18] Henry Oppenheimer, London. His sale, July 10–14, 1936, Christie's, Lot 196. Frick, 1936.

NOTES

1. [A. M. Hind,] *Vasari Society for the Reproduction of Drawings by Old Masters*, Ser. 2, Pt. 2, London, 1921, p. 7, No. 9.

2. W. Ames, *Drawings of the Masters: Italian Drawings from the 15th to the 19th Century*, New York, 1963, p. 30.

3. W. R. Rearick, *Tiziano e il disegno veneziano del suo tempo*, Florence, 1976, p. 41, No. 18, and *Maestri veneti del cinquecento*, Florence, 1977, p. 27, No. 9.

4. K. Oberhuber, *Disegni di Tiziano e della sua cerchia*, Vicenza, 1976, pp. 15, 35, 132, and "Tiziano disegnatore di paesaggi," in *Tiziano e il manierismo europeo*, ed. R. Pallucchini, Florence, 1978, pp. 121, 124.

5. T. Pignatti, *Tiziano disegni*, Florence, 1979, p. 8, cat. XVI.

6. J. B. Shaw, "Titian's Drawings: A Summing-Up," *Apollo*, CXII, 1980, p. 387.

7. E. Saccomani, "Domenico Campagnola disegnatore di 'paesi': dagli esordi alla prima maturità," *Arte Veneta*, XXXVI, 1982, pp. 81, 94, note 11.

8. M. A. C. M. Wiel, "Per un catalogo ragionato dei disegni di Tiziano," in *Saggi e memorie di storia dell'arte*, XVI, 1988, p. 47, and

Tiziano Corpus dei disegni autografi, Milan, 1989, p. 88, No. 19.

9. A. E. Popham, *Italian Drawings Exhibited at the Royal Academy, Burlington House, London, 1930*, London, 1931, p. 74, No. 271.

10. H. Tietze and E. Tietze-Conrat, *The Drawings of the Venetian Painters in the Fifteenth and Sixteenth Centuries*, New York, 1944, p. 329, No. 1995.

11. D. Rosand, "Titian Drawings: A Crisis of Connoisseurship?," *Master Drawings*, XIX, 1981, p. 307, note 12.

12. H. E. Wethey, *Titian and His Drawings*, Princeton, 1987, pp. 50, 159, No. 43.

13. Most authors who attempt to date the drawing place it in the earlier period, but Oberhuber (1978, p. 121) argues for a date in the 1530s. Wethey (*loc. cit.*) suggests a date of about 1535.

14. C. Hope, review of Wethey (*op. cit.*) in *Times Literary Supplement*, No. 4, 1989, p. 505.

15. For a summary of the Lawrence-Woodburn sales, see F. Lugt, *Les Marques de collections*, Amsterdam, 1921, I, p. 455, No. 2446.

16. The purchase date 1836 preceded Esdaile's initials written on the old mount of the drawing.

17. Lugt states (p. 491, No. 2617) that many drawings were bought at the Esdaile sales for Andrew James. James' daughter, the next owner of the drawing, inherited much of his collection.

18. According to Lugt (p. 275), the Heseltine mark was stamped on his drawings in 1912 by P. and D. Colnaghi when they bought most of his collection.

SIR PETER PAUL RUBENS

1577–1640

A cultivated and cosmopolitan gentleman, Rubens made his home in Antwerp but traveled to many of the major European cities, sometimes on diplomatic missions, often to paint the palaces, portraits, and churches of the eminent patrons who clamored for his works. Frequently conceived on a vast scale, his decorative cycles, festival decorations, and other important commissions were accomplished with the aid of an extensive shop. Rubens' drawings served a range of purposes and hence vary widely in type. They include careful studies that might guide his assistants, finished oil modelli to be sent to distant patrons for approval, and countless sketches that seem to transmit motifs freshly and directly from eye and mind to hand. His catholic tastes and keen interest in the art of other countries and periods are demonstrated by his own rich collections and the drawings he made from works of art of all kinds.

STUDIES OF VENUS(?) (*recto*); STUDIES FOR A LAST JUDGMENT (*verso*) (36.3.59)

Pen and brown ink, 8 × 11⅟₁₆ in. (20.3 × 28.1 cm).

MARK & INSCRIPTIONS: Watermark: cross within a drop-shaped loop ending in two small loops 1⁹/₁₆ in. high. Inscribed on recto in faded ink at lower left: *43* [?] *P. P. Rubens*; and in brown ink vertically along the lower left side: *Pagan* [?].

DESCRIPTION: On a diagonal, one above the other beginning at lower right, are three studies of a nude woman, probably Venus, reclining on drapery and pillows. In the first study she appears to lie sleeping, her eyes closed, her head resting against her right arm. In the second study, propped higher by the pillows, she stares out, her chin supported on her right hand, while behind her an infant Cupid clasps her left shoulder and seems to whisper in her ear. At the top, she lies with her back to the spectator, her right arm flung across the pillows, her head turned to glance outward, as though startled by the embrace of Cupid, who faces her, his left hand grasping her right shoulder. Above Cupid appear a pair of crossed feet (see below). On the verso are sketches for a Last Judgment, consisting of nine figures of angels and blessed women ascending toward heaven. Two of the figures lightly sketched at bottom left barely rise above the margin; only the arms, clasped hands, and raised head of one and the torso, crossed arms, and head of another can be seen. Above them a pair of entwined women are drawn upward by an angel, while higher and beyond this group a second angel propels aloft a solitary woman with arms outstretched before

25

her. Below them a woman, held in the arms of another, reaches upward as though clutching at an invisible support.

CONDITION: The drawing has been cut from a larger sheet (see below) and is creased in several places.

COUNT Antoine Seilern was the first to observe the connection between his double-sided drawing by Rubens, now in the Courtauld Institute Galleries, London, and the sheet of studies in The Frick Collection.[1] After initial doubts about the Frick drawing, Held not only accepted the attribution but demonstrated that the Frick and Seilern drawings had once formed a single page which had been cut approximately across the middle, with only a slight loss between the two parts.[2] The dimensions of the two are nearly identical (the Seilern sheet measures 20×28.3 cm), the paper appears to be the same, and in both a crease runs vertically about 1 cm from the left edge. Combined, the two would have measured at least 41 cm high, a normal size for the artist.

On one side of each of these sheets are pen studies of reclining nude women, several of them sleeping. At top center of the Frick sheet is a pair of feet, severed and forever separated from the sleeping woman at the bottom of the Seilern sheet. One of the four women on the recto of the Seilern drawing is spied upon by a satyr; two of the three in the Frick portion are caressed by a small Cupid. On the verso of both drawings are other sketches of nude women, these being lifted aloft by angels. The Seilern verso has an additional faint sketch of a Virgin and Child with three male figures.

Of all of these figure studies, only a pair on the verso of the Frick drawing seems to relate closely enough to a surviving painting to suggest a direct connection. The sketch at top center of an angel propelling a supplicating woman upward resembles a pair toward the top left in the lunette of the *Small Last Judgment* in the Alte Pinakothek, Munich (No. 611), though a man rather than an angel clasps the woman in the painting. The two partial figures with hands joined as in prayer lightly sketched at bottom left may also relate to similar motifs at top left in the painting, though the pose is not uncommon in Rubens' work. The *Small Last Judgment* is believed to date about 1618–20, but the lunette top is an addition to the altarpiece, perhaps contemporary with it or possibly slightly later;[3] this uncertainty clouds the dating of the drawing, which is often assigned nevertheless to those same years.[4]

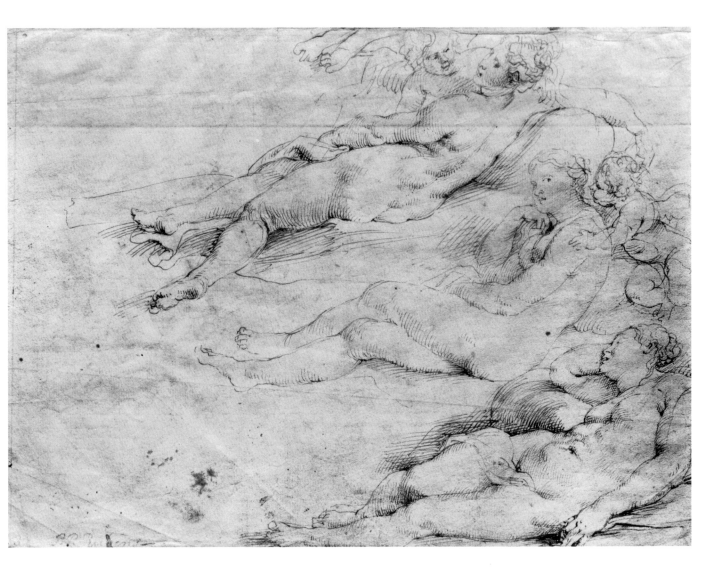

A further complication is introduced by the group of an angel hoisting two women upward, which appears twice on the verso of the Seilern sheet and once on the Frick drawing. (Toward the right on the Frick work, a second version presents the two women alone, without their angel.) Yet another sketch for this group is found in the British Museum (No. 1885–5–9–51) amidst a sheet of figure studies, some evidently related to the Munich *Fall of the Damned* (No. 320) but others seemingly associated with the Munich *Assumption of the Blessed* (No. 353);[5] the former canvas is believed to date from the end of the 1610s, but the date of the latter is uncertain and may be somewhat later. A motif similar to these various sketches

27

of the trio—but with only one woman supported by an angel (a man raised by another angel is pressed so close beside them that the four seem a unit) and with the figures differently posed—does appear in a painting by Rubens, the *Great Last Judgment*, also in Munich (No. 51), datable to 1615–16. Several hypotheses could be elaborated to explain how the sketches might have functioned in preparing the altarpieces and the lunette top of the *Small Last Judgment*. However, with no valid objective evidence to sustain one argument over another, one can only suggest the obvious: that the subject of the Last Judgment and related themes occupied Rubens' imagination during the second half of the second decade and that he invented, then developed or discarded, many interrelated ideas for these projects.[6]

While the visions of salvation and damnation worked out on the verso of the Frick-Seilern drawing and in the related paintings are permeated with memories of Rome and Michelangelo, the recto of the drawing recalls the sensuous world of Venice. The languorous nymphs and goddesses of Giorgione and Titian are evoked but not directly copied, nor were the recumbent figures in the drawing exact models for any surviving canvas by Rubens. Venus or Diana, Iphigenia or Angelica or Antiope: these legendary beauties all assume similar poses in his paintings, but the subject and purpose of the sketches are as yet undetermined.

B. F. D.

COLLECTIONS: William Young Ottley, London. His sale, June 6–23, 1814, T. Philipe, London, Lot 1170. Sir Thomas Lawrence (Lugt 2445, recto, bottom left). Samuel Woodburn. His sale, June 4 *et seq.*, 1860, Christie's, Lot 912(?).[7] Robert Prioleau Roupell (Lugt 2234, verso, top left). His sale, July 13, 1887, Christie's, Lot 1132. Sir J. Charles Robinson(?).[8] John Postle Heseltine, London (Lugt 1507, verso, bottom left).[9] P. and D. Colnaghi. Henry Oppenheimer, London. His sale, July 10–14, 1936, Christie's, Lot 307. Frick, 1936.

NOTES

1. *Flemish Paintings and Drawings at 56 Princes Gate London SW7*, London, 1955, I, p. 97.

2. J.-A. Goris and J. S. Held, *Rubens in America*, New York, 1947, p. 56; J. S. Held, *Rubens Selected Drawings*, London, 1959, pp. 112–13 (repeated in revised ed., 1986, p. 122).

3. D. Freedberg, *Rubens: The Life of Christ After the Passion (Corpus Rubenianum Ludwig Burchard, Pt. VII)*, London–New York, 1984, p. 215.

4. Held, 1959, p. 113.

5. J. Rowlands, *Rubens Drawings and Sketches: Catalogue of an Exhibition ... in the British Museum*, London, 1977, No. 89.

6. Freedberg (p. 210) suggested that figures

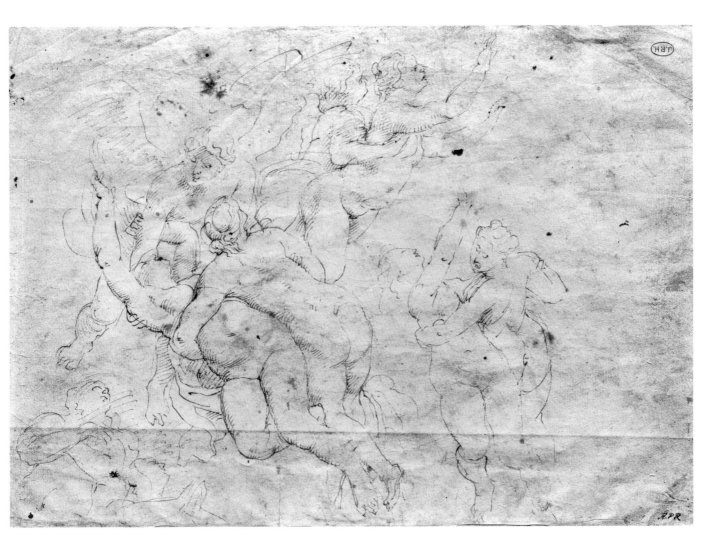

on the verso of the Seilern drawing that seem to be a sketch for an Adoration of the Magi may relate to the altar in Mechlin, in place by 1617. L. Burchard and R.-A. d'Hulst (*Rubens Drawings*, Brussels, 1963, I, p. 142) pointed out that other paintings of these years include "ravishing" motifs with similar figure groups, such as the *Rape of Proserpine*.

7. Two drawings sold from the Woodburn collection might be the by-then divided Frick and Seilern sheets: Lot 785, "Nymphs sleeping—delicately drawn with the pen; with other studies on the back"; and Lot 912, "Nymphs sleeping—delicate pen; with some studies of females on the back."

8. M. Rooses (*Rubens*, trans. H. Child, London, 1904 [French ed. 1886–92], II, p. 623) illustrated the recto of the drawing, with the caption: "Lately in the collection of Sir Charles Robinson." However, in another publication of the same years ("Oeuvre de Rubens. Addenda et corrigenda," *Bulletin–Rubens* [*Annales V*],

1897, p. 196), Rooses catalogues the drawing as in the Heseltine collection, describing but not illustrating it.

9. According to F. Lugt (*Les Marques de collections*, Amsterdam, 1921, I, p. 275), this mark was stamped on the Heseltine drawings in 1912 by P. and D. Colnaghi when they bought most of his collection.

ADDITIONAL REFERENCE

K. E. Simon, "Rubens' Satyrn und die ruhende Diana," *Jahrbuch der Preussischen Kunstsammlungen*, LXIII, 1942, p. 113, note 3.

CLAUDE LORRAIN

1600–1682

The name by which Claude Gellée is best known comes from his birthplace, the duchy of Lorraine. Around 1613 he traveled to Rome, where he became an assistant to the landscape painter Agostino Tassi and learned the rudiments of painting and the technique of fresco. After a stay in Naples he returned to Lorraine in 1625–26, assisting the court painter Claude Deruet with frescoes for the Carmelite church in Nancy. There is no record of his having left Italy again. Claude devoted himself chiefly to idealized landscapes of Rome and the surrounding Campagna and, in later years, to Biblical and mythological subjects; among his patrons were popes, princes, and members of the nobility. His drawings were highly valued by his contemporaries. Of the approximately thirteen hundred sheets known today, the largest number are composition and figure studies for specific paintings, followed by plein-air sketches conceived as autonomous works and by reproductive drawings intended as visual records of his canvases. This last group he brought together in an album known as the Liber Veritatis. Claude is ranked among the greatest of draftsmen.

VIEW FROM TIVOLI (82.3.123)

Inscribed, on the verso at lower left: *faict Claud 1651 Tivoli*. Black chalk, pen and iron-gall ink, and two shades of iron-gall wash, on white laid paper, 7⅞ × 10½ in. (19.9 × 26.8 cm).

MARK: Watermark: a bird on three mounts inscribed in a circle.

DESCRIPTION: Depicted in brown ink in the foreground are three hunters—two at left and one to the right of center—about to descend into a valley. They wear doublets and large plumed hats and carry long-barreled rifles over their shoulders; the heads of those at left are silhouetted against an area of white. Beyond the figures stretches a panorama of rolling, tree-covered hills and low mountains, those in the middle distance drawn in ink and chalk with areas of light wash, and the farthest ridge represented only in chalk outline. The scene is bordered by a line of brown ink just inside the margins; below, the line disappears except at right.

CONDITION: The drawing is in good condition. In 1983 it was treated to reduce foxing and some glue stains left by former mounts, and old hinges and adhesives were removed. At

31

lower left, the iron-gall ink has fractured the pa-per, which is supported in that area by Japanese tissue. There are stains at upper left, right, and at center from a previous mounting.

THIS nature study is the earliest of three drawings by Claude in The Frick Collection, all of which come from an album of the artist's work that had long been lost. Comprised originally of eighty-one drawings mounted to the pages of a book, the album came to light in 1957 and was purchased by Georges Wildenstein in 1960.[1] It is not known who assembled the album, but Roethlisberger, who first catalogued the drawings, speculates that it was put together soon after Claude's death by one of his heirs, perhaps with a specific buyer in mind.[2] It is first recorded in an inventory of 1713 made after the death of Prince Don Livio Odescalchi (1653–1713), one of the foremost collectors of the seventeenth century.[3] Although it has been conjectured that the album had previously been owned by Queen Christina of Sweden, who lived principally in Rome from 1655 until her death there in 1689 and whose famed collection of paintings, sculpture, drawings, and decorative art was bought *en bloc* by Odescalchi in 1692, there is no firm documentation to support this assumption.[4] The album contained outstanding examples, in superb condition and in a variety of techniques and media, of all the major types of drawings Claude executed during his career.

Roethlisberger claims that the artist's viewpoint in this drawing must have been looking northward from Tivoli, with the area of white behind the hunters' heads at left representing haze, not water as has been believed.[5] Dated 1651, the sketch comes at the end of a decade of frequent forays by Claude to Tivoli and its environs, where he executed some of his finest nature studies. The fashionably dressed hunters who overlook the panorama of rolling hills and mountains, enveloped in atmosphere, are characteristic of the figures from everyday life that populate Claude's plein-air studies of the Roman countryside.[6]

The composition of the drawing, consisting of alternating horizontal and diagonal bands of light and dark with few framing elements at the sides, is notable for its simplicity. A similarly spare composition characterizes the *Panorama from the Sasso near Rome* (also from the Wildenstein album) of two years earlier.[7] Although most of Claude's drawings are unsigned, both of these panoramic vistas bear the artist's signature, inscriptions identifying the place where they were executed, and a date, suggesting their special importance to him.[8]

The blurring of the outlines of the backlit hunters, and the use of different media

32

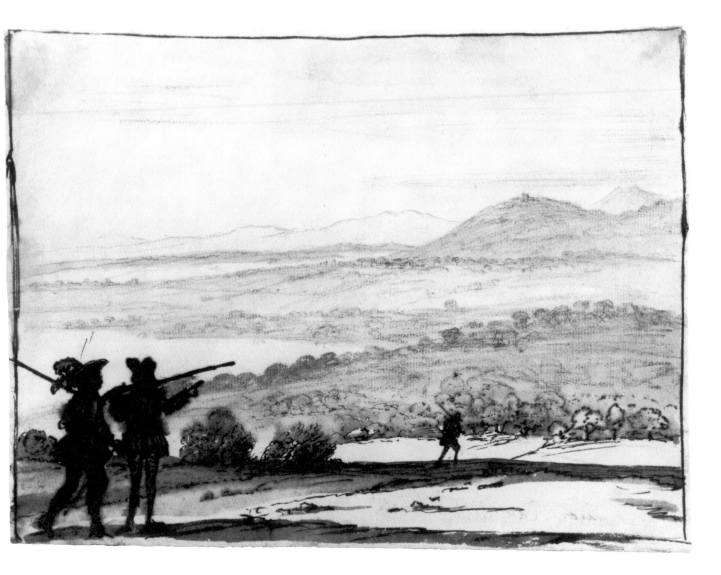

in the foreground, middle distance, and background, reveal Claude's sensitivity to the optical effects of light, and his ability to find graphic equivalents to express them. Whether this drawing was executed entirely before the motif, as were many of Claude's Tivoli drawings of the 1640s, or begun outdoors and finished in the studio is impossible to determine. According to Roethlisberger, the highly finished quality of the drawing, taken with the fact that Claude traveled little in his later years due to poor health, suggests that the work was either completed in the studio, or executed there entirely, after a preliminary sketch.[9]

Like most of Claude's nature studies, this drawing has not been connected with a known canvas. In its simplicity of structure and deep atmospheric space, however, it anticipates the heroic landscapes of the 1650s in which mythological and Biblical scenes are set, such as The Frick Collection's *Sermon on the Mount* of 1656.

S. G. G.

EXHIBITED: San Francisco, California Palace of the Legion of Honor, Claude Lorrain Drawings, 1970.

COLLECTIONS: Inventoried in 1713 in the collection of the late Prince Don Livio Odescalchi. Collection of a Polish family (1845). Swiss collection (1939). Georges Wildenstein, 1960. Norton Simon, 1968. Eugene V. Thaw, New York, about 1980. Frick, 1982.

NOTES

1. See the following publications by M. Roethlisberger: *Claude Lorrain: The Wildenstein Album*, Paris, 1962, No. 5, p. 15, pl. 5; *Claude Lorrain: The Drawings*, Berkeley—Los Angeles, 1968, I, No. 707, and p. 271, II, pl. 707; *The Claude Lorrain Album in the Norton Simon, Inc. Museum of Art*, Los Angeles, 1971, No. 32, p. 24, pl. 24; and "Claude Lorrain: Ses Plus Beaux Dessins retrouvés," *Connaissance des Arts*, December 1962, pp. 138–47.

2. Roethlisberger (1971, pp. 7–8) assumed from the consistent quality of the selection that only someone who both knew Claude's work well and had access to his studio could have put the album together. Claude rarely parted with his drawings.

3. For a recent discussion of this collection, see M. Roethlisberger, "The Drawing Collection of Prince Livio Odescalchi," *Master Drawings*, XXIII–XXIV, No. 1, 1986, pp. 5–30. Of the original eighty-one drawings in the album, eight were acquired and removed in 1957 by the London dealer Hans Calmann, another nine were removed before 1960,

and three or four may be missing. The album was taken apart in 1980, and the works were sold individually (*idem*, p. 27, note 56). See also M. Mahoney, "Salvator Rosa Provenance Studies: Prince Livio Odescalchi and Queen Christina," *Master Drawings*, III, No. 4, 1965, pp. 383–88.

4. At Queen Christina's death, her collection, including some two hundred seventy-five paintings and two thousand drawings, passed to Cardinal Decio Azzolini, who died only a few months later; the cardinal left it to his nephew, Marchese Pompeo Azzolini, who sold it to Prince Livio Odescalchi. On the collection of Queen Christina, see J. Q. van Regteren Altena, *Les Dessins italiens de la reine Christina de Suède*, Stockholm, 1966.

5. Roethlisberger, 1971, p. 24.

6. On the use of figures in Claude's nature sketches, see M. Kitson, "Claude as a Figure Draughtsman," in *Drawing: Masters and Methods, Raphael to Redon*, London, 1992, pp. 67–68.

7. See M. Roethlisberger, "A Panoramic View by Claude Lorrain," *Art Institute of Chi-*

cago Museum Studies, 11, No. 1, Spring 1985, pp. 103–15. The Frick drawing is reproduced on p. 108.

8. *Idem*, p. 104.

9. *Idem*, p. 107. Roethlisberger cites a notebook discovered in 1982 containing very slight working sketches, presumably executed before the motif, that Claude might normally have destroyed. Compared with these, he comments, "the bulk of his drawings appear in a very different light, as definitive showpieces of painstaking execution."

HEROIC LANDSCAPE (*recto*); SKETCHES OF CASSONI, FIGURES, AND CLOUDS (*verso*) (82.3.124)

Drawn about 1655–58. Pen, iron-gall ink, brown wash, gray wash, and white heightening applied by brush, on cream laid paper, sheet size 11⅞ × 15¹¹⁄₁₆ in. (30.1 × 39.6 cm), image within drawn border 8¾ × 13 in. (22.2 × 33 cm).

DESCRIPTION: On the recto, the foreground is dominated at left by two men approaching the top of a rise and at the right edge by a tall tree. In the middle distance at left, a small stand of trees grows from a rocky outcropping, while at right the land drops to disclose more trees, a valley, a large body of water with isolated buildings along its shore, and distant low mountains. A heavy storm cloud hangs over the water, and two diagonal flocks of birds converge at upper center. The figures are drawn in brown ink, with dark brown wash and white heightening; gray wash is used over brown ink in the middle distance; and the farther mountains and clouds are sketched in brown ink with light brown and gray washes. At center on the verso are studies for the storm cloud seen on the recto. Above them is a sketch for what appears to be a cassone, with three arched panels dividing a scene of a sunrise over water; below are three variations on the cassone, one of them incorporating putti. Three more putti appear across the bottom of the sheet, and two men in antique garb stand at left.

CONDITION: In 1983 the sheet was inlaid with Japanese tissue fibers and starch paste along the edges. Some surface abrasion has occurred, the iron-gall ink has darkened, the white heightening has taken on a bluish cast, and staining and some pigment loss appear along the right edge. Otherwise, the drawing is in good condition.

THIS elaborate compositional study—which was also taken from the Wildenstein album discussed in the previous entry—has been identified by Roethlisberger as an experimental *pensée* for Claude's *Landscape with David and the Three Heroes*, a large canvas of 1658 now in the National Gallery, London.[1] The painting depicts an event from David's battles with the Philistines (2 Samuel 23: 13–17) which extols the virtue of stoicism. Looking down on the enemy camp at Bethlehem from his mountain refuge, David longed for water from the well at the town gate. When three soldiers broke through the enemy ranks to bring him some, however, the King refused to accept it, because the men had put their lives at risk; instead he offered it to the Lord.

The Frick drawing, which Roethlisberger placed at the first stages of the development of the painting, reflects only a fragment of the episode, yet some elements of the final work are in place.[2] The two figures ascending the hill, whose role is unspecific here, reappear again in more developed form in a later preparatory sketch for the painting, a drawing of about 1658 in the Museum Boymans-van Beuningen,

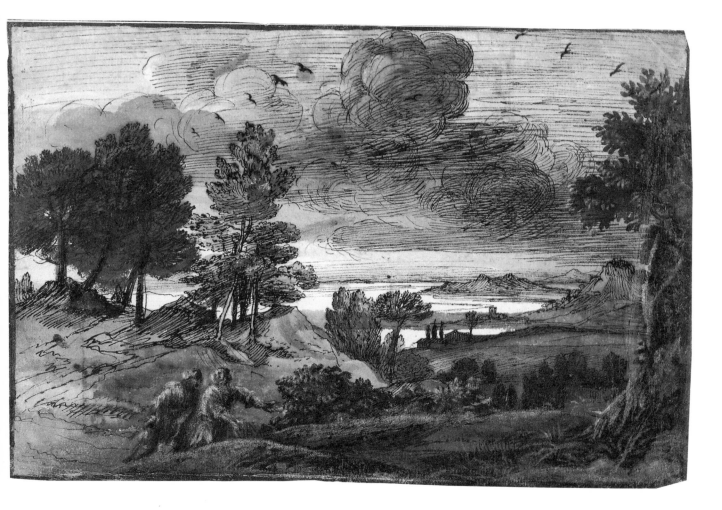

Rotterdam.[3] In that work, they correspond closely to two soldiers who in the painting approach the principal group from the left and thereby direct attention to it. The central protagonists—David, the three heroes, and some onlooking soldiers—were treated in a separate preparatory figure study that was also in the Wildenstein album.[4]

Executed in a combination of virtuoso pen and brush techniques and conceived as an autonomous drawing, complete with framing trees, the Frick work is, as Roethlisberger notes, unusual among Claude's elaborate preparatory sketches for its "searching quality"; the artist can be seen here actively working out his composition, seeking an appropriate landscape setting for the Biblical story.[5] The downward compression of the swelling forms of the storm cloud on water below (prob-

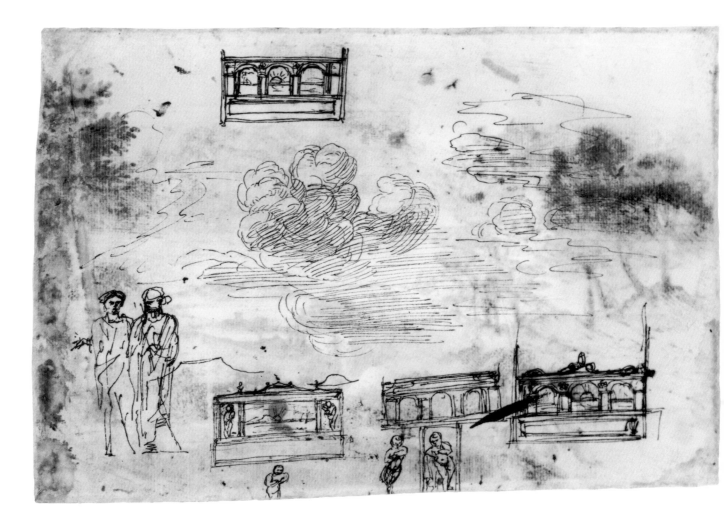

ably meant to represent the Dead Sea) and the strong contrasts of light and dark contribute to an accentuation of expression and a sense of anticipation. As he developed the painting, however, Claude abandoned the early dramatic conception of the landscape seen here in favor of a more serene setting and peaceful atmosphere.

On the back of the Frick drawing, Claude executed studies for the threatening storm cloud that dominates the scene, along with other miscellaneous sketches.[6] The four cassone sketches, Roethlisberger speculates, may have been for a cabinet Claude was designing for himself; the inventory of his studio made after his death listed one that measured "one hand high and two hands wide, and four hands long" and was "full of engravings and drawings,"[7] but lacking a more specific description

there is no way of connecting these sketches to that chest. The two male figures in antique garb shown at left in the drawing are reminiscent of two men seen in yet another drawing from the Wildenstein album contemporary with the Frick drawing, a study for the *Landscape with Queen Esther Approaching the Palace of Ahasuerus* of 1658.[8]

<div align="right">S. G. G.</div>

EXHIBITED: Same as preceding entry. COLLECTIONS: Same as preceding entry.

NOTES

1. M. Roethlisberger, *The Claude Lorrain Album in the Norton Simon, Inc. Museum of Art*, Los Angeles, 1971, p. 26, No. 38, pl. 38, and "Claude Lorrain: Ses Plus Beaux Dessins retrouvés," *Connaissance des Arts*, December 1967, repr. p. 140, No. 2. For the painting, see M. Roethlisberger, *Claude Lorrain: The Paintings*, New Haven, 1961, I, No. LV 145, p. 343, II, fig. 240.

2. Roethlisberger, 1971, p. 26.

3. M. Roethlisberger, *Claude Lorrain: The Drawings*, Berkeley—Los Angeles, 1968, I, No. 809 recto, p. 304, II, pl. 809 recto. Roethlisberger notes that while the figures correspond closely with those in the painting, the setting differs.

4. *Idem*, I, No. 810, p. 304 II, pl. 810. See also M. Roethlisberger, *Claude Lorrain: The Wildenstein Album*, Paris, 1962, No. 55, p. 31, pl. 57.

5. Roethlisberger, 1968, I, p. 292.

6. On the subject of clouds in Claude's work, see M. Roethlisberger, "Some Early Clouds," *Gazette des Beaux-Arts*, 6e pér., CXI, 1988, pp. 287–88.

7. Roethlisberger, 1962, No. 61, p. 33, pl. 61.

8. *Idem,* No. 14, p. 17, pl. 14.

JACOB, RACHEL, AND LEAH AT THE WELL (82.3.125)

Drawn in 1666. Pen with iron-gall ink, gray wash, and black chalk, on white laid paper, sheet size 8⁷⁄₁₆ × 12⁷⁄₈ in. (20.7 × 31.8 cm), image within drawn border 7¹⁵⁄₁₆ × 12⅛ in. (20 × 30.1 cm).

DESCRIPTION: Standing on open ground before a backdrop of trees and low bushes are two women at left, one holding her arm around the shoulder of the other, and a man at right leaning on a staff and gesturing toward a low well. Behind them, a line of sheep approaches to drink from the well, and in the distance at upper right rises a lightly sketched castle on a hill. The figures and sheep are drawn in brown ink with gray wash, the landscape elements behind them in black chalk.

CONDITION: The drawing is in good condition. Old hinges were removed in 1983, at some earlier time a small loss was repaired in the lower right corner, and glue stains remain from a former mount. There is abrasion in the face of the second female figure from the left.

ONE of fifteen large figural compositions from the Wildenstein album—the source of all three drawings by Claude in The Frick Collection (see pp. 31–42)—this sheet relates directly to the central group in a 1666 painting by the same name now in the Hermitage Museum, St. Petersburg.[1] The subject is Jacob's first encounter with his cousin Rachel at the well to which she came to water her father's flock (Genesis 29: 10–11). Jacob agreed to serve his uncle Laban for seven years in exchange for Rachel's hand, but at the wedding ceremony he was tricked into marrying Rachel's older sister, Leah. Although Leah was not present during the episode at the well, she is frequently added to representations of the scene.[2]

The highly finished quality of this drawing and the close correspondence between the arrangement of the three figures here and in the painting—with Jacob to the right, the two sisters on the left, and the sheep behind them—have raised questions whether the drawing was executed before the canvas, after it, or while it was in progress. In the opinion of Roethlisberger, it is "the ultimate preliminary study for the figures and not a copy from the finished painting.[3] The overall composition of the drawing (and the treatment of the two women in particular) has been linked with Raphael's depiction of the same subject in his fresco in the Vatican Logge, the source for many of the figures in Claude's mythological and Biblical works of the 1650s and 1660s.[4] In addition to the Frick figural composition, five preliminary studies for the painting as a whole are known; one of them, thought to be the first model for the painting, was also in the Wildenstein album.[5]

Twelve years earlier, in 1654–55, Claude had executed a large painting of a closely related subject, the *Landscape with Jacob, Laban, and His Daughters* now at Petworth

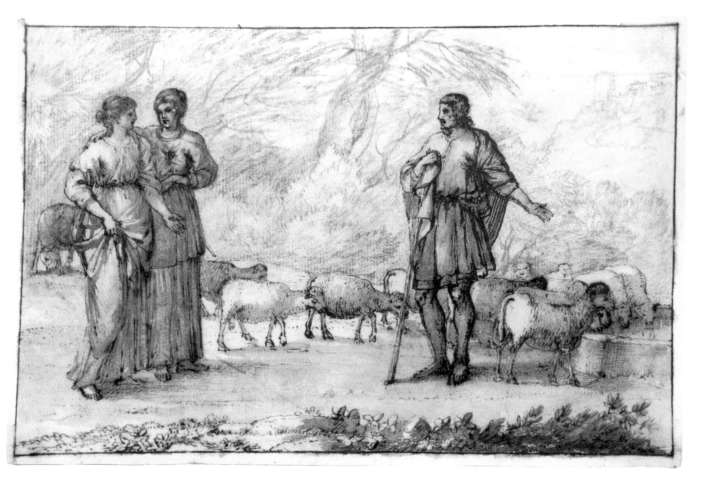

House, Sussex, in which Jacob bargains with his uncle for Rachel's hand.[6] In a preparatory study for that painting—again from the Wildenstein album[7]—the three characters who appear in the Frick drawing are represented, along with Laban, in a similarly elongated horizontal format. As in the Frick study, the arrangement of the four protagonists depends from the compositional group in the corresponding scene in Raphael's Vatican Logge frescoes, although here Claude departed more freely from his model.[8] Comparison of the animated gestures and flowing drapery of the figures in the 1654–55 group, all of them linked together, with the more static, columnar figures of the Frick study demonstrates the progression in Claude's later art toward a more hierarchical and monumental style.

S. G. G.

EXHIBITED: Same as the two preceding entries.

COLLECTIONS: Same as the two preceding entries.

NOTES

1. For the present drawing, see M. Roethlisberger, *Claude Lorrain: The Wildenstein Album*, Paris, 1962, No. 43, p. 27, pl. 43, and *Claude Lorrain: The Drawings*, Berkeley—Los Angeles, 1968, I, No. 964, p. 358, II, pl. 964. For the painting, see M. Roethlisberger, *Claude Lorrain: The Paintings*, New Haven, 1961, I, No. LV 169, pp. 399–401, II, fig. 272. The painting was among six commissioned by Henri van Halmale (made bishop of Ypres in 1672), one of the major patrons of Claude's later years. Van Halmale's paintings included a later pendant to *Jacob, Rachel, and Leah*, the *Landscape with Jacob Wrestling with the Angel* of 1672 (*idem*, I, No. LV 181, p. 426, II, fig. 295).

2. Roethlisberger, 1961, p. 399.

3. Roethlisberger, 1962, p. 27. There are a few more sheep in the drawing, and the cover of the well is not shown.

4. M. Roethlisberger, in *The Claude Lorrain Album in the Norton Simon, Inc. Museum of Art*, Los Angeles, 1971, p. 30, notes that the two women recur in another drawing of twenty years later from the Wildenstein album, No. 27. On Raphael's frescoes of Jacob, see B. F. Davidson, *Raphael's Bible: A Study of the Vatican Logge*, University Park—London, 1985, Bay 6, Jacob, pp. 71–72, figs. 55, 56. For a recent discussion of Claude's use of Raphael's figures, see M. Kitson, "Claude as a Figure Draughtsman," in *Drawing: Masters and Methods, Raphael to Redon*, London, 1992, pp. 64–68.

5. Roethlisberger, 1968, I, Nos. 959–65, pp. 356–58. The drawing, No. 2 in the Wildenstein album, is No. 959 in Roethlisberger.

6. Roethlisberger, 1961, I, No. LV 134, p. 286, II, fig. 227.

7. The drawing was one of the eight acquired from the album in 1957 by the London dealer Calmann. See Roethlisberger, 1968, I, No. 754, p. 286, II, pl. 754.

8. *Idem*, I, p. 286.

ADDITIONAL REFERENCE

M. Roethlisberger, "The Drawings of Claude Lorrain," *Alhambra*, 1965, repr.

REMBRANDT HARMENSZ. VAN RIJN

1606–1669

The quantity and kinds of drawings made by Rembrandt suggest that the artist seldom left behind his sketchbook. Everywhere he went he seems to have taken note of persons, animals, landscapes, and buildings, occasionally copying from works of art he found interesting or jotting down ideas for his own paintings and prints. Most often drawn with pen or brush, sometimes with chalk or other media, the sketches convey a freshness and immediacy, whether he is recording the seventeenth-century world of the Netherlands or imagining stories from the Bible or antiquity. Yet for all their spontaneity, Rembrandt's drawings are composed with an innately classical sense of structure and balance that imbues even the slightest sketch of a beggar or a hog with the dignity and monumentality that distinguish his greatest paintings.

LANDSCAPE WITH COTTAGE, TREES, AND STREAM (13.3.25)

Pen with brown ink, brown and gray wash applied by brush, 6⁵⁄16 × 9¹⁄16 in. (16 × 23 cm).

INSCRIPTIONS: By a later hand in brown ink (much faded), at lower right: *Rembrandt*; on backing paper in pencil: *Rembrandt -/ La Chaumière; avec trois arbres.*

DESCRIPTION: A thatch-roofed cottage stands among trees on the low bank of a stream that flows diagonally across the foreground. Next to the cottage rise the poles of a hayrick. Farther left are a small lean-to shed and beside it a flat-topped wagon. Fields stretch toward the horizon at far left, and a grove of trees fills the middle ground at right.

CONDITION: A gray wash has been added by a later hand[1] to the foreground stream and to some of the foliage, most notably that of the leaning tree by the side of the cottage. Other touches of gray have been added to the trees behind the lean-to at left and the ground before it, as well as to the ground at right, especially beneath the large trees. A brown ink border was at some later date drawn around the margins, which may have been trimmed. The paper is slightly stained. About ⁵⁄16 in. from the top at upper right runs a horizontal slash in the paper, some 1¼ in. long. The drawing is laid down. In 1981, old tape, glue, and hinges were removed, but the backing paper was retained.

REMBRANDT's landscape drawings are remarkable for the ordinariness of their subjects and the intensely narrow range of his interests. The dramatic bird's-eye vis-

tas so dear to many of his sixteenth-century Netherlandish predecessors did not entice him. Instead he repeatedly selected a low viewing point for his sketches, and in place of mountainous panoramas chose to portray undistinguished cottages and farm buildings that hug the ground (only occasionally varied by a church spire or windmill), groves of bushy trees, and slow-winding roads and rivers. Rembrandt seldom shows any interest in capturing the more fleeting aspects of nature—the seasons, weather, the time of day, or even the distinguishing characteristics of botanical species; his trees and grasses are generic, not individual. He seems to have sought obsessively the lowest common denominator of his surroundings, the essence of the Dutch rural landscape, with its flat, watery terrain, spreading horizon, large skies, and unpretentious architecture. But within the tightly restricted limits of this subject matter, Rembrandt achieved an extraordinary and subtle diversity.

Comparison of the present landscape drawing with one in the Museum Boymans-van Beuningen, Rotterdam (No. R 114), depicting the same cluster of farm buildings offers an example of how Rembrandt could play variations on a very modest theme.[2] The location of this nondescript site is presumed to be somewhere within walking distance of Rembrandt's house in Amsterdam, and the existence of the two views—the Rotterdam version drawn at a greater distance from the subject than the Frick sketch—strongly suggests that they were executed outdoors, on the spot. The Rotterdam drawing is more summary, less detailed in description of forms and spaces, so that one cannot understand very clearly the individual elements or their location within the setting. The space itself—blank sky, empty foreground—is as much the subject as the motifs scratched so vigorously across the middle of the page. With the closer view seen in the Frick drawing, the empty areas lose their dominance, the shapes assume identities, and the space is measured out with concise clarity by the tree trunks and the light cast behind them. The viewer can understand now certain forms that are illegible except as compositional accents in the Boymans sketch. To the left are visible the wheels of a flat wagon left by the side of a shed, and beyond them to the right stand the posts of a hayrick. From the low level of the remaining hay one might guess the season to be spring or early summer. The curving stream now appears diminished from the scope implied by the vacant spaces of the Rotterdam drawing.

Authorities generally agree that the Frick sheet is by Rembrandt and that it dates from the 1650s.[3] Some place it about 1653, others a few years later. However, since

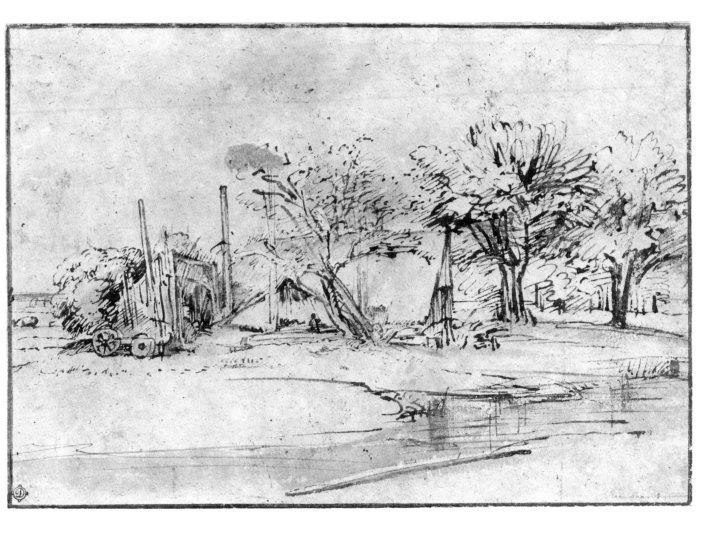

Benesch's catalogue of all drawings that might possibly be by Rembrandt includes 1,384 items, of which very few are signed or can be identified as preliminary studies for paintings or prints, the attribution and dating of Rembrandt drawings can hardly be considered a precise science.[4] Nor do his etchings offer useful chronological clues for the Frick drawing; the latest date inscribed on a comparable landscape print is 1652.

B. F. D.

COLLECTIONS: E. Desperet, Paris (Lugt 721, on recto). His sale, June 7–20, 1865, Hôtel des Commissaires-Priseurs, Paris, Lot 276, as *La Chaumière aux trois arbres*. Jacob de Vos Jacobzoon, Amsterdam (Lugt 1450, on backing paper). His sale, May 22–24, 1883, Brakke, Amsterdam, Lot 400, bought for 265 florins by Thibaudeau for Heseltine. John Postle Heseltine, London (Lugt 1507, on backing paper).[5] P. and D. Colnaghi.[6] Knoedler. Frick, 1913.

NOTES

1. Gray wash has been added to many drawings by Rembrandt, but he seems to have used it occasionally himself, as did several pupils and followers.

2. G. Luijten and A. W. F. M. Meij, *From Pisanello to Cézanne: Master Drawings from the Museum Boymans-van Beuningen*, Rotterdam, 1990, p. 111, No. 37.

3. See: O. Benesch, *The Drawings of Rembrandt*, London, 1957, VI, p. 369, No. 1325; S. Slive, *Drawings of Rembrandt*, New York, 1965, I, pl. 205. A number of scholars in recent years have studied the drawing and reached the same — if sometimes tentative — conclusions about attribution and date, which they have generously discussed with The Frick Collection; these include Carlos van Hasselt, Egbert Haverkamp-Begemann, William W. Robinson, Martin Royalton-Kisch, Peter Schatborn, Cynthia Schneider, and Christopher White.

4. J. Giltaij, in *The Drawings by Rembrandt and his School in the Museum Boymans-van Beuningen*, Rotterdam, 1988, pp. 11, 90, No. 27, discusses the Frick and Boymans landscape drawings, dating them about 1653. But in 1989 he preferred (orally) to suggest a date of 1650–55 for the Frick drawing.

5. *Original Drawings by Rembrandt in the Collection of J.P.H.*, London, 1907, No. 75.

6. According to F. Lugt (*Les Marques de collections*, Amsterdam, 1921, I, p. 275), the Heseltine mark was stamped on his drawings in 1912 by P. and D. Colnaghi when they bought most of his collection.

ADDITIONAL REFERENCES

O. Benesch, *Rembrandt, Werk und Forschung*, Vienna, 1935, p. 57.

O. Benesch, *A Catalogue of Rembrandt's Selected Drawings*, London–New York, 1947, p. 43, No. 222.

The Frick Collection Catalogue, New York, 1951, IV, p. 32, No. 25.

C. Hofstede de Groot, *Die Handzeichnungen Rembrandts*, Haarlem, 1906, p. 237, No. 1048.

F. Lippmann, *Original Drawings by Rembrandt Harmensz van Rijn*, London, 1892, Pt. IV, No. 189b.

E. Michel, *Rembrandt, His Life, His Work and His Time*, trans. F. Simmonds, New York, 1894, II, p. 255.

H. Tietze, *European Master Drawings in the United States*, New York, 1947, p. 144.

FARMYARD WITH TREE AND FIGURES (13.3.24)

Pen with brown ink, gray wash applied by brush, 4⅞ × 10⅛ in. (12.4 × 25.7 cm).

MARK: Watermark: a horn suspended within in a cartouche.[1]

DESCRIPTION: A thatch-roofed farmhouse is built in an irregular U shape, its asymmetrical wings framing a central yard before which rises a large tree, the foliage mostly cut by the upper margin. A smaller tree grows in the rear right corner of the yard. On a wooden bench in front of the wing at right sit two figures. To the left of the large tree are bushes and another bench.

CONDITION: All the margins appear to have been trimmed. A brown ink border, in part cut off but visible at the sides and bottom of the drawing, evidently was added later. A line of brown stain, probably from the inner edge of a mat, runs within all four margins. There is some abrasion. The gray wash and some of the pen lines appear to be later additions (see below). In 1981, old tape, hinges, and adhesive were removed.

THE drawing has provoked widespread disagreement and uncertainty among scholars about whether or not it is by Rembrandt and how much has been subtracted from the original sheet by cutting, or added to it through the evidently extensive retouching.[2] There can be no doubt that these subtractions and additions have distorted the appearance of the drawing in several significant ways, making any final judgment concerning its authorship a dubious undertaking.

The alterations not merely involve details lost or embellished; they seriously affect the design and structure of the composition. One need only imagine, for example, how much grander and more spacious the scene would have looked with a lofty, leafy tree arching up and over the small enclosed farmyard. One can also imagine how much less statically balanced and planar the tree and buildings would have seemed without the added gray wash lending weight to the cottage wall at left, obscuring the recession of the central building, flattening the right side of the composition, and overemphasizing the foreground with a clutter of dabs and strokes. How many of the brown pen lines also are additions cannot be determined, but the wall at left, with its clumsy treatment of roof and shuttered window, and the rather heavy-handed pen strokes of the foreground are suspect. The original drawing must have been much more open, delicate, suggestive, and movemented.

Benesch, who considered the drawing to be by Rembrandt but reworked by a good pupil, perhaps Abraham Furnerius, dated it 1653.[3] Royalton-Kisch, who also accepts the underlying drawing as Rembrandt but does not venture to propose the author of the amendments, suggested a slightly earlier date of about 1650.[4] Schat-

born accepted Rembrandt's basic responsibility, but did not suggest a date or attempt to identify the second hand.[5] White is doubtful that the original drawing was by Rembrandt but feels it reflects his style of the 1640s.[6] Haverkamp-Begemann believes the drawing should be assigned to Rembrandt's school, dating from the 1640s or early 1650s.[7] Lugt, according to notes in his files, doubted the attribution to Rembrandt,[8] as does Robinson.[9] Schneider feels that the drawing could have been begun by Rembrandt in the early 1650s and finished by a student.[10] There is much overlap but little concurrence among the experts about precisely which elements of the drawing are alterations to the original design.

<div align="right">B. F. D.</div>

EXHIBITED: London, Grosvenor Gallery, Winter Exhibition, 1878–79, No. 206, as *The Farm House*, lent by Robert P. Roupell.

COLLECTIONS: Jean Gisbert, Baron Verstolk de Soelen(?).[11] Edward Bouverie, Delapré Abbey, Northampton (Lugt 325, on recto). Robert Prioleu Roupell, London (Lugt 2234, inscribed in pen on verso: R.P.R.).[12] His sale, July 12–14, 1887, Christie's, Lot 1084, as *A Landscape with Cottages and Figures*. John Postle Heseltine, London (Lugt 1507, on verso).[13] P. and D. Colnaghi.[14] Knoedler. Frick, 1913.

NOTES

1. The watermark is similar to others found in Dutch papers of the seventeenth century.

2. Marjorie Shelley, Conservator in the Department of Paper Conservation, Metropolitan Museum of Art, New York, points out that as Rembrandt used a variety of pens and inks— sometimes more than one for a single drawing—a technical analysis of the inks would not sort out the master's touch from a pupil's additions.

3. O. Benesch, *The Drawings of Rembrandt*, London, 1957, VI, pp. 367–68, No. 1313.

4. Martin Royalton-Kisch, orally, November 13, 1987.

5. Peter Schatborn, orally, November 29, 1989.

6. Christopher White, orally, April 17, 1997.

7. Egbert Haverkamp-Begemann, orally, April 15, 1997.

8. Information kindly reported by Carlos van Hasselt, letter of June 10, 1973.

9. William W. Robinson, letter of February 3, 1988.

10. Cynthia Schneider, orally, June 23, 1997.

11. According to the above-cited letter from van Hasselt, Lugt identified the drawing with one sold in the Verstolk de Soelen sale, March 22, 1847, Amsterdam, Lot 234 ("Un homme et une femme assis sur le banc d'une ferme, sur laquelle se trouvent un grand arbre, une grange et des habitations … à la plume et au bistre"). If this was indeed the Frick drawing, Edward Bouverie (1767–1858; see *Collections*) could have bought it from the Amsterdam sale.

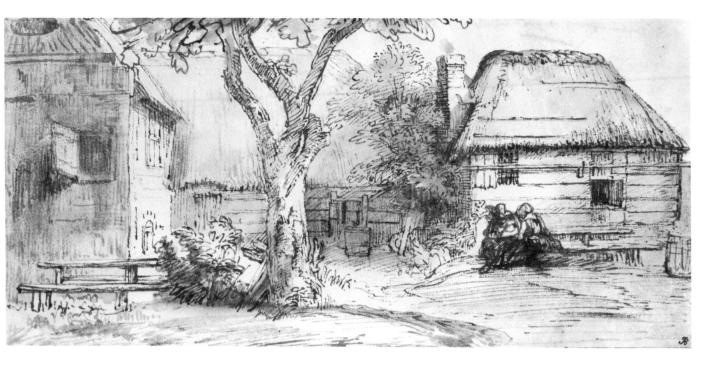

12. The original mount, according to a note in the Frick Collection files, was inscribed: *RPR / Rembrandt / from Richardson's Collection / RPR / Rembrandt / Bouverie Coll / Grosvenor Gallery Exhibition / winter 1878–9*. It seems likely that the inclusion of Richardson was an error, based on the similarity of his well-known mark (Lugt 2184) to Bouverie's.

13. *Original Drawings by Rembrandt in the Collection of J.P.H.*, London, 1907, No. 42.

14. According to F. Lugt (*Les Marques de collections*, Amsterdam, 1921, I, p. 275), the Heseltine mark was stamped on his drawings in 1912 by P. and D. Colnaghi when they bought most of his collection.

ADDITIONAL REFERENCES

The Frick Collection Catalogue, New York, 1951, IV, pp. 31–32, No. 24.

C. Hofstede de Groot, *Die Handzeichnungen Rembrandts*, Haarlem, 1906, p. 238, No. 1054.

E. Michel, *Rembrandt, His Life, His Work and His Time*, trans. F. Simmonds, New York, 1894, II, p. 255.

ISAAC BLESSING JACOB (13.3.26)

Pen with brown ink, brown and gray wash applied by brush, traces of white heightening, 6¾ × 8¾ in. (17.2 × 22.2 cm).

MARK & INSCRIPTIONS: Indecipherable watermark. Inscribed on mount: *Rembrandt* in pencil; *I* [or *F*] *359* in ink at bottom right; and *Nº 635* at bottom right on verso.

DESCRIPTION: The figures of Isaac and his son Jacob are seen silhouetted against light from a door or window at the rear of the shadowy chamber. Isaac bends forward from the pillows of his canopied bed and makes a gesture of blessing over the clasped hands of Jacob, who kneels at the far side of the bed. At right hovers the figure of Rebekah, an open doorway behind her. A chair stands to the left of the bed.

CONDITION: The edges of the drawing, which have several small tears and weak areas, are slightly irregular, suggesting that they have been trimmed. There are traces of brown ink lines along both sides, indicating that a border line may once have framed the drawing. In 1981, the mount and backing, with their old adhesives, were removed. The condition of the drawing is difficult to assess. It appears blurred and faded, perhaps from water or exposure to light (see below).

ISAAC blessing Jacob was a subject drawn repeatedly by Rembrandt and his pupils, a curious choice given the inherent awkwardness of its traditional *mise en scène*.[1] As narrated in the Old Testament (Genesis 27), Isaac, near death and dim of vision, is tricked by his wife Rebekah into blessing his son Jacob in place of Esau, the first-born of the twin brothers. By this act of deception, the messianic line was to be preserved through Jacob and his future wife, Rachel, while Esau, who sold his birthright to Jacob and married out of the tribe, forfeited his place in the chosen lineage. Unlike Raphael, who painted the scene in the Vatican Logge, Rembrandt and his followers omitted Esau and the three other sons of Rebekah from their compositions, focusing instead on the ceremonial act of blessing, on the moment of designating the chosen leader, rather than on other less significant happenings of the Biblical story.

Among the many drawings by Rembrandt and his circle illustrating this subject are: one at Chatsworth, the Devonshire Collection (Benesch 891); a drawing listed by Benesch (892) as in the collection of Lady Melchett, London; one formerly with Van Diemen, Berlin (Benesch 507); one in Groningen, Museum voor Stad en Lande (Benesch 508); one formerly with Oscar Bondi, Vienna (Benesch 509); one at Angers, Musée Turpin de Crissé (Benesch 510); one in Amsterdam, Rijksmuseum (No. A 629, 1886), which Schatborn suggests is a copy after a lost drawing by Carel Fabritius (a second copy, he mentions, is in Berlin);[2] a drawing attributed to Samuel

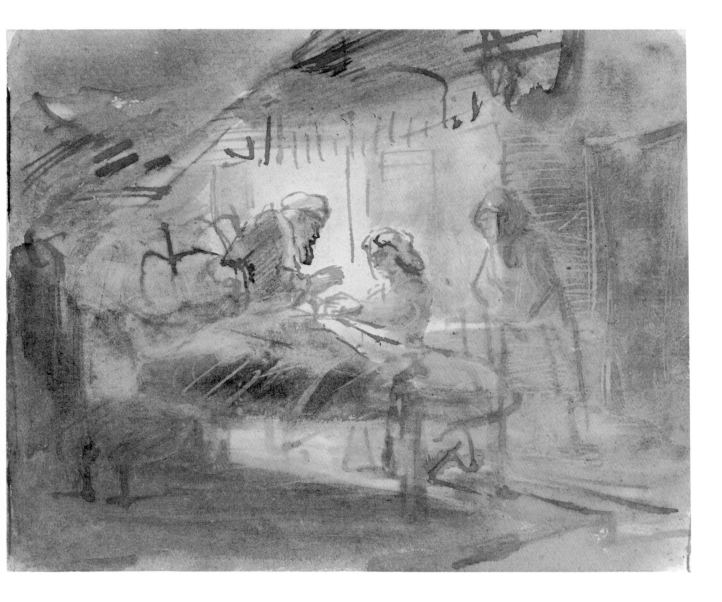

van Hoogstraten formerly in the collection of Baron Brincard;[3] one in Munich, Graphische Sammlung (No. 1113); and still others ascribed to various artists of Rembrandt's circle.

The attribution of the Frick drawing to Rembrandt was accepted by Benesch (1065) and a number of earlier writers,[4] but is questioned by most experts today, perhaps because its puzzling condition quite literally clouds the issue. Marjorie Shelley, Conservator at the Metropolitan Museum of Art, New York, suggests that

the blurring of the sheet may have resulted from the paper having been dampened, possibly when the wash was applied or from some undocumented restoration. Some of the ink lines in the shadows are lighter than the wash, giving the false impression of having been protected or scratched through the wash. It is more likely that these lines were drawn in a different, rather pale ink, which because of its composition or aging characteristics may have repelled the wash, resulting in the present appearance. When one examines the drawing under ultraviolet light, the underlying pen sketch in brown ink can be seen more distinctly and strongly, as though freshly drawn, while the gray wash recedes. Without the gray wash, a more powerful drawing emerges, one comparable, as Benesch proposed, to such late sketches of the 1660s as the *Raising of the Daughter of Jairus* (Berlin, Kupferstichkabinett; Benesch 1064), *St. Peter at the Deathbed of Tabitha* (Dresden, Kupferstichkabinett; Benesch 1068), or the *Meeting of Christ with Martha and Mary* (Cleveland Museum of Art; Benesch 1068A). It seems possible that the washes were indeed a later addition, as Benesch suggested.

The taut, solemn drama between father and son, their two bowed profiles reverently framing the hands about to bestow and to receive the blessing, is distilled to its most effective and moving essence when seen in the bare bones of the ink sketch. As Rosenberg observed: "Rembrandt was so organized that he could not abandon any thread he had once taken up … this constant development of favorite subjects, with an ever deepening interpretation, [is] reflected in his drawings."[5] Nevertheless, until methods of technical analysis become refined enough to explicate the physical history and condition of the drawing, it remains one of the attributed drawings almost unanimously rejected by Rembrandt specialists today. Among those who have expressed doubts in recent years, either orally or by letter, are: Haverkamp-Begemann, who believes it to be a school piece of the 1650s, worked over by a later—possibly much later—hand;[6] Giltaij;[7] van Hasselt;[8] Robinson;[9] Royalton-Kisch, who suggests that it comes from the school of Rembrandt;[10] Schatborn, who thinks it could be a studio work;[11] and White,[12] who suggests that it is by a good pupil of Rembrandt. Sumowski published the drawing with an attribution to Aert de Gelder, but his opinion depended from his assumption that the washes are unquestionably original to the drawing and that the lighter lines are scratched in the wash; this led him to find stylistic inconsistencies with Rembrandt and certain similarities to de Gelder's work.[13] Slive, who felt that the washes appeared to have been added later, included the drawing in his monograph but con-

ceded that it was "a difficult drawing to place."[14] And Valentiner expressed similar uneasiness, commenting that the drawing was "nicht ganz zweifellos."[15] According to notes in his files, Lugt accepted the drawing as "echt."[16]

<div align="right">B. F. D.</div>

EXHIBITIONS: London, Royal Academy, Exhibition of Works by Rembrandt, 1899, No. 134, lent by J. P. Heseltine.

COLLECTIONS: Sir W. W. Knighton, Bart. John Postle Heseltine, London (Lugt 1507, on recto of mount).[17] P. and D. Colnaghi.[18] Knoedler. Frick, 1913.

NOTES

1. Some earlier representations of the subject are discussed by R. Haussherr in "Rembrandts Jacobssegen. Überlegungen zur Deutung des Gemäldes in der Kasseler Galerie," *Abhandlungen der Rheinisch-Westfälischen Akademie der Wissenschaften*, LX, 1976. It should be noted that the subject of the Kassel painting has since then been identified as Jacob blessing the sons of Joseph (see C. Tümpel, *Rembrandt*, New York, 1993, p. 393, No. 26, with earlier bibliography on the identification of the subject). No painting by Rembrandt of Isaac blessing Jacob is known to exist.

2. P. Schatborn, *Tekeningen van Rembrandt, zijn onbekende leerlingen en navolgers*, The Hague, 1985, pp. 140–41, No. 64.

3. Sale, Hôtel Drouot, Paris, May 31, 1988, Lot 7.

4. O. Benesch, *The Drawings of Rembrandt*, London, 1957, V, p. 305, No. 1065; F. Lippmann, *Original Drawings by Rembrandt Harmensz van Rijn*, London, 1889, Pt. 1, No. 47; E. Michel, *Rembrandt, His Life, His Work and His Time*, trans. F. Simmonds, New York, 1894, II, p. 256; and C. Hofstede de Groot, *Die Handzeichnungen Rembrandts*, Haarlem, 1906, pl. 224, No. 984.

5. J. Rosenberg, "Rembrandt the Draughtsman with Consideration of the Problem of Authenticity," *Daedalus: Proceedings of the American Academy of Arts and Sciences*, LXXXVI, 1956, p. 124.

6. Egbert Haverkamp-Begemann, orally, April 15, 1997.

7. Jeroen Giltaij, orally, November 29, 1989.

8. Carlos van Hasselt, orally, May 1973.

9. William W. Robinson, letter of April 7, 1997.

10. Martin Royalton-Kisch, letter of November 13, 1987.

11. Peter Schatborn, letter of April 16, 1997.

12. Christopher White, orally, April 17, 1997.

13. W. Sumowski, *Drawings of the Rembrandt School*, ed. and trans. W. L. Strauss, New York, V, n.d., p. 2408, No. 1081.

14. S. Slive, *Drawings of Rembrandt*, New York, 1965, I, pl. 47.

15. W. R. Valentiner, *Rembrandt: Des Meisters Handzeichnungen*, Stuttgart, 1925, I, p. 466, note 65.

16. Information kindly supplied by Carlos van Hasselt in a letter of June 10, 1973.

17. *Original Drawings in the Collection of J.P.H.*, London, 1907, No. 22.10.

18. According to F. Lugt (*Les Marques de collections*, Amsterdam, 1921, I, p. 275), the Heseltine mark was stamped on his drawings in 1912 by P. and D. Colnaghi when they bought most of his collection.

ADDITIONAL REFERENCES

O. Benesch, *Rembrandt, Werk und Forschung*, Vienna, 1935, p. 68.

The Frick Collection Catalogue, New York, 1951, IV, pp. 33–34, No. 26.

N. Konstam, "Rembrandt's Use of Models and Mirrors," *Burlington Magazine*, CXIX, 1977, pp. 94ff.

Style of
FRANÇOIS BOUCHER
1703–1770

Born in Paris, Boucher probably received his first training from his father, Nicolas Bouché, a painter and lace designer. In 1720 he studied briefly with François Le Moyne. He was awarded the Prix de Rome in 1723 and in 1727 left for Italy, where he remained for several years. He was elected to the Academy in 1734. Boucher worked in many media. He provided designs for the Beauvais tapestry factory, later served as director of the Gobelins works, and throughout his career designed for the Sèvres porcelain works. He was appointed Premier Peintre *to Louis XV in 1765 and was employed by Madame de Pompadour for many commissions. Boucher was also well-known as an etcher, illustrator, and draftsman. He produced book illustrations for the engraver and publisher Jean-François Cars, drew illustrations for Père Daniel's* Histoire de France *in 1727–28, and around the same time was recruited by Jean de Jullienne to execute etchings after Watteau's* Figures des différents caractères. *During this period, Boucher became more facile with red chalk drawing and was introduced to Watteau's* trois crayons *method of using red, black, and white chalks in the same drawing. Boucher continued to mature in this medium and later added pen-and-ink drawings to his range of techniques, used for both compositional studies and finished drawings. He also occasionally executed pastels.*

SCULPTURE (66.3.98)

Signed and dated, at lower left: *f. Boucher 1761.* Black chalk, with stumping, on cream laid paper, 10⁹⁄₁₆ × 12⅝ in. (26.8 × 32 cm).

MARK & INSCRIPTIONS: Stamped on mat at lower right: *J.-B. Glomy.* Inscribed in pencil on back of mount: inscriptions in Swedish.

DESCRIPTION: A small boy posing as a sculptor is represented in three-quarter view facing right. Holding a chisel in his left hand and a mallet in the right, he pauses to admire his work in progress—a marble bust of a young girl which rests on a tall stand. A large window at left admits light into the studio. Behind the stand at right, a relief of children rests on an easel, and another relief, of a seated male nude, is propped up against a chest. Scattered on the floor are plaster casts of a head and foot near the

55

stand and, at left, a pail, mop, scroll of paper, and set of calipers. The sculptor's coat is draped on a wooden box.

CONDITION: The drawing is in good condition. In 1980 it was removed from an earlier wood-pulp mat, treated to reduce foxing, flattened and inlaid, hinged to a sheet of rag paper, and mounted in a rag board mat.

PAINTING (67.3.99)

Signed in brown ink, at bottom center: *Boucher*. Black chalk on cream laid paper, 10½ × 8¹⁵⁄₁₆ in. (16.7 × 22.8 cm).

MARK & INSCRIPTIONS: Watermark: *IV*. Inscribed on edge of mounting sheet: *6,5,6,7,4,9*; and on verso in pencil at lower left: *D 3972.F. 139.10.0.*

DESCRIPTION: A child painter, portrayed in profile facing right, sits in a garden drawing from the stone bust of a young girl supported on a block of stone in front of him. His sheet rests on a portfolio on his lap. In his right hand he holds a portcrayon, and his left hand supports his chin. On an easel beyond the bust is a large painting in progress of a seated female nude. Brushes and a palette are seen at left behind the boy, and further back is a stone pillar garlanded with leaves; branches of a tall fir tree extend over the pillar. At bottom right, a portfolio of drawings is propped up, and a figure drawing hangs over the edge of the stone block on which the bust rests. On the ground are scattered objects including an open box, a knife for sharpening chalk, a discarded sheet of paper, and a loaf of bread.

CONDITION: The drawing is in good condition. In 1980 it was removed from an earlier wood-pulp mat, treated to reduce foxing, flattened and inlaid, hinged to a sheet of rag paper, and mounted in a rag board mat.

POETRY (67.3.100)

Signed in brown ink, at lower right: *Boucher*. Black chalk, on cream laid paper, 10¹⁵⁄₁₆ × 9¹⁄₁₆ in. (27.8 × 23 cm).

MARK & INSCRIPTIONS: Watermark: *IV*. Inscribed on verso in pencil, at upper left: *296*; at lower left: *F. Boucher 3398*; and at lower right: *3398*.

DESCRIPTION: A tousled-haired child wearing a crown of flowers is seated on the ground in a landscape, facing forward, writing on a scroll with a quill pen. His left hand and arm are extended. Beside him are two doves, and in front are a medallion of a man's head in profile, a lyre, a trumpet, a wreath of flowers, an arrow, and two crossed wind instruments. At lower left swim two swans. A fir tree towers over the child, and a wooded grove can be seen in the distance.

CONDITION: In 1980 the drawing was

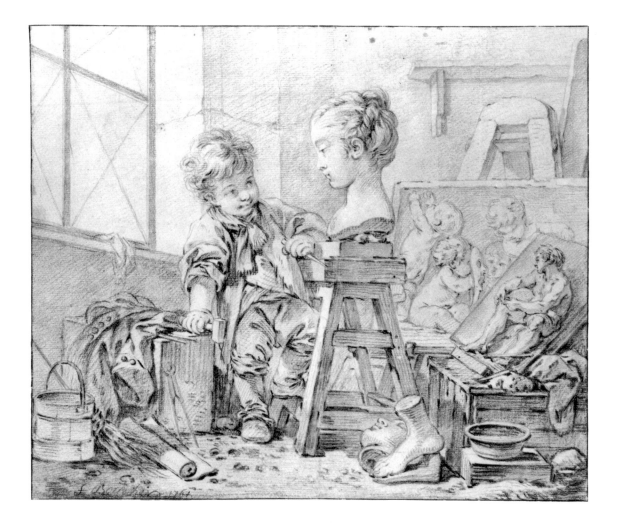

removed from its wood-pulp mat, and foxing was reduced. It was then flattened and inlaid, hinged to a sheet of rag paper, and placed in a rag board mat. The drawing is in good condition.

THESE three drawings are linked with the eight panels by Boucher in The Frick Collection entitled *The Arts and Sciences*.[1] However, the nature of the connection, as well as the provenance of the drawings and their authorship, cannot be determined with certainty. Two more drawings related to *The Arts and Sciences* are in the Victoria and Albert Museum, London.[2]

The Frick panels are traditionally believed to have been painted by Boucher for Madame de Pompadour's octagonal *cabinet en bibliothèque* in the Château de Crécy,

near Dreux, which she bought in 1746.[3] Between 1747 and 1755, the Marquise made extensive renovations to the estate and gardens, commissioning numerous artists and artisans to decorate and furnish the interior.[4] Most of the payments for furniture and decorative objects were made between 1750 and 1753, the period to which the panels have been presumed to date, but no record for the panels has yet come to light.[5] The curvilinear contours of the compositions within the panels have led to speculation that they may be based on cartoons for tapestry covers for the seats and backs of chairs.[6]

In contrast to the rounded compositions of the panels, bordered by flowers, all three Frick drawings are rectangular in format, and all deviate in detail to some extent from their painted counterparts. Furthermore, all are executed in a dry and regularized technique and are highly finished, differing from the searching quality characteristic of Boucher's preliminary studies for paintings. For this reason, experts have suggested that the drawings were executed after the panels, not as preparations for them, most likely as an intermediary stage for work in another medium.[7]

There is a set of four engravings in rectangular format based on Boucher's "infant subjects" by Claude Duflos *le jeune*, one of the painter's major interpreters in the graphic medium. The set, which includes *Le Berger*, *Le Pêcheur*, *Le Souffleur*, and *Le Poëte*,[8] was announced in the December 1753 issue of the *Mercure de France*; two of them, *Le Souffleur* and *Le Poëte*, are closely related to the Frick panels entitled *Chemistry* and *Poetry*.[9] However, only one of the three Frick drawings, *Poetry*, was engraved. This may be explained by the fact that, as Laing notes, Boucher accused Duflos "in the March 17, 1755 issue of the *Mercure de France* of using drawings surreptitiously made from his paintings by his least competent students as the basis for a recent set of engravings, thus damaging his reputation."[10] Duflos engraved nothing further after Boucher once the article appeared.[11]

Sculpture differs in several respects from the other two Frick drawings. It is the only one that is both signed and dated, the only one horizontal in format, and the most technically assured. Furthermore, it is the only one to bear on its mount the mark *J.-B Glomy*, referring to one of the best-known Parisian framers and art dealers, who frequently worked for Boucher.[12] The inscribed date of 1761 places it well beyond the period of Duflos' engravings after Boucher, but the autograph quality of both the date and the signature have been questioned by Laing.[13]

The drawing also differs in some significant ways from the Frick painting of the same subject. While the format of the panel is upright and curvilinear, that of the

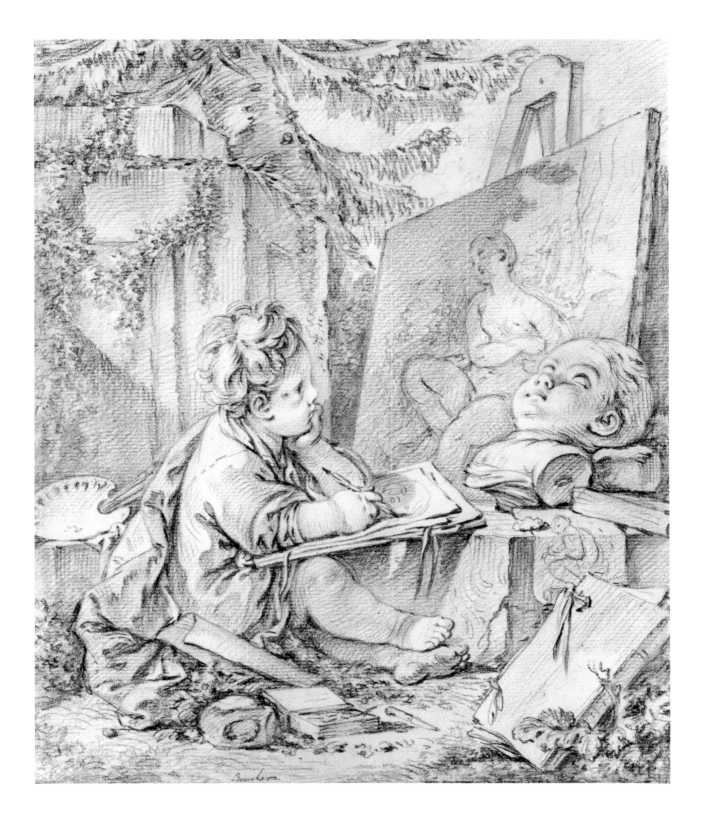
Boucher

drawing is a horizontal rectangle. Furthermore, in the drawing the viewer is brought up closer to the figure in his studio, and there are additions to the composition at both sides: half of a window bay and a mop and pail at left, and a plank resting against the wall in the corner at right. Certain distortions in perspective in the drawing also differ from the image in the panel. In the drawing, the gray marble relief—based on Du Quesnoy's *The Children with the Goat*[14]—pitches forward, and the heads of both the sculptor and the bust on which he is working—a popular piece of the period by Jacques-François-Joseph Saly[15]—are somewhat enlarged and less graceful than the figures in the panel. These discrepancies, however, may be explained by the existence of another canvas, *Sculpture*, which appeared in 1958. Like the Frick drawing, that canvas is rectangular in format and includes the details at the left and right margins that are missing in the Frick panel.[16] But in other respects—notably in the small sculptures visible through the trestle and on the shelf at upper right—it is closer to the panel than to the drawing.

If the date on the drawing is authentic, this rectangular canvas would be a later variant of the Frick panel, and the drawing could be either a preliminary study for it or executed after it.[17] But it is also possible that the rectangular canvas could be, as Laing once proposed, the original painting on which the Frick panel was based.[18] Another painting in a rectangular format, *Allegory of Architecture*, which corresponds to the Frick panel of *Architecture*, came to light in 1984.[19] More importantly, however, in 1996 Loche published an oval painting by Boucher of *Architecture*, given to the Musée d'Art et d'Histoire, Geneva, in 1981, that not only corresponds exactly to the Frick panel, but bears a genuine signature of Boucher, with the date of 1761.[20] This was evidently the model for the Frick panel, which puts the whole set of panels in an entirely new light: for in 1757, Madame de Pompadour had sold Crécy to the Duc de Penthièvre, as she also sold Bellevue back to the King. The panels cannot, therefore, have been painted for her, but if the traditional provenance from Crécy is correct, must have been painted for the Duc de Penthièvre. He may subsequently have removed them to another home that he acquired in 1775, the Château de Sceaux, since two sets of decorative panels by Boucher were recorded there in 1793.[21] The correspondence in shapes between the painting in Geneva and the Frick panel further suggests that all Boucher's lost original paintings were of upright oval or rectangular format, as in the corresponding panels, so that any paintings or drawings of different format are derivative rather then preparatory.

At the time of their purchase by The Frick Collection, all three drawings were

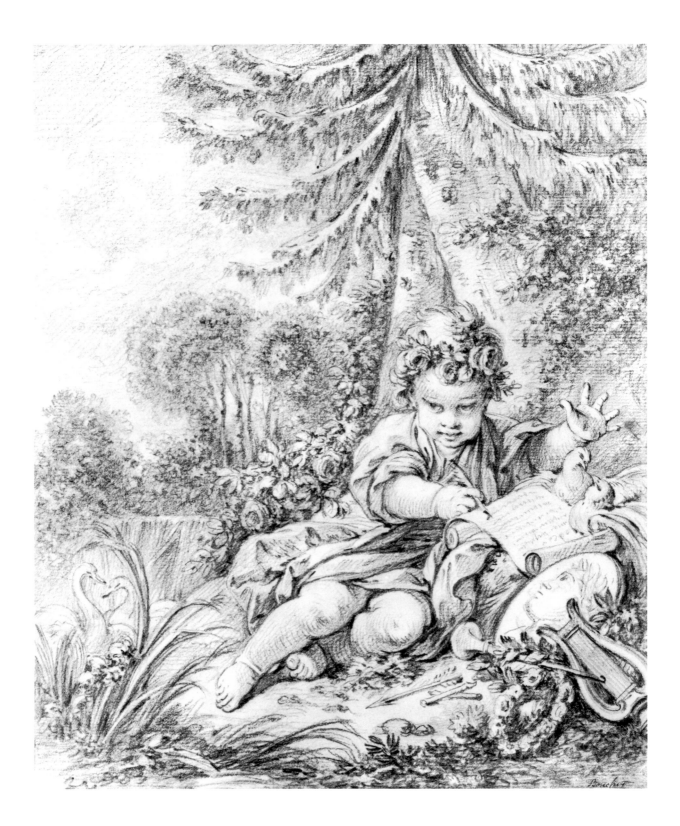

Boucher

accepted by Ananoff as authentic works by Boucher.[22] In the late 1980s, however, other experts, including Bean, Laing, Roland Michel, and Rosenberg, questioned or rejected the attribution to this master, although all believed that they were executed in the eighteenth century—perhaps by a student of Boucher's or a member of his workshop.[23] Of the three drawings, *Sculpture* was considered closest to Boucher's hand. According to Laing, it may have been touched up by the master himself and given his signature; an eighteenth-century source refers to Boucher's practice of completing his students' drawings.[24]

Painting also departs in some respects from the corresponding image in the Frick panel, although the upright format of the panel is maintained. In the drawing, the child artist is at work on a canvas on which a seated nude in a landscape is lightly sketched in. In the panel painting, however, this figure is barely discernable. In addition, there are perspectival distortions in the drawing that are not found in the panel: the stone block behind the artist is turned at an awkward angle, and the palette that rests upon it is tipped upward. The legs of both the artist and the nude depicted on the canvas are awkwardly rendered.

Laing considers the drawing a copy after a painting or tapestry cartoon or after a lost drawing for work in another medium, perhaps an engraving that, as far as is known, was never executed.[25]

As is the case with the other two drawings, there are numerous differences between the Frick panel of *Poetry* and the drawing of the same subject. Most notably, on the left side of the panel the body of water in which the two swans swim extends back in space and is bordered by a grove of trees, while in the drawing the space has been compressed, and the swans in the little pool are pushed to the foreground.

Duflos' print *Le Poëte* is closer in several respects to the drawing than to the panel, but it deviates in some ways from both. The idealized profile of Apollo on the medallion in both drawing and panel is transformed in the print into a portrait of Louis XV—a flattering allusion, no doubt, to the King's role as a patron of literature and to his own poetical writings.[26] In addition, a sun mask, an attribute of Apollo, was added in the print to the top of the lyre. To Laing, these differences suggest that the drawing was probably not a preparatory study for the engraving.[27] Exactly what the drawing relates to, and whether it is a preparatory study for or executed after a yet-undiscovered painting (perhaps for the purposes of engraving), cannot be determined at this point.

<div align="right">S. G. G.</div>

COLLECTIONS: Jean-Baptiste Glomy (Lugt 1085). Marquess of Lansdowne. Sale, November 9–12, 1966, Bukowski-Auktioner, Stockholm, Lot 223. Frick, 1966.

PAINTING *and* POETRY

COLLECTIONS: Porter. René Fribourg. Wildenstein. Frick, 1967.

NOTES

1. Extensive research on these drawings was carried out at The Frick Collection by Edgar Munhall, Bernice Davidson, and Nadia Tscherny. Frédéric Gangerot-Louis, curatorial intern, assisted. The Frick Collection is grateful to Alastair Laing for his consultation on these drawings, his review of the text, and his substantial additions. For Boucher's series of paintings *The Arts and Sciences*, see *The Frick Collection: An Illustrated Catalogue,* II, 1968, pp. 8–23.

2. *Fishing* and *Hunting*, both black chalk and wash. Both were engraved by Le Prince; see P. Jean-Richard, *L'Oeuvre gravé de François Boucher dans la Collection Edmond de Rothschild*, Musée du Louvre, Paris, I, 1978, Nos. 1385, 1384, p. 332, repr. p. 333.

3. *The Frick Collection: An Illustrated Catalogue*, II, p. 14.

4. For recent accounts of the Château de Crécy, which was demolished in 1840, see: J. Bastien, "Madame de Pompadour à Crécy," *Demure historique*, 1991–92; Y. Bizardel, "French Estates, American Landlords," *Apollo*, February 1975, pp. 108–15; and P.-X. Hans, "La Folie de bâtir: Le château de Crécy," in *Madame de Pompadour et les arts*, exhib. cat., Versailles, 2002, pp. 110–16.

5. *The Frick Collection: An Illustrated Catalogue*, II, p. 16. On the authenticity of the pan- els, see a letter of March 4, 1985, from A. Laing to The Frick Collection and a letter of June 3, 1991, from Laing to R. Loche, a copy of which was sent to The Frick Collection. Both letters are in the curatorial files.

6. J. Bastien, *Mme. de Pompadour et la Floraison des Arts*, Montreal, 1988, p. 88. Bastien asserts that the canvases by Boucher "are in reality cartoons for tapestries for chairs destined for Bellevue which were reused at Crécy." For a rebuttal to his claim, see a letter of December 20, 1989, from A. G. Bennett, Curator of Textiles Emerita of the Fine Arts Museums of San Francisco, to The Frick Collection (curatorial files). For further discussion of the tapestries and their relation to the Frick panels, see a letter of May 12, 1989, in the curatorial files from Bastien to Edith Standen, Curator Emerita in European Sculpture and Decorative Arts at the Metropolitan Museum of Art, New York.

7. In preparation for a small exhibition on the issue of the attribution of these drawings, which was not realized, Davidson invited a group of experts to examine the works at The Frick Collection in the late 1980s. Participating scholars included Jacob Bean, Alastair Laing, Marianne Roland Michel, Pierre Rosenberg, and Eunice Williams. The opinions of these scholars on the drawings are recorded in David-

son's report in the curatorial files of The Frick Collection.

8. See Jean-Richard, Nos. 933–37, p. 240, repr. p. 241. A set of these prints is in the Metropolitan Museum.

9. Le Prince also executed prints after two other Frick panels, *Horticulture* and *Fowling*.

10. A. Laing, *François Boucher, 1703–1770*, New York, 1986, p. 29. Laing notes that these can only be the "infant" compositions published in December 1753 and August 1754.

11. *Idem.*

12. F. Lugt, *Les Marques de collections*, Amsterdam, 1921, No. 1085, p. 189.

13. Letter of June 3, 1991, cited in note 5, above.

14. J. Cailleux, "L'Art du dix-huitième siècle," supplement, *Burlington Magazine*, December 1977, p. vii.

15. A copy of this bust, signed *Marest,* is in The Frick Collection. See T. Hodgkinson, in *The Frick Collection: An Illustrated Catalogue,* IV, pp. 92–94. The subject of the work was once believed to be Alexandrine d'Étiolles, daughter of Madame de Pompadour. For an assessment of its character, see *Madame de Pompadour et les arts*, No. 224, pp. 518–19.

16. *The Frick Collection: An Illustrated Catalogue,* II, p. 21. On the painting see also: Cailleux, pp. vi–vii, repr.; and sale, Sotheby's New York, January 19, 1984, Lot 94.

17. Cailleux, p. vii.

18. Letter of June 3, 1991, cited in note 5.

19. Formerly Stephen Mazoh and Co., Inc., New York.

20. See R. Loche, *Catalogue raisonné des Peintures et Pastels de L'Ecole française: xvi^e, xvii^e, et xviii^e siècles*, Musée d'Art et d'Histoire, Geneva, 1996, No. 8, pp. 54–57.

21. For a more detailed rehearsal of these arguments, see A. Laing, "Madame de Pompadour et 'Les Enfants de Boucher,'" in *Madame de Pompadour et les Arts*, esp. pp. 45–49.

22. See A. Ananoff, *François Boucher,* Paris, 1976, II, Nos. 368/5, 368/9, 370/19, pp. 70–71, repr.

23. See the report cited in note 7.

24. See *Mémoires du Chevalier Christian de Mannlich*, ed. J. Delage, Paris, 1948, p. 25: "Il nous occupa longtemps à copier ceux de ses plus beaux dessins qu'il voulait garder dans son portefeuille. Ce sont des copies, que nous devions seulement préparer sans les finir, qu'il se reserrait de retouche pendant son déjeuner et dont il faisait des originaux qu'il vendait deux louis pièce." The case is slightly different here, however, since the drawing seems to have been prepared for some specific practical purpose. The Glomy blind-stamp nonetheless indicates that it was purchased at an early date.

25. Letter from Laing dated March 4, 1988, and notes from a visit on May 10, 1988, by Laing to The Frick Collection, both in the curatorial files.

26. A source for this portrait has been suggested by Standen in a letter to The Frick Collection dated November 3, 1993 (curatorial files). See also E. Standen, "Country Children: Some *Enfants de Boucher* in Gobelins Tapestry," *Metropolitan Museum Journal*, XXIX, 1994, pp. 111–33.

27. See note 25.

JEAN-BAPTISTE GREUZE

1725–1805

According to tradition, Greuze's talents as a draftsman first manifested themselves when the artist was eight years old and deceived his father into believing that a drawing the boy had executed for him after an engraving was a print. His earliest known drawing to survive—dating prior to 1751—bears an inscription stating that it was done at the Academy under the supervision of Charles Natoire. During his Italian sojourn between 1755 and 1757, Greuze executed many drawings in chalk, ink, and watercolor recording local costumes and as preparations for paintings. As his first exhibited drawing, one of these was included among his Salon entries for 1757. Subsequently, other drawings appeared in 1759, 1761, and 1765. At the last-mentioned exhibition he showed for the first time a work in pastel. In 1769 appeared six major drawings with dramatic subjects as well as three têtes d'enfants. Throughout the century, collectors sought out Greuze's drawings, the most notable purchase being that made by the Russian general Ivan Iv. Betzkoy in the 1760s: an ensemble of over two hundred sheets that he transferred to Catherine II's Imperial Academy of Fine Arts in 1769. The sale of prints reproducing Greuze's drawings brought the artist considerable wealth, but his fortune was largely decimated by the onerous settlement he was obliged to pay his former wife at the time of their divorce in 1793. In his final self-portrait, exhibited the year before his death, Greuze chose to depict himself holding a drawing instrument.

BAPTISTE *Aîné* (96.3.126)

Pastel, on cream paper, 16½ × 13¼ in. (41.9 × 33.7 cm), affixed at the time of execution to a larger sheet, 17¾ × 14¾ in. (45.1 × 37.5 cm), mounted on stretchers.

DESCRIPTION: Turned three-quarters to his right, Baptiste *aîné* is depicted wearing a high-collared, gray-blue, double-breasted outercoat, a white waistcoat with large lapels, and a stock tied round his neck up to his chin. From a bow at the base of the neck, the fabric billows out to the right. The subject's hair is powdered light gray. His eyes are blue. A blank, light blue background suggests the sky.

CONDITION: The pastel is in excellent condition except for some rubbing along the bottom and right edges of the support sheet and minor losses along the subject's left shoulder.

NICOLAS-Pierre-Baptiste Anselme, called Baptiste *aîné* (for *fils aîné*), was born in Bordeaux June 18, 1761, the son of Joseph-François Anselme, called Baptiste *l'ancien*, and Marie Bourdais; he died in the Batignolles quarter of Paris November 30, 1835.[1] Baptiste was the most illustrious of several generations of a family of actors and actresses. After performing hither and yon with his parents, he established himself as an actor and singer in Rouen between 1783 and 1790. Prior to 1785, he had married there Anne-Françoise Gourville. By 1791, the entire Anselme family was performing in Paris at the Théâtre du Marais—Baptiste *aîné* and his wife, his parents, his younger brother, and his uncle. In 1792, Baptiste established his reputation in the principal role in La Martelière's *Robert, Chef des Brigands*. The following year he joined the company of the Théâtre de la République, in 1798 that of the Théâtre Feydeau, and the next year the newly-reorganized Comédie-Française, where he remained until his retirement on April 1, 1828. Between 1809 and 1828, he also taught acting at the Conservatoire. Two of Baptiste *aîné*'s children pursued careers in the theater, his son Joseph playing occasionally at the Comédie-Française and his daughter Françoise-Joséphine becoming a *sociétaire* of that company.

Among the over one hundred roles Baptiste *aîné* performed at the Comédie-Française were parts in classics by Corneille, Molière, and Racine, as well as in many contemporary works by Beaumarchais, Chénier, Fabre d'Églantine, Sedaine, and Voltaire. During his stay at the Théâtre de la République, he was described by La Harpe, writing to the Grand Duke of Russia, as "combining a deeply intelligent dramatic sense with a clear diction, sophisticated manners, and a realistic tone." Other contemporary accounts were more critical, such as this one: "His good qualities include a perfect intelligence, a relaxed manner, a precise diction, a pure voice, an attractive physiognomy, a passionate love of his art. ... His faults are: a height too great for the theater, a way of performing that is mannered, a delivery that is precious and slow, the affectation of stressing every word, of underlining every detail; in short, an absence of feeling. ... He enunciates everything, including periods and commas." Besides being renowned for his professional assiduity, Baptiste *aîné* also, as one colleague recalled, "made himself loved by everyone through his proverbial affability; never, over his long career, did he appear jealous of a comrade's success." Another added: "In his private life, Baptiste was most gentle and easy-going."

Commenting on the sparse turnout for the benefit performance that concluded the actor's career, one critic noted: "If one considers the so-called gratitude the

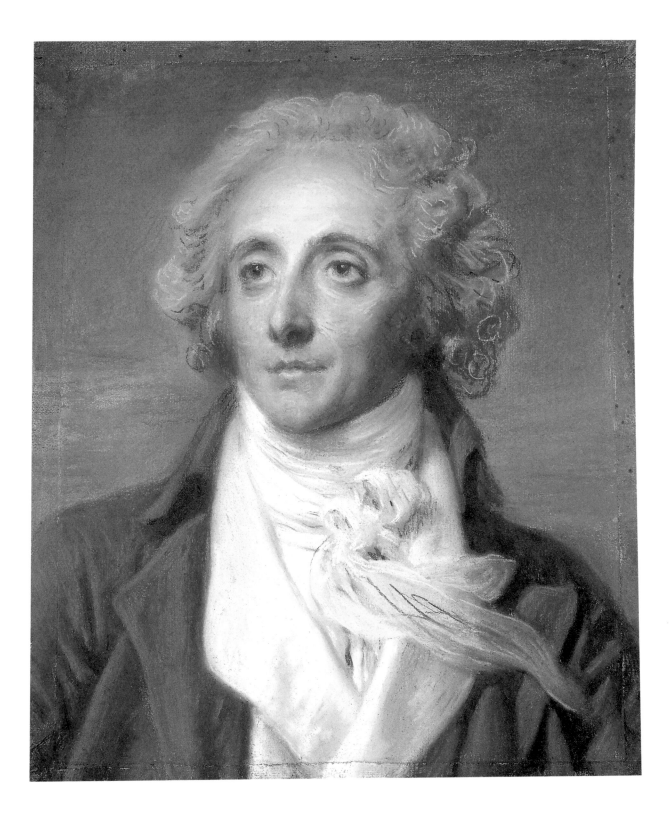

public owes an actor, Baptiste *aîné* would certainly have had claim to it, his public and private conduct never having been anything but praiseworthy."

Baptiste's fame, his unusual height—the source of his nickname *"Le Télégraphe"*—and his generally striking appearance inspired many artists to execute portraits of him. Besides Greuze, they include: Étienne Bouchardy (Comédie-Française), Henri-Pierre Danloux,[2] Martin Drolling (Comédie-Française, Musée de Caen), Frédéric-Désir Hillemacher, Jean-Baptiste Isabey (Comédie-Française), and Muneret (Comédie-Française). But it was Louis-Léopold Boilly who seemed most fascinated with the actor. He first portrayed him, full-length, seated, and in profile right, at the center of his *Reunion of Artists in Isabey's Studio* (Louvre), shown at the Salon of 1798. The engraver Alexandre Clément reproduced from this group portrait a collection of heads that he published in 1804 as a *Réunion d'artistes*, in which the profile of Baptiste *aîné* appears at center left, identified in the accompanying key as "Baptiste aîné Artiste du Théâtre Français." Boilly then introduced Baptiste's unmistakable profile in the center of the crowd depicted in *The Public in the Salon of the Louvre, Viewing the Painting of the "Sacre"* (private collection, New York), begun in 1808, and in the preparatory drawing for that work (National Gallery of Art, Washington).[3] Unfortunately, there exists no documentation of the relations between Boilly and his distinctive model, but it is recorded that at this time such well-known theatrical personalities as Baptiste *aîné* were the object of an impassioned *théâtromanie*. "Actors and actresses inspire passions; their private life is the object of an already insatiable curiosity; their playing inspires … a philosophy of the theater."[4]

Based on the evidence of Baptiste's clothing and hair-styling—and more specifically on that of Madame Baptiste in her pendant portrait (see next entry)—the costume historian Michele Majer suggests a date at the very end of the eighteenth century (1798–1800) for the two. Otherwise, there is no documentation concerning their execution that could suggest a more precise dating. However, Baptiste's joining the Comédie-Française in 1799 might have been the occasion for commissioning the two portraits.

<div align="right">E. M.</div>

EXHIBITED: Paris, Association des artistes, 26 Boulevard des Italiens, 1860, No. 315, as *Portrait de Baptiste aîné, acteur de la Comédie Française*, lent by L. Godard. New York, Metropolitan Museum of Art, Eighteenth-Century French Drawings in New York Collections, 1999, No. 100. New York, Frick Collection, and Los Angeles, J. Paul Getty Museum, Greuze the Draftsman, 2002, No. 91.[5]

COLLECTIONS: L. Godard, Paris, 1860. Senator Antonio Santamarina, Buenos Aires, acquired *c.* 1950–52 in Paris, until 1974. Bequeathed to his son Miguel M. Santamarina, Buenos Aires. Acquired by The Frick Collection in 1996 with funds bequeathed in memory of Suzanne and Denise Falk.

NOTES

1. This summary biography and that of Madame Baptiste *aîné* are based primarily on archives preserved in the Collection Auguste Rondel at the Bibliothèque de l'Arsenal, Paris, as well as those held in the Bibliothèque de la Comédie-Française and in the Archives de Paris. See also: E. Laugier, *Documents historiques sur la Comédie Française pendant la règne de S. M. L'Empereur Napoléon I^{er}*, Paris, 1853, pp. 94–168, *passim*; H. Lyonnet, *Dictionnaire des comédiens français*, Geneva, 1969, I, pp. 7–74; and E. D. de Manne, *Galerie historique des comédiens de la troupe de Talma, Notices sur les principaux secrétaires de la Comédie Française depuis 1789 jusqu'aux trente premières années de ce siècle*, Lyon, 1866, pp. 181–90.

2. Sold at Christie's, New York, January 30, 1997, Lot 163, as *Portrait of a Gentleman*.

3. The author is indebted to Philippe Bordes for having pointed out the presence of Baptiste *aîné* in these works by and after Boilly.

4. G. Morel, *Histoire des spectacles, Le XVIII^e Siècle, Le Théâtre et la Société*, Paris, 1965, p. 767.

5. This entry and the following one were first published in the present author's catalogue of that exhibition, pp. 252–56.

MADAME BAPTISTE *Aîné* (96.3.127)

Pastel, on cream paper, 18 × 14⅝ in. (45.6 × 36.6 cm).

DESCRIPTION: Turned three-quarters to her left, Madame Baptiste *aîné* is shown wearing a short-sleeved white gown and a pale pink scarf knotted at her breast. A ribbon of a similar tone is bound about her plaited brown hair, which descends in curls at either side of her face. The subject's eyes are blue, and she is depicted against a blue-gray background suggestive of an interior.

CONDITION: The pastel is in excellent condition except for some rubbing in the upper right corner.

FAR less is known about Madame Baptiste *aîné* than about her celebrated husband. Née Anne-Françoise Gourville, she married Baptiste in Rouen at some point between 1783 and 1785. By 1791—known as "Madame Baptiste *bru*"—she was performing in Paris at her husband's side, the two described as "*le jeune ménage.*" By the time the couple was performing two years later at the Théâtre de la République, she was being assigned roles of increasingly lesser importance. Finally, the *Opinion du Parterre* of Germinal, An XI, recorded the end of her career in unflattering terms: "She had a terrible fault, which consisted of not allowing to be heard a single verse that she delivered. Never did she dare look at the audience; her eyes were fixed on the wings, to which she addressed her entire role. She has been offered her retirement."[1]

Extant correspondence suggests that a warm union linked Baptiste *aîné* and his wife. A letter he addressed to her from Metz dated 18 Pluviose An II concludes "a thousand and thousand kisses for you, for our children, and for our respectable family—from your faithful husband."[2]

There are no other known portraits of Madame Baptiste *aîné*.

E. M.

EXHIBITED: Paris, Association des artistes, 26 Boulevard des Italiens, 1860, No. 316, as *Portrait de la femme de Baptiste aîné*, lent by L. Godard. New York, Frick Collection, and Los Angeles, J. Paul Getty Museum, Greuze the Draftsman, 2002, No. 92.

COLLECTIONS: Same as preceding entry.

NOTES

1. H. Lyonnet, *Dictionnaire des comédiens français*, Geneva, 1969, I, p. 75.

2. Collection of the Bibliothèque de la Comédie-Française.

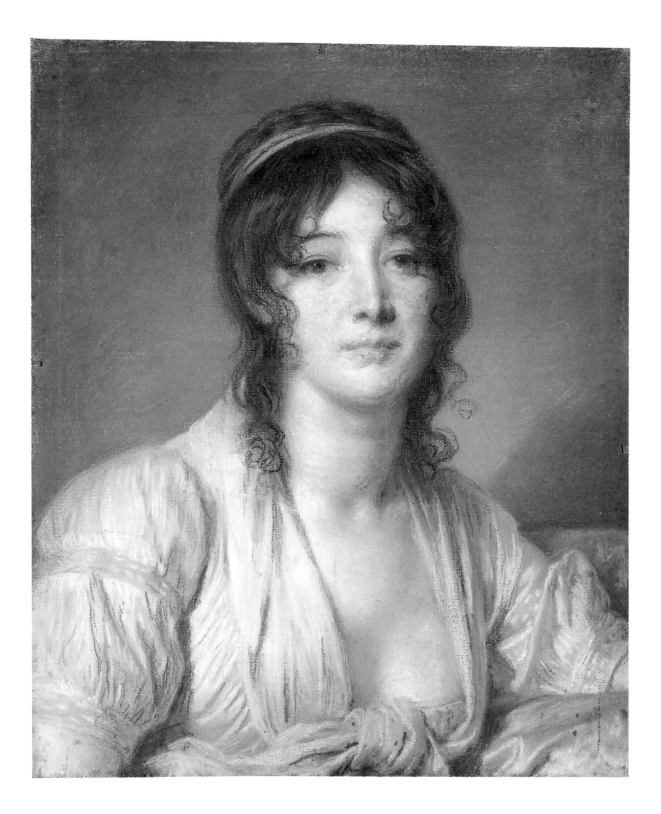

THOMAS GAINSBOROUGH

1727–1788

Gainsborough was born in Sudbury, Suffolk, and studied in London. He spent periods working in Ipswich, Bath, and later in London, where he died. Renowned as a painter of portraits and landscapes, he was also a prolific and highly original draftsman. Although few of his drawings are preparatory studies for paintings, some figure sketches—executed either from life or from mannequins he dressed in costumes—can be connected to portraits in oil, as composition or costume studies. As is true of his paintings, Gainsborough's figure studies are far outnumbered by landscape drawings. Some of the latter were executed directly from nature, while many others were done in the studio from memory, at times with the aid of models he assembled from bits of grass, branches, stones, glass, and debris; into these scenes he often wove stock picturesque and pastoral motifs. Gainsborough was skilled at combining media in innovative ways, and some of his recipes for achieving rich painterly effects, as well as his unorthodox techniques for applying pigment to paper, have been preserved in his letters. Nevertheless, he attached little importance to his drawing, which he did primarily for pleasure and experimentation, often working long into the night to the accompaniment of music; he almost never dated his sheets and gave many away to friends. After his death, his drawings were much sought after, and Gainsborough is now ranked among the leading draftsmen of his time.

STUDY OF A WOMAN FACING LEFT, Possibly Ann Ford
(Later Mrs. Philip Thicknesse) (13.3.6)

Drawn about 1760. Black chalk (with evidence in places of chalk dipped in oil), on buff laid paper, 15⅝ × 10⅜ in. (39.7 × 26.4 cm).

INSCRIPTION: In pencil on verso: *S–/45*.

DESCRIPTION: The subject is seen in three-quarter view, seated in a landscape looking to the left, with her left leg crossing the right. Her head is supported on the left hand, while her right hand rests on a sheet of paper on her lap. She wears a square-necked gown trimmed at the bodice and elbows with lace and a laced stomacher with a row of bows down the center. The head and torso are drawn with relative precision, but the lower body appears unfinished. Overhanging branches and landscape elements are rudimentarily suggested

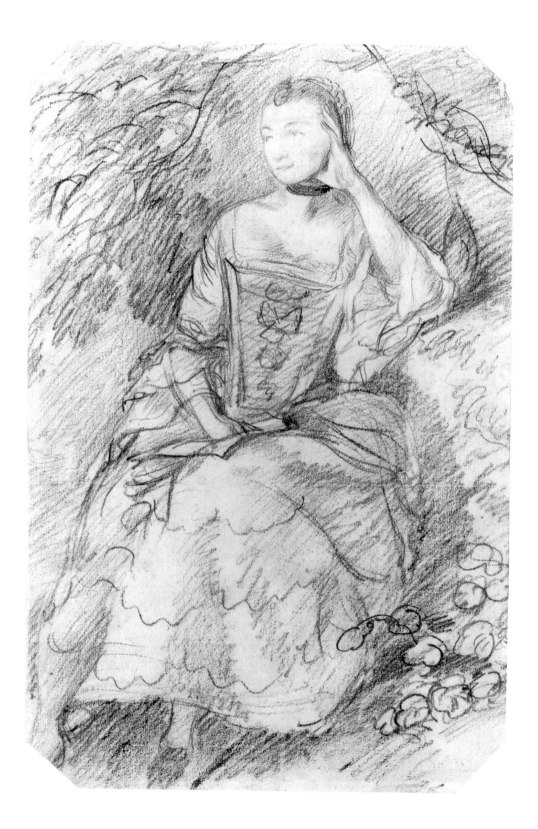

through a combination of broad sweeping strokes and hatched lines.

CONDITION: All four corners are cut. In 1980, the sheet was removed from a secondary support to which it had been entirely adhered and treated with methanol to reduce yellow discoloration. It was then flattened, inlaid, and hinged to a backing of rag paper. The drawing is in good condition.

STUDY OF A WOMAN FACING RIGHT, Possibly Ann Ford (Later Mrs. Philip Thicknesse) (13.3.7)

Drawn around 1760. Black chalk (with evidence in places of chalk dipped in oil) and pencil, on buff laid paper, 14⅛ × 10⅜ in. (36.8 × 26.4 cm).

INSCRIPTION: In pencil on verso: *Sr/45*.

DESCRIPTION: The figure, in three-quarter view, is seated in a landscape facing right, her right leg crossed over the left. Her head, supported by her left arm, turns slightly frontward, with her hair pulled back from the face and secured in a braid or ribbon partially visible at the side; a ribbon passes around her neck. She wears a gown similar to that seen in the companion drawing, but here a shawl or cape is wrapped loosely around her arms. High-heeled shoes with buckles extend from below her skirt. A few hasty lines in the background suggest branches and foliage and what might be the beginning of a balustrade at right.

CONDITION: All four corners are cut. In 1980 the sheet was removed from the board to which it had been attached with hinges and paper strips. It was immersed in water to reduce foxing, flattened, inlaid, and rehinged to a sheet of rag paper. Except for some discoloration around the edges and an oil stain on the lower right edge, the drawing is in good condition.

UNLIKE many of Gainsborough's figure drawings, the two Frick studies can be linked, at least provisionally, with a specific portrait in oil: that of Ann Ford, later Mrs. Philip Thicknesse, painted in 1760 and now in the Cincinnati Art Museum, Gainsborough's first major commission in Bath.[1] In these drawings, the artist appears to be working out his initial ideas for the figure's pose and the fall of the drapery of her dress, measures he would be likely to have taken given the importance of the portrait in securing further commissions in his new home.[2] However, the pose of the figure in the Frick sketches differs from that seen in the Cincinnati portrait, as well as that in a compositional study for it in the British Museum, London.[3]

In the more finished of the two Frick sketches, No. 13.3.7, the woman looks frontward and her head is supported by her left arm, while in the painting the subject faces left and her upper body is given an emphatic twist that is entirely lacking

74

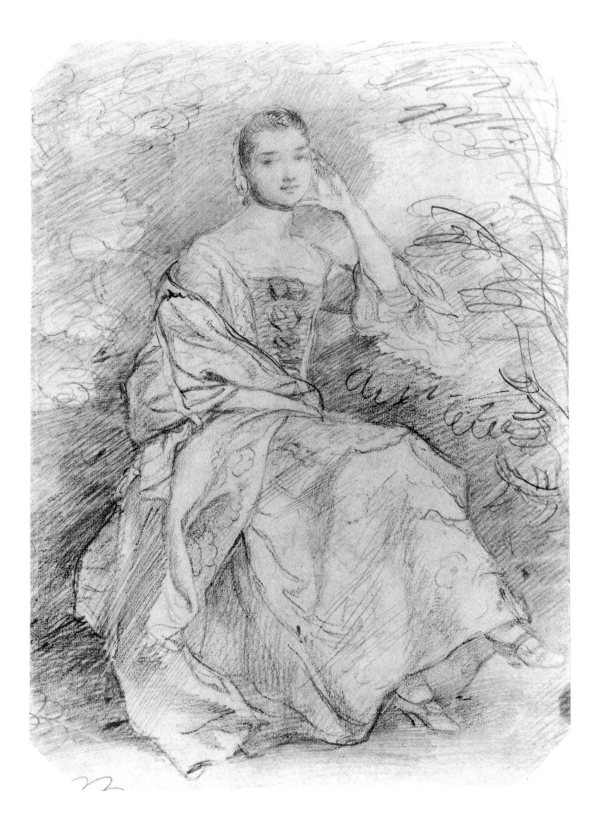

here. Nevertheless, the position of the lower body, the light and shadow and pattern of folds on the skirt, and even the design and placement of the high-heeled, buckled shoes are repeated almost exactly in the oil.[4]

From the more summarily executed drawing, No. 13.3.6, Gainsborough appears to have derived the position of the head and torso in the painting, although in the oil he gives the head a marked tilt upward and changes the position of the supporting hand. The lower body in this drawing is less resolved, and the rendering of the feet appears unfinished, while the indication of a "third" leg at far left shows Gainsborough open to experiment as he works out the pose at this early stage.

Aspects of the poses of both Frick drawings are combined in the British Museum study, but there the setting has undergone a complete transformation: the lady is seen indoors, a garden is visible through a window behind her at left, and on her lap she holds a cittern. The greater fluidity of the British Museum sketch, in which all parts of the drawing are integrated at the same level of finish, suggests that it represents a later stage in the development toward the oil portrait. The interior setting and cittern are retained in the canvas.

Not all scholars have accepted the connection of the Frick drawings with the Cincinnati painting. In his 1970 catalogue raisonné of Gainsborough's drawings, Hayes concluded of No. 13.3.7, "There is no evidence ... to support the view that it is a preliminary study for that portrait," calling it simply a "costume and composition study, probably drawn from an articulated doll."[5] Responding to Hayes, Stainton argued that the vitality of the two figures indicates that they could only have been drawn from life; furthermore, the sitter in the Frick drawings can be linked with an unidentified model in a portrait study in the Victoria and Albert Museum, London.[6]

As the coiffures and costumes of the figures in the Frick drawings are almost identical (although the shawl or cloak appears in only one), it seems likely that the same model is represented in both. The faces, however, are not exactly alike; the sharper features of the less finished figure in No. 13.3.6 are somewhat closer to the refined face in the painting, whereas the more rounded visage in No. 13.3.7 is reminiscent of that of Gainsborough's wife (although the angle of the head may account in part for the difference). In a half-length portrait painted in the mid 1750s, Gainsborough shows his wife wearing a dress and cloak similar to those in the Frick drawings.[7] Whether the model for one or both of the Frick sketches was Mrs. Gainsborough in a somewhat idealized form, or the woman in the above-men-

tioned Victoria and Albert study, or two different women, remains unresolved, although the Frick sketches probably were executed from life.

Ann Ford (1737–1824), a talented and independent-minded musician and dancer, was twenty-three when Gainsborough painted her. During that year she gave a series of public viola da gamba and cittern recitals in London, over the strong opposition of her family.[8] In 1762 she became the third wife of Philip Thicknesse, governor of Landguard Fort and one of Gainsborough's important patrons, who commissioned the Cincinnati portrait. Some years later the couple had a falling-out with Gainsborough over a portrait Mrs. Thicknesse commissioned of her husband as a companion piece to her own, but which the painter never completed.[9]

S. G. G.

NO. 13.3.6

EXHIBITED: London, Colnaghi, 1906, No. 8. New York, Knoedler, 1914, No. 9.

COLLECTIONS: William Benoni White. Probably his sale, Christie's, London, May 24, 1879, Lot 200 or part of Lot 201, both bought by Thibaudeau. John Postle Heseltine, London (Lugt 1507), until at least 1902.[10] Colnaghi (?). Knoedler. Frick, 1913.

NO. 13.3.7

EXHIBITED: London, Colnaghi, 1906, No. 6. New York, Knoedler, 1914, No. 15.

COLLECTIONS: The artist's widow, Margaret Gainsborough (d. 1798). Her daughter, Margaret Gainsborough (d. 1820). By descent to either Henry Briggs or, through Sophia Lane, to Richard Lane, Gainsborough's great-nephew. Probably Lane sale, Christie's, London, February 25, 1831, part of Lot 96 or Lot 98. John Postle Heseltine.[11] Colnaghi (?). Knoedler. Frick, 1913.

PRINT REPRODUCING THE DRAWING: Lithograph by Richard Lane, 1825.[12]

NOTES

1. The connection is developed in *The Frick Collection Catalogue*, IV, 1951, p. 12. For the oil painting, see E. Waterhouse, *Gainsborough*, London, 1958, No. 660, p. 92, pl. 62.

2. As noted in L. Stainton, *Gainsborough Drawings*, Washington, 1983, p. 72.

3. No. 1865–6–12–11, pencil and watercolor, 13³⁄₁₆ × 10⅛ in. See J. Hayes, *The Drawings of Thomas Gainsborough*, London, 1970, text vol., No. 16, p. 114, plate vol., pl. 327.

4. See Stainton, *loc. cit.*

5. Hayes, text vol., No. 18, p. 114; compare Hayes' No. 19, p. 115, and on Gainsborough's use of a mannequin for costume studies see p. 35.

6. Stainton, *loc. cit.* (Dyce 596). See also

Hayes' reply in "Gainsborough Drawings: A Supplement to the Catalogue Raisonné," *Master Drawings*, XXI, No. 4, Winter 1983, pp. 370–71.

7. See Waterhouse, No. 297, p. 67, pl. 7, present whereabouts unknown.

8. *Gainsborough and His Musical Friends*, London, 1977, No. 16, n.p.

9. *Idem*.

10. *Original Drawings by British Painters in the Collection of J.P.H.*, London, 1902, No. 14, repr.

11. *Idem*, No. 17, repr.

12. R. J. Lane, *Studies of Figures by Gainsborough*, London, 1825, reproduces No. 13.6.7 (in reverse), pl. III.

ADDITIONAL REFERENCES

Sir W. Armstrong, *Gainsborough and his Place in English Art*, London—New York, 1898, No. 13.3.7 repr. facing p. 288.

L. Stainton, "Gainsborough as a Draftsman," *Drawing*, V, No. 5, January–February 1984, pp. 103–08.

LANDSCAPE WITH CATTLE CROSSING A BRIDGE (13.3.8)

Drawn probably about 1785. Oil over black chalk with white chalk highlights, on white laid paper, varnished, 8⅝ × 12⁵⁄₁₆ in. (22 × 31.3 cm).

DESCRIPTION: In the foreground a herdsman on horseback drives cattle over a double-arched bridge that spans a stream. The path continues at right up a steep rise surmounted by a clump of small trees. A single tall tree fills the left edge of the drawing, and in the center distance is a small cluster of buildings below hills that lead up to a mountain ridge. The scene is executed in gray and brown washes, highlighted locally with salmon pink and blue.

CONDITION: There are losses in all four corners (including a scratch at lower left), the varnish has discolored somewhat, and foxing is visible on the verso, but the drawing is otherwise in good condition. In 1980 it was removed from an old backing and hinged to a sheet of rag paper.

GAINSBOROUGH made his first trip to the Lake Country in 1783, traveling with a Suffolk friend, Samuel Kilderbee. Although he did some drawings there directly from nature, he executed many more after returning to London—works in which picturesque and pastoral motifs of cattle and herdsmen, arched bridges crossing streams, and distant towers or farm buildings were combined with his memories of the rugged landscape.[1]

The site depicted in the Frick drawing has not been identified, but both the distinctive sharp, flat ridge of the distant mountain and the shapes of the lower hills recall, in a general way, the Langdale Pikes, which appear in other drawings as well as paintings by Gainsborough at this time.[2]

Although the Frick drawing does not seem to be a preparatory study for a known oil painting, it does share its compositional scheme and certain motifs with a landscape painting commissioned by the Prince of Wales (later George IV), which Gainsborough executed soon after his return from the Lake Country: both incorporate a steeply rising hill or cliff at right balanced by a lone tree at left, a herdsman with cows and water in the foreground, and buildings nestled in the foothills of a distant mountaim.[3] Of the Prince of Wales' painting, a contemporary critic wrote that "Mr. Gainsborough painted [it] on his return from the *Lakes*; and though not a portrait of any particular spot, the picture is highly characteristic of that country."[4] This observation could also apply to the Frick drawing.

Since the 1770s, Gainsborough had been experimenting with new ways of combining media and with various techniques of creating in his drawings rich painterly effects that would give them, in Stainton's words, "the force and depth of tone which could compete with oil painting."[5] In a letter of 1773, the artist revealed some

79

of his recipes and methods to his friend William Jackson, pledging him to secrecy. The substitution of white lead for white chalk, the stretching of the paper on a frame after it had been dipped in skimmed milk, and the application of varnish over the washes were among his unorthodox techniques,[6] although it is difficult to know exactly what procedures he followed in the Frick drawing, aside from its being varnished on the recto. Many other drawings, it is worth noting, were varnished on both sides.

The breadth and grandeur of the vista in this work, the diffused light that appears to come from no specific source, the broadly painted forms with open contours, and the painterly drawing technique are all characteristic of Gainsborough's later, more monumental style.

S. G. G.

COLLECTIONS: Sir Thomas Lawrence (?). John Postle Heseltine, London (Lugt 1507).[7] Knoedler. Frick, 1913.

NOTES

1. On Gainsborough's use of picturesque motifs, see J. Hayes, *The Drawings of Thomas Gainsborough*, London, 1970, text vol., pp. 51–52.

2. Compare the *Study for the Langdale Pikes* of 1783, Hayes, text vol., No. 577, p. 242, plate vol., No. 179, presumed to have been made before the motif.

3. J. Hayes, *The Landscape Paintings by Thomas Gainsborough*, London, 1982, II, No. 146, p. 514, repr. See also the study for this painting, No. 146b, p. 515, repr., which is closer still to the Frick drawing.

4. *The Morning Post*, April 6, 1789, quoted in Hayes, 1982, II, p. 516. The painting was exhibited at Schomberg House.

5. L. Stainton, "Gainsborough as a Draftsman," in *Drawing*, V, No. 5, January–February 1984, p. 105.

6. Letter to William Jackson, Bath, January 29, 1773, quoted in *The Letters of Thomas Gainsborough*, ed. M. Woodall, London, 1963, pp. 177–78.

7. *Original Drawings by British Painters in the Collection of J. P. H.*, London, 1902, No. 11, pl. 11.

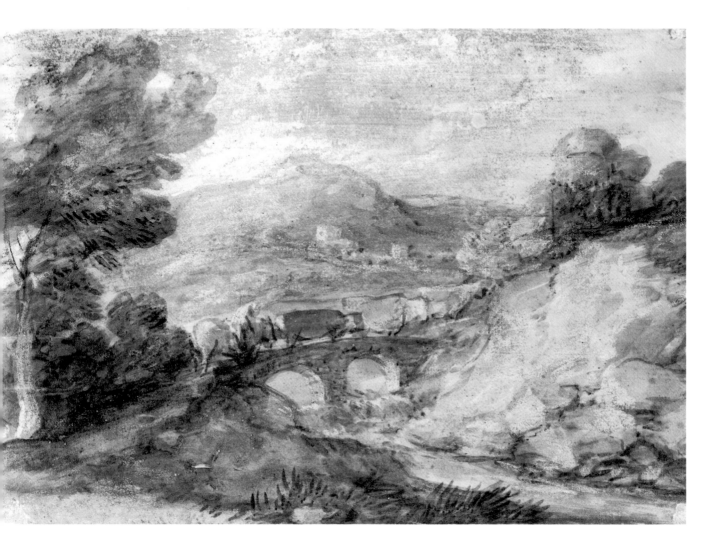

Style of
JEAN-HONORÉ FRAGONARD
1732–1806

Apprenticed briefly to Chardin and then to Boucher, Fragonard won the Prix de Rome in 1752, but it was not until 1755 that he left for Italy, having spent the interim preparing at the École Royale under Carle Van Loo. During his five years in Rome, he continued his studies at the French Academy under Natoire and developed a love of outdoor sketching. Back in Paris, he prepared to enter the Académie Royale as a history painter but soon forsook official patronage to devote himself to a more personal body of work, concentrating on paintings in oil, decorative panels, etchings, illustrations, miniatures, and drawings. Fragonard's drawings, in varied tones of wash and chalk, exhibit great freedom and individuality, developing the sketch and the preliminary composition into autonomous works of art. Throughout his career, drawing served an important role, paralleling his paintings but not necessarily connected to them.

CUPID SACRIFICING HIS WINGS for the Delight of the First Kiss (63.3.94)

Bistre over graphite, with overdrawing in black chalk, bordered in bistre, on white laid paper, 8⅛ × 6³⁄₁₆ in. (20.7 × 15.7 cm).

INSCRIPTION: In graphite on verso: *H. Fragonard.*

DESCRIPTION: Hovering over a rectangular altar on which he sets a pair of small wings, a putto with a quiver bound to his waistband receives a kiss from a girl whose naked winged torso materializes through shafts of light streaming from upper left. Clouds fill the remainder of the sky, and foliage borders the bottom of the composition.

CONDITION: The drawing is in good condition. In 1980 it was removed from an earlier wood-pulp mat, hinged to a sheet of rag paper, and mounted in a rag board mat.

THE Frick drawing follows in most respects an oil painting on panel of the same name in the collection of John Mortimer Schiff, New York.[1] The painting, which is neither signed nor dated, depicts Cupid setting his small wings on an altar inscribed with the words "Au Bonheur Du 1. Baiser." Although the subject of the kiss appears in Fragonard's art frequently and in numerous permutations, from

82

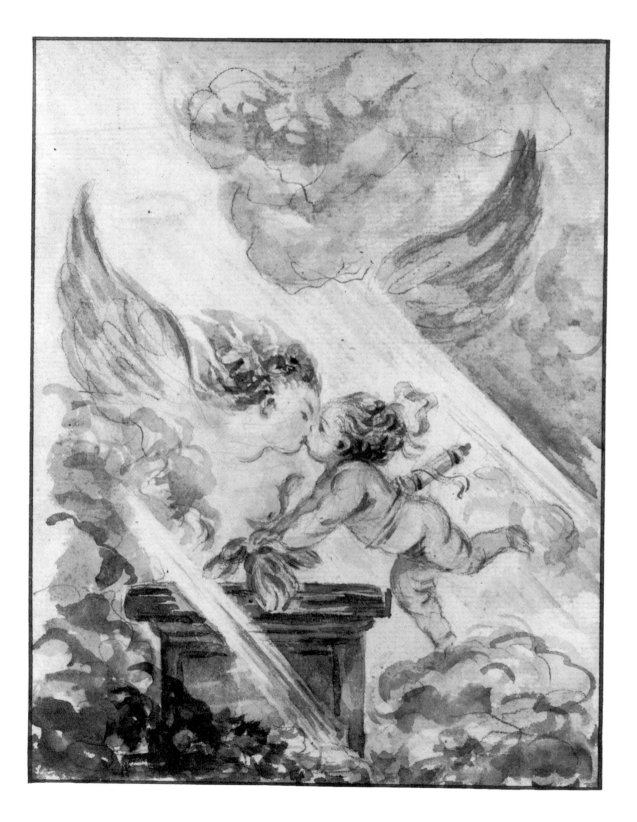

explicit representations of lovers embracing to mothers tenderly holding their infants, this allegorical treatment of the theme—an evident allusion to the surrender of freedom for love—is unusual in his oeuvre, if not unique.

Wildenstein placed the Schiff painting within the period 1765–72, during which Fragonard first won popularity in Paris as a genre painter of amorous and pastoral subjects and decorative scenes of children and putti.[2] Closely related to the painting are two oval compositions, known in numerous examples, representing *Love the Jester* and *Love the Sentinel*,[3] figures that Fragonard also incorporated into two rectangular overdoors that form part of the series called *The Progress of Love* now in The Frick Collection.[4] The small body, pudgy legs, and flowing hair of the putto in the oval *Love the Jester* are reminiscent of the buoyant infant in the Schiff panel and the Frick drawing, and the recent attribution of a previously unknown color mezzotint of the composition to Arnauld-Éloi Gauthier d'Agoty, an engraver who died in 1771, would seem to further support Wildenstein's dating of the panel.[5] Nevertheless, the intensity of feeling in the painting, as well as its neoclassical iconography, set it apart from the decorative oval pairs of putti, and suggest a connection with—or perhaps anticipate—works of the 1780s, such as *The Invocation to Love* in the Cleveland Museum of Art.[6] During that later period, the happy lovers of the 1770s are replaced, in the words of Williams, by "more carefully drawn classicizing figures who seem eternal in their facial idealizations and frozen poses."[7]

The Frick drawing has been described as a preparatory sketch for the Schiff panel,[8] but this view has been contested in recent years, as has the drawing's authorship. Several obvious discrepancies exist between the two works. In the drawing, for example, the altar is rectangular rather than circular, and it lacks an inscription. Still more pronounced is the difference in the rendering of the female figure, which is given emphasis equal to the putto in the drawing, whereas in the painting she appears only as a hovering ghostly presence, dissolved in light. Most telling of all are the disparities between the technique employed in the drawing and that found in works on paper of the 1770s acknowledged to be by Fragonard. In the drawing, the putto and the profile of the female figure are outlined more or less completely, although elsewhere the graphite is used more freely. As Rosenberg has noted, the bistre wash here closely follows the drawn contours of the figures—a method at odds with Fragonard's usual methods of draftsmanship in the 1770s;[9] more characteristically, his drawings exhibit, as Williams states, "the interplay between free underdrawing and veils of wash."[10] Overall, the drawing lacks the ener-

gy and improvisatory quality of Fragonard's preliminary studies of subjects of action and fantasy. Rather than preparatory to the Schiff painting, the drawing may have been either executed after it—perhaps in preparation for a print—or fabricated as a later pastiche or copy.[11]

<div align="right">S. G. G.</div>

COLLECTIONS: Comtesse de Z.[12] Christie's, London, March 25–26, 1963, Lot 233, as *Le Baiser*. Frick, 1963.

NOTES

1. The panel, formerly in the collection of Mrs. George Baker, New York, measures 32 × 24 cm; see G. Wildenstein, *The Paintings of Fragonard*, London, 1960, p. 270, No. 315, fig. 141. The primary research on the Frick drawing was done by Bernice Davidson.

2. The first published reference to the oil is in an inventory drawn up in 1794 (*idem*).

3. *Idem*, Nos. 319–25, pp. 271–72, figs. 142–44.

4. For which see *The Frick Collection: An Illustrated Catalogue*, II, 1968, pp. 94–120. The overdoors are generally assumed to have been executed in Grasse in 1790–91 as part of a project incorporating four large panels painted in 1771–73 for Madame du Barry but subsequently rejected. Recently, however, Rosenberg has asserted that the overdoors "appear to have been executed long before 1790, probably at the time of the four principal compositions" (P. Rosenberg, *Fragonard*, New York, 1988, pp. 322–23).

5. See *Jahrbuch der Staatlichen Kunstsammlungen in Baden-Württemberg*, XVI, 1978, pp. 95–106. The mezzotint is in the collection of the Kunsthalle, Karlsruhe.

6. See E. Williams, *Drawings by Fragonard in North American Collections*, exhib. cat., Washington, National Gallery, 1978, No. 50, p. 128, repr. p. 129.

7. *Idem*, p. 128.

8. See A. Ananoff, *L'Oeuvre dessiné de Jean-Honoré Fragonard*, II, Paris, 1963, No. 1014, p. 155, fig. 271. The drawing came to The Frick Collection with a certificate of attribution from Ananoff dated 1962.

9. Communication in the curatorial files of The Frick Collection.

10. *Op. cit.*, p. 22.

11. The drawing has been rejected by, among others, Jacob Bean, Marianne Roland Michel, Pierre Rosenberg, and Eunice Williams.

12. Ananoff, *loc. cit.*

FRENCH

Last Quarter of the Eighteenth Century

PORTRAIT OF THE MARQUIS DE MIROMESNIL (73.3.107)

Drawn probably between 1775 and 1800. Graphite, on white laid paper, 5¼ × 4³⁄₁₆ in. (13.4 × 10.7 cm).

DESCRIPTION: Portrayed bust-length and in left profile, Miromesnil wears a heavy, curled wig, a soft neckcloth, and the robes of a magistrate. His face, animated by a slightly furrowed brow and a suppressed smile, is modeled largely in subtle gradations from light to dark, but the eye, nostril, and mouth are drawn in precise detail. The wig and robe are indicated by a few light lines, and the neckcloth is shaded but left unfinished.

CONDITION: Apart from stains around the edges and creases across the bottom, the drawing is in good condition.

THE identification of the subject as Armand-Thomas Hue, fourth Marquis de Miromesnil (1723–96), was made by Davidson in 1973.[1] The drawing appears to be based on one of three closely related versions of a bust of Miromesnil executed in marble by Jean-Antoine Houdon (1741–1828).[2] The first version, signed and dated 1775, is now in the Victoria and Albert Museum, London. The second signed and dated work, executed two years later, is in The Frick Collection. A third version, in the Musée Fabre, Montpellier, is unsigned and undated but must have been done no earlier than 1781, the year that Miromesnil was awarded the Order of the Saint-Esprit; although the decoration itself has been effaced from the bust, presumably during the Revolution, the ribbon remains, along with traces of an embroidered emblem.[3] Yet another version, a bronzed plaster, is in the Musée de Peinture et de Sculpture in Orléans.[4]

The 1775 and 1777 marble busts, considered autograph, differ only in slight details: the furrows in the brow of the earlier version are omitted in the Frick marble, and the treatment of the eye varies. The Frick drawing, in which the furrows are clearly indicated, is likely to have been based on the 1775 version, which was displayed in Paris in the Salon of that year.[5]

While the identification of the subject of the Frick drawing, and its connection with the Houdon bust, which it follows in most details, appear to be relatively secure, the authorship of the drawing remains open to speculation. When acquired

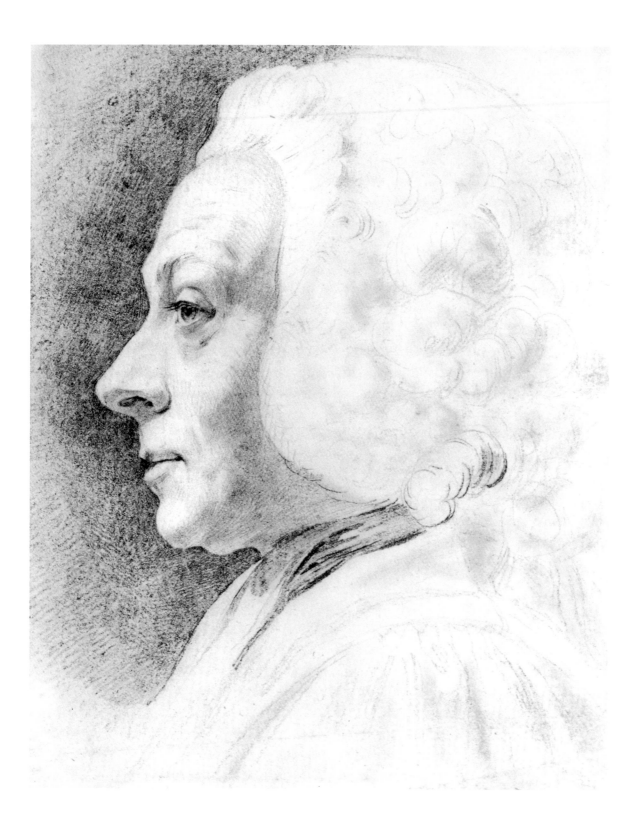

by The Frick Collection, the drawing was attributed to Augustin de Saint-Aubin (1736–1807), one of the leading French engravers of the eighteenth century, known for his scenes from contemporary life, historical works, and portraits of famous persons of the present and past. However, Miromesnil is not listed among the subjects of the some three hundred engraved portraits—based on his own drawings and those of other artists—for which Saint-Aubin is best known.[6] Furthermore, the defined outline around the subject's face and the regularized pattern of hatched lines indicating shadow bear little relation to Saint-Aubin's animated drawing style. On recent examination, Roland Michel rejected the attribution to Saint-Aubin on the basis of style, while accepting it without reservation as a work of the eighteenth century.[7]

From an ancient Norman family, the Marquis de Miromesnil served as president of the Norman parliament in Rouen before he was appointed Garde des Sceaux (Minister of Justice) by Louis XVI in 1774.[8] A popular figure of his time—as attested by the number of replicas of the marble bust—Miromesnil was portrayed in engravings of the period by a number of artists, some of which were based on the Houdon sculpture.[9] The Frick drawing may well have served as an intermediary step between the sculpture and a print. Probably the best-known of the graphic representations of Miromesnil is an engraving by B.-L. Prévost after a drawing by Charles-Nicolas Cochin the younger, dated 1773.[10] There, however, Miromesnil wears a simple buttoned jacket that predates his appointment as Garde des Sceaux, and the date precludes the possibility that the drawing was executed after the Houdon bust.

There are similarities between the Frick drawing and two other engraved portraits of Miromesnil, although the evidence is insufficient to establish a secure connection with either of them. In 1776, the engraver and draftsman Noël Le Mire (1724–1801) published an allegorical portrait of Miromesnil,[11] an impression of which is in the Metropolitan Museum of Art, New York. In the print, a profile of the subject that appears to be based on the Houdon bust of 1775 is set in a medallion in the center of a monument, behind which extends a vast panorama of the city of Rouen. Comparison of the medallion with the Frick drawing reveals a similarity in the representation of the subject's eye, nose, and chin and in the artist's precise manner of outlining these features. That the subject faces right instead of left in the print would support the connection between them, as the image would normally be reversed in the printing process. A drawing for the entire

print was recorded in the Lorimer collection, Rouen, in the catalogue of Le Mire's oeuvre,[12] but no drawing is listed for the likeness of Miromesnil alone. Le Mire was a native of Rouen and an almost exact contemporary of Miromesnil, and thus would have had reason to take an interest in him. Yet the relatively few known drawings by Le Mire preclude the possibility of connecting the Frick sheet with works from his hand.

Another engraved portrait of Miromesnil bears the inscription: *Dessiné et Gravé par J. L. Anselin*.[13] Here, the magistrate is shown bust-length in an oval medallion above a rectangular tablet bearing his coat of arms. The subject's name is inscribed on the upper edge of the tablet, as if carved in stone. The engraved figure follows the Houdon portrait bust, but the presence of ribbons and decoration on the subject's chest and an emblem attached to the left lapel of his robe indicate that the source for this image was the Musée Fabre version. The print would thus have to have been executed sometime after 1781 and before Revolution, when the decorations presumably were effaced.[14] Here, as in the print by Le Mire, there are similarities in the treatment of the features and in the facial expression.

An engraver of Scottish ancestry who was born in Paris, Jean-Louis Anselin (1754–1823) learned his trade from Augustin de Saint-Aubin and was a prized pupil.[15] If indeed Anselin executed the Frick drawing, and if he maintained a connection with his master over time, Anselin may have given it to Saint-Aubin, perhaps to be engraved in the latter's series of famous contemporaries. The drawing could have remained in Saint-Aubin's studio and been confused with the master's oeuvre in the sales of his work after his death, thus accounting for an erroneous attribution to Saint-Aubin despite the evident discrepancies in style.

As no specific links have yet been found to connect the Frick drawing to a particular artist or engraver of the period, it remains designated as the work of an unidentified French draftsman.

<div align="right">S. G. G.</div>

EXHIBITED: New York, Wildenstein, 1973.
COLLECTIONS: H. Houppe. By descent to M. Fraudin. Wildenstein. Frick, 1973.

NOTES

1. The work was exhibited in 1973 at Wildenstein, New York, as *Bust of a Man*. Bernice Davidson, then Research Curator of The Frick Collection, identified the subject on the basis of

the drawing's close resemblance to the marble bust of Miromesnil by Houdon in The Frick Collection.

2. For the marble busts, see: T. W. I. Hodgkinson, in *The Frick Collection: An Illustrated Catalogue*, IV, 1970, pp. 120–26; and L. Réau, *Houdon: Sa Vie et son oeuvre*, Paris, 1964, III/IV, No. 163, p. 37, pl. LXXV, Nos. 163 a,b,c, I/II, pp. 325–27.

3. Hodgkinson, p. 122.

4. *Idem.*

5. See *Explication des peintures, sculptures et gravures de messieurs de l'Académie Royale*, Paris, 1775, No. 253: *Le Buste de M. le Marquis de Miromesnil, Garde des Sceaux.*

6. See E. Bocher, *Augustin de Saint-Aubin: Catalogue raisonné des estampes, vignettes, eaux-fortes, pièces en couleur au bistre et au lavis, de 1700 à 1800*, Paris, 1879. However, as Roy Fisher of Wildenstein noted in a letter of January 18, 1973, in the curatorial files of The Frick Collection, the drawing could have been done for an engraving that was never executed.

7. Marianne Roland Michel of Galerie Cailleux, Paris, examined the work at The Frick Collection in January 1994. She confirmed her opinion in a conversation with Susan Galassi in Paris in June 1997. The Frick Collection is grateful for her generous assistance in research on this drawing.

8. Hodgkinson, p. 122.

9. For a list of engraved portraits of Miromesnil, see G. Brière, "Notes sur quelques bustes de Houdon," in *Archives de l'art français*, Paris, N.S. VII, 1913, p. 350.

10. See letter of February 1, 1994, from Roland Michel to Davidson in the curatorial files of The Frick Collection. An impression is in the New York Public Library.

11. See J. Hédou, *Noël Le Mire, 1724–1801, et son oeuvre gravé*, Amsterdam, 1968, No. 28, pp. 63–66.

12. *Idem*, No. 2, pp. 279–80.

13. M. Roux, *Inventaire du Fonds français, Graveurs du XVIII Siècle*, Paris, Bibliothèque Nationale, 1931, No. 14, p. 168: *A. T. Hue, Mis de Miromenil*. A photograph of this work is in the N2 Portrait Folio in the Cabinet des Estampes, Bibliothèque Nationale, Paris, vol. 1261, D 214673. As noted in Roux (*loc. cit.*), the print is undated, but the catalogue of the 1791 Salon lists "two small portraits" by Anselin, one of which may have been the portrait of Miromesnil.

14. Hodgkinson, p. 120.

15. Roux, p. 165.

FRANCISCO
DE GOYA Y LUCIENTES
1746–1828

Goya is one of those uncommon artists whose fame derives as much from his graphic works as from his paintings. Renowned particularly for his sets of prints, such as the Disasters of War, *the* Caprichos, *and the bullfight series, he also filled albums and single sheets with hundreds of drawings, similar in both style and subject matter to the prints. Intense, striking, often savage, at times comic or tender, Goya's drawings comment on the foibles and miseries of Spanish life in a period of wars and social turmoil.*

THE ANGLERS (36.3.60)

Drawn after July 1, 1799. Brush and brown wash, lifted in places, probably by blotting, to give transparency, possibly also some slight traces of scraping, $7\frac{3}{4} \times 5\frac{5}{16}$ in. (19.7 × 13.5 cm).

MARK & INSCRIPTIONS: Watermark, partially visible at center but truncated by the left margin: a cross surmounting a foliated base with scrolls to either side.[1] Inscribed in pen on recto: *En el dia 1.º De Junio De 1799 se cancela / ron Dela Primera partida De las sig.^{tes} / 10 acciones de mi…se…q^{ue} / renobar^{on} i se gastaron…a 25 del / mismo, y se cobraron siete reales / en el dia 1.º De Julio Del mismo año.*[2]

DESCRIPTION: A dark, undefined shape resembling the mouth of a cave fills the upper and right-hand sides of the sheet. Through the opening a group of fishermen is seen from the rear silhouetted against the light. Two are seated in the foreground, the one at left with a rod supported across his knee. Standing just beyond them is a figure holding up a fish suspended on a line from a rod which rises past his left shoulder. At left, another standing figure appears to thrust a rod downward. To his right are the vague shapes of a head and shoulders and a face. At far right sketchy outlines of another figure are visible beyond a cylindrical form which cuts diagonally across the bottom right corner.

CONDITION: The sheet has been trimmed at the edges. In 1972 it was removed from its backing and a horizontal crack, about 1 in. below the upper margin, was repaired. The paper has fractured slightly in the area of the inscription.

THE study of anglers almost certainly comes from the so-called Album F, a large group of drawings by Goya all executed on the same kind of paper[3] in brush and brown wash. Though some of Goya's "albums," now broken up and dispersed, are

believed to have comprised bound sketchbooks, others, including Album F, are thought to have originated as loose sheets that Goya eventually arranged in thematically related sequences and then numbered at the top of the page.[4] The highest surviving number inscribed on a drawing of the F group is 106, but only 88 of the series have been found and identified. The Frick drawing, which has been trimmed at the edges, no longer bears any number, but the paper, watermark, medium, figural scale, and subject matter taken from everyday life are characteristic of the F group. Unlike most sheets from other albums, those of Album F do not bear titles commenting on the drawings.

Goya sketched his scene of fishermen over the record of a financial transaction, evidently not written by him.[5] This curious utilization of a blemished sheet is difficult to explain. The answer probably is neither parsimony nor a possible shortage of paper at whatever date the drawing was made, for the verso of the sheet is untouched, and the writing has emerged only slightly, with time, at the back. An infrared photograph reveals what appear to be several scattered blots of ink toward the bottom of the recto. Perhaps, like Alexander Cozens not many years earlier, Goya felt challenged by the configuration of script and splotches to compose a capriccio around them.[6] Other sheets from Album F also include various defects that have been covered over or incorporated within the design.[7]

The compositional pattern of figures silhouetted against light beneath an ill-defined overhanging shadow was one Goya loved—it is found at least ten times in Album F alone—so perhaps the defacing elements on the page simply afforded him yet another excuse for exploiting the motif. Such strong contrasts of light and dark created drama, regardless of subject, and heightened the theatrical effects of tragic or violent scenes. Goya's admiration for Rembrandt may have inspired his dramatic manipulations of lighting.

Since the inscription on the Frick sheet refers to payments made in 1799, the sketch drawn over it obviously is later, but no one can be certain how much later. The chronology proposed for the albums and their drawings has varied significantly in recent publications. Album F, for example, is dated by scholars anywhere between 1812 and 1823, but with little firm evidence to place individual drawings within this broad range of time.[8] Few of them can be directly linked to dated prints or paintings. Sayre has proposed reducing the span to about 1817–20.[9] But in a letter of 1988, Gassier suggested a probable date for *The Anglers* between 1812 and 1819, the period during which he believes Goya executed The Frick Collection's

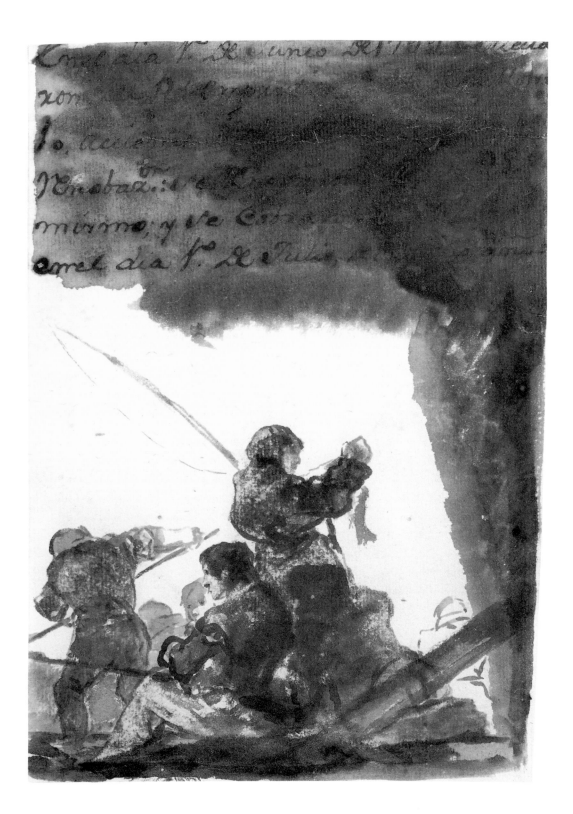

painting of *The Forge*.[10] A study of *Three Men Digging* at the Metropolitan Museum of Art, New York, closely related to *The Forge*, also belongs to Album F.

By curious coincidence, as Gassier pointed out in the above-mentioned letter, Goya wrote a petition for a license to fish at the Casa del Campo in 1799, the year of the transaction written on the Frick sheet.[11] Many drawings testify to the artist's interest in hunting; fishing seems to have attracted him too. As a realistic report of piscatorial activity, however, the drawing is not convincing. It is impossible to make logical sense of the crowd of figures, their relation to each other or to some presumed but invisible body of water. One suspects that the artist may indeed have been playing with ink blots—possibly starting with one that resembled a dangling fish—and simply spun out the conceit to create this lively sketch of anglers.

<div align="right">B. F. D.</div>

COLLECTIONS: C. Fairfax Murray. Henry Oppenheimer, London. His sale, July 10–14, 1936, Christie's, Lot 449.[12] Frick, 1936.

NOTES

1. Reproduced in P. Gassier, *The Drawings of Goya: The Complete Albums*, London, 1973, p. 387, F.I.

2. A partial transcription and translation are provided by Gassier, p. 496. Other scholars, including a team from the Hispanic Society of America, have also kindly contributed their readings to this composite effort.

3. Sayre identifies the manufacturer of the paper as PAULAR (A. E. Pérez Sánchez and E. Sayre, *Goya and the Spirit of Enlightenment*, Boston, 1989, p. cxx).

4. Gassier, p. 13. Sayre (*loc. cit.*) states that Album F was sewn together at the left side, but she does not explain whether this was done before or after the drawings were made; the sense of her text implies that she believes the former.

5. There is general agreement that the inscription was not written by Goya. See for example: Gassier, p. 496; P. Gassier and J. Wilson, *The Life and Complete Work of Francisco Goya*, New York, 1971, p. 375, No. 1455; J. Camón Aznar, *Goya*, Saragossa, 1982, IV, p. 125; and Eleanor Sayre, orally, December 3, 1987.

6. A. Cozens, *A New Method of Assisting Invention in Drawing Original Compositions of Landscape*, London [1785], ed. P. Lavezzari, Treviso, 1981.

7. Sayre, 1989, p. cxxi, note 2.

8. See: Gassier, 1973, p. 386, for dating of the album and individual drawings; and P. E. Muller, review of *Goya and the Spirit of Enlightenment*, in *Master Drawings*, XXVII, 1989, No. 4, p. 376.

9. Sayre, 1989, p. 334.

10. Gassier, letter of January 1, 1988. However, there is no firm evidence for dating *The Forge*, and no agreement exists on that issue ei-

ther; see *The Frick Collection: An Illustrated Catalogue*, II, 1968, p. 296.

11. See D. de la Valgoma y Diaz-Varela, "Goya, Pescador fluvial y abogado del miniaturista Ducker," *Goya*, Nos. 148–50, 1979, pp. 220ff. The Frick Collection is indebted to Pierre Gassier for this reference. A tapestry of 1775 also depicts an angler, but Goya appears to have studied hunters with greater enthusiasm.

12. Listed as "From the Fairfax Murray Collection."

ADDITIONAL REFERENCES

A. L. Mayer, *Francisco de Goya*, trans. R. West, London–Toronto, 1924, p. 197, No. 729.

A. Hyatt Mayor, *Goya: 67 Drawings*, New York, 1974, No. 34.

The Vasari Society, 2nd ser., Pt. II, Oxford, 1921, p. 13, pl. 19.

DANIEL GARDNER

1750–1805

Son of a master baker and an amateur watercolorist, Gardner was born in Kendal, Westmorland, where he received early instruction in art from his fellow townsman George Romney. He left for London around 1768, entered the newly established Royal Academy in 1770, and on completing his studies in 1772 worked briefly in the studio of Sir Joshua Reynolds in exchange for further instruction. He exhibited at the Royal Academy only once, in 1771, and subsequently devoted himself to portrait painting. Although best known for work in gouache and pastel, he also painted in oil, often combining media in innovative techniques, the recipes of which he guarded jealously. In his later years he developed a close friendship with the young John Constable, whose work he greatly admired. Famed in his lifetime, Gardner has only recently gained new recognition.

PORTRAIT OF A LADY (16.3.106)

Gouache and pastel, on paper, 25 × 21½ in. (63.5 × 54.6 cm).

DESCRIPTION: Seated in a wooded glade, the subject is seen in three-quarter length, her head turned slightly to the left. She has brown eyes, prominent eyebrows, a rosy complexion, and full, powdered hair swept back from the face. She wears a grayish-white dress trimmed at the bodice with blue ribbon and white lace, a white scarf tucked into the bodice, and a dark gray shawl that covers her shoulders and crosses over her lap, on which rest her clasped hands. A thin brown ribbon circles her neck, and a blue ribbon matching the trim on her dress is threaded through her hair and appears to be attached to a loosely sketched hat or veil. Flecks of Prussian blue and a linear pattern enliven her skirt, and a similar blue is repeated in the shadows of the landscape.

CONDITION: The portrait was restored in 1938 and 1980. In the latter treatment, the canvas to which it had been attached was cut from its frame, and the paper was peeled away from the canvas and hinged to a heavy rag board panel. The surface was treated with a gelatin solution to consolidate flaking in the gouache, but some abrasions remain. The work is in fair condition.

THE portrait is executed in Gardner's characteristic combination of media and styles: the face and hands are rendered in pastel in fine detail with subtle color nuances, while the costume and landscape setting are broadly painted in thickly im-

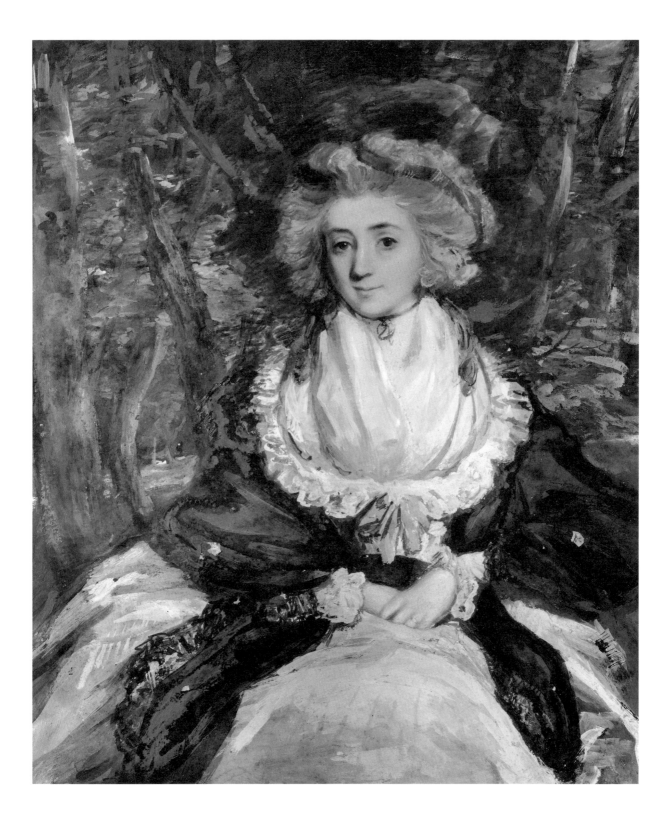

pastoed gouache with numerous *pentimenti*. Also typical of Gardner is his inventive use of color in the shadows, an innovation that would later be developed in the work of Constable and the Impressionists; here the freely dabbed patches of Prussian blue in the dark recesses of the glade behind the sitter—the same blue as the trimmings of her costume—suggest glimpses of sky or possibly a stream. Gardner frequently worked in a broad and hasty manner, especially in executing the backgrounds of his portraits, but the degree of sketchiness of the hat or veil and the shawl in this work suggests that it may be unfinished. The similarity in style between the Frick gouache and one of Gardner's few dated portraits, *Lady Diana Le Fleming and her Daughter Sophie*,[1] a gouache and pastel executed in 1790, indicates a date for the former portrait late in Gardner's career.

Although the sitter has not been identified, she does bear a strong resemblance to Elizabeth Mathew of Felix Hall, Essex, who appears in another portrait by Gardner with her husband, Robert Monckton Arundell, fourth Viscount Galway, and their daughter Elizabeth Mary.[2] The shape of the face, the coiffure, the line of the eyebrows, the large, protruding eyes, the long nose, and the short neck are closely similar in both portraits. (It must be acknowledged, however, that many of Gardner's sitters look alike.) Yet there is nothing in the known provenance of the gouache that supports a connection with Viscountess Galway.

The only recorded previous owner of the *Portrait of a Lady* is John Robert Townshend, Earl Sydney, who died in 1890.[3] In the 1780s and 1790s, Gardner painted portraits of several members of the illustrious Townshend family and its relatives by marriage.[4] Since most of Gardner's painted portraits remained in the families of the original owners until early in the twentieth century, it may be that the sitter for the Frick portrait was a member of the Townshend family, or connected with it through marriage, friendship, or even employment. There are no direct links between the Monckton Arundell and Townshend families in the genealogical records.

Even the connection of the Frick portrait with Earl Sydney remains elusive. Henry Clay Frick acquired the work in December of 1915 from Knoedler, which had held it on joint account with Sulley & Co. of London since July of that year.[5] The fact that the Sydney collection—and the family estate at Frognal, Chislehurst, Kent—had been put up for sale in a twelve-day auction during the previous month opens the possibility that the Frick gouache came from that sale.[6] But the work does not appear in the sale catalogue, although two other portraits by Gardner were listed there (one or both depicting a Townshend); nor does the *Portrait of a Lady*

appear in the catalogue of a previous auction of items from the Townshend collection.[7] Still, the gouache did come to Knoedler with several major works from the Townshend collection, including portraits of family members by Lawrence, Reynolds, Angelica Kauffmann, and Lely.[8]

If the Frick work did come from the Frognal sale, as seems likely, who might it depict? In the late eighteenth century, John Robert Townshend's grandfather, Thomas Townshend (1733–1800), first Viscount Sydney, who served as a secretary of state and as leader of the House of Commons, occupied the family estate at Frognal.[9] His wife, Elizabeth Powys of Suffolk, appears in a portrait by Reynolds, which was purchased by Knoedler with the Gardner. The couple had three sons and four daughters. The subject of the Frick portrait, who wears a plain band on her left hand, might thus have been any one of their three daughters who married. Or perhaps she was the wife of the oldest son, John Thomas, the only son who married, who became second Viscount Sydney and inherited the family estate. In 1790, John Thomas wed the Hon. Sophie Southwell, who died five years later. A daughter of Edward Southwell, seventeenth Baron de Clifford, Sophie had been painted by Gardner as a child of two or three with her parents and siblings; perhaps she kept up a connection with the artist and selected him to do her portrait as a young woman.[10]

<div align="right">S. G. G.</div>

COLLECTIONS: John Robert Townshend, Earl Sydney (?). Sulley & Co., London. Knoedler, 1915. Frick, 1916.

NOTES

1. For which see G. C. Williamson, *Daniel Gardner, Painter in Pastel and Gouache,* London–New York, 1921, p. 97, repr. p. 8, formerly in the collection of Mrs. S. H. Le Fleming, Ambleside, Westmorland (present whereabouts unknown). Lady Diana was the daughter of the fourteenth Earl of Suffolk and Berkshire. For additional background on Gardner, see H. Kapp, *Daniel Gardner, 1750–1805,* London, 1972.

2. Williamson, repr. p. 74. The couple was married in 1779 and must have posed for their portrait in the early or mid 1780s. The thinner face of the sitter in the Frick portrait (if in fact it is the same person) would suggest a later date for this work, around 1790.

3. Information from Knoedler in the curatorial files of The Frick Collection. Earl Sydney died without issue, at which time the title became extinct. His nephew, the Hon. Robert Marsham Townshend, inherited the family estate and its contents.

4. For the Townshend family, see: *Dictionary*

of *National Biography,* London, 1921–22, XIX, pp. 1036–60; *Burke's Peerage, Baronetage and Knightage,* ed. L. G. Pine, London, 1956, pp. 2168–70.

5. Information from Knoedler.

6. Knight, Frank, & Rutley, London, June 7–18, 1915.

7. Christies, London, March 5–7, 1904.

8. Information from Knoedler.

9. *Dictionary of National Biography,* XIX, pp. 1058–60.

10. For *The Family of Edward Southwell,* see Williamson, p. 97, repr. p. 98. There appear to be no other portraits by Gardner of the family of Thomas Townshend; the artist did, however, portray members of the family of his cousin, Charles Townshend, Chancellor of the Exchequer.

JEAN-AUGUSTE-DOMINIQUE INGRES

1780–1867

Born in Montauban, to whose civic museum he would one day bequeath thousands of drawings, Ingres came to Paris in 1797 to study with Jacques-Louis David. He was awarded the Prix de Rome in 1801, but for political reasons he was unable to establish himself in Italy until 1806. He remained until 1824, when he returned in triumph to Paris. Ten years later, he was back in Rome as Director of the French Academy. He settled in Paris permanently in 1841, teaching there and executing his last great portraits and mural commissions. Ingres' prowess as a draftsman was evident from his earliest years at the Academy of Toulouse, where he began his artistic studies in 1791, until his death in Paris seventy-six years later. Referring to drawing as "the probity of art," Ingres used the medium to define his visual concepts, to set down data required for his portraits and subject pictures, and often as an end in itself.

STUDY FOR THE PORTRAIT OF THE COMTESSE D'HAUSSONVILLE (59.3.92)

Drawn probably in 1843 or 1844. Graphite and black chalk on cream paper, 14⁵⁄₁₆ × 7⁵⁄₁₆ in. (36.4×18.7 cm), glued down to a larger sheet of mulberry paper, 14⁹⁄₁₆ × 7⁵⁄₈ in. (36.9×19.3 cm).

MARK: Stamped in blue in the lower right corner: *IJ*.[1]

DESCRIPTION: The subject appears in a three-quarter position facing left. She is represented nearly full length, down to the lowest flounce of her gown. A shawl is draped below her left shoulder and over the left arm. The study focuses primarily on the variations of light that accentuate the folds of the gown and the shadows along the raised arm and at the waist. In contrast to such details, the Countess' head, facial features, and arms are only summarily indicated. Behind and above this central study, there appears to the right another depiction of the folds below the waist of the gown, as seen from behind—presumably a study for the reflection in the mirror that appears in Ingres' final painting. The horizontal line that extends from the skirt on the left through the one on the right was probably intended to suggest the mantel against which the Countess is shown leaning in her portrait.

CONDITION: The sheet has been somewhat discolored by exposure to light. It was treated for foxing and remounted on its present support sheet in 1966.

101

THE drawing is one of fifteen surviving studies executed by Ingres for his portrait of Louise d'Haussonville. Commenced in 1842 and completed, signed, and dated in 1845, that work was acquired in 1927 by The Frick Collection.[2] This sheet belongs to a group of four closely related drawings in which the artist sought to define the intricate folds of the pleated silk gown worn by his subject, and the play of light and shade on them and on the figure.[3] In the first three of these, including this one, Ingres utilized a traced reduction of a black chalk study of Louise d'Haussonville's arms (Musée Ingres, Montauban) with a schematized rendering of the head. Judging from the sequence of dated preparatory studies, the Frick Collection sheet was executed probably in 1843 or 1844.

E. M.

EXHIBITED: New York, Frick Collection, Ingres and the Comtesse d'Haussonville, 1985, checklist No. 41.

COLLECTIONS: J.-A.-D. Ingres, 1843/44–66. Étienne-François Haro, Paris, 1866–67.[4] Ingres posthumous sales, Paris, April 27 and May 6–7, 1867(?). Berthelot, Paris.[5] Otto Wertheimer, Paris. Purchased from him by The Frick Collection in 1959.

NOTES

1. The stamp is a collector's mark affixed to drawings that appeared in Ingres' posthumous sales of April 27 and May 6–7, 1867 (Lugt 1477). However, no lot corresponding to this study is described in the catalogue of either sale.

2. *The Frick Collection: An Illustrated Catalogue*, New York, II, 1968, pp. 134–40.

3. E. Munhall, *Ingres and the Comtesse d'Haussonville*, New York, 1985, pp. 59, 60.

4. According to F. Lugt (*Les Marques de collections*, Amsterdam, 1921, p. 218, No. 1241), Haro bought a number of paintings and drawings from Ingres in 1866 that subsequently appeared in Ingres' posthumous sales of 1867.

5. Information in an invoice from Otto Wertheimer to The Frick Collection dated June 25, 1959.

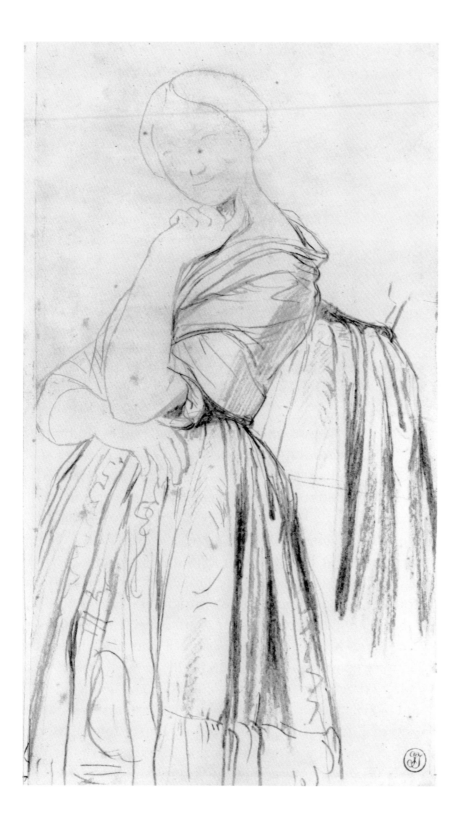

SEATED FEMALE NUDE HOLDING A FLOWER:
Study for *The Golden Age* (97.3.131)

Signed in graphite, at lower right: *Ingres*. Drawn probably between 1843 and 1847. Graphite and black chalk on tracing paper laid down to wove paper, 15¼ × 11⅝ in. (38.7 × 29.5 cm).

DESCRIPTION: A nude female figure shown in profile facing right is depicted from the thighs to the jaw. Her right arm extends across her waist, and her closed hand, resting on her left thigh, holds the stem of a schematically indicated flower with unfolding leaves. Her left arm, the elbow tucked in at the waist, rises up so that her hand with splayed fingers supports her chin. At the bottom of the drawing, the lower abdomen and the right thigh are summarily indicated. A vertical line at upper right appears to be an alternate study for the adjoining left wrist and arm.

CONDITION: The sheet has been clipped at the top and along the left and right edges. A diagonal tear across the lower left corner has been repaired, as have a few losses along the bottom edge. In 1998, the drawing was separated from the board to which it had been glued down and was hinged to a rag board.

THIS drawing is one of more than four hundred studies Ingres made in preparation for and during the evolution of *The Golden Age*, a monumental composition commissioned from him in Rome by the Duc de Luynes in 1839. It and a projected *Age of Iron* were intended to ornament the Salon of Minerva in the Duke's château of Dampierre, some twenty miles southwest of Paris. *The Golden Age*, painted in oil on prepared plaster, remains *in situ*; *The Age of Iron* exists only in a preparatory state. Ingres began his work at Dampierre in 1843, two years after he returned to Paris from Rome, but legally abandoned the project in 1850, partly as a result of the Duke's discomfort over the superabundant nudities of the decoration, partly over the despair that engulfed Ingres after the death of his wife on July 27, 1849.

This *Seated Female Nude Holding a Flower* is a study for a figure shown reclining alongside her male companion in a group to the left of center in the mural.[1] In notations on related drawings, Ingres referred to her as a "jeune fille qui joue avec un bouquet" and to her action as "la jeune fille tient des fleurs."[2] She appears in the earliest compositional studies for *The Golden Age* (Musée Ingres, Montauban; Musée des Beaux-Arts, Lyon), as well as in the small-scale replica of the mural that Ingres painted in 1862 (Fogg Art Museum, Cambridge, Massachusetts).[3]

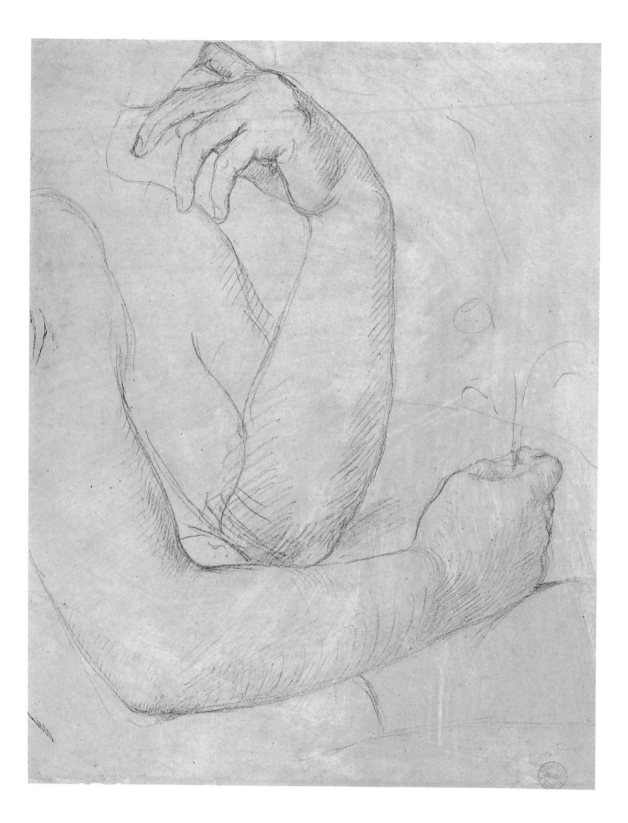

The dating of Ingres' many studies for *The Golden Age* is problematical. Within the broadest range, this sheet must be dated between August 1843, when Ingres took up residence at Dampierre, and November 1847, when he effectively ceased working on *The Golden Age*.[4] But the evidence of a letter Ingres wrote about his mural to his friend Gilibert on September 14, 1843, would suggest a date on the early side, for there Ingres had stated: "le tout est dessiné."[5]

<div align="right">E. M.</div>

EXHIBITED: New York, Pierpont Morgan Library, Drawings from the Collection of Lore and Rudolf Heinemann, 1973, No. 19. New York, Frick Collection, Ingres and the Comtesse d'Haussonville, 1985, checklist No. 108.

COLLECTIONS: Étienne-François Haro (d. 1897), Paris (Lugt 1241). Lore and Rudolf G. Heinemann, New York, before 1973. Bequeathed to The Frick Collection by Lore Heinemann in memory of her husband, Dr. Rudolf G. Heinemann, 1997.

NOTES

1. G. Wildenstein, *Ingres*, London, 1954, pls. 84–85.

2. G. Vigne, *Dessins d'Ingres: Catalogue raisonné des dessins du Musée de Montauban*, Paris, 1995, p. 306, No. 1717, p. 325, No. 1825.

3. *Idem*, pp. 306, 307, 325; E. Camesasca, *L'Opera completa di Ingres*, Milan, 1968, p. 113; R. Rosenblum, *Jean-Auguste-Dominique Ingres*, New York, 1967, p. 167, colorplate 47.

4. For the relevant chronology, see Wildenstein, p. 24.

5. Vigne, p. 325.

JEAN-BAPTISTE-CAMILLE COROT

1796–1875

Though far better known as a painter, chiefly of landscapes, Corot was also a prolific and inventive draftsman. Nearly a thousand drawings have survived, ranging from brief sketchbook notations, often recording landscapes and figures seen on his travels in Italy, France, England, and Switzerland, to more finished compositional studies. He employed a broad selection of media, often using combinations of techniques and sometimes including color.

STUDY FOR *SOUVENIR OF MORTEFONTAINE* (94.3.148)

Signed in dark brown charcoal, at lower right: COROT. Drawn probably in 1864. Charcoal with brown chalks and stumping, 9³⁄₁₆ × 12¹¹⁄₁₆ in. (23.4 × 32.2 cm).

MARK: Watermark: *Glaslan.*[1]

DESCRIPTION: The foreground shore and the trees to either side—a single trunk to the left, a thicker growth of gnarled trunks and branches to the right—frame a view of a lake. A high, rugged bluff descends into the lake from the right, casting a mirror image on the water. To the left of this point, the far shore reflects a paler band on the water. The rich black strokes of the charcoal stand out against the various earth-brown tones of the land and its reflections.

CONDITION: The drawing is in excellent condition.

IN 1864 Corot sent two paintings to the Salon held at the Palais des Champs-Élysées. One was the *Souvenir of Mortefontaine*, a landscape inspired by a park, about twenty miles north of Paris, which Corot had visited some years earlier. The *Souvenir of Mortefontaine* has long been recognized as one of the finest achievements of Corot's career. Now in the Louvre, it was purchased from the Salon for the State by Napoleon III. For Corot too the painting seems to have been particularly significant. He made many variants of the composition, and at his death a photograph identified as "Mortefontaine" was seen hanging above his bed.[2] Just before sending the *Souvenir of Mortefontaine* to the 1864 Salon, he distributed a

number of rough pen sketches of it to friends, another indication of the pride Corot took in this painting.

One of these sketches is in the Louvre (RF 24.211), a second is in a private collection, and, according to Martin Dieterle, similar ones exist.[3] The two sketches cited bear virtually the same inscription: "D'après votre désir, je vous fais remettre le croquis d'un tableau / (*Souvenir de Morte-fontaine*) que j'envoie cette année au Salon. / le 17 mars 1864 C Corot." Though the Salon did not open until May 1, entries for it were supposed to be delivered between March 10 and 20.[4] However summarily, the sketches therefore represent the finished work. The Louvre version, however, must have been copied very hastily from one of the other sketches, because it omits from the inscription the word "cette" before "année" and, more significantly, the figures that in the painting are grouped around the slender tree at left are missing.

The Frick Collection's drawing differs from these pen sketches in both medium and purpose. It is executed in shades of brown, ranging from the palest transparent tones that almost appear to be washes to dark, rich strokes approaching the blackness of the charcoal. Corot wrote in his notebooks, "Les deux premières choses à étudier, c'est la forme, puis les valeurs."[5] In this drawing, form and values are the building blocks for Corot's creation of a landscape, his memories of a landscape.

The drawing offers an almost diagrammatic revelation of how the artist built his landscapes, thinking first in terms of a balanced interplay between line and shape, distance and front plane, solid mass and reflection. This feeling for structure, which can so often be sensed beneath the filmiest of his landscapes, harks back to Claude and the classical tradition. The brown hues of the drawing suggest that Corot studied those influential landscapes through Richard Earlom's sepia-toned mezzotints after Claude. At the same time, the drawing clearly leads to Monet, especially to such works of the 1890s as *Morning on the Seine near Giverny* (Metropolitan Museum of Art, New York), where similar shapes are mirrored by their reflections.

The most striking difference between Corot and the paintings by Monet of the 1890s is, of course, color. Color, in Corot's opinion, added charm to a painting. But it could also, as with the figures at left in the final *Mortefontaine*, add balancing elements to a composition, weighing there against the mass of trees at right. The figures are not included in the Frick drawing perhaps because only when he began painting did the artist decide that a few touches of color were desirable to add

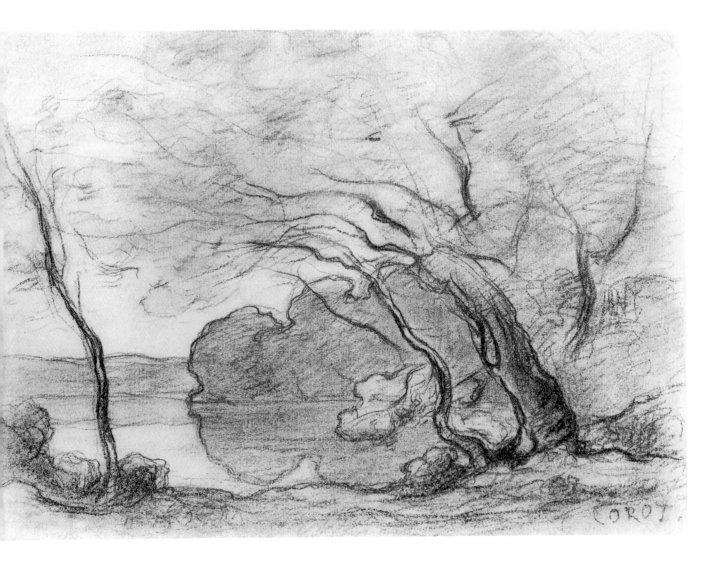

visual weight to the left side. No doubt they were omitted also from the Louvre pen sketch copy of the canvas because Corot did not see them as essential to a monochrome summary of the composition. The pen sketches, reporting on the appearance of the final composition, give greater prominence than the Frick drawing to the screen of foliage that fans out diagonally from the trees; the leaves here do not yet veil the underlying architecture of the landscape elements.

B. F. D.

EXHIBITED: New York, W. M. Brady & Co., Master Drawings 1760–1890, May 1994, No. 28.

COLLECTIONS: Nicolas-August Hazard sale, December 1–3, 1919, Galerie Georges Petit, Paris, Lot 317, bought for 1,620 francs by Rosenthal.[6] Private collection, Lisieux.[7] Gallery Hopkins-Thomas, Paris, 1992. Marc de Montebello Fine Art, New York. W. M. Brady & Co., New York. Frick, 1994, purchased with a gift from Mr. and Mrs. Roswell L. Gilpatric.

NOTES

1. See G. Rouchès and R. Huyghe, *Cabinet des Dessins du Musée du Louvre: École française*, Paris, 1938, XI, No. 257.

2. A. Robaut, *L'Oeuvre de Corot*, Paris, 1905, I, pp. 324-25.

3. Orally, March 22, 1995. Dieterle generously provided a photograph of one of the drawings, which was also reproduced by Robaut (I, p. 221) but cropped on all sides, omitting the inscription.

4. *Explication des ouvrages de peinture ... des artistes vivants, exposés au Palais des Champs-Élysées*, Paris, 1864, p. xxv.

5. É. Moreau-Nélaton, *Corot raconté par lui-même*, Paris, 1924, I, p. 126.

6. Hazard, a collector who lived in Orrouy (Oise), often bought directly from painters, including Corot ("Les grandes ventes de l'automne," *La Renaissance de l'art français*, II, No. 9, September 1919, p. 403). The Hazard sale was a great success ("Chronique des ventes," *Les Arts*, No. 180, 1919, p. 24).

7. Information kindly supplied by Martin Dieterle.

STUDY FOR *BANK OF THE POND AFTER THE STORM* (65.3.95)

Drawn about 1870.[1] Charcoal, with stumping, some of the medium lifted to reveal the cream-colored paper, 16⅛ × 23⁷⁄₁₆ in. (41 × 59.7 cm).

MARK: Stamped in the lower left corner in red-brown ink: VENTE / COROT.[2]

DESCRIPTION: A stream flows between low banks from the center foreground to an expanse of water in the middle distance. The opposite shore is indicated by a flat stretch of land at the horizon. Two trees with sparse leafage rise from the bank in the left foreground. Others, with thicker foliage, grow on the right bank. In a punt by the shore at left are two figures, one seated, the other standing and holding a long pole. A third figure sits on the ground at far right. Toward the center, the white sail of a small boat is silhouetted against the distant shore. A charcoal line frames the image on all sides, ranging within ½ to 1¼ in. from the edge of the paper.

CONDITION: When the drawing was restored in 1965, it was removed from a pulp mat and placed in a press to reduce buckling. A few minor tears were mended. There is some foxing, and minor abrasion is visible left of center, above and below the horizon. A fixative, which lends a warm tonality, is slightly and unevenly discolored.

WHEN the drawing was exhibited in 1965 in Zurich, the subject was identified in the catalogue as *Le Batelier de Mortefontaine*, and an association with Corot's painting *The Boatman of Mortefontaine* in The Frick Collection was proposed.[3] However, in 1977, Alden Rand Gordon, then a Lecturer at The Frick Collection, observed that the drawing was instead a study for the painting entitled *Bank of the Pond after the Storm*, which was recorded in the Porto-Riche sale of 1890 (when it was illustrated with an etching by Kratke)[4] and more recently, in 1996, in the gallery of Robert C. Noortman, London and Maastricht.

Though loosely handled and lightly sketched, Corot's study must represent a nearly final stage in his planning for that canvas. Seemingly derived from his *Boatman of Mortefontaine* and clearly related to the many other compositions inspired by the park of Mortefontaine, the present drawing is close in every detail as well as in its general design to *After the Storm*. Yet the turbulent movement and atmosphere of the painting, the streaked clouds, and the trees torn and bowed by the wind, are less dramatic in the study. Here, no lingering menace of storm disturbs the serene expanse of empty sky and calm waters. In mood, if not in composition, the drawing does resemble the *Boatman of Mortefontaine* and the many other poetic landscapes of this series.

Corot's method in this drawing of lifting the charcoal to reveal the paper creates luminous effects, as seen, for example, in the boat sail and the streaks along the tree branches. This procedure is related to techniques he used in his prints, especially in the clichés-verres.

<div align="right">B. F. D.</div>

EXHIBITED: Newark, New Jersey, Newark Museum, Nineteenth Century Master Drawings, 1961, No. 16, as *Landscape with Tree and Lake*, lent by Dr. W. W. Jacobi. Zurich, L'Art Ancien S.A., Ausstellung von Aquarellen und Zeichnungen neuerer Meister, 1965, No. 3, as *Le Batelier de Mortefontaine*.

COLLECTIONS: Dr. W. W. Jacobi, 1961. L'Art Ancien S.A., Zurich, 1965. Frick, 1965.

NOTES

1. Date proposed by A. Robaut, *L'Oeuvre de Corot*, Paris, 1905, III, No. 1878.

2. The sale stamp was authenticated by Martin Dieterle on August 10, 1994, but the drawing cannot be identified among the many vaguely titled works in Corot's posthumous sales.

3. *Ausstellung von Aquarellen und Zeichnungen neuerer Meister*, L'Art Ancien S.A., Zurich, 1965, p. 1, No. 3.

4. Porto-Riche sale, May 14, 1890, Galerie Georges Petit, Paris, Lot 2, as *Après l'orage*, purchased (according to a marginal note) by Bernheim for 6,700 francs.

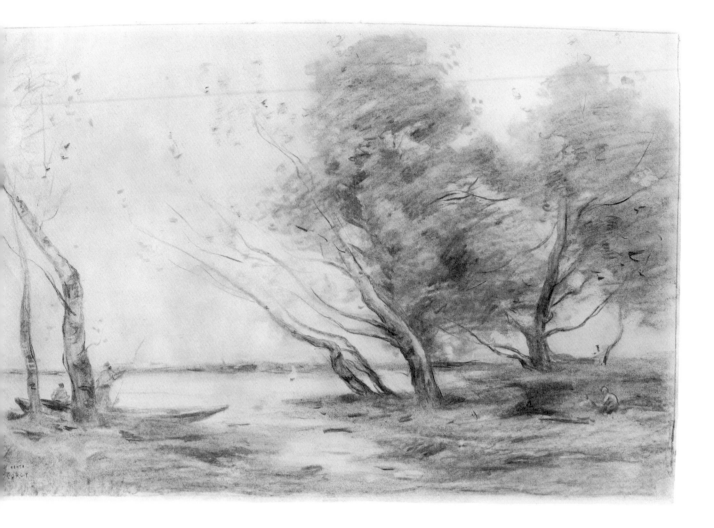

JAMES McNEILL WHISTLER

1834–1903

Son of a railway engineer, Whistler was born in Lowell, Massachusetts, and attended the United States Military Academy at West Point for three years. In 1855 he went to study art in Paris, working in the studio of Charles Gleyre. He moved in 1859 to London, where he remained on and off for the rest of his life, although he maintained close contact with the Continent. Over time he achieved notoriety in London's bohemia for his outspoken advocacy of "art for art's sake," his advanced style of painting, and his contentious behavior. Drawing was crucial to Whistler's artistic process. His first chalk drawings date from his adolescence, and in later years he frequently used pastel in pre-liminary studies for his portraits. It was not until a series of vibrant plein-air studies executed in Venice in 1879–80, however, that the artist fully exploited the potential of pastel as an independent medium.

THE CEMETERY: VENICE (15.3.39)

Signed, at lower left, with the butterfly mono-gram. Drawn in 1879. Pastel, with some stumping, over traces of underdrawing in graphite, on dark brown wove paper, 8 × 11⅞ in. (20.3 × 30.1 cm).

INSCRIPTIONS: In pencil at lower left: *Nº 2. 10¾ × 6½;* and at lower right: *2.*

DESCRIPTION: A light blue sky touched with green is reflected in a similarly colored la-goon. At right, again reflected in the water, are white ecclesiastical buildings with brown roofs and a brown-and-white wall above which emerge dark green trees. A large black gondola with a dark green canopy appears at left, and one or two others float closer to the shore. Small pink and white buildings are visible on the horizon at left. Much of the sheet along the lower edge is left blank.

CONDITION: The drawing is in good con-dition. In 1980 it was removed from a wood-pulp backing and hinged at all four corners to a sheet of rag paper. Tack holes are visible in the corners.

IN mid September of 1879, a year after his libel suit against John Ruskin led him into bankruptcy, Whistler left for Venice to carry out a commission from the Fine

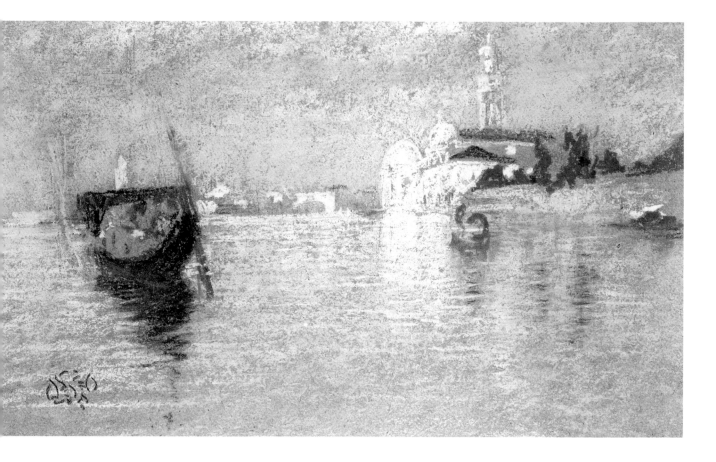

Art Society of London to create a set of twelve etchings.[1] Although his agreement with the Society—a commercial art gallery—specified that he would return to London with the completed prints in December, Whistler remained in Venice for fourteen months, during which he executed some fifty plates of the city and approximately one hundred pastels, in addition to a few paintings in oil and some watercolors.[2]

In the present drawing, the island of S. Michele—site of Venice's renowned cemetery—is depicted at upper right, with its fifteenth-century church of the same name, attached convent, and adjacent burial ground enclosed by a long wall. The land on the horizon at left is the island of Murano, and the canopied vessel in the foreground is a funeral boat approaching or leaving the cemetery. Whistler's vantage point has been identified as aboard a gondola off the Fondamente Nuove.[3]

Because of the somewhat heavy application of the chalk seen here—relatively little of the dark brown paper shows through the pastel strokes, and the sky has been lightly rubbed—MacDonald places *The Cemetery* in the early months of Whistler's stay.[4] The similarity of the size, style, and position of the artist's butterfly signature to the monogram found in *The Old Bridge—Winter*, a pastel dated 1879, further links this work with the artist's winter in Venice.[5]

Although Whistler had not yet achieved the fluidity of style characteristic of pastels from the second half of his Venetian stay, *The Cemetery* was singled out for praise by several critics when it was exhibited in London in January of 1881.[6] A reviewer for *The Athenaeum* admired the artist's ability to capture reflections on rippling water, deeming it "one of the finest examples."[7] *The Observer*'s critic described it as "perhaps the most agreeable pastel for a permanent possession," with the caveat that "justice is not done to the sky and sea."[8] In two other reviews, Whistler's handling of light and color in this pastel evoked comparison with Turner.[9]

S. G. G.

EXHIBITED: London, Fine Art Society, Venice Pastels, 1881, No. 36. London, Marchant, 1903, No. 171, and 1904, No. 22. Paris, École des Beaux-Arts, Whistler, 1905, No. 155, lent to this and the following exhibitions by R. A. Canfield. New York, Metropolitan Museum, Whistler, 1910, No. 23. Buffalo, Albright Art Gallery, Whistler, 1911, No. 22. New York, Knoedler, Whistler, 1914, No. 24.

COLLECTIONS: R. A. Canfield, Providence, Rhode Island, probably bought from Whistler.[10] Knoedler, 1914. Bought by Stephen C. Clark, New York, in 1914 and returned to Knoedler in 1915. Frick, 1915.

NOTES

1. For Whistler's Venice etchings, see pp. 253–93. On the libel suit, see L. Merrill, *A Pot of Paint: Aesthetics on Trial in Whistler vs. Ruskin*, Washington–London, 1992.

2. R. H. Getscher, *James Abbott McNeill Whistler: Pastels*, New York, 1991, p. 11.

3. *The Frick Collection Catalogue*, IV, 1951, p. 47, pl. 39

4. M. F. MacDonald, *James McNeill Whistler: Drawings, Pastels, and Watercolours: A Cata-logue Raisonné*, New Haven–London, 1995, No. 738, p. 270, repr. p. 271. Getscher (p. 112, No. 37) dates the work to 1880.

5. See Getscher, p. 108, No. 35.

6. The exhibition, held shortly after Whistler's return in December of 1880, was a critical and financial success.

7. "Mr. Whistler's Pastels," *The Athenaeum*, No. 2780, February 5, 1881, p. 206, reprinted in Getscher, p. 180.

8. "Art: Venice Pastels," *The Observer*, February 6, 1881, reprinted in Getscher, pp. 182–83.

9. "Venice in Pastel," *St. James Gazette*, February 9, 1881, p. 184; "Mr. Whistler's Venice Pastels," *The Times*, No. 30, 113, February 9, 1881, p. 4. See also "Whistler's Wenice; Or, Pastels by Pastelthwaite," *Punch*, February 12, 1881, p. 69, and *Fanfulla*, February 26, 1881. All are reprinted in Getscher, pp. 175, 183–88.

10. MacDonald, p. 270.

ADDITIONAL REFERENCES

E. L. Cary, *James McNeill Whistler*, London, 1913 (first pub. 1907), repr. between pp. 198 and 199.

M. F. MacDonald, *Palaces in the Night: Whistler in Venice*, Berkeley, California, 2001, pp. 25, 44, 55, 103, repr. p. 42.

NOCTURNE: VENICE (15.3.38)

Signed, at lower right, with the butterfly monogram. Drawn in 1880. Pastel, with some evidence of stumping, on dark brown wove paper, 8 × 11⅞ in. (20.3 × 30.1 cm).

INSCRIPTION: In pencil at lower left: *N19 10¾ × 7½.*

DESCRIPTION: Dimly perceptible in the foreground is a stretch of shore along which are moored two masted boats and some gondolas. On the horizon appears a line of low buildings, with a larger one at right; their yellow lights are reflected in the water. The scene is drawn primarily in delicate black lines; the sky and water are blue.

CONDITION: The paper has darkened, but the drawing is in good condition. In 1980 it was removed from a wood-pulp backing and hinged at all four corners to a sheet of rag paper.

IN the spring of 1880, Whistler moved to a room in the Casa Jankovitz at the east end of the Riva degli Schiavoni; it may well have been from his window there that he executed this nocturnal scene of boats moored along the quai, with S. Maria della Salute visible at right across the canal and the Giudecca at left.[1] Similar views appear in an etching by Whistler in The Frick Collection, also entitled *Nocturne*, and in numerous other works.[2] The calligraphic drawing technique used in this pastel demonstrates Whistler's versatility with the medium and ability to adapt his methods to a given subject. His delicate hatched black lines depart freely from the contours of objects, enveloping them in a soft evening atmosphere. To prevent smudging, Whistler probably laid in the opalescent blue of the sky and water first, leaving spaces for sketching in the boats and buildings—a procedure he followed in a closely related pastel, the *Nocturne: San Giorgio* now in the Freer Gallery, Washington.[3] The yellow of gaslights on the distant shore and their reflections in the water is the only additional color in this almost monochromatic work. Although the subdued colors of *Nocturne: Venice*, like those of the *Venetian Canal* (see next entry), relate it to both the early and late months of Whistler's stay, MacDonald places this work in the later period because of the spontaneity of the drawing technique.[4]

In Venice, Whistler employed several media to produce a series of variations on the theme of the nocturne, a subject he had begun to explore in London and Valparaiso in the 1870s and for which he had become well known. Undoubtedly he

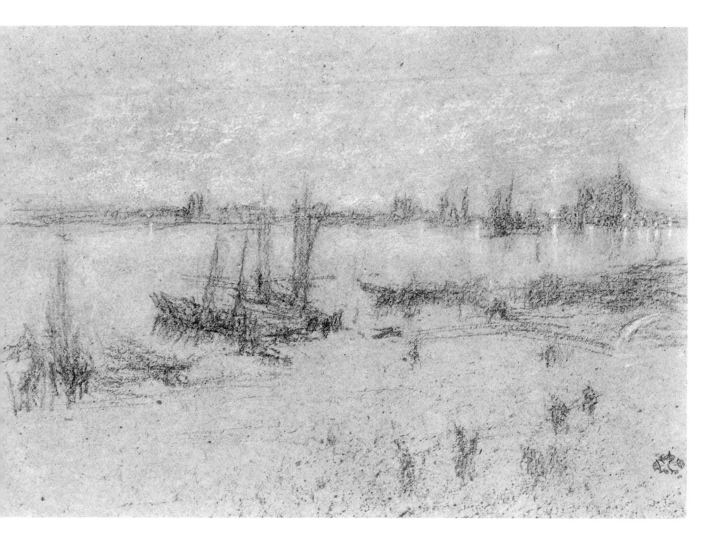

was inspired by the beauty of cities at night, but his Venetian nocturnes can also be
seen, as MacDonald notes, as "an assertion of his aesthetic position."[5] It was in fact
one of his night paintings, *Nocturne in Black and Gold: The Falling Rocket, Cre-
morne Gardens*, that prompted Ruskin's attack on Whistler and the subsequent tri-
al that led to the artist's bankruptcy and his trip to Venice.[6]

Shown at the Fine Art Society in London in 1881, *Nocturne: Venice* was described
by the critic of the *British Architect* as "exquisitely true to nature, and yet it con-
tains on examination nothing beyond some dark scribble, some scattered blue, and

some very pale yellow dots—except art, and this has made of it the Riva at night."[7] The nocturnal pastels were also singled out for praise by the critic of the *Daily News* as "a series of little masterpieces which pleases as music pleases."[8]

<div align="right">S. G. G.</div>

EXHIBITED: London, Fine Art Society, Venice Pastels, 1881, No. 10. London, Marchant, 1903, No. 175, and 1904, No. 27. Paris, École des Beaux-Arts, Whistler, 1905, No. 154, lent to this and the following exhibitions by R. A. Canfield. New York, Metropolitan Museum, Whistler, No. 24. Buffalo, Albright Art Gallery, Whistler, 1911, No. 17. New York, Knoedler, Whistler, 1914, No. 19.

COLLECTIONS: R. A. Canfield, acquired about 1904, perhaps from the London dealer Marchant.[9] Knoedler, 1912. Bought by Stephen C. Clark in 1914 and returned to Knoedler in 1915. Frick, 1915.

NOTES

1. O. Bacher, *With Whistler in Venice*, New York, 1909, pp. 13–14. It was into Bacher's apartment that Whistler moved. On this work, see M. F. MacDonald, *James McNeill Whistler: Drawings, Pastels, and Watercolours: A Catalogue Raisonné*, New Haven–London, 1995, No. 799, p. 299, repr. p. 300.

2. For more on this, see pp. 265–67.

3. See R. H. Getscher, *James Abbott McNeill Whistler: Pastels*, New York, 1991, p. 88, No. 25, repr. p. 89. Of that work Getscher notes, "If the blue had been rubbed after the boats were drawn in, the charcoal would have smeared."

4. P. 300.

5. Personal communication to author at The Frick Collection in 1994.

6. See H. Honour and J. Fleming, *The Venetian Hours of Henry James, Whistler and Sargent*, Boston–Toronto–London, 1991, p. 48.

7. E. W. Godwin, *British Architect*, February 4, 1881, reprinted in Getscher, pp. 178–79.

8. *Daily News*, January 31, 1881. See also: *Punch*, February 12, 1881, p. 69, repr.; *The Queen*, February 12, 1881. All are reprinted in Getscher, pp. 175, 177–78, 185–86.

9. MacDonald, 1995, *loc. cit.*

ADDITIONAL REFERENCES

The Frick Collection Catalogue, IV, 1951, No. 38, pp. 45–46.

M. F. MacDonald, *Palaces in the Night: Whistler in Venice*, Berkeley, California, 2001, p. 137, repr. p. 59.

T. R. Way and G. R. Denis, *The Art of James McNeill Whistler: An Appreciation*, London, 1903, p. 52, repr. p. 33.

VENETIAN CANAL (15.3.40)

Signed, at lower left, with the butterfly monogram. Drawn probably in the spring of 1880. Black chalk and pastel, on dark brown wove paper, 11⅞ × 8¹⁄₁₆ in. (29.8 × 20.3 cm).

INSCRIPTION: In pencil at lower left: *N 33./ 11 × 5–*.

DESCRIPTION: A narrow canal, flanked by buildings that rise almost to the top of the sheet, terminates in a short flight of steps. The shutters of the houses at right are orange, light green, and blue; at left, a dark green vine tumbles down the blank façade of a large corner building. A bridge, on which a passerby pauses, arches over the canal, and three gondolas are moored in the foreground below. An uneven succession of houses extends beyond the bridge.

CONDITION: The drawing is in good condition. In 1980 it was removed from its wood-pulp backing and hinged at all four corners to a sheet of rag paper.

THE unidentified quiet backwater canal depicted in this drawing is typical of the lesser-known sites Whistler favored as subject matter for his Venetian pastels and etchings. Similarly, the technique he employed here exemplifies the method of pastel drawing he pioneered in Venice, as described firsthand by his fellow artist Otto Bacher: "In beginning a pastel, he drew his subject crisply and carefully in outline with black crayon upon one of those sheets of tinted paper which fitted the general color of the motive. A few touches of sky-tinted pastels, corresponding to nature, produced a remarkable effect with touches of reds, grays, and yellows for the buildings here and there."[1] In the present drawing, the spare network of geometric lines extending outward from the center to the relatively empty margins was undoubtedly drawn in front of the motif, but the flat, mosaic-like areas of color may well have been added later, as was often Whistler's practice. The muted tones of the buildings, with their crumbling surfaces, are effectively represented by the coarse brown paper, which is left largely uncovered. The sky and water are slightly rubbed.

The leafless tree in the roof garden at upper left and the overall somber tonality of the drawing suggest that it was executed in early spring. While the color range of this pastel relates it to both the beginning and the end of Whistler's Venice stay, the sureness of his handling of the medium and the economy of means it evinces place it in his second year in the city.[2] One of the most spare and delicate of the Venetian pastels, reflecting Whistler's appreciation of Oriental art, this drawing was

praised in a review by E. W. Godwin of the artist's 1881 London exhibition as "a quite exquisite picture."[3]

S. G. G.

EXHIBITED: London, Fine Art Society, Venice Pastels, 1881, No. 7. Probably London, Marchant, 1903.[4] Paris, École des Beaux-Arts, Whistler, 1905, No. 157, lent by R. A. Canfield to this and the following exhibitions. New York, Metropolitan Museum, Whistler, 1910, No. 21. Buffalo, Albright Art Gallery, Whistler, 1911, No. 20. New York, Knoedler, Whistler, 1914, No. 22.

COLLECTIONS: R. A. Canfield, perhaps bought from the London dealer Marchant.[5] Knoedler, 1914. Bought by Stephen C. Clark in 1914 and returned to Knoedler in 1915. Frick, 1915.

NOTES

1. O. Bacher, *With Whistler in Venice*, New York, 1909, pp. 75–76.

2. M. F. MacDonald, *James McNeill Whistler: Drawings, Pastels, and Watercolours: A Catalogue Raisonné*, New Haven–London, 1995, No. 779, p. 288, repr. p. 289.

3. E. W. Godwin, *British Architect*, February 4, 1881, reprinted in R. H. Getscher, *James Abbott McNeill Whistler: Pastels,* New York, 1991, p. 179. See also "Whistler's Wenice; Or, Pastels by Pastelthwaite," *Punch,* February 12, 1881, No. 7, reprinted in Getscher, p. 175.

4. MacDonald, *loc. cit.*, notes: "From the title, the pastel drawing at Marchant's in 1903 might have been one of several (Nos. 14, 17, 42, 50 in the 1881 exhibition). ..."

5. See MacDonald, *loc. cit.*, for additional information about this provenance.

ADDITIONAL REFERENCES

The Frick Collection Catalogue, IV, New York, 1951, No. 40, pp. 47–48.

H. Honour and J. Fleming, *The Venetian Hours of Henry James, Whistler and Sargent*, Boston–Toronto–London, 1991, p. 45, repr.

M. F. MacDonald, *Palaces in the Night: Whistler in Venice*, Berkeley, California, 2001, pp. 53, 55.

T. R. Way, *Memories of James McNeill Whistler,* London–New York, 1912, No. 7, repr. between pp. 52 and 53.

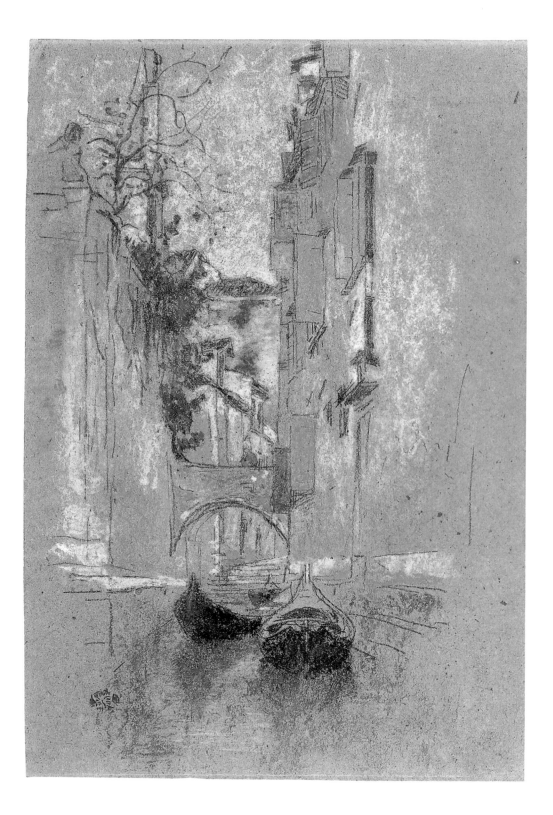

PRINTS

EXPLANATORY NOTE
and Acknowledgments

In the physical description of the prints, any manuscript signatures and inscriptions by the artist are recorded, along with any signatures and inscriptions made within the plate itself. The printmaking medium, the ink color, and the nature of the paper support are described. Measurements are of the plate area or, if the sheet has been trimmed within the platemark, of the extant sheet; height precedes width. Under the heading *References* are included the most prominent catalogues raisonnés of the printmaker's work, indicating the state of the Frick impression and the total number of recorded states. Included under *Marks and inscriptions* are descriptions of watermarks, if any, and inscriptions entered by persons other than the artist. Collectors' marks do not appear under this heading; if they are recorded in F. Lugt, *Les Marques de collections*, Amsterdam, 1921, and *Supplément*, The Hague, 1956, the Lugt number will be mentioned under *Collections*.

The author wishes to acknowledge here past and present members of the Frick Collection staff, especially Charles Ryskamp, Edgar Munhall, Susan Galassi, Joseph Focarino, and William Stout. In addition, thanks go to John Ittmann, Marjorie Cohn, George Keyes, Nicholas Stogdon, Joaneath Spicer, Patrick Noon, Scott Wilcox, Anne-Marie Logan, Martha Buck, Inger Schoelkopf, David Mannings, Nancy Finlay, James Bergquist, Jessica Banks, Martha Tedeschi, Nesta Spink, Irena Zdanowicz, and Roger Collins. Finally, acknowledgment should be made to A. Hyatt Mayor, whose early contributions to a catalogue of the prints in The Frick Collection were never brought to completion, but whose eye and prose have long inspired the present author and many others in the print field.

D. P. B.

The majority of the entries that follow were submitted for publication in early 1998, and therefore do not reflect scholarship since that time. Among the most pertinent recent publications are the following.

REMBRANDT: N. Ash and S. Fletcher, *Watermarks in Rembrandt's Prints*, Washington, 1998; A. Eeles, "Rembrandt's Ecce Homo: A Census of Impressions," *Print Quarterly*, XV, 1998, pp. 290–96, XVII, 2000, p. 49; E. Hinterding, G. Luijten, M. Royalton-Kisch, *et al., Rembrandt the Printmaker*, exhib. cat., Rijksmuseum, Amsterdam, and British Museum, London, 2000; C. White, *Rembrandt as an Etcher*, 2nd ed., New Haven–London, 1999.

WHISTLER: A. Grieve, *Whistler's Venice*, New Haven–London, 2000; M. F. MacDonald, *Palaces in the Night: Whistler in Venice*, Berkeley, California, 2001.

ENGLISH REPRODUCTIVE PRINTS: A. G. Cross, *Engraved in the Memory: James Walker, Engraver to the Empress Catherine the Great, and his Russian Anecdotes*, Oxford–Providence, 1993; E. G. D'Oench, *"Copper into Gold": Prints by John Raphael Smith*, New Haven–London, 1999; D. Mannings, *Sir Joshua Reynolds: A Complete Catalogue of his Paintings*, 2 vols., New Haven–London, 2000.

ALBRECHT DÜRER

1471–1528

Dürer was born in Nuremberg, the son of a goldsmith and godson of the printer Anton Koberger. Nuremberg was then a city of active intellectual and artistic life, and the young Dürer took full advantage of its potential, becoming a learned artist and humanist. He undoubtedly acquired engraving skills at an early age under his father's tutelage. At fifteen he was apprenticed to Michael Wolgemut, from whom he learned both painting and woodcutting, as Wolgemut's shop produced illustrations for many of the most important books of the time. In 1490 Dürer set off on four years of travel, with stays of varying duration in Strasbourg, Colmar, and, most notably, Basel, where he was involved in designing sets of woodcut illustrations. He visited Venice and other Italian cities in 1494–95 and again in 1505–07, absorbing theories and artistic models from antiquity and the Italian Renaissance. Except for an extended journey to the Netherlands in 1520–21, he spent the remainder of his career in or near Nuremberg. Dürer attached great importance to the function of printmaking in his artistic production, arguing that it was as valid a medium as painting or sculpture for representing creative ideas.[1] He also realized at an early age the potential of prints for spreading his ideas and images throughout Europe. His first engravings date from about 1494, and he had already developed his style to a very high degree by the early sixteenth century (see The Fall of Man *of 1504, p. 135). He produced several influential religious books illustrated with woodcuts (beginning with the* Apocalypse *of 1498), experimented with both etching and drypoint, and published theoretical treatises on measurement, human proportion, and fortification. He also was involved in large decorative woodcut projects for the Emperor Maximilian I.[2] The four prints in The Frick Collection are among the finest examples of Dürer's mature engraving and represent some of the most original and famous images he produced in any medium.*

D. P. B.

ESSENTIAL REFERENCES

A. Bartsch, *Le Peintre-graveur*, 21 vols., Vienna, 1802–21.

C. Dodgson, *Albrecht Dürer: Engravings and Etchings*, London, 1926.

J. Meder, *Dürer-Katalog*, Vienna, 1932.

K. G. Boon and R. W. Scheller, ed., *Albrecht Dürer*, Amsterdam, 1968, vol. VII of F. W. H. Hollstein, *German Engravings, Etchings and Woodcuts ca. 1400–1700*, Amsterdam, 1954–.

NOTES

1. See: M. B. Cohn, in *Albrecht Dürer 1471–1528: A Selection from His Prints*, exhib. cat., Mount Holyoke College, South Hadley, Massachusetts, 1971, pp. 20–21; and W. M. Conway, *Literary Remains of Albrecht Dürer*, Cambridge, England, 1889, p. 244.

2. The most recent full biography is J. C. Hutchison, *Albrecht Dürer: A Biography*, Princeton, 1990; the classic study of Dürer's life and career is E. Panofsky, *The Life and Art of Albrecht Dürer*, fourth ed., Princeton, 1955.

COAT OF ARMS WITH A SKULL (16.3.2)

Signed in the plate, on the tablet at lower center: AD [in monogram]; dated, on the stone slab below the tablet: 1503. Engraving, printed in black ink on cream-colored antique laid paper, 8¾ × 6¼ in. (22.2 × 15.9 cm).

REFERENCES (in each case, only state): Bartsch 101; Dodgson 36; Meder 98; Boon and Scheller 98.

INSCRIPTIONS: On verso in pen and brown ink: *194* [struck through] *202*; and in graphite: *Nz 931 / 898 / C.1129 / B.101 / Nº 31*.

DESCRIPTION: At left stands a richly dressed, crowned woman being embraced from behind by a wild man who holds a forked stick. She grasps the end of a leather strap that passes over the stick, and from the strap is suspended a jousting helmet with ornamental acanthus leaves and upstretched wings. The helmet in turn rests on an elaborate heraldic shield displaying a skull.

CONDITION: Apart from slight thinning on the verso along the left and upper edges and in an area to the right of the acanthus, the sheet is in good condition.

SEVERAL rich iconographic traditions are skillfully woven into this arresting image—a heraldic coat of arms, a memento mori, an ill-assorted couple, even a representation of love and death. The woman's crown identifies her as a bride; her sumptuous gown is based on a watercolor costume study in the Offentliche Kunstsammlung, Basel, labeled by the artist as a typical dress worn to a dance.[1] However, she certainly seems not to resist the advances of the creature (presumably not her bridegroom) caressing her, and she cannot see the warning skull on the shield before her. The hirsute wild man was a common symbol in Northern art of the period, often representing unbridled—hence reckless—nature, but he was also portrayed supporting heraldic shields in the guise of a faithful strongman, at times accompanied by his mate.[2] The wild man figure seen here recalls that in one of Dürer's earliest engravings, *The Ravisher* of about 1495 (Bartsch 92). The fantastic assemblage of shield, jousting helmet, acanthus leaves, and wings,[3] all tied to a leather strap held by the woman and propped up by the wild man's crook, resembles the shields crowned by helmets that were often carved in wood on contemporary memorials of Nuremberg nobility.[4] Several small roundel engravings by Martin Schongauer depicting wild men and women holding shields seem to be the only printed precedents.[5] Dürer here has ambiguously combined themes of death, love, and sexuality in a solemn, contained composition of great appeal.

The technical skill and visual fascination of the print nearly overwhelm its subject. The textures of cloth, hair, metal, leaves, wings, and fur are rendered with consummate control. Panofsky has cited this print as an important achievement for

Dürer in synthesizing the graphic strength of his earliest engraving style with the tour-de-force surface finish seen in such prints as his *St. Eustace* and *Nemesis* of about 1501–02 (Bartsch 57, 77).[6] Dürer placed his unlikely group on a bare spot of ground against a totally blank background, emphasizing the play between the real figures and the fantasy inherent in their juxtaposition. Emison has pointed out that the two "lovers" are cut by the frame of the image, whereas the other elements are fastidiously contained within the margins.[7] The haunting hyperrealism of the figures and objects within the engraving (especially the disintegrating skull) neatly combats the traditional two-dimensionality of the heraldic print.

COLLECTIONS: Prince Nicolas Esterhazy (Lugt 1966). Junius S. Morgan (Lugt 1536). Brayton Ives. His sale, New York, American Art Association, April 12–14, 1915, Lot 313. Knoedler. Frick, 1916.

NOTES

1. See *Dürer in America: His Graphic Work*, ed. C. Talbot, exhib. cat., National Gallery of Art, Washington, 1971, p. 130, No. 27, note 1. The costume study is reproduced in W. Strauss, *The Complete Drawings of Albrecht Dürer*, New York, 1974, II, p. 516, No. 1500/7.

2. For the history of the wild man motif, see: R. Bernheimer, *Wild Men in the Middle Ages: A Study in Art, Sentiment, and Demonology*, Cambridge, Massachusetts, 1952, esp. pp. 183–84 for this print; and T. Husband, *The Wild Man: Medieval Myth and Symbolism*, exhib. cat., Metropolitan Museum of Art, New York, 1980, esp. pp. 193–96, No. 58, for this print.

3. Dürer depicted the helmet shown here in a watercolor now in the Louvre (Strauss, I, p. 358, No. 1495/49, repr.).

4. This connection was noted in P. Emison, *The Art of Teaching: Sixteenth-Century Allegorical Prints and Drawings*, exhib. cat., Yale University Art Gallery, New Haven, 1986, p. 75, note 2. A typical memorial is illustrated in *Gothic and Renaissance Art in Nuremberg 1300–1550*, exhib. cat., Metropolitan Museum of Art, New York, 1986, p. 203, No. 61.

5. Bartsch 100, 103–05. The Housebook Master had executed several similar, satirical prints, without wild people (J. P. Filedt Kok, *The Master of the Amsterdam Cabinet, or The Housebook Master, ca. 1470–1500*, exhib. cat., Rijksprentenkabinet, Amsterdam, 1985, Nos. 79–89).

6. E. Panofsky, *The Life and Art of Albrecht Dürer*, fourth ed., Princeton, 1955, p. 83; the same author (p. 90) has also tied the macabre elements of this print to various bizarre natural events that took place in the year of its execution, and to Dürer's own serious illness at that time.

7. Emison, p. 72.

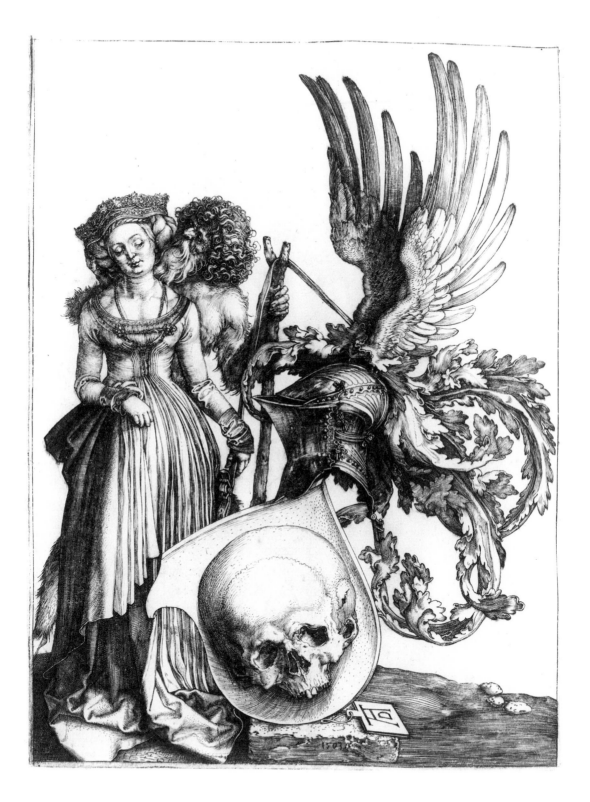

THE FALL OF MAN (Adam and Eve) (15.3.1)

Signed and dated in the plate, on the tablet hanging above Adam's right shoulder: ALBER-T9[VS] / DVRER / NORICVS / FACIEBAT / AD [in monogram] 1504. Engraving, printed in black ink on cream-colored antique laid paper, $9\frac{7}{8} \times 7\frac{11}{16}$ in. (25.2 × 19.5 cm).

REFERENCES: Bartsch 1; Dodgson 39 IV/V; Meder 1 II/III; Boon and Scheller 1 IV/V.

MARK & INSCRIPTIONS: Watermark of a bull's head (Meder 62). Inscribed in graphite on recto: *N. 33.* [?]; and on verso: *B.1 9958. OVXX.*

DESCRIPTION: Adam and Eve, nude, stand to either side of a tree around which coils a serpent who offers Eve a fruit. The figures are seen before a dark, wooded background, beyond which at top right is a goat poised on a rocky pinnacle. About the couple's legs appear an ox, elk, rabbit, cat, and mouse. A parrot perches above Adam's head.

CONDITION: An old crease runs horizontally through the center of the sheet. The paper is thinned on the verso in the margins and near Eve's navel, and a pinprick is visible in the border below the cat.

THE proper title for this engraving is indicated by several iconographic features not immediately apparent to the modern viewer. Dürer has depicted literally and symbolically the imminent Fall of Man from the innocent state of grace in the Garden of Eden, as described in Genesis 2–3. In addition to the inherent tension between Adam and Eve as they are being tempted by the serpent to taste the fateful fruit, there is also, as Panofsky has pointed out, the analogous, emblematic juxtaposition of Adam holding onto the mountain ash (the Tree of Life) and Eve standing under the "forbidden fig tree" (the Tree of Knowledge). Further, Dürer pairs the parrot, a symbol associated with the Virgin, with the diabolical serpent, and the innocent mouse with the sly, crouching cat that seems about to pounce.[1] Following the scholastic doctrine concerning the Fall of Man, Dürer shows the peaceful coexistence, preceding the Fall, of the four humors—or temperaments—of man, represented by, as Panofsky noted, "the elk denoting melancholic gloom, the rabbit sanguine sensuality, the cat choleric cruelty, and the ox phlegmatic sluggishness."[2] The mountain goat seen at top right has been interpreted by Talbot as standing for the unbelieving—thus symbolic of the pair being tempted by the serpent not to believe—and by Peters as a portent of the sin brought to humankind by the couple's decision.[3]

Maintaining the assured engraving technique seen in the *Coat of Arms with a Skull* of the year before (see preceding entry), Dürer achieved here a virtual encyclopedia of textures and substances, from the smooth flesh of the figures, to the rough bark

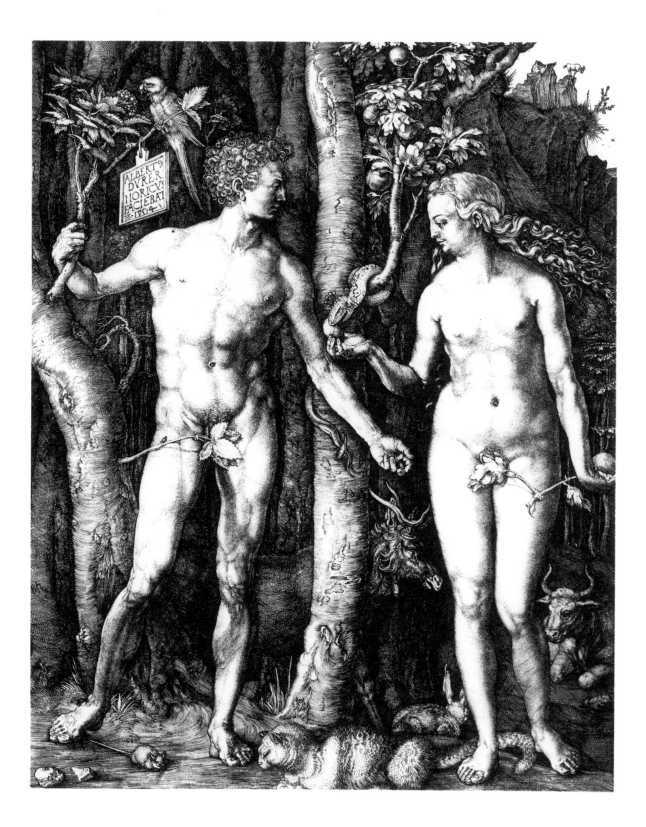

of the trees, to the evocative shade of the background forest. But the end to which all these effects were directed is the portrayal of the ideal proportions and beauty of the human body. Striving to surpass his predecessors, Dürer had studied the works of Italian artists (including compositions by Andrea Mantegna and Jacopo de' Barbari, the latter of whom had come to Nuremberg in 1500), theoretical works by Vitruvius, the prototypes afforded by classical sculptures (obvious sources are the *Apollo Belvedere* for Adam and types similar to the *Medici Venus* for Eve[4]), and even measurements of the bodies of his friends and of models in order to arrive at his ideal forms for this print. Human proportion fascinated him throughout his career; he published a long treatise on it in the year of his death, entitled *Vier Bücher von menschlicher Proportion* (Four Books on Human Proportion).

Panofsky reasons from evidence of several preparatory drawings for both figures that Dürer originally intended to engrave a pendant pair of copperplates, each with a single figure.[5] One of the final studies for *The Fall of Man* is in the Pierpont Morgan Library, New York, but the lack of transfer marks on that drawing indicates that one or more further steps intervened before the actual engraving.[6] There exist at least two trial impressions from the copperplate in an unfinished state, with much of the background forest engraved but the figures existing in barely indicated outline.[7] Many Northern European printmakers repeated the motif subsequent to Dürer's version, most notably Lucas van Leyden, Hans Baldung Grien, and Rembrandt.[8] Three years after *The Fall of Man*, Dürer further explored the theme in two large panel paintings of *Adam* and *Eve* now in the Prado, Madrid.[9]

In this engraving, the artist posed his ideal man and woman in classic contrapposto stance and delineated the volume and surfaces of their bodies with finely detailed stippling of dots and light strokes of the engraver's burin. Scholars have noted that this is the first instance in which Dürer depicted actual sunlight casting shadows (for instance, the fig branch on Adam's leg), an effect he continued to exploit in his prints thereafter.[10] The full measure of his accomplishment can best be appreciated only in the earliest impressions from the plate (as in the Frick impression), where the sculptural solidity of the figures softly modeled by the light has not yet disappeared. Dürer has rendered the surface perfection of man and woman made in God's image, yet eminently susceptible to sin. Koerner has interpreted Dürer's ambitions in this print as actually recreating the true vision of human perfection before the Fall, thereby assuming the role of medium, or channel, to that objectively unknowable period. He self-confidently signed his full name and place

of origin on a tablet that he hung from the Tree of Life itself, in effect rendering his name immortal. Koerner further points out that the unusual use of the imperfect tense *faciebat* ("was making") reinforces the concept of the artist's activity as continuing—even through the reprintings of the plate in the years to come.[11]

COLLECTIONS: According to a note on an old mount, the print was formerly owned by Joseph Gulston (see Lugt 1113) and appeared in his sale, Greenwood, London, 1786, 38th night, Lot 61, sold for £5 2s 6p to Robert Grave. Grave sale, London, December 2, 1805, Lot 68. Brayton Ives. His sale, New York, American Art Association, April 12–14, 1915, Lot 277.[12] Knoedler. Frick, 1915.

NOTES

1. See E. Panofsky, *The Life and Art of Albrecht Dürer*, fourth ed., Princeton, 1955, p. 85. See also *Dürer in America: His Graphic Work*, ed. C. Talbot, exhib. cat., National Gallery of Art, Washington, 1971, p. 132. R. Schoch, in *Gothic and Renaissance Art in Nuremberg 1300–1550*, exhib. cat., Metropolitan Museum of Art, New York, 1986, p. 295, associates the parrot merely with "cleverness," in juxtaposition with the "seductive" serpent. I. B. Jaffé, in "The Tell-Tale Tail of a Parrot: Dürer's 'Adam and Eve,'" *Print Collector's Newsletter*, XXIV, 1993, pp. 52–53, ties the depiction of the parrot, exotic specimens of which at the time were being brought to Europe from the Americas, with the supposed location of the Garden of Eden in the New World.

2. Panofsky, *loc. cit.*

3. Talbot, *loc. cit.* J. S. Peters, in *Six Centuries of Master Prints: Treasures from the Herbert Greer French Collection*, exhib. cat., Cincinnati Art Museum, 1993, p. 64, No. 33 and note 12. Peters draws a connection to the German word for scapegoat, *Sündenbock*—literally "sin-goat."

4. The exact discovery date of the *Apollo Belvedere* now in the Vatican is uncertain, but it is assumed to have been generally known by the mid 1490s (see: F. Haskell and N. Penny, *Taste and the Antique: The Lure of Classical Sculpture, 1500–1900*, New Haven–London, 1981, p. 148; W. S. Sheard, *Antiquity in the Renaissance*, exhib. cat., Smith College Museum of Art, Northampton, 1979, Nos. 50–51). The *Medici Venus* now in the Uffizi, Florence, is not documented until 1638, when François Perrier engraved it (Haskell and Penny, p. 325). Presumably Dürer was working from antique copies or similar figures.

5. Panofsky, p. 86.

6. The Morgan Library drawing is discussed and illustrated in Talbot, pp. 50–52, No. XII. The two figures were actually drawn on separate sheets of paper and later joined. In the drawing, both hold the forbidden fruit, whereas Adam has yet to take any in the final engraving. A subsequent sheet in the British Museum shows five studies of Adam's arm and hand, with and without the fruit, revealing Dürer's care in determining his specific characterization (see D. Landau and P. Parshall, *The Renaissance Print 1470–1550*, New Haven–London, 1994, p. 313, repr. fig. 330).

7. *The Complete Engravings, Etchings, and Drypoints of Albrecht Dürer*, ed. W. L. Strauss, New York, 1972, pp. 88–90, Nos. 42a–b, repr.

8. See H. D. Russell and B. Barnes, *Eva/Ave: Woman in Renaissance and Baroque Prints*, Washington–New York, 1990, pp. 112–29; Dürer's *Fall of Man* is discussed on p. 116, exploring broader themes of the conflict between the spirit and the flesh. Dürer's print was also directly copied many times; see *Vorbild Dürer*, exhib. cat., Germanisches Nationalmuseum, Nuremberg, 1978, pp. 99–103.

9. Panofsky, pp. 119–21 and figs. 164, 165.

10. *Albrecht Dürer: Master Printmaker*, exhib. cat., Museum of Fine Arts, Boston, 1971, pp. xvii and 115, under No. 84.

11. J. L. Koerner, *The Moment of Self-Portraiture in German Renaissance Art*, Chicago–London, 1993, pp. 201–02, 237. Dürer's specific prototype for the signature tablet has been recognized as emulating one of his printed models of the nude human form, Antonio del Pollaiuolo's *Battle of the Nudes* of about 1470–75 (reproduced in Panofsky, fig. 54).

12. According to a note in the sale catalogue, this impression is a duplicate from the British Museum, although there are no indications of such on the print itself.

KNIGHT, DEATH, AND THE DEVIL (16.3.3)

Signed and dated in the plate, on the tablet at lower left: s·1513·/AD [in monogram]. Engraving, printed in black ink on dark cream-colored antique laid paper, 9⅝ × 7⅜ in. (24.5 × 18.7 cm).

REFERENCES (in each case, only state): Bartsch 98; Dodgson 70; Meder 74; Boon and Scheller 74.

INSCRIPTION: In graphite on verso: *a 39162 e. 1128 MSXX.—*.

DESCRIPTION: A knight wearing armor and carrying a lance is shown in profile riding a horse leftward through a rocky defile. A figure of Death holding an hourglass rides beside him, and a grotesque devil walks behind. A dog and lizard appear below the knight's horse, and a fortified town rises in the far distance at the top of the composition.

CONDITION: Apart from an old vertical fold running through the center and a horizontal fold a third of the way up from the lower edge, the sheet is in good condition.

Knight, Death, and the Devil is the earliest of the three so-called *Meisterstiche* (master prints) of Dürer, the two others being *St. Jerome in His Study* (Bartsch 60) and *Melencolia I* (see following entry), both of which are dated 1514. Though probably not conceived by the artist as a strictly related group, they are allied in format, technique, and thematic complexity, leading subsequent viewers to link them, often describing them respectively as representing ideals of moral, theological, and intellectual virtue. In his writings, Dürer referred to the present engraving simply as the *Reuter* (rider), but many commentators, beginning with Joachim van Sandrart in 1675, ascribed to the central figure an interpretation of a Christian knight, citing a text first published in 1504 by Erasmus, *Enchiridion militis Christiani* (Handbook of the Christian Soldier).[1]

According to this interpretation, Dürer's impassive horseman follows the narrow path of virtue through the dark route of tribulation, toward the goal of salvation—seen here as the far-distant fortress at the top of the composition. While passing through the "valley of death," he is taunted by Death himself and by a caricatural cross-eyed devil with a pig's face, claws, and a rhinoceros' horn. Death is a particularly gruesome characterization, with rotting flesh, twisting snakes, and a sparse beard lending realistic macabre details to his presence; his tired nag affords a striking contrast to the knight's classical specimen of equine beauty and strength. The knight is accompanied by his faithful dog, symbolic of zeal, learning, and truthful reasoning.[2] A skull lies directly in their path at lower left.

The presence of death in person and in proxy (the skull at lower left) has persuaded some scholars toward a viewing of the print as either a memento mori or a

Dance of Death, even recalling Dürer's 1510 woodcut *Death and the Lansquenet* (Bartsch 132).[3] Other interpretations have ranged from a ghostly Phantom-Rider derived from contemporary legend to an allegory related to the numerous *Raubritter* (robber knights) endemic in Germany in the sixteenth century.[4] As Dürer never indicated any program for his print, however, scholars have accepted its ultimate ambiguity. Hutchison has pointed out the lasting influence of Dürer's knight in this print as a symbol of German national virtue, culminating in its profligate use by artists during the Nazi regime.[5]

The action found here stands in strong contrast to the quiet atmosphere of scholarship and contemplation seen in the engraving of the well-ordered study of St. Jerome. However, the two representations can be interpreted as opposite sides of the same coin, complementary paths toward the common goal of religious salvation. Visually, the prints are quite different, though they exhibit equal technical prowess. The *St. Jerome* is a tour-de-force of deep perspective rendering, combined with a subtle treatment of sunlight filling the interior space. *Knight, Death, and the Devil*, on the other hand, is presented as a flat tableau with little depth, showing the principal figures outlined against a dark backdrop of unruly nature (itself a counterpoint to the knight's perfect control).

Dürer's portrayal of the knight's horse is a culmination of his search for ideal equine proportions, gleaned from his study of Italian Renaissance models, including the work of Leonardo and probably the well-known examples of monumental sculpture he would have seen in Venice, such as the horses of St. Mark's basilica and the *Colleoni* monument by Andrea del Verrocchio.[6] His horse and rider derived ultimately from a watercolor study of 1498 in the Albertina, Vienna, and a subsequent double-sided compositional study in Milan. The latter shows the artist's changes to the horse's raised rear leg, which are resolved only in the final print. There are further individual sketches for the dog and part of the background.[7] Dürer had also developed his proportion studies of horses in his engravings *St. Eustace* of about 1501 (Bartsch 57) and *The Small Horse* of 1505 (Bartsch 96). Again, Dürer's controlled engraving technique in *Knight, Death, and the Devil* is apparent in the myriad textures and subtle spacial differences depicted within a limited tonal range. These qualities are visible only in early impressions from the plate.

COLLECTIONS: Knoedler. Frick, 1916.

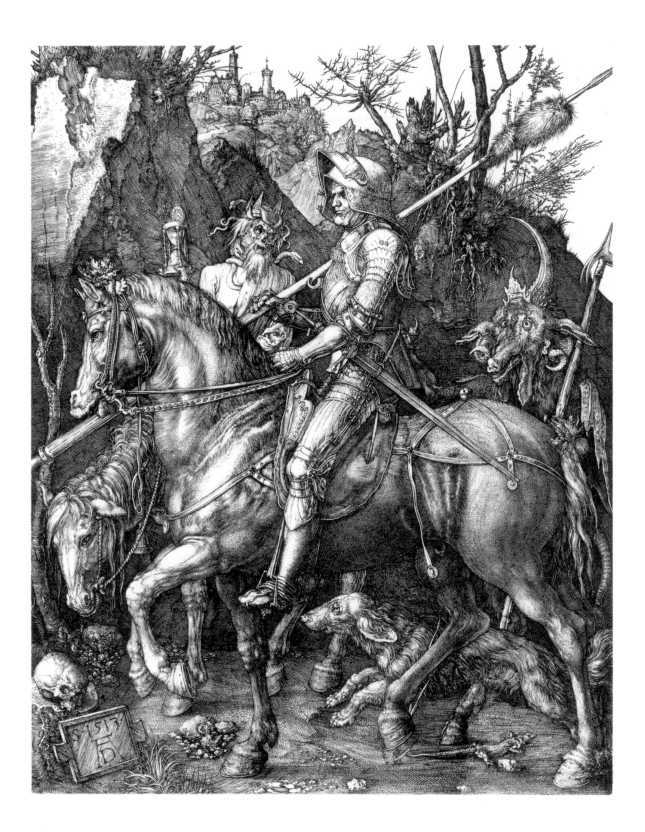

NOTES

1. E. Panofsky's influential statement of this interpretation is contained in his *The Life and Art of Albrecht Dürer*, fourth ed., Princeton, 1955, pp. 151–54. Other interpretations of the subject (with bibliography) are usefully outlined by J. C. Hutchison, in *Six Centuries of Master Prints: Treasures from the Herbert Greer French Collection*, exhib. cat., Cincinnati Art Museum, 1993, pp. 79–80.

2. Panofsky, p. 153.

3. E. Gombrich, cited in *Dürer in America: His Graphic Work*, ed. C. Talbot, exhib. cat., National Gallery of Art, Washington, 1971, p. 144.

4. See U. Meyer, "Political Implications of Dürer's 'Knight, Death and Devil,'" *Print Collector's Newsletter*, IX, 1978, pp. 35–39, for a re-view of the historical and political use of these varying interpretations.

5. See Hutchison, *loc. cit.*, further citing Heinrich Wölfflin's reference to *Knight, Death, and the Devil* as "perhaps the best known picture in German art." See also J. C. Hutchison, *Albrecht Dürer: A Biography*, Princeton, 1990, p. 201 and pl. 37, which reproduces a politically-charged woodcut of about 1936 derived from Dürer's model.

6. Hutchison, *Six Centuries*, p. 79.

7. The Vienna watercolor is reproduced in W. Strauss, *The Complete Drawings of Albrecht Dürer*, New York, 1974, I, p. 356, No. 1495/48. For reproductions of the other preparatory drawings, see Strauss, I, p. 340, No. 1495/40, and III, pp. 1338–42, Nos. 1513/1–3.

MELENCOLIA I (40.3.61)

Signed and dated in the plate, on the face of the step at lower right: 1514 / AD [in monogram]. Engraving, printed in black ink on cream-colored antique laid paper, 9½ × 7⁷⁄₁₆ in. (24.1 × 18.9 cm).

REFERENCES: Bartsch 74; Dodgson 73 II/II; Meder 75 II/II; Boon and Scheller 75 II/II.

INSCRIPTIONS: In graphite on verso: *#30178 10791*, followed by indecipherable letters in a fraction.

DESCRIPTION: In the right foreground a richly dressed, winged female figure sits surrounded by tools of carpentry and architecture before an unspecific construction, upon which is inscribed a magic square. A balance, hourglass, and bell hang from the sides of the construction, and a ladder is propped against it. To the left of the figure, a putto sits atop a millstone working on a tablet. A dog sleeps at lower left, between a sphere in the foreground and a polyhedral form behind. A large body of water and shoreline are seen in the left distance under a dark sky with a rainbow, a comet, and a bat on whose outstretched wings the title of the print is lettered.

CONDITION: An old horizontal fold is visible at center, and the sheet has been pressed.

DÜRER endowed this enigmatic print with a plethora of symbolic attributes and private emblems, combined in a cool richness of texture and tonality. It has been the subject of an enormous amount of scholarly exercise, dominated by Panofsky's intensive studies interpreting it as an artistic and spiritual self-portrait, yet it still eludes definitive explication.[1] This highly sophisticated message from the artist combines skillfully realized, familiar, but often apparently contradictory objects placed together in an unrecognizable setting.

On an immediate level, the despondent winged female figure is representative of the melancholic human temperament. Her slack mien follows the medieval model for melancholy, and here can be seen as reflecting frustration at her inability to penetrate the metaphysical mysteries that are beyond measurable intellectual disciplines. Panofsky and others conceive of her predicament in a positive, humanist sense, as a specific attribute of artistic genius. Koerner has further related the figure's placement of head-on-hand to self-portrait drawings by Dürer in the same pose, thereby refering more personally to the "inwardness" of the artist.[2] Dürer has fused this iconography with another traditional allegory of the practical art of geometry; Panofsky has detailed the close similarity with a contemporary woodcut in Gregor Reisch's *Margarita Philosophica*.[3] The subject's mastery of the measurable realm of geometry is represented by the profusion of architectural and carpen-

try tools that surround her, as well as the compass and book in her lap. Even the scales and hourglass on the wall behind her relate to objective measurement, as does the magic square (whose rows of figures add up to thirty-four in any direction and include on the bottom line the date of the print, 1514).[4]

Most of the elements in *Melencolia* are also interconnected through the attributes of Saturn, long associated with the melancholic humor, which is itself related to the earth. In his aspect as earth god, Saturn ruled the art of geometry, used for the measurement and partition of land and buildings. Comets were thought to emanate from Saturn and were also alleged to cause floods, a notion perhaps alluded to here by the distant seascape. The magic square was believed to thwart the evil influence of Saturn. The wreath worn by the melancholic figure has recently been identified as lovage, a "watery" plant said to ward off the effects of dry melancholy.[5] Most writers have seen the industrious putto seated on the millstone as writing, but Fehl and Koerner suggest him as perhaps another "self-portrait," wielding an engraver's burin on an object strikingly similar to Dürer's monogram tablets in all three of the preceding prints, as well as *St. Jerome in His Study*.[6]

The numeral that forms part of the inscribed title has also been subject to varying interpretations. Inferring a proposed series, Panofsky suggested that the present image represents one of three types of melancholic temperament, those dominated respectively by the mind, by reason, and by imagination. The last of these, imagination, is the province of artists and craftsmen, who are also gifted with the ability to prophesy natural phenomena—such as the rainbow and comet seen in the engraving; the dominance of reason is found in scientists or statesmen, while the mind dominates in theologians. These theories were put forth in a contemporary text by Cornelius Agrippa of Nettesheim. Panofsky therefore places Dürer's representation here as the lowliest form of "genius"—that is, an ability to invent and build, but an inability to enter the metaphysical world.[7] Hoffmann ascribes the title solely to the bat who carries it, as symbolizing the "black" melancholy of superstition, opposed to the superior, more noble melancholy represented by the prime figure of the composition.[8]

Although there is no evidence that the three *Meisterstiche* were conceived as a tightly bound trio, Panofsky and others have seen the *Melencolia* as a conscious contrast to at least the *St. Jerome in His Study*—that is, the contemplative, organized religious ideal opposed to the doomed attempt to solve the mysteries of human creation by rational means.[9] Koerner, however, broadly relates *Melencolia* to both of

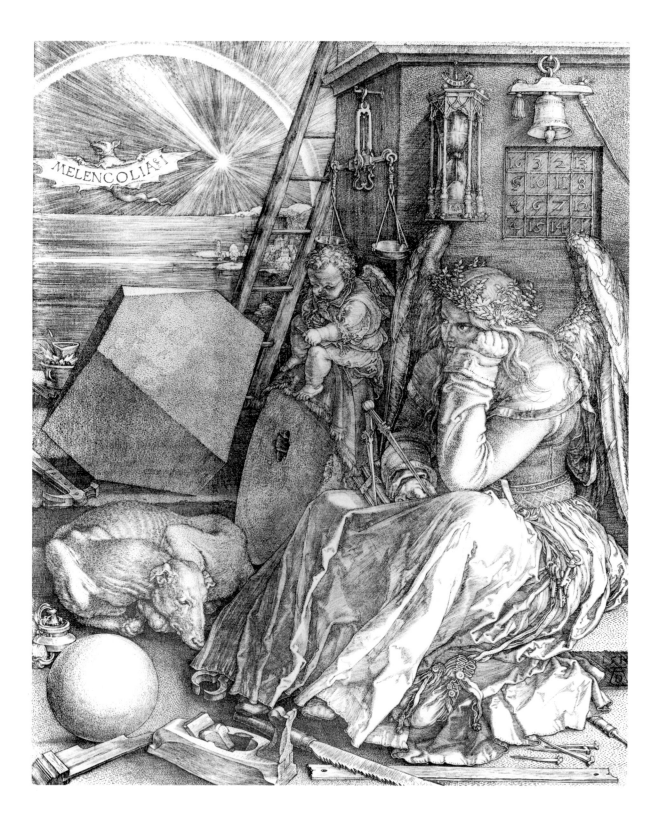

the other master prints. Arguing that the obscurity of the engraving is at least part of the artist's intention, he states that *Melencolia* "seems designed to generate multiple and contradictory readings," leading its viewers on an exercise in ultimate self-reflection. In this way, all three prints become linked: "Each print pictures a relation of self to itself, inflected variously in intellectual, spiritual, and moral labor and enacted always against the temporalizing horizon of death (the ubiquitous hourglass)."[10] Carrying further the idea of Dürer's intentional obfuscations, Bałus proposes that he not only was delineating an allegory of melancholy, but also was translating "melancholy emotions into the language of artistic forms."[11]

In the end, despite all the scholarly investigation of this tantalizing image, *Melencolia I* would remain inert were it not for Dürer's consummate mastery of engraving technique and visual drama. The cold moonlight that illuminates the scene (indicated most clearly by the cast shadow of the hourglass) gives the woman's face an appropriately black complexion, pierced by the intense white glare of her eyes. She wears rich finery, with keys and purse (symbols of power and wealth respectively[12]), but she sits on a cold stone slab, her wings lifeless. The atmosphere is almost oppressively still, the only sounds to be heard emanating from the eviscerated bat, the putto's scratching, and perhaps the falling sand in the hourglass. The engraving is executed in a subtly modulated range of grays, unrelieved by bright highlights or defined shadows. Koehler has pointed out how effectively Dürer depicted differing qualities of light in each of his three master prints, evocatively reflecting the emotional moods of each subject.[13] The intellectual power and artistic success of this print were to exert great influence on subsequent artists' and writers' psychic self-portraits, especially during the Romantic movement in the early nineteenth century in Northern Europe.[14]

CONDITION: Knoedler. Frick, 1940.

NOTES

1. E. Panofsky's thesis is set forth in his *The Life and Art of Albrecht Dürer*, fourth ed., Princeton, 1955, pp. 156–71, and further expounded in R. Klibansky, F. Saxl, and E. Panofsky, *Saturn and Melancholy*, New York, 1964, pp. 284–373. K. Moxey has investigated Panofsky's personal identification with this print in his "Panofsky's Melancolia," *Künster-*

ischer Austauch/Artistic Exchange (Acts of the 28th International Congress of the History of Art [1992]), Berlin, 1993, II, pp. 681–92. Other valuable discussions are contained in: Dürer in America: His Graphic Work, ed. C. Talbot, exhib. cat., National Gallery of Art, Washington, 1971, pp. 145–46, No. 59; C. Talbot, From a Mighty Fortress: Prints, Drawings, and Books in the Age of Luther, 1483–1546, exhib. cat., Detroit Institute of Arts, 1983, p. 278, No. 154; T. D. Kaufmann, "Hermeneutics in the History of Art: Remarks on the Reception of Dürer in the Sixteenth and Early Seventeenth Centuries," in New Perspectives on the Art of Renaissance Nuremberg, ed. J. C. Smith, Austin, 1985, pp. 23–39; P.-K. Schuster, Melencolia I: Dürer's Denkbild, Berlin 1991 (reviewed by J.-M. Massing in Burlington Magazine, CXXXV, 1993, pp. 220–21); and J. C. Hutchison, in Six Centuries of Master Prints: Treasures from the Herbert Greer French Collection, exhib. cat., Cincinnati Art Museum, 1993, pp. 81–82, No. 49.

2. J. L. Koerner, The Moment of Self-Portraiture in German Renaissance Art, Chicago–London, 1993, p. 27. Writing separately, Koerner (loc. cit.) and Hutchison (p. 81) do caution against unquestioningly accepting Dürer's own identification with melancholy, citing the slim contemporary evidence.

3. Reproduced in Panofsky, p. 161, fig. 219.

4. Idem.

5. The connection with Saturn is discussed in Panofsky, pp. 166–69. For the identification of Melancholy's wreath, see Dürer in America, p. 146 and note 6.

6. P. P. Fehl, "Dürer's Signatures: The Artist as Witness," Continuum, I, 1991, p. 26; Koerner, p. 27.

7. Panofsky, pp. 168–70.

8. K. Hoffmann, "Dürer's 'Melencolia,'" Print Collector's Newsletter, IX, 1978, p. 34. Another theory relates the numeral I to the base unit of all numbers, following an interpretation of Dürer's melancholic figure in theoretical and practical fields of knowledge (Talbot, From a Mighty Fortress, p. 278).

9. Dürer is known on occasions to have presented the two prints together, as evidenced by entries in his diary for his 1520–21 trip to the Netherlands (Panofsky, p. 156; see also J. C. Hutchison, Albrecht Dürer: A Biography, Princeton, 1990, p. 117). For a cautionary dissenting view on this question, see R. Grigg, "Studies on Dürer's Diary of his Journey to the Netherlands: The Distribution of the Melencolia I," Zeitschrift für Kunstgeschichte, XLIX, 1986, pp. 398–409.

10. Koerner, p. 23.

11. W. Bałus, "Dürer's Melencolia I: Melancholy and the Undecidable," Artibus et Historiae, XV, 30, 1994, p. 19.

12. As identified by Dürer himself on a study in the British Museum, London (W. Strauss, The Complete Drawings of Albrecht Dürer, New York, 1974, III, p. 1442, No. 1514/25, repr.).

13. S. R. Koehler, A Chronological Catalogue of the Engravings, Dry-Points and Etchings of Albert Dürer, exhib. cat., Grolier Club, New York, 1897, p. 65.

14. For the influence of Melencolia on later artists, see Panofsky, p. 170, and Hutchison, Six Centuries, p. 81 and note 1, referring to J. Bialostocki, Dürer and His Critics 1500–1971 (Saecula Spiritalia, VII), Baden-Baden, 1986, esp. pp. 189–218. Recently, for instance, some scholars have seen an influence from Melencolia on the contemporary American artist Jasper Johns, whose complex images have created their own large body of interpretive scholarship (see J. Cuno, "Reading The Seasons," in Jasper Johns:

Printed Symbols, exhib. cat., Walker Art Center, Minneapolis, 1990, pp. 83–89, esp. pp. 85–86). And the German artist Anselm Kiefer constructed in his studio a debris-filled glass and metal version of Dürer's polyhedron (J. H. Neff, "Reading Kiefer: The Meanings of Lead," *MoMA: The Museum of Modern Art Members Quarterly*, No. 49, 1988, n.p.).

SIR ANTHONY VAN DYCK

1599–1641

Van Dyck's fame as an original printmaker rests chiefly on a mere fifteen etchings, all of them portraits intended for his highly popular series of printed depictions of celebrated contemporaries known as the Iconography.[1] *He executed only three other etchings:* The Reed Offered to Christ, Titian and His Mistress, *and one portrait that was not included in the* Iconography. *The original print did not play a large part in Van Dyck's artistic outlook, and it has been argued that, unlike such painter-printmakers as Dürer and Rembrandt, he used it solely as a technical step in the process of reproducing his designs for wider purposes.[2] As Rubens also had done very successfully, he did utilize the reproductive print in multiplying his designs. Van Dyck employed many of the engravers who worked for Rubens, and he probably learned his etching skills from one of them, perhaps Lucas Vorsterman (1595–1675), during the early stages of developing the* Iconography, *around 1630–31.[3] Nevertheless, Van Dyck's original portrait etchings have had an influence far beyond their small number. He developed a very clear, open style for delineating his subjects, reflecting his fluent draftsmanship. He focused almost exclusively on the head and face and only cursorily indicated a setting, occasionally leaving the background completely blank. Though the slightly younger Rembrandt was known for the intense chiaroscuro of many of his etched portraits, he may be seen to have utilized Van Dyck's clarity in such portraits as his* Clement de Jonghe *(see p. 183).[4] Van Dyck's example set universal standards for later portrait etching, especially during the nineteenth-century etching revival. The Frick Collection owns three of his etchings for the* Iconography, *one of which is modeled after his oil portrait of Frans Snyders also in the Collection.*

D. P. B.

ESSENTIAL REFERENCES

F. Wibiral, *L'Iconographie d'Antoine van Dyck d'après les recherches de H. Weber*, Leipzig, 1877.

M. Mauquoy-Hendrickx, *L'Iconographie d'Antoine van Dyck: Catalogue raisonné*, rev. ed., 2 vols., Brussels, 1991.

1. The most recent treatment of his prints is C. Depauw and G. Luijten, *Anthony van Dyck as a Printmaker*, exhib. cat., Museum Plantin Moretus / Stedelijk Prentenkabinet, Antwerp–Rijksprentenkabinet, Amsterdam, 1999–2000. Three other etchings included in the *Iconography*—those of Cornelissen, Triest, and van de Wouver (Mauquoy-Hendrickx Nos. 3, 13, and 18, respectively)—are now considered by most authorities not to be autograph; see J. Spicer, "Anthony van Dyck's Iconography: An Overview of Its Preparation," *Van Dyck 350* (National Gallery of Art, *Studies in the History of Art*, 46), Washington, 1994, pp. 337 and 354, note 75. Luijten (Depauw and Luijten, cat. No. 21) considers van de Wouver's head attributable to Van Dyck himself.

2. Spicer, p. 337.

3. *Idem*. Depauw and Luijten, p. 75.

4. Depauw and Luijten (p. 11) cite Rembrandt's ownership of an album including Van Dyck's portraits. They also draw a parallel between Van Dyck's *Self-Portrait* etching (see next entry) and Rembrandt's early *Self-Portrait in a Soft Hat* of 1631 (Bartsch 7), the first four states of which featured Rembrandt's head alone on an otherwise blank sheet.

SELF-PORTRAIT (66.3.96)

Etching, printed in black ink on cream-colored antique laid paper, 9⅝ × 6⅛ in. (24.4 × 15.6 cm).

REFERENCES: Wibiral 4 I/IV; Mauquoy-Hendrickx 4 I/VII.

MARK & INSCRIPTIONS: Watermark of two interlaced c's, crowned, with a cross of Lorraine superimposed (Mauquoy-Hendrickx, pl. 123, No. 1 or *ibis*, datable to *c.* 1636–45). In-scribed on verso: *T.P.n / Nº. 20* in pen and brown ink; *tx / 64 / J.J.V.* in graphite.

DESCRIPTION: The bust-length portrait depicts the artist looking back toward the viewer over his right shoulder. The subject is placed toward the upper center of the otherwise blank plate.

CONDITION: Aside from the remains of old foxing spots, the print is in good condition.

As conceived by Van Dyck, his *Iconography* was to consist of portrait prints in the same format of three groups of notables: princes and generals; statesmen and philosophers; and artists and amateurs. There had been a number of precedents in the previous century, particularly the collections of Domenicus Lampsonius (1572) and J.-J. Boissard (1599), but Van Dyck was able to transform portrait prints from approximate icons like theirs to distinctive and suave portrayals reflective of his increasingly celebrated painted portraits. His series was also the first to feature the work of a single artist. Most of his subjects were prominent individuals from the southern Netherlands, especially Antwerp.

The genesis, working process, and publication history of the *Iconography* still remain unclear in many respects. Mauquoy-Hendrickx has made a thorough inventory of the prints and the printing history of the series, while a number of art historians have investigated the steps employed by Van Dyck in preparing models for the engravers. Spicer has assembled the most information concerning these models and has essayed a clearer chronology of Van Dyck's working method.[1] She has proposed that the project was essentially unfinished in the artist's lifetime, and that therefore, no "perfect" copy or state of the *Iconography* ever was realized. The first, undated collections of the prints were issued by the Antwerp publisher Martin van den Enden, presumably in collaboration with Van Dyck himself, between about 1635 and the artist's death in 1641. The early van den Enden sets, which did not include any title-frontispiece, included eighty portraits, of which fifty-two depicted artists.

Van Dyck's etched self-portrait, seen here in the first state, at its most simple and unadorned, was in fact not included in the group published by van den Enden, nor

were any of his other original portrait etchings. They were not joined to the larger series until after Van Dyck's death, when another Antwerp publisher, Gilles Hendrickx, acquired the plates for both these etchings and the rest of the series.[2] Most of the Van Dyck etchings were touched up at that point by professional engravers to fill in details of dress and setting. Hendrickx added a total of twenty portraits (making an even one hundred) as well as a frontispiece that incorporated Van Dyck's etched self-portrait. The latter had been elaborated by Jacob Neeffs (for whom see p. 159), who engraved a circular pedestal, flanked by busts of Minerva and Mercury, below the artist's bust.[3] The title of the series was inscribed on the pedestal, advertising Van Dyck's portrayals "from life" of the included subjects, and Hendrickx' name as publisher was added. Arguing from the fact of this posthumous addition, it is generally accepted that Van Dyck never had intended this plate as a frontispiece, but as a fully-realized portrait to be included in the series. Hendrickx issued his editions beginning about 1645–46. Further portraits continued to be added by later publishers until the total reached over two hundred subjects. There was never a consistent order of prints within any of the various collections of the *Iconography*, which were issued well into the eighteenth century.[4] In 1851 the plates were acquired by the Chalcographie du Louvre.

Van Dyck worked on the models for his *Iconography* from the late 1620s, after his return to Antwerp from Italy, to the mid 1630s. There is a confusing amount of material extant that must be included in discussion of his preparatory studies for the prints in the series. These include his formal oil portraits, more informal oil sketches, finished drawings, and even his own etched portrayals. Spicer has recently posited that Van Dyck developed his process through three distinct chronological stages, but that, for the most part, all the prints in the *Iconography* ultimately owe their genesis to his formal painted portraits and were intended as much to show off his paintings as to serve as a gathering of notable individuals.[5] The first step in the process usually consisted of black chalk drawings taken from oil portraits, often adapting the grander format of the paintings to the more constricted one of the *Iconography* prints.

Spicer and Luijten feel that in casting about for an effective means of preparing engravers' models, Van Dyck first executed the group of his own autograph etchings in a brief period after 1630 and before his departure for England in 1632, intending that these would serve both as artistic prototypes and as first stages in the final print, with the costume and background to be filled in later by engravers.[6] This

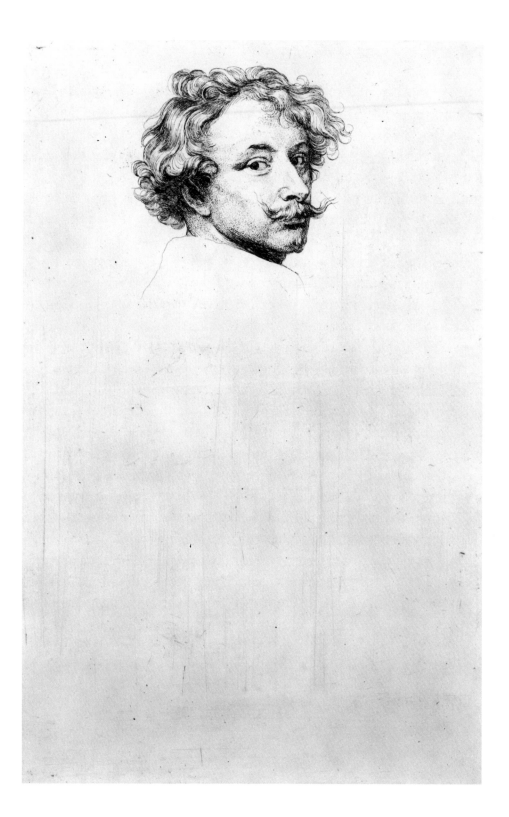

process would be analogous to his painting the face of a sitter but leaving the rest of the depiction to studio assistants. However, sets of Van Dyck's pure etchings apparently were circulated among friends and admirers, judging both from his continued ownership of his own plates until his death, and from the fairly large number of surviving impressions (as many as twenty) of first states of his etched portraits. The inherently sensitive portrayals and their seemingly unfinished quality appealed to both artists and collectors.[7]

A number of highly developed, shaded drawings are known to have been directly utilized as preparatory to engravings for the *Iconography*. They are all incised for transfer. Spicer feels that they formed a secondary stage in Van Dyck's evolving working process for the series, developed after his removal to England (and perhaps his lack of access to a printing studio).[8] Finally, a later process used by Van Dyck for his preparatory studies involved grisaille oil sketches, more than forty of which are known, dating from perhaps 1634–35.[9]

The deceptive simplicity of the pose in this state of his *Self-Portrait* and the assured technique reveal Van Dyck's skills at portraiture. The placement of the head within the blank rectangular format of the plate, implying the missing figure, is especially apposite, as is its direct, informal over-the-shoulder gaze toward the viewer. Luijten finds a prototype for this pose in a self-portrait etching by Ottavio Leoni (1578–1630).[10] Evidenced particularly in his artist portraits, this quality of casual grace, revealed through the figure, is seen as Van Dyck's conscious effort to reflect the inner source of artistic genius.[11] No direct preparatory drawing or oil sketch is known for this etching, but Spicer has identified a bust-length oil self-portrait in a private collection in Switzerland as the ultimate model.[12] It is of course possible that Van Dyck drew directly on the copperplate from the painting. Typified by this etching, he most effectively incorporated etched dots in a stippled manner to supplement his fluid linear technique, achieving subtle variations in the surface texture of his faces.

COLLECTIONS: William H. Schab Gallery. Frick, 1966.

NOTES

1. See J. Spicer, "Anthony van Dyck's Iconography: An Overview of Its Preparation," *Van Dyck 350* (National Gallery of Art, *Studies in the History of Art*, 46), Washington, 1994, pp. 327–28, and p. 350, note 2, citing the prior bibliography.

2. See C. Depauw and G. Luijten, *Anthony van Dyck as a Printmaker*, exhib. cat., Museum Plantin Moretus/Stedelijk Prentenkabinet, Antwerp–Rijksprentenkabinet, Amsterdam, 1999–2000, pp. 86–87, for a discussion of the relations between the two publishers.

3. The device derives, as noted by Mauquoy-Hendrickx (p. 35), from Rubens' design for the printer's mark of Jan van Meurs (J. R. Judson and C. van de Velde, *Book Illustrations and Title-Pages* [*Corpus Rubenianum Ludwig Burchard*, XXI], London–Philadelphia, 1978, I, p. 255, No. 6, II, fig. 204). Mauquoy-Hendrickx also cites (p. 33) a source in a cartouche by Agostino Mitelli. The British Museum owns a counterproof of the first state of the *Self-Portrait* on which is drawn a sketch for the frontispiece design (repr. Depauw and Luijten, cat. No. 5c); an earlier concept for the frontispiece is drawn on an impression of the first state now in Brussels (repr. Depauw and Luijten, cat. No. 5b). All scholars feel that none of the additions are by Van Dyck.

4. Spicer (p. 328) states her failure to locate any provable original Hendrickx edition, citing earlier scholars' vagueness on the subject. The physical parameters of assembling bound copies of series of prints (themselves printed on individual sheets) that are not individually numbered or dated, that were executed by different printmakers and at different times, and that do not include any accompanying letterpress text or explanation militate against any rational system for describing the bibliography of bound copies of the *Iconography*. Many copies were undoubtedly assembled at later dates.

5. Almost every print in the series was inscribed "van Dyck pinxit [painted]"; see Spicer's lengthy discussion, pp. 329–34.

6. Spicer, p. 337; Luijten, in Depauw and Luijten, p. 79. Indeed, some three of Van Dyck's autograph etchings, including the *Self-Portrait*, were duplicated by fully elaborated engravings for van den Enden's printings; see Mauquoy-Hendrickx Nos. 79 (self-portrait), 88 (de Momper), and 37 (Snellincks).

7. Depauw and Luijten, pp. 24, 79, 104, 142.

8. Spicer, p. 341.

9. The largest group belongs to the Duke of Buccleuch, Boughton House (Spicer, p. 344). See also: E. Larsen, *The Paintings of Anthony van Dyck*, Freren, 1988, pp. 482–84; C. Brown, *The Drawings of Anthony van Dyck*, exhib. cat., Pierpont Morgan Library, New York, 1991, pp. 192–93; and Depauw and Luijten, pp. 81–83, fig. 22.

10. Bartsch 6 (Depauw and Luijten, p. 98).

11. See: J. M. Muller, "The Quality of Grace in the Art of Anthony van Dyck," in *Anthony van Dyck*, ed. A. K. Wheelock *et al.*, exhib. cat., National Gallery of Art, Washington, 1990, pp. 27–36, esp. p. 29; and Depauw and Luijten, p. 98.

12. Spicer, p. 354, note 83.

PIETER BRUEGHEL THE YOUNGER (16.3.4)

Etching, printed in black ink on cream-colored antique laid paper, 9⁹⁄₁₆ × 6⅛ in. (24.3 × 15.5 cm).

REFERENCES: Wibiral 2 I/V; Mauquoy-Hendrickx 2 I/VI.

MARK & INSCRIPTIONS: Partial watermark of a phoenix within laurel branches (Mauquoy-Hendrickx, pl. 180, No. 252, datable to *c.* 1640–45). Inscribed in graphite on verso: *Pierre Bruegel / a 18601 13206.*

DESCRIPTION: The waist-length portrait shows the sitter bare-headed and wearing a ruff, a jacket, and a cape gathered around his waist. His right hand is visible toward the bottom of the plate.

CONDITION: The sheet shows slight foxing marks, some thinning at the upper left margin, and a tear at the lower right corner.

MEMBER of a sizable artistic family, the subject was the eldest son of the celebrated painter Pieter Bruegel the Elder (*c.* 1525–69). Born in Brussels in 1564 or 1565, he is believed to have been taught watercolor painting by his grandmother, Mayken Verhulst; he won membership in the Antwerp painters' guild in 1584–85. He and his assistants copied his father's works in considerable numbers (as many as sixty replicas are known of a single composition) and specialized in scenes of peasant life and grotesqueries, often on a miniature scale. He died in Antwerp in 1637 or 1638.[1]

The Frick impression of this etching by Van Dyck for his *Iconography* is in the first state, before the title was engraved at the bottom of the plate. Unlike the majority of Van Dyck's autograph etchings, the present plate escaped subsequent additions of large areas of engraved detail or background, perhaps because the artist had already substantially indicated the body, clothes, and setting. Two black chalk studies related to this print are known: a directly preparatory study in the Hermitage, St. Petersburg; and a version with a slightly different pose in the Devonshire collection at Chatsworth.[2] Both Spicer and Luijten feel that the two studies were probably drawn from life on the same occasion.[3]

COLLECTIONS: Alexander Shilling. Knoedler. Frick, 1916.

NOTES

1. For the Brueghel family, see: *Brueghel: Une Dynastie de peintres*, exhib. cat., Palais des Beaux-Arts, Brussels, 1980; and K. Ertz and C. Nitze-Ertz, *Breughel–Breughel: Pieter Breughel de Jonge (1564–1637/38) en Jan Brueghel de Oude (1568–1625): een Vlaamse schildersfamilie rond*

156

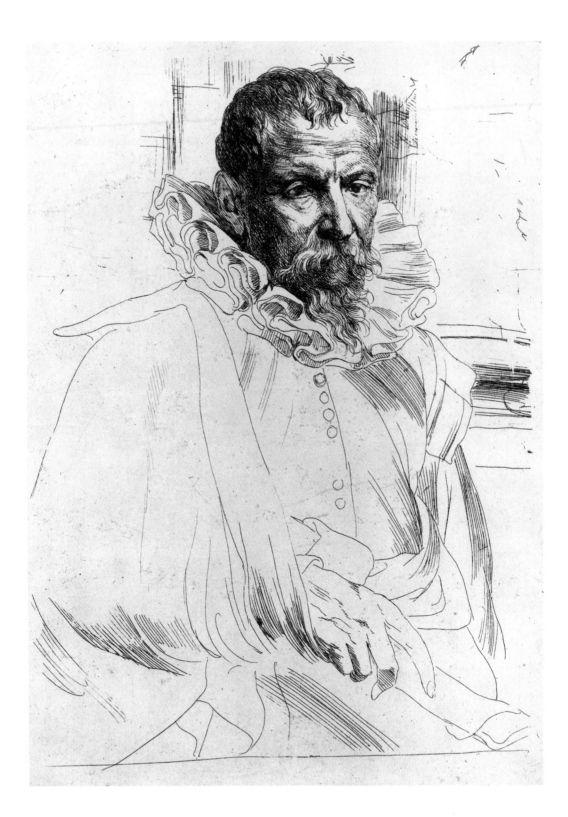

1600, exhib. cat., Kulturstiftung Ruhr, Essen–Kunsthistorisches Museum, Vienna–Koninklijk Museum voor Schone Kunsten, Antwerp, 1997–98.

2. Both are reproduced in: C. Brown, *The Drawings of Anthony van Dyck*, exhib. cat., Pierpont Morgan Library, New York, 1991, pp. 196–97; and C. Depauw and G. Luijten, *Anthony van Dyck as a Printmaker*, exhib. cat., Museum Plantin Moretus / Stedelijk Prentenkabinet, Antwerp–Rijksprentenkabinet, Amsterdam, 1999–2000. cat. No. 7a–b.

3. J. Spicer, "Anthony van Dyck's Iconography: An Overview of Its Preparation," *Van Dyck 350* (National Gallery of Art, *Studies in the History of Art*, 46), Washington, 1994, p. 338; Depauw and Luijten, p. 108. Luijten dates the portrayals to about 1630. No painted portrayal by Van Dyck is known.

SIR ANTHONY VAN DYCK
and
JACOB NEEFFS
1604 – after 1667

Neeffs became a master in the Antwerp guild in 1632–33 and was a prolific reproductive printmaker, working for Rubens and members of his circle. He is thought to have learned the art of engraving from Lucas Vorsterman. Neeffs illustrated a number of books and contributed at least three portraits to Van Dyck's Iconography, *including the background to Van Dyck's* Self-Portrait *(see p. 152).*[1]

FRANS SNYDERS (58.3.91)

Inscribed in the plate, at bottom: FRANCIS-CVS SNYDERS / VENATIONVM, FERARVM, FRVCTVVM, ET OLERVM PICTOR ANTV-ERPIAE / *Ant. van Dyck pinxit et fecit aqua forti. Iac. Neeffs sculpsit.* Etching and engraving, printed in black ink on dark cream-colored antique laid paper, 9¹³⁄₁₆ × 6³⁄₁₆ in. (24.9 × 15.8 cm).

REFERENCES: Wibiral II IV/IV; Mauquoy-Hendrickx II VII/VII.

MARK: Watermark: J HONIG / & / COMP.

DESCRIPTION: The waist-length portrait shows the sitter bare-headed and wearing a richly embroidered jacket, a shirt with lace collar and cuffs, and a cape over his right shoulder. He rests both hands on the back of a leather chair visible at lower right; an architectural element appears at upper left.

CONDITION: There are repaired tears at the lower edge, a hole in the area of the sitter's right sleeve, and remnants of old stains.

BORN in Antwerp, Frans Snyders (1579–1657) trained with Pieter Brueghel the Younger (see preceding entry) and probably with Hendrik van Balen, and became a master in the painters' guild in 1602. As specified in the inscription on this print, he was celebrated as a painter of "hunts, wild animals, fruits, and vegetables." He often collaborated on large commissions with Rubens and other painters. Aside from brief trips to Italy and the northern Netherlands, Snyders spent his entire career in Antwerp. He was a close friend of Van Dyck, whose grand oil portraits of him and his wife Margareta are in The Frick Collection.[2] The Frick oil of Snyders, painted about 1620, was the prototype for this print, which in its earli-

est etched state by Van Dyck alone consists only of his head, reversed in relation to the painting.[3]

Van Dyck's etching was greatly elaborated in engraving by Jacob Neeffs. While respecting the integrity of the head, Neeffs added all the other details of dress as well as the chair and architectural motifs, following the precedent of the Frick portrait but adapting the position of the hands to the narrower format of the print. There is no known preparatory drawing or oil sketch for this print, but such an intermediary step is assumed by Spicer and Depauw to have existed, taking into account the above-mentioned changes from painting to print.[4]

<div align="right">D. P. B.</div>

COLLECTIONS: Frick, 1958.[5]

NOTES

1. The most recent biographical sketch of Neeffs, based on extensive archival research, is published in C. Depauw and G. Luijten, *Anthony van Dyck as a Printmaker*, exhib. cat., Museum Plantin Moretus / Stedelijk Prentenkabinet, Antwerp–Rijksprentenkabinet, Amsterdam, 1999–2000, pp. 380–81.

2. *The Frick Collection: An Illustrated Catalogue*, New York, I, 1968, pp. 168–75.

3. See Mauquoy-Hendrickx, II, pl. 8.

4. J. Spicer, "Anthony van Dyck's Iconography: An Overview of Its Preparation," *Van Dyck 350* (National Gallery of Art, *Studies in the History of Art*, 46), Washington, 1994, p. 340; Depauw and Luijten, p. 142.

5. An impression of the first state of this print formerly in The Frick Collection was purchased by Mr. Frick in 1916 and was subsequently stolen; for that print, see *The Frick Collection Catalogue*, New York, IV, 1951, p. 10, No. 5, pl. V.

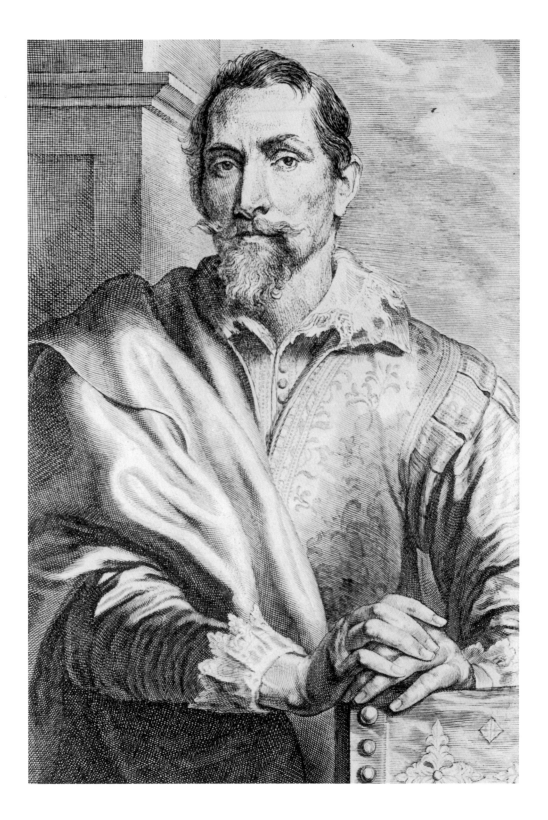

REMBRANDT HARMENSZ.
VAN RIJN

1606–1669

Rembrandt was active as a printmaker virtually throughout his career, executing some three hundred etchings and drypoints between approximately 1626 and 1665. Only his contemporary Hercules Segers was more innovative in developing printmaking techniques, and no other artist of the time so radically altered his images during the process of working the printing plate. Rembrandt experimented with different methods of printing, including varying his ink tones and using different types of paper, as well as vellum (see p. 188). His prints occupied a prominent place within his work, and they were for the most part independent of his paintings, often including subjects he rarely treated in oils, such as genre figures and landscape. His prints gained immediate renown throughout Europe, with collectors, commentators, and imitators from England to Italy. Little is known of Rembrandt's methods of distributing his prints; there is no explicit record of a formal relationship with any publisher.[1] It would seem that he pursued his experimental etching in relative privacy. In addition to three paintings[2] and three drawings by or attributed to Rembrandt (for the latter, see pp. 43–54), The Frick Collection owns eleven of the master's prints, all from his mature period. The earliest is dated 1643, by which time he had developed his most intense printed chiaroscuro in a search for tonal effects depicting light—both indoor and outdoor, daytime and night. His groundbreaking efforts have been seen as spurring the contemporary invention of the tonal printmaking technique of mezzotint.[3] Rembrandt's extraordinary technical achievements in his prints have been emulated by printmakers ever since, most conspicuously during the etching revival of the nineteenth century in Europe and the United States.

D. P. B.

ESSENTIAL REFERENCES

A. Bartsch, *Catalogue raisonné de toutes les estampes qui forment l'oeuvre de Rembrandt, et ceux de ses principaux imitateurs*, Vienna, 1797.

A. M. Hind, *A Catalogue of Rembrandt's Etchings*, London, 1923.

C. White and K. G. Boon, *Rembrandt's Etchings: An Illustrated Critical Catalogue*, Amsterdam–New York, 1970, vols. XVIII and XIX of F. W. H. Hollstein, *Dutch and Flemish Etchings, Engravings and Woodcuts ca. 1450–1700*.

O. Benesch, *The Drawings of Rembrandt*, 6 vols., 2nd rev. ed., London, 1973.

NOTES

1. H. Bevers, P. Schatborn, and B. Welzel, *Rembrandt: The Master & His Workshop, Drawings & Etchings*, New Haven–London, 1991, p. 167. However, the publisher Clement de Jonghe (see p. 181) did acquire over seventy of Rembrandt's original etching plates.

2. See *The Frick Collection: An Illustrated Catalogue*, I, 1968, pp. 252–69.

3. See C. S. Ackley, *Printmaking in the Age of Rembrandt*, Boston, 1981, pp. xix–xxvi.

LANDSCAPE WITH THREE TREES (15.3.28)

Signed and dated in the plate, at lower left: *Rembrandt f 1643* (barely visible). Etching, drypoint, and engraving, printed in black ink on cream-colored antique European laid paper, 8⅜ × 11 in. (21.2 × 27.8 cm).

REFERENCES (in each case, only state): Bartsch 212; Hind 205; White and Boon 212.

MARK & INSCRIPTIONS: Watermark of a foolscap with five-pointed collar.[1] Inscribed on verso: *LJD / 3.3.0,* twice in graphite; an indecipherable paraph above *no 6; 204 / 13259*; and an old pen-and-ink ownership inscription that has been effaced.

DESCRIPTION: Three large trees stand together on the edge of a bluff to the right of center. A dramatic, cloud-filled sky accentuates strong light coming from the right, while diagonal slashes of rain fill the upper left corner. A distant city is seen beyond flat fields at left. An older man and woman fish beside a body of water at lower left, and a pair of lovers is dimly discernible in the undergrowth at lower right. A horsedrawn cart, a man with a staff, and a seated figure are outlined on the horizon at right.

CONDITION: The print is in good condition.

THE largest of Rembrandt's etched landscapes, this dramatic vista is also virtually unique in its depiction of changing atmospheric phenomena, showing rain, high clouds, and bright sunlight; by contrast, the majority of his landscape etchings have totally blank skies. There has been much discussion in the literature concerning both the actual weather conditions depicted in the *Three Trees* and Rembrandt's possible intentions. Scholars have debated whether the rain is approaching the scene or receding from it, or whether the clouds should even be interpreted as stormy. Recent consensus favors a clearing sky, reading from the unconcern of the human inhabitants and from the prominence of the sunlight, which so strongly highlights the trees, whose branches bend in the wind that comes from the sun's direction.[2] Several scholars have commented on a possible prototype for this grand atmospheric depiction in Rubens' earlier painted landscapes featuring storms, some of which were reproduced in engravings by Schelte à Bolswert. Schneider and others have related the *Three Trees* to Rembrandt's own painted landscapes of the 1630s and 1640s, several of which feature similar chiaroscuro treatment.[3] Bevers also proposes an influence from the evocative landscape etchings of Claude Lorrain, executed during the 1630s.[4]

This subject is a perfect example of Rembrandt's skill at integrating numerous small, human-scaled details within a grand overall compositon. They reveal themselves only when the viewer is willing to wander slowly through the complex landscape. Such vignettes as the town in the far left distance (probably inspired by Am-

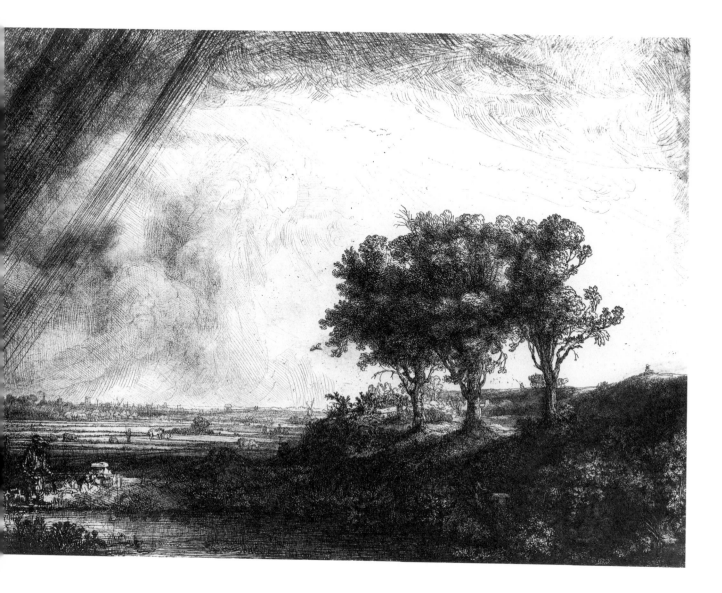

sterdam, though the scene has been considerably idealized), the wagon full of travelers on the ridge behind the trees, the artist sketching on the same ridge at far right, the pair fishing at left, and the lovers hidden in the underbrush are introduced as if at random. The very profusion of these elements, combined with the signal prominence of the three trees themselves, has prompted several scholars to read emblematic connotations into this print. Indeed, closer readings of many of Rembrandt's etchings have followed on recent research into the social context and iconography of seventeenth-century Dutch art.

The three trees have been seen as symbolizing the three crosses at the Crucifixion, and more generally as representing fortitude through their struggles against the elements. The latter reading is taken by scholars from several contemporary emblems of trees that draw moralizing parallels to the ability to weather life's turmoils by the strength drawn from one's figurative roots in virtuous pursuits.[5] Ziemba has seen these emblematic inferences and the strong contrasts of light and dark, sunlight and gloom, as representative of the conflict between good and evil, in the guise of a heroic landscape.[6] Treating Rembrandt's landscape prints more broadly, Stone-Ferrier argues that he wished to emphasize the contrast between the traditional values of the countryside and its inhabitants and the ambivalent progress embodied in the new cities seen on the distant horizon in several of his prints.[7] Within a multifaceted analysis, Kuretsky has seen the *Three Trees* as an allegory of natural and manmade creation, related to an Arcadian vision of the "Garden of Holland" in the period before the final peace with Spain in 1648.[8] Most observers have noticed Rembrandt's prominent inclusion of a draftsman on the ridge at the right edge of the print sketching a scene invisible to the viewer, perhaps an allusion to the artist's own inner vision.

In contrast with many of his more spare printed landscapes of the 1640s and 1650s (see for instance *Cottage with a White Paling* and *The Goldweigher's Field*, pp. 173, 179), Rembrandt worked the present plate with a dense mixture of intaglio techniques, combining them so smoothly that the drypoint and engraved accents are hardly distinguishable from the primary etching. As Ackley, among others, has pointed out, Rembrandt here brought outdoors the dense chiaroscuro he had developed for his indoor scenes.[9] The artist's innovative exploration of printed effects extended to the use of a fine granular bitten tone in the fields in the middle distance at left, creating a subtle cloud shadow.[10]

COLLECTIONS: Alfred Strolin. Knoedler. Frick, 1915.

NOTES

1. C. P. Schneider, *Rembrandt's Landscapes: Drawings and Prints*, Washington, 1990, p. 274, No. 5.

2. See, most recently: Schneider, p. 241 ("an oncoming storm"); H. Bevers, P. Schatborn, and B. Welzel, *Rembrandt: The Master & His Workshop, Drawings & Etchings*, New Haven–London, 1991, pp. 218–20 ("perhaps the atmosphere of morning or evening, with a rising or setting sun—but not a storm in the

real sense"); and B. Kirsch, "Rembrandt's *The Three Trees*," *Print Quarterly*, VIII, 1991, pp. 436–38 ("the storm is in retreat"). M. B. Cohn, in "The Three Trees (Continued)," *Print Quarterly*, IX, 1992, pp. 386–87, reproduces the print in reverse—the orientation in which Rembrandt would have executed the plate—to reinforce the argument that it represents "clearing weather."

3. Schneider, p. 241; Bevers *et al.*, p. 220; and G. Keyes, in *Six Centuries of Master Prints: Treasures from the Herbert Greer French Collection*, exhib. cat., Cincinnati Art Museum, 1993, p. 164.

4. Bevers *et al.*, p. 218.

5. See: L. Stone-Ferrier, *Dutch Prints of Daily Life: Mirrors of Life or Masks of Morals?*, exhib. cat., Spencer Museum of Art, University of Kansas, Lawrence, 1983, pp. 169–70; and Keyes, p. 165, citing A. Ziemba, "Rembrandts Landschaft als Sinnbild Versuch einer ikonologischen Deutung," *Artibus et Historiae*, VIII, No. 15, 1987, pp. 123–25. Ziemba also notes tree images from Psalms 1:1–3 and 92:13–15. See further the lengthy analysis by A. Werbke, "Rembrandts 'Landschaftsradierung mit drei Baumen' als visuell-gedankliche Herausforderung," *Jahrbuch der Berliner Museen*, N.S. XXXI, 1989,

pp. 225–50, which subjects the print to both geometric and symbolic analysis.

6. Keyes, *loc. cit.*

7. L. Stone-Ferrier, "Rembrandt's Landscape Etchings: Defying Modernity's Encroachment," *Art History*, V, 1992, pp. 403–33.

8. S. D. Kuretsky, "Worldly Creation in Rembrandt's *Landscape with Three Trees*," *Artibus et Historiae*, XV, No. 30, 1994, pp. 157–91, esp. pp. 177–79.

9. C. S. Ackley, *Printmaking in the Age of Rembrandt*, Boston, 1981, p. 199.

10. Usually referred to as sulphur tint, the technique was a precursor to aquatint, which was not invented until the mid eighteenth century. See: A. Griffiths, *Prints and Printmaking*, Berkeley–Los Angeles, 1996, p. 90; Ackley, p. 151, under No. 97; and M. B. Cohn, "Rembrandt's Landscapes: Drawings & Prints," *Print Collector's Newsletter*, XXI, 1990, pp. 87–88, clarifying the distinction between two kinds of bitten tone that Rembrandt used, both of which have been referred to as sulphur tint. It has also been pointed out that Rembrandt adapted portions of a composition of the Death of the Virgin that he had previously begun to etch on the plate he used for the *Three Trees*, most notably in the clouds (Bevers *et al.*, p. 220).

CHRIST PREACHING (The Hundred Guilder Print) (19.3.33)

Etching, drypoint, and engraving, printed in black ink on dark cream-colored Japanese wove paper, 11 × 15½ in. (28 × 39.3 cm).

REFERENCES: Bartsch 74; Hind 236 II/II; White and Boon 74 II/II.

INSCRIPTIONS: On recto in pen and brown ink in margin at lower left: *Aº, e, b,* [?]; and on verso: *a, W,* two indecipherable paraphs, and, in graphite, *ovxx54 / 16 / K845 / MK / C 2285.*

DESCRIPTION: The composition is set within a large, shadowed space into which light falls from the right over a high wall and through a tall archway. Amidst a crowd of people, Christ, dressed in a simple robe, stands before a low wall just to the left of center, his left hand raised and his right arm extending downward to the left; rays of light emanating from his head are outlined against black shadow. Groups of richly dressed figures watch and argue among themselves at far left. Surrounding Christ are several children, a woman holding a baby, a seated young man, and many infirm figures. Most direct their gaze toward Christ. More individuals enter through the arch at right, among them an older man with a walking stick, an older woman pushing a wheelbarrow on which lies an invalid, and men leading an ass and a camel. A dog lies on the ground at lower left.

CONDITION: The sheet is in good condition. There are touches of gray wash in Christ's hair and beard and in the darker areas of drypoint.

Christ Preaching represents a culmination of Rembrandt's painterly printmaking capabilities, as well as a pinnacle in the entire history of the medium. Several incidents from the Gospel of St. Matthew (19:1–24) are conflated here, including: the Pharisees arguing about divorce at upper left; Christ rebuking the Apostles for preventing the children from approaching him at center; Christ healing the sick who flock around him; and even, sitting to Christ's right, the rich young man pondering Christ's admonition to sell his possessions and give to the poor. The camel within the gate at far right has been interpreted as an allusion to Christ's statement that it would be "easier for a camel to go through the eye of a needle than for a rich man to enter the kingdom of God." Above all stands Christ, calmly dominating the composition, a subtle radiance emanating from his figure.

This print has had several titles, none able to reflect completely all of the events in it; one of its most popular, however, has been *The Hundred Guilder Print,* reflecting the high value set on it even during the artist's lifetime, although the precise origin is obscure.[1] Rembrandt employs here a veritable dictionary of intaglio print techniques, from open, sketchy linework in the figures at left to the deepest chiaroscuro in the shadows at right—all set off against a dramatic, though simply defined, stage-like backdrop. The composition of so many figures is neatly

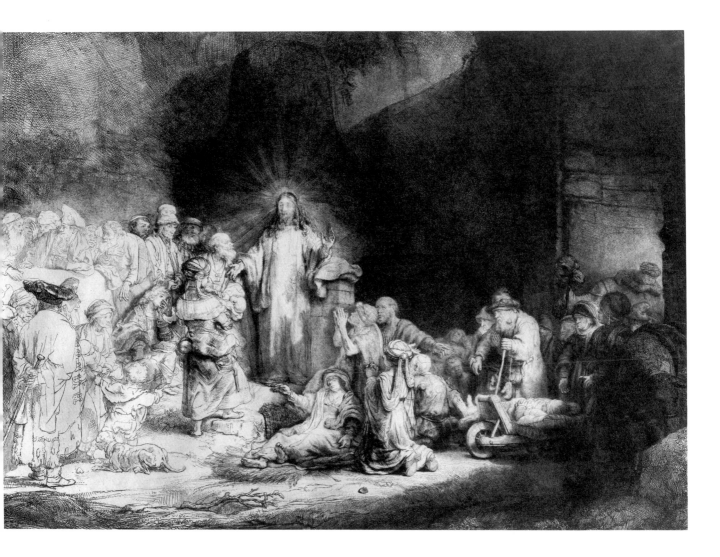

tied together with a set of interlocking diagonals, and the etching, drypoint, and engraving strokes blend so smoothly as to be inseparable. The extraordinary luminosity of the print encompasses the full range of tone from bright highlights to darkest shadows. One of many remarkable touches is the expressive shadow cast on Christ's robe by the beseeching figure at his left. Rembrandt enhanced such soft effects of light by printing on warmer-colored surfaces, often using Asiatic papers such as here.

The rich complexity of this image occupied Rembrandt over a period of years and represented a careful development both of the composition and of various

printmaking techniques. Its painterly aspirations place it in a virtually unique position within Rembrandt's printed oeuvre. Unusually, *Christ Preaching* is neither signed nor dated in the plate, and the date, at least, has been a continuing source of speculation. Most authorities assume the first preparatory drawings and perhaps initial work on the plate to have begun in the early 1640s, possibly as early as 1639. Yet the technical advance of printmaking skills evident here argues for a completion time in the later 1640s, as do lessons clearly learned from the large and crowded figural composition of the painting called *The Night Watch*, finished in 1642. Most scholars date the final execution of the print between 1647 and 1649.[2]

The intricate developmental process of this composition can only be hinted at, through a small group of preparatory drawings as well as remnants of previous work on the plate that can still be detected underneath the final image. No partially-worked proofs for this print are known; the earliest extant impressions from the plate are already fully finished (the changes between the first and second state are minor). There do survive, however, a few individual drawn studies for some of the thirty-eight principal figures. These include sketches for the sick woman lying directly below Christ, the man with upraised arms behind her, the old man with a stick being guided by his wife at right, and perhaps the woman who approaches Christ holding a baby. In addition, there is a fairly well-resolved study of the entire group of the sick. While these drawings had themselves previously been individually dated from the 1630s to the later 1640s, recent scholars favor dating the entire group to about 1647.[3]

Rembrandt spent considerable effort on the figure and particularly the face of Christ, the focal point of the entire composition. Close inspection reveals changes in the position of the head, the eyes, and the left hand, which originally was held lower. Previously it had been assumed that Christ's face in the present print was based on a group of oil sketches of the head of Christ. Arguing that this would have been a most unusual procedure for Rembrandt at this point and that the sketches are datable to the 1650s (and are largely no longer thought of as by Rembrandt), Welzel dismisses those prototypes and compares Christ's portrayal in a more general way to works of the 1640s, such as the *Christ at Emmaus* oil of 1648 in the Louvre, Paris.[4]

Such a considered and complex grouping of figures has prompted scholars to seek possible prototypes available to Rembrandt. Antique busts as well as compositions by Leonardo and Raphael have been cited, as have works by Annibale Car-

racci and Lucas van Leyden.[5] All such influences, whether direct or indirect, have been subsumed within the smooth fabric of Rembrandt's ambitious composition, sermon and meditation united in an intimate printed image, one of the artist's most famous works in any medium. Focusing on the consistent description of *Christ Preaching* as being of great rarity and the highly unusual fact that it is unsigned, Welzel has suggested that Rembrandt reserved impressions expressly for gifts of friendship, as a self-conscious demonstration of his printmaking virtuosity.[6]

COLLECTIONS: W. Benoni White (Lugt 2592). Carl Schlösser (Lugt 636; this impression cited). Schlösser sale, Frankfurt, June 7 *et seq.*, 1880, Lot 509, sold for 4,100 marks to Thibaudeau. John Postle Heseltine. Knoedler. Frick, 1919.

NOTES

1. See C. White, *Rembrandt as an Etcher*, London, 1969, p. 55. For the later use of this most famous plate, see: E. Hinterding, "The History of Rembrandt's Copperplates, with a Catalogue of those that Survive," *Simiolus*, XXII, 1993–94, pp. 271–72; N. Stogdon, "Captain Baillie and 'The Hundred Guilder Print,'" *Print Quarterly*, XIII, 1996, pp. 53–57.

2. White, pp. 61–64. See also L. Slatkes, review of White in *Art Quarterly*, XXXVI, 1973, pp. 258–59, arguing for an even later date. Welzel (in H. Bevers, P. Schatborn, and B. Welzel, *Rembrandt: The Master & His Workshop, Drawings & Etchings*, New Haven–London, 1991, p. 244) also addresses the question of the time range of work on the plate.

3. For discussions of these drawings, some of whose attributions are disputed, see: White, pp. 58–61; P. Schatborn, *Drawings by Rembrandt, his Anonymous Pupils and Followers*, Amsterdam, 1985, No. 21, pp. 48–49; Bevers *et al.*, *loc. cit.*

4. Bevers *et al.*, pp. 244–45. The Louvre painting is reproduced in G. Schwartz, *Rembrandt: His Life, His Paintings*, London, 1991, p. 247, fig. 278.

5. For a list of a number of suggested models, see B. P. J. Broos, *Index to the Formal Sources of Rembrandt's Art*, Maarssen, 1977, pp. 79–80. See also: Slatkes, pp. 258–59, and p. 263, notes 75–79; A. K. Wheelock, Jr., "The Influence of Lucas van Leyden on Rembrandt's Narrative Etchings," *Essays in Northern European Art Presented to Egbert Haverkamp-Begemann*, Doornspijk, 1983, pp. 291–96; R. Baldwin, "Rembrandt's Visual Sources from Italy and Antiquity," *Source*, IV, 1984, p. 23.

6. Bevers *et al.*, pp. 244–45.

COTTAGE WITH A WHITE PALING (16.3.27)

Signed in the plate, at lower left: *Rembrandt* [*f*?]. Etching, printed in black ink on dark cream-colored antique European laid paper, 5 ⅛ × 6¼ in. (13 × 15.8 cm).

REFERENCES: Bartsch 232; Hind 203 I/II; White and Boon 232 I/III.[1]

INSCRIPTIONS: On verso in graphite: *127* [crossed out] / *G 224*Ire / *B.232* / *11066*.

DESCRIPTION: Flanked by two tall trees, a farmhouse stands at the lower center of the composition, largely concealed behind a brightly lit, rough-hewn fence and some shrubbery. A quiet pond or canal in the lower left foreground extends to the base of the fence. At left a small figure sits by the water's edge, and at right a cart is seen on a road before a distant hill.

CONDITION: The print is in good condition.

IN contrast to the *Landscape with Three Trees* (see p. 165), this view depicts a more intimate aspect of the Dutch topography, shown at closer range and with a less dramatic sense of weather. Although sketches drawn from nature are known that relate generally to several of Rembrandt's other landscape prints, the *Cottage with a White Paling* is unusual in having a very close preparatory drawing, now in the Rijksprentenkabinet, Amsterdam.[2] Comparison of the two views affords a glimpse into Rembrandt's development of a motif. In the drawing, the placement of the compact group of house and trees, fronted by the plain white fence, dominates the composition, set quite close to the picture plane and leaving little framing space at the top and sides. In the print (which is in reverse to the drawing), Rembrandt adds considerably to the foreground depth by introducing a strip of ground to anchor the bottom margin and by enlarging and enclosing the pond. He also substantially raises the top margin of the print to create a large expanse of sky, effectively evoking the presence of the Dutch atmosphere despite the lack of any printed lines. Final additions are the generalized features of a windmill in the far left distance and cows on the right horizon. A rare suggestion of mortality in his landscape prints is found in the cow's skull prominently placed by the side of the road at lower right.

The depiction of the cottage itself is at once intimate and monumentalized, with its extraordinarily detailed etching of the trees and of each board of the fence that mysteriously hides much of the (after all) rather humble building. White has remarked on the evocative contrast between the substantial presence of the structure

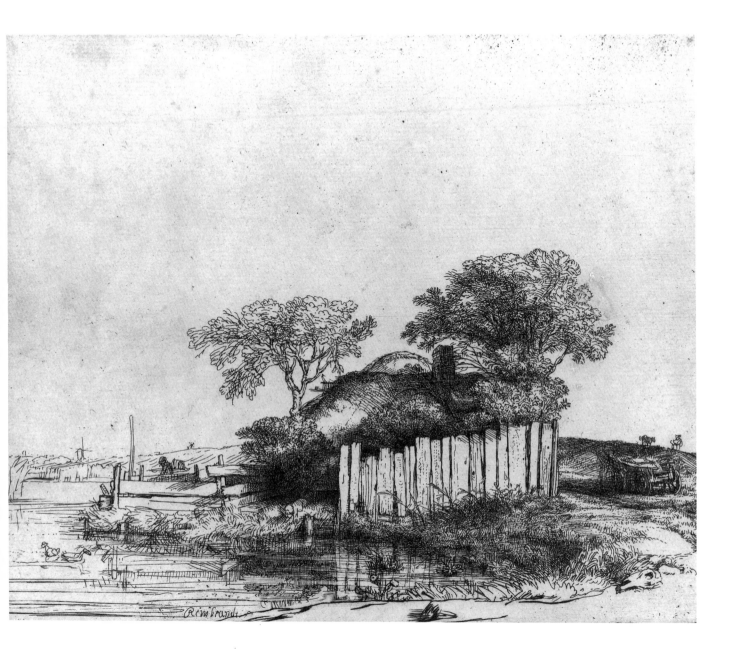

and its "shimmering, shifting intangible image" reflected in the water before it.[3]
The Frick impression is printed from the first state of the plate, before shading lines
were added in drypoint on the dike at left and before the date was introduced be-
low the signature in the third and final state.[4] The date is very difficult to decipher,
and the print has been dated from 1642 to 1652. White argued for a reading of the

date as 1648, while Schneider doubted that the digits were inscribed by Rembrandt, using stylistic evidence alone to date the print to the late 1640s.[5] The Frick impression is printed on bright European paper, following Rembrandt's practice for many of his landscape etchings, in order to reveal more clearly his carefully worked etched lines and tones and to allow the paper in unworked areas to assume a palpable atmosphere of its own.[6]

COLLECTIONS: Heneage Finch, fifth Earl of Aylesford (Lugt 58). Henry Studdy Theobald (Lugt 1375). His sale, Stuttgart, May 12–14, 1910, Lot 675, sold for 3,900 marks to Colnaghi. Edward G. Kennedy. Knoedler. Frick, 1916.

NOTES

1. The Frick impression is cited in Hind and in White and Boon as that belonging to E. G. Kennedy; both references mistake the state number.

2. Reproduced in: Benesch, IV, No. C 41; and C. P. Schneider, *Rembrandt's Landscapes: Drawings and Prints*, Washington, 1990, p. 95, fig. 2. See also C. White, "Rembrandt's Etching and Drawing of a *Cottage with a White Paling*," *Burlington Magazine*, CX, 1968, pp. 390–94. White maintains (p. 393) that the considered nature of the drawing argues for its having been done in the studio as a direct preliminary for the etching, rather than as a sketch from nature that was later used for the print.

3. White, p. 394.

4. An impression of the first state in Teylers Museum, Haarlem (see Schneider, p. 95, fig. 1), reveals areas in gray wash that seem to be preparatory notations for the addition of the drypoint accents on the dike in the second state.

5. White, p. 393; Schneider, p. 95.

6. Schneider (p. 25) has documented Rembrandt's use of subtly toned papers in both his landscape drawings and his prints to further explore ways of suggesting atmosphere.

LANDSCAPE WITH THREE GABLED COTTAGES (16.3.30)

Signed and dated in the plate, at lower left: *Rembrandt f 1650*. Etching and drypoint, printed in black ink on thin European cream-colored antique laid paper, 6⅜ × 8 in. (16.1 × 20.3 cm).

REFERENCES: Bartsch 217; Hind 246 III/III; White and Boon 217 III/III.

MARK & INSCRIPTIONS: Watermark of a fleur-de-lis in a crowned shield over the letters PR.[1] Inscribed on verso in graphite: *C 244[−] / OUXZ 14 / 2437*.

DESCRIPTION: The right half of the composition is dominated by a large tree, to the left of which a row of three cottages recedes diagonally. A road beginning in the middle foreground follows the line of the cottages into the far distance at the left edge of the composition. A group of figures stand in front of the middle cottage.

CONDITION: There are losses at both lower corners and the upper left corner, and the margin at upper center is thinned.

THIS striking composition is dominated by the tree in the right foreground, extending the entire height of the plate and threatening to become the subject of the print in itself. Rembrandt has constructed a particularly strong visual framework through the bold perspectival line that recedes from the lower right corner and follows the line of cottages and the road into the left distance, echoed and reinforced by the diagonal line from upper right to lower left along the height of the trees and distant cottages (leaving the entire area of the sheet above this diagonal unworked). Schneider enumerates Rembrandt's earlier efforts exploring this theme of spatial recession, including a drawing in Stockholm of the mid 1630s (Benesch 795), the etching *Cottage beside a Canal* of the early 1640s (Bartsch 228), and the etching *Landscape with an Obelisk* of about 1650 (B. 227).[2] Welzel remarks that the monumentality of the print is emphasized by the rounded upper corners, which recall the format of artistically "higher" history paintings.[3]

A roughly contemporary drawing by Rembrandt in Berlin most probably documents the actual site depicted in this print, although the drawing, done from life, does not have the compositional strength of the etching, and includes only two cottages. The pen sketch (in reverse to the print) places the group of buildings in the center of the sheet, with a significantly less commanding tree bending in the wind in front of the foremost cottage.[4] Bakker has pointed out the accuracy of Rembrandt's portrayal of a classic form of Dutch *langhuis* (long house), and has identified the location as a property on the Sloterweg near Amsterdam.[5] There has been

some debate, prompted by the pentimenti apparent in the area of the tree, as to whether Rembrandt may have worked on the plate directly from life in the landscape. Visible underneath its left half are burnished etched lines that formerly had depicted the tree as much more detailed and leaf-filled. Schneider postulated that perhaps Rembrandt first drew on the plate on site, then reworked his composition in the studio.[6] Welzel dismisses this notion, stating flatly that "there seems to be no evidence that seventeenth-century artists carried etching plates around with them to be used like a sketch book."[7]

Within his landscape prints, Rembrandt used drypoint prominently for the first time in the *Landscape with Three Gabled Cottages*. The two earlier states of the print differ little in detail from this one, but the muscular drypoint lines with their rich burr dominate earlier impressions even more than they do here. Drypoint involves the scratching of a very sharp metal tool through the hard surface of the copper plate, and is thus notoriously difficult to control; it possesses neither the smooth forward inscribing motion of the engraver's burin nor the free draftsmanship of the etching needle, which merely needs to penetrate the relatively soft protective ground on the plate surface. In subsequent landscape prints such as the *Landscape with Haybarn and Flock of Sheep* (p. 185) and *Goldweigher's Field* (p. 179), Rembrandt would more subtly modulate its characteristics. He of course would later exploit the medium's very roughness at its richest in his large pure drypoints of *Christ Crucified between Two Thieves* (p. 189) and *Christ Presented to the People* (p. 193).

COLLECTIONS: Knoedler. Frick, 1916.

NOTES

1. C. P. Schneider, *Rembrandt's Landscapes: Drawings and Prints*, Washington, 1990, p. 279, No. 18.

2. *Idem*, p. 113.

3. H. Bevers, P. Schatborn, and B. Welzel, *Rembrandt: The Master & His Workshop, Drawings & Etchings*, New Haven–London, 1991, p. 256.

4. Benesch 835; reproduced in Schneider, p. 113, fig. 2, and Bevers *et al.*, p. 256, fig. 32a.

5. B. Bakker, "Langhuis and Stolp: Rembrandt's Farm Drawings and Prints," in Schneider, pp. 38–40. See also Bakker's "Het onderwerp van Rembrandts ets De drie boerenhuizen," *Kroniek van het Rembrandthuis*, XC, 1990, pp. 21–29. He has identified another drawing in Berlin of the same site (Benesch 1293), although done later than the print.

6. Schneider, p. 113.

7. Bevers *et al.*, *loc. cit.*

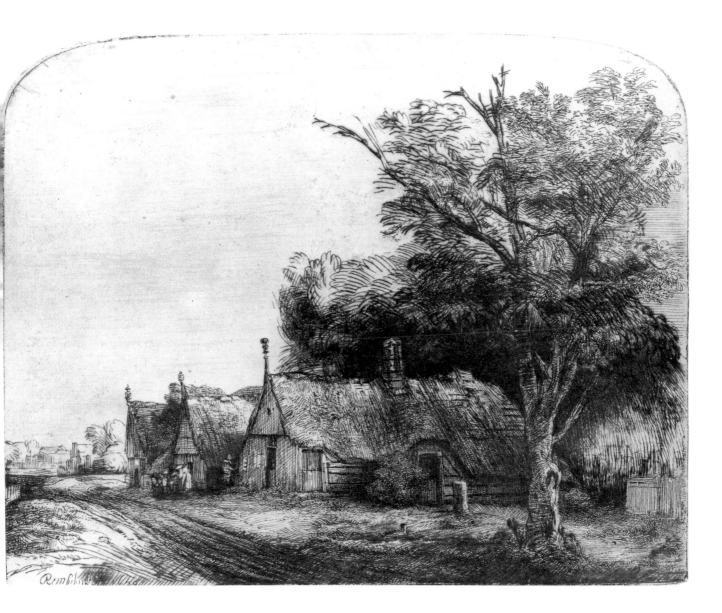

THE GOLDWEIGHER'S FIELD (15.3.31)

Signed and dated in the plate, at lower left: *Rembrandt 1651*. Etching and drypoint, printed in black ink on cream-colored European antique laid paper, 4¾×12⁹⁄₁₆ in. (12×31.9 cm).

REFERENCES (in each case, only state): Bartsch 234; Hind 249; White and Boon 234.

MARK & INSCRIPTIONS: Fragmentary watermark of a Paschal lamb within a shield.[1] Inscribed on verso in graphite: *Bl. 334 / 234 / 231 / 10 / 11098 / C 718 / NSXX–*.

DESCRIPTION: The shallow horizontal composition is bisected by the line of the distant horizon, broken only by the far-off profiles of a large church at left and a closer church tower toward the right. The lower half of the scene is a sweeping panorama of open fields interrupted by woods and by a village centered around the church at right. Small figures dot the fields. The sky is completely clear.

CONDITION: There is a small loss in the lower left corner, and a dark spot appears in the sky at center right.

THIS print has been known by its present title since the early eighteenth century. The view had been supposed to represent the area surrounding the home of Jan Uytenbogaert, the Receiver General of Amsterdam, whose portrait Rembrandt etched in 1639 in the guise of a goldweigher (Bartsch 281). However, van Regteren Altena has determined that it actually shows the country house of Christoffel Thijszoon, a merchant from whom Rembrandt had bought his own Amsterdam home (and to whom he still owed money). Called Saxenburg, the house appears at the edge of the woods to the left of center in the print. The city of Haarlem rises on the skyline at left, dominated by the profile of the Grote Kerk (formerly St. Bavo). The village in the right middle distance surrounded by trees is Bloemendaal, seen across fields in which cloth is being bleached. The prospect is taken from the dunes outside Haarlem, probably from the heights of one called Het Kopje (The Head).[2] As customary, Rembrandt did not bother to reverse his drawing of the scene on the plate, so it appears here in reverse to topographical reality. Considering that a sketch the artist executed of the same scene is not directly preparatory to the print, some scholars have speculated whether he drew directly on the copperplate for *The Goldweigher's Field*, which would then of course reverse the scene when it was printed.[3] The existence of six known counterproofs of this print indicates that Rembrandt was conscious of the topographic lapse in such a precisely drawn scene.

For this etching, one of his most audacious despite its apparent simplicity, Rembrandt dramatized the panorama considerably from his slight drawn sketch. He

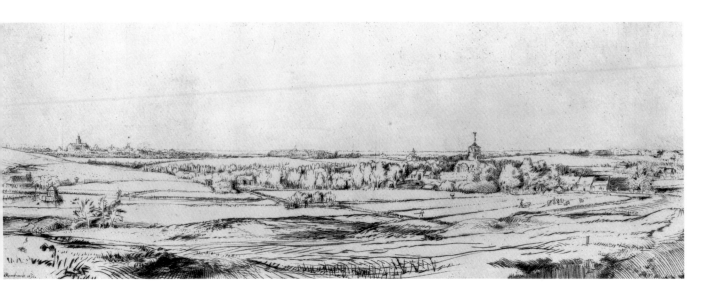

brought the foreground down to the bottom margin of the print, as if the grass were within reach of the viewer. He constructed the receding perspective on a diagonal extending toward Haarlem, broken along the way by features that draw the eye in other directions—toward the village in the trees, or toward the exotic structure in the middle of the pond at far left—in effect intersecting that diagonal with others, the result of which is to make a grid. Bevers has noted precedents for the severely narrow format of Rembrandt's panorama, particularly in similar scenes by Hercules Segers, such as his *View of Amersfoort* of about 1630.[4] Mayor has called attention to the uncanny sensation of movement in the landscape, as if it were revolving under "the drive of invisible wind around a pivot on the horizon, as level lands seem to wheel when watched from a fast train."[5]

The Goldweigher's Field is a complex mixture of etching with many drypoint additions, and shows extreme sensitivity to differences in printing quality. The effective recession toward the horizon depends upon a subtle lightening of weight and tone in the printed lines, broken as they are by occasional accents of shadow and definition. A few of the earliest impressions have rather blotchy spots of black drypoint in the trees around the village, unbalancing the atmospheric panorama. Rembrandt apparently scraped some of the metal burr in those areas to achieve lighter inking in the ensuing impressions.[6]

White notes that by the time of this print Rembrandt had developed an increasingly sophisticated use of the drypoint medium, appreciating its qualities for drawing directly into the surface of the plate. Acknowledging the difficulty of distinguishing the two techniques in this work, he observes Rembrandt adapting his simplified etched outlines to the "less flexible, angular lines produced by drypoint."[7] Ackley, declaring *The Goldweigher's Field* the "ultimate expression of the development of the panoramic Dutch landscape in print form," credits Rembrandt here with giving "definition to the intangible."[8]

COLLECTIONS: Colnaghi. Knoedler. Frick, 1915.

NOTES

1. C. P. Schneider, *Rembrandt's Landscapes: Drawings and Prints*, Washington, 1990, p. 276, No. 10.

2. J. Q. van Regteren Altena, "Retouches aan ons Rembrandt-beeld. 2: Het Landschap van den Goudweger," *Oud-Holland*, LXIX, 1954, pp. 1–17. A detail of an eighteenth-century map of the area is reproduced in Schneider, p. 261, fig. 1. Schneider surmises (p. 260) that Rembrandt may have executed the etching expressly for Thijszoon, even hoping to "appease his creditor with this magnificent vista centered upon his estate." L. Stone-Ferrier ("Rembrandt's Landscape Etchings: Defying Modernity's Encroachment," *Art History*, XV, 1992, p. 412) feels that such a personalized commission would explain the anomaly within Rembrandt's landscape etchings of such an eccentric composition.

3. The drawing (Benesch 1259) is reproduced in Schneider, No. 83. Concerning the possibility of Rembrandt working directly in the landscape on his etching plates, see H. Bevers, P. Schatborn, and B. Welzel, *Rembrandt: The Master & His Workshop, Drawings & Etchings*, New Haven–London, 1991, p. 246, note 8 (for this print), and pp. 221–22 on the topic in general and the sketchy landscape *Six's Bridge* (Bartsch 208).

4. Bevers *et al.*, p. 245; for the Segers, see p. 246, fig. 28a.

5. A. H. Mayor, *Prints and People*, New York, 1971, No. 504.

6. C. White, *Rembrandt as an Etcher*, London, 1969, I, p. 215.

7. *Idem*, pp. 214–15.

8. C. S. Ackley, *Printmaking in the Age of Rembrandt*, Boston, 1981, p. 232.

CLEMENT DE JONGHE (16.3.36)

Signed and dated in the plate, at lower right: *Rembrandt f 1651*. Etching, printed in black ink on cream-colored European antique laid paper, 8⅛ × 6⅜ in. (20.7 × 16.1 cm).

REFERENCES: Bartsch 272; Hind 251 I/VI; White and Boon 272 I/VI.

MARKS & INSCRIPTIONS: Watermark of an indecipherable monogram (probably a manufacturer's countermark); unidentified collector's mark on recto at lower left. Inscribed on verso in graphite: *774/13 / B.272 Rov.1 / xx5 / B.380 / first imp. / 4 / 71*.

DESCRIPTION: A man, seen in three-quarter length, sits in a chair facing the viewer. He wears a full cloak, a plain buttoned coat with a white collar, long gloves, and a wide-brimmed, flat-topped dark hat. He rests his right elbow on the chair arm and holds his left arm over his left knee. Apart from shadows, the background is blank.

CONDITION: The print is in good condition.

THIS subject was first described as Clement de Jonghe only in 1731, and recently some question as to his identity has surfaced, without, however, eliciting a convincing alternative.[1] De Jonghe (1624/25–77) was active as a printseller and publisher in Amsterdam from about 1650 until his death. He published at least two prints after compositions by Rembrandt and owned a large collection of the artist's etchings (and original copperplates). Indeed, the inventory made after his death was the first description of a significant number of Rembrandt's etched works.

The artist has placed his subject in a plain studio chair, gazing directly at the viewer and with no objects descriptive of an occupation visible. His hands rest idle, his cloak and hat are still on, and he almost slumps in his chair. The glove he wears denotes a traditional attribute of a nobleman.[2] Rembrandt's straightforward, almost matter-of-fact depiction of the sitter has elicited comparison with Van Dyck's earlier etched portraits, in both iconography and technique (see pp. 149–61). Chapman notes the similarity in pose to Van Dyck's portrait of Martin Rykaert, included in his printed *Iconography*.[3] Bevers suggests that the very formality of this portrait indicates that it was commissioned, arguing that the "tense," distant pose must have been chosen by the subject to emphasize "both his retiring nature and official and social rank."[4] There is no articulation to the background; in later states Rembrandt added a plain framing arch above.

Particularly in this first state, the etching technique seems deceptively simple, employing relatively light crosshatching to bring out the figure's volume and the

shadows cast by the brim of the hat and by the drapery. The face is minutely drawn, with short strokes and mere dots on the chin and cheek. Rembrandt was particularly concerned with the effect of the eyes, developing the sitter's uncanny gaze through at least five states of the print. The present state is done in pure etching; only later were various drypoint accents added.

Interestingly, Rembrandt seemed to discover that the clean lines of this etching were best served by being printed on relatively bright European laid paper, as here, rather than the warmer Japanese papers he often favored for his murkier subjects.[5] The lighter paper also heightens the subtle tonal effect at the top caused by lines of abrasion in the plate when it was roughly polished; indeed, in this impression clear spots are visible above the hat where the plate was burnished smooth, probably to remove a couple of unsightly marks.

COLLECTIONS: Colnaghi. Knoedler. Frick, 1916.

NOTES

1. See H. Bevers, P. Schatborn, and B. Welzel, *Rembrandt: The Master & His Workshop, Drawings & Etchings*, New Haven–London, 1991, pp. 251 and 252, note 3, for a discussion of the sitter's identification, including J. R. Voûte's suggestion ("Clement de Jonghe exit," *Kroniek van het Rembrandthuis*, XXXIX, 1987, pp. 21–27) of Rembrandt's patron and friend Jan Six. See also: S. Dickey, in *Rembrandt/Not Rembrandt in the Metropolitan Museum of Art: Aspects of Connoisseurship*, New York, 1996, II, pp. 214–15 and 216, notes 5–6; and E. Hinterding, "The History of Rembrandt's Copperplates, with a Catalogue of those that Survive," *Simiolus*, XXII, 1993–94, pp. 260–63. If de Jonghe was indeed the subject, it is surprising that no record of the printing plate for this portrait appears in his estate inventory, which included a detailed listing of seventy-four etching plates. The plate for the print is now in the Historisch Museum, Amsterdam (Hinterding, p. 300).

2. Bevers *et al.*, *loc. cit.*

3. H. P. Chapman, *Rembrandt's Self Portraits: A Study in Seventeenth-Century Identity*, Princeton, 1990, pp. 93–94; Van Dyck's painted and printed portraits of Rykaert are reproduced in figs. 136–37. The printed portrait was engraved by Jacob Neeffs (M. Mauquoy-Hendrickx, *L'Iconographie d'Antoine van Dyck: Catalogue raisonné*, rev. ed., 2 vols., Brussels, 1991, No. 168).

4. Bevers *et al.*, p. 252. Bevers also states that the "severe frontality" of the pose recalls the hieratic image of Christ.

5. See *Rembrandt: Experimental Etcher*, exhib. cat., Museum of Fine Arts, Boston, and Pierpont Morgan Library, New York, 1969, p. 55, for comparative illustrations of two impressions of this state on different papers, in addition to impressions of the print from four later states.

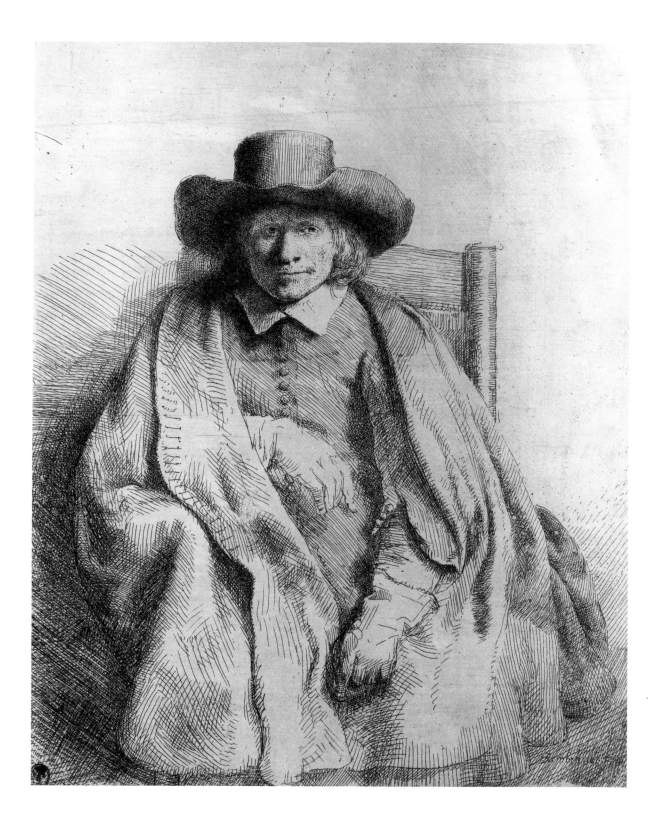

LANDSCAPE WITH HAYBARN AND FLOCK OF SHEEP (16.3.29)

Signed and dated in the plate, at lower left: *Rembrandt f 165–* [last digit indecipherable].[1] Etching and drypoint with sulphur tint, printed in black ink on cream-colored European antique laid paper, 3¼ × 6⅞ in. (8.3 × 17.5 cm).

REFERENCES: Bartsch 224; Hind 241 II/II; White and Boon 224 II/II.

MARK & INSCRIPTIONS: The base only (three circles) of a foolscap watermark. Inscribed on verso: *MK 12882 / B 224II / C–12* in graphite and an indecipherable pen-and-ink paraph.

DESCRIPTION: The horizon of a panoramic landscape is dominated by a group of trees, amid which rises a large haybarn with a conical top. A flock of sheep is being driven along a road at left, headed toward a distant cluster of buildings; three figures stand against the horizon at far left. In the right foreground, horses and cows graze in a field, through the bottom of which runs a stream or ditch. The upper corners of the plate are rounded.

CONDITION: The print is in good condition.

THIS rich landscape well illuminates Rembrandt's skills at combining a view of a specific site with a generalized vignette of the Dutch countryside. As Ackley has pointed out, farm structures like this nestled in a protective group of trees can still be seen in many places in the flat terrain of Holland.[2] The present view was identified by Lugt as a farmstead along the Diemerdijk between Houtewaal and Zeeburg, outside Amsterdam;[3] it is also the subject of a contemporary drawing now in the Ashmolean Museum, Oxford.[4] The etching reproduces the scene in reverse, both pulling back from and monumentalizing it. As revealed in instances where related drawings of the same sites survive, Rembrandt worked on his landscape etchings in the studio using direct nature sketches as he developed his more considered, less particularized printed compositions.

Rembrandt has combined in this print a foundation of etched lines with darker drypoint accents in a delicate balance of spatial effect, much like his *Goldweigher's Field* (p. 179) of approximately the same date. In addition, here he has included subtle areas of printed sulphur tint tone in the meadow below and to the right of the horse, in the sky above the farm buildings, and on the horizon at right. While the composition was essentially complete in the first state, he subsequently added the crucial hazy horizon line at far left, the lone bare branch on the left side of the

184

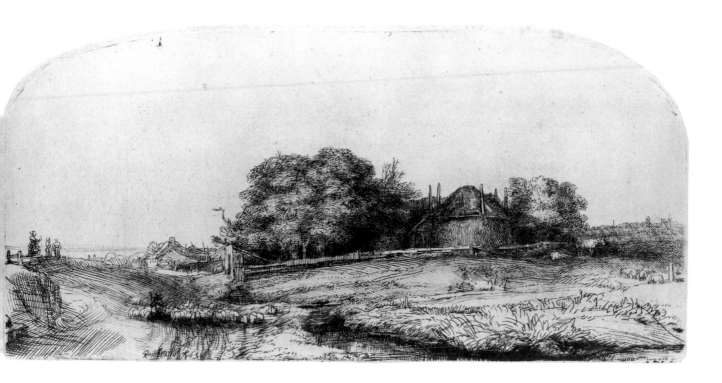

clump of trees, and various subtle shading lines throughout.[5] As in the *Landscape with Three Gabled Cottages* (p. 177), Rembrandt framed his view more formally within rounded upper corners.

What at first seems a straightforward view of a farm site reveals on more leisurely perusal numerous details that enliven the scene. The figures on the horizon at far left, the flock of sheep meandering along the road, and in particular the horse rolling on its back in the field at right all contribute to the characteristic sense of absorption generated by Rembrandt's landscape prints. Schneider has suggested that the motif of the flock of sheep may have been inspired by Titian's imaginary *Landscape with Flute-Playing Shepherd*, which would have been known at the time through etched copies.[6]

COLLECTIONS: Colnaghi. Knoedler. Frick, 1916.

1. Given the ambiguity of the figure, the print has been dated from 1650 to 1652, though most commentators now favor the later date. See discussion under White and Boon 224, and C. P. Schneider, *Rembrandt's Landscapes: Drawings and Prints*, Washington, 1990, p. 125 and note 6.

2. C. S. Ackley, *Printmaking in the Age of Rembrandt*, Boston, 1981, p. 236.

3. F. Lugt, *Mit Rembrandt in Amsterdam*, Berlin, 1920, pp. 139–40.

4. Benesch 1226; it is also reproduced in Schneider, p. 124, fig. 1.

5. For a highly detailed study of the development and technique of this print, see P. Morse, *Rembrandt's Etching Techniques: An Example*, U.S. National Museum Bulletin No. 250 (Contributions from the Museum of History and Technology, Paper 61), Washington, 1966.

6. Schneider, p. 125, with a reproduction (fig. 3) of the print after Titian.

CHRIST CRUCIFIED BETWEEN TWO THIEVES

(The Three Crosses) (19.3.34)

Drypoint and engraving, printed in black ink on cream-colored vellum, 15⅛ × 17⅝ in. (38.4 × 44.6 cm).

REFERENCES: Bartsch 78; Hind 270 I/v; White and Boon 78 I/v.

INSCRIPTION: On verso in graphite: *K 847 MK C2287.*

DESCRIPTION: Christ is shown at upper center on a cross that directly faces the viewer. Two figures hang from crosses seen in profile and near profile at either side. The sky is dramatically lit at the center of the composition, but it abruptly turns to deep shadow at the sides. A large crowd mills around the crosses. An armored soldier kneels to the left of Christ's cross, and beyond him are more soldiers on horseback. At right are a group of sorrowing women and a man with his arms raised in anguish. Two aging, richly dressed men hurry from the lower foreground.

CONDITION: The top edge of the sheet is slightly yellowed, a small area above Christ's right hand is abraded, and there is overall cockling of the sheet.

By the early 1650s, Rembrandt's mastery of the drypoint needle was such that he chose to execute two very large plates entirely in that medium. If the earlier *Christ Preaching* (see p. 169) was a culmination for him in terms of a highly finished, painterly masterwork, the *Christ Crucified* and *Christ Presented to the People* (see next entry) represent peaks of pure dramatic strength and expressiveness in the printmaking medium. Conceived on the scale of paintings, these two images were roughly drawn directly into the metal surface of the plate, in a format unprecedented then and intimidating even today. Nearly identical in dimensions, these scenes from the Passion were perhaps intended to form part of a larger series on a similar scale.

The moment depicted in the early states of *Christ Crucified* seems to be that described in the Gospel of St. Luke 23:44–48, focusing on the conversion of the centurion, who is seen here kneeling before the cross with arms outspread. On the right side of the plate are the anguished figure of St. John, with hands at his temples, and the Virgin Mary being supported by her companions. Roman soldiers dominate the area to the left of the central cross. Many of the other figures are beginning to move away from the horrifying scene. Although the composition is crowded, it is still dominated by the central figure of the crucified Christ, with darkness closing in at the sides.

Because of the fragility of the drypoint burr, which quickly wore down in printing, comparatively few impressions of the *Christ Crucified* survive. They vary

187

markedly in the manner in which they are printed and in their support, with at least ten first-state impressions, including the Frick example, on vellum. As a group they demonstrate Rembrandt's desire to achieve an overall atmospheric effect rather than a careful delineation of individual figures or details. Very often, as here, he printed impressions leaving a film of ink on the surface of the plate, producing a grayer, more somber tonality; further, when such printings are done on vellum, which is relatively unabsorbent, the plate tone and the strength of line already captured by the heavy drypoint burr are reinforced, casting an umbrous twilight over all and producing opaque dark areas.[1]

The fleeting strength of drypoint impressions also led Rembrandt to rework the plate continually in order to maintain the visual power of his printings. These revisions resulted in several states; indeed, the changes he made in the fourth state are among the most radical for any image in the history of printmaking. The composition was begun in or slightly before 1653, the date that appears on the third state.[2] Most scholars feel that the extensive changes in the fourth state date from several years later, probably around 1660.[3] In that state, Rembrandt obscured many of the figures featured earlier (one of the fleeing figures is totally suppressed), added a noble horseman (perhaps meant to represent Pontius Pilate) to the left of the kneeling centurion, and scored virtually the entire surface of the plate with a heavy scrim of vertical lines of drypoint, emphasizing the "darkness over all the earth" at the hour of Jesus' death. Bevers has suggested that Rembrandt continued to contemplate further alterations in the composition, visible in more lightly-inked later counterproofs.[4]

The scarcity of surviving preparatory drawings for this print raises the possibility that Rembrandt started his work directly on the plate, without a preliminary model in another medium. Only two small figure studies are known that potentially relate to *Christ Crucified*, one for the figure at the very foot of the cross and another for three of the men walking away at left.[5] Drawing with the drypoint needle through the resistant metal surface of the printing plate requires considerable strength and control to execute a coherent design. The resultant tension of the drypoint lines, with their lack of graceful curves (note the centurion and the cavalrymen above him), reveals the power and rapidity of their execution. Ackley has focused on the resemblance of the *Christ Crucified* to "the blocky stylization characteristic of Rembrandt's late drawing style."[6]

The substantial changes Rembrandt made in this plate and in that of *Christ Pre-*

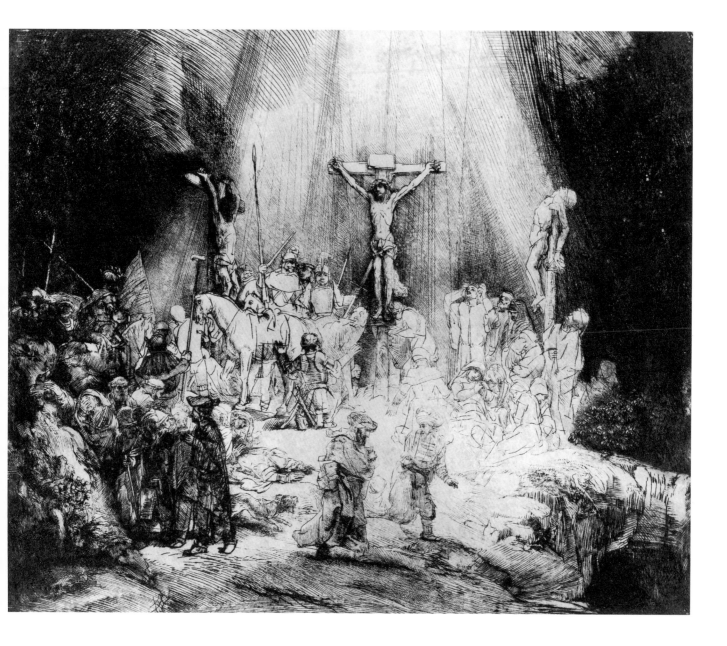

sented to the People have also been interpreted as closely reflecting his evolving inner thoughts on these incidents from the Passion. Carroll has related these images and their reworkings to contemporary Dutch poetry, likening them to a personal meditation and noting that print sequences such as this were virtually unprecedented at the time.[7] Numerous visual prototypes have been cited for both plates. For the *Christ Crucified* in its early states, as here, one clear source is a 1532 engraving by the Master B with the Die of *The Conversion of the Centurion*, which itself interprets a Raphaelesque design.[8] Aside from the mounted horseman in the fourth state, which is quite directly borrowed from a Pisanello medal, other sources are much harder to pinpoint and instead reflect the artist's absorption in and filtration of many precedents.[9] After such a gestation process, this printmaker's printmaker proceeded to render his own profoundly moving vision. Rosenberg has declared of this work that "light and dark are here the most powerful agents in creating the general mood and they raise the event … to cosmic dimensions."[10]

COLLECTIONS: Carl Schlösser (Lugt 636, this impression cited). His sale, Frankfurt, June 7 *et seq.*, 1880, Lot 513, sold for 3,000 marks to Thibaudeau. Sir Francis Seymour Haden (Lugt 1227, this impression cited). His sale, June 15 *et seq.*, 1891, Lot 458, sold for £80 to Deprez. John Postle Heseltine. Knoedler. Frick, 1919.

NOTES

1. See *Rembrandt: Experimental Etcher*, exhib. cat., Museum of Fine Arts, Boston, and Pierpont Morgan Library, New York, 1969, pp. 86–100, for reproductions of comparative impressions of *Christ Crucified*. Although this catalogue (p. 86) describes vellum as "very absorbent," see A. Robison, *Paper in Prints*, Washington, 1977, pp. 14–15, characterizing the "extreme lack of absorbency of vellum."

2. Rembrandt also inscribed the date 1653 on an impression of the first state now in the British Museum, London (White and Boon, p. 43).

3. H. Bevers, P. Schatborn, and B. Welzel, *Rembrandt: The Master & His Workshop, Drawings & Etchings*, New Haven–London, 1991, p. 266.

4. *Idem*, p. 268.

5. See C. White, *Rembrandt as an Etcher*, London, 1969, I, p. 77 and note 10.

6. C. S. Ackley, *Printmaking in the Age of Rembrandt*, Boston, 1981, p. 246.

7. M. Carroll, "Rembrandt as Meditational Printmaker," *Art Bulletin*, LXIII, 1981, pp. 585–610.

8. Bartsch 3; repr. in White, II, fig. 88.

9. For a full listing of suggested prototypes, see B. P. J. Broos, *Index to the Formal Sources of Rembrandt's Art*, Maarssen, 1977, pp. 81–82.

10. J. Rosenberg, *Rembrandt: Life and Work*, revised ed., London, 1964 (reprinted Ithaca, 1980), pp. 209–10.

CHRIST PRESENTED TO THE PEOPLE (*Ecce Homo*) (20.3.32)

Drypoint, printed in black ink on cream-colored Asiatic wove paper,[1] 15⅛ × 17¾ in. (38.3 × 45 cm).

REFERENCES: Bartsch 76; Hind 271 I/VII; White and Boon 76 II/VIII (this impression cited erroneously as first state).

INSCRIPTIONS: On verso in pen and dark brown ink: *Sxx*; and in graphite: *K 846 MK / first state*.

DESCRIPTION: The setting is the courtyard of a massive stone building, before which a bare tribune projects toward the viewer. Two life-sized statues support the cornice of the building, and a darkened arch at the rear of the tribune frames three central figures, who stand surrounded by soldiers and others. A large crowd is arrayed below, many of its members seen from the rear; several onlookers lean from windows.

CONDITION: The paper shows an old central vertical crease, mended tears on all sides and extending along the crease, a v-shaped loss at upper center, and a loss at the right edge. The entire sheet has been rebacked.

REMBRANDT worked on this monumental plate at about the same time as the *Christ Crucified* (see preceding entry), the third state of which is dated 1653. As with that composition, also done almost entirely in drypoint, the artist revised *Christ Presented to the People* repeatedly—in fact, through eight progressive states (the seventh of which is dated 1655). Previously thought to be the first state, the Frick impression can now be identified as the second, a variant, discovered by Münz, that incorporates darker shading within the doorway in the left background but was printed before further hatching was added on the thigh of the man at extreme left on the tribune.[2] The major changes Rembrandt made in subsequent states were a significant cutting down of the plate at the top and the total elimination of the crowd of spectators in front of the tribune, to be replaced by two arched entrances to an underground chamber, with the ghostly vision of a bearded man dimly perceptible emerging from shadows. In this early Frick impression, the crowd of onlookers, seen either in profile or from behind, serves as a masterful device intended to include the viewer as a participant in the scene. There is a marked tension between the relatively static group on the tribune and the turbulent crowd below. According to Mayor, however, it was precisely this fascination with the costumes and gestures of the agitated spectators that Rembrandt came to feel detracted from the essential drama of Christ's presentation, and that therefore demanded their removal in the sixth state.[3] Most of the remaining changes made in the plate were drypoint accents added to the figures as the fragile burr wore out in successive printings.

Rembrandt had depicted the theme of Christ Presented to the People in another very large print twenty years before, executed in his highly detailed early style. The two monumental versions of the same scene afford instructive contrasts of composition, draftsmanship, and execution. The earlier etching was made, with the probable assistance of his pupil Jan Joris van Vliet, from a 1634 grisaille painting now in the National Gallery, London.[4] This later drypoint was drawn directly on the copperplate, quite possibly without preliminary compositional sketches. No drawn study survives for it, nor do any drawings for individual figures.

The architectonic solemnity of the composition of *Christ Presented to the People* is certainly influenced by the engraving of the same event done in 1510 by Lucas van Leyden, who also placed Christ and Pilate on a raised platform in a city square, with crowds of spectators visible below and leaning out of surrounding windows. Rembrandt is known to have owned an impression of Lucas' print, and he would have seen the work of the earlier artist as a special standard to be emulated and, indeed, surpassed.[5] The architecture in both of these prints has been linked with the prison at Leiden, the Gravensteen, where public trials and executions took place.[6] The large statues at the top of the tribune have the attributes of Justice and Fortitude, identifying the setting as one of judgment. The *Ecce Homo* was depicted frequently in Northern art in the sixteenth and seventeenth centuries, and prototypes for Lucas and Rembrandt have been seen in works by Hieronymus Bosch, Jacques Callot, Claes Jansz. Visscher, and Nicolas de Bruyn, among others. Some have also suggested an inspiration from outdoor theatrical performances in city squares.[7]

As in so many of his prints, Rembrandt skillfully inserted here a myriad of details to gratify the viewer who gives them extended study. One example is the elegantly coiffed woman in the window at left, identified as Pilate's wife, who warned her husband not to pass judgment on Jesus (Matthew 27:19); the soldier carrying her message can be seen in the next window.[8] The figures on the tribune are depicted larger than those in the crowd below, further constricting the space and denying normal perception. Rembrandt's expressive depiction of hands is exemplified by Pilate's gesture of entreaty and by those of the crowd below, in particular the old man at the right edge of the tribune, whose shadow falls on the wall. Rembrandt often exploited the evocative symbolism of hands in works in all media.[9]

Despite their similarities of technique and scale and their affinity as deep personal meditations on the Passion,[10] the *Christ Crucified* and *Christ Presented* offer many contrasts. They are very different in treatment. The former is an apocalyptic,

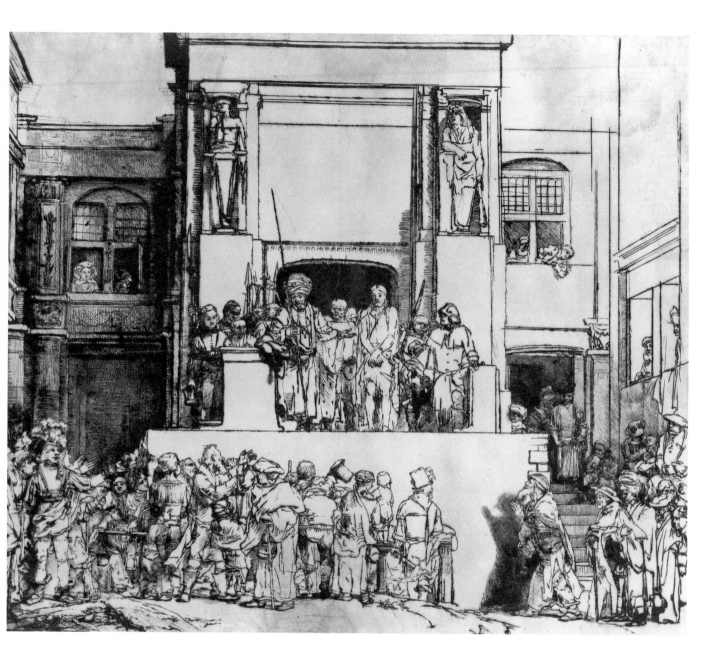

violently active scene, built up of atmospheric lights and darks, portrayed from a relative distance. The present work is done in lighter, more even tonalities, is quite static (except for the implied clamor of human voices), and has an almost claustrophobic atmosphere, weighed down by the architecture and its strict frontality. Both, however, are characteristically expressive of human emotion aroused by powerful events. This notably rare and celebrated pair of monumental drypoints, perhaps intended to be part of a larger series of prints on the subject of the Passion, was acquired by Mr. Frick in the last year of his life; indeed, this print is said to have been on his desk at his death.[11]

COLLECTIONS: John Postle Heseltine. Knoedler. Frick, 1920.

NOTES

1. White describes the paper of the Frick impression as "Chinese," while stating that this term itself is incorrect (C. White, *Rembrandt as an Etcher*, London, 1969, I, p. 15 and note 19). White also (*loc. cit.* and p. 89, note 25) erroneously identifies the Frick impression as of the first state.

2. See White and Boon, p. 41, under No. 76.

3. A. H. Mayor, *Rembrandt and the Bible*, New York, 1979, p. 36 (reprinted from *Metropolitan Museum of Art Bulletin*, Winter 1978/79). Mayor reproduces several striking details of this print.

4. White, I, p. 39; for the painting, see his fig. 28. See also M. Royalton-Kisch, "Over Rembrandt en van Vliet," *Kroniek van het Rembrandthuis*, No. 1/2, 1984, pp. 3–23, and his "Rembrandt's Sketches for his Paintings," *Master Drawings*, XXVII, 1989, pp. 133–35.

5. Bartsch 71; see E. S. Jacobowitz and S. L. Stepanek, *The Prints of Lucas van Leyden and his Contemporaries*, Washington, 1983, pp. 96–97, under No. 30.

6. *Idem.*

7. For the most complete listing of suggested prototypes, see B. P. J. Broos, *Index to the Formal Sources of Rembrandt's Art*, Maarssen, 1977, pp. 80–81.

8. White, p. 88.

9. This aspect of Rembrandt's work has been noted by W. M. Ivins in *Prints and Books: Informal Papers*, New York, 1969, p. 128.

10. On this subject, see especially: E. Winternitz, "Rembrandt's *Christ Presented to the People*—1655. A Meditation on Justice and Collective Guilt," *Oud Holland*, LXXXIV, 1969, pp. 177–98; M. Carroll, "Rembrandt as Meditational Printmaker," *Art Bulletin*, LXIII, 1981, pp. 585–610.

11. E. DeT. Bechtel, in *The Frick Collection Catalogue*, New York, IV, 1951, foreword (n.p.). An intriguing feature of this impression is the clear imprint of a hand—most probably the artist's—in the ink at upper right.

194

JAN LUTMA THE ELDER (16.3.37)

Signed and dated in the plate, in the window at upper center: *Rembrandt / f.1656*; inscribed by another hand in the plate, to the right of the sitter's left elbow: *Joannes Lutma Aurifecx / Natus Groningæ*. Etching and drypoint, printed in black ink on cream-colored European antique laid paper, 7¾ × 5⅞ in. (19.7 × 14.9 cm).

REFERENCES: Bartsch 276; Hind 290 II/III; White and Boon 276 II/III.

MARK & INSCRIPTIONS: Watermark of a foolscap with five-pointed collar and the letters IC [?]. Inscribed on verso in graphite: *Rembrandt B. No. 276. / 24442.*

DESCRIPTION: A bearded man is portrayed in three-quarter length seated in a leather-covered chair with lion's-head finials. Facing the viewer diagonally, he wears a soft dark cap and a plain buttoned coat under a loose gown. His arms rest on those of the chair, and in his right hand he holds a statuette. Atop a table at right lie a small mallet, a cylindrical container holding other tools, and an ornamental metal bowl. A window penetrates the thick stone wall behind him.

CONDITION: Aside from traces of old foxing stains, the print is in good condition.

JAN Lutma (1587–1669) was a noted Amsterdam silver- and goldsmith. His son was also a metalworker as well as an innovative printmaker,[1] and in fact engraved a portrait of his father in the same year that Rembrandt did.[2] Here, the senior Lutma is depicted with two products of his craftsmanship: the statuette in his hand and the bowl in the Dutch auricular (or lobate) style that rests on the table beside him, along with a goldsmith's hammer and punches.

Rembrandt executed perhaps seven densely-worked portraits of his friends and associates between 1655 and 1658, in addition to likenesses of his family and himself. The fancy chair with animal-head finials seen here was also used in his etchings of Arnold Tholinx and Thomas Haaring.[3] In contrast to Rembrandt's earlier portrait of Clement de Jonghe (p. 183), that of Lutma employs a relatively detailed setting, including personally characteristic objects. In one of his most introspective portrayals, Rembrandt shows Lutma enveloped in an atmospheric dusk, with brow furrowed and eyes unfocused and downcast. The richness of the drypoint additions, with their resulting velvety black tones, heightens the mood. Ackley has stressed Rembrandt's psychological penetration into his subjects as a unique contribution to portrait prints, remarking of this work that "shadow makes Lutma's expression ambiguous and mobile, suggesting a range of possible interpretations

and hinting at human complexity."[4] Keyes has related the striking monumentality of Rembrandt's painted *Self-Portrait* of 1658 in The Frick Collection to Lutma's pose and stature in this etching of two years earlier.[5]

COLLECTIONS: Pierre Mariette (Lugt 1788–90, dated 1670). Knoedler. Frick, 1916.

NOTES

1. See C. S. Ackley, *Printmaking in the Age of Rembrandt*, Boston, 1981, p. 280, No. 195.

2. F. W. H. Hollstein, *Dutch and Flemish Etchings, Engravings, and Woodcuts, ca. 1450–1700*, Amsterdam, 1949–, XI, p. 113, No. 5.

3. C. White, *Rembrandt as an Etcher*, London, 1969, I, pp. 138, 142 (Haaring is Bartsch No. 274, Tholinx Bartsch 284).

4. Ackley, p. 204.

5. G. Keyes, in *Six Centuries of Master Prints: Treasures from the Herbert Greer French Collection*, exhib. cat., Cincinnati Art Museum, 1993, p. 173, under No. 90, note 4. For the painting, see *The Frick Collection: An Illustrated Catalogue*, New York, I, 1968, pp. 266–69. The original copperplate for this print is in a private collection in the United Kingdom (E. Hinterding, "The History of Rembrandt's Copperplates, with a Catalogue of those that Survive," *Simiolus*, XXII, 1993–94, p. 301).

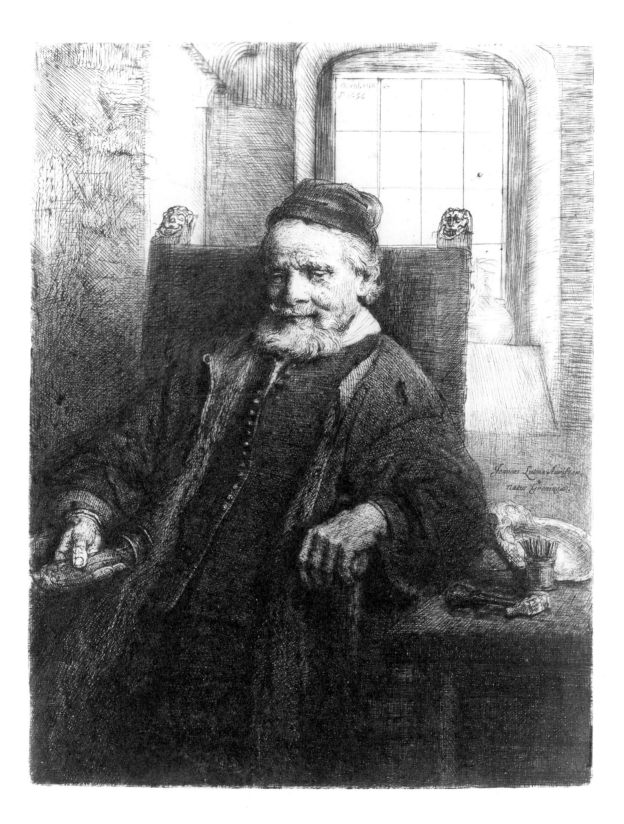

ST. FRANCIS PRAYING BENEATH A TREE (16.3.35)

Signed and dated in the plate, at lower right (twice): *Rembrandt f. 1657.* Drypoint, etching, and engraving, printed in black ink on dark cream-colored European antique laid paper, 7¹/₁₆ × 9⅝ in. (18 × 24.4 cm).

REFERENCES: Bartsch 107; Hind 292 II/II; White and Boon 107 II/II.

INSCRIPTIONS: On verso in graphite: *C 1229 MK / A 78500 / 112 / B 930 / EHOX.*

DESCRIPTION: At the center of the composition, a bearded, bareheaded monk wearing a cowled robe kneels in prayer to the right of a large tree. A nearly life-sized crucifix stands in deep shadow to the left of the tree trunk. Beyond and to the right of the first figure prays a second monk, his head covered. A squat stone belfry rises in the distance at upper right.

CONDITION: The print is in good condition.

THE *St. Francis Praying beneath a Tree* is Rembrandt's last print in which landscape plays a major role. Mayor has speculated that he may have begun it as a pure landscape study built around the central tree and then added the figure of the saint almost as an afterthought.[1] However, there are several precedents within the artist's work for placing figures within hilly, Italianate landscapes like that shown here—derived, in fact, from Venetian prototypes by Titian and Campagnola. Some years earlier, for example, Rembrandt had executed a larger print of *St. Jerome Reading* (Bartsch 104) in an even more elaborate Italianate landscape.[2] Although Rembrandt depicted St. Jerome in some seven prints, this is the only instance in which he featured the essentially Catholic figure of St. Francis; another curious anomaly here is his portrayal of the saint, who died young, as a white-bearded old man.[3] However, the cowled figure of Francis' companion Brother Leo in the background confirms the identification. Rembrandt chose not to represent the dramatic and familiar episode of Francis receiving the stigmata of Christ's wounds from the visionary crucifix, but instead the moments of prayer before the event.

Working in reverse from his normal procedure, Rembrandt here added considerable etched detail to his original drypoint sketch, recorded in the first state of the print, which featured an almost mystical, light-filled aura above Francis' head and behind the tree. Only in the second state did he add the hilly landscape and second figure and the complex web of lines that now highlight the saint's head profiled against the darkness behind. He also clarified the saint's expression of closed eyes and open mouth. Schneider raises the possibility that the first state of the print

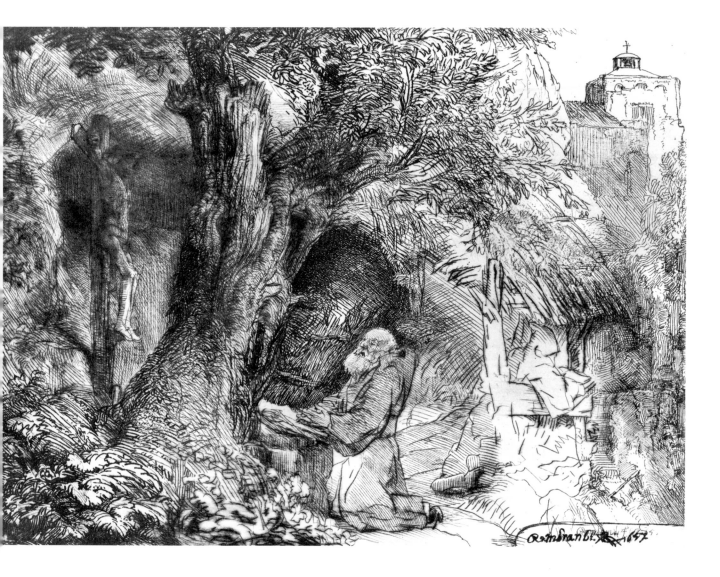

should not necessarily be considered an unfinished preliminary working proof, citing Stechow's observation that Rembrandt clearly signed and dated it.[4] She compares the effects of the two states as possibly representing two slightly different interpretations of the scene, thereby relating Rembrandt's work on this plate to the more radical changes he made to his slightly earlier *Christ Crucified between Two Thieves* (p. 189).

The shaded, shimmering presence of the crucifix appears as a visionary counterpart to the human saint on the opposite side of the tree trunk. Mayor has

suggested that the cross represents the Tree of Life, and the central tree may stand for the Tree of Knowledge that grew in the Garden of Eden.[5] Such ambiguous, meditative references afford additional levels of engagement to Rembrandt's etched religious scenes. The dominant presence of the tree trunk also recalls the similar motif in the 1648 *St. Jerome beside a Pollard Willow* (Bartsch 103).

Each impression of *St. Francis Praying* seems to have been printed with special care by the artist, achieving effects ranging from bright sunlight to dusky shadow. Rembrandt used different colors and textures of both European and Asiatic papers, and in several instances vellum. He often left varying layers of ink on the surface of the plate to further enhance the atmosphere.[6] The Frick impression is one of the more cleanly wiped and less murky in overall tone.

COLLECTIONS: H. Danby Seymour and Alfred Seymour (Lugt 176). Knoedler. Frick, 1916.

NOTES

1. A. Hyatt Mayor, unpublished manuscript in The Frick Collection.

2. Compare also the 1654 print of *Christ Returning from the Temple with his Parents* (Bartsch 60) and the approximately contemporary drawing of *The Prophet Elisha and the Widow with her Sons* (Benesch 1027) in the Museum of Fine Arts, Boston.

3. W. Stechow ("Rembrandt's Etching of St. Francis," *Allen Memorial Art Museum Bulletin*, X, 1952, p. 8) and Mayor (*loc. cit.*) suggest that Rembrandt may indeed have thought first of the figure of St. Jerome, then changed his mind.

4. C. P. Schneider, *Rembrandt's Landscapes: Drawings and Prints*, Washington, 1990, pp. 173 and 174, note 2.

5. Mayor, *loc. cit*. See also a similar juxtaposition across the Tree of Knowledge in Dürer's *The Fall of Man* (p. 135).

6. For excellent comparative reproductions, including details, of five impressions of *St. Francis Praying*, see *Rembrandt: Experimental Etcher*, exhib. cat., Museum of Fine Arts, Boston, and Pierpont Morgan Library, New York, 1969, pp. 154–61.

CHARLES MERYON

1821–1868

Meryon was born in Paris, the illegitimate son of a French actress named Pierre-Narcisse Chaspoux (called Narcisse Gentil) and Charles Lewis Meryon, an English doctor and naturalist who did not recognize the boy until he was three.[1] After early schooling in Paris, young Meryon entered the École Navale in Brest in 1837. During the next decade he completed two long sea voyages, one around the Mediterranean from 1839 to 1841, the other to South America and the South Pacific from 1842 to 1846. The many sketches that survive from these trips demonstrate his early devotion to drawing. After returning to Paris in 1846, Meryon resigned from the Navy to pursue an artistic career. He began his training with Charles-François Phélippes, a student of Jacques-Louis David's, and successfully submitted a drawing based on his South Seas experience to the Salon of 1848. However, he decided to pursue printmaking, perhaps as a result of the discovery that he was color-blind, and he undertook an apprenticeship with the landscape etcher Eugène Bléry, whom he had met in 1848. It was Bléry who taught him etching and set him to copying earlier works—notably by such seventeenth-century printmakers as the Italian Salvator Rosa and the Dutchman Reynier Nooms (called Zeeman)—to perfect his technique. Meryon exhibited his first original print, The Petit-Pont *(see p. 209), at the Salon in 1851; it was to be the start of his famed series of etched views of Paris, upon which he worked for the next four years. He also etched three scenes of Bourges at this time. Recognition of his work was slow in developing, but his evocative views were favorably received by such writers as Charles Baudelaire and Victor Hugo. In the mid 1850s, Meryon began to suffer increasingly severe attacks of mental illness, which in 1858 resulted in a stay in the Charenton asylum outside Paris. After his release he confined himself for the most part to commissioned portraits and to copies of earlier works, although in 1863 he executed some views and vignettes based on his travels in the South Pacific. Also in 1863, the noted critic and collector Philippe Burty published a catalogue and appreciation of his prints in the* Gazette des Beaux-Arts. *But Meryon was destined to spend an increasingly disturbed and impoverished existence before his last admission to the hospital of Saint-Maurice near Charenton in 1866. He died there two years later. Meryon's work, particularly his views of Paris, strongly influenced the etching revival that began in France and England in the 1860s.*

201

Such printmakers as Whistler (see pp. 253–96), Seymour Haden, Félix Bracquemond, and Maxime Lalanne emulated the clarity and finesse of his technique. His prints are unusually well represented in American collections, due both to his enormous popularity among print connoisseurs at the turn of the century and to the dispersal in New York in 1917 of the Macgeorge collection, the largest and finest group of Meryon's prints and drawings ever assembled.[2] The Frick Collection owns superb early impressions of fourteen etchings, all but two of them from the Macgeorge collection.

ETCHINGS OF PARIS (17.3.10–17.3.22)

The Petit-Pont (17.3.11)

Saint-Étienne-du-Mont (17.3.17)

The Tour de l'Horloge (17.3.15)

Turret on the Rue de la Tixéranderie (17.3.16)

The Notre-Dame Pump (17.3.18)

The Gallery of Notre-Dame (17.3.13)

The Arch of the Pont Notre-Dame (16.3.12)

The Pont-Neuf (17.3.19)

The Rue des Mauvais Garçons (17.3.14)

The Vampire (17.3.10)

The Pont-au-Change (16.3.20)

The Morgue (17.3.21)

The Apse of Notre-Dame de Paris (17.3.22)

The Rue des Toiles at Bourges (17.3.23)

INTRODUCTION

GENERAL DESCRIPTIVE NOTES: Of the fourteen etchings, only three are signed: *The Arch of the Pont Notre-Dame*, *The Vampire*, and *The Rue des Toiles, Bourges* (all signed in the plate, with an additional graphite signature on *The Rue des Toiles*). Only *The Arch of the Pont Notre-Dame* and *The Rue des Toiles* are dated (both 1853). The etchings are all printed in black or brownish-black ink, either on simulated Asiatic paper or on modern European laid paper. The sheets differ markedly in color, ranging from cream-colored to tan to pale gray-green; only *The Morgue* bears a watermark. For further specifications, see separate entries below.

CONDITION: Apart from minor imperfections (most in the form of printer's creases and discolorations), the fourteen prints are in very good condition.

THE precise genesis of the views known collectively as the *Etchings of Paris* is unclear. How Meryon chose his subjects, the order in which he executed the prints,[3] and even when he first conceived of them as a connected series are unknown, and can only be surmised from scant documentary evidence. The etched title plate inscribed *Eaux-Fortes sur Paris* (Delteil-Wright 17; Schneiderman 22) is dated 1852, some two years after the completion of the first print in the set, *The Petit-Pont* (p. 209). Writing to his father on January 3, 1853, Meryon indicated his plan at that time for ten views in all, mentioning that *The Notre-Dame Pump* (p. 221) was the fifth to be finished.[4] As it evolved, the series encompassed twelve large views plus several vignettes, along with incidental verses written and etched by Meryon on separate plates. Félix Bracquemond's portrait of Meryon, etched in imitation of a stone relief, also was included,[5] and the whole set was enclosed in a colored paper folder, with the title plate printed on the upper sheet of the cover. Meryon himself is supposed to have issued the earliest printings of the series in three parts, between 1852 and 1854.[6] A later edition with numbers assigned to the major views was issued in 1861, printed by Auguste Delâtre (1822–1907). Complete and uniform sets of the Paris etchings in their original format are practically unknown today. Further complicating matters, Meryon used a variety of printing papers for his etchings, ranging from thin simulated Asiatic papers to antique off-white laid to greenish-gray modern laid. He also varied the tonal wiping of his plates to achieve different effects of lighting and contrast for printings of the same subject. The Frick Collection owns all twelve of the large Paris views, plus one of the smaller vignettes, *The Rue des Mauvais Garçons* (p. 235).

Meryon was reticent on the subject of artistic sources for his project, but he did identify two of them. One was Victor Hugo, particularly the evocation of the medieval city in his *Notre-Dame de Paris*, which had appeared in 1831. Hugo's chapter delineating a bird's-eye view of fifteenth-century Paris from the Cathedral towers is strikingly like Meryon's scenes, in particular Meryon's aerial view in *The Vampire* (p. 237). The Cathedral dominates the modern city in the etchings as surely as it does the medieval city in Hugo's novel. In his manuscript response to Philippe Burty's 1863 *Gazette des Beaux-Arts* article on his prints, Meryon acknowledged the critic's references to Hugo's novel and accepted them "with the humility owed on my part."[7] Secondly, Meryon dedicated his series to the seventeenth-century Dutch artist Zeeman, in the form of an etched poem (Delteil-Wright 18; Schneiderman 33) extolling the latter's depiction of maritime subjects. Again in his unpublished *Observations*, he acknowledged that from the time he first saw Zeeman's series of etched views of Paris, he determined to execute his own depictions of the city.[8]

Other, more contemporary prototypes may be deduced for Meryon's conception of a unified set of views. Meryon's teacher, Bléry, had issued sets of etched rural views and plant studies during the 1840s.[9] Influential series of literary illustrations were done by Eugène Delacroix for *Faust* in 1828 and for *Hamlet* in 1843 and by Théodore Chassériau for *Othello* in 1844; Delacroix's *Faust* lithograph of Mephistopheles flying over the city at night (Delteil 58) is an obvious relative of Meryon's winged devil hovering over the gates to the Palais de Justice in a vignette from his Paris set (Delteil-Wright 19; Schneiderman 34B). Another important precedent was the *Voyages pittoresques et romantiques dans l'ancienne France* by Charles Nodier and Baron Isidore Taylor, a multi-volume illustrated series evoking ancient and medieval monuments throughout France, published between 1820 and 1878. Meryon was further known to have been familiar with the new art of photography; the obsessively careful, almost surreal observation he exhibited in constructing and delineating his views may be seen as related to that art.[10]

Apart from the question of artistic precedents, Meryon's set of Paris views has occasioned a great deal of scholarly interpretation as to its possible sociological, psychological, and symbolic meanings. It has been seen as a lament for the destruction of the old city by the urban renewal programs undertaken before and during the Second Empire; as a reflection of the contemporary revival of Romantic interest in the Gothic; and as a visualization of the horrors of city life and the vices it fostered.[11] What is certain is that Meryon invested his visions of Paris in a time of

flux between old and new with a dimension of emotion and hyperrealism beyond that found in the work of both his contemporaries and his future imitators.

D. P. B.

EXHIBITIONS: Six of the fourteen etchings were exhibited at the Burlington Fine Arts Club, London, in 1879, five lent by the Rev. James J. Heywood (*The Petit-Pont, The Gallery of Notre-Dame, The Vampire, The Rue des Mauvais Garçons,* and *The Morgue*) and one lent by Sir Francis Seymour Haden (*The Apse of Notre-Dame de Paris*). *The Pont-au-Change* alone was shown at Frederick Keppel & Co., New York, in 1911. All but *The Arch of the Pont Notre-Dame* and *The Pont-au-Change* were exhibited at Knoedler, New York, in 1917.

COLLECTIONS: Eight of the fourteen etchings belonged to Jules Niel of Paris, or his daughter Gabrielle, or perhaps both: *The Vampire, The Gallery of Notre-Dame, The Rue des Mauvais Garçons, The Tour de l'Horloge, Turret on the Rue de la Tixéranderie, The Notre-Dame Pump, The Morgue,* and *The Rue des Toiles at Bourges*. Six were owned by the Rev. James J. Heywood (Lugt 1276; see also the 1880 Ellis & White catalogue of his collection); these in-clude *The Vampire, The Petit-Pont, The Gallery of Notre-Dame, The Rue des Mauvais Garçons, Saint-Étienne-du-Mont,* and *The Morgue*. Three were in the collection of A. W. Thibaudeau (Lugt 2412): *The Tour de l'Horloge, Turret on the Rue de la Tixéranderie,* and *The Rue des Toiles*. One, *The Pont-Neuf,* belonged to A. Wasset (Lugt 201), and one, *The Apse of Notre-Dame,* to Sir Francis Seymour Haden (see Lugt 1227; mark not present). Two were purchased by Mr. Frick from Knoedler in 1916; one of these, *The Arch of the Pont Notre-Dame,* had previously been owned by Bryan Lathrop (Lugt 2972), and the other, *The Pont-au-Change,* by A. M. Burritt, Tracy Dows (Lugt 2427), and Frederick Keppel. The remaining twelve etchings were purchased by Mr. Frick in 1917, again from Knoedler; all of these had previously been in the collection of B. B. Macgeorge, Glasgow (Lugt 394), from whom they were acquired by Colnaghi and subse-quently by Knoedler.

MERYON REFERENCES CITED IN ABBREVIATED FORM

BECKER, 1991: D. P. Becker, "[Review of] R. S. Schneiderman, *Charles Meryon: The Catalogue Raisonné of the Prints," Print Quarterly,* VIII, No. 1, March 1991, pp. 91–97.

BRADLEY, 1917: W. A. Bradley, "Some Meryon Drawings in the MacGeorge [*sic*] Collection," *Print Collector's Quarterly,* VII, No. 3, October 1917, pp. 222–55.

BURKE, 1974: J. D. Burke, *Charles Meryon: Prints & Drawings,* exhib. cat., Yale University Art Gallery, New Haven, 1974.

BURTY, 1863: P. Burty, "L'Oeuvre de M. Charles Meryon," *Gazette des Beaux-Arts,* XIV, June 1863, pp. 519–33, XV, July 1863, pp. 75–88.

COLLINS, 1999: R. Collins, *Charles Meryon: A Life,* Devizes, United Kingdom, 1999.

DELTEIL, 1907: L. Delteil, *Le Peintre-Graveur illustré, II: Charles Meryon*, Paris, 1907.

DELTEIL–WRIGHT, 1924: L. Delteil, *Catalogue Raisonné of the Etchings of Charles Meryon*, ed. and amplified by H. J. L. Wright, New York, 1924.

DUCROS, 1968: J. Ducros, *Charles Meryon, Officier de Marine, Peintre-Graveur, 1821–1868*, exhib. cat., Musée de la Marine, Paris, 1968.

ELLIS & WHITE, 1880: *A Descriptive Catalogue of a Collection of Drawings and Etchings by Charles Meryon Formed by the Rev. J. J. Heywood*, Ellis & White, London, 1880.

FRANKFURT–HAMBURG, 1975: *Charles Meryon: Paris um 1850, Zeichnungen, Radierungen, Photographien*, exhib. cat., Städelsches Kunstinstitut und Städtische Galerie, Frankfurt am Main, and Kunsthalle, Hamburg, 1975.

GENEVA, 1981: *Charles Meryon — David Young Cameron*, exhib. cat., Musée d'Art et d'Histoire, Geneva, 1981.

GRAD AND RIGGS, 1982: B. L. Grad and T. A. Riggs, *Visions of City and Country — Prints and Photographs of Nineteenth-Century France*, exhib. cat., Worcester Art Museum and American Federation of Arts, New York, 1982.

KNOEDLER, 1917: *Etchings and Drawings by Charles Meryon from the B. B. MacGeorge [sic] Collection*, exhib. cat., Knoedler, New York, 1917.

SCHNEIDERMAN, 1990: R. S. Schneiderman, *The Catalogue Raisonné of the Prints of Charles Meryon*, London, 1990.

VERDIER, 1983: P. Verdier, "Charles Meryon, *Mes Observations (1863),*" *Gazette des Beaux-Arts*, 6ᵉ pér., CII, 1983, pp. 221–36.

NOTES

1. For the definitive biography of Meryon, with extensive discussion of his work, see Collins, 1999.

2. The collection is itemized in Knoedler, 1917; see also Bradley, 1917, pp. 222–55. In 1898, a comprehensive exhibition of Meryon's works in United States collections was mounted at the Grolier Club, New York, and a 1974 Yale University Art Gallery exhibition also was drawn entirely from United States collections.

3. Numbers were not added to the major views in the Paris set until the edition printed in 1861 by Delâtre, and would seem to be somewhat arbitrary. See individual entries in Delteil-Wright or Schneiderman for the numbers.

4. For excerpts from the letter, see Ducros, 1968, under No. 724.

5. Delteil-Wright 17A. See also J.-P. Bouillon, *Félix Bracquemond — Le Réalisme absolu — Oeuvre gravé 1849–1859, Catalogue raisonné*, Geneva, 1987, No. Aa 15.

6. See Delteil-Wright, under No. 17, for a complete listing of the set.

7. Verdier, 1983, p. 225, under No. 50.

8. *Idem*, p. 222, under Nos. 6–9. Meryon had in fact made etched copies of four of Zeeman's Paris views in 1849–50 (Delteil-Wright 9–12; Schneiderman 12–15).

9. Meryon apparently etched the title page for one of them dated 1850 (reproduced in Frankfurt–Hamburg, 1975, p. 17, No. D 64).

10. See especially: E. P. Janis, "Charles Meryon und die Photographen von Paris," in Frankfurt–Hamburg, 1975, pp. 139–44; and

E. P. Janis, "The Man on the Tower of Notre Dame: New Light on Henri Le Secq," *Image*, XIX, 1976, pp. 20–25.

11. For further discussion of the Paris series, along with bibliographical references, see: A. M. Holcomb, "*Le Stryge de Notre-Dame*: Some Aspects of Meryon's Symbolism," *Art Journal*, XXXI, 1971–72, pp. 150–57; Burke, 1974; and Grad and Riggs, 1982, especially pp. 118–19. The most exhaustive bibliography of all of Meryon's work is R. D. J. Collins, *Charles Meryon: A Bibliography*, Dunedin, New Zealand, 1986, a 237-page listing of items published from 1837 to 1984; see also the same author's "Où en est notre connaissance de Meryon?" *Nouvelles de l'estampe*, Nos. 130–31, 1993, pp. 19–25.

THE PETIT-PONT (17.3.11)

Etching, printed in black ink on tan simulated Asiatic paper, 10³⁄₁₆ × 7½ in. (25.9 × 19.1 cm).

REFERENCES: Delteil-Wright 24 I/VII; Schneiderman 20 I/IX.

INSCRIPTION: In graphite on verso: *LD. 24¹ / From the Heywood collection*.

DESCRIPTION: The towers and south transept roof of the Cathedral of Notre-Dame rise above a row of apartment houses that recedes into the right distance. The arched Petit-Pont runs parallel to the picture plane, extending from the houses at left to the right margin, and beneath it the Seine flows toward the lower left corner.

CONDITION: The sheet is in good condition.

BY Meryon's own account his first original print, *The Petit-Pont* was finished by the summer of 1850, inasmuch as the artist sent an impression to his father with a letter of August 5; another impression was submitted in December to that year's Salon, which did not open until February 24, 1851.[1] The view is from the Left Bank of the Seine looking eastward toward Notre-Dame on the Île de la Cité. Meryon consciously combined two vantage points in his composition, delineating the houses and bridge as seen from the level of the river, then moving up to the street level to depict more fully the two Cathedral towers and roof. The earliest study for the etching clearly reveals the conflation of the two viewpoints.[2] Done in graphite on tracing paper with the aid of a camera lucida, it shows the much-reduced height of the towers as seen from the river level. Over this, Meryon has sketched his conception of the final composition in a vertical format, compressing the bridge and raising the towers. In numerous further studies for the etching, he minutely depicted each detail of the final print, adding careful notes on building construction and materials.[3]

A comparatively large number of first-state impressions of *The Petit-Pont* survive, all printed in rich black ink on thin, oatmeal-textured, simulated Asiatic papers, variously known as Japan, India, or Madagascar paper.[4] They show the image completely finished but lacking any inscriptions. Intimations of Meryon's later, more foreboding visions are evident here in the harsh sunlight, strong contrasts, almost claustrophobic atmosphere, and very low viewpoint. The tiny figures standing atop the towers of the Cathedral are eerily reminiscent of the ubiquitous birds in many of Meryon's skies, although the birds themselves are miniscule here. Meryon is thought to have printed impressions of the first four states of the etching himself, on a press in his studio. Later impressions—as is the case for all of the Paris

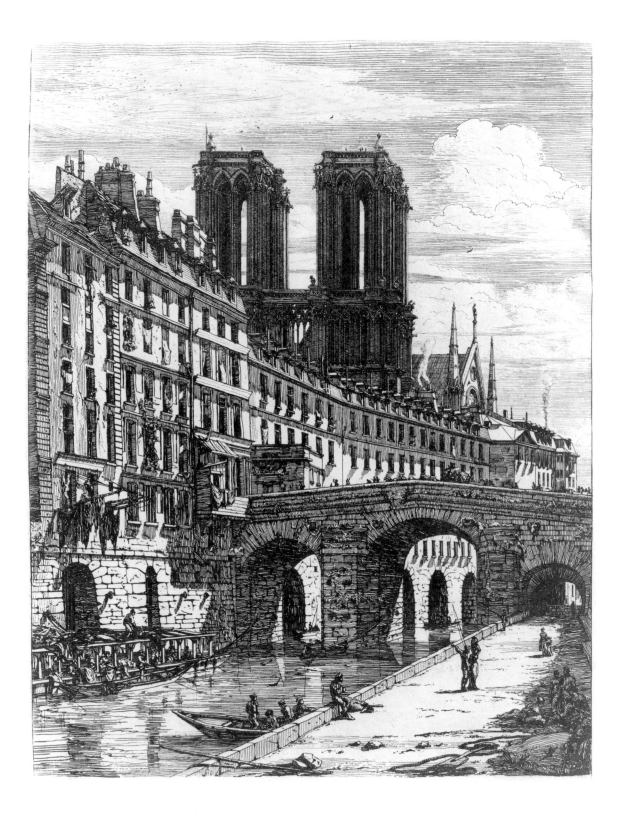

set—were printed by Auguste Delâtre. The fifth state was done in an edition of six hundred for inclusion in the magazine *L'Artiste* in December 1858.[5] The final printing in 1861 for a new edition of the complete Paris set carries the clearly incorrect date 1852 in the lower margin.[6] In a remark recorded by Baudelaire in 1860, the artist noted the coincidental resemblance between the shadow cast by the porch of the house at the left end of the Petit-Pont and the profile of a sphinx, making an anachronistic connection with Louis-Napoleon's coup d'état, which took place soon after—not before—this print was executed.[7]

EXHIBITED: London, Burlington Fine Arts Club, 1879, No. 24.

COLLECTIONS: J. J. Heywood (No. 45.1 in the 1880 Ellis & White catalogue of his collection). B. B. Macgeorge. Colnaghi. Knoedler (No. 24a in its 1917 Macgeorge catalogue). Frick, 1917.

NOTES

1. See Ducros, 1968, under No. 711. *Le Petit-Pont* was listed as No. 5818 in the official *Explication* of the Salon.

2. This double viewpoint was first commented on by Philippe Burty (see Burke, 1974, pp. 39–40). The study, inscribed by Meryon "pris sur nature à la chambre claire," is now in the Toledo Museum of Art (see Burke, No. 14). Compare a photograph of the same view taken from street level by Henri Le Secq in 1852 (repr. in Frankfurt–Hamburg, 1975, No. P 3).

3. Two of the detail studies are also in the Toledo Museum (see Burke, Nos. 15, 16). Three others are in the Bibliothèque Nationale, Paris (No. A.C. 8524), and the National Gallery of Art, Washington (Nos. B. 8690, B. 8691).

4. Becker, 1991, p. 93 and note 6.

5. V, No. 14, December 5, 1858.

6. This date, clearly incorrect for the execution of the print, is a curious addition, though consistent with other misdatings on other plates in the series.

7. Part of Baudelaire's letter is translated in Burke, p. 40.

SAINT-ÉTIENNE-DU-MONT (17.3.17)

Etching, printed in black ink on tan simulated Asiatic paper, 9⅞ × 5⅟₁₆ in. (25.1 × 12.9 cm).

REFERENCES: Delteil-Wright 30 III/VIII; Schneiderman 25 III/VIII.

INSCRIPTIONS: In graphite on recto at upper left, possibly entered by the artist: *I*; and on verso: *L.D. 30 III From the Heywood Collection*.

DESCRIPTION: The brightly lit façade of the church is seen in the central distance, the finial of its cupola nearly reaching the top margin. Partly visible in the foreground, framing both sides of the composition, are the Collège de Montaigu at left and the Panthéon at right, the latter with small figures at work on scaffolding.

CONDITION: The sheet is in good condition.

IT is not clear which of the Paris set was executed next in sequence after *The Petit-Pont*. In a letter to his father of September 15, 1851, Meryon detailed his "faults" in marketing his first Paris etching, which thereupon would force him "to make a pendant and insert it in a suite of views (a first installment of four, for example)," in order to recover some of his expenses. It is possible that *Saint-Étienne-du-Mont* was conceived as this pendant.[1] Two preliminary drawings for it date from early February 1851,[2] and an impression was exhibited in the Salon of 1852, which opened on April 30.[3] Indeed, the print could well have been finished in 1851, for an impression of the first state in the Cleveland Museum of Art is inscribed by a previous owner: "Presented to me by Monsieur Meryon. Paris Jan^y 1852."[4] The view is toward the façade of Saint-Étienne-du-Mont, rising above the Place Sainte-Geneviève, with the medieval Collège de Montaigu (formerly a prison) on the left and a corner of the eighteenth-century Panthéon at the right edge.[5] At the time the print was made, Meryon's studio was located quite close by, at Rue Neuve St.-Étienne-du-Mont, 26.[6]

This composition typifies the claustrophobic sense that so often permeates Meryon's Paris etchings. Daylight barely penetrates the foreground, leaving the viewer at the base of a canyon of buildings, facing the bright church in the distance. What light does fall is harsh, casting decisively cut shadows. The small figures recall those in Giovanni Battista Piranesi's Roman views; but Meryon's are even more suggestive of insects lurking in the shadows of the old city. The harshness of the sunlight is mitigated somewhat in the Frick impression by the use of a warm-toned paper.

COLLECTIONS: J. J. Heywood (No. 51.2 in the 1880 Ellis & White catalogue of his collection). B. B. Macgeorge. Colnaghi. Knoedler (No. 30b in its 1917 Macgeorge catalogue). Frick, 1917.

NOTES

1. Ducros, 1968, under No. 711. The author is grateful to John Ittmann for first suggesting to him that this print was the proposed pendant.

2. Both now in the Toledo Museum of Art (see Burke, 1974, Nos. 39, 40, repr.). The final preparatory drawing, done on tracing paper and complete in all details, also is at Toledo (*idem*, No. 41, repr.).

3. Shown as *Saint-Etienne-du-Mont et l'ancienne prison de Montaigu*, it was No. 1598 in the printed *Explication*.

4. Schneiderman, p. 48.

5. A contemporary photograph of the church is reproduced in Frankfurt–Hamburg, 1975, No. P 8.

6. Meryon includes his home in the later states of his 1864 aerial view of the Collège Henri IV (Delteil-Wright 43; Schneiderman 91). It is indicated by his initials on a building very close to the top center of the print, to the left of the left medallion at the upper margin; Saint-Étienne-du-Mont is seen at the left edge of the composition. The scene was drawn from the tower of the Panthéon.

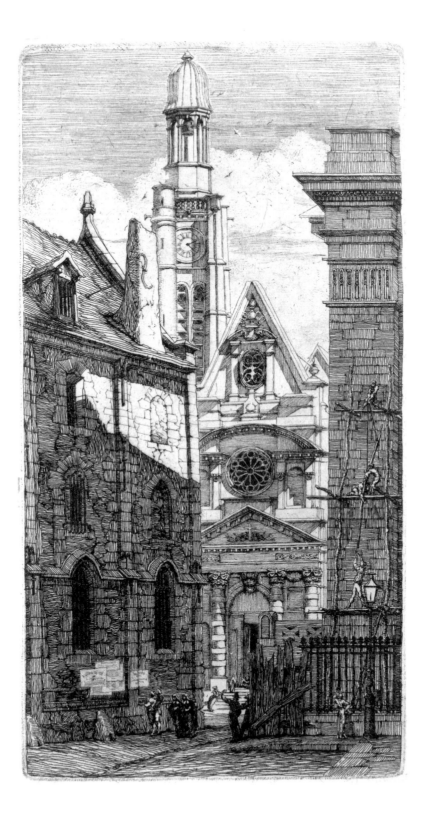

THE TOUR DE L'HORLOGE (17.3.15)

Etching, printed in black ink on tan simulated Japan paper, 10⅜ × 7⁵⁄₁₆ in. (26.3 × 18.6 cm).

REFERENCES: Delteil-Wright 28 II/X; Schneiderman 23 II/X.

DESCRIPTION: The brightly highlighted Pont-au-Change crosses the lower portion of the image, while the top is largely filled by a single building, the Palais de Justice, partially encased in scaffolding. A barge emerges from an arch of the bridge.

CONDITION: The sheet shows a slight discoloration from an old adhesive along the left edge, a loss at the lower left corner, a small stain at the upper right corner, and a long printer's crease running vertically through the clock tower, partially touched in with dark brown ink.

THE building dominating this scene is the Palais de Justice. Its clock tower is located at the corner nearest the foreground, but as the building was in the midst of restoration at the time, the clock is obscured by the brightly-lit, mullioned scaffolding at the base of the tower.[1] The viewer looks downstream from a point near the Notre-Dame pump (see p. 221). Several surviving preparatory drawings reveal the complex process through which Meryon composed his view. The earliest complete study, in the Metropolitan Museum of Art, New York, shows a broader aspect of the side of the palace facing the river than does the etching.[2] While eventually substituting a sharper angle for that façade, Meryon retained the earlier breadth of the clock tower itself, hence combining two viewpoints in his final composition.[3] An impression of the finished print was shown in the Paris Salon of 1852.[4] The sixth state was printed in an edition of six hundred impressions for the October 1858 issue of *L'Artiste*, at a time when the old Pont-au-Change was scheduled to be demolished.[5]

Although it shows somewhat more sunlight than many of Meryon's Paris scenes, this view of the Palais de Justice is still dominated by one compressed, dimly featured, darkly shadowed façade of the building. Perhaps a symbolic meaning can be inferred from Meryon's dim view of the city's home of justice. (In later states, Meryon would allow dramatic shafts of light to pierce the previous uniformly black face.) The freighted building appears in three more of Meryon's Paris views, *The Arch of the Pont Notre-Dame* (p. 227), the *Pont-au-Change* (p. 241), and *The Gallery of Notre-Dame* (p. 225). Its forbidding gate and towers are the sole subject of a vignette for the Paris set (Delteil-Wright 19; Schneiderman 34B). Below the Palais, the Pont-au-Change teems with dozens of people making their passage across the river. In a tiny vignette easily overlooked, a fisherman tries his luck standing in the

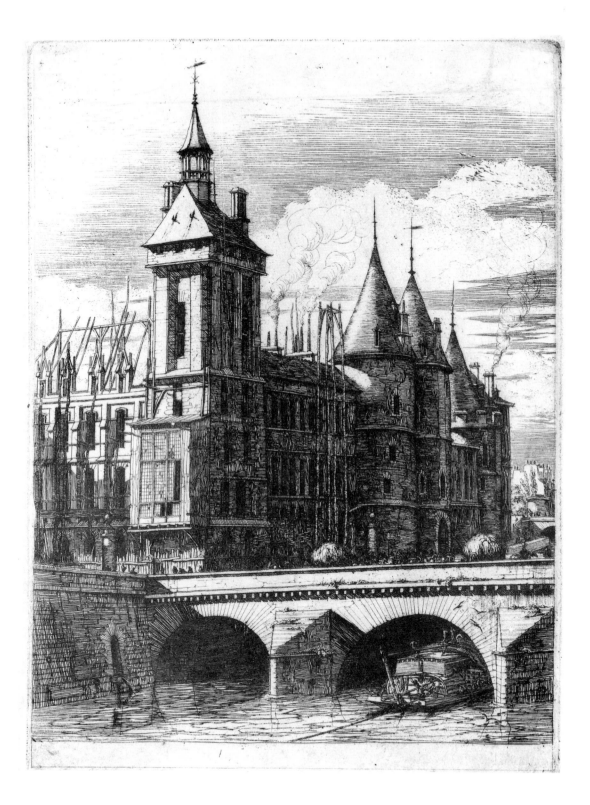

sewer outlet in the shadows at lower left.[6] The plumes of smoke seen billowing from various chimneys, a feature increasingly evident in Meryon's prints at this time, seem to signal pockets of nefarious activity.

COLLECTIONS: Gabrielle Niel.[7] A. W. Thibaudeau. B. B. Macgeorge (mark not visible). Colnaghi. Knoedler (No. 28a in its 1917 Macgeorge catalogue). Frick, 1917.

NOTES

1. For an unobstructed photograph of the clock tower taken about 1858, see Frankfurt–Hamburg, 1975, No. P 14.

2. See Burke, 1974, No. 30.

3. The process is apparent in two compositional drawings, one in the Toledo Museum of Art (*idem*, No. 32, repr.), the other in the Bibliothèque Nationale, Paris (Ducros, 1968, No. 717, repr.). At least one graphite study also in Toledo of a river barge is plausibly preparatory to this print (see Burke, No. 31).

4. No. 1597 in the printed *Explication* ("Le Palais-de-Justice et le pont au Change").

5. V, No. 9, October 31, 1858. Delteil-Wright (under No. 28) quotes from the article, which stated "in a few days the 'Pont-au-Change' will be only a memory."

6. This detail is reminiscent of the Daumier lithograph from 1840 of the same theme, *The Determined Fisherman* (see Grad and Riggs, 1982, p. 105, fig. 55).

7. According to Delteil-Wright, under No. 28.

TURRET ON THE RUE DE LA TIXÉRANDERIE (17.3.16)

Etching, printed in black ink on tan simulated Asiatic paper, 9¹³⁄₁₆ × 5³⁄₁₆ in. (24.9 × 13.2 cm).

REFERENCES: Delteil-Wright 29 I/V; Schneiderman 24 I/V.

INSCRIPTION: In graphite on verso: *LD 29¹ / From the Mlle Niel & Thibaudeau collections / 43 22*.

DESCRIPTION: A narrow house with a Gothic turret on the corner nearest the viewer is in the center of the composition; sunlight strikes it and the buildings on either side. Several figures are seen in the houses and on the narrow street at the bottom.

CONDITION: The sheet shows a tear at the upper right corner, some thinning along the right edge, a circular white stain to the right of the third-floor window at left, and several printer's creases throughout.

THE turreted house that forms the focus of this print was torn down in 1851 during an extension of the Rue de Rivoli. It stood at the corner of the Rue du Coq on the Right Bank, across from the Hôtel de Ville. Victor Hugo had spoken of the street in his *Notre-Dame de Paris*, and the photographer Henri Le Secq took a photograph in 1851 almost identical in viewpoint to Meryon's virtually contemporary print.[1] A graphite detail study of the turret by Meryon is in the Bibliothèque Nationale, Paris,[2] and a preliminary composition study done from an angle slightly different from that found in the print is in the Carnegie Institute, Pittsburgh.[3] Meryon's final detailed preparatory drawing in graphite, now in the Art Institute of Chicago, includes all the figures, foliage, and curling smoke exactly as they appear in the etching.[4] Le Secq's photograph and the Carnegie and Chicago studies reveal that for the print Meryon monumentalized the turret by extending its peak above the roof line of the house and lowering the building at left; the turret itself is precisely centered in the plate. An impression of the print was exhibited in the 1852 Paris Salon.[5]

Meryon has depicted the turret as being taken over by vines, in the midst of people at their daily occupations; two figures lean on a fence in the foreground pointing toward the medieval fragment, while a blacksmith is seen in mid-swing through the doorway at left. So modest a building becomes a more affecting monument as a result of such concentrated attention. The Frick impression is of the first state, brilliantly clear in effect, printed, like so many of Meryon's earliest proofs, on warm-toned, thin imitation Asiatic paper. The overall effect is intimate, even elegiac.

COLLECTIONS: Gabrielle Niel. A. W. Thibaudeau. B. B. Macgeorge. Colnaghi. Knoedler (No. 29a in its 1917 Macgeorge catalogue). Frick, 1917.

217

NOTES

1. Burke, 1974, p. 52. Le Secq's photograph is reproduced in Frankfurt–Hamburg, 1975, No. P 7.

2. Burke, *loc. cit.*

3. *Idem*, No. 35, repr.

4. *Idem*, No. 36, repr.

5. No. 1599 in the printed *Explication* ("Tourelle rue de la Tixeranderie à Paris, démolie en 1851").

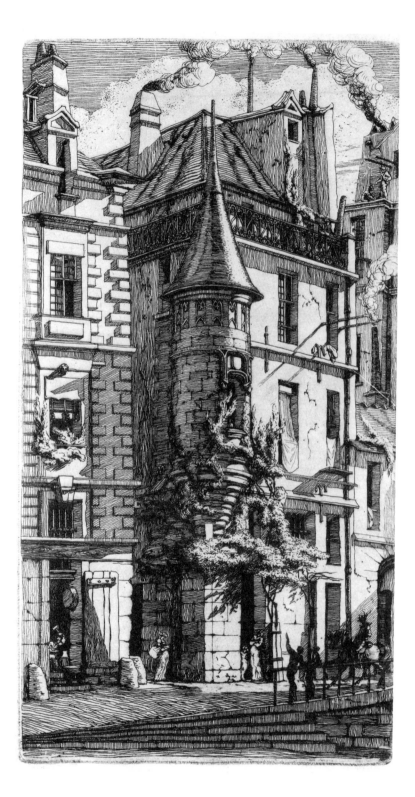

THE NOTRE-DAME PUMP (17.3.18)

Etching and drypoint, printed in black ink on dark cream-colored simulated Japan paper, 6¹¹/₁₆ × 9⅞ in. (17 × 25.1 cm).

REFERENCES: Delteil-Wright 31 III/IX; Schneiderman 26 IV/X.

INSCRIPTIONS: In graphite on recto below image: *2ᵉᵐᵉ* [?] *état avant toutes lettres. le filet teinté / From the collection of Monsieur Niel LD 31ᴵᴵᴵ*; on recto above image: *43*; and on verso: *23*.

DESCRIPTION: The left half of the image is dominated by the foreshortened structure of the Notre-Dame pump, its tower nearly reaching the upper border. Discernible behind the pump is the arched Pont Notre-Dame running perpendicular to the quai, which in turn extends to the right margin. Above the quai rise apartment buildings and the towers of the Cathedral of Notre-Dame. Several manned boats appear on the river.

CONDITION: The sheet is in good condition.

DEPICTING the side of the Île de la Cité opposite that seen in *The Petit-Pont* (p. 209), this view looks south across the island to the just-visible towers of Notre-Dame. As Burke has pointed out, Meryon's vantage point here—and in five other prints from the Paris set—essentially is that of a boatman on the water.[1] The Notre-Dame pump, used since the seventeenth century for the city's water supply, was slated for demolition at the time Meryon portrayed it so imposingly.[2] Set on a web of piles resembling the legs of a monster centipede and topped by a tower that suggests a helmeted head, the pump assumes the forbidding aspect of a great creature lurking on the surface of the river. Ducros has remarked on the tower's resemblance to a lighthouse.[3] The pump reappears above the bridge in Meryon's *Pont-au-Change* (p. 241), and its pilings add another sinister presence to *The Arch of the Pont Notre-Dame* (p. 227).

The earliest known study for this print, in the Museum of Fine Arts, Boston, is dated 1852.[4] Its composition, although similar to that of the final work, is framed by what seems to be an arch forming part of the quai construction on the north riverbank.[5] In a later study for the etching, now in the Bibliothèque Nationale, Paris, Meryon brought his view out into the open.[6] The final preparatory drawing, also dated 1852, is in the National Gallery of Victoria, Melbourne.[7] Interestingly, it includes a considerable number of observers on the far end of the bridge and the neighboring quai who do not appear in the print.

Dated 1852 in later states, *The Notre-Dame Pump* was exhibited in the Salon of 1853 and in the Universal Exposition of 1855. In an 1853 letter to his father, Meryon indicated that this print was the fifth of his Paris set to be finished.[8] *L'Artiste*

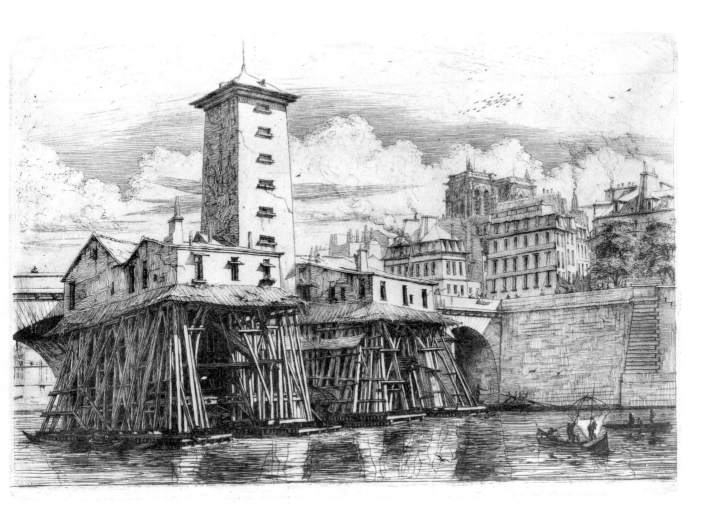

published it in November 1858,[9] in an edition of six hundred impressions, offering it as "consolation" to readers who missed the recently demolished pump.[10] In 1854, Meryon etched a small vignette of the pump (Delteil-Wright 32; Schneiderman 39), intended as a head- or tailpiece for the Paris set. It contains a verse that includes the punning refrain "Poor Pump, without pomp you must die!"[11] Aside from the awkwardly menacing aspect of the structure itself, this print is one of the sunniest of all Meryon's Paris views. The Frick example is a crisp early impression of a state before any inscriptions and before the artist added further detailed shading.

COLLECTIONS: Jules Niel. B. B. Macgeorge. Colnaghi. Knoedler (No. 31a in its 1917 Macgeorge catalogue). Frick, 1917.

NOTES

1. Burke, 1974, p. 57.

2. *Idem*, p. 56. For contemporary photographs of the pump, see Burke's fig. 3 and Frankfurt–Hamburg, 1975, Nos. P 10 and P 12.

3. Ducros, 1968, under No. 723.

4. Burke, No. 44, repr.

5. It is difficult to determine the precise site from which Meryon drew this view, but he clearly was standing on land under the arch. Therefore, he could not have been under an arch of the downstream Pont-au-Change, nor under the Pont Notre-Dame (as stated by Burke, p. 57), which is seen behind the pump in both the Boston drawing and the etching.

6. Reproduced in Frankfurt–Hamburg, 1975, No. Z 21.

7. See Becker, 1991, p. 94 and fig. 57.

8. Ducros, under No. 724.

9. V, No. 13, November 28, 1858.

10. Cited in Delteil-Wright, under No. 31.

11. "Pauvre Pompe, / Sans pompe, / Il faut mourir."

THE GALLERY OF NOTRE-DAME (17.3.13)

Etching and drypoint, printed in dark brownish-black ink on pale gray-green modern laid paper, 10^{13}/16 × 6^{13}/16 in. (27.5 × 17.3 cm).

REFERENCES: Delteil-Wright 26 I/V; Schneiderman 29 I/VI.[1]

INSCRIPTIONS: In graphite on recto at upper right: *38*; on recto below image: *épreuve d'essai, avant toutes lettres, et le ciel blanc. 1er état 3*; and on verso: *LD 26^1 From the Niel & Heywood collections / 21.*

DESCRIPTION: The viewer is enclosed within a medieval stone gallery in one of the towers of Notre-Dame Cathedral, with an aerial view of Paris visible through the arches at left. Two dark birds fly in between the columns to join three others on the stones below.

CONDITION: The sheet is in good condition.

ONE of the most famous images of the Paris set, this print is a heady combination of Romantic evocation, Gothic mood, a foreboding web of shadows, and a distant vision of freedom glimpsed through the screen of columns at left. The only inhabitants of this aerie are the crows and two small but menacing demons peering out of the gloom from atop columns at upper right. In his manuscript *Mes Observations*, Meryon acknowledged the close connection between Victor Hugo's *Notre-Dame de Paris* and this haunting scene.[2] A more precise prototype may be found in a wood engraving after Charles-François Daubigny also depicting the gallery of the Cathedral, from an 1844 edition of Hugo's novel.[3] Recognizable in Meryon's bird's-eye view of Paris are the towers of the Palais de Justice, including the clock tower portrayed in *The Tour de l'Horloge* (see p. 215).

That Meryon had been working on this print through 1852 can be inferred from an inscription of December of that year on the final preparatory drawing for it, in the Bibliothèque Nationale, Paris.[4] It must have been essentially finished by early in the new year, because he hoped to submit an early state of the etching to the Salon of 1853 in March; however, the print was rejected, probably, according to the artist, because it was not completely finished in detail.[5] Later states carry the date 1853 in the plate.

The image is virtually complete in the present example; subsequent additions were limited to shading on the clouds, the distant buildings, and the wings of one of the flying crows at left. In early impressions, such as the Frick's, that he printed himself, Meryon often applied subtle ink tone to the plate, emphasizing features such as the demons' heads and a few spots of sunlight penetrating the pervading umbra. This impression, like several others in The Frick Collection, was owned by

Meryon's great patron Jules Niel, a librarian of the Ministry of the Interior who became his close friend and owned a large collection of his prints and drawings. Meryon gave etching lessons to Niel's daughter Gabrielle, who executed several views of the Near East and a series called *Eaux-Fortes sur le Vieux Paris*.[6]

EXHIBITED: London, Burlington Fine Arts Club, 1879, No. 29.

COLLECTIONS: Jules Niel. J. J. Heywood (No. 47.1 in the 1880 Ellis & White catalogue of his collection). B. B. Macgeorge. Colnaghi. Knoedler (No. 26a in its 1917 Macgeorge catalogue). Frick, 1917.

NOTES

1. The Frick impression (the only one known in this state) was previously thought to be of the first state, but a recently-discovered earlier state has appeared on the art market (reproduced in C. G. Boerner, Düsseldorf, *Neue Lagerliste*, 97, 1991, 1, No. 75). The changes are in the aerial view and in the clouds; apparently the previous work in those areas was largely burnished out and re-etched in the Frick's state, which now becomes the second. The author is grateful to James Bergquist and Susan Kaye for bringing this to his attention.

2. Verdier, 1983, p. 225, No. 38.

3. Reproduced in Frankfurt–Hamburg, 1975, p. 85, No. D 27. The engraving is the chapter heading to Book 3, which includes Hugo's "bird's-eye view of Paris."

4. See Ducros, 1968, No. 714. In a letter of January 3, 1853, to his father (*idem*), Meryon mentioned that he was "engraving part of the Gallery of Notre-Dame."

5. *Idem*.

6. H. Beraldi, *Les Graveurs du XIX^e siècle*, Paris, 1885–92 (reprint, Nogent-le-Roi, 1981), X, pp. 197–98.

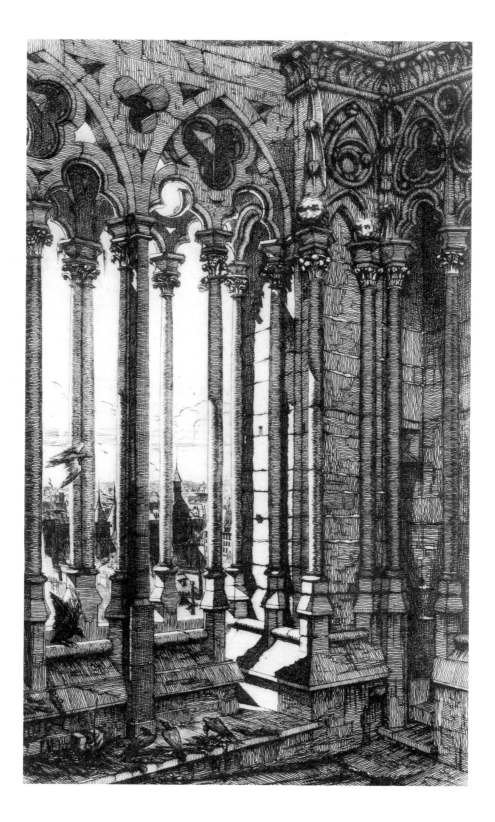

THE ARCH OF THE PONT NOTRE-DAME (16.3.12)

Inscribed in the plate, at left below image: *C. Meryon del. sculp. imp. Rue N^e. S^t. Étienne du Mont 26.*; and at right below image: *Paris 1853.* Etching and drypoint, printed in black ink on pale gray-green modern laid paper, 5¹⁵⁄₁₆ × 7⁹⁄₁₆ in. (15.1 × 19.2 cm).

REFERENCES: Delteil-Wright 25 IV/VII; Schneiderman 28 IV/VII.

INSCRIPTION: In graphite on verso: *C 24452 11780 Sxx.–.*

DESCRIPTION: The horizontal image is dominated by a darkened arch of the Pont Notre-Dame framing a view toward the Pont-au-Change. Above the left end of the latter, on the Île de la Cité, rise the turrets of the Palais de Justice, and partially visible between the turrets and the left pier of the foreground arch are the pilings of the Notre-Dame pump. Men navigate the river at center and at right, while a worker climbs a rope ladder at far right.

CONDITION: The sheet is in good condition.

IN this extraordinary scene looking downstream toward the Palais de Justice, Meryon uses the compositional device, familiar to stage designers, of framing his view within an arch through which an angular recession creates a feeling of depth—here anchored by a distant backdrop (the Pont-au-Change) running parallel to the picture plane. Piranesi employed the same device often, particularly in his architectural fantasies, and the seventeenth-century French etcher Israël Silvestre used it in his own Paris series, in a view of the Louvre seen through an arch of the Pont-Neuf.[1] Meryon's vantage point here is at river level, that of the sailors with whom he always nostalgically identified. The heavy blackness of the arch is particularly oppressive, relieved only by a white cloth hanging on a rickety scaffolding. By leaving a tone of ink over the entire surface of the plate as he printed it, Meryon further enhanced the gloomy atmosphere of the Frick impression.

Although Meryon clearly dated later states of this print 1853, its dating has occasioned some scholarly discussion. The artist's first sketch for this view, now in the Art Institute of Chicago and identical in composition to the final etching, was made with the aid of a camera lucida.[2] Burke dates the sketch about 1850, arguing that it must have been executed at about the same time as a drawing, also done with the camera lucida, for *The Petit-Pont* (see p. 209).[3] He also finds in the composition an obvious source for an early study in Boston for *The Notre-Dame Pump* (p. 221); however, that drawing is dated 1852.[4] In his 1863 catalogue of Meryon's prints, Philippe Burty stated that *The Arch of the Pont Notre-Dame* was the earliest of the

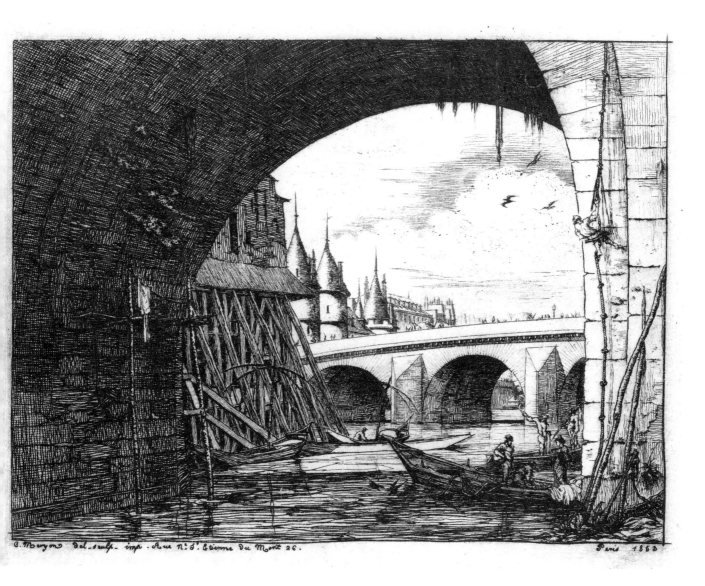

Paris etchings to be finished, but there is no documentary proof for this assertion. Meryon is known to have submitted an impression to the Salon of 1853 in March of that year, and to have sent another one to his father in June.[5] A dating of 1852 to 1853 would seem to be most likely.

Several other drawings have survived for this print, illuminating Meryon's careful method of first establishing the outlines of the composition and then minutely

refining each detail before entrusting it to the copper plate. The final preparatory drawing, in the Clark Art Institute, Williamstown, corresponds exactly in scale and in every feature to the etching.[6] Many of the drawings are on tracing paper, as is typical of Meryon's technique, necessitated by the reversals inherent in the print-making process and by the requirement of topographic accuracy. An impression of the final state of *The Arch of the Pont Notre-Dame* was exhibited in the Salon of 1864.

COLLECTIONS: Bryan Lathrop. Knoedler. Frick, 1916.

NOTES

1. See R. M. Mason, "L'Habitation poétique, et autres états," in Geneva, 1981, p. 120, figs. 6–7. Robison has traced the ultimate source of the device to Andrea Palladio's illustration of the Rialto Bridge in Venice in his *Quattro libri dell'architettura* of 1570 (A. Robison, *Piranesi: Early Architectural Fantasies. A Catalogue Raisonné of the Etchings*, Washington–Chicago, 1986, p. 20).

2. Reproduced in Burke, 1974, No. 20; the drawing is inscribed by Meryon "pris à la chambre claire." The artist also acknowledged using the camera lucida in his autograph *Observations* (see Verdier, 1983, p. 225, No. 37).

3. Burke, p. 43.

4. The Boston drawing is reproduced in Burke, No. 44.

5. See Ducros, 1968, Nos. 713–14. Burty's statement is excerpted in Delteil-Wright, under No. 25.

6. Three preparatory drawings, including the Chicago and Williamstown sheets, are reproduced in Burke, Nos. 21–23. Another detail sketch of river boats is in the Art Institute of Chicago (*idem*, p. 43, note 3).

THE PONT-NEUF (17.3.19)

Etching, printed in brownish-black ink on very thin, tan Japan[1] paper, 7³⁄₁₆ × 7³⁄₁₆ in. (18.3 × 18.3 cm).

REFERENCES: Delteil-Wright 33 IV/XI; Schneiderman 30 IV/X.

INSCRIPTIONS: In graphite on recto: *LD 33^{IV} (From the Wasset collection) 823 Essai de l'eau forte pure (de la main de Meryon sur la monture) 14*; and on verso: *213 fr.*

DESCRIPTION: Viewed from water level, three piers of the Pont-Neuf occupy the right half of the image, receding toward the left to meet the quai. Above the latter rises the corner of an apartment house in shadow. The tops of other apartment buildings and a tall smokestack appear in the middle and right distance. Figures occupy two boats at lower left.

CONDITION: Apart from tears in the upper corners at the site of old hinges, the sheet is in good condition.

THIS compressed, claustrophobic view looks south across the downstream tip of the Île de la Cité, toward apartment buildings on the Left Bank of the Seine. The large chimney at right belching smoke is that of the National Mint. Meryon's low vantage point gives the piers of the bridge a somber monumentality, a sense heightened by the darkened spaces under the arches, which seem not to lead into any light at their far sides. The semicircular turrets on the bridge resemble fortified castle towers, and the overall effect is one of imprisonment. The figures in the boats can be seen as seeking escape from their enclosed space. Meryon's abiding love of the sea may be recalled here, in concert with his sometimes ambivalent love of the confining spaces of Paris, his native city. Meryon wrote to his father in March 1852 of his customary walks along the quais by the Seine that "a view over water is almost a necessity for me."[2] A year later, he wrote to his father of a delay in finishing his series of Paris views, "in order to be able to go see a bit of the sea again. The beaches struck by waves are always dear to me; the land by itself seems sterile."[3]

At the time Meryon drew this view, the Pont-Neuf, built in 1578, was undergoing renovations; they were finished in 1853, the date Meryon later inscribed in the plate.[4] In 1854, he added these eight plaintively appropriate lines of verse to the sixth state, below the image:

> Here lies, of the old Pont-Neuf,
> An exact likeness
> All newly refitted
> According to recent ordinance

229

O learned physicians
Skilled surgeons
Like this bridge of stone
Why can you not treat us?[5]

Meryon sent an impression of *The Pont-Neuf* to his father in 1854, and trusted that he, a surgeon himself, would not disapprove of the sentiments expressed in the verses, "in which it seems to me is found the spirit of your way of regarding medicine."[6]

A detail study in the Bibliothèque Nationale, Paris, shows one of the semicircular bridge piers, occupied by small shops at pavement level.[7] A compositional sketch is in the Toledo Museum of Art.[8] The whereabouts of the final preparatory drawing, once in the Macgeorge collection, are unknown.[9] In the next-to-last state of the print (probably done in the late 1850s or 1861), Meryon reworked the plate to eliminate the large chimney and many of the houses in the distance, thereby lending a greater openness to the composition. An example of Meryon's careful attention to the printing of his plates for special effects is found in an impression of the ninth state in the National Gallery of Victoria, Melbourne, which is inscribed by Philippe Burty: "Meryon told me that this proof, which he valued highly, though I find it a bit somber, is a rainy day."[10]

COLLECTIONS: A. Wasset. B. B. Macgeorge. Colnaghi. Knoedler (No. 33b in its 1917 Macgeorge catalogue). Frick, 1917.

NOTES

1. The paper used for this impression, thinner than that used in other early impressions among the Meryon prints in The Frick Collection, may be of genuine Japanese origin. An impression of the second state in the Art Institute of Chicago (No. 1909.276) is printed on paper with Japanese characters in red ink on the verso (see Burke, 1974, No. 49).

2. Ducros, 1968, under No. 729.

3. *Idem*, No. 416.

4. Burke, p. 60.

5. Meryon had earlier considered a version of the fifth and sixth lines that read "Surgeons, Moralists / Physicians and Jurists." See Verdier, 1983, p. 233, note 41.

6. Letter dated April 17, 1854. Meryon had sent his father an impression in February (Ducros, No. 727).

7. Burke, *loc. cit.*

8. *Idem*, No. 48, repr.

9. Reproduced in Bradley, 1917, p. 241. The drawing is reproduced in reverse; this may be

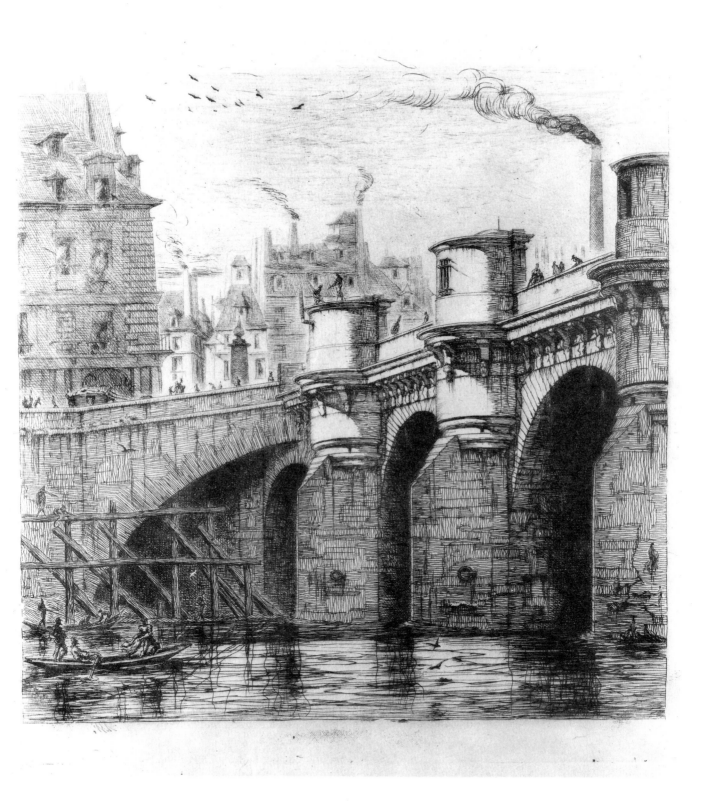

an anomaly, or it could have been executed on tracing paper, which itself was then mounted in reverse. Meryon used tracing paper for most of his preparatory drawings, enabling him to work on both sides of the sheet.

10. No. P.100/1970 (information kindly supplied to the author by Irena Zdanowicz, Curator of Prints and Drawings).

THE RUE DES MAUVAIS GARÇONS (17.3.14)

Etching, printed in black ink on light brown imitation Asiatic paper, 5 × 3⅞ in. (12.7 × 9.8 cm).

REFERENCES: Delteil-Wright 27 I/III; Schneiderman 38 I/III.

INSCRIPTIONS: In graphite on recto: *39.* [with an unidentified monogram that may read *CB*] / *1ᵉʳ état. B LD 27ᴵ From the Niel / & Heywood collⁿˢ*; and on verso: *36.*

DESCRIPTION: On a narrow street, the façades of three houses confront the viewer; harsh sunlight accents shadowed doorways and barred windows. The address *12* appears above the door at left. Two women walk together at lower right, their backs to the viewer.

CONDITION: The sheet is in good condition.

ACCORDING to Philippe Burty, this small but evocative plate was included as a tailpiece to the first installment of the Paris set to be issued,[1] and was therefore not one of the twelve large principal views in the series. Improbable as the name sounds, the Rue des Mauvais Garçons—the Street of the Bad Boys, or Bad Fellows' Street—actually existed, running near the Hôtel de Ville not far from the site depicted in Meryon's *Turret on the Rue de la Tixéranderie* (p. 219). It was partially razed after 1851 to make way for the Rue de Rivoli.[2] Practically deserted in this print, the street is striking for its oppressive air of mystery. The viewer is left to imagine events and inhabitants that would justify its name.[3]

To further this uneasy atmosphere, Meryon has compressed the scene in all dimensions, implying a very narrow alley, and has treated the etched surface of the plate with a roughly bitten tone and lines less delicately rendered than customary. In the third and last state of the etching, he added three verses of equivocal poetry, exhorting the viewer to find out personally who and what dwelt in these houses, whether it was "silent, poor virtue" or "crime—a vicious soul." At some point before 1863, Meryon fashioned a longer version of his poem.[4]

The only known preparatory drawing for this print is in the Bibliothèque Nationale, Paris.[5] The Frick impression, printed on dark-toned paper that renders this already desolate scene even less bright, is one of a small number of examples done before Meryon added the verses and his address. In later impressions, the plate is dated "54" at the end of the poem.

EXHIBITED: London, Burlington Fine Arts Club, 1879, No. 31.

COLLECTIONS: Jules Niel. J. J. Heywood (No. 48.1 of 1880 Ellis & White catalogue). B. B. Macgeorge. Colnaghi. Knoedler (No. 27a in its 1917 Macgeorge catalogue). Frick, 1917.

1. See Delteil-Wright, under No. 27.

2. See Geneva, 1981, p. 51, No. 14, with a detail plan reproduced from T. Jacoubet, *Atlas général de la Ville, des Faubourgs et des Monuments de Paris*, 1836. There has been some confusion in the literature about the location depicted in this print. For instance, Wright stated that the street portrayed here was on the Left Bank, replaced by the present Rue Grégoire-des-Tours, near Saint-Sulpice (Delteil-Wright, under No. 27).

3. The name is said by some to derive from its reputation as the haunt during the sixteenth century of Henry III's male favorites (*mignons*). During the nineteenth century, No. 12 was a house of prostitution (Verdier, 1983, p. 233, note 40).

4. The full text is reprinted in Delteil-Wright, under No. 27, and in Burke, 1974, pp. 48–49; the amended version is cited from a letter to Philippe Burty, in Verdier, *loc. cit.*

5. Burke, p. 48; reproduced in Delteil, 1907, under No. 27. A drawing now in the National Gallery of Victoria, Melbourne, reproduced in Bradley, 1917, p. 245, may depict houses on the same street.

THE VAMPIRE (17.3.10)

Signed in the plate, on a chimney at bottom left: *CM*. Etching and drypoint, printed in dark brown ink on pale gray-green modern laid paper, 6⅝ × 5¼ in. (16.9 × 13.3 cm).

REFERENCES: Delteil-Wright 23 III/VIII; Schneiderman 27 III/X.

INSCRIPTIONS: In graphite on recto at upper right: *35.*; and at bottom: *From the M.*

Niel & Heywood collections / épreuve d'essai terminée, avec le monogramme CM. état non constaté par B. / LD 23[III].

DESCRIPTION: From the right foreground, a winged and horned stone gargoyle surveys an aerial view of Paris. The medieval tower of Saint-Jacques rises above residential buildings in the middle distance. Dark birds soar in front of the beast and around the tower. The entire scene is enclosed within an oval frame.

CONDITION: The sheet is in good condition. There is a small printer's crease at center left.

MERYON originally referred to this print as *La Vigie* (*The Lookout*), inscribing the present title, *Le Stryge* (*The Vampire*), in the plate only in the last two states, datable near 1861.[1] The idea of a lookout may allude to the artist's maritime experiences, with the vampire of Notre-Dame surveying the sea of houses under its gaze.[2] The sculpture Meryon depicted was in fact a recent restoration by Eugène Viollet-le-Duc of an original gargoyle from the porch of the Cathedral by the north tower. Meryon's view is looking north across the Seine toward Montmartre, with the tower of Saint-Jacques-la-Boucherie rising prominently from its site near the Place du Châtelet on the Right Bank. The artist seems to have foreshortened the perspective so that it resembles a photographic view taken through a telephoto lens, both compressing the space and rendering the tower larger relative to the vampire.[3]

Perhaps the most memorable image among Meryon's Paris etchings, this print has occasioned much scholarly and poetic speculation, both as to its meaning and as to the moral significance intended by the artist.[4] The aerial viewpoint is clearly reminiscent of the bird's-eye view from the towers of Notre-Dame in Victor Hugo's novel centering on the Cathedral.[5] But *The Vampire* surely reflects Meryon's own attitude toward the city he was so closely depicting in his series of etchings, striking an inescapably macabre note within the context of the artist's personal attitude of vigilance. Writing to his father in April of 1854, Meryon stated that his monster truly existed, and was the personification of "Luxuria" (Lust).[6] The two lines below

236

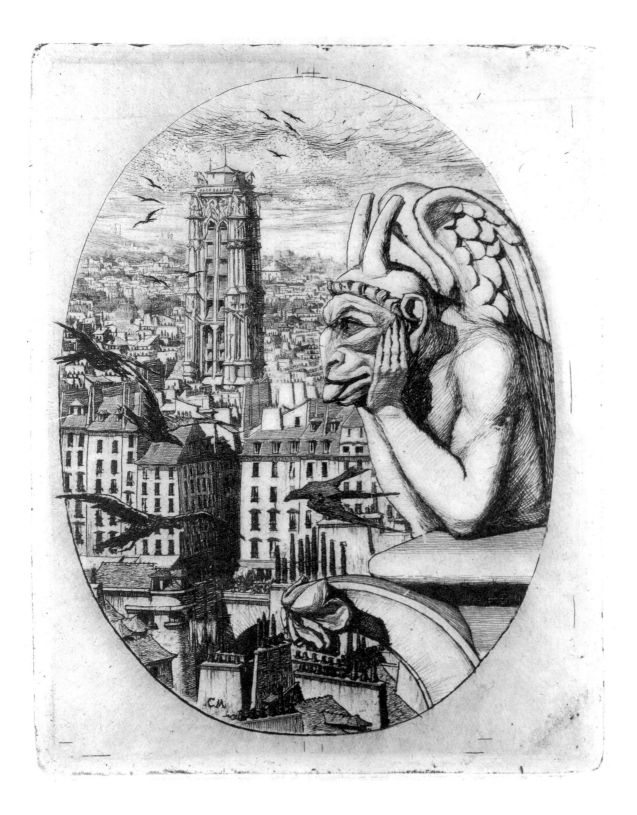

the image that Meryon inserted in the first published state of 1853 (the one following the Frick example) read: "Insatiable vampire, eternal lust / Above the Great City covets its prey."[7]

New as it was, the demon portrayed by Meryon was well known to his audience, and therefore also carried contemporary references; its vantage point over the ever-changing city was a favorite spot for tourists, artists, and photographers. Henri Le Secq, who would later become a friend of Meryon, was documenting the sculpture of the Cathedral at this time and was himself photographed by Charles Nègre standing next to the same gargoyle, probably in the year this etching was completed.[8] Writers have stressed the increased fascination of society with the problems of urban life and health that were becoming manifest at this time.[9] Meryon seems to have subjected the entire urban maelstrom to the double—and perhaps conflicting—gazes of the presumably objective viewer and the malevolent monster. His representation of the sprawling city, concealing a personal drama behind each carefully depicted shutter, surpasses all later imitations in this genre.

The technical means by which Meryon executed *The Vampire* are unusual in that he seems to have worked on the tower and gargoyle independently from the overall aerial view. Two drawings in the Clark Art Institute, Williamstown, that cast light on this process are identical in format but complementary, in that one concentrates on the tower and gargoyle, while the other depicts only the remaining elements of the aerial view.[10] Continuing this polarity (undoubtedly by means of tracings and careful registration), the artist first completely etched only the background cityscape on the plate, leaving the tower and gargoyle blank.[11] Perhaps he intended to experiment with printing the plate in two colors, as he did with several of his New Zealand subjects, among others.[12] However, after printing only two known impressions of that first state, he etched the tower of Saint-Jacques and the gargoyle to complete the image. Although this print was not the first of the Paris series to be executed (being clearly dated 1853 in the plate), Meryon chose to place it first in his 1861 numbering of the set when it was republished at that time. The Frick impression was printed on the pale gray-green laid paper that Meryon favored for much of his subtly toned printing. The impressions on this paper evoke a more subdued, overcast lighting than the warmer, sunnier impressions printed on tan imitation Oriental papers (such as *The Petit-Pont*, p. 209) or off-white European papers (like *The Notre-Dame Pump*, p. 221).

238

EXHIBITED: London, Burlington Fine Arts Club, 1879, No. 20.

COLLECTIONS: Jules Niel. J. J. Heywood (No. 44.1 in the 1880 Ellis & White catalogue of that collection). B. B. Macgeorge. Colnaghi. Knoedler (No. 23c in its 1917 Macgeorge catalogue). Frick, 1917.

NOTES

1. See Verdier, 1983, p. 225, No. 35.

2. Scholars have noted the resemblance of the figure's facial features to the canoe prow sculptures of the Maori in New Zealand, examples of which Meryon drew during his Oceanic voyage (Verdier, p. 232, note 32). One such drawing is reproduced in F. Connelly, "Charles Meryon's Oceanic Sketches: A Precocious Primitivism?" *Print Collector's Newsletter*, XXIV, 1993, p. 47. Connelly argues for Meryon's desire in *The Vampire* "to recover something of a 'primitive' sensibility lost to the modern sophistication of 19th-century Paris"—and thus finds a prototype for the early modern artists' fascination with "primitive" arts.

3. For a contemporary photograph that shows a more realistic view, see E. P. Janis, "The Man on the Tower of Notre Dame: New Light on Henri Le Secq," *Image*, XIX, 1976, p. 22.

4. See: A. M. Holcomb, "*Le Stryge de Notre-Dame*: Some Aspects of Meryon's Symbolism," *Art Journal*, XXXI, 1971–72, pp. 150–57; Janis, pp. 20–21; and Connelly, pp. 44–49, esp. p. 47.

5. As acknowledged by the artist in his *Observations* (Verdier, p. 225, No. 35).

6. Ducros, 1968, under No. 710.

7. In a further reference to Hugo's novel, Verdier (p. 232, note 33) points out that its heroine, Esmeralda, was herself branded a "striga" in the Latin text accusing her of sorcery.

8. Reproduced in Janis, p. 14, and in Burke, 1974, fig. 2.

9. Grad and Riggs, 1982, p. 93.

10. See Burke, Nos. 8, 9, repr.

11. *Idem*, No. 10, repr.

12. See, for example, *The Pilot of Tonga* (Delteil-Wright 64, Schneiderman 59).

THE PONT-AU-CHANGE (16.3.20)

Etching and drypoint, printed in brownish-black ink on pale gray-green modern laid paper, 6⅛ × 13⅛ in. (15.6 × 33.3 cm).

REFERENCES: Delteil-Wright 34 II/XII; Schneiderman 40 II/XII.

INSCRIPTIONS: In graphite on recto below image: *106*; and on verso: *a 65798 / 6981 / B.46 1ᵉʳ etat / H xvx.*

DESCRIPTION: A panorama of the Seine is seen from a vantage point at water level, spanned by the Pont-au-Change in the left middle distance and dominated at right by the Palais de Justice. The tower of the Notre-Dame pump rises above the bridge, which is crowded with people. A balloon inscribed [S]PERANZA floats in the sky at left. Several boats filled with figures ply the river, as a man in distress gesticulates from the water at lower center.

CONDITION: The sheet is in good condition aside from faint traces of an old mat burn.

WRITING to his father, Meryon referred to the *Pont-au-Change* as the tenth print in his Paris series, of a total of twelve he by then envisioned.[1] Within the set, this prospect upriver, with the Île de la Cité on the right, is matched in its wide expanse only by *The Apse of Notre-Dame* of about the same date (see p. 249). Though it was eventually dated 1854 in the plate, the artist had begun this image two years earlier, as evidenced by the highly finished preparatory drawing in the Clark Art Institute, Williamstown, which is dated 1852.[2] An early study for the bridge alone is in the Art Institute of Chicago, and two small sketches for bizarre cloud figures also are in the Clark Art Institute.[3]

This plate saw at least twelve changes of state, primarily involving elements that appear in the sky. Meryon would later replace the balloon seen in this early state with a menacing flock of large black birds, only to remove these and introduce more balloons and a crescent moon in the final states. On one proof of the seventh state in the Metropolitan Museum of Art, New York, Meryon added several pencil sketches in the clouds, including a serpent-headed figure, a chariot driver, and other fanciful shapes.[4] Through all changes of state, the bottom portion of the print, including the river, the bridge, and all the buildings, remains the same.

The Pont-au-Change is perhaps the first print in the Paris series to reflect, through its various metamorphoses, Meryon's increasing mental disorder—a development that proceded from the merely disconcerting atmosphere of *The Gallery of Notre-Dame* (p. 225), for instance, to the plainly unreal, menacing, bird-filled sky in the tenth state of this print. Meryon himself put forth disjointed explanations for its imagery, ranging from a supposed release of eagles by the government in-

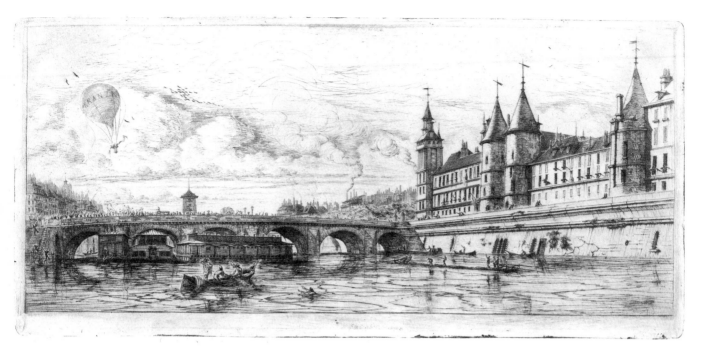

tended to "study omens after the rite"[5] to an acknowledged borrowing from a wood-engraved vignette by Tony Johannot for the balloon labeled *Speranza*.[6] Baudelaire speculated that Meryon's imagery was influenced by the poet's own recently published translation of Edgar Allan Poe's *The Raven*.[7] Meryon altered the last state of the print to include balloons christened *Vasco da Gama*, *L'Asmodée*, *Le Protée*, and *Le Saint-Elme*.[8]

Meryon also etched a separate small plate of verses to accompany at least the early states of the print, titled *L'Espérance* (Delteil-Wright 35; Schneiderman 41). The verses offer a bleak reflection on man's search for a meaningful life, whether as a sailor, a soldier, or a "poor engraver. ... Where alas too often, false mirage, / The hope that entices us, goes to die on the shore."[9] As pointed out by Grad and Riggs, this explicit explanation by Meryon may be reflected in the balloon of Hope rising up out of the viewers' reach, diverting the attention of those who might otherwise aid the drowning man gesturing toward them in the foreground of the peculiarly becalmed river.[10] Burke has even seen a funeral cortege in the close-

pressed crowd crossing the Pont-au-Change.[11] Interestingly, the next year Meryon etched two views of the Pont-au-Change as it appeared in the late eighteenth century, copying drawings by Victor-Jean Nicolle (1754–1826).[12]

COLLECTIONS: A. M. Burritt. Tracy Dows.[13] Frederick Keppel & Co., New York. Knoedler. Frick, 1916.

NOTES

1. Ducros, 1968, under No. 728. In another letter to his father, on February 5, 1854, he wrote, "I believe I've already said that I want to make twelve in all" (*idem*, under No. 727).

2. Reproduced in Burke, 1974, No. 52. An earlier compositional drawing was in the Macgeorge collection (present location unknown; reproduced in Bradley, 1917, p. 249).

3. Burke, pp. 62–63. One Clark cloud study is reproduced as Burke's No. 53; the other is reproduced in E. Haverkamp-Begemann, S. D. Lawler, and C. W. Talbot, Jr., *Drawings from the Clark Art Institute*, New Haven–London, 1964, No. 254, pl. 103.

4. Reproduced in Burke, No. 57.

5. *Idem*, p. 63.

6. See Verdier, 1983, p. 233, note 42. See also J. L. Yarnell, "Meryon's Mystical Transformations," *Art Bulletin*, LXI, 1979, pp. 289–91,

for a hypothesis concerning Meryon's connections with cabalistic circles in Paris, and a mystical-political analysis of this image.

7. Burke, pp. 63–64.

8. See Burke, p. 64, for commentaries on these names.

9. The full text is quoted in both Delteil-Wright and Schneiderman and in Burke, pp. 67–69.

10. Grad and Riggs, 1982, p. 123.

11. Burke, p. 62.

12. *The Pont-au-Change, About 1784* (Delteil-Wright 47; Schneiderman 52) and *The Pont-Neuf and the Samaritan Seen from Under the First Arch of the Pont-au-Change* (Delteil-Wright 46; Schneiderman 53).

13. See *Print-Collector's Quarterly*, I, 1911, pp. 68, 96.

THE MORGUE (17.3.21)

Etching, printed in black ink on cream-colored modern laid paper, 9⅛ × 8⅛ in. (23.2 × 20.6 cm).

REFERENCES: Delteil-Wright 36 II/VII; Schneiderman 42 II/VII.

MARK & INSCRIPTIONS: Watermark: CONTRIBUTIONS DIRECT. Inscribed in graphite on recto at upper right: *48.*; at bottom: *avant retouches et trait. / LD 36ᴵᴵ (From the Niel & Heywood collections) 59.*; and on verso, possibly in the artist's hand: *II.*

DESCRIPTION: The image is almost entirely filled by buildings, leaving only shallow indications of sky at the top and a thin strip of the Seine below, with laundry barges moored to the quai across the bottom of the plate. On the riverside pavement at left, a uniformed officer directs the removal of a body toward the Morgue, the building to the right of center. A mourning woman and child appear to the right of two men carrying the corpse; curious onlookers lean over the parapet of the quai. Smoke belches from two chimneys of the Morgue in front of a row of apartment buildings with many windows, and more smoke issues from a window in the shadows at far left. A stairway to the left of the Morgue leads from the river up to the quai. Strong sunlight from the left creates deep shadows, particularly in the lower left corner.

CONDITION: Other than a horizontal printer's crease beneath the lower platemark and a diagonal one across the lower left corner, the sheet is in good condition.

THIS print is justly famed for its macabre atmosphere and oppressively constructed composition. Its peculiarly compressed space focuses the viewer's eye on the scene as if through a telescopic lens, flattening the picture plane and allowing no relief or escape. Meryon's vantage point was presumably on the Left Bank opposite the Île de la Cité, just downstream from the site shown in *The Petit-Pont* (see p. 209); Notre-Dame Cathedral would be beyond the right margin of the print, and the Pont Saint-Michel would be the source of the triangular shadow at lower left. The Morgue, built in 1568, stood between the two bridges. It once served as a slaughterhouse, a fact that may have influenced Meryon's treatment.[1] At this time it was used to exhibit the unclaimed bodies (most of them fished out of the Seine) of those who had died by murder, suicide, or accident, and was a required attraction for tourists.[2] In a lively discussion of the sights and social life of Paris in 1835, Frances Trollope described a trip to the Morgue:

> No visit to a tomb, however solemn or however sad, can approach in thrilling horror to the sensation caused by passing the threshold of this charnel-house. … I was steadfast in my will to visit it, and I have done it. The building is a low, square, care-

fully-whited structure, situated on the Quai de la Cité. It is open to all; and it is fearful to think how many anxious hearts have entered, how many despairing ones have quitted it.[3]

Although the Paris Morgue had previously been depicted by other artists, Meryon's view has evoked special attention, with its harsh light, disorienting jumble of surfaces, and seemingly matter-of-fact reportage of a daily drama. The artist composed a poem that he etched and included with a few impressions of the print. Entitled *L'Hôtellerie de la mort* (The Inn of Death), the verses are a bleak and satiric recitation of miseries in a dark city that provides its poor and homeless with "free bed and board" at the Morgue, before they find final peace in a "saintly halo of Love and Happiness."[4] Meryon's contemporary champion Philippe Burty wrote of *The Morgue*:

> This pile of roofs, these colliding angles, this blinding light that serves to throw into greater relief the contrasts between the various shadows, this old building that assumes a vague resemblance to an antique tomb under the needle of the artist, all present to the mind an unknown enigma, of which the people speak the sinister word.[5]

Meryon's view of the resonant building, including the personal drama playing itself out in full daylight, undoubtedly reflects his attitude about the dark underside of contemporary life in Paris. The dense overcrowding of the cities is amply symbolized by the cramped houses and the swarming figures who inhabit them; their indifference and the isolation of the two mourners further demonstrate the price of living there. A fire burns, apparently unnoticed, in the shadows at far left. The filthy smoke rising from the Morgue, the stains running down its outside wall, the sewer emptying its contents into the river below the stairs, and the activities of the laundries immediately below combine to emphasize the pollution inherent in cities.[6]

A drawn study for this print survives in the Bibliothèque Nationale, Paris.[7] The Frick impression represents the second state of seven, before the artist etched in his signature and the date 1854. In the fifth state, Meryon changed the date improbably to 1850 and added inscriptions onto the walls of several buildings, including *Sabra Dentiste du peuple* on the house directly above the Morgue and *Hotel des trois balances meuble* on the one at left. Meryon's own printings of the plate varied widely, ranging from cleanly wiped, straightforward effects to more heavily inked impressions, often on duskier papers, that create a distinctly gloomier atmosphere.

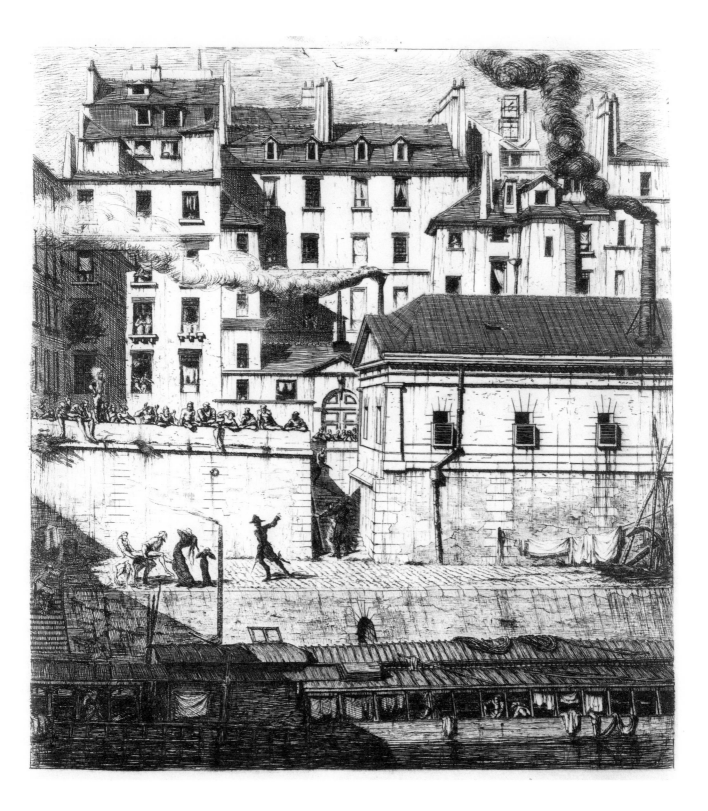

In his manuscript commentary on his work, *Mes Observations*, Meryon reveals his concern for the mood of this print, pointing out several mysterious strokes of the burin that "maliciously disfigured" the expression of one of the men carrying the corpse from a look of commiseration to one of disgust; he often attributed such changes in his plates to occult powers.[8]

EXHIBITED: London, Burlington Fine Arts Club, 1879, No. 66.

COLLECTIONS: Jules Niel. J. J. Heywood (No. 57.1 in the 1880 Ellis & White catalogue of his collection). B. B. Macgeorge. Colnaghi. Knoedler (No. 36b in its 1917 Macgeorge catalogue). Frick, 1917.

NOTES

1. Burke, 1974, p. 69.

2. See, for instance: F. Coghlin, *A Visit to Paris, or, The Stranger's Guide to Every Object Worthy of Notice in that Gay City*, London, 1830, p. 17; and L. Gozlan, "La Morgue," in *Paris, ou Le Livre des cent-et-un*, Paris, 1831, I, pp. 301–32. Champfleury (Jules Fleury-Husson) wrote an early essay, "La Morgue," which was published in *Chien-Caillou, Fantaisies d'hiver*, Paris, 1847, pp. 115–18.

3. F. Trollope, *Paris and the Parisians in 1835*, New York, 1836, p. 194.

4. The full text is transcribed and translated in Delteil-Wright, under No. 37, and in Burke, pp. 71–74. A contemporary, and quite pedestrian, view of the Morgue is reproduced in Frankfurt–Hamburg, 1975, p. 89, upper right. Other views are cited in Burke, p. 70. For a macabre nocturnal portrait drawing by François Bonvin showing a beggar woman in front of the Morgue, see *The Ackland Art Museum: A Handbook*, Chapel Hill, 1983, No. 110.

5. Delteil-Wright, under No. 37.

6. See Grad and Riggs, 1982, p. 126. For one interpretation of the identity of the drowned corpse, see A. E. Miller, "Autobiography and Apes in Meryon's 'Eaux-Fortes sur Paris,'" *Burlington Magazine*, CXLI, January 1999, pp. 4–11.

7. Reproduced in Delteil, 1907, under No. 36.

8. Verdier, 1983, p. 225 and p. 233, note 43; see also note 44 concerning Meryon's etched verses for *The Morgue*.

THE APSE OF NOTRE-DAME DE PARIS (17.3.22)

Etching and drypoint, printed in black ink on cream-colored modern laid paper, 6½ × 11¾ in. (16.5 × 29.9 cm).

REFERENCES: Delteil-Wright 38 III/VIII; Schneiderman 45 III/IX.

INSCRIPTION: In graphite on verso: *31 / LD 38^{III} From the Haden Collection / One of two proofs thus, printed by Delâtre for Haden / in Haden's presence.*

DESCRIPTION: The panoramic view is dominated by the Cathedral of Notre-Dame, rising above the Seine at upper right. The low, arched Pont de l'Archevêché, above which are seen blocks of buildings, extends toward the left margin from the Île de la Cité. Several figures, a cart with two horses, moored boats, and a large anchor appear on the quai in the foreground. In the sky are puffy clouds and flocks of birds.

CONDITION: Other than slight thinning along the upper edge and several small orange metal deposits, the sheet is in good condition.

THIS is perhaps the most picturesque of Meryon's scenes of Paris. Along with the *Pont-au-Change* (p. 241), it presents the greatest expanse of free sky, so that the viewer feels less hemmed in by the crowded city. Meryon's vantage point was on the Quai de la Tournelle, on the Left Bank upstream from the Cathedral, looking west toward its apse, choir, and towers; the Île Saint-Louis would be to the right, beyond the margin of the print. At least two characteristically careful preliminary drawings for this etching survive—the first a rather sketchy view without figures now in the Bibliothèque Nationale, Paris, the second a highly finished drawing in a private collection, New York.[1] In addition, Burke cites nine detail studies also in the Bibliothèque Nationale.[2]

Burty called this Meryon's "most beautiful" plate, directly comparing its importance and its identification with Notre-Dame Cathedral to Victor Hugo's novel celebrating the same monument. In his *Observations*, Meryon humbly accepts the comparison to "one of the great names of our era."[3] The plate was published as the final large view in the *Etchings of Paris* series, and can therefore be seen as its capstone. It was exhibited in the Paris Universal Exhibition of 1855.[4] The less foreboding, almost sunny atmosphere is remarkable; Meryon's omnipresent flocks of birds and occasional smoking chimneys remain as the only reminders of the darker presences so dominant in his other views of the city. Many contemporary artists—as well as photographers—were attracted to this picturesque vantage point, including the British landscapist Thomas Girtin and the Dutch painter Johan Barthold Jongkind.[5]

The Frick impression is of the third state of the plate, finished in all details but

247

done before Meryon had etched his signature and the date 1854 below the subject. The inscription on the verso of the sheet (see above) reveals that the famed Paris printer Auguste Delâtre proofed this impression, probably on an etching press in Meryon's studio.[6] Meryon also etched a brief poem concerning *The Apse of Notre-Dame*, which sardonically ends with a description of the Cathedral as massive, yet still "too small to hold even the élite of our least sinners!"[7]

EXHIBITED: London, Burlington Fine Arts Club, 1879, No. 74 or 75.

COLLECTIONS: Sir Francis Seymour Haden (No. 22b in the 1901 catalogue of his collection, H. Wunderlich, New York). B. B. Macgeorge. Colnaghi. Knoedler (No. 38b in its 1917 Macgeorge catalogue). Frick, 1917.

NOTES

1. Both are illustrated in Bradley, 1917, pp. 225, 227 respectively. For the New York sheet, see also Burke, 1974, fig. 4.

2. Burke, p. 76, note 2.

3. Verdier, 1983, p. 225, under No. 50.

4. Ducros, 1968, Nos. 427, 735.

5. Burke (p. 76) argues that Meryon's composition may derive from a strikingly similar painting by Jongkind datable to 1848–49. For a photographic view, see Frankfurt–Hamburg, 1975, No. P15.

6. An impression of this state in the National Gallery of Art, Washington, is inscribed by Delâtre "Fourth proof. The most beautiful that I have printed from this plate" (R. E. Fine, *Lessing J. Rosenwald: Tribute to a Collector*, exhib. cat., National Gallery of Art, Washington, 1982, p. 82). Burke, p. 29, refers to a fifth-state impression of *Pont-au-Change* (p. 241) inscribed by Delâtre "printed by me at my friend Meryon's." Burke surmises that Meryon carefully distinguished states of his etchings that he printed himself from those printed by others; but in light of Delâtre's known collaboration, Burke's statement that Meryon printed all impressions of early states of his etchings remains unprovable.

7. Delteil-Wright 39; Schneiderman 46. This plate is extremely rare; Schneiderman records only two impressions of the first state and none of the second.

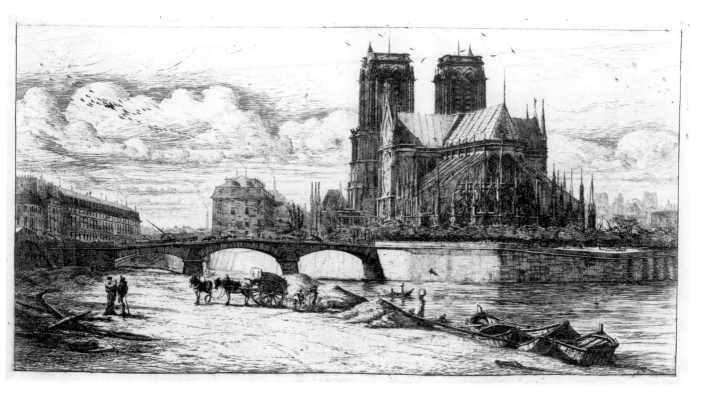

THE RUE DES TOILES AT BOURGES (17.3.23)

Signed and dated in graphite, below image: *C. Meryon del. sculp. 1853*; signed in the plate, on a shield by the door of the house at far right: *M*; dated in the plate, on the chimney at far right: *1853*. Etching, printed in black ink on pale gray-green modern laid paper, 8⁵⁄₁₆ × 4⁵⁄₈ in. (21.1 × 11.8 cm).

REFERENCES: Delteil-Wright 55 II/IX; Schneiderman 31 II/IX.

INSCRIPTIONS: In graphite on recto at bottom: *Trial proof 1ˢᵗ St B 58*; and on verso: *From the Mlle. Niel & Thibaudeau collections LD.55¹ (now 2nd state)*.

DESCRIPTION: A cramped row of medieval houses, most of them in deep shadow, extends along a narrow street or alleyway that recedes into the left distance. At the left is the façade of a tall house seen in severely foreshortened perspective. The second house from the right is brightly highlighted; a tree grows to the right of it. Various figures appear in doorways along the street.

CONDITION: The sheet is in good condition.

MERYON intended this print to form part of a series of views of the city of Bourges, one that would parallel his *Etchings of Paris*. He visited Bourges in 1850 and 1851 and executed numerous drawings. A set of ten plates was projected, to include "views of the old quarter of the City and its decaying houses," as outlined in an 1854 letter to the Ministry of the Interior.[1] However, the artist etched only three plates: *Doorway to an Ancient Convent* in 1851 (Delteil-Wright 54, Schneiderman 21); the present plate in 1853; and *An Old House, or The Musician's House* (Delteil-Wright 56, Schneiderman 70).[2] Two manuscript title pages indicate that Meryon planned to call the series *Two Views of Streets and Fragments of the Middle Ages*.[3]

Meryon clearly was attracted to the picturesque aspects of the old houses of the city, elements he felt would soon disappear, as was happening so rapidly in Paris. He in fact was forced to cobble together features from different houses to construct this scene of the Rue des Toiles. It is thought that he used a daguerrotype view to draw from, then replaced the ground floors, which had been modernized, with features from houses in other quarters of the city.[4] The final preparatory drawing for the print is in the Art Institute of Chicago.[5]

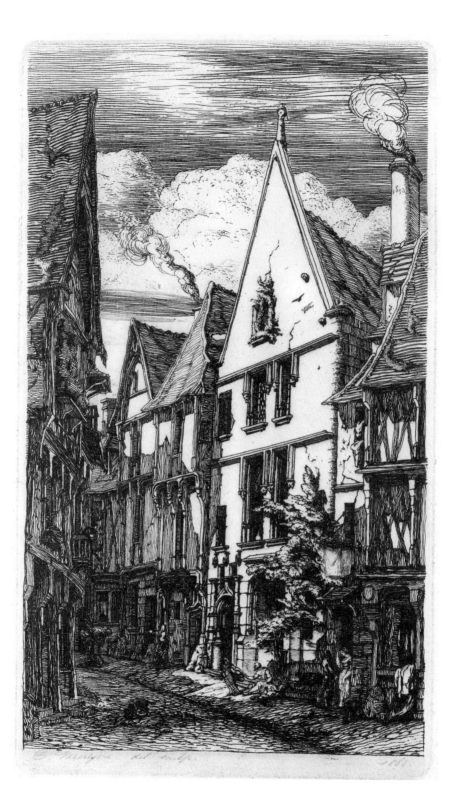

COLLECTIONS: Gabrielle Niel. A.W. Thibaudeau. B.B. Macgeorge. Colnaghi. Knoedler (No. 55a in its 1917 Macgeorge catalogue). Frick, 1917.

NOTES

1. Delteil-Wright, under Nos. 54–56.

2. *An Old House* is dated 1860 by Wright and Schneiderman, but documentary evidence for that date is its publication that year in the *Gazette des Beaux-Arts*. The preliminary drawing is dated 1852, and the plate could have been etched at that time.

3. Delteil-Wright, under Nos. 54–56.

4. Burke, 1974, pp. 90–91.

5. *Idem*, No. 87, repr.

JAMES McNEILL WHISTLER

1834–1903

Whistler was born in Massachusetts, studied in Paris, and spent most of his career in London, with frequent trips abroad. For a brief review of his life, see the biography that appears on p. 114, where the three pastel drawings by him in The Frick Collection are discussed. The text below summarizes his career chiefly as it pertains to his etchings and lithographs.

WHISTLER AS PRINTMAKER

DURING the course of his career, Whistler executed some four hundred and fifty etchings and drypoints and about one hundred and eighty lithographs. Printmaking was central to his work, helped to defray considerable expenses, and reflected the various styles and experiments that were crucial both to his own evolution and to contemporary aesthetic movements. His imagery and the technical means he developed for etching and printing his plates influenced not only his fellow printmakers in Europe and America but many others subsequently.[1] Like Rembrandt—to whose etched work critics often compared his own[2]—Whistler rarely copied his painted compositions; he preferred to draw his subjects directly on the plate, occasionally incorporating motifs from drawn sketches.[3] The Frick Collection owns thirteen prints by Whistler, comprising the twelve etchings known familiarly as the First Venice Set and a lithograph after Whistler's oil portrait of the Comte de Montesquiou, which also hangs in The Frick Collection. In addition, the Collection owns a lithograph version of the Montesquiou portrait by Whistler's wife, Beatrice, as well as the three above-mentioned drawings, done in Venice at the same time as the etchings.

Whistler learned the craft of etching in 1854–55 while employed briefly at the United States Coast and Geodetic Survey in Washington. He published his first set of genre studies, entitled *Douze Eaux-fortes d'après nature*, in Paris in 1858. Known popularly as the French Set, it was printed by the celebrated Auguste Delâtre, who became the favored printer for artists associated with the etching revival in France

253

and England during the 1860s—and who, incidentally, had printed much of Charles Meryon's work. Beginning at this time, Whistler spent extended periods with his half-sister and her husband, the physician and etcher Sir Francis Seymour Haden (1818–1910). The two artists experimented together, and Whistler learned much from studying Haden's extensive print collection, which included many fine Rembrandts and other Old Masters in addition to contemporary French etchings.

Whistler's residence in the London dock area of Wapping starting in 1859 led to his series of etchings known as the Thames Set, and 1859 also saw the exhibition of two etchings at the Paris Salon (although a painting entry was rejected). Whistler's move toward Aestheticism and away from strict realism developed in the later 1860s, during which time he etched few prints. The period of his work for the Liverpool shipowner Frederick Leyland produced several haunting drypoint portraits of the Leyland family and others, remarkable for their elegant yet spare qualities.

During 1879 and 1880, Whistler spent fourteen months in Venice, where he completed some fifty etchings. From these, both of his so-called Venice Sets evolved, the first in 1880 (see below), the second in 1886. The later 1880s saw series of prints of subjects found in Paris and Amsterdam, along with a growing interest in lithography, which the artist had taken up seriously in 1878. In 1900 Whistler won a grand prize for etching in the Paris Exposition Universelle.

Whistler exercised considerable influence on the connoisseurship of printmaking and print collecting. He experimented with different aesthetics of creating printed images, printing them, and even framing and exhibiting them. He printed most of his later etchings himself, varying the qualities of each impression more than any previous artist save Rembrandt. He self-consciously trimmed the impressions of his prints to the platemark, leaving only a small tab for his signature, in reaction to the mania of contemporary collectors for wide margins on Old Master prints.[4] Whistler had a great influence on print collecting, particularly in the United States, and was crucial to the formation of many of the country's finer printrooms.[5] No collector's portfolio at the turn of the century was considered worthy without the prints of Rembrandt, Meryon, and now Whistler.[6] Indeed, these three artists form the core of The Frick Collection's group of master prints, rigorously reflecting the hierarchy in print connoisseurship during the second decade of the twentieth century, when Mr. Frick was making his print purchases from M. Knoedler & Co. in New York.

D. P. B.

THE FIRST VENICE SET (15.3.41–15.3.52)

INTRODUCTION

GENERAL DESCRIPTIVE NOTES: All twelve prints are signed in graphite on a small tab below the platemark with Whistler's butterfly monogram followed by the abbreviation *imp* (for *impressit*), indicating that he printed the plate himself. In addition, all but one—*Nocturne*—are signed in the plate with the butterfly monogram. None of the plates are dated. The scenes are subtly etched, with touches of drypoint added on all but *The Piazzetta*. Exept for *The Traghetto, No. 2*, they were printed in various brownish-black inks, ranging from warm to dark, with extensive use of ink tone evident throughout the set. All of the paper is cream-colored, but the manufacture differs; only *The Traghetto, No. 2* bears a watermark. For further specifications, see separate entries below.

CONDITION: In general, the twelve prints are in very good condition.

255

WHISTLER had planned to visit Venice at least as early as 1876, when he issued a prospectus for a series of prints of that city.[7] His famous libel suit of 1878 against John Ruskin and the increasing financial troubles it entailed delayed his intentions, but in the summer of 1879 he announced in *The Academy* his renewed plan to travel to Venice and publish a set of twenty views.[8] That September, he was able to secure a commission from the Fine Art Society of London to furnish a set of twelve plates of Venice for an advance of £150, with delivery promised by December 20. Earlier that year, the Society had purchased the plates for the Thames Set and published it in a second edition, along with several individual new prints.[9]

Whistler arrived in Venice on September 18. He was not to return until November of 1880, despite increasingly frantic entreaties from the Fine Art Society, thus delaying the exhibition of his Venice etchings by almost a year. He came back with a total of fifty etchings, one hundred pastels, and a number of watercolor and oil sketches.[10]

Whistler had arrived in Venice officially bankrupt, with his home and possessions about to be auctioned; the Fine Art Society's fee and a few supplementary personal grants were his only support.[11] Complicating his problems, there were no sophisticated printers or dealers in art supplies in the city, and he was sometimes forced to ask friends to send him suitable papers for proofing his new plates.[12] He had brought about two dozen blank plates with him, but he was able to acquire more of these in Venice.[13] While there, he made the acquaintance of the American artist Frank Duveneck and a group of his students, one of whom, Otto Bacher, offered Whistler the use of his own printing press and became Whistler's printing assistant during his stay in the city.[14] Although he printed progressive proofs of most of his plates in Venice, Whistler produced no full editions until after his return to London.

In developing his images, Whistler drew onto the copper plates directly at the site, deliberately seeking out less familiar scenes. In a letter to Marcus Huish of the Fine Art Society in January of 1880, he stated, "I have learned to know a Venice in Venice that the others never seem to have perceived."[15] The city had of course been enormously popular with European travelers, particularly the English, and countless painters had celebrated its views; among Whistler's models were Guardi, Canaletto, and especially Turner, whose atmospheric abstractions undoubtedly had a significant influence on his own approach. Whistler's lack of interest in complete topographical accuracy is reflected in the fact that he did not bother to reverse his

views before drawing them on the plate; hence, the resulting prints are not topographically correct. Many of the sites depicted have been identified by Grieve.[16]

In Venice, Whistler further developed the increasingly atmospheric, almost minimal, graphic and coloristic style that he had pioneered in the mid 1870s with his famed *Nocturne* oils. He evolved an etching style approaching the abstract for some of his more experimental prints, often combining the sketchiest lines etched into his plates with carefully manipulated tones of ink applied during printing. Other plates are composed of dense webs of textured, scratched lines covering larger areas of the surface. Throughout the set, there is a tendency toward two-dimensionality, reflected in high horizon lines in the longer vistas and an almost claustrophobic, flat frontality of textured surface in such prints as *Two Doorways* (p. 287). Whistler also pioneered an innovative means of drawing his views, working outward from the center of the composition so that he could stop at any point and still achieve a finished image, concentrating first on the detail or motif of greatest interest in the subject depicted.[17] He also used this technique in combination with the familiar device of vignetting images in a more nebulous space.[18]

The original title for the Fine Art Society's commission was "Venice, Whistler. Twelve Etchings." The composition of the set remained in flux even after Whistler's preliminary selection was finally installed in the Fine Art Society exhibition in the last days of November 1880.[19] A schematic drawing now at Wesleyan University showing images from the set includes all but one of the etchings that appeared in the final group;[20] it is clear from an early printed checklist and from published reviews that the etching *The Bridge* (Kennedy 204) was at first among the works shown, only to be replaced by *The Little Mast* (p. 269). Whistler controlled every aspect of the installation, consistent with his sophisticated aesthetic of interior decoration and theories of looking at works of art. According to reports, the set of twelve etchings was hung on a single line in a room by itself, three works to a wall, alternating horizontal and vertical compositions and further interspersing scenes with land in the foreground and those with water. The prints were arranged against a maroon-colored fabric, and numbers corresponding to the printed checklist were roughly chalked beneath each work.[21] After fulfilling his obligation under the terms of the Fine Art Society commission, Whistler made a further selection of twenty-one Venice subjects that were included in a set of twenty-six etchings published by Dowdeswell & Dowdeswell in 1886, often referred to as the Second Venice Set.[22]

257

As noted above, Whistler did not begin to print the edition of the first set for the Fine Art Society until his return to London, after he had made his final selection and had access to better presses and materials. As the Society had specified an edition of one hundred impressions of each of the twelve plates, the printing job was a major one, particularly since Whistler would not entrust it to a commercial printer. He had been taking increasing pains with the printing of his new plates, producing a virtually unique impression each time. In fact, the printing of the Society's set dragged on for years, with editions of two prints—or possibly more—completed only posthumously.[23] As the work progressed, Whistler did train at least two assistants in London to help in the printing, Walter Sickert and Mortimer Menpes, both of whom became printmakers very much in the Whistlerian mode.[24]

Whistler's innovations in printing his Venice etchings were crucial to the effect—and to the criticism—that these extremely atmospheric and sketchily-worked images elicited. He took infinite pains with the selection of his papers, the color of his inks, and the inking of the plates. His practice of leaving a film of ink on the surface of the copper plate and then manipulating it, as opposed to wiping the surface completely clean, had its most notable precedent in Rembrandt's use of similar tonal printing. More recently, he had witnessed Auguste Delâtre create atmosphere by similar manipulations of plate tone in printing plates for his contemporaries. It is also possible that Whistler was stimulated by seeing Otto Bacher and other students in Duveneck's Venice circle create full-fledged monotypes by painting with ink directly on an unetched plate and printing the image, usually in but a single readable impression.[25]

Whistler also took great care with the actual etching—the biting—of each plate, delicately controlling the acid and its corrosive action, largely through the use of a feather.[26] At least one plate, *Little Venice* (p. 263), was not etched until after his return to London.[27] Occasionally he would add accents to his plates in drypoint, and several plates from the set show changes in the figural staffage, particularly during the early proofing stages. Bacher marveled at Whistler's ability to capture ink from the most subtly etched lines in his prints:

All the theory Whistler hinted at was delicacy of biting, of printing, and of dry-point. Delicacy seemed to him the keynote of everything, carrying more fully than anything else his use of the suggestion of tenderness, neatness, and nicety.[28]

Most of the early proofs from the Venice plates were printed in black ink, but Whistler switched to brownish tones for the final printing of the series. The Frick set is done in various brownish tones, some with a golden, warm effect and others quite dark; different impressions of the same plates vary as much in ink color as in wiping effects.[29]

The innovative, increasingly suggestive linear style of Whistler's Venice etchings, combined with their tonal printing, marked a significant departure from the accepted conventions of contemporary etching, and the critics did not unanimously welcome them. One went so far as to say, "On the whole, we think that London fogs and the muddy old Thames supply Whistler's needle with subjects more congenial than do the Venetian palaces and lagoons."[30] Only eight sets were sold from the exhibition, and it was a financial disaster.[31] But after a showing of Whistler's Venice pastels in January of 1881 fared considerably better, the print-collecting public converted. The Venice etchings became objects of competition (as Whistler had probably intended) among collectors and dealers seeking "selected proofs," as so annotated by the artist—at times on demand.[32] The Frick set does not carry such annotations.

COLLECTIONS: Ernest Dressel North. Knoedler. Frick, 1915.

WHISTLER REFERENCES CITED IN
ABBREVIATED FORM

BACHER, 1909: O. Bacher, *With Whistler in Venice*, New York, 1909.

CHICAGO, 1998: The Art Institute of Chicago, *The Lithographs of James McNeill Whistler*, I, *A Catalogue Raisonné*, ed. H. K. Stratis and M. Tedeschi, Chicago, 1998.

FINE, 1984: R. E. Fine, *Drawing Near: Whistler Etchings from the Zelman Collection*, exhib. cat., Los Angeles County Museum of Art, Los Angeles, 1984.

GETSCHER, 1971: R. H. Getscher, *Whistler and Venice*, Ann Arbor, 1971.

GETSCHER, 1977: R. H. Getscher, *The Stamp of Whistler*, exhib. cat., Allen Memorial Art Museum, Oberlin College, Oberlin, Ohio, 1977.

GRIEVE, 1996: A. Grieve, "The Sites of Whistler's Venice Etchings," *Print Quarterly*, XIII, 1996.

KENNEDY, 1910: E. G. Kennedy, *The Etched Work of Whistler*, New York, 1910.

LEVY, 1975: M. Levy, *Whistler Lithographs: A Catalogue Raisonné*, London, 1975.

LOCHNAN, 1984: K. A. Lochnan, *The Etchings of James McNeill Whistler*, New Haven–London, 1984.

MACDONALD, 1995: M. F. MacDonald, *James McNeill Whistler: Drawings, Pastels, and*

Watercolours, A Catalogue Raisonné, New Haven–London, 1995.

MCNAMARA AND SIEWERT, 1994: C. McNamara and J. Siewert, *Whistler: Prosaic Views, Poetic Vision*, New York–Ann Arbor, 1994.

WAY, 1905: T. R. Way, *Mr. Whistler's Lithographs: The Catalogue*, London, 1896; 2nd ed., London–New York, 1905.

WAY, 1912: T. R. Way, *Memories of James McNeill Whistler*, London–New York, 1912.

WHISTLER, 1890: J. M. Whistler, *The Gentle Art of Making Enemies*, London, 1890.

WIEHL, 1983: M. L. Wiehl, *A Cultivated Taste: Whistler and American Print Collectors*, exhib. cat., Davison Art Center, Wesleyan University, Middletown, Connecticut, 1983.

NOTES

1. See especially Getscher, 1977.

2. In *The Reader* of April 4, 1863, William Michael Rossetti commented: "As an adept in the technicalities of etching ... Mr. Whistler stands quite exceptionally high; one might cast about in one's mind to name his superior since the days of Rembrandt" (quoted in Getscher, 1971, p. 206).

3. For a number of his earliest etchings at the time of the French Set (1858), Whistler did execute preliminary drawings, which he then transferred directly to his plates. See Lochnan, 1984, p. 38 (especially note 6), pls. 43, 47, 52, 54.

4. *Idem*, pp. 212–13. See also R. Fine, in R. Dorment, M. F. MacDonald, *et al.*, *James McNeill Whistler*, New York, 1995, p. 183, under No. 103.

5. On this, see in particular Wiehl, 1983.

6. *Idem*, p. 11, quoting from an 1887 English newspaper review. However, to the renowned English print historian A. M. Hind (*A History of Engraving & Etching*, rev. ed., London, 1923, pp. 327, 324), "the most notable representative[s] of the art in the nineteenth century" were Haden and Alphonse Legros, while Whistler was only "the greatest personality in the history of etching."

7. Getscher, 1971, pp. 7–8, note 5. For reference to a preliminary list of subscribers at that time, see also Fine, 1984, p. 21.

8. *The Academy*, July 18, 1879. See Getscher, 1971, p. 28, for the text of the announcement, which added: "these will in all probability be followed at some later period by a second series ... of studies in Holland and on the banks of the Seine."

9. Lochnan, pp. 178–79.

10. Dorment, MacDonald, *et al.*, p. 179. The etchings are listed in Kennedy, Nos. 183–232.

11. Getscher (1971, pp. 42–43, note 14) discusses Whistler's very real poverty during his Venice sojourn, quoting a line from a letter written by Henry Wood in August 1880: "Whistler has been borrowing money from everybody." This was in stark contrast to the high style of living the artist had enjoyed only a few months previously.

12. Lochnan, p. 185. Whistler also haunted Venetian bookshops seeking antique papers as he could find them.

13. See Getscher, 1971, pp. 34–47, for an extensive discussion of the plates used for the Venetian prints, of which a fairly large number have survived.

14. Bacher's valuable personal reminiscences were published in his *With Whistler in Venice*, New York, 1909.

15. Lochnan, p. 184.

16. Grieve, 1996, pp. 20–39.

17. *Idem*, p. 189.

18. See Getscher, 1971, pp. 48, 54–55, 62.

19. *Idem*, pp. 154–65. Bacher (pp. 155–56) speaks of Whistler often debating choices between the "Fine Art's" set and his other Venetian prints.

20. See MacDonald, 1995, No. 836. The drawing was also described as a preliminary selection in Way, 1912, p. 43. Getscher (1971, pp. 154–57) discusses the sketch carefully, pointing out the reversal of the images in most of the subjects (probably because they were drawn directly from the plates), and surmising that the top two lines of six subjects each were Whistler's choice at the time, with the two single prints below as alternates. The twelve sketched at the top included *San Biagio* (Kennedy 197) but did not include *The Little Mast* (Kennedy 185) from the final set. Subsequently, *The Bridge* (Kennedy 204—one of the single sketches at bottom) was shown in the Fine Art Society exhibition in place of *San Biagio*, but was finally replaced in the published set by *The Little Mast*.

21. See Getscher, 1971, p. 164, and D. M. Bendix, *Diabolical Designs: Paintings, Interiors, and Exhibitions of James McNeill Whistler*, Washington–London, 1995, pp. 217–18.

22. See Lochnan, pp. 232–36.

23. By 1887, only fifty-six of the hundred sets had been completed (Wiehl, p. 24; Lochnan, p. 221). See also Fine, pp. 23–24 and note 36, for a discussion of the printing and continued reworking of the plates.

24. Lochnan, pp. 220–21.

25. These efforts were dubbed "Bachertypes" (see Bacher, pp. 116–17). Getscher (1971, pp. 66–73) disputes Bacher's influence and argues for Whistler's acquaintance with the monotypes of the Vicomte Ludovic Lepic, an amateur French printmaker and friend of Degas. Lochnan (p. 213) quotes A. Hyatt Mayor's report that Whistler enhanced the effect of his tonal printing by heating his copper plates "hot enough to calender the damp paper," thereby creating a glossy sheen on the surface of the impression.

26. Bacher (p. 109) offers a valuable eyewitness account.

27. Wiehl, pp. 24–25, No. 28.

28. Bacher, p. 103. See also p. 112 for a description of Whistler's actual wiping technique.

29. The New York Public Library owns an original set printed entirely in black ink; see Wiehl, p. 24, under No. 25.

30. *Daily News*, December 7, 1880 (quoted in Fine, p. 23). Whistler published several of the critics' choicest remarks in the catalogue of his 1883 Fine Art Society exhibition, entitled *Mr. Whistler and his Critics: A Catalogue* (reprinted in Whistler, 1890, pp. 91–105). For an analysis of Whistler's attitude toward his critics and the potential audience for his prints, see M. Tedeschi, "Whistler and the English Print Market," *Print Quarterly*, XIV, 1997, pp. 15–41, esp. p. 34 for reference to the Venice etchings.

31. Lochnan, p. 216.

32. See, for example, Wiehl, p. 25, under No. 34.

LITTLE VENICE (15.3.41)

Signed in the plate, at lower left, with the butterfly monogram; signed in graphite on a tab below the platemark with the butterfly monogram and *imp*. Etching and drypoint, printed in brownish-black ink with light tone on dark cream-colored heavy wove paper, 7⅜ × 10½ in. (18.6 × 26.6 cm).

REFERENCE: Kennedy 183 (only state).

DESCRIPTION: The skyline of Venice dominates the far-off horizon, with scattered clouds indicated cursorily above. Several sketchily drawn gondolas float in the middle distance, and four mooring posts rise from the water nearer the viewer.

CONDITION: The sheet is in good condition aside from slight surface abrasion at the upper edge, especially in the hinge areas.

WHISTLER left no clear indication of either the order in which he executed the plates that comprise the First Venice Set or his preferred sequence of presentation within the group.[1] This uncertainty was already apparent at the time of the Fine Art Society's exhibition in 1880: while the original printed checklist was numbered (with the present work as No. 1), the numbers do not coincide with the order in which the prints were actually hung. *Little Venice* does in effect serve as an introduction to the set, depicting every visitor's first glimpse of the fabled skyline as seen across the water. It is one of the sketchiest plates in the series, its radical expanse of unworked area at the bottom of the composition evoking the similarly blank skies in several of Rembrandt's landscape etchings.[2] Much of the atmospheric effect of water and sky is due to Whistler's tonal inking of the plate in printing each impression; the Frick example is very delicately overlaid with a light tone, darkening slightly toward the foreground at the bottom of the plate as though the artist had wiped it with a circular motion.

Little Venice may in fact have been one of the later subjects to be drawn on the plate in Venice, for Whistler did not actually etch the plate until after his return to London, where the printer Thomas Way witnessed the operation.[3] Whistler seems to have touched up the gondola at right with drypoint accents. On the other hand, the full edition of this print was one of the first to be completed; the canceled plate was delivered to the Fine Art Society in December of 1889.[4] As usual with his Venetian etchings, Whistler did not bother to render the subject in reverse on the plate; hence, this evocative view is a mirror image of topographical truth.

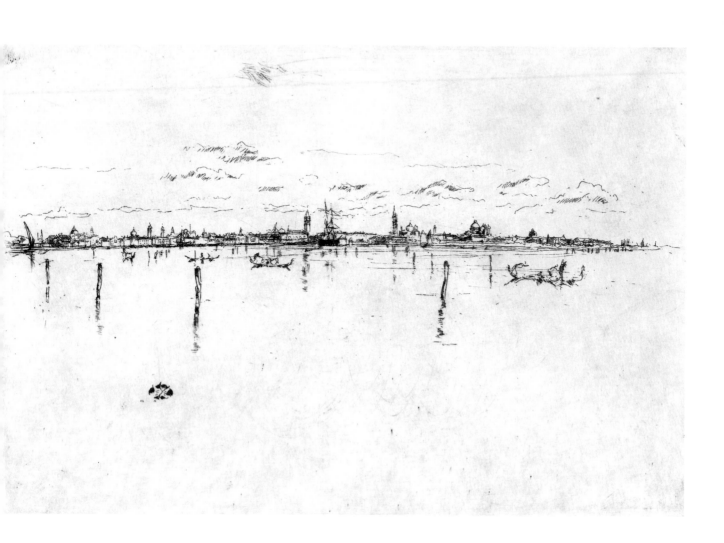

1. The order followed here is that used in Kennedy's catalogue raisonné and that of The Frick Collection's accession numbers. The curatorial files of the Collection indicate that the prints were so labeled by Knoedler at the time of their purchase, but they also record another numbering sequence that does not correspond to any discovered by the present writer. The order given in the printed checklist for the Fine Art Society's 1880 exhibition is reproduced in Lochnan, 1984, p. 214; however, that sequence still included *The Bridge* (Kennedy 204), which was later replaced by *The Little Mast* (see p. 268). Getscher, 1971, p. 164, lists the order of hanging in the 1880 exhibit and argues for a subtle balance of horizontal and vertical compositions, of those that include water and those that primarily depict land scenes.

2. In McNamara and Siewert, 1994, No. 33, Siewert draws a particularly close parallel with Rembrandt's *View of Amsterdam* (Bartsch 210).

3. Wiehl, 1983, pp. 24–25, No. 28.

4. Fine, 1984, No. 65.

NOCTURNE (15.3.42)

Signed in graphite on a tab below the platemark with the butterfly monogram and *imp*. Etching and drypoint, printed in brownish-black ink with tone on dark cream-colored Japanese paper, 8 × 11⅝ in. (20.2 × 29.5 cm).

REFERENCE: Kennedy 184 III/V.

DESCRIPTION: The Venice skyline extends across the horizon, with a broad expanse of water below. The profiles of S. Marco and the Campanile rise above the city toward the right, balanced at left by a three-masted steamship. Several gondolas float in the middle distance. All is reflected in the water, the surface of which is indicated by the barest of etched lines.

CONDITION: An old crease extends from upper left toward lower right at the top of the subject. Surface abrasion is visible in the area of the hinges at upper left and right and in the water below the steamship.

THE most dramatic print in the First Venice Set, *Nocturne* achieves its effect largely through the manner in which Whistler manipulated the ink tone on the surface of the plate. The actual etched lines are few—none in the sky and mere strokes in the water. Each impression of *Nocturne* differs in visual impact; the artist evoked dramatically different lighting and weather conditions by leaving varying amounts of ink tone on the unworked plate surface, primarily the large areas of sky and water.[1] The Frick impression is comparatively restrained, with slightly darker values in the water at the bottom, particularly at lower left, and in the sky at upper right. The delicately rendered mood suggests the quiet of dusk and fading daylight. Feathery strokes of drypoint, periodically reinforced through the course of printing the edition, create the particularly ephemeral quality of the floating gondolas. In a subtle touch on some impressions, Whistler carefully depicted on the steamship a decklight gleaming through the darkness.

The effect of such radically innovative printmaking cannot be overestimated; critics had never before seen anything like it. As one caustically remarked:

> *Nocturne* ... can hardly be called, as it stands, an etching; the bones as it were of the picture have been etched, which bones consist of some shipping and distant objects, and then over the whole of the plate ink has apparently been smeared. We have seen a great many representations of Venetian skies, but never saw one before consisting of brown smoke with clots of ink in diagonal lines.[2]

Others, however, soon realized the connections between such fluid, painterly printmaking and related works by Whistler in oil and pastel that had already captured viewers' imaginations. A closely related pastel, entitled *Nocturne: Venice*, is in The

Frick Collection (see p. 119). Of the only two major oils that Whistler is known to have painted in Venice, one is a very similar view of steamship, skyline, and gondolas; now in the Museum of Fine Arts, Boston, it is entitled *The Lagoon, Venice: Nocturne in Blue and Silver*.[3]

A proof of *Nocturne* dated 1879 and inscribed "1st state—1st proof" survives at the University of Glasgow, the only Venice view dated to Whistler's early days in the city.[4] The artist had finished the edition of *Nocturne* by April of 1889, when he delivered the canceled plate to the Fine Art Society; it is now in the Metropolitan Museum of Art, New York.[5]

NOTES

1. See Lochnan, 1984, pp. 198–99, pls. 229–32, for four variant impressions, including one in the National Gallery of Art, Washington, that is totally covered by a dense plate tone evocative of murky darkness.

2. *British Architect*, December 10, 1880, quoted in Fine, 1984, under No. 59.

3. A. McL. Young, M. F. MacDonald, *et al.*, *The Paintings of James McNeill Whistler*, New Haven–London, 1980, I, No. 212, II, pl. 151.

4. See Getscher, 1977, p. 95.

5. Lochnan, p. 197, pl. 228.

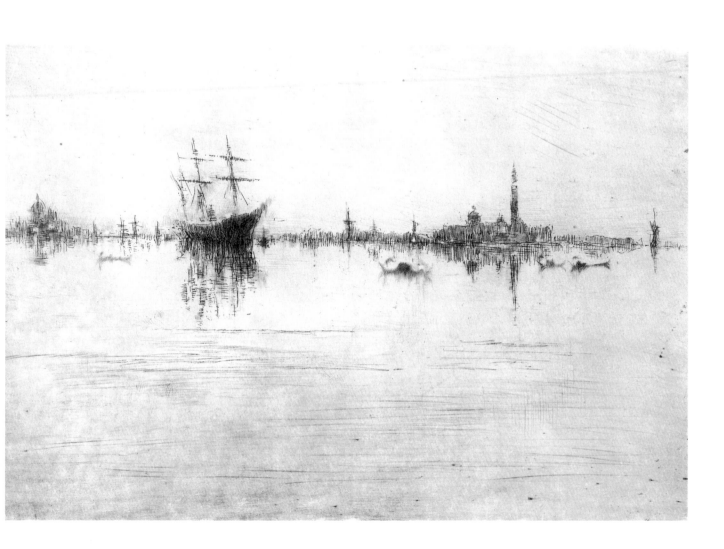

THE LITTLE MAST (15.3.43)

Signed in the plate, at upper right, with the butterfly monogram; signed in graphite on a tab below the platemark with the butterfly monogram and *imp*. Etching and drypoint, printed in dark brown ink with tone on cream-colored laid paper, 10½ × 7⅜ in. (26.6 × 18.6 cm).

REFERENCE: Kennedy 185 I/IV.

DESCRIPTION: A view of a small piazza is dominated by a tall mast that nearly bisects the composition. A row of buildings with apartments above shops anchors the left edge of the image, while the right side is indicated by a sketchy fragment of another building. The masts of a large ship and the sails of smaller boats appear at the horizon. Figures in groups populate the walkway near the water's edge, and some children stand clustered in the foreground.

CONDITION: The sheet is in good condition.

The Little Mast was probably the last of the works that Whistler selected for inclusion in the Fine Art Society portfolio. It does not appear among the thumbnail sketches on the above-mentioned sheet at Wesleyan (see p. 257), which otherwise includes all the prints in the First Venice Set, and indeed it was substituted after the Fine Art Society exhibition had opened, replacing *The Bridge* (Kennedy 204).[1] Whistler's choice of this image probably related to its functioning as a pendant to *The Mast* (p. 293); the two exemplify the sort of modest views of the city that held greater appeal for Whistler than the grand vistas theretofore more popular. The artist later quoted the critic P. G. Hamerton's snide remark on the pair, with his own snider retort:

> The Mast and the Little Mast are dependent for much of their interest, on the drawing of festoons of cord hanging from unequal heights. [Whistler's] Reflection: At the service of critics of unequal sizes.[2]

The Little Mast reveals the great variety of graphic manipulation of the etched line that Whistler utilized in his Venice prints, from the relatively fully delineated façades at left to the scratchily depicted paving stones, the cursory children, the faintest cloud lines, and the delicate drypoint touches in the masts of the ship at center. On the Frick impression, a brown ink tone has been lightly applied over the entire surface of the plate, turning slightly darker in the shadows of the building at right.

NOTES

1. See Getscher, 1971, pp. 160–62.
2. From *Mr. Whistler and his Critics*, quoted in Whistler, 1890, p. 100.

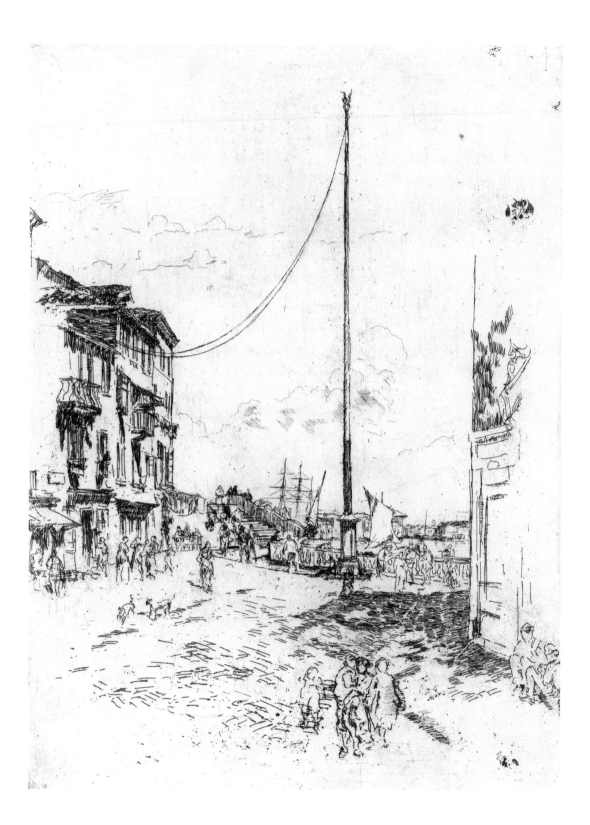

LITTLE LAGOON (15.3.44)

Signed in the plate, at lower right, with the butterfly monogram; signed in graphite on a tab below the platemark with the butterfly monogram and *imp*. Etching and drypoint, printed in dark brown ink with tone on dark cream-colored antique laid paper, 9×6 in. (22.7×15.3 cm).

REFERENCE: Kennedy 186 II/II.

DESCRIPTION: A large vessel lies at the upper center of the composition, its two masts crossing the high horizon. Several gondolas surround it, and other boats appear on the horizon. Two mooring posts rise from the water at lower left.

CONDITION: Other than old repairs at the hinges at the upper corners, the sheet is in good condition.

ANOTHER of Whistler's seemingly slight images of Venice, *Little Lagoon* is a remarkably serene evocation of a peaceful evening on the water. The only activity depicted is that of Whistler's characteristically bug-like gondoliers plying the waters. The artist's vision here demonstrates his innovative modesty of theme—no grand vista or featured tourist sight—and his economy of technical means. In terms of technique, Fine has compared this plate with Rembrandt's similarly spare *The Goldweigher's Field* (p. 179).[1] The horizon is quite high, a device reinforced by the vertical format, and much of the effect of the etching is determined by the careful tonal wiping in the lower, watery area of the plate during printing.

The Frick impression is characterized by a subtle, warm light brown ink tone, creating a shimmering effect on the surface of the water in the middle distance. The tone gradually darkens toward the bottom of the plate. The paper used in this impression is an antique laid sheet, undoubtedly taken from an old book.[2] *Little Lagoon* is the smallest of the plates in the First Venice Set.

NOTES

1. R. Dorment, M. F. MacDonald, *et al.*, *James McNeill Whistler*, New York, 1995, p. 193, under No. 114.

2. The darker brown edges of the sheet identify its only previously exposed surfaces, as in a bound volume.

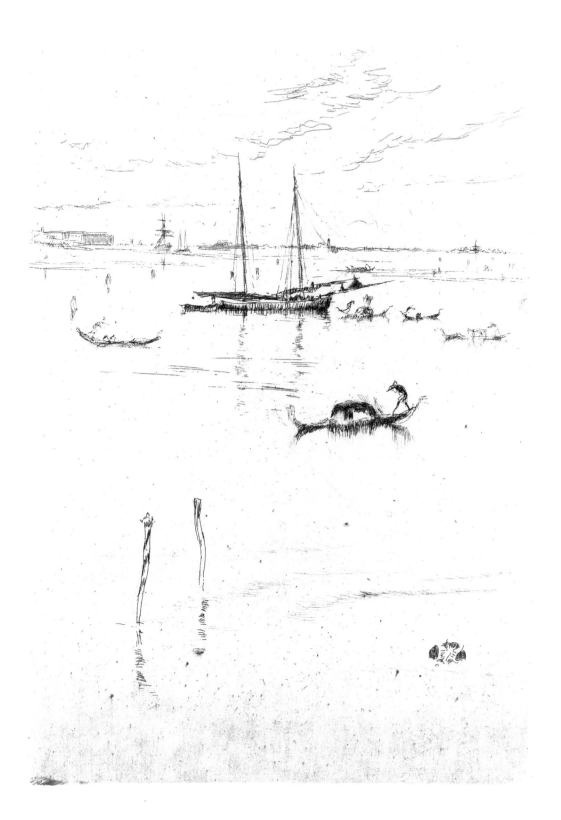

THE PALACES (15.3.45)

Signed in the plate, at upper left, with the butterfly monogram; signed in graphite on a tab below the platemark with the butterfly monogram and *imp*. Etching and drypoint, printed in dark brown ink with tone on cream-colored antique laid paper, 10 × 14⅛ in. (25.3 × 35.9 cm).

REFERENCE: Kennedy 187 II/III.

DESCRIPTION: The horizontal image is dominated by the ornate façades of two grand Venetian palaces rising above a canal. Several gondolas are tied up before them, and others ply the water. A glimpse of a distant vista appears at left.

CONDITION: An old horizontal crease runs about 5 cm below the upper platemark; surface abrasion appears along the crease and in places where there are foreign objects in the paper.

The Palaces is the largest plate in the First Venice Set—indeed, the largest that Whistler ever etched. It depicts the façades of two buildings on the Grand Canal: the Palazzo Sagredo, admired by John Ruskin in his Venetian writings, and the smaller Palazzo Pesaro to the right.[1] Whistler characteristically does not name the sites, although this is perhaps the most reportorial plate in the series, albeit reversed from topographical truth. It also is one of the most graphically complex, full of descriptive detail that covers much of the surface. Yet even while the depiction is apparently objective and straightforward, the entire mass of buildings and boats appears to float magically on the water, as there is little to anchor the composition to the bottom of the plate. *The Palaces* is an elaborate example of Whistler's vignetting technique and follows his method of working outward from a central point of interest. Here that point seems to be the darkened doorway of the Palazzo Sagredo, with a small figure enigmatically framed within it, as is common in the artist's Venetian etchings.

The technical means used to etch this image are equally complex. In addition to the latticework of varying etched lines that make up the descriptive portrayal of the buildings, Whistler laid down a subtle etched plate tone, most visible around the left-hand doorway of the Palazzo Sagredo, on the façade of the Palazzo Pesaro, and (more lightly) in the sky above the palace roofs. Combined with a subtle application of ink tone on the plate during printing, this etched tone imparts a gritty texture evocative of the architectural surface itself.[2] As is usual within the First Venice Set, the inks used to print impressions of this plate vary within a range from warm brownish tones to cooler shades of black. The Frick impression is printed in brownish ink with a fairly evenly applied plate tone, darkening somewhat in the area of the water.

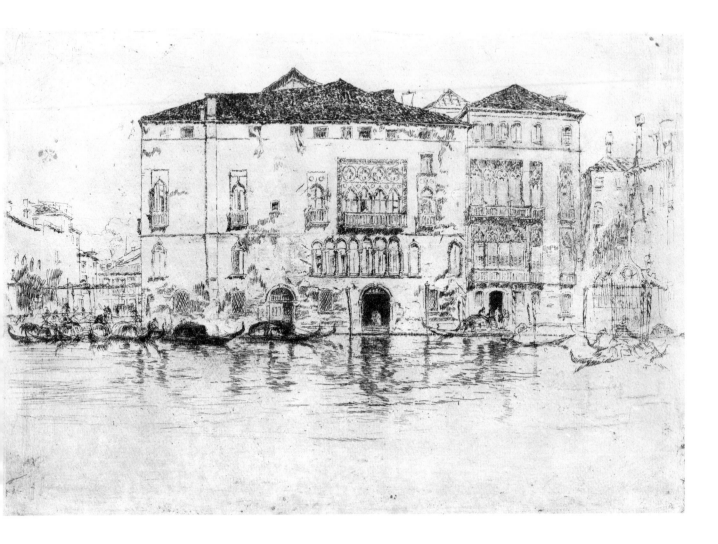

NOTES

1. For a recent photograph of the palaces, see Grieve, 1996, p. 29, fig. 18.

2. This bitten tone, with its sandpaper-like quality, results either from a form of aquatint or, more probably, from acid applied directly to the plate—an intentional foulbiting. Whistler's purposes are made clear by his careful application of stopout to prevent the tonal biting from appearing in areas he wished to leave clean. See Fine, 1984, p. 123, No. 54.

273

THE DOORWAY (15.3.46)

Signed in the plate, above the window at upper left, with the butterfly monogram; signed in graphite on a tab below the platemark with the butterfly monogram and *imp*. Etching and drypoint, printed in dark brown ink with tone on dark cream-colored antique laid paper, 11½ × 7⅞ in. (29.2 × 20.1 cm).

REFERENCE: Kennedy 188 IV/VII.

DESCRIPTION: An elaborate arched doorway flanked by two latticework windows is seen close to the picture plane. Water rises to the lowest doorstep, above which a young woman stands at right. A second figure appears within the darkened interior.

CONDITION: A vertical crease runs about 5.2 cm from the left platemark. Some abrasion is visible in the area of the water.

WHISTLER was fascinated with both the pictorial and literal functions of doorways, and depicted them often in his Venetian etchings. At least one other plate in the First Venice Set, *Two Doorways* (see p. 287), overtly features them, and three more utilize the theme of figures standing within doorways or passageways: *The Palaces*, *The Traghetto, No. 2*, and *The Beggars* (pp. 273, 281, 291). In addition, such Venetian images as *The Balcony* (Kennedy 207), *Doorway and Vine* (Kennedy 196), and *Nocturne, Furnace* (Kennedy 213) display this motif prominently. In all of these, the doorway is parallel to the picture plane and is seen within a series of receding planes; the plate-mark of the etching visually implies a further doorway. Often, ambiguous figures stand within the door frame or the interior space seen through it.

The present plate is a classic example of Whistler's preoccupation with this theme, elaborated by the ornately detailed architecture of the doorway and by the careful delineation of practically every facet of it. Otto Bacher reproduced a photograph of the model for the door in his book *With Whistler in Venice*, remarking that Whistler drew the plate from his gondola about "fifteen or twenty feet across the canal near the Doge's palace."[1] More recently, the building has been identified as the Palazzo Gussoni on the Rio de la Fava, built around 1500.[2] Getscher points out that Whistler contrasted the great age of the architecture with the youthful woman, and even exaggerated the grand scale of the doorway by placing her slight, stooping figure within it.[3]

Although its reviewer liked in general the Fine Art Society's exhibition of the First Venice Set, *The Times* pedantically said of this plate that Whistler "did not capture the sharp contrast between the Byzantine and Renaissance ornament which

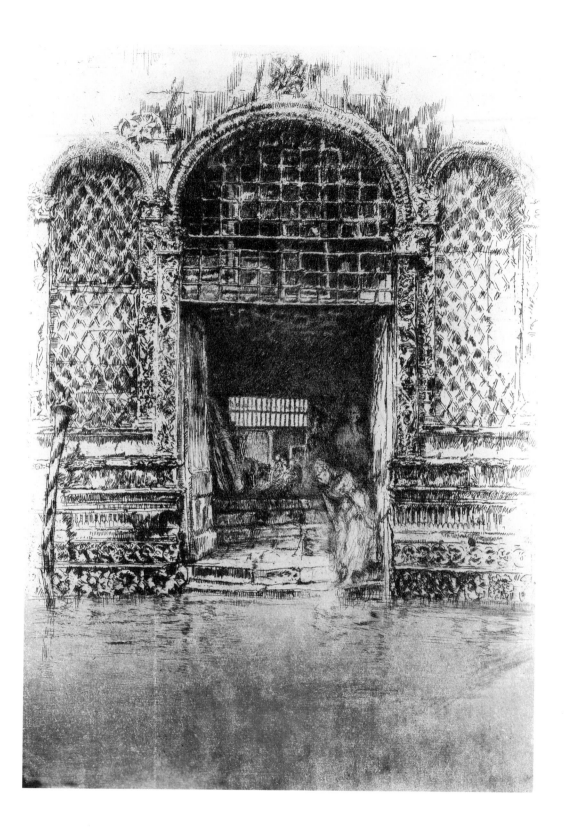

was the particular feature of the actual building."[4] Ironically in this connection, Bacher relates an anecdote in which Whistler quizzed him as to the objects dimly seen hanging within the darkness beyond the doorway. Bacher, who correctly identified them as rush-bottomed chairs, remarked that Whistler "often asked questions of this kind in order to make sure that he was describing rightly to other eyes."[5] The artist subtly incorporated his butterfly monogram as an integral feature of the architectural decoration.[6]

The Doorway is remarkable within the First Venice Set for almost totally filling the surface of the plate with detail, while still retaining Whistler's characteristic style of seeming to float his composition within a vignetted area on the paper—here surrounding the deep penetration of space within the doorway. The Frick impression is printed with a tone of dark brown ink, especially richly applied in the water. Carefully handling the surface of the water, Whistler wiped the plate so as to portray the reflections of the architectural elements. The figures of the young woman in the doorway and of those seen through it are subtly wiped to heighten their presence. Some of the fuzzy tones within the water are achieved by a light application over the etching ground of a roulette, a small tool with a pointed wheel that is rolled over the plate surface.

NOTES

1. Bacher, 1909, pp. 193–95.
2. See Grieve, 1996, p. 33, fig. 22.
3. Getscher, 1971, p. 86.
4. *Idem*, p. 219.

5. *Idem*, p. 194.
6. As observed in McNamara and Siewert, 1994, p. 105.

THE PIAZZETTA (15.3.47)

Signed in the plate, at the base of the column at left, with the butterfly monogram; signed in graphite on a tab below the platemark with the butterfly monogram and *imp*. Etching, printed in dark brown ink on dark cream-colored antique laid paper, 10 × 7⅞ in. (25.5 × 18.1 cm).

REFERENCE: Kennedy 189 IV/V.

DESCRIPTION: The Piazzetta—seen in reverse—is crowded with figures and birds. The façade of S. Marco at left is largely obscured by the lower portion of the column of St. Theodore, around the base of which sit several people. The Torre dell'Orologio stands at the far end of the square, with three flagpoles rising before it at right.

CONDITION: Except for occasional small rust spots, the sheet is in good condition.

STANDING with the Grand Canal behind him, Whistler depicted this most famous site in Venice with typical understatement, deliberately obscuring the famed façade of the basilica of S. Marco with the blunt base of the statue of St. Theodore, populated by loungers. The most recognizable building is the clock tower—the Torre dell'Orologio—at the far end of the square. Situated around the corner from the Piazza di S. Marco, the Piazzetta was depicted by every view-artist of Venice, from Renaissance topographical painters through Canaletto to Whistler's contemporaries.[1] As usual, Whistler did not bother to reverse his view, so it is a mirror image of topographical truth.

In contrast to most scenes in the First Venice Set, this image bustles with figures and activity. Except for *The Riva, No. 1* (see p. 285), all of the other prints show quiet corners of the city or peaceful vistas over the water. Whistler captured his view of the Piazzetta with the casualness of a modern tourist who has just rounded the corner onto the square while on a snapshot-taking tour through the city. The Piazzetta virtually bursts with people and birds, and Whistler reflects the crowd with an equivalent graphic noise and texture. He combines the finely detailed façade of the clock tower with mere fragments of other buildings and with sketchy figures, at times not even indicating facial features. One of the more highly finished etchings in the series, *The Piazzetta* was seldom printed with significant plate tone; the Frick impression does show some tone on the figure leaning against the column, but it otherwise carries only a slight overall tint. The printing of the edition was completed by mid June of 1892; the copper plate is now in the Freer Gallery of Art, Washington.[2]

NOTES

1. See, for instance, the representative views reproduced in *The Origins of the Italian Veduta*, exhib. cat., Bell Gallery, Brown University, Providence, 1978, fig. 4 and Nos. 25, 26, 28, and 54.

2. Fine, 1984, p. 125, No. 55.

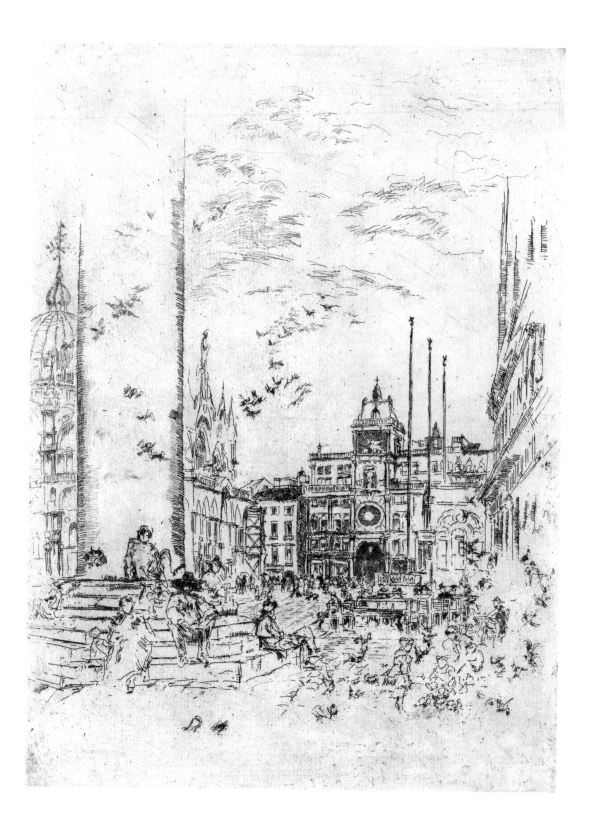

THE TRAGHETTO, No. 2 (15.3.48)

Signed in the plate, on the wall at left, with the butterfly monogram; signed in graphite on a tab below the platemark with the butterfly monogram and *imp*. Etching and drypoint, printed in grayish-black ink with tone on cream-colored laid paper, 9½ × 12 in. (24 × 30.5 cm).

REFERENCE: Kennedy 191 IV/VI.

MARK: Watermark: *1814*.

DESCRIPTION: Four men sit around a table at right beside the entrance to a large, arched passageway. At the far end of the passage appear more figures and gondolas on a canal. Several slight trees stand in the foreground; at far left a child holds a baby.

CONDITION: A horizontal crease runs about 4 cm below the upper platemark, and occasional surface abrasion appears over foreign particles embedded in the paper.

THIS is the second of two versions of the same composition. Whistler had previously drawn the scene in virtually identical fashion, except that the passageway was shown more nearly at center. Having decided that the result was overworked, he sought to replicate the essentials of the design on a new plate and carry that one to completion. Bacher describes in detail the careful technical process Whistler used to transfer to the new plate just those lines he wished to carry through to the second design.[1] The task challenged Whistler, for even after his return to London and during the final preparations for his 1880 Fine Art Society exhibition he burnished out a great deal of the composition on the second plate and re-etched it before finishing it.[2]

The resultant print is among the richer in texture of the set, with the deep shadows in the passageway achieved through a dense network of etched lines supplemented by drypoint to create more depth. The atmosphere is simultaneously casual and mysterious, with its group of men sitting at right, its isolated children at the left edge of the composition, and the great, dark void in between. McNamara has remarked on the dynamic tension between the deep recession seen in the passageway and the flatness created by means of the screen of bright leaves falling before the blackness of the passage, a spatial technique that Whistler incorporated from Japanese prints.[3] The Frick impression is printed in a cool, grayish-black ink with some tone, the wiping marks most clearly visible at bottom right. Although it is difficult to determine, more ink may have been applied in the dark shadows of the passageway. Unlike the other plates in the set, this one was printed frequently in black ink, even beyond the early states; the copper plate, now in the Freer Gallery of Art, Washington, was canceled by mid June of 1892.[4]

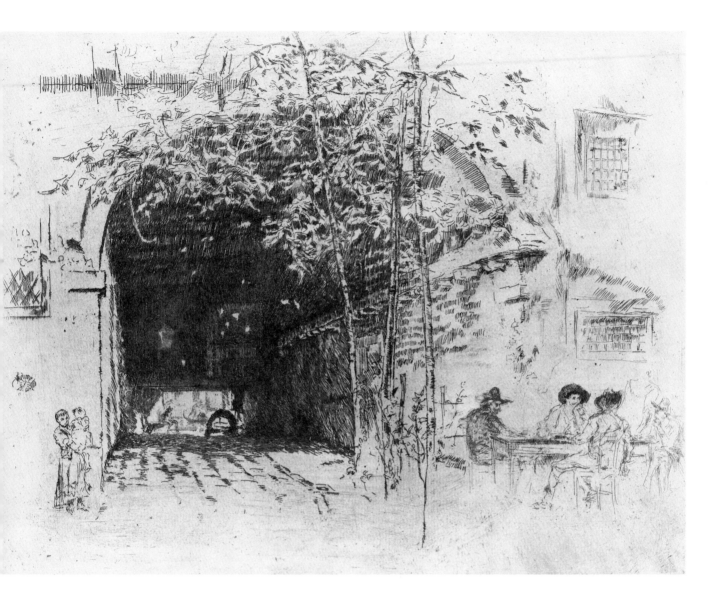

NOTES

1. Bacher, 1909, pp. 165–80.

2. Getscher, 1971, p. 77. Thomas Way's description of Whistler's last-minute corrections is quoted in McNamara and Siewert, 1994, p. 97.

Getscher (p. 81) notes a related charcoal drawing in the Freer Gallery of Art, Washington.

3. McNamara and Siewert, *loc. cit.*

4. Fine, 1984, p. 113, No. 49.

THE RIVA, No. 1 (15.3.49)

Signed in the plate, on the wall at upper left, with the butterfly monogram; signed in graphite on a tab below the platemark with the butterfly monogram and *imp*. Etching with drypoint, printed in dark brown ink with tone on cream-colored laid paper, $7^{15}/16 \times 11^{5}/8$ in. (20.1 × 29.5 cm).

REFERENCE: Kennedy 192 III/IIIa.

DESCRIPTION: Dominating the lower half of the plate is a quay seen from above, dotted with groups of figures. It curves from bottom right toward upper left, where an arched bridge leads over a narrow canal and onto an adjacent quay. A receding row of façades extends along the top of the composition. Boats are moored along the embankments, and several gondolas cross the water. A large, square building fills the upper left corner.

CONDITION: A crease runs horizontally about 3 to 4 cm from the upper platemark. Occasional surface abrasion appears in areas where particles are embedded in the paper.

WHISTLER etched two almost identical versions of this scene. The view is from the windows of his rooms in the Casa Jankovitz, where he lived during the latter part of his Venetian stay, and where Otto Bacher and other American students of Frank Duveneck also had their studios; once again, the etching is reversed from nature.[1] The second version, *The Riva, No. 2* (Kennedy 206), has fewer figures, eliminates several boats at center, and cuts off the Campanile (seen here in the upper right corner). Both versions probably combine at least two vantage points to encompass all that Whistler includes. The open area in the foreground is the public square before the church of S. Biagio, and the sweep of the structures at the top follows the Riva degli Schiavoni toward the domes of S. Marco and the Campanile.

The two versions of *The Riva* differ most markedly in the arrangement of the figures, reflecting Whistler's attention to this aspect of his Venetian etchings. Although seemingly subsidiary elements, his figures were often the subject of many changes between printed states as he reworked them during the proofing stage or even while printing editions. In *The Doorway* (see p. 275), for example, Whistler continually modified the demeanor and age of the young woman. Similar alterations occurred in *The Mast* (p. 293). Figures were especially important in establishing the often enigmatic mood of quieter prints, such as *The Traghetto, No. 2* (p. 281).[2]

The technique of *The Riva, No. 2* is somewhat cleaner and eliminates various compositional details, confirming it as the second, more considered version of the scene. It is therefore intriguing to speculate upon Whistler's decision to include the present version among his first set of twelve etchings for the Fine Art Society. Getscher

surmises that the figures at lower right in the revised composition may have seemed too similar to those he used in *The Traghetto, No. 2*.[3] Whistler did, however, include *The Riva, No. 2* in the Second Venice Set of 1886, perhaps intending that the scene serve within each set as an overall contextual reference for the more out-of-the-way sites.[4] A sketch of the scene now in the Cleveland Museum of Art was probably done between the two etchings.[5] Frank Duveneck etched a very similar scene of the Riva at the same time as Whistler, causing at least one celebrated instance of confusion between the two etchers.[6]

NOTES

1. For a recent photograph of the site, see Grieve, 1996, p. 37, fig. 27.

2. See Getscher 1971, p. 82.

3. Getscher, 1977, p. 74.

4. McNamara and Siewert, 1994, p. 92.

5. Getscher, 1971, pl. 2; MacDonald, 1995, No. 734. MacDonald feels that the drawing is an incomplete pastel.

6. Lochnan, 1984, p. 217; for the Duveneck print, see p. 219, pl. 249.

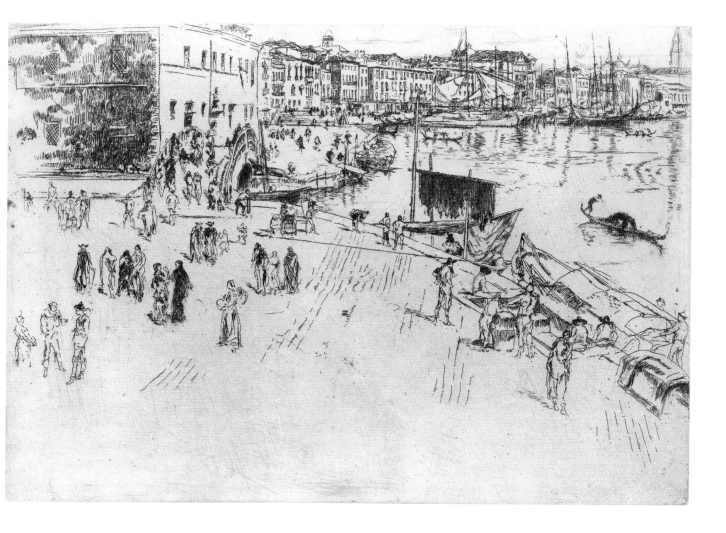

TWO DOORWAYS (15.3.50)

Signed in the plate, on the wall to the left of the open doorway, with the butterfly monogram; signed in graphite on a tab below the platemark with the butterfly monogram and *imp*. Etching with drypoint, printed in brownish-black ink with tone on cream-colored antique laid paper, 8 × 11½ in. (20.3 × 29.3 cm).

REFERENCE: Kennedy 193 IV/VII.[1]

DESCRIPTION: The façade of a building with two large, arched doorways curves along the edge of a canal from the left foreground toward the right. Two figures (or possibly more) appear inside the open doorway at left. Buildings line the opposite side of the canal at right.

CONDITION: There are old repairs in the hinge areas at the edges of the sheet.

THIS eccentric view of a twilit corner of Venice typifies Whistler's seeking out of the city's forgotten aspects. The site is the junction of the Rio del Fontega dei Tedeschi and the Rio de la Fava, quite near the palace depicted in *The Doorway* (p. 275).[2] In his loving depiction of the old brick façade that stretches across the plate, the artist recalls Meryon's obsessive detailing of the old stones of Paris (see pp. 201–49), although the latter usually included notable landmarks in his views. Not only is *Two Doorways* claustrophobic in effect, offering only one means of escape, at right, but the ambiguity of its title, implying a choice, is also subtly unsettling. Whistler has incorporated several contrasting motifs of open and closed doorway and window, solids and voids, and light and dark tonalities. Suspended inexplicably over the water, the viewer feels like a voyeur, spying on the figures in the darkened doorway at left. The still surface of the canal echoes the quiet mood of the scene.

Whistler lavished great care on his depiction of the doorways and the foreground building, including some bitten tone applied in the shadows and elsewhere. The Frick impression was printed with a brownish plate tone, darker in the doorways; other impressions show more plate tone in the water at the bottom of the image. The printing of *Two Doorways* was finished by mid June of 1892. The plate is now in the Hunterian Art Gallery, University of Glasgow.[3]

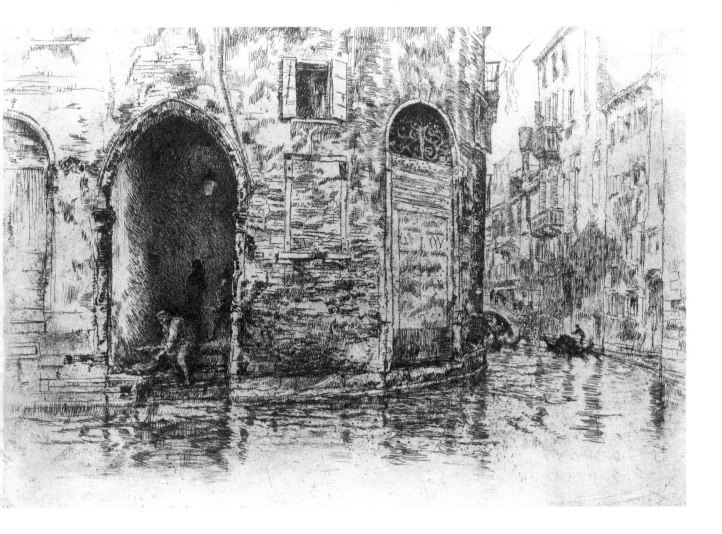

NOTES

1. Although the Frick impression matches the illustration of the third of six in Kennedy's reproductions, Kennedy noted in an addendum to his catalogue another state before his previous first, therefore making seven states in all, with the Frick's representing the fourth state.

2. Grieve, 1996, p. 35, fig. 24.

3. Fine, 1984, p. 99, No. 40.

THE BEGGARS (15.3.51)

Signed in the plate, on the wall at upper left, with the butterfly monogram; signed in graphite on a tab below the platemark with the butterfly monogram and *imp*. Etching and drypoint, printed in dark brown ink with tone on cream-colored antique laid paper, $11^{15}/_{16} \times 8^{1}/_{4}$ in. (30.3 × 21 cm).

REFERENCE: Kennedy 194 IV/IX.

DESCRIPTION: A perspective view through a dark, covered passageway, with a lantern hanging above the entrance at top center, occupies the entire plate. An aging woman and a young girl stand at right, looking at the viewer. Three more figures appear in the passage, and a fourth strides along a brightly lit walkway visible beyond.

CONDITION: The sheet is in good condition.

THE atmosphere in *The Beggars* is bleak, recalling certain of Whistler's early Paris etchings of similar figures within dismal spaces, such as *La Marchande de moutarde* (Kennedy 22) and *The Rag Gatherers* (Kennedy 23). In fact, the figures in this print greatly occupied Whistler, as he changed their disposition and appearance through at least nine states. The first state shows an old man and a girl; then follow a young woman with a little girl; and finally, as here, come a distinctly older woman with the young girl. Formally, *The Beggars* is greatly concerned with the depiction of perspective and the effects of light and deep shadow, but the aforementioned figural changes serve to focus attention on the couple at the right edge of the composition, as does the very title of the print. It is indeed the only title in the series that highlights the figures, rather than architectural or landscape elements. The passageway Whistler depicted has been identified recently as the Corte delle Carrozze, leading to the Campo S. Margarita.[1] MacDonald has surmised that Whistler must have paid models to pose for his figures, because the passageway "was no busy thoroughfare, and no sensible beggar would choose to stand there."[2]

A study related to this print—drawn essentially in charcoal, with pastel accents probably added at a later time—is in the Freer Gallery of Art, Washington.[3] It is in reverse to the print, of comparable dimensions, and depicts a young woman and little girl, suggesting that it was an intermediary study made after the first state of the print. The drawing was titled *The Beggars—Winter*, revealing its genesis during the winter months of 1879–80. The ghostly figure seen here walking in the middle of the passageway is not included in the drawing and was most likely added to the print after Whistler's return to London; indeed, Thomas Way claimed that he posed for it.[4] Preparatory drawings for Whistler's Venetian etchings are rare. He

seems to have used them only during the working process, in order to check on and resolve certain figural problems. Whistler was particularly proud of his labors on this plate, remarking in 1891 that it "may do to stand with the Rembrandts, eh?"[5]

The Frick impression of *The Beggars* employs extensive manipulation of ink tone. The remarkable luminosity within the dark passageway results from the careful wiping of ink around the outline of the mysterious male figure, and the figure itself—drawn primarily with delicate touches of drypoint—is printed with a great deal of ink left on the surface of the plate, making it still more insubstantial.

NOTES

1. See Grieve, 1996, p. 23, fig. 14. Grieve remarks (p. 25) on the similarity of this composition to works by the seventeenth-century Dutch painter Pieter de Hooch.

2. MacDonald, 1995, under No. 727.

3. *Idem*, No. 727; see also D. P. Curry, *James McNeill Whistler at the Freer Gallery of Art*, Washington, 1984, pl. 257.

4. Way, 1912, p. 46. See MacDonald, No. 864, for a slight sketch of the composition dated 1881.

5. H. Mansfield, "Whistler as a Critic of his Own Prints," *Print Collector's Quarterly*, III, 1913, p. 376 (reprinted in pamphlet form, New York, 1935).

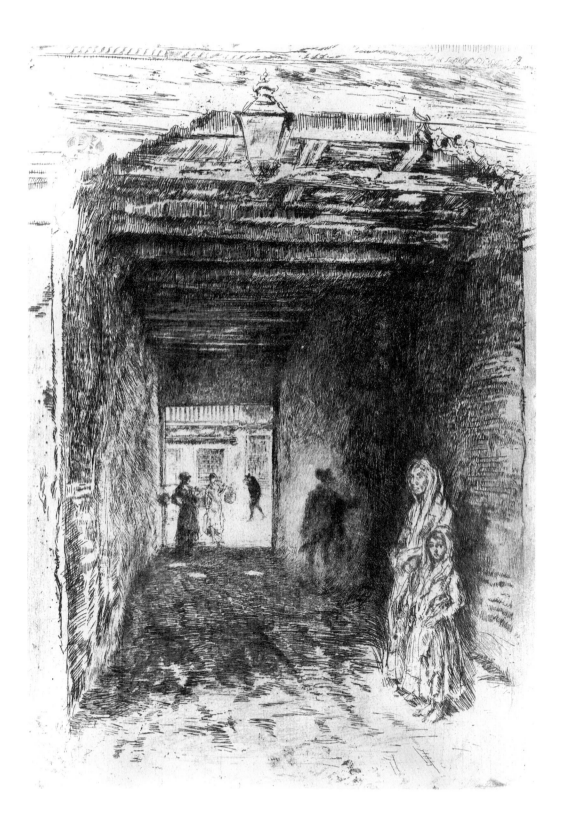

THE MAST (15.3.52)

Signed in the plate, at center left, with the butterfly monogram; signed in graphite on a tab below the platemark with the butterfly monogram and *imp*. Etching and drypoint, printed in brownish-black ink on dark cream-colored Japanese wove paper, 13½ × 6 in. (34.2 × 15.3 cm).

REFERENCE: Kennedy 195 V/VI.

DESCRIPTION: The narrow vertical composition is dominated by a tall, thin mast surmounted by a statuette of a winged lion. It stands in the middle of a street that extends toward the horizon, where some trees are lightly indicated. A rope curves downward from the top of the mast and is fastened to one of the buildings at left. Other, more fully articulated buildings line the opposite side of the street from the right edge toward the horizon. At lower left is a group of seated and standing figures, and at lower right are a man carrying an object and a boy leaning against the base of the mast.

CONDITION: The sheet is in good condition.

The Mast is another example of Whistler's predilection for views of the quieter, more out-of-the-way corners of Venice. In terms of motif and structure, it relates closely to *The Little Mast* (see p. 269), also from the First Venice Set. Whistler developed his composition to place the viewer quite intimately—and somewhat claustrophobically—within the scene, as if looking over the shoulders of the group at lower left, much as the young man at extreme left looks downward toward the seated women. The narrow perspective of the closely confined street draws the eye toward the vista at the horizon, with its delicately indicated line of trees done in drypoint.

The treatment of light and shade in this print is undramatic. The inking of the Frick impression is consistent with the overall modulated effect, showing only the slightest darkening of plate tone in the sky toward the upper right. The darker areas in the figures at far left and far right are the result of granular tone etched into the plate itself. Other impressions of this plate also exhibit a fairly even ink tone, and some are quite cleanly wiped. The edition of *The Mast* was printed by mid June of 1892; the plate is now in the Hunterian Art Gallery, University of Glasgow.[1]

NOTE

1. Fine, 1984, p. 129.

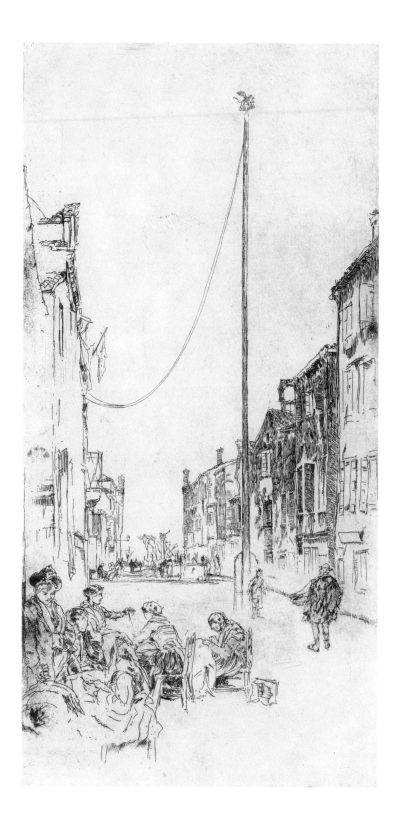

COUNT ROBERT DE MONTESQUIOU (87.3.146)

Signed in the stone, to the left of the subject's right hand, with the butterfly monogram. Lithograph, printed in black ink on cream-colored wove paper, 8¹⁵⁄₁₆ × 3¾ in. (22.7 × 9.6 cm).

REFERENCES (in each case, only state): Way 138; Levy 133; Chicago 84.

INSCRIPTION: In graphite at lower left: *Whistler Duc de Montesquiou. 2.*

DESCRIPTION: The full-length portrait shows Montesquiou in evening dress standing in three-quarter view against a sketchily indicated dark background. He carries a cloak over his left arm and holds a cane in his right hand.

CONDITION: The sheet is in good condition.

WHISTLER executed some one hundred and eighty lithographs during his career, experimenting, as in his etchings, with different techniques of draftsmanship, image transferal, and printing, consistently taking great care in the production of these often pale, ethereal works. After some student efforts in lithography during the 1850s, he abandoned the medium until 1878, when he was encouraged to take it up again by the London printer Thomas Way. At least partly encouraged by his wife, Beatrice, herself a lithographer, he became particularly active after 1887, and during the next decade he drew many subjects, including images of city life, portraits, and numerous single models and nudes. He drew his images almost exclusively on transfer paper rather than on the bulky lithographic stones.

Dating from 1894, the present lithograph was done after the celebrated oil portrait of Montesquiou now in The Frick Collection, which Whistler had painted in 1891–92.[1] Following the successful first showing of the painting at the Paris Salon in the spring of 1894, several journals, including the prestigious *Gazette des Beaux-Arts*, asked for permission to reproduce the oil portrait. After seeing and disliking an etched version by Henri-Charles Guérard (1846–97) proposed by the *Gazette*, Whistler persuaded the editors to withold it, and he set out to attempt his own version.[2] The existence of a total of four lithographic portraits of Montesquiou, all once attributed to Whistler himself, has considerably confused their prior cataloguing, and their chronology is still obscure. It now seems clear that Whistler in fact executed two drawings on transfer paper, one of which was printed as a trial by Thomas Way in London (Way 137; Levy 138; Chicago 85) and a second one that was printed at the firm of Lemercier in Paris—the print discussed here. In addition, Beatrice Whistler also essayed two lithograph versions of her husband's portrait of Montesquiou, which were also printed at Lemercier.[3]

294

While the authors of the 1998 Chicago lithograph exhibition catalogue feel that Whistler executed the Lemercier version first, and then tried Way, Munhall feels that he went first to Way, who was his customary lithographic printer, in early July of 1894.[4] That the result in both cases was unsatisfactory is proven by the fact that neither lithograph was ever published. Way stated that he had printed only eight impressions of his version. In a letter to Way of July 15, 1894, Whistler declared: "The portrait is damnable!—I don't mean the printing. … No, my drawing … is … no more like the superb original than if it had been done by my worst and most incompetent enemy."[5] He then ordered Way to destroy the stone.

Munhall feels the present version of the Montesquiou lithograph was printed toward the fall of 1894, in concert with Beatrice's two versions, the artist perhaps having been encouraged by his wife to try again with a different printer. All three drawings were executed on a smooth, glassy "végétal" paper that was then transferred to lithographic stones by Lemercier.[6] Although Munhall suggests that Whistler was slightly more pleased with this second version of his lithograph, neither it nor his wife's prints were deemed suitable by him for a large magazine printing, and the artist had the stones destroyed in 1902.[7] The Chicago catalogue lists only thirteen known impressions of this lithograph from the uncanceled stone.

COLLECTIONS: Earl Carter, White Plains, New York. Frick, 1987.

NOTES

1. See: *The Frick Collection: An Illustrated Catalogue*, 1, 1968, pp. 21–25; and E. Munhall, *Whistler and Montesquiou: The Butterfly and the Bat*, New York–Paris, 1995, pp. 58–84.

2. Munhall, p. 112; see p. 111, fig. 85, for the Guérard etching.

3. For the two Beatrice Whistler lithographs, see Chicago, 1998, figs. 84a (an impression of which is in The Frick Collection; see next entry) and 84b.

4. Chicago, under No. 84; Munhall, p. 112–13. This print is often titled *Count Robert de Montesquiou, No. 2*.

5. Munhall, p. 114.

6. *Idem*, p. 116.

7. Chicago, under No. 84, note 84.5.

BEATRICE GODWIN WHISTLER

1857 – 1896

The daughter of the Scottish sculptor John Birnie Philip, Beatrice married first in 1876 the architect E. W. Godwin, who had designed two of Whistler's homes. An accomplished artist, she exhibited at the Royal Society of British Artists beginning in 1885. She and Whistler had become familiar before her husband's death in 1886, and they married two years afterward. Beatrice's younger sister Rosalind Birnie Philip became Whistler's sole legatee and executrix of his estate. She left her large collection of the artist's work and letters to the Hunterian Art Gallery of the University of Glasgow.

COUNT ROBERT DE MONTESQUIOU, after James McNeill Whistler (66.3.97)

Lithograph, printed in black ink on cream-colored laid paper, size of image 7¹¹⁄₁₆ × 3⅛ in. (19.5 × 8 cm).

REFERENCES (in each case, only state): Way 139 (as James Whistler); Levy 132 (as James Whistler); Chicago, fig. 84a.

INSCRIPTION: In graphite at lower left:

Way 139 / Count Robert de Montesquiou, No 3.

DESCRIPTION: The composition, though simplified, is in most respects identical to that of the preceding lithograph.

CONDITION: The sheet is in good condition.

THIS lithograph is one of two drawn by Beatrice Whistler after her husband's oil portrait of Montesquiou now in The Frick Collection (see preceding entry). Both had often been ascribed to Whistler himself, but they were correctly attributed by MacDonald and Spink.[1] They were printed at the same time as one of his own versions of the portrait at the Lemercier lithographic firm in Paris, probably in the late summer or fall of 1894. Beatrice's prints are clearly recognizable because neither carries Whistler's distinctive butterfly monogram signature at lower left, and her draftsmanship shows very even and pronounced downward strokes. Spink feels that all three Lemercier lithographs were probably traced from a photographic reproduction of the painting.[2] In a 1901 letter concerning the final disposal of impressions from the Lemercier stones, Whistler himself refers to "two lithographs my wife did—far more beautiful."[3]

D. P. B.

297

COLLECTIONS: University of Glasgow (duplicate from the Whistler archives). Colnaghi. Frick, 1966.

NOTES

1. M. F. MacDonald, "Whistler's Lithographs," *Print Quarterly*, V, 1988, p. 30, note 46; Chicago, 1998, under No. 84.

2. Chicago, *loc. cit.*; E. Munhall, *Whistler and Montesquiou: The Butterfly and the Bat*, New York–Paris, 1995, p. 116. Beatrice Whistler's other lithograph is illustrated in Chicago, fig. 84b, and Munhall, fig. 90.

3. Munhall, p. 118.

JACOBUS HENDRIKUS MARIS

1837–1899

Born in The Hague, Maris trained there and then in Antwerp, returning to his native city in 1857. Around 1865 he left for Paris, where he was influenced by the landscape painters who worked in and around Barbizon. Back home again in 1871, he became a leading figure in the Hague School of painting, as were his younger brothers Matthijs and Willem. Original printmaking did not figure prominently in the work of Maris and the other members of the Hague School. Only six etchings, dating from the 1870s, are ascribed to Maris himself, and of these just two were published in significant editions. Their sketchy, free style and effective use of black and white clearly show the influence of Rembrandt, as well as that of the etching revival that began in the 1860s in England and on the Continent.

THE BRIDGE (14.3.9)

Signed in graphite, at right below the platemark: *J Maris*. Etching, printed in black ink on cream-colored wove paper, 3⅜ × 7⅞ in. (8.5 × 20 cm).

REFERENCE: Zilcken, No. 4.[1]

INSCRIPTIONS: In graphite on recto: *2½ mat / 52423 / 13⅞ × 10 S / 177 / Show ½" top & sides*; and on verso: *52423*.

DESCRIPTION: A wooden bridge spans a canal at the center of the composition, with sailboats moored beyond. A man pilots a narrow boat in the left foreground. At right, a woman carrying buckets from a yoke hung over her shoulders climbs a path that curves from the lower foreground toward a group of small houses and the bridge. A lone house stands at upper left.

CONDITION: Other than a thinned spot at upper left, the sheet is in good condition.

THE etching is related to a Maris painting of 1885, also called *The Bridge*, now in The Frick Collection, the largest and best-known version of a composition that also exists in at least twelve other examples done in oil and in watercolor.[2] The etching was printed for the Dutch art periodical *Kunstkronijk* in 1875, along with a brief appreciation of Maris' work by Carel Vosmaer.[3] The print reproduces quite

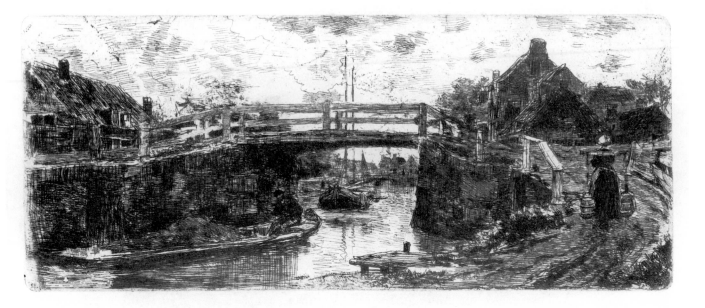

closely, though in reverse, an 1872 oil now in the Philadelphia Museum of Art.[4] That painting, or another dated the same year, was the earliest version of the composition; one of the two was exhibited in the Paris Salon of 1873. Maris identified the site he depicted variously as Rijswijk or Loosduinen, on the outskirts of The Hague.[5]

The Philadelphia painting and the etching both cut the top of the composition closely above the roofs of the houses, whereas in the Frick oil the sky occupies almost the entire upper half of the picture. The Frick painting also adds a man on the middle of the bridge and a second woman on the path. Executed at least ten years prior to the Frick oil, Maris' etching serves as neither a study for it nor a reproduction after it. The Frick painting was, however, reproduced in two etchings done by another artist, the Dutch printmaker Philip Zilcken (1857–1930). The first of these, in a large format (21 × 26 in.), was executed in 1886 and published in The Hague the following year; the second, a smaller version, was done for a portfolio entitled *Twelve Landscapes after Jacob Maris*, first published in London in 1888.[6]

<div style="text-align: right">D. P. B.</div>

COLLECTION: Frick, 1914.

1. P. Zilcken, *Peintres hollandais modernes*, Amsterdam, 1893, pp. 72, 174, No. 4. Zilcken reproduces another Maris etching, depicting a windmill, on p. 71.

2. See *The Frick Collection: An Illustrated Catalogue*, I, 1968, pp. 240–42. The many versions are enumerated in *The Hague School: Dutch Masters of the 19th Century*, exhib. cat., Grand Palais, Paris, Royal Academy of Arts, London, and Haags Gemeentemuseum, The Hague, 1983, pp. 206–07, under No. 52. A watercolor version quite close to the Frick oil is in the Metropolitan Museum of Art, New York (Inv. No. 95.24).

3. C. Vosmaer, *Kunstkronijk*, N.S., XVII, 1875, pp. 10–11, repr. facing p. 10. Although on its title page volume XVII is dated 1875, it probably did not appear until 1876; in the set of the *Kunstkronijk* in the Fine Arts Library at Harvard University, the original publisher's binding for volume XVII carries the latter date, while volume XVI is dated 1875 and volume XVIII is 1877.

4. See *The Hague School, loc. cit.*, color repr. p. 65.

5. Writing in *The Hague School*, J. Sillevis gives the title of the Philadelphia painting as *Dutch Canal, Rijswijk* (see No. 52); however, the same author refers to the present etching as *The Bridge by the Loosduinse Weg* (p. 84). Vosmaer (*Kunstkronijk*, p. 11) calls the etching *A View in the Northwestern Outskirts of The Hague (Gesicht aan 's Gravenhage's noordwestelijken buitensingel)*.

6. A. Pit, G. Bourcard, and G. Smit, *Catalogue descriptif des eaux-fortes de Ph. Zilcken*, Amsterdam, 1918, Nos. 77 and 117 respectively. The Avery Collection in the New York Public Library has impressions of both prints, which reproduce the composition in the same direction as the painting.

ENGLISH REPRODUCTIVE PORTRAIT PRINTS

THE Frick Collection owns a small but select group of prints representative of two quite specialized reproductive printmaking techniques widely popular in eighteenth-century England, most notably in the production of portraits: the mezzotint, and the stipple engraving.

Eleven of the Frick prints are done in the intaglio tonal process known as mezzotint (literally, half-tone). Invented in Amsterdam in 1642 by Ludwig von Siegen, the technique was further developed in the mid 1650s by Prince Rupert, Count Palatine of the Rhine and nephew of Charles I; it was Rupert who transmitted its secrets to England, where it was first mentioned by John Evelyn in his *Sculptura* of 1662. At about the same time, several Dutch artists, avid practitioners of the medium, emigrated to England and increased its popularity there.[1] Particularly suitable for reproducing the softer effects of chiaroscuro in paintings, mezzotint caught on so strongly in England that the method came to be known on the Continent as *la manière anglaise*.

Coinciding with a rage for collecting printed portraits, the mezzotint provided a natural outlet for circulating the work of British portraitists, beginning with Godfrey Kneller and reaching a peak with Sir Joshua Reynolds during the late eighteenth century.[2] Reynolds in particular exploited the potential of mezzotints to circulate his portrait compositions, in the process both advertising his illustrious clientele and increasing his own reputation. Potential sitters too realized the advantage of having portrait prints of themselves to distribute to friends and associates. It is estimated that between 1754 and Reynolds' death in 1792 over four hundred authorized engravings (the great majority of them mezzotints) were issued after his paintings.[3] In this endeavor, Reynolds made regular use of about twenty engravers, some of whom established their reputations through their interpretive skills and the importance of the works they engraved after the master. It should be noted that usually the prints appeared in the same orientation as the paintings they reproduced, correcting the reversal inherent in printmaking and thus avoiding any confusion for sitters and viewers.

Reynolds took particular care in the reproductive translation of his paintings, believing that mezzotint was the most successful technique for capturing the strong effects of chiaroscuro he created in oil.[4] He is known to have kept in his studio a

303

portfolio of prints after his paintings, from which prospective customers could select poses and accessories.[5] Reynolds' involvement with the success of mezzotint may extend to his executing some of his paintings on speculation—that is, without specific commissions—for their value as source material for engravings.[6] It has even been suggested that certain broad effects of light in Reynolds' painting style were themselves influenced by the requirements of the mezzotint medium.[7] Five mezzotints after his compositions are represented in The Frick Collection (see pp. 309, 311, 315, 319, 329).

Other painters whose works were often reproduced in mezzotint include Thomas Gainsborough, George Romney (see pp. 321, 325, 327, 331, 335), Sir Thomas Lawrence (p. 339), and John Hoppner (p. 343)—all of whom, along with Reynolds, are represented by oil paintings in The Frick Collection. With the advent of still newer reproductive techniques, such as aquatint and lithography, the mezzotint lost much of its popularity during the nineteenth century, although it did achieve isolated high spots, such as David Lucas' remarkable interpretations of Constable landscape paintings and John Martin's nocturnal visions based on his own often apocalyptic paintings. The collecting of classic English mezzotint portraits has passed through cycles, most recently achieving enormous popularity in the first years of the twentieth century—when Mr. Frick paid large sums for several of his impressions—only to fall during the Depression and regain merely limited favor in the current print market.[8]

In the last quarter of the eighteenth century, the stipple engraving emerged in England as the only serious competition for mezzotint. Derived from the so-called crayon manner engraving developed in France in the 1750s, it too was a tonal medium built up with a myriad of dots—or stipples. It lent itself much more easily to color printing, thus presenting a further selling point for its reproductive qualities. Its chief exponent was an Italian expatriate, Francesco Bartolozzi (see p. 336), who trained a sizable studio of British engravers. As the new medium rose in popularity, several practitioners of mezzotint, such as John Raphael Smith (p. 323) and William Dickinson (see p. 310), also learned stippling. Its colorful presence rendered stipple engraving particularly suitable for decorative—and often sentimental—genre scenes intended to be framed, a category known as "furniture prints."

D. P. B.

ESSENTIAL REFERENCES

J. Chaloner Smith, *British Mezzotinto Portraits*, London, 1878–83.

A. W. Tuer, *Bartolozzi & His Works*, London, 1881.

E. Hamilton, *A Catalogue Raisonné of the Engraved Works of Sir Joshua Reynolds*, rev. ed., London, 1884.

A. Whitman, *British Mezzotinters: Valentine Green*, London, 1902.

J. Frankau, *John Raphael Smith, 1752–1812, A Catalogue Raisonné*, London, 1902.

J. Frankau, *William Ward A.R.A.—James Ward R.A.: Their Lives and Works*, London, 1904.

M. C. Salaman, *Old English Mezzotints*, London–Paris–New York, 1910.

C. E. Russell, *English Mezzotint Portraits and Their States*, New York–London, 1926; Russell's vol. II is a continuation and correction of Chaloner Smith, with references to his numbering.

A. DeVesme and A. Calabi, *Francesco Bartolozzi—Catalogue des Estampes*, Milan, 1928.

NOTES

1. On the formative years of the mezzotint, see: J. Bayard and E. D'Oench, *Darkness into Light: The Early Mezzotint*, exhib. cat., Yale University Art Gallery, New Haven, 1976; and A. M. Hind, "Prince Rupert and the Beginnings of Mezzotint," *Connoisseur*, XCII, No. 388, 1933, pp. 382–91. Its full history and range are described in C. Wax, *The Mezzotint: History and Technique*, New York, 1990.

2. The literature on the development and flowering of the mezzotint in England is large. Good, concise introductions to the subject can be found in: R. Godfrey, *General History of British Printmaking*, Oxford, 1978; A. Griffiths, "Prints after Reynolds and Gainsborough," in *Gainsborough and Reynolds in the British Museum*, exhib. cat., London, 1978, pp. 29–42; D. Alexander and R. Godfrey, *Painters & Engraving: The Reproductive Print from Hogarth to Wilkie*, New Haven, 1980; and D. Alexander, "The Mezzotint Portrait in the Age of Reynolds," *Gazette of the Grolier Club*, N.S. XXXVIII, 1986, pp. 11–29. See also C. Lennox-Boyd, G. Shaw, and S. Halliwell, *Theatre: The Age of Garrick—English Mezzotints from the Collection of the Hon. Christopher Lennox-Boyd*, London, 1994. The essential catalogue for portraits remains Chaloner Smith, 1878–83, and its supplement by Russell, 1926 (see Essential References).

3. Griffiths, p. 31. This figure was determined after eliminating copies, posthumous piracies, etc., from earlier catalogues of engravings after Reynolds' oeuvre, the first of which was published in 1784. Reynolds painted over two thousand works.

4. *Idem*, p. 29. Reynolds also wrote on the successful reproduction of paintings in black and white. See his remarks on engravings after Rubens cited in *Reynolds*, ed. N. Penny, exhib. cat., Royal Academy, London, 1986, p. 36 and note.

5. Griffiths, p. 37.

6. See Penny, p. 35.

7. Godfrey, p. 48.

8. M. Knoedler & Co., *Some Information Regarding Eighteenth Century Mezzotinto Engravers and their Work*, New York, 1906, pp.

23–26, lists record auction prices for special impressions of the time, ranging as high as $6,090 for Smith's *Mrs. Carnac* after Reynolds. Mr. Frick paid $4,500 in 1908 for an impression of Walker's *Miss Frances Woodley* after Romney (p. 321). Mr. Frick's selections seem to follow closely the taste of the time, at least as reflected in a lavish contemporary picture book, Salaman's *Old English Mezzotints* of 1910, in which every print Mr. Frick purchased receives prominent mention. For an excellent survey of the collecting of mezzotints, see S. O'Connell, "William Second Baron Cheylesmore (1843–1902) and the Taste for Mezzotints," in *Landmarks in Print Collecting: Connoisseurs and Donors at the British Museum since 1753*, ed. A. Griffiths, London, 1996, pp. 134–45.

JAMES WATSON

c. 1740–1790

Watson was born in Dublin and received his early artistic training there. About 1760 he moved to London, where he probably learned mezzotint engraving from James McArdell and where, beginning in 1762, he exhibited at the Society of Artists. He engraved some two hundred plates, sixty-two of them after compositions by Reynolds. Watson occasionally published his own prints but usually worked for others, including John Boydell.

MISS GREENWAY, after Sir Joshua Reynolds (84.3.155)

Mezzotint, printed in black ink on cream-colored antique laid paper, 12¹⁵⁄₁₆ × 8⅞ in. (32.9 × 22.5 cm).

REFERENCES: Chaloner Smith 65 1/11; Hamilton, p. 102, 1/11; Russell, p. 386, 1/11.

MARK & INSCRIPTIONS: Dupuy manufacturer's watermark on two lines. Inscribed in graphite on verso: *Miss Greenway after Reynolds by Jas Watson / No 65*, followed by indecipherable numbers; other inscriptions have been effaced.

DESCRIPTION: A seated woman is portrayed half-length looking toward the right, her dark hair falling over her left shoulder, her left elbow resting on tasseled pillows. She wears a flowing dress with a sash at the waist and pearls and a pendant jewel on her right arm. The background is blank.

CONDITION: Though slightly darkened from exposure to light, the print is in good condition.

ELIZA Greenway was the daughter of John Greenway, Keeper of his Majesty's Stores at Portsmouth Dockyard. She married Francis Napier, third son of the fifth Lord Napier, in 1771. The portrait by Reynolds that served as model for this print was painted in 1765.[1] Watson's mezzotint was published jointly by William Wynne Ryland, an engraver later executed for forging bills, and Henry Bryer, a partnership that lasted from 1766 to 1771; their names appear together on the second state of this print, thus approximately dating its execution.[2] Declaring *Miss Greenway* to be found in the "choicest" collections, Salaman wrote in 1910 that "no mezzotint ever suggested more sensitively and harmoniously the intrinsic beauty of paint."[3] The Frick impression is of the first state, before the inscription was added in the blank space below the image.

COLLECTIONS: Knoedler. Frick, 1916. Miss Helen C. Frick. Gift of Miss Frick, 1984.

NOTES

1. There are at least six other engravings after this painting; see F. O'Donoghue, *Catalogue of Engraved British Portraits ... in the British Museum*, London, III, 1912, p. 308. The current location of the painting is unknown; its last recorded owner was André de Coppet (information kindly supplied by David Mannings in correspondence).

2. C. Lennox-Boyd, G. Shaw, and S. Halliwell, *Theatre: The Age of Garrick—English Mezzotints from the Collection of the Hon. Christopher Lennox-Boyd*, London, 1994, p. 69.

3. M. C. Salaman, *Old English Mezzotints*, London–Paris–New York, 1910, p. 21.

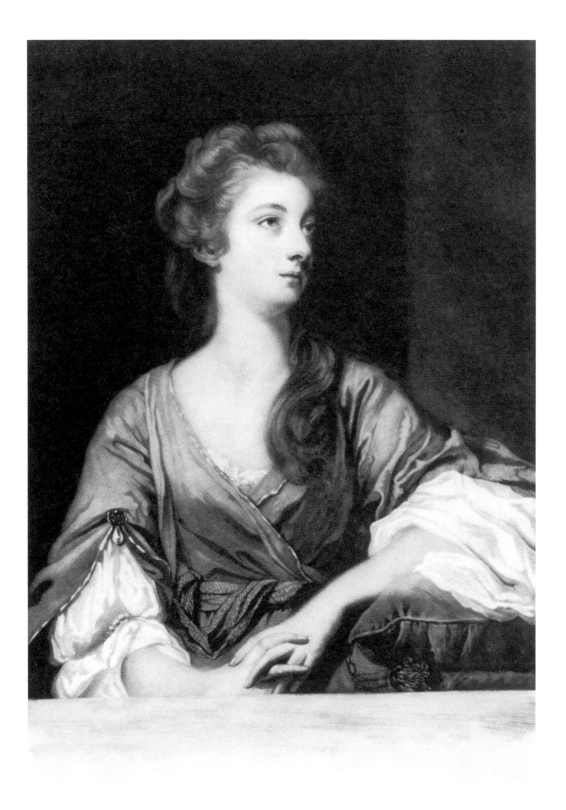

WILLIAM DICKINSON

1746/47–1823

A native Londoner, Dickinson exhibited at the Society of Artists beginning in 1769. He executed some one hundred plates, primarily portraits, in both mezzotint and stipple engraving, including twenty-two after Reynolds. Dickinson worked in partnership with the engraver and printseller Thomas Watson from 1776 to 1781, and subsequently was involved more in selling and publishing prints than in original printmaking. He published plates by, among others, Charles Knight and Francesco Bartolozzi (for both, see p. 336). He was declared bankrupt in 1793, and his stock, including about four hundred plates, was auctioned the following year. Dickinson moved to Paris after 1800 and died there in 1823.

JANE, DUCHESS OF GORDON, after Sir Joshua Reynolds (78.3.111)

Inscribed in the plate, at right below image: *Engrav'd by W. Dickinson.*; at left below image: *Painted by Sir Joshua Reynolds.*; and at center below image: *Publish'd Feb.ʸ 28ᵗʰ 1775, by W. Dickinson.* Mezzotint, printed in dark brown ink on cream-colored antique laid paper, 14¹⁵⁄₁₆ × 10¹⁵⁄₁₆ in. (38 × 27.8 cm).

REFERENCES: Chaloner Smith 28 1/11; Hamilton, p. 102, 1/11; Russell, p. 48, 1/111.

MARKS: Watermark of a cross over the initials IHS above a heart with three arrows, all within an oval. Inscriptions in graphite on the verso are obscured by an old mount.

DESCRIPTION: The half-length portrait shows a young woman facing frontward, head turned to her right. She wears a belted gown with full sleeves and high collar, a beaded choker, and a long necklace from which hangs a small portrait of a man. The background is unelaborated, and a simple rectangular frame encloses the composition.

CONDITION: The sheet is in good condition. There are remnants of a previous mount at the edges.

JANE Maxwell (1748–1812), eldest daughter of Sir William Maxwell of Monreith, married Alexander, fourth Duke of Gordon, in 1767. She was a leading society figure, particularly noted for her matchmaking abilities: three of her daughters married dukes (those of Richmond, Manchester, and Bedford), another became the Marchioness Cornwallis, and another Lady Sinclair. Estranged from her husband for some years before her death, she was described by a contemporary as a woman

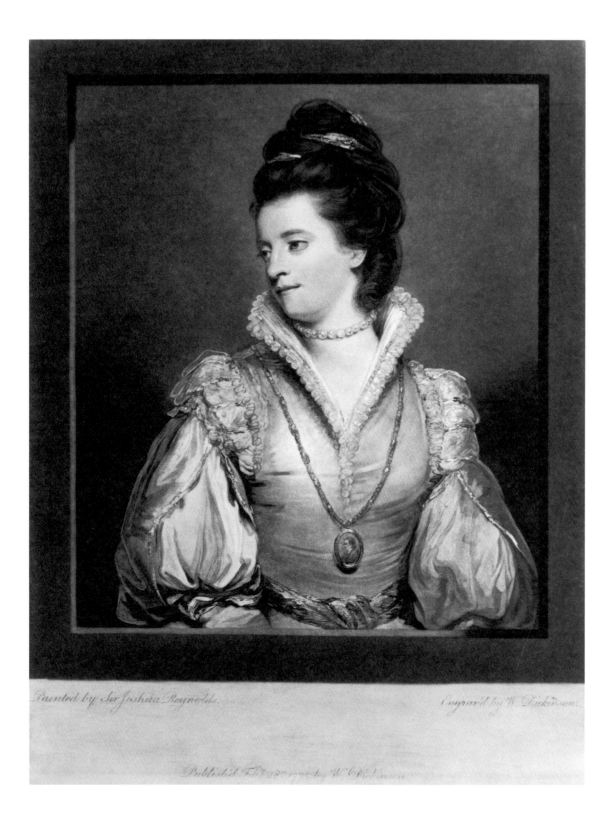

Painted by Sir Joshua Reynolds. Engraved by W. Dickinson.

Publish'd Feb.y 28.th 1774 by W. Dickinson

"with an open ruddy countenance, quick in repartee, and no one excelling her in performing the honors of the table, her society is generally courted."[1] The oil upon which Dickinson based his print was painted by Reynolds in 1774 and exhibited at the Royal Academy the next year; it is now in the collection of the Duke of Richmond and Gordon at Goodwood House, West Sussex.[2] Four years later, Reynolds painted a full-length portrait, now in the Norton Gallery and School of Art, West Palm Beach, Florida.[3]

This comparatively sober likeness is typical of Reynolds' many half-length portrayals of sitters who were not to be shown in elaborate landscape or interior settings. The Duchess' opulent dress was well-suited to reproduction by mezzotint, which excelled at showing the values of light on fabric. The Frick impression is particularly rich, with a soft sepia tone often favored by Dickinson. The "scratched letter" inscriptions in the lower margin were replaced in the final state by a more formal engraved style. As mezzotints became more popular and collectors grew increasingly competitive, publishers began artificially separating the "proof" stage of printing a plate into several progressive categories before the final "published" state. In 1796, Dickinson engraved a smaller, reversed copy of this print within an oval frame (Chaloner Smith 29).

COLLECTIONS: Knoedler. Frick, 1916. Gift of Mr. and Mrs. I. Townsend Burden, 1978.

NOTES

1. G. E. Cokayne *et al.*, *The Complete Peerage*, London, VI, 1926, pp. 5–6.

2. *Dictionary of British Portraiture*, ed. R. Ormond and M. Rogers, New York, 1979–81, II, p. 90; E. K. Waterhouse, *Reynolds*, London, 1941, pl. 169.

3. A photograph of the Norton painting is in the Photograph Archive of the Yale Center for British Art, New Haven, No. 119740. For further prints after this and other portraits, see F. O'Donoghue, *Catalogue of Engraved British Portraits ... in the British Museum*, London, II, 1910, p. 352.

VALENTINE GREEN

1739–1813

Born in Salford, Warwickshire, Green first studied law in Worcester and while there learned engraving and mezzotint from Robert Hancock. Moving to London in 1765, he exhibited at the Society of Artists the following year, became mezzotint engraver to the King in 1773, and was elected an associate member of the Royal Academy in 1774. His reputation was established with mammoth mezzotints after historical compositions by Benjamin West, measuring some two by three feet. In all, Green engraved about four hundred plates, including many after the most celebrated portrait painters of the day. From 1779 to 1783, he published a notable series of prints reproducing Reynolds' full-length portraits of society women, sold by subscription under the title Beauties of the Present Age. *Green's travels to the Netherlands and the Rhineland in 1775 presumably led to his appointment as engraver to the Elector Palatine in that year, and in 1789 he secured the right to engrave the paintings in the Düsseldorf Gallery. But due to the wars on the Continent, he was unable to stay in business there and in 1799 went bankrupt. Green was actively involved in publishing and printselling as well as printmaking. At the end of his life he was appointed the first Keeper of the British Institution for Promoting the Fine Arts in the United Kingdom.*

LADY LOUISA MANNERS, after Sir Joshua Reynolds (78.3.119)

Mezzotint, printed in black ink on cream-colored antique laid paper (trimmed), 23⁹⁄₁₆ × 15⅛ in. (59.8 × 38.4 cm).

REFERENCES: Chaloner Smith 84; Hamilton, pp. 116–17; Whitman 80.[1]

MARKS & INSCRIPTIONS: Watermark of a cross over the initials I H S above a heart with three arrows, all within an oval; Dupuy manufacturer's mark. Inscribed in graphite on verso: *Lady Louisa Manners / M63 / proof 1–11–6.*

DESCRIPTION: A standing woman in a flowing gown gazes to the right, her left hand touching her cheek, her dark hair falling over her left shoulder, her left leg crossed before the right. She leans on a parapet at right, over which hangs a curtain. Behind her are trees, with a landscape and stream in the distance at left.

CONDITION: The sheet has been trimmed to the image but is otherwise in good condition.

THE subject, Louisa Tollemache (1745–1840), daughter of the Earl of Dysart, married John Manners of Grantham in 1765 and in 1821 became Countess of Dysart in her own right. Green's print was done after an oil portrait by Reynolds that was exhibited at the Royal Academy in 1779 and is now in the Iveagh Bequest at Kenwood House, London.[2]

Lady Louisa Manners is one of the plates from Green's celebrated series *Beauties of the Present Age*, depicting portraits by Reynolds of society women. It and a companion print of the subject's sister, *Lady Jane Halliday* (Chaloner Smith 61; Whitman 79), were the first pair of the series to be published, on December 24, 1779. They were issued by subscription, the price being twelve shillings each to subscribers, fifteen to others. Some impressions were sold tinted subtly with watercolor.[3] Six prints were envisioned originally, but nine were executed by 1783.[4] They are mezzotints in the grand manner, fully reflecting the importance of the painted portraits they reproduce. Green's accomplished skills were able to evoke the richness of Reynolds' depictions of light and shade playing over rich fabrics, as well as his confident poses. Hamilton also records a stipple engraving after Reynolds' oil executed in 1806 by Charles Knight (see p. 336).[5]

The Frick impression is exceptionally fine. Although it is printed in black ink, its lighter areas—that is, the most burnished—allow the paper color to show through, creating warm, luminous values. This impression, surely one of the earliest to come from the plate, has been carefully preserved, thus protecting the delicate printed surface; as a result, the darkest areas are a deep, velvety black. Since mezzotint plates tended to wear quickly during printing, vibrant impressions such as this are comparatively rare. Even with the inscription area trimmed—resulting, technically, in an "incomplete" subject—Mr. Frick paid the large price of $4,250 for this example in 1908, testifying to the importance of Green's *Beauties* series to serious mezzotint collectors of that time.[6]

COLLECTIONS: Knoedler. Frick, 1908. Gift of Mr. and Mrs. I. Townsend Burden, Jr., 1978.

NOTES

1. As the inscription area has been trimmed off the Frick impression, its state cannot be determined.

2. See E. K. Waterhouse, *Reynolds*, London, 1941, pl. 212.

3. *Reynolds*, ed. N. Penny, exhib. cat., Royal

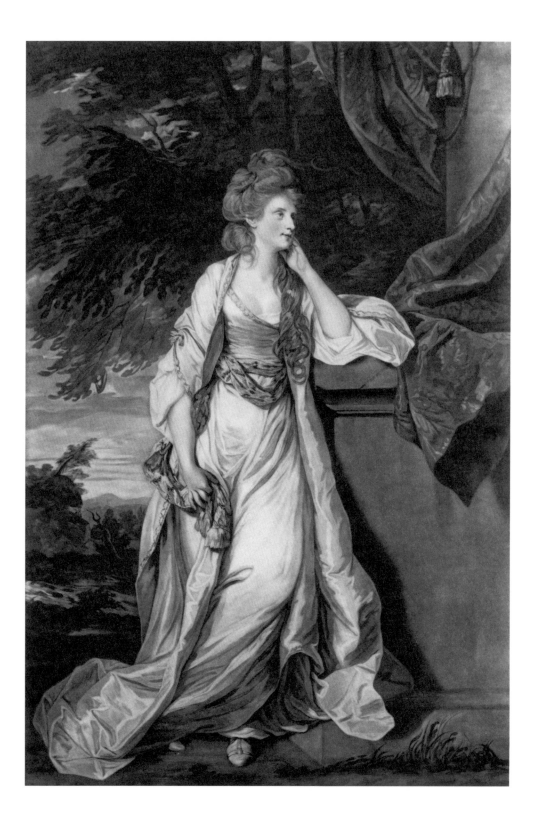

Academy, London, 1986, pp. 273–75, under No. 102.

4. A. Whitman, *British Mezzotinters: Valentine Green*, London, 1902, p. 15.

5. E. Hamilton, *A Catalogue Raisonné of the Engraved Works of Sir Joshua Reynolds*, rev. ed., London, 1884, pp. 116–17.

6. Mr. Frick had already acquired Reynolds' oil portrait of Lady Skipwith in 1906, and would purchase his portrait of Lady Taylor in 1910; see *The Frick Collection: An Illustrated Catalogue*, New York, I, 1968, pp. 95–102.

JOHN DEAN

c. 1750–1798

A student of Valentine Green (see p. 313), Dean produced prints carrying dates from 1776 to 1789. At least twenty-eight portrait mezzotints are recorded.

LADY ELIZABETH HERBERT AND HER SON CHARLES,
after Sir Joshua Reynolds (84.3.152)

Inscribed in the plate, at right below image: *John Dean Fecit*; at left below image: *Sr Joshua Reynolds Pinxit*; and at center below image: *Published Jan.y 1st 1779 by J. Dean.* Mezzotint, printed in black ink on dark cream-colored antique laid paper (trimmed), 18⅜ × 13⅞ in. (46.7 × 35.2 cm).[1]

REFERENCES: Chaloner Smith 11 between 1 and 11/11; Hamilton, p. 107, between 1 and 11/11; Russell, p. 44, 11/111.

MARKS: Watermark of a cross over the initials IHS above a heart with three arrows, all within an oval; Dupuy manufacturer's mark.

DESCRIPTION: A woman in a long flowing gown sits on the ground under trees, her knees bent and her right arm resting on a stone plinth. She looks down at a nude young boy seated at left, his left hand touching her chin, his right arm resting on her lap.

CONDITION: The sheet, which is trimmed at the bottom edge, has darkened from exposure to light. There are small abrasions on the woman's forehead, her left hand, the boy's right shoulder, and elsewhere.

ELIZABETH (1752–1826), daughter of Charles, second Earl of Egremont, married Henry Herbert, later created Baron Porchester and Earl of Carnarvon. The child is Charles, her second son, born in 1774. Reynolds' oil, now owned by Mervyn Herbert, was painted in February of 1777 and exhibited in that year at the Royal Academy.[2] Dean published the first state of this print on August 1, 1778.

COLLECTIONS: Knoedler. Frick, 1916. Miss Helen C. Frick. Gift of Miss Frick, 1984.

NOTES

1. As the sheet has been trimmed within the platemark at bottom, the height measurement is that of the extant plate area.

2. E. K. Waterhouse, *Reynolds*, London, 1941, pl. 187. David Mannings kindly informed the author of the painting's current whereabouts.

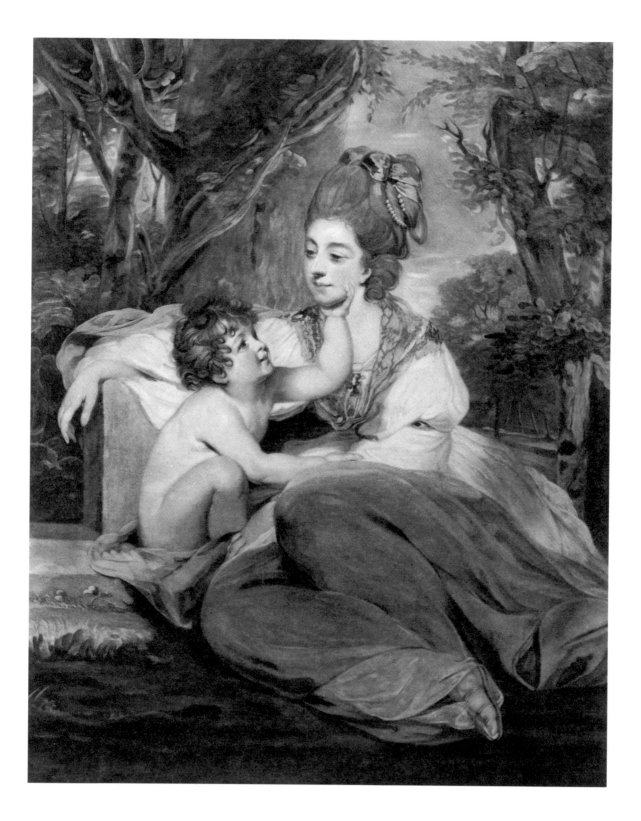

JAMES WALKER

c. 1760 – c. 1822/25

Walker was apprenticed to Valentine Green (see p. 313) in 1773 and began working independently in 1780, executing during his career almost two hundred plates in both mezzotint and stipple. He exhibited at the Society of Artists in 1783 and the next year went to Russia, where he worked until 1802. He was appointed engraver to Catherine the Great in 1785 and became a member and councilor of the Imperial Academy of Arts in St. Petersburg. After his return to England, Walker continued to engrave and publish prints. The date of his death is unknown; an auction of his plates and print stock occurred in 1822, but a print bearing his name as engraver appeared in 1825.[1]

MISS FRANCES WOODLEY, Later Mrs. Bankes,
after George Romney (78.3.110)

Mezzotint, printed in black ink on dark cream-colored wove paper, 24¼ × 15 in. (61.5 × 38.2 cm).

REFERENCES: Chaloner Smith 19 post ii/ii; Russell, p. 342, post ii/ii (see below).

MARKS & INSCRIPTIONS: Dovecote watermark; Tamizier manufacturer's mark with the date 1783. Inscribed in pen and brown ink in the margin at bottom: *Miss Woodley / 2*; and in graphite: *K-A*, followed by indecipherable numbers and letters.

DESCRIPTION: The full-length standing portrait shows a young woman wearing a loose, flowing dress with a tasseled sash. Turning her head to her left, she leans her right elbow on a draped pedestal and holds her right hand to her throat. There are small plants in the right foreground, and trees and a cloudy sky occupy the background.

CONDITION: Other than some foxing and the remnant of an old mat burn, the sheet is in good condition.

FRANCES Woodley (1760–1822) was the daughter of William Woodley, Governor of the Leeward Islands from 1766 to 1771. She married Henry Bankes of Kingston Lacy, Dorset, in 1784. The portrait on which Walker's print is based was painted by Romney in 1781;[2] Walker published his mezzotint in December of the same year. The Frick impression appears to have been printed after the published states and after the plate itself had been cut down. The platemark is apparently complete, but it measures almost 1 in. less in height than impressions that include the

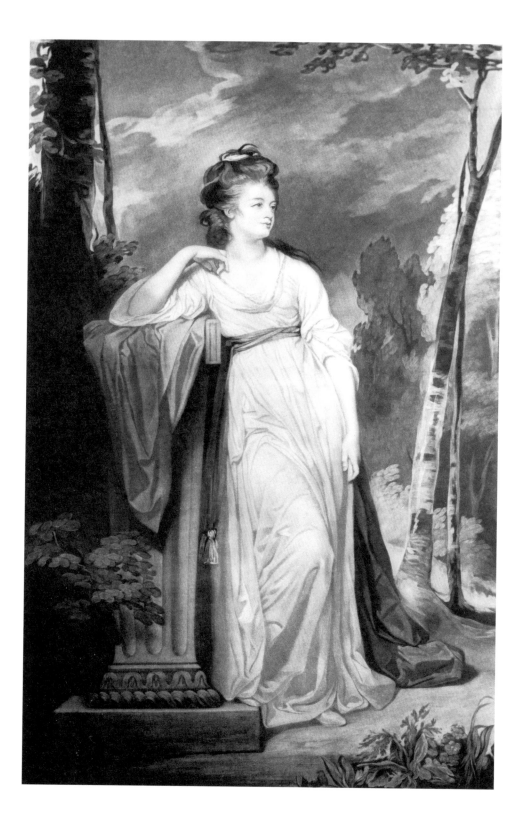

inscription area at the bottom. The impression is printed on a full sheet of *colombier* (dovecote) paper with a watermarked date of 1783.[3]

Writing in 1910, Salaman called *Miss Woodley* a "gem of mezzotint," praising its "sheer beauty of accomplishment."[4] Mr. Frick, who would acquire a total of five Romney oil portraits, paid the extraordinary price of $4,500 for this print in 1908, testifying to its rarity and to the competition for such works at that time. The price seems the more unusual given the later state of this impression, although its printed tones are still quite rich.

COLLECTIONS: Knoedler. Frick, 1908. Gift of Mr. and Mrs. I. Townsend Burden, Jr., 1978.

NOTES

1. D. Alexander, "James Walker: A British Engraver in Russia," *Print Quarterly*, XII, 1995, pp. 412–14.

2. H. Ward and W. Roberts, *Romney*, London, 1904, II, p. 174, listed as in the collection of W. R. Bankes in 1881.

3. The platemark of an impression of the first state at the Yale Center for British Art, New Haven (B 1970.3.356), measures 25⅛ × 15 in. (63.7 × 38.2 cm), which is in agreement with Chaloner Smith. For a discussion of paper sizes used by British printers, see T. Clayton, *The English Print 1688–1802*, New Haven–London, 1997, pp. 21–22. The 1783 watermark probably indicates a terminus post quem for this impression; as the dates on French watermarks pertain to those of papermaking regulations, paper with specific dates often continued to appear for a number of years after the date given.

4. M. C. Salaman, *Old English Mezzotints*, London–Paris–New York, 1910, p. 32.

JOHN RAPHAEL SMITH

1752–1812

Born in Derby, Smith was first employed as a linen draper but learned mezzotint engraving after moving to London in 1767. He showed at the Society of Artists from 1773 and at the Royal Academy from 1779, and was appointed mezzotint engraver to the Prince of Wales in 1784. He was also a painter of miniatures and executed many portraits in pastel. Smith engraved nearly four hundred plates, many after his own designs but most after works by Reynolds (a total of forty-one subjects from 1774 to 1784), Gainsborough, Romney, Lawrence, George Morland, and Wright of Derby. He utilized stipple and aquatint in addition to mezzotint. Smith developed a successful publishing business, acquiring exclusive publication rights for the popular genre painter Morland. He gave up printmaking after 1802. Three of Smith's children became artists—Emma, Sophia, and John Rubens Smith, the last of whom emigrated in 1809 to the United States.

LADY LOUISA STORMONT, after George Romney (78.3.116)

Inscribed in the plate, at right below image: *Engraved by J.R. Smith*; at left below image: *Painted by G. Romney*; and at center below image: *London Publishd 18th of may 1780 by JR. Smith No 10 Batemans Buildings Soho Square.* Mezzotint, printed in black ink on cream-colored antique laid paper (trimmed), 19⅞ × 13¾ in. (50.5 × 34.9 cm).

REFERENCES: Chaloner Smith 159 I/II; Frankau 336 II/III; Russell, p. 303, II/III.

MARK & INSCRIPTION: Manufacturer's watermark on three lines, probably that of Tamizier. Inscribed in graphite below image: *Henrietta Vernon Countess of Warwick* (see below).

DESCRIPTION: A young woman sits at right, shown in nearly full profile facing to the left, her arms folded across her waist. She wears a turban-like hat and a long-sleeved gown with a train of darker drapery; the train is clasped at her shoulder and passes down her back and over her left knee, which is crossed over the right. Behind her is a masonry wall topped by overhanging vines; a distant landscape appears at far left.

CONDITION: The sheet, which is trimmed to the platemark, is in good condition.

CONTRARY to the penciled inscription on this impression, Smith's mezzotint reproduces the 1776 oil portrait by Romney of Louisa, Lady Stormont (1758–1843).[1] Daughter of the ninth Baron Cathcart, she was married in 1776—the year of the painting—to David, seventh Viscount of Stormont (d. 1796). At the death of her husband's uncle, the Earl of Mansfield, in 1793, she inherited the title Countess of Mansfield. She married secondly in 1797 her first cousin, the Rt. Hon. Robert Fulke-Greville, Earl of Warwick. She was also painted by John Hoppner, in 1797. At the time of her first marriage, she was described by a contemporary thus: "The Ambassadress lady Stormont is pretty, she holds herself badly, and has not a charming manner, but her expression is full of intelligence."[2]

The Frick impression is of the second state of the print, published by Smith himself in 1780. The next year saw another publisher, James Birchall, take over the plate. In this work, which was described by Salaman in 1910 as "among the most beautiful mezzotints in existence,"[3] Smith had ample opportunity to exploit the potential of the medium for depicting the values of layered, draped clothing. Mr. Frick purchased his impression in 1914 for $3,700.

COLLECTIONS: Knoedler. Frick, 1914. Gift of Mr. and Mrs. I. Townsend Burden, Jr., 1978.

NOTES

1. See: H. Ward and W. Roberts, *Romney*, London, 1904, II, pp. 151–52; and *George Romney: Paintings and Drawings*, exhib. cat., Iveagh Bequest, Kenwood, London, 1961, No. 25, in which the painting was listed as in the collection of Earl Cathcart. Mr. Frick had bought Romney's portrait of Henrietta Vernon, Countess of Warwick, and her children in 1908 (for which see *The Frick Collection: An Illustrated Catalogue*, New York, I, 1968, pp. 109–12); the graphite inscription on the Frick print would seem to be a coincidental anomaly.

2. G. E. Cokayne *et al.*, *The Complete Peerage*, VIII, London, 1932, p. 390, quoting Madame du Deffaud.

3. M. C. Salaman, *Old English Mezzotints*, London–Paris–New York, 1910, p. 35.

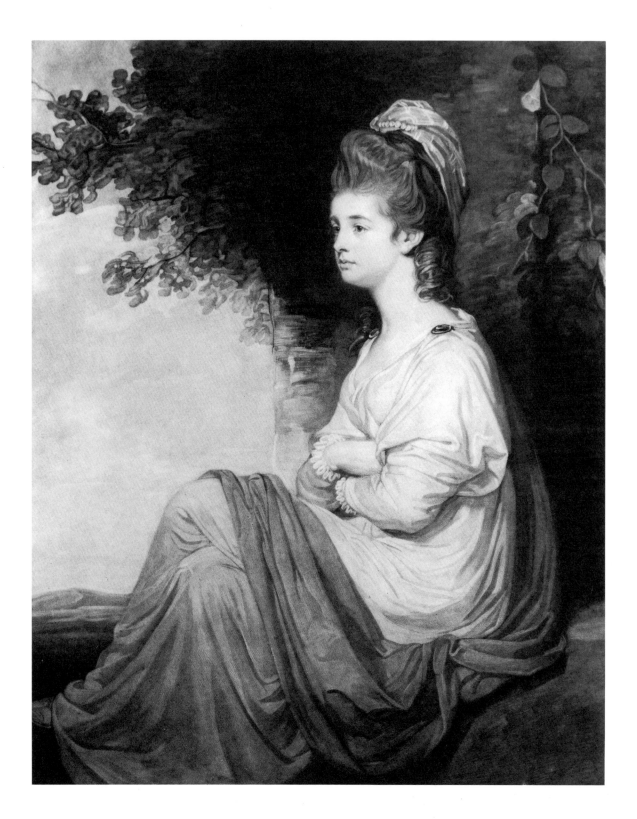

MRS. STABLES AND HER DAUGHTERS HARRIET AND MARIA, after George Romney (84.3.154)

Inscribed in the plate, at right below image: *Engraved by J.R. Smith*; at left below image: *Painted by G. Romney*; and at center below image: *M^rs Stables & two daughters Harriet & Maria / London publishd Novem^r 1^st 1781 by JR Smith N^o 83 opposite the Pantheon Oxford Street*. Mezzotint, printed in black ink on cream-colored antique laid paper, 19⅞ × 13¹⁵⁄₁₆ in. (50.5 × 35.4 cm).

REFERENCES: Chaloner Smith 157 II/II; Frankau 334 II–III/III; Russell, pp. 302–03, II/III.[1]

MARKS: Watermark of a cross over the initials I H S above a heart with three arrows, all within an oval; Dupuy manufacturer's mark.

DESCRIPTION: A woman in a flowing dress is depicted nearly full-length seated on a stone bench at right, embracing a young girl in a white dress who clasps her arms around her mother's neck. Another child holding a basket of fruit is seen at left behind the bench. A fluted column is at far right, and trees occupy the background.

CONDITION: The sheet, which has darkened somewhat from exposure to light, has been trimmed to the platemark and remargined.

THE subjects are the wife and children of John Stables, a member of the Supreme Council in Calcutta. The print reproduces a Romney painting of 1778.[2]

COLLECTIONS: Knoedler. Frick, 1916. Miss Helen C. Frick. Gift of Miss Frick, 1984.

NOTES

1. There is some confusion in the literature concerning states of this print. Frankau places this state after a formally inscribed state with a March 1781 date. But according to Russell, proofs with the November date precede, not follow, the March publication state. Chaloner Smith does not mention states with the November date.

2. See H. Ward and W. Roberts, *Romney*, London, 1904, II, p. 148, listing the owner at that time as the Baron Alphonse de Rothschild.

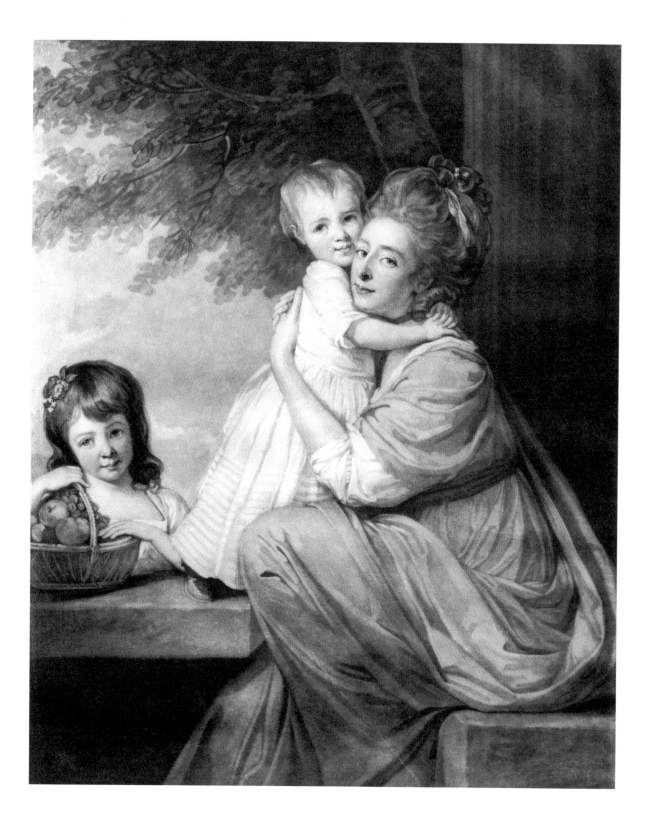

LADY CATHERINE PELHAM CLINTON,
after Sir Joshua Reynolds (84.3.151)

Inscribed in the plate, at right below image: *Engraved by J. R. Smith*; at left below image: *Painted by Sr Joshua Reynolds*; and at center below image: *Lady Catharine* [sic] *Pelham Clinton London publishd feb.y 1t 1782 by JR Smith No 83 opposite the Pantheon Oxford Street.* Mezzotint, printed in black ink on cream-colored antique laid paper, 19^{11}⁄$_{16}$ × 13⁷⁄$_8$ in. (50 × 35.2 cm).

REFERENCES: Chaloner Smith 43 I/III; Frankau 86 I/III; Russell, p. 285, I/IV.

MARKS & INSCRIPTIONS: Watermark of a cross over the initials I H S above a heart with three arrows, all within an oval; Dupuy manufacturer's mark. Inscribed on verso in pen and brown ink: *N 22094 / 10"6*; and in graphite: *Proof.*

DESCRIPTION: A young girl, shown full-length, gazes toward the right as she walks forward in a park landscape, feeding a flock of chickens and a turkey at lower left. She wears a light-colored dress tied with a sash at the waist and a flowered bonnet. A vine-covered tree stands at right, and a landscape with a pond and more trees fills the left distance.

CONDITION: The sheet has darkened slightly from exposure to light, and remnants of a previous mount appear at all four edges.

BORN in 1776, Catherine Pelham Clinton was the daughter of the Earl of Lincoln. She married William, Viscount Folkestone, in 1800 and died in childbirth four years later. The painting after which this print is modeled was painted by Reynolds in 1781 and is now in the collection of the Earl of Radnor, Longford Castle.[1]

COLLECTIONS: Knoedler. Frick, 1916. Miss Helen C. Frick. Gift of Miss Frick, 1984.

NOTE

1. See E. K. Waterhouse, *Reynolds*, London, 1941, pl. 226. The subject's pose recalls that of Reynolds' 1774 portrait of *Mrs. Pelham Feeding Poultry* (collection of the Earl of Yarborough), although there seems to be no direct family relationship between the two women.

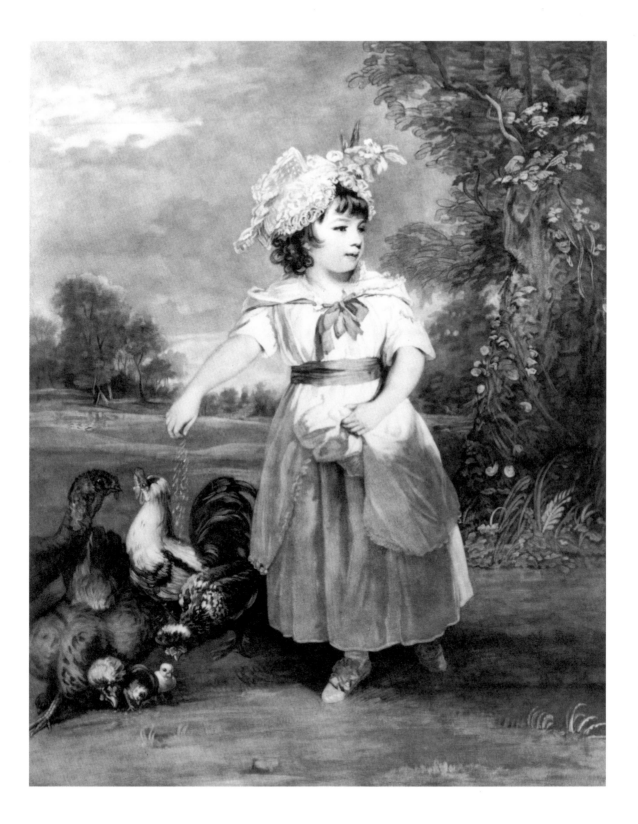

LADY HAMILTON AS 'NATURE,' after George Romney (78.3.117)

Inscribed in the plate, at right below image: *Engrav'd by J.R. Smith / Mezzintinto Engraver to his Royal / Highness the Prince of Wales*; at left below image: *Painted by G: Romney*; at center below image: NATURE / *Flush'd by the spirit of the genial year, / Her lips blush deeper sweets, the breath of Youth; / The shining moisture swells into her eyes / In brighter glow; her wishing bosom heaves / With palpitations wild.*; and below the latter: *London Publishd May 29 1784 by IR Smith N° 83 Oxford Street*. Mezzotint, printed in black ink on cream-colored antique laid paper, 14⅞ × 10⅞ in. (37.8 × 27.6 cm).

REFERENCES: Chaloner Smith 76 I/II; Frankau 168 II/IV; Russell, p. 291, II/V.

MARK & INSCRIPTIONS: Dovecote watermark. Inscribed in graphite on recto below the plate: *K. 1707 / C. 5365 / 7*, with previous marks erased; and on verso: *10*, with previous marks erased.

DESCRIPTION: The half-length portrait shows a young woman at right, turned to the left but facing the viewer. She holds a small spaniel under her left arm, restraining it with her right hand. She has long, flowing hair and wears a dark, long-sleeved dress with a low neckline. A few trees and a distant landscape appear at left, and a dark, cloudy sky and foliage outline the figure. A simple frame encloses the composition.

CONDITION: Apart from slight darkening within the area of a previous mat opening, the sheet is in good condition.

EMMA, Lady Hamilton, was born in 1765, the daughter of a Cheshire blacksmith. Moving to London about 1779, she pursued a succession of working-class jobs until she became the mistress first of Charles Greville and then of his uncle, Sir William Hamilton, whom she married in Italy in 1791. Notorious for her liaison with Lord Nelson, she eventually died in poverty in Calais in 1815.

Smith's print reproduces the 1782 painting of her by George Romney now in The Frick Collection,[1] probably the earliest of over twenty likenesses of Lady Hamilton that Romney executed. She was also portrayed by Angelica Kauffmann, Gavin Hamilton, Élisabeth Vigée-Lebrun, and Sir Joshua Reynolds, among others. There are numerous prints after these compositions, including a series of line engravings portraying her celebrated "attitudes."[2] Another mezzotint after the Frick portrait was executed by Henry Meyer.[3] In 1784, Smith also did a mezzotint after Reynolds' portrait of Lady Hamilton as a bacchante (Chaloner Smith 75; Frankau 167).

The inscription on the present print is apparently the earliest reference to the composition's title as "Nature." The Frick impression, purchased in 1905, is a very rich, early one full of dramatic effects of light and shadow. The subject is framed by a severely simple frame, which itself casts an illusionistic shadow.

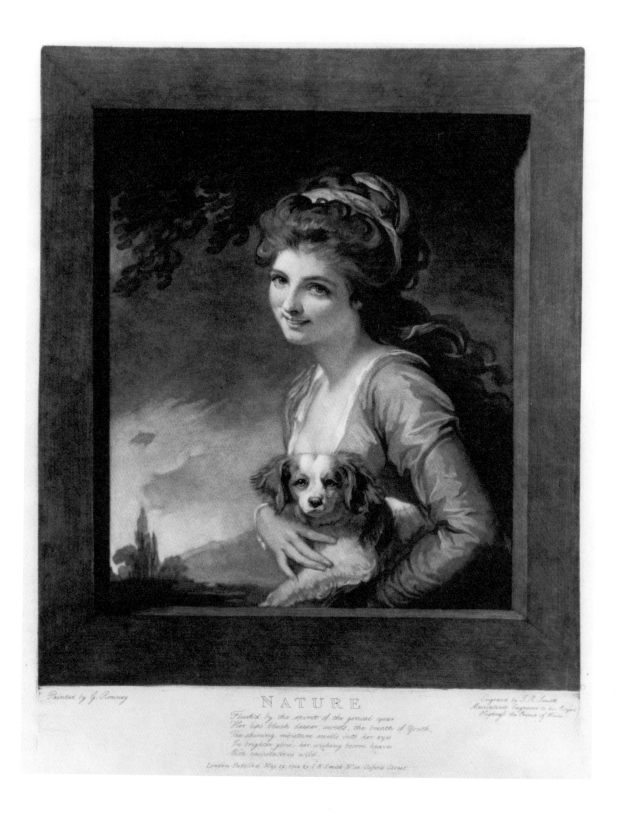

Painted by G. Romney

NATURE

Flush'd by the spirit of the genial year
Her lips blush deeper sweets, the breath of Youth,
The shining moisture swells into her eyes
In brighter glow, her wishing bosom heaves
With palpitations wild.

Engraved by J. R. Smith
Mezzotinto Engraver to his Royal
Highness the Prince of Wales.

London Publish'd May 29, 1784 by I. R. Smith N° 30 Oxford Street.

COLLECTIONS: Knoedler. Frick, 1905. Gift of Mr. and Mrs. I. Townsend Burden, Jr., 1978.

NOTES

1. See *The Frick Collection: An Illustrated Catalogue*, 1, 1968, pp. 106–08.

2. See F. Rehberg, *Emma Hamilton's Attitudes*, facsimile ed. by R. Wendorf, Cambridge, 1990.

3. An impression is at the Yale Center for British Art (B 1970.3.335).

JOHN JONES

Active 1775–1797

Jones worked in London, engraving and publishing mezzotints and stipple prints after such painters as Reynolds, Romney, Gainsborough, and Raeburn. Eighty-seven portrait prints by Jones are known, the majority of them self-published.

CAROLINE, DUCHESS OF MARLBOROUGH,
after George Romney (84.3.153)

Inscribed in the plate, on the plinth at right: *Painted by Geo. Romney / Engraved by J. Jones Engraver Extraordinary to His R.H. the Prince of Wales and / Principal Engraver to His R.H. the Duke of York, / Publish'd as the Act directs July 30, 1791, / by J. Jones Nº. 75 Great Portland Street.* Mezzotint, printed in black ink on cream-colored antique laid paper, 24 × 15 in. (61 × 38 cm).

REFERENCES: Chaloner Smith 53, only state; Russell, p. 183, I/II.

MARKS: Watermark of a dovecote and an indistinct manufacturer's name.

DESCRIPTION: A woman stands with legs crossed beside a tall plinth at right, on which she leans her left elbow and rests the fingertips of her right hand. She wears a flowing gown and a ribbon in her hair. Behind her rise large trees, with a domed pavilion visible in the right background and a distant prospect at left.

CONDITION: The sheet has darkened from exposure to light and water stains, and there are repaired losses in the margins.

CAROLINE (1743–1811), the only daughter of the fourth Duke of Bedford, married the fourth Duke of Marlborough in 1762. Romney painted the portrait after which this print is modeled between 1779 and 1792; it is now in the collection of the Duke of Marlborough at Blenheim Palace.[1] The print would seem to be the pendant to one of Caroline's husband that Jones had engraved in 1786, again after Romney (Chaloner Smith 54). Caroline was also portrayed by Reynolds several times, notably in a monumental family portrait of 1778–79.[2]

COLLECTIONS: Knoedler. Frick, 1916. Miss Helen C. Frick. Gift of Miss Frick, 1984.

NOTES

1. See H. Ward and W. Roberts, *Romney*, London, 1904, II, p. 100. The second state of this print, published in 1792, shows changes in the headdress, hair, and ribbon that may reflect final revisions to the oil portrait made that year.

2. See *Reynolds*, ed. N. Penny, exhib. cat., Royal Academy, London, 1986, No. 108, color repr. p. 137.

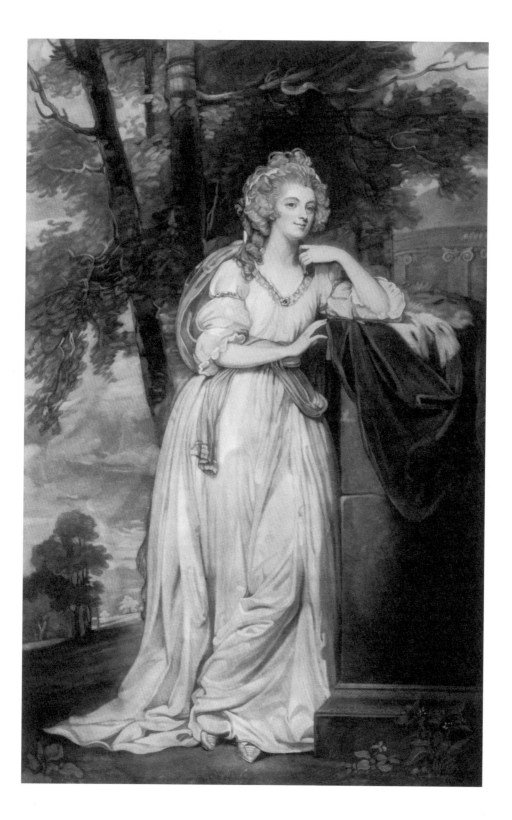

CHARLES KNIGHT

1743 – after 1826

An engraver and painter of miniatures, Knight practiced in London for many years, dating his last print when he was eighty-two. He specialized in producing stipple prints for various publishers after compositions by Henry William Bunbury, Thomas Stothard, Angelica Kauffmann, Francis Wheatley, Sir Joshua Reynolds, and others. Francesco Bartolozzi also employed his services. Knight was a governor of the Society of Engravers, founded in 1803.

FRANCESCO BARTOLOZZI

1728–1815

The son of a goldsmith, Bartolozzi was born in Florence, learned engraving at the Academy of Fine Arts there, and in 1745 was apprenticed to the Venetian engraver Joseph Wagner, for whom he executed prints after contemporary masters. In 1764 Bartolozzi was invited to England to engrave copies of the large group of Guercino drawings in the Royal Collection, and soon after he was appointed engraver to the King. Settling in London, he joined the Society of Artists in 1765 and four years later became a founding Royal Academician—nominally on his qualifications as a painter, as engravers did not yet qualify for full membership. He ran a large business supplying both private collectors and publishers with copies after Old Masters as well as contemporary works, especially those of Giovanni Battista Cipriani and Angelica Kauffmann. After about 1773, Bartolozzi developed a particular skill in the new stippling technique of building up non-linear tones by covering the copper plate with dots and flicks of varying sizes, produced in a combination of etching and engraving. Stipple engravings lent themselves easily to color printing. Over 2,500 prints are listed under Bartolozzi's name, although quite a few were probably executed by his assistants and pupils, of whom as many as fifty were employed at one time. In 1802, Bartolozzi was summoned by the Prince Regent of Portugal to become director of the Art Academy at Lisbon; he died in that city in 1815.

ELIZABETH FARREN, LATER COUNTESS OF DERBY,
after Sir Thomas Lawrence (78.3.109)

Inscribed in the plate, at right below image: *F. Bartolozzi Sculp.ᵗ R.A. Engraver to his Majesty*; at left below image: *T. Lawrence Pinxt*; and at center below image: *Publish'd Jan.ʸ 2, 1792 by Bull & Jeffryes Ludgate Hill London*. Etching and stipple engraving, printed in colors on cream antique laid paper (trimmed), 19¹¹/₁₆ × 12½ in. (50 × 31.8 cm).

REFERENCES: Tuer 1662; Nash, between IV and V/VI;[1] DeVesme and Calabi 1075, between IV and V/VI.

DESCRIPTION: A standing young woman is seen full-length, facing left with her head turned toward the viewer. Her cheeks and lips are pink, her eyes blue. She wears a white gown with a cloak trimmed in gray-brown fur and holds in her left hand a rose-colored glove and a gray-brown fur muff decorated with blue ribbon. Her right hand is raised to her collar. A landscape with sheep and trees opens at left onto an extensive vista. The sky is printed in tones of blue, the landscape in blues and browns.

CONDITION: The sheet has been trimmed to within .2 cm of the image at the top and sides and within .3 cm at the bottom. It is severely thinned in large areas on the verso, as the result of the removal of an earlier mount.

ELIZABETH (or Eliza) Farren was born in Cork about 1759 and became a celebrated actress, appearing first in Bath in 1773 and making her London debut in 1777. She married Edward Smith, twelfth Earl of Derby, on May 1, 1797, retired from the stage at that time, and died in 1829. The present engraving reproduces an oil portrait by Lawrence now in the Metropolitan Museum of Art, New York.[2] The painting was finished in 1790 and shown in the Royal Academy exhibition of that year, along with Lawrence's full-length portrait of Queen Charlotte.[3] The two grand works helped to establish Lawrence's reputation as the younger successor to Reynolds. His portrayal of Miss Farren was quite popular, prompting one reviewer to remark:

> We have seen a great variety of pictures of Miss Farren, but we never before saw her mind and character upon canvas. It is completely Elizabeth Farren; arch, spirited, elegant and engaging.[4]

The sitter had complained to Lawrence that she appeared very thin, and that he "must make it a little *fatter*, at all events, diminish the *bend* you are so attached to. ..."[5] Lawrence's composition was the source for at least five additional engravings. Miss Farren was also the subject of a number of other portraits, including:

paintings by Johann Zoffany and, perhaps, Richard Cosway; drawings by John Downman, Edward F. Burney, and Ozias Humphrey; several theatrical prints; and a marble bust by Anne Seymour Damer.[6]

While Bartolozzi's name appears under the image on the Frick print, it seems probable that virtually all of the work on the plate was executed by Charles Knight. The first three states of the print are inscribed with his name alone as engraver and I. Jeffryes as publisher, and they all carry a publication date of February 25, 1791 — over ten months prior to the January 2, 1792, Bull and Jeffryes publication date that appears on the Frick impression.[7] Impressions of the first three states reveal that Knight had essentially completed the print in etching and stipple; the fourth state, which still carries the February 1791 publication date but does not have Knight's name as engraver, shows further subtle stipple work and some engraved hatching in the dress.[8] The fifth state, the first to carry Bartolozzi's name, reveals a few further engraved touches in the dress. It is the sixth state that is the first to have the Bull and Jeffryes address and a date of January 1, 1792; it does not yet have a title.[9] The Frick impression is of the seventh state, which is dated one day after the sixth and carries the title, *Miss Farren*, in a delicate round hand script (trimmed off in this impression). The last two states are later publications of 1797 (on the occasion of Miss Farren's marriage) and 1803.

The reason for the exchange of engravers' names is obscure, but Godfrey asserts that many of the prints that emanated from Bartolozzi's studio were in large part the work of his assistants, "his signature being in the nature of a trademark."[10] It is not known how often Knight was subcontracted by Bartolozzi, or, assuming he was regularly employed by him, whether he was occasionally allowed to publish prints over his own name. One commentator suggests that after Lawrence's oil painting had achieved such great success, Bartolozzi imposed his signature over Knight's on the print in order to claim the credit for himself.[11] Knight executed another, half-length stipple engraving after Lawrence's portrait in 1813.[12]

The effects produced by the stipple technique are as remarkable in their way as those of mezzotint. The most obvious difference is in the color printing, which enables the print to assume the appearance of an almost jewel-like miniature reproduction of a painting, an effect somewhat diluted in the present example by its comparatively large format. Other impressions of this print are known executed in brown or black inks alone.[13] Done after one of the most celebrated society portraits of its time, *Miss Farren* became much sought after, commanding a price of $3,000

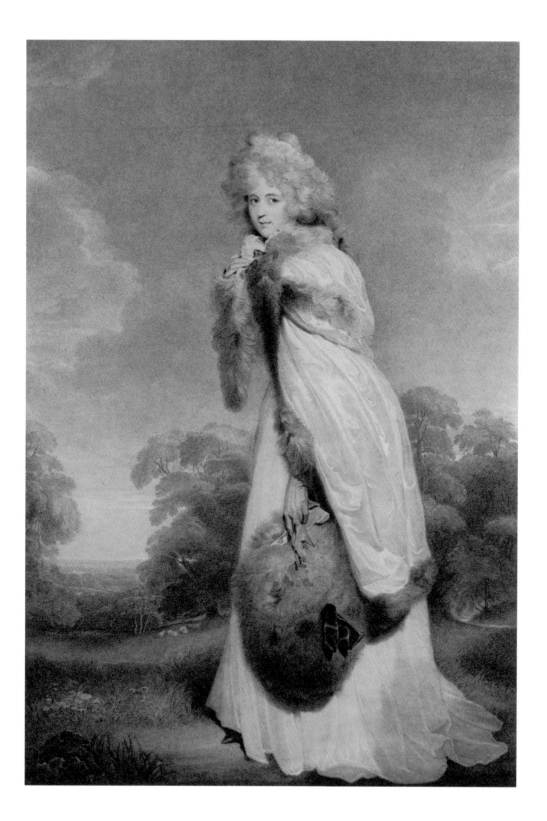

when Mr. Frick purchased it in 1908.[14] It is often cited among the highlights of collections of eighteenth-century prints.

COLLECTIONS: Knoedler. Frick, 1908. Gift of Mr. and Mrs. I. Townsend Burden, Jr., 1978.

NOTES

1. E. B. Nash, "Miss Farren," *Magazine of Art*, IX, 1886, p. 143. Nash and DeVesme-Calabi each describe six states of this print, though they differ in details. There are in fact at least nine states, as described here.

2. K. Garlick, *Sir Thomas Lawrence: A Complete Catalogue of the Paintings*, Oxford, 1989, p. 187, No. 294(a), color pl. 5; for a preliminary oil sketch of Miss Farren's head, see p. 188, No. 294(b). The painting is also reproduced in color in H. Hibbard, *The Metropolitan Museum of Art*, New York, 1980, p. 378, fig. 680.

3. Garlick, p. 168, No. 186, color pl. 4.

4. *The Public Advertiser*, April 30, 1790, quoted in M. Levey, *Sir Thomas Lawrence 1769–1830*, exhib. cat., National Portrait Gallery, London, 1979, No. 4.

5. Letter quoted in Levey, *loc. cit.*

6. A total of sixteen portrait engravings are listed in F. O'Donoghue, *Catalogue of Engraved British Portraits ... in the Department of Prints and Drawings in the British Museum*, London, 1908–22, II, pp. 39–40; portraits in other media are listed in *Dictionary of British Portraiture*, ed. R. Ormond and M. Rogers, comp. E. Kilmurray, New York, 1979, II, p. 62.

7. The description of the states of this print given here is based on examination of eight impressions at the Yale Center for British Art in New Haven (all but one of them from the extensive collection of English reproductive prints formed by J. Pierpont Morgan) and two impressions at the Cincinnati Art Museum, in addition to the Frick example. There may very well be more than nine states; for instance, DeVesme and Calabi describe one inscribed only with Knight's name, a state that has not been seen by the present writer and would be prior to the first state.

8. An impression of the earliest state known to the present author, with the image essentially complete but without finishing details in the sky and dress, is reproduced in K. L. Spangenberg *et al.*, *Six Centuries of Master Prints: Treasures from the Herbert Greer French Collection*, exhib. cat., Cincinnati Art Museum, Cincinnati, 1993, No. 114a. The next two states (examples in the Yale Center for British Art, B 1970.3.450–451) are distinguished by progressive additions of such detailing.

9. At least two impressions of this state are known, one in the Cincinnati Art Museum (see Spangenberg, No. 114b) and one on the art market in 1993 (see C. G. Boerner, Düsseldorf, *Neue Lagerliste Nr. 101*, 1993, No. 9). The latter impression is printed in brown ink; the title on it is undoubtedly handwritten.

10. R. T. Godfrey, *General History of British Printmaking*, Oxford, 1978, p. 55.

11. Nash, *loc. cit.*

12. Garlick, p. 187, under No. 294(a).

13. The Cincinnati Art Museum has an impression printed in black ink (see note 9); the Yale Center for British Art has one of the same

state as the Frick example but printed in brown (B 1970.3.454).

14. When Mr. Frick acquired the print in 1908, Lawrence's oil of Miss Farren was in the possession of his fellow collector J. Pierpont Morgan (see note 7). Four years earlier, Mr. Frick had purchased Lawrence's celebrated portrait of Lady Peel (for which see *The Frick Collection: An Illustrated Catalogue*, I, 1968, pp. 78–81).

WILLIAM WARD

1766–1826

Elder brother of the better-known painter and printmaker James Ward (1769–1859), William was born in London and became a student and assistant to John Raphael Smith (see p. 323) before striking out on his own in 1786. In 1807 he was appointed mezzotint engraver to the Duke of York, and in 1814 he became a member the Royal Academy and engraver to the Prince Regent (later George IV). In addition to engravings after the Old Masters, Ward executed contemporary subjects including many plates reproducing designs by his brother and by his brother-in-law George Morland.

DAUGHTERS OF SIR THOMAS FRANKLAND, BART.,

after John Hoppner (05.3.105)

Inscribed in the plate, at right below image: *Engraved by W. Ward*; at left below image: *Painted by I. Hoppner R.A. Portrait Painter to His Royal Highness the Prince of Wales*; and at center below image: DAUGHTERS OF SIR THOMAS FRANKLAND BAR^T / *Publish'd March 1, 1797, by W. Ward, Delancey Place, Hampstead Road*. Mezzotint, printed in black ink on dark cream-colored wove paper, 22¾ × 17¹³⁄₁₆ in. (57.9 × 45.3 cm).

REFERENCES: Chaloner Smith 38 III/IV; Frankau 125 III/IV; Russell, p. 363, III/IV.

INSCRIPTION: In graphite on verso: *17608*.

DESCRIPTION: Two girls are shown seated in a heavily wooded landscape. The one at right is turned leftward, her head facing the viewer; wearing a light-colored, long-sleeved gown and a turban-like headdress, she holds a portfolio of prints in her right hand and rests her left arm at her side. The second girl leans against her sister's right shoulder and holds her left arm around her sister's neck; she gazes off to the left, with her right arm raised to her chest. A spaniel sleeps at the girls' feet. A vista opens at left.

CONDITION: The sheet is somewhat weakened and has been reinforced from the verso at the platemark. It shows remnants of earlier mounts, and the paper color has darkened within the area of an earlier mat opening.

THE print reproduces an oil by John Hoppner (1758–1810) that was exhibited at the Royal Academy in 1795, under the title *Portraits of Young Ladies*, and is now in the National Gallery of Art, Washington.[1] It depicts the daughters of Sir Thomas Frankland, sixth baronet: Marianne (1778–95) is shown on the left and Emily, or Amelia (1777–1800), on the right.[2] Marianne evidently died soon after the paint-

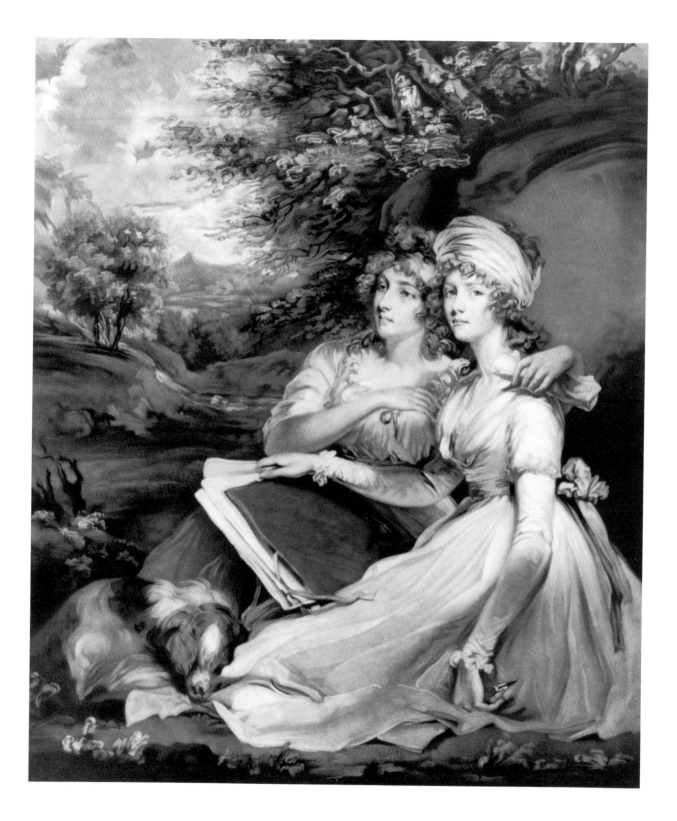

ing's completion, as there exists a condolence letter from Hoppner to her father written in September of 1795.[3]

This grand mezzotint is often reproduced in anthologies of the medium as one of Ward's master prints and as a highlight of the mezzotint art of the period. Ward has used a roulette (a toothed wheel set at the end of a handle) to reinforce some of the darker values, giving the landscape almost as much prominence as the two sitters. He also produced a number of color mezzotints, notably after landscapes by George Morland.

Mr. Frick purchased two oils by Hoppner, including a somewhat similar portrait of the two daughters of the third Earl of Darnley.[4]

COLLECTIONS: Frick, 1905.

NOTES

1. See *National Gallery of Art: European Paintings—An Illustrated Catalogue*, Washington, 1985, p. 206, repr.

2. The early literature on the painting and print often confused the girls' father with their grandfather, Adm. Sir Thomas Frankland; see C. E. Russell, *English Mezzotint Portraits and Their States*, New York–London, 1926, II, p. 363.

3. Transcribed in W. McKay and W. Roberts, *John Hoppner, R. A.*, London, 1909, pp. 87–88.

4. See *The Frick Collection: An Illustrated Catalogue*, I, 1968, pp. 73–77.

PAINTINGS

ANDREA DI BARTOLO

1358/64 – 1428

Andrea di Bartolo Cini was born in Siena, son of the celebrated Bartolo di Fredi Cini, with whom he trained until around 1390. Unlike his father, whose painting is characterized by an expressive use of line and naturalistic detail, Andrea followed a more traditional Sienese style based on the compositions of Simone Martini. He received numerous commissions from local Sienese patrons, including members of the Dominican and Franciscan orders, as well as from the Veneto. Although most of his commissions were completed in Siena, Andrea also worked in Treviso between 1425 and 1428, during which years his conventional Sienese style remained little influenced by Venetian iconography and love of rich ornament. Andrea died in Siena.

MADONNA AND CHILD (84.1.181)

Tempera, on panel, 21 × 13 in. (53.3 × 33 cm).

DESCRIPTION: The Virgin wears a blue robe, a red dress with gold brocade, and a white veil over her blond hair. She sits on a gold-brocaded red cushion close to the flower-covered ground. The Child, wearing a reddish-pink dress, sits on her left leg. Both figures turn their heads to the right. Greenish undertones show through the flesh colors of the faces, which are also marked by bright pink cheeks and lips. Two diminutive angels, kneeling in prayer, hover on a cloud to the right of the Virgin's head. The background is covered in gold leaf. The tabernacle frame is a modern replica in the Venetian style.

CONDITION: The work is in fair condition, with lifting and cracking of the paint on the Virgin's robe and some paint loss at bottom right. The faces and bodies, however, are well preserved. The blue pigments have darkened, and the reds have turned somewhat brown. Red bole shows through parts of the gold-leaf background.

THIS painting represents a variation on the theme of the Madonna of Humility, a common subject in Siena after the mid fourteenth century that typically depicted the Virgin seated on the ground nursing her Child.[1] The prototype for the composition is thought to have been a lost painting by Simone Martini, one that probably resembled his fresco at Notre-Dame-des-Doms in Avignon; the latter, painted around 1340–43, is the only Madonna of Humility by Simone to survive. The subject became prevalent among Sienese followers of Simone, such as Lippo Memmi[2]

347

and Bartolommeo da Camogli,[3] who presumably based their copies on the lost smaller and earlier version by Simone. Later Sienese artists, such as Andrea di Bartolo and his shop, made slight variations to Simone's composition. Some depicted the Madonna and Child floating on a cushion on a cloud to create a more celestial image of the pair. Others changed the setting to a domestic interior to evoke a simpler, more contemporary image of the Virgin. In both of these variations, the Child is seldom seen suckling as in Simone's prototype.

The present painting represents yet another variation on Simone's composition that was adopted in northern Italy and Siena around 1400. This version of the Madonna of Humility depicts the Virgin and Child seated in a garden, and may be linked to manuscript illuminations that depict the Madonna in a *hortus conclusus*, or enclosed garden. In paintings of this composition the Child rarely suckles, but instead stands or sits on the Madonna's lap, gazing outward like his mother. Four other versions of this type have been attributed to Andrea di Bartolo.[4]

The affectionate and personal character of this Madonna type made the composition popular in fourteenth- and fifteenth-century Siena. The simple features of the Virgin and her humble position seated on or near the ground have been regarded as a personification of the contemporary republican values of Italian communes including Siena.[5] The delicate forms of the figures and their interaction both with each other and with the viewer greatly contrast with Florentine variations of the theme of the Madonna of Humility, which evoke a more monumental and detached image of the holy pair.

<div align="right">A. T.</div>

COLLECTIONS: Achillito Chiesa, Milan. His sale, November 27, 1925, American Art Galleries, New York, Lot 49, sold to Helen Clay Frick. Frick Art Museum, Pittsburgh. Frick Art Reference Library. Frick Collection, 1984.

NOTES

1. For the origin and meaning of this type, see M. Meiss, *Painting in Florence and Siena after the Black Death*, Princeton, 1951, pp. 132–56.

2. Kaiser-Friedrich Museum, Berlin, No. 1072, cited in Meiss, p. 133.

3. Museo Nazionale, Palermo, cited in Meiss, p. 132.

4. Meiss, p. 140, note 35. The four paintings include: one in the Brooklyn Museum of Art; one in the Goodhart collection in New York;

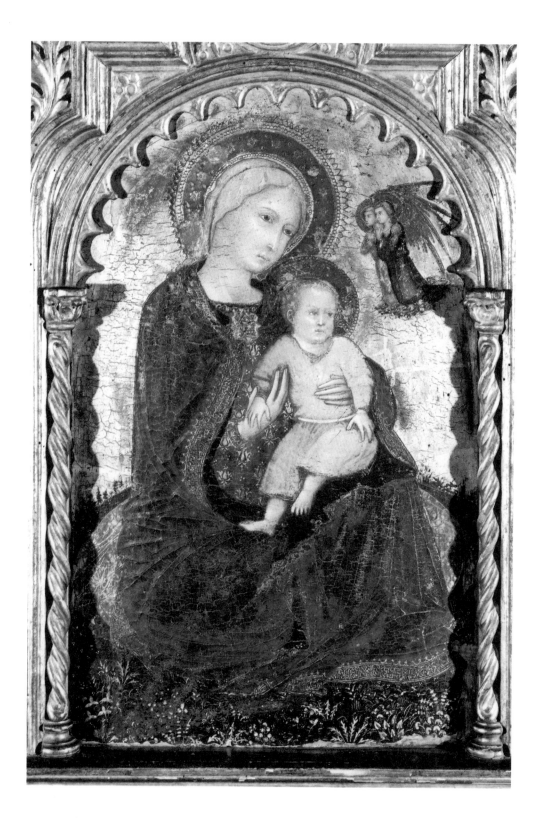

and two reproduced in *International Studio*, January 1931, p. 30. See also: B. Berenson, "Lost Sienese Trecento Paintings—Part IV," *International Studio*, April 1931, pp. 30–32, and "Quadri Senza Casa," *Dedalo*, November 1930, p. 344; and G. de Nicola, "Andrea di Bartolo: Documenti inediti," *Rassegna d'arte senese*, XIV, 1921, p. 14, note 1.

5. Meiss, p. 151.

GENTILE DA FABRIANO

Before *c.* 1385–1427

Born in Fabriano, Gentile is first documented working in Venice in 1408. Nothing is known about his youth or education, which may have been as peripatetic as his subsequent career. In 1420, after spending some years in Brescia and probably in other North Italian centers, he settled temporarily in Florence. Over the next few years, Gentile received important commissions from churches in Florence, Siena, and Orvieto as well as from leading families of Tuscany. By 1427 he had left Tuscany for Rome, where he worked for Pope Martin V and members of the papal court until his death later that year.

MADONNA AND CHILD, with Sts. Lawrence and Julian (66.1.167)

Signed, on the base of the frame: *gentili*[*s?*] [*de?*]. ... Painted about 1423–25. Tempera, on panel (cradled), picture surface 35¾ × 18½ in. (90.8×47 cm), frame H. 46½ in. (118.1 cm), w. at bottom 24 1/16 in. (61.2 cm).

DESCRIPTION: The Madonna, holding the Child on her lap, is seated on a throne draped with a vermilion cloth which displays a yellow-green lining. Figure and throne are silhouetted against a gold background. A tress of Mary's blond hair escapes from beneath the deep blue mantle that envelops her. The mantle has a gold border and a lining of dark green spangled with gold dots. The bodice and sleeve of her robe are woven of red and gold brocade. Mary looks down at the Child, who in turn looks toward a bird fluttering from the end of a string held in his left hand. The gold of Christ's tunic is fairly well preserved, but, except for its white fur lining, the cloth wrapped around him is worn down to the red bole ground. Two figures kneel on the pale lavender pavement before the throne. At left, his grid beside him, is St. Lawrence, wearing over his white tunic a stiffly brocaded gold and white dalmatic embroidered with blue and red rosettes. St. Julian, at right, holding a palm frond, wears a dark green velvet coat lined with white fur, trimmed with a gold border, and belted with a chain of gold disks from which hangs a red scabbard with gold mounts. His boots are wine red. The gold of the garments and haloes is richly patterned with tooled and punched designs. Pseudo-Cufic lettering decorates the Madonna's halo. The frame, composed of old and new elements (see *Condition*), is formed of a pointed arch supported on four twisted colonettes that rest on a base. Decorating the exterior of the arch are carved and gilded acanthus leaves that twist and curl upward; behind the leaves the flat surface

of the arch is painted a deep blue-green at left, a dark red at right. These colors are repeated on the outer of two bands of the intrados of the arch; the inner band is composed of molded and gilded rosette designs. The broad frieze of the base bears three incised squares, each framing a stylized thistle-like flower, and two incised rectangles painted dark green and scraped through to the underlying gold layer to reveal inscriptions with the saints' names: SC. LAVRETIVS at left and SC. IVLIANVS at right. In a cartellino on the base molding, beneath the central flower, is the artist's signature written in Gothic miniscule.

CONDITION: On the whole, the painting is well-preserved.[1] When it was cleaned in 1967–68, certain areas were found to have been completely and unnecessarily overpainted in an earlier treatment of unknown date—for example, the cloth draped over the throne and the lining of the Madonna's mantle. The chief areas of loss appear in the Madonna's mantle below her right knee and in the gilding of the cloth wrapped around Christ, which has almost entirely disappeared. Other, more limited losses may be seen beneath the Madonna's jawline, in her mantle by her elbow, in St. Julian's face, which is abraded, and in his coat, which has flaked to reveal the gold lying beneath the translucent green surface. A small loss appears in the throne cloth behind St. Lawrence, and another is in the pavement by his knee. The lower ledge of the pavement has also suffered losses, as have the other edges. The gold background was regilded in some previous restoration, but the gold of the haloes and garments is generally well preserved. The precise structure of the panel has not been determined, because the pine cradle and the frame conceal the sides and most of the back. It would seem that the paint film was transferred to a new poplar panel, since what is visible of this support at the back appears free of the wormholes that pock the paint film and riddle the frame. X-rays reveal that a tightly woven canvas lies between the panel and the gesso layer beneath the painted surface. The painting and gilding of the frame are of relatively recent date, except for the frieze with the inscriptions, which has been considerably retouched. The surviving letters of the signature on the cartellino have also been strengthened. Portions of the frame are not original; the colonnettes were added in 1968, and other parts, such as the upper and lower moldings of the base, the side moldings, and perhaps the molded and gilded gesso border of the intrados, appear to be replacements of an earlier date.

THE *Madonna and Child, with Sts. Lawrence and Julian* is a major work by one of the leading Italian painters of the early fifteenth century, yet for more than five centuries it evidently remained unknown. Thus far, no documents of commission for the panel have been found, nor any mention of it in early Italian guidebooks or writings concerning the artist. The altarpiece came to light in Italy—possibly Florence—in 1846, at which date it entered the collection of the Duc de Broglie, whose family apparently retained it for more than a century. It was brought to public attention only in 1958, when it was published for the first time, by Sterling.[2]

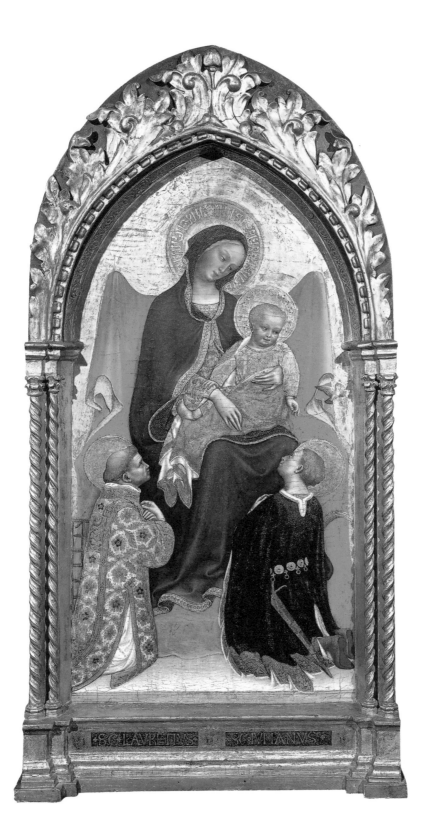

SC LAVRETIVS · SC·IVLIANVS

Possibly the small scale of the panel offers some clue to the puzzle of its lost history. Perhaps it was designed for the private family chapel of a palace in Florence or elsewhere in Tuscany and thus was never accessible to public view from the date of execution. Or possibly the painting was commissioned for some institution that was semiprivate in nature, such as the hospital of S. Giuliano, the oratory and private apartments of which must have contained works of art. Or the altarpiece might have adorned a chapel of a church in the environs of Florence, beyond the path of the ordinary traveler's itinerary, such as S. Lorenzo near Settimo, S. Giuliano in Settimo, or the Collegiata in Castiglion Fiorentino, which was dedicated to S. Giuliano, the patron saint of that town.

Both St. Lawrence and St. Julian were particularly revered in Florence, and one of the many Florentines named after either of them might have commissioned the altarpiece. Lawrence, a famous Roman martyr, was among seven deacons of that city under Pope Sixtus II in the third century. He was tortured and, according to tradition, burned on a gridiron. The grid, St. Lawrence's attribute, appears to his left in the Frick painting.

Several saints named Julian have often been confused with one another. Gentile probably intended to represent St. Julian the Hospitaler, who was especially venerated in Florence because his feast happened to be celebrated on August 31, the anniversary of the Ciompi rebellion of 1378. According to the *Golden Legend*, it had been predicted that Julian would murder his father and mother. To avoid this fate he left home in his youth, taking service with a prince who knighted him. But his precautions were futile; by mistake he did kill his parents, and as penance he built a refuge for travelers. Gentile equipped the saint not only with the sword and costume of a knight but also with a palm branch, symbol of martyrdom, even though this St. Julian did not die a martyr.

It is not easy to trace the evolution of Gentile's style, and thereby date his paintings, because so little is known of his background or training before he arrived in Florence. Few of his early works have survived, and many of the most important later paintings — such as the frescoes for the Lateran in Rome — have been destroyed or are in ruined condition. Judging from the remaining visual evidence, the Frick painting would appear close in time to Gentile's best-known masterpiece, the Strozzi *Adoration of the Magi* (Uffizi), dated 1423, and may be slightly earlier than the Quaratesi altarpiece of 1425 and other Madonnas of his last years — for example those at Orvieto and Velletri.

The flowers on the base of the frame flanking the saints' names also appear on the Strozzi frame, suggesting a possible connection between the two commissions. But no clear heraldic or iconographic significance to the motif has been established. Nor do the blue and red painted in the upper part of the frame offer meaningful evidence, as these hues were commonly found together on fifteenth-century altarpieces and coats of arms.

<div align="right">B. F. D.</div>

COLLECTIONS: Duc de Broglie, 1846. Frick, 1966.

NOTES

1. For photographs of the painting before restoration, which document areas of damage, see C. Sterling, "Un Tableau inédit de Gentile da Fabriano," *Paragone*, IX, May 1958, pp. 26–33.

2. *Idem.*

ADDITIONAL REFERENCES

K. Christiansen, *Gentile da Fabriano*, Ithaca, New York, 1982, pp. 37–38, 100.

B. F. Davidson, "Gentile da Fabriano's Madonna and Child with Saints," *Art News*, LXVIII, 1969, pp. 25ff.

B. F. Davidson, "Tradition and Innovation: Gentile da Fabriano and Hans Memling," *Apollo*, XCIII, 1971, pp. 28ff.

D. D. Davisson, "The Iconology of the S. Trinità Sacristy, 1418–1435: A Study of the Private and Public Functions of Religious Art in the Early Quattrocento," *Art Bulletin*, LVII, 1975, p. 327.

A. De Marchi, *Gentile da Fabriano: Un viaggio nella pittura italiana alla fine del gotico*, Milan, 1992, pp. 172–73, 109, note 44.

E. Micheletti, *L'opera completa di Gentile da Fabriano*, Milan, 1976, p. 91, No. 41.

Circle of

KONRAD WITZ

c. 1400 – *c.* 1447

Born in Rottweil, Würtemberg, perhaps between 1400 and 1410, Witz spent most of his life in Basel (where he is first mentioned in 1434) and Geneva. By 1447 he had died, ending a successful if brief career. Though removed from the mainstream of Netherlandish art, Witz was aware of developments in the Low Countries; in turn he influenced artists of diverse national origins whose identities and careers remain to be defined.

PIETÀ (81.1.172)

Oil and tempera (?), on panel, 13⅛ × 17½ in. (33.3 × 44.4 cm).

DESCRIPTION: Christ's body, gray in death, is loosely draped in a white transparent veil and supported across the knees of the Virgin, who wears a pale gray-blue robe. At left, dressed in a bleached rose mantle, kneels Mary Magdalene, who supports Christ's head. At right, almost hidden in the voluminous drapery of her orange cloak, Mary Salome crouches upon a yellow Gothic cloth. At extreme right, part of an open tomb is seen, and behind the Virgin rises the upright of Christ's cross. In a green meadow beyond these figures, the two thieves, their bodies slashed with bleeding wounds, hang from crosses of roughhewn tree trunks. On the horizon is Jerusalem, represented as a walled city with many spires, roofs, a building with a ribbed dome, and, most prominently, the lofty spire and choir of a church with flying buttresses and, to the right of it, the ruins of a cylindrical structure. Figures walk before the city walls. In the far distance are green-blue snow-capped peaks; a blue sky, streaked with a few clouds, lightens to pale yellow toward the horizon at left.

CONDITION: The condition of the painting is relatively good, though it has suffered from abrasion, scattered paint losses, and the slightly flattened surface that often results from transferring wood to wood.[1] The first technical examination was made at the Fogg Art Museum in 1937, when previous restoration was noted but, evidently, none was undertaken at that date.[2] Sometime before 1941, when the painting again was examined at the Fogg, William Suhr restored both the surface and the worm-tunneled back of the panel.[3] He transferred the painting to the current wood support (5/16 in. thick) and constructed the mahogany cradle enclosing it. Veneer strips were added to the edges, which had been cropped on all sides. The ivory-colored chalk ground is visible through cracks in the paint layers.[4] A network of fine

craquelure and quite extensive abrasion affect the Virgin's robe, the shadows at Christ's neck and torso, and sections of the yellow cloth and green hills. Further abrasion is seen in the diaphanous shroud and in numerous final details: the features of Mary Magdalene, the Virgin's fingers, Christ's chest wound, the small figures in the background, and some of the black outlining. Because the thinly painted surface became more transparent with time, these areas of abrasion have grown more evident. There is a flame-shaped damage in Christ's right arm, and smaller losses are seen in his forehead and the bridge of his nose. Other losses appear in the sky. Small localized damages visible thoughout the work were retouched in a confined manner.

THE *Pietà* is a "beautiful puzzle," a description once applied to its equally mysterious double, the *Pietà with Donor*.[5] The latter painting, a repetition of the former with the addition of a kneeling donor, was acquired in 1907 by Henry Clay Frick.[6] The *Pietà* without a donor appeared on the art market some fifteen years later and was purchased by Helen Clay Frick, Mr. Frick's daughter. An attribution for this painting to Konrad Witz was credited to M. J. Friedländer and A. L. Mayer in a 1924 article by Valentiner.[7] Since that date, many theories about the two paintings have been advanced, but nothing was determined with absolute certainty, not even their relationship, so obvious yet so elusive. Technical analysis has now provided many clues, if few incontestable solutions.

Today it is generally agreed that the *Pietà* is not by Witz himself but by an artist who knew the Swiss master's work. It has been further submitted, from information provided by infrared reflectography, that while this artist had studied paintings by Witz, he had not apprenticed in Witz's workshop.[8] The style of his underdrawing, executed with an extremely fine brush, is quite unlike Witz's broader, more diagrammatic underdrawings. From this evidence it is argued that the unknown artist had not been trained to prepare his panels in the manner practiced by the Witz shop.

Two other panel paintings have been attributed to the author of the *Pietà*, both also formerly assigned to Witz but now generally felt to be works from his circle. One is a *Crucifixion* in Berlin, which strongly resembles the Frick panel. The second is the Naples *Holy Family in a Church*, which is less obviously related.[9] A third work may perhaps be associated with these: a funerary fresco for Philibert Monthouz (d. 1458) in the church of St.-Maurice, Annecy, in Savoy.[10] Savoy was a crossroads for travelers coming from many directions, and the probable date of the fresco is not too far from the dating in the 1440s or 1450s usually proposed for the *Pietà*.

With so slight a body of work, no external documentation, and a geographic re-
gion so rich in political and cultural complexities that national characteristics are
hard to isolate, it is not surprising that attempts to identify the artist or even the
locus of his activity lack conviction. Provence, Savoy, and Burgundy, all suggested
as domiciles for the artists of the two *Pietàs*, stretched north in sequence from the
coast, and were traversed by broad river valleys. The Swiss cantons were contigu-
ous with the eastern border of Savoy. In addition to proximity, matrimonial, mili-

tary, and commercial alliances linked these centers and further extended their horizons beyond the immediate neighborhood. The Dukes of Burgundy, for example, had close ties with Brabant and Holland, through family inheritance and military conquests, and a son of Amadeus VIII of Savoy became Count of Geneva. Other regions also were easily accessible. The Rhine valley offered an avenue from the Low Countries and Cologne to Basel. Ships from Aragon, Naples, and North Italy could reach the south of France in a matter of days, carrying merchants, armies, or artists. Local courts—even small ones—attracted a floating population of cosmopolitan visitors, including artists. It is not surprising that many of these itinerants, however gifted, are difficult to pin down—to identify, document, or even define in clearcut national terms.

The *Pietà* is far closer stylistically to Witz and North European painting of the mid fifteenth century than the *Pietà with Donor*. Most scholars have agreed that a more southern temperament is at work in the latter, and the gesso ground on which it is painted indicates an artist trained in Italy or the south of France. Infrared reflectography reveals that, at least for the most part, the *Pietà* was original in conception and that the version with a donor was not. As he developed the composition, the artist of the *Pietà* made numerous changes, many of which are visible in the underdrawing. He added figures, adjusted limbs and drapery, and altered features of the city and landscape. No such evolution appears beneath the surface of the *Pietà with Donor*, though some corrections were made, often related to size, probably because the copy is slightly larger than its model. The *Pietà* grew in stages, beginning with the Virgin and Christ, who were drawn on the chalk ground. The green landscape was then added. The two Marys were painted over the green and over portions of the Virgin's drapery. The city wall was introduced after the Mary at right. The crosses of the thieves are also painted on top of the landscape. Buildings in the city underwent significant changes, with many sketchy indications of roofs and towers eventually omitted, as well as major alterations to some of those retained; the round ruined edifice, for example, began as a taller building with a cupola, possibly octagonal in design. Some of the building contours are sketched with incised lines. Given these changes in architectural design, it is clear that the artist was not portraying an existing city or even specific buildings, however realistic his structures may seem.

Conceivably, the figures of the Virgin and Christ, which were the first to be drawn on the chalk ground, were derived from a lost Witz prototype, and possibly

even the Marys reflect some unidentified source in Witz or another model, but the expressive and inventive powers of the unknown artist seem more than sufficient to render unnecessary a search for such dependencies. Without external evidence, it is meaningless even to speculate precisely where the *Pietà* was painted.[11] The painter may have come from a place far from that of his patron, and his painting did not necessarily remain where it was executed; the copy, with its more meridional flavor, suggests that one or both of the panels may have traveled, as did, evidently, their authors.

<div align="right">B. F. D.</div>

EXHIBITED: Cambridge, Massachusetts, Fogg Art Museum, 1936–39 and 1946, lent to this and the following exhibitions by Helen Clay Frick. Pittsburgh, Carnegie Institute, French Painting 1100–1900, 1951, No. 30. New York, Frick Collection, 1958 and various later dates. New York, Wildenstein, The Italian Heritage, 1967, No. 37. Pittsburgh, Frick Art Museum, 1971 and 1979. New York, Richard L. Feigen & Co., Bedford Collects, 1972, No. 3.

COLLECTIONS: Private collection, Naples. Durlacher Bros., New York. Helen Clay Frick, 1922(?).[12] Gift of Helen Clay Frick, 1981.

NOTES

1. The summary analysis of condition and the results of infrared reflectography discussed here are condensed from a study undertaken in February 1995 by the Department of Paintings Conservation of the Metropolitan Museum of Art, New York. The Frick Collection is particularly indebted to Maryan Ainsworth, whose support and expertise were invaluable. Her colleagues Charlotte Hale, George Bisacca, Margaret Koster, and Christopher McGlinchey also contributed, as did Hubert von Sonnenburg, Sherman Fairchild Chairman of Paintings Conservation.

2. Records dated November 2 and 9, 1937, and December 23, 1941, Harvard University Art Museums.

3. The William Suhr Archive, Getty Center, Los Angeles.

4. The chalk ground (identified as calcium carbonate by R. J. Gettens in the November 9, 1937, report for the Fogg Art Museum) is typical of North European paintings.

5. Letter from Paul J. Sachs to Helen Clay Frick, July 27, 1923. Sachs suggested both works were "Franco-Flemish, produced in Provence, under Italian influence, or by a master familiar with painting in Venice and Padua." In other replies to Miss Frick's inquiries, Frank Jewett Mather (January 20, 1922) suggested "Riviera School under mixed Italian and Flemish influence," J. Guiffrey (February 12, 1924) thought the *Pietà* "d'origine française probablement de l'école d'Avignon," and A. Kingsley Porter (no date) believed both paintings were by French masters but under Venetian influence.

6. For the *Pietà with Donor*, see *The Frick Collection: An Illustrated Catalogue*, II, 1968, pp. 124–29.

7. W. R. Valentiner, "Hans and Conrad Witz," *Art in America*, XII, 1924, p. 132.

8. The Frick Collection is indebted to Julien Chapuis for this and the following observations.

9. See H. Röttgen, "Konrad Witz—der Farbkünstler und der Zeichner," *Zeitschrift für Schweizerische Archäologie und Kunstgeschichte*, XLIV, 1987, pp. 90, 98ff. Röttgen also discusses earlier literature and various groundless attempts to attribute the paintings to a Hans Witz. See also M. Barrucand, *Le Retable du Miroir du Salut dans l'oeuvre de Konrad Witz*, Geneva, 1972, pp. 4–5. In a letter of December 1, 1989, Röttgen suggested that the *Pietà* should be attributed to the Burgundian-Savoyan circle of Witz, c. 1440/50.

10. C. Gardet, *De la Peinture du Moyen Âge en Savoie*, Annecy, 1965, I, pp. 127ff.

11. It has been claimed (O. Pächt, "René d'Anjou—Studien II," *Jahrbuch der Kunsthistorischen Sammlungen in Wien*, LXXIII, 1977, p. 24) that the kneeling Mary at left is reflected in a miniature by Jean Colombe, active in Dijon c. 1480–85, and that the *Pietà*, therefore, was then in Dijon. The basic pose of the figure, however, goes back to antiquity, and other similar derivations can be found in medieval French and Italian painting and sculpture. The squatting version of the pose seen in the miniature is closer to classical models than the kneeling Mary of the *Pietà*.

12. The 1967 Wildenstein exhibition catalogue credits Ralph W. Forbes and Paul Sachs with the discovery of the painting. A letter to Professor Sachs from Miss Frick (January 20, 1923, archives of the Harvard University Art Museums) reveals that Sachs relinquished an option on the painting "in favor of The Frick Collection."

ADDITIONAL REFERENCES

U. Feldges-Henning, "Werkstatt und Nachfolge des Konrad Witz," *Basler Zeitschrift für Geschichte und Altertumskunde*, LXVII, 1967, pp. 25–26.

M. Laclotte and D. Thiébaut, *L'École d'Avignon*, Tours, 1983, p. 96.

M. Roques, *Les Apports néerlandais dans la peinture du sud-est de la France*, Bordeaux, 1963, p. 117.

C. Sterling, "L'Influence de Konrad Witz en Savoie," *Revue de l'art*, LXXI, 1986, pp. 17ff.

G. Troescher, *Burgundische Malerei*, Berlin, 1966, I, pp. 341–43.

PIERO DELLA FRANCESCA

c. 1415–1492

Piero, born in the Tuscan town of Borgo Sansepolcro, is recorded working there in 1436. By 1439 he was in Florence, where he assisted Domenico Veneziano on the frescoes (now lost) of S. Egidio. Later Piero undertook commissions in Ferrara, Rimini, Rome, Urbino, and elsewhere, but his best-known work is the cycle of frescoes illustrating the Legend of the True Cross *in S. Francesco, Arezzo. Deeply interested in perspective and geometry, he wrote a treatise on the subject entitled* De prospectiva pingendi.

THE CRUCIFIXION (61.1.168)

Tempera, on poplar panel (cradled), 14¾ × 16³⁄₁₆ in. (37.5 × 41.1 cm).

DESCRIPTION: Silhouetted against a gilded background suggesting sky, Christ is stretched on the cross, which rises above a stony landscape, barren except for a single, leafless tree. To the left of the cross stand two holy women supporting the Virgin, assisted by Mary Magdalene, whose flowing blond hair and red cloak contrast with the subdued gray-blue and plum garments of her companions. At the right, St. John, wrapped in a bleached red mantle, steps toward the cross, his eyes raised to Christ. Seated in the center foreground is a trio of soldiers drawing lots for Christ's robe, which is also a bleached red. Their costumes are in muted shades of blue, rose, and green, except for the soldier at right, whose stockings and scabbard are red. Flanking the central figures are groups of soldiers, their upright lances forming a rhythmic pattern against the gold background. The men at left are all mounted. An armored centurion riding a white horse joins his hands as if in prayer while looking toward Christ. The red of his saddle and bridle are echoed in the red shirt of one soldier and the red banner held by another. To the right, a line of foot soldiers carry red shields (the nearest inscribed SPQR), a red banner, and another banner of lavender-gray. A soldier riding a prancing brown horse gestures with a baton toward the still figure of Christ on the cross.

CONDITION: The painting has suffered considerable damage and has been restored several times, to judge from surviving photographs. The earliest known photograph is said to date from about 1910–15.[1] It reveals that the *Crucifixion* had already been crudely repainted, either at that date or earlier. The rocky terrain of the background had been transformed into a gently rolling landscape, the bare tree had sprouted thick foliage, and a second bushy tree-top had sprung to life at far right. The figures were similarly worked over with a heavy hand. The basic elements of this restoration can still be seen in a reproduction published in 1917, af-

ter the painting had entered C. W. Hamilton's collection, but by then restorers had further added to or altered many portions.[2] The most conspicuous changes include an even greater elaboration of the already overpainted landscape, replacement of the eagle on the central banner with another design, and extensive retouching of faces and other areas. The painting may have been partially stripped of overpaint and again restored around 1925, while still in Hamilton's collection. According to William Suhr's cleaning report, written in 1951, the painting was restored yet again while in the collection of John D. Rockefeller, Jr., when Suhr removed almost all of the layers of overpaint, thus revealing the original rocky landscape with the single bare tree. The foliage of the trees, which had been painted in oil, covered the earlier crackle. Prior to 1951, the panel, which was riddled with wormholes and channels, had been thinned to approximately ⅜ in. Suhr evidently transferred the panel to a new support some time after the date of his cleaning report; he perhaps then reattached the oak cradle that he described in the report, and which is still fixed to the panel today. The painting was last cleaned and restored in 1986 by Mario Modes-tini. The condition of the panel, the gesso ground, and the paint film at the margins suggests that the sides have been cut down, but a thin veneer of wood applied to all the edges makes them difficult to examine. A narrow black band borders the painting at top and bottom, which may not have been cut by much, but fragments of missing figures (such as part of an equestrian's foot at right) point to larger losses at the sides. Among areas of total loss in the paint film are: a roughly semicircular loss, just below center at the left margin, which curves about 1¼ in. into the picture to include the tail of the white horse; losses along other edges, especially intrusive above the heads of the soldiers at far right, where a tree had been added; and chips missing the length of a horizontal break which runs approximately across the center, passing through the face of the praying centurion at left. There are many smaller, scattered areas of loss, among them the face of the soldier to the right of St. John. Much of the surface has suffered abrasion, but the horses are relatively well preserved, as is the figure of Christ except for his right leg above the knee. Most of the gilding in the background has been restored.

THE Frick Collection owns one of four large panels with standing saints from an altarpiece Piero della Francesca painted for S. Agostino in Borgo Sansepolcro, as well as two much smaller, three-quarter-length images of an Augustinian monk and nun which may have formed part of the same commission.[3] The present *Crucifixion* panel has also been connected to that altarpiece by several writers.[4] However, despite various elaborate and creative arguments in favor of such an association, no substantive evidence has been found to link the *Crucifixion* with the S. Agostino commission.[5]

Toward the end of the seventeenth century, four small paintings ("quadretti") said to be by Piero della Francesca were cited in the collection of Luca and

Francesco Ducci at Borgo Sansepolcro.[6] The subjects were a Flagellation, a Crucifixion, a Deposition, and a Resurrection. The Crucifixion is described in considerable detail: "sonvi due gruppi di figure a cavallo acconciamente fatti e tre soldati ch'a pie' della Croce in terra seggono per giocarsi la veste altresi bellissimi sono, come la Vergine dalle Marie accompagnata ed il S. Gio. che par ch'al Redentore favelli. ..."

This description so precisely responds to the scene depicted in the Frick *Crucifixion* that there seems no reason to doubt that the panel formed part of the dismembered predella once in the Ducci collection. The provenance also strongly suggests that this predella was painted by Piero or his workshop in Borgo Sansepolcro; it does not, however, provide evidence for the original destination of the predella. Also in the Ducci collection, in another room, were four large panels by Piero of standing saints, which are described clearly enough in the manuscript to be recognized as the four surviving portions of the S. Agostino altarpiece, even though only two of the saints are correctly identified (St. Michael and St. Augustine).[7] According to the Ducci document, these four paintings belonged formerly to the "Pieve di S. Ago. in questa Citta," and an additional notation specifies "tavola dell altar maggiore." No such provenance is named for the four small predella panels, which might equally well have belonged to some other altarpiece by Piero.

When the *Crucifixion* first emerged from private collections to public view early in this century, leading connoisseurs were deeply impressed by its quality, despite some reservations about the condition. Berenson, though not disinterested, seems in his 1915 letters to Duveen to have been genuinely moved by the painting.[8] Pope, who wrote the first article about the *Crucifixion*, when it was exhibited at the Fogg Art Museum in 1917,[9] and Venturi,[10] the following year, both praised it in glowing terms, while Offner declared: "Battered and restored in parts, the panel still remains one of the supreme masterpieces in America."[11] Since then, opinions have in general been more cautious, especially concerning the problem of whether the painting was executed by Piero himself or is partly or entirely the work of assistants. Given the deterioration of the paint film, however, all statements about attribution must be regarded with skepticism, especially since few if any writers had informed knowledge of the condition of the painting.[12] One could nevertheless argue with some justification that the *Crucifixion* was Piero's design, whether or not he set hand to it. Though small, the painting is impressive in its monumentality, in the austerity of the artist's conception, and in the controlled intricacy of the compo-

sition, organized with a formal clarity that accents the significant events of the narrative.

Dating the panel is also problematic, as with much of Piero's oeuvre. The figures of Christ and St. John closely resemble those in the *Crucifixion* from Piero's *Misericordia* polyptych in Borgo Sansepolcro, while the mounted soldiers are related to the cavalry depicted at Arezzo in the fresco of Constantine's victory over Maxentius. Both those commissions—like the S. Agostino altarpiece—advanced at intervals over the years, making comparisons for purposes of chronology a futile exercise. Because the composition of the *Crucifixion* is so effectively designed and so authoritative in its restrained dramatization, one would imagine the painting to be a work of Piero's mature years, but more assured hypotheses concerning the date and destination of the commission are not yet possible.

B. F. D.

EXHIBITED: Cambridge, Massachusetts, Fogg Art Museum, 1917, lent to this and the following three exhibitions by C. W. Hamilton. New York, Metropolitan Museum, Fiftieth Anniversary Exhibition, 1920.[13] New York, Duveen, Early Italian Painting, 1924, No. 24. San Francisco, Palace of the Legion of Honor, A Group of ... Art Objects from the Collection of Carl W. Hamilton, New York, 1928, No. 46. New York, Century Association, Italian Paintings of the Renaissance, 1935, No. 13, lent by John D. Rockefeller, Jr. Princeton University, Art Museum, 1966–85, lent by The Frick Collection.

COLLECTIONS: Luca and Francesco Ducci, Borgo San Sepolcro, *c.* 1680. Marco Antonio Colonna, Prince of Paliano.[14] Doria, Milan.[15] Luigi Grassi, Florence.[16] Bernard Berenson, 1914. Duveen. Carl W. Hamilton, Great Neck, Long Island, New York. His sale, New York, Anderson Galleries, May 8, 1929, Lot 1, sold for $375,000 to Duveen. John D. Rockefeller, Jr., New York. Bequeathed by him to The Frick Collection, 1961.

NOTES

1. E. Battisti, *Piero della Francesca*, Milan, 1979, II, p. 48. Phot. neg. no. Reali 248, Kunsthistorisches Institut, Florence. Writers occasionally assume that the clumsy landscape seen in the photograph was original and was removed in restoration (see, for example, A. di Lorenzo, "Il polittico agostiniano di Piero della Francesca: Dispersione, collezionismo, restauri, ricostruzione," *Quaderni di studi e restauri del Museo Poldi Pezzoli*, II, 1996, p. 22), but this is incorrect; the foliage was painted in oil on top of the original rocky landscape.

2. A. Pope, "A Small Crucifixion by Piero della Francesca," *Art in America*, V, 1917, pp. 217ff.

3. See *The Frick Collection: An Illustrated Catalogue*, II, 1968, pp. 232–42.

4. The proposal was first published by R. Longhi (*Piero della Francesca*, Milan, 1947

[1942], pp. 187, 189), who then added in a letter (*Burlington Magazine*, LXXXIX, 1947, p. 286) that the *Crucifixion* accorded in style and dimensions with the small panels of the Augustinian monk and nun. In fact, the *Crucifixion* is ½ in. lower in height than the two other panels, and its condition as well as the great difference in figure scale make stylistic comparisons unreliable.

5. In reconstructions of the altarpiece attempted by several writers, the *Crucifixion* is placed beneath the lost central panel (see, for example, Battisti, *loc. cit.*). Di Lorenzo (p. 36) believes it was beneath the panel of *St. Michael*, to the left of the central panel. Other recent scholarship tends to question the arguments favoring a provenance associated with the S. Agostino altar (see, for example: C. Bertelli, *Piero della Francesca*, trans. E. Farrelly, New Haven–London, 1992, p. 202; R. Lightbown, *Piero della Francesca*, New York–London–Paris, 1992, p. 218).

6. A. Parronchi, "Ricostruzione del Polittico di Sant'Agostino di Piero della Francesca," *Michelangelo*, XIII, No. 16/47, 1984, p. 30. The author is grateful to Frank Dabell for sharing his transcription of the document, which she has used here in part.

7. *Idem*.

8. The archives of the Isabella Stewart Gardner Museum, Boston, contain four letters written in 1915 by Bernard Berenson to Duveen enthusiastically recommending the *Crucifixion* and one dated January 27, 1916, from Duveen to Mrs. Gardner offering her the painting.

9. Pope, *op. cit.*

10. A. Venturi, "Un quadro di Piero della Francesca in America," *L'Arte*, XXI, 1918, pp. 3–4.

11. R. Offner, "A Remarkable Exhibition of Italian Paintings," *The Arts*, V, 1924, p. 248.

12. Opinions concerning the degree of Piero's participation in executing the painting range from Berenson's enthusiastic advocacy (see note 8 above) to judgments such as M. Salmi's that the execution is almost entirely shopwork (*La pittura di Piero della Francesca*, Novara, 1979, p. 116).

13. *Bulletin of The Metropolitan Museum of Art*, XV, July 1920, p. 162.

14. Pope, p. 217.

15. W. R. Valentiner, *A Catalogue of Early Italian Paintings Exhibited at the Duveen Galleries*, New York, 1924, No. 24.

16. C. Simpson (*The Partnership: The Secret Association of Bernard Berenson and Joseph Duveen*, London, 1987, p. 195), not a consistently reliable source, states that Berenson bought the panel from Grassi for $10,000 and sold it in partnership with Duveen to Hamilton for $65,000.

ADDITIONAL REFERENCE

Il Polittico Agostiniano di Piero della Francesca, ed. A. di Lorenzo, Turin, 1996, *passim*.

HANS MEMLING

Active 1465–1494

Memling (or Memlinc) was born in Seligenstadt, near Frankfurt am Main, presumably about 1440. Nothing is known of his training, begun perhaps in Germany, but even his earliest surviving works reflect a thorough assimilation of the Flemish manner, especially that of Roger van der Weyden and Dieric Bouts. Memling is first documented in 1465, as a new citizen of Bruges, where his career flourished. The port city of Bruges—a banking and commercial center that attracted a cosmopolitan clientele—supplied the artist with patrons who came not only from the Netherlands but from England, Spain, Germany, and Italy. St. John's Hospital at Bruges houses some of his best-known works, but Memling's altarpieces and portraits were shipped throughout Europe. Few of them can be dated, and undated paintings are difficult to place chronologically, chiefly because his style changed so slightly over the years and also because little is known about his assistants' capabilities or responsibilities. Memling died in Bruges on August 11, 1494.

PORTRAIT OF A MAN (68.1.169)

Painted probably about 1470. Oil, on oak panel, 13³⁄₁₆ × 9¹⁄₁₆ in. (33.5 × 23 cm).

DESCRIPTION: The subject is portrayed bust length, turned slightly to the left, his short brown hair silhouetted against a deep blue sky. The sober simplicity of his brown doublet, with only a trace of white shirt revealed at the neck, seems consistent with his serious demeanor and the steady gaze of his brown eyes. His right hand—of which only the thumb and two fingers are visible—grasps a black cornette, a scarf-like attachment to a hood or hat, which hangs out of sight behind his right shoulder.[1] A black band borders the sides and top of the panel, suggesting but not describing a window frame beyond which a landscape and the sky stretch toward a pale horizon. Gently rolling meadows and full leafy trees are threaded together by slow-winding paths and a calm stream. A church spire pierces the horizon line at left, and at right a church with a square tower rises before the more distant silhouetted roofs of a town.

CONDITION: In 1963, the Belgian restorer Albert Philippot gave the painting a superficial cleaning and retouching. In 1969, after acquisition by The Frick Collection, a more comprehensive restoration was undertaken. The bond between panel and ground is now firm, but some flaking had occurred in the past. The paint film had suffered considerable abrasion, though it is well preserved in more opaque

areas such as the sky and landscape. The most serious losses and abrasions are found in the darker areas of the face, including the eyes, eyebrows, and hair and shadows modeling the flesh. Neither X-rays nor infrared reflectography yield significant information. The back of the panel, which is coated with dark paint, is beveled at the top and trimmed at the sides.[2] A lighter margin ¼ in. wide at the bottom presumably slotted into a frame.

THE first record of the *Portrait of a Man* seems to date from 1929, the year inscribed on the back of a photograph by the restorer William Suhr, with the further information that the painting then belonged to the dealer Zatzenstein, of the Matthiesen Gallery, Berlin.[3] M. J. Friedländer saw the portrait at Matthiesen's in 1930. In 1932 he wrote in reply to an inquiry from Baron Joseph van der Elst that it was a fine, authentic Memling, and he encouraged the Baron to make the purchase.[4] The history of the painting prior to 1929 has not been clarified, though van der Elst did make an attempt. It may have come to Berlin through Pietro Accorsi, a dealer in Turin, who, however, when questioned by van der Elst some years later, was either too secretive or too aged to offer a consistent account.[5] Friedländer first published his attribution to Memling in 1937, and that attribution has been accepted ever since.[6]

The *Portrait of a Man* is believed to be an early work by Memling, dating from roughly about 1470.[7] The paucity of securely dated paintings, the lack of identification of many sitters, and disparities in degree of preservation all render firm judgments concerning the chronology of Memling's portraits inadvisable. The only dated portrait from his earliest years is the *Gilles Joye* in the Clark Art Institute, Williamstown, Massachusetts, inscribed on the frame 1472. But that painting is difficult to compare with the Frick portrait; the face is in poor condition, and the background is a dark, uniform monochrome. Much closer stylistically is the *Man in a Red Hat* in Frankfurt, which unfortunately is not dated, nor is the subject identified.[8] Though De Vos suggests a date of about 1467–70 for that panel and about 1470–72 for the Frick panel,[9] the opposite might be argued, based on apparent slight advances from the Frick to the Frankfort image: the establishment of an enlarged physical presence for the figure, a more convincing structure for the window frame, and a more complex integration of figure with landscape background. In the Frankfurt painting—as in later works, though with greater subtlety—Memling designed the landscape to follow the lines of shoulder and costume and to echo the shape of the hands. By comparison, the Frick portrait seems relatively flat, stiff, and abrupt. But whatever their sequence, the two paintings cannot be far apart in date.

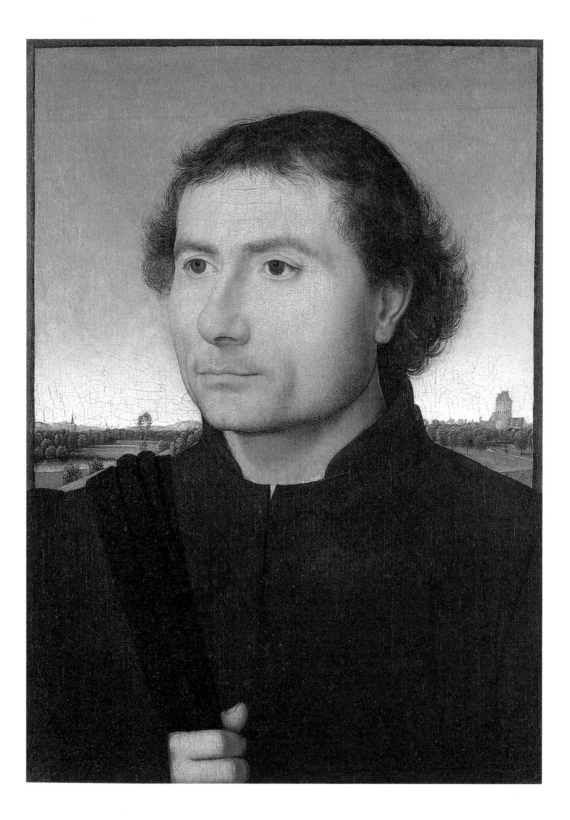

Both are early examples of a type Memling was to exploit and which would win him particular fame: the bust or half-length portrait with a landscape in the background. The format was not unprecedented—a few prototypes both in the Netherlands and in Italy have been noted[10]—but Memling soon developed a successful formula which he repeated, with slight variations, throughout his career. In some portraits, architectural elements frame a limited view of landscape beyond a window or loggia, but more often the setting is at most a narrow ledge at the bottom and a slender frame around top and sides, as in the Frick portrait. Pushed forward close to the viewer (but usually ignoring him), placed high above an expansive and peaceful countryside, the sitter is endowed with an air of assured ascendancy over his world. It was a formula with obvious appeal to Memling's clients.

Nothing in the sober, conservative clothing of the Frick subject provides evidence of his occupation or nationality, but possibly the landscape offers a clue. Many landscapes in Memling's portraits contain no architecture or other elements that might be associated with the subject's domain or his family emblems, but little effort has been made to identify buildings that do appear in some of them. It is suggested here, with great caution and hesitation, that the square tower behind the sitter in the Frick portrait may represent the church of St. Gilles as seen from the north, looking toward the southeast. Built beyond the medieval ramparts of Bruges, St. Gilles is where Memling was buried and was only a short walk from his house in the northern quarter of the city.[11] About 1470–71, considerable building expansion was recorded at the church; its present spire was not added until the sixteenth century.[12] Alongside the church, Memling has placed a round tower. Conceivably this structure is intended as an emblematic reference to the Torreman family, whose chapel just to the left of the main altar of St. Gilles includes several coats of arms with similar round towers. The chapel was founded by Jacob Torreman, who was mentioned as church warden in 1471 and who died in 1488.[13] With the hope of stimulating future research in the archives of Bruges, it is tentatively proposed that he or another family member might possibly be the subject of the portrait.

<div align="right">B. F. D.</div>

EXHIBITED: New York, Knoedler, Flemish Primitives, 1942, lent anonymously (Baron van der Elst).[14] Brussels, Palais des Beaux-Arts, Chefs-d'oeuvre de l'art ancien dans les musées et collections belges, 1953, No. 13, lent from a private collection.[15] Bruges, Musée Communal,

Le Portrait dans les anciens Pays-Bas, 1953, No. 13, lent from a Rome private collection (Baron van der Elst).[16]

COLLECTIONS: North Italian collection (?).

Matthiesen Gallery, Berlin, by 1929. Baron Joseph van der Elst, 1932. Baroness Allison Roebling van der Elst, Geneva. Frick, 1968.

NOTES

1. Stella Mary Newton (letter of May 3, 1971) kindly analyzed the costume and summarized it as very conservative, a particularly dignified style, possibly some kind of official dress.

2. Two indecipherable ink stamps on the back probably are customs stamps.

3. Information in a note from William Suhr, October 24, 1968.

4. Friedländer gave Zatzenstein a certificate authenticating the painting, dated November 29, 1930, and wrote to van der Elst on May 23, 1932, confirming his opinion.

5. Information in an undated memorandum from van der Elst.

6. M. J. Friedländer, *Die altniederländische Malerei, XIV (Pieter Bruegel und Nachträge zu den früheren Bänden)*, Leiden, 1937, p. 103.

7. L. Campbell, *Renaissance Portraits*, New Haven–London, 1990, p. 109 (1470s); D. De Vos, *Hans Memling: The Complete Works*, Antwerp, 1994, p. 110. See also notes 14 and 15 below.

8. The Frankfurt portrait is admirably catalogued by J. Sander, *Niederländische Gemälde im Städel 1400–1550*, Mainz, 1993, pp. 295–305. See pp. 301 ff. for the Frick portrait.

9. De Vos, pp. 96, 110.

10. See, for example: B. Davidson, "Tradition and Innovation: Gentile da Fabriano and Hans Memling," *Apollo*, XCIII, 1971, pp. 381–85; Campbell, pp. 115–21; De Vos, pp. 367–70.

11. For a discussion of Memling's houses, see M. Ryckaert, "Het huis van Memling in Brugge," *Hans Memling: Essays*, Bruges, 1994, pp. 104–08.

12. C. de Flou, *Promenades dans Bruges*, n.d., pp. 160–62; E. Rembry, *De Bekende Pastors van Sint-Gillis te Brugge*, Bruges, 1890–96, pp. vii–viii.

13. Rembry, pp. viii–ix.

14. "Probably painted between 1467 and 1472," according to the exhibition catalogue (G. Philippart), p. 42.

15. The catalogue again dates the portrait between 1467 and 1472. It adds "Provient d'une collection italienne."

16. The exhibition catalogue suggests that the portrait was painted between 1462 and 1472. The first date is surely a typographical error as the text is otherwise derived from the 1942 Knoedler catalogue, which is repeated in the Brussels catalogue.

ADDITIONAL REFERENCES

L. von Baldass, *Hans Memling*, Vienna, 1942, pp. 28, 41.
M. Corti, *L'opera completa di Memling*, Milan, 1969, No. 110.

ANTOINE WATTEAU

1684–1721

Watteau, son of a roofer, was born in Valenciennes, a city in the former Spanish-ruled south Flanders that had been taken by the French in 1677. By 1702 he was in Paris, where he studied first with Claude Gillot and later with Claude Audran III. During those years he also executed decorative wall panels for various Parisian residences. Watteau, who became known mainly for his theater-related works and for introducing the fête galante *as a separate genre, was received into the Royal Academy in 1717 with the painting* The Pilgrimage to the Island of Cythera *(Louvre). He died only four years later in Nogent-sur-Marne.*

THE PORTAL OF VALENCIENNES (91.1.173)

Painted about 1709–10. Oil, on canvas (lined), 12¾ × 16 in. (32.5 × 40.5 cm).

DESCRIPTION: The base of an enormous arch dominates the right half of the painting. Its colors vary from yellow and light green to a strong tone of golden brown above. A long pike leaning against the wall points toward a crowned shield displaying the French royal arms, bathed in golden light. Four soldiers accompanied by two dogs are depicted at the base of the arch. Three more soldiers stand at left, and beyond them, on the far side of a bridge, rises a fortress painted in white and gray, with green plants growing atop its walls. Two of the soldiers smoke pipes, one lies on the ground asleep, and four carry muskets; a fifth musket rests on the ground beside a drum and one of the dogs. The soldiers' uniforms are gray, ocher, and brown, corresponding to the colors of the ground. The sky above the fortress—light blue and gray with reflections of white and pink—contrasts sharply with the brown and gold of the arch.

CONDITION: The painting is in very good condition. It was originally executed as an oval composition; the corners, later filled in, have remained untouched.

THE painting today known as *The Portal of Valenciennes* and commonly dated to around 1710 remained out of sight for almost two hundred years. Only in 1892 did it make its first public appearance, at the posthumous sale of the noted collection formed by the art historian Théophile Thoré, who after 1849 published under the pseudonym of William Bürger. His collection had been bequeathed to "des mains fidèles"[1] and apparently remained intact until the 1892 auction at the Hôtel Drouot

in Paris. There it was entitled *Les Gardes du fort* and attributed to Jean-Baptiste Pa-
ter (1695–1736), but with a catalogue note adding: "Fin et spirituel tableau de
l'artiste, ayant toute la fermeté des oeuvres d'Antoine Watteau."[2] At later sales in the
early twentieth century it was always listed as the work of Pater's teacher, Watteau,
an attribution that is now generally accepted.[3] The painting probably remained un-

known for so long because it had left France, or at least Paris, early on and had become unavailable for comment or reproduction.[4]

At the sale of the Jacques Doucet collection in 1912, the work appeared for the first time as *The Portal of Valeniennces*, with the attribution to Watteau. According to his early biographers, Watteau spent several weeks or months in his hometown after participating in the prize competition at the Royal Academy in 1709. At that time, in the midst of the War of the Spanish Succession, Valenciennes served as winter quarters for part of the French army. The painting's new title reflected the idea that it had been executed during or shortly after Watteau's stay there and may have depicted parts of the town's original fortifications. While there is much debate concerning this assumption, it is very likely that the artist at least drew some preparatory sketches while at Valenciennes. Three surviving drawings of soldiers by Watteau are obviously related to several of the figures in the painting.[5]

It was during the period 1710–12 that Watteau concentrated on military paintings. Works such as *The Halt* and *The Bivouac* show groups of soldiers marching, resting, or keeping guard, smoking and conversing. For the most part, these men were depicted in large numbers and among various townspeople, including children. Such pictures belonged to the kind of military genre painting that had originated in Flanders during the seventeenth century and became popular in Paris around 1700, showing soldiers, usually unaccompanied by officers, in peaceful settings. While Watteau depicts only a few soldiers and no civilians at all in *The Portal of Valenciennes*, this painting is similar in spirit to his other military genre scenes and conveys the painter's sensitivity to the unspectacular and human aspects of a soldier's life.

<div align="right">H. M.</div>

COLLECTIONS: Théophile-Étienne-Joseph Thoré, Paris, probably after 1859. His sale (posthumous), Hôtel Drouot, Paris, December 5, 1892, Lot 39, sold for 2,250 francs. Jacques Doucet, Paris. His sale, Paris, June 6, 1912, Lot 192, repr., sold for 56,000 francs. Albert Lehmann, Paris. His sale, Paris, June 8, 1925, Lot 222, repr., sold for 96,000 francs. Otto Bemberg, Paris, 1961. Luis Bemberg and by descent. Sotheby's, London, December 12, 1990, Lot 7, repr., sold for £530,000. Colnaghi, New York. Sold to The Frick Collection, February 15, 1991, purchased with funds from the bequest of Arthemise Redpath.

1. See P. Mantz, "W. Bürger," preface to the Thoré sale catalogue, Paris, 1892, p. 8.

2. Thoré sale catalogue, p. 27.

3. E. Munhall, *Little Notes Concerning Watteau's* Portal of Valenciennes, New York, 1992, p. 11. A condensed version of this publication appeared as "Notes on Watteau's 'Portal of Valenciennes,'" *Burlington Magazine*, January 1992, pp. 4–11.

4. *Idem*, pp. 9–10.

5. These are: *Three Studies of a Soldier*, Courtauld Institute Galleries, London; *Two Studies of Soldiers, One Seen from Behind*, present whereabouts unknown; and *Two Studies of Soldiers, Seen in Profile*, Paris art market. All three drawings are executed in red chalk and dated to about 1709–10. See Munhall, pp. 14–16.

JEAN-ÉTIENNE LIOTARD

1702–1789

Born in Geneva to recently-emigrated French Huguenot parents, Liotard first trained there with Daniel Gardelle as a miniaturist in enamel. In 1723 he went to Paris to work with the engraver Jean-Baptiste Mass, and then established himself as an independent artist. Frustrated in his efforts to enter the Académie because of his religion, Liotard journeyed to Italy in 1735 and remained there for three years. With his patron Sir William Ponsonby, later second Earl of Bessborough, he traveled in 1738 to Constantinople, where he lived until 1742, drawing and painting portraits of local subjects and distinguished foreigners. His appearance dramatically transformed with a long beard and Turkish garments, he returned to Europe via Moldavia. For the remainder of his life, Liotard was an itinerant portrait artist, enjoying great success in Amsterdam, The Hague, Karlsruhe, London, Paris, Venice, and Vienna, as well as his native Geneva. In his later years, he painted some still lifes and a unique landscape. In 1781 Liotard published his Traité des principes et des règles de la peinture par M. J. E. Liotard, Peintre, Citoyen de Genève.

TROMPE L'OEIL (97.1.182)

Signed and dated, at upper left: *par J. E. Liotard 1771*. Oil, on silk, transferred to canvas, 9⅜ × 12¾ in. (23.3 × 32.3 cm).

DESCRIPTION: Against the background of a pine panel, two plaster reliefs are depicted hanging by a cord from screws, brass at the left, steel at the right. The relief at left represents a reclining female nude, asleep and facing right, with a sleeping Cupid resting on her thigh; that at right depicts another reclining female nude, facing left, being embraced by a Cupid with a quiver by his outstretched left foot. Below the reliefs appear two drawings, crumpled and with irregular edges, affixed to the pine support with red sealing wax. The one at left shows a man's head three-quarters to the left, wearing a large turban; the one at right depicts a woman's head three-quarters to the left, wearing a pronged headgear and ribbons around her neck. The former is inscribed at bottom left: *coeffure Turque*; the latter, also at bottom left: *coeffure de Ulm*. Strong shadows fall to the left of the screws, the sculptural reliefs, and the two drawings.

CONDITION: There is some evidence of

craquelure to the left of the left-hand sculptur-
al relief and evidence of repainting beyond the

upper right corner of the right-hand relief, but
otherwise the painting is in good condition.

OF the two dozen or so still lifes painted by Liotard, a few were specifically de-
scribed by the artist as *deceptio visus* or "trompe l'oeil."[1] The present one, dated 1771,
was painted probably in Paris, where Liotard had gone that year to portray the fu-
ture Louis XVI and the Dauphine Marie-Antoinette.

Only one model for the sculptural reliefs and drawings depicted in the Frick *Trompe l'Oeil* can be identified with certainty. The sculptural relief at left is based on Michel Aubert's engraving in reverse of François Boucher's painting *Vénus endormie sur un lit de repos* of 1734 (New York, private collection).[2] The relief at right resembles in many ways another painting by Boucher—his *L'Amour qui caresse sa mère* of 1739 (New York, private collection)—but the differences are too numerous for it to be considered a precise model for Liotard.[3] The drawing depicted at left, as its inscription suggests, resembles in a general way many that Liotard executed in Constantinople showing turbaned men. While that at the right bears a general resemblance to images of European women drawn by Liotard, the peculiar pronged headgear relates it geographically to the city cited in the inscription—Ulm. There in southern Germany, from the Middle Ages into the nineteenth century, women frequently wore wired headpieces called *schniepen* or *stirnen*, which were attached to the head with prongs extending over the ears and down to the center of the forehead. To this frame could be attached fabric, false hair, feathers, etc.[4] Considered altogether, the drawings and relief sculptures would seem to allude to various stages of Liotard's life, passed alternately in Paris, Constantinople, and Germany—Ulm being a port on the Danube the artist might have utilized in his frequent trips to and from Vienna.

By fooling spectators into believing that with this picture they were looking at real sculptures and real drawings, Liotard was making a bravado demonstration of the illusionism he believed to be the basis of all art.

E. M.

EXHIBITIONS: London, A Collection of Pictures to be seen on Great Marlborough Street, facing Blenheim Street, at Mr. Liotard's, 1773, No. 51.[5]

COLLECTIONS: Jean-Étienne Liotard, London, 1773. His sale, London, April 15, 1774, Lot 74, bought by the second Earl of Bessborough for £10 10s. William Ponsonby, second Earl of Bessborough.[6] Or, bought by the second Earl of Clanbrassil and by descent to the Earl of Roden.[7] Captain the Rt. Hon. the eighth Earl of Roden, R.N. His sale, Sotheby's, London, March 6, 1957, Lot 175, sold for £1550 to Edward Speelman. Vitale Bloch, The Hague and Paris.[8] Lore and Dr. Rudolf Heinemann, New York. Bequeathed to The Frick Collection by Lore Heinemann in memory of her husband Dr. Rudolf J. Heinemann, 1997.

NOTES

1. See R. Loche and P. Rosenberg, "Une 'transparence' de Jean-Étienne Liotard au Musée des Beaux-Arts de Budapest," *Geneva*, XXXI, 1983, pp. 65, 66, note 24.

2. A. Ananoff, *François Boucher*, I, Lausanne–Paris, 1976, I, pp. 226–27, No. 97; P. Jean-Richard, *L'Oeuvre gravé de François Boucher* (Musée du Louvre, Cabinet des Dessins, Collection Edmond de Rothschild: Inventaire général des gravures—École Française), Paris, 1978, p. 74, No. 192.

3. Ananoff, p. 357, No. 242.

4. See F. Hohenroth, *Les Costumes chez les peuples anciens et modernes*, Paris, 1896, p. 155, fig. 196, Nos. 5, 6, and *Deutsche Volkstrachten—Städtische und Ländtliche—von XIV Jahrhundert bis Anfang des XIX Jahrhundert*, Frankfurt, 1898, p. 114.

5. The picture is described in the English version of the catalogue as "another *deceptio visus*, in oil" and in the French version of the catalogue as "Deux bas reliefs pendus a des vis, et deux morceaux de papier, sur lesquels sont dessinez deux tetes, collez par places avec du pain enchanté, rouge sur une planche de Sapin, tableau fait pour tromper l'oeil peint a l'huile." With the words "pain enchanté," Liotard was apparently utilizing a current slang expression whereby the term for the host in a Catholic mass ("pain à chanter") was utilized in referring to similarly-shaped disks of sealing wax ("pain à cacheter"). Information kindly supplied to the author by Marcel Röthlisberger in an electronic mail message dated May 2, 2000.

6. Described in the Christie's sale catalogue as "Liotard A deception of two small basso relievos." Information kindly supplied by Marcel Röthlisberger.

7. Information kindly supplied by the Earl of Roden in a letter to the author dated April 4, 2000.

8. Provenance cited in R. Loche and M. Röthlisberger, *L'Opera completa di Liotard*, Milan, 1978, No. 283.

ADDITIONAL REFERENCE

J. S. Held and D. Posner, *Seventeenth- and Eighteenth-Century Art: Baroque Painting, Sculpture, Architecture*, New York, 1970, p. 17, fig. 6.

FRANCESCO GUARDI

1712 – 1793

Born in Venice, Francesco was the son of the painter Domenico Guardi. His brothers Giovanni Antonio and Nicolò and his son Giacomo were also painters, and his sister Cecilia married Giovanni Battista Tiepolo. When Domenico died in 1719, the oldest son, Giovanni Antonio, took over the family workshop, and Francesco probably received his early training from him. The Guardi studio produced copies and variations of works by painters past and present and also carried out commissions for religious and history paintings. It was in later life that Francesco emerged as a painter of vedute, *on which his reputation largely rests. He initially relied on drawings and engravings by Canaletto as his models, and indeed he may have spent some time in Canaletto's workshop. After the older painter's death in 1768, Guardi carried further his own distinctive mode of* veduta *painting, bringing a subjective and poetic vision to his images of Venetian festivities, regattas, and scenes of everyday life, which he painted in light, rapid brushstrokes. Guardi's* vedute *found a ready market among British residents in Venice, but official recognition was slow, and only at the age of seventy-two was he admitted to the Venetian Academy.*

VIEW OF VENICE (84.1.179)

Signed, on a case in the boat at far right: *F.G.P.* [for *Francesco Guardi Pinxit*]. Oil, on canvas, 19¼ × 30½ in. (49.5 × 77.5 cm).

DESCRIPTION: A diagonal sweep of blue-green water, narrowing as it moves left, fills the bottom of the canvas. Buildings of varying sizes, bathed in light, rise from the quay bordering the right side of the canal. Midway down the quay, and occupying the center of the composition, stands a large, imposing palazzo painted in neutral tones that are accented by green window blinds on the second floor and gilded window grills at ground level. To the left of the palazzo, the embankment curves gently into the distance. At far left, a three-arched bridge connects the quay to the left bank, of which only a small section is shown. The upper area of the painting is filled with a luminous blue sky and a few soft white clouds; at left, the blue gives way to a rosy tone. In the lower left

382

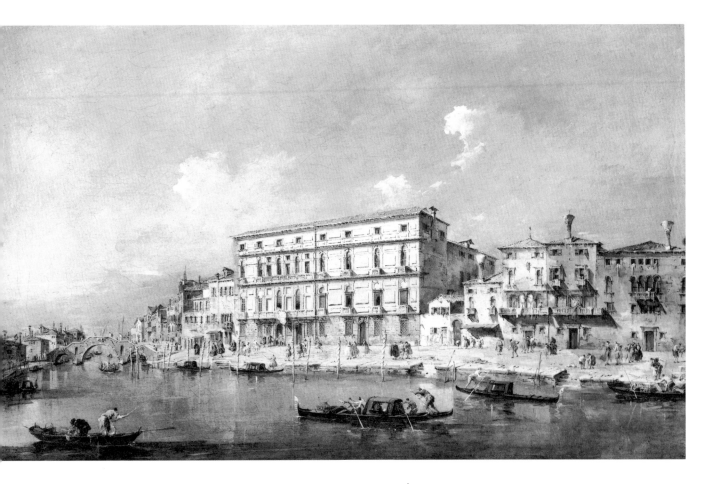

foreground two men fish from a boat, further to the right two gondolas carry passengers across the water, and at far right a boat pulled up to the quay is being loaded with cargo. The various boatmen are dressed in shades of blue, green, gray, and white; a fishermen in the foreground stands out in yellow. Other boats and gondolas navigate the canal or are moored along it. On the embankment before the large central palazzo, figures in wigs and formal dress in shades of blue, yellow, green, and red line up to receive a visitor. Further right, townspeople stroll and gather informally in small groups in front of apartment houses with picturesque balconies, chimneys, and laundry hanging out to dry. The houses are painted in warm tones of beige and red.

CONDITION: The painting is in generally good condition. Some small paint losses have recently been filled in.

THOUGH Guardi devoted a large number of his *vedute* to the Grand Canal, he also painted scenes along the Cannaregio, Venice's second widest canal, which connects the Grand Canal with the Lagoon near Mestre. He depicted the Cannaregio from various viewpoints, some focusing on its entrance from the Grand Canal, marked at the intersection by the tall campanile of S. Geremia.[1] In two other views, more closely connected with the Frick painting, Guardi focused on the Ponte dei Tre Archi near S. Giobbe, toward the far end of the canal.[2] This bridge, which appears at far left in the Frick painting, was designed by Andrea Tirali and built in 1688.

In the Frick painting, Guardi took his viewpoint midway down the canal on the bank opposite the Fondamenta di Cannaregio, looking northwest toward the Ponte dei Tre Archi.[3] At the center of the painting stands the massive Palazzo Surian-Bellotto, designed by Guiseppe Sardi and built at the end of the seventeenth century. In the eighteenth century, it served as the residence of the French ambassador.[4] This section of the quay provided Guardi with a rich variety of architectural styles and a cross section of social classes. The austere formality of the classical palazzo contrasts with the houses to the right with their picturesque chimneys and balconies draped with laundry. Likewise, the graceful elegance of the officials of the French embassy, dressed in wigs and brightly colored suits and arranged in lines to greet a visitor, sets off the informality of the strolling townspeople who gather in small groups to the right. In the lower section of the canvas are vignettes of various tradesmen—fishermen, gondoliers, and laborers.

Canaletto also painted the Cannaregio on numerous occasions. In *The Cannaregio* (Duke of Bedford, Woburn Abbey), he depicted almost the same stretch of the canal as in the Guardi painting, but from a different viewpoint.[5] The Ponte dei Tre Archi is in the center of his painting, and the Palazzo Surian-Bellotto is seen at a greater distance and at an angle. More of the left bank is shown as well. As in the Guardi painting, boats cut across the canal in the foreground. If the Canaletto canvas served as a model, it was only an indirect one.

A drawing related to the Frick painting is in the Kupferstichkabinett, Berlin.[6] The scene, however, is depicted from a slightly different angle, and there are no figures. Three drawings survive for the figures in front of the Palazzo Surian: one in the Cooper-Hewitt Museum, New York,[7] and two in the Museo Correr, Venice.[8]

Morassi designates this painting one of the masterpieces of Guardi's first maturity (1765–75), noting in particular his exquisite handling of light.[9] The painting is

pendant to *Regatta in Venice*, also in The Frick Collection (see next entry). Both works were purchased by John Strange, British minister to Venice from 1773 to 1788, a major collector of Guardi's *vedute*.[10]

<div align="right">S. G. G.</div>

EXHIBITED: Cambridge, Massachusetts, Fogg Art Museum, 1932–36, lent by Helen C. Frick to this and the following institutions. University of Pittsburgh, 1938. Dallas Art Museum, 1942–49. Pittsburgh, Carnegie Institute, 1950. New York, Frick Art Reference Library.

COLLECTIONS: John Strange, 1774–86. Rev. C. Nares. Lady Henry S. Churchill, 1841. Rev. G. Cecil White. Knoedler, New York. Mrs. Rathbone Bacon. Henry Clay Frick, New York, 1913. Helen C. Frick, New York. Helen Clay Frick Foundation, Pittsburgh. Frick Collection, 1984.

NOTES

1. See A. Morassi, *Guardi: I Dipinti*, 2nd ed., Venice, 1993, I, Nos. 571–74, pp. 416–17, II, figs. 544–45, 549–50.

2. *Idem*, I, Nos. 576–77, p. 418, II, figs. 546–47.

3. *Idem*, I, p. 249, No. 575 (as *Ponte dei Tre Archi a Cannaregio* and *Ricevimento a Palazzo Surian*), p. 417, II, fig. 548.

4. G. Lorenzetti, *Venice and Its Lagoon*, Trieste, 1975, p. 449. Lorenzetti notes that in the eighteenth century the palace was the home of the French ambassador Montaigne and his secretary Jean-Jacques Rousseau.

5. W. G. Constable, *Canaletto*, rev. J. G. Links, Oxford, 1989, II, No. 287, pp. 330–31, I, pl. 56, fig. 287.

6. J. Byam Shaw, *The Drawings of Francesco Guardi*, London, 1951, No. 15, p. 60, pl. 15.

7. *Idem*, No. 38, p. 67, pl. 38.

8. R. Pallucchini, *I disegni del Guardi al Museo Correr di Venezia*, Venice, 1943, Nos. 46–47a, p. 43, cited in Morassi, I, No. 575, pp. 417–18.

9. Morassi, I, p. 249.

10. On Guardi's relations to his patron, see F. Haskell, "Su Francesco Guardi vedutista e alcuni suoi clienti," in *Francesco Guardi: Vedute, Capricci, Feste*, Venice, 1993, pp. 15–26.

REGATTA IN VENICE (84.1.178)

Painted about 1770. Oil, on canvas, 19⅛ × 30⅞ in. (49 × 78.5 cm).

DESCRIPTION: A wide body of water fills the foreground and converges rapidly to a distant point at lower center where a bridge connects the opposite quays. A regatta is in progress. Innumerable spectators watch from a multitude of boats pulled up along the banks and from the windows and balconies of the palazzi that line the canal. In the lower left foreground, men in capes and tricorne hats look out over the water from a temporary viewing stand, a section of which is seen at far left, and more spectators appear in boats in front of the stand. To the right of center, a team of eight oarsmen in fantastic blue costumes and caps with long feathers rows a boat with decorative finials and scalloped blue drapery. Similar boats bearing teams of oarsmen in costumes of pink, yellow, and green are seen at left and right along the canal. From the bottom right corner of the canvas, racers in single gondolas issue forth and cut across and down the canal. An imposing five-story palazzo rises at left, and beyond it a row of smaller buildings extends down the quay; all are bathed in light. The buildings across the canal are largely in shadow. The luminous blue sky, interrupted by a few wispy white clouds, takes on a rosy color over the bridge. The water is painted in tones of blue and green.

CONDITION: The painting is in excellent condition.

As in many of his *vedute*, Guardi used a work by Canaletto as his point of departure for the present composition, varying it with his own observations made on the spot. Here the source has been identified as Canaletto's *Regatta in the Grand Canal* of 1730–35 now at Windsor Castle, which was engraved by Visentini.[1] The Canaletto canvas remained in Venice until 1762, and Guardi may have seen it there.[2] A Guardi pen-and-wash drawing from this period depicting the lower section of the Canaletto painting—executed either from the original or after Visentini's engraving of it—attests to Guardi's early interest in the image; he returned to it in several paintings and drawings in the 1770s.[3]

In the Frick painting, the viewer looks northeast toward the Rialto bridge, a portion of which can be glimpsed in the lower center of the canvas. The vantage point is probably from a window in the Ca' Foscari. In the lower left corner of the painting is depicted a section of the temporary viewing stand known as the *macchina*, erected on a floating platform in the mouth of the Rio di Ca' Foscari at the point where the Grand Canal makes a sharp bend—thus the title *Regatta in Volta di Canal* by which the painting is sometimes known. The *macchina* was designed for each festival by artists and architects; from it, officials and dignitaries viewed the regatta and awarded prizes. To the right of the structure is the imposing Palazzo

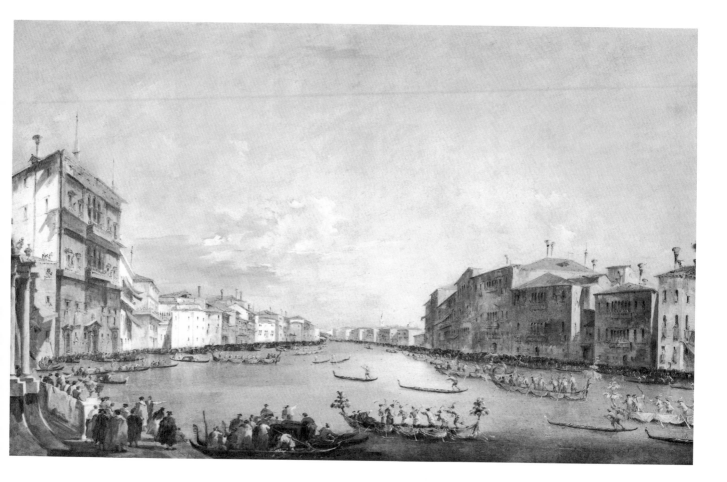

Balbi (1582–90), designed by Alessandro Vittoria in a classical style, dominating the left bank of the canal. On the opposite quay, the second building in from the right has been identified as the Palazzo Contarini dalle Figure.[4]

In the gondoliers' regatta, competitors raced alone—as depicted here—or in pairs or teams. The races, which date back as far as the fourteenth century, were held at various times throughout the year to mark special occasions, such as the election of a doge or the visit of a foreign dignitary.[5] The racers were accompanied on the water by teams of eight oarsmen dressed in elaborate costumes. Rowing long, narrow barges (*bissone*) draped in cloth and ornamented with fanciful, carved finials, these ceremonial teams maintained order during the race.[6]

Of the several versions Guardi executed of the regatta from the bend in the canal, a canvas in the Gulbenkian Museum, Lisbon, is closest to the Frick painting.[7] Morassi dates the Gulbenkian version around 1770 and the Frick work as contemporaneous or a little later.[8] In comparing these paintings with their source, it can be noted that Guardi takes a viewpoint further back from that of Canaletto, widens the expanse of water in the foreground, introduces several racing boats down the center of the canal, and arranges the figures differently on the *macchina*. Another painting from the same series, with slight variations, was formerly with the Gallery Fischer, Lucerne.[9] In yet another version, now in Philadelphia, the viewpoint is from the opposite bank, looking across the water directly at the *macchina*.[10] Guardi painted another series of regattas in the Grand Canal from a point closer to the Rialto bridge.[11]

There are several known drawings by Guardi in pen and ink of the regatta seen from the same vantage point as in the Frick painting, although none is considered a direct preparatory study for the oil. A drawing in a private collection in Paris comes nearest.[12] A closely related pen-and-ink study in the British Museum, London, is probably a study for the Gulbenkian painting.[13]

S. G. G.

EXHIBITED: Same as preceding entry. COLLECTIONS: Same as preceding entry.

NOTES

1. W. G. Constable, *Canaletto*, rev. J. G. Links, Oxford, 1989, II, No. 347, pp. 364–66, I, pl. 65, fig. 347. The connection to Visentini (A. Visentini, *Prospectus Magni Canalis*, Venice, 1735, pt. I, pl. XIII, 1742 and 1751, pt. I, XIII) is also noted in A. Morassi, *Guardi: I Dipinti*, 2nd ed., Venice, 1993, I, p. 199, and in J. Byam Shaw, *The Drawings of Francesco Guardi*, London, 1951, No. 39, p. 68. For the Frick painting, see Morassi, I, No. 300, II, fig. 328.

2. Byam Shaw, *loc. cit.*

3. *Idem.*

4. On the identification of the buildings in the Canaletto painting on which the Guardi is based, as well as the tradition of the regatta, see M. Levey, *National Gallery Catalogues: The Eighteenth Century Italian Schools*, London, 1956, p. 26–27. See also Morassi, I, pp. 199, 202.

5. G. Lorenzetti, *Venice and Its Lagoon*, Trieste, 1975, p. 21, and Levey, p. 27.

6. A. Moreau, *Antonio Canal*, Paris, 1894, p. 50, cited in the catalogue of the Sigismond Bardac sale, Galerie Georges Petit, Paris, May 10–11, 1920, Lot 7.

7. Morassi, I, No. 299, pp. 366–67, II, fig. 326. See also F. Shapley, *European Paintings from the Gulbenkian Collection*, National Gallery of Art, Washington, 1950, No. 16, p. 42.

8. Morassi, I, p. 202.

9. *Idem*, I, No. 298, p. 366, II, fig. 327.

10. *Idem*, I, No. 301, p. 367, II, fig. 329.

11. *Idem*, I, Nos. 303, 305–07, pp. 367–68, II, figs. 330–33.

12. A. Morassi, *Guardi: I Disegni,* 2nd ed., Venice, 1993, No. 299, p. 130, fig. 295.

13. *Idem,* No. 297, p. 130, fig. 298.

ADDITIONAL REFERENCE

A. C. Sewter, "An Unpublished Guardi at the Barber Institute," *Burlington Magazine*, XCI, May 1949, pp. 133–34.

SIR JOSHUA REYNOLDS

1723–1792

Reynolds was born at Plympton St. Maurice in Devonshire, son of the headmaster of the local grammar school. Briefly apprenticed to Thomas Hudson in London, he returned to Devonshire in 1743 to begin his career as a portraitist. Three years spent in Italy (1749–52) profoundly affected his art. By the 1760s, Reynolds was established as the preeminent painter in London. He was elected first president of the Royal Academy upon its founding in 1768 and was knighted the following year. The fifteen "Discourses" he delivered at the Academy demonstrated his broad knowledge of the art of the past and his desire to link it to the present. He painted nearly every notable figure of his time.

LADY CECIL RICE, Later Baroness Dynevor (79.1.171)

Painted probably in 1762. Oil, on canvas (lined), 49¾ × 39⅝ in. (126.4 × 100 cm).

DESCRIPTION: Lady Rice, depicted in three-quarter length, is seated before a leafy bank under gray skies. Her head is turned toward the left. Trunks and branches of a tree are shown at upper right and roses above her left elbow. She wears a white satin dress, the sleeve at left circled with two strands of pearls. A magenta sash is tied about her waist, and ribbons of a similar color adorn her wrists. She wears a blue-gray sleeveless coat, lined in white and edged with lace, which is draped over her lap and falls by her side at left. Lady Rice wears a pearl earring, and pearls are entwined in her dark brown hair. Two pink roses, one open and one in bud, are fastened to her bodice. Her eyes are dark brown.

CONDITION: The painting is in good condition. The pallor of the flesh areas, frequently encountered in Reynolds' early works, is the result of the artist's use of fugitive red pigments such as carmine and lake.[1]

THE subject, Cecil Talbot (1733–93), was the only child of Mary de Cardonnel and William Talbot, created first Earl Talbot in 1761, who served as Lord Steward of the royal household. Her father was further created, in 1780, Baron Dynevor, with special remainder of that peerage to his only daughter. On August 16, 1756, Cecil married the Hon. George Rice (1724–79), member of a prominent family in South Wales. The couple had three sons and three daughters. Rice was a Member of Parliament from 1754 until his death, representing the county of Carmarthen (Wales). At the time of his death, he was treasurer of the King's chamber and member of the

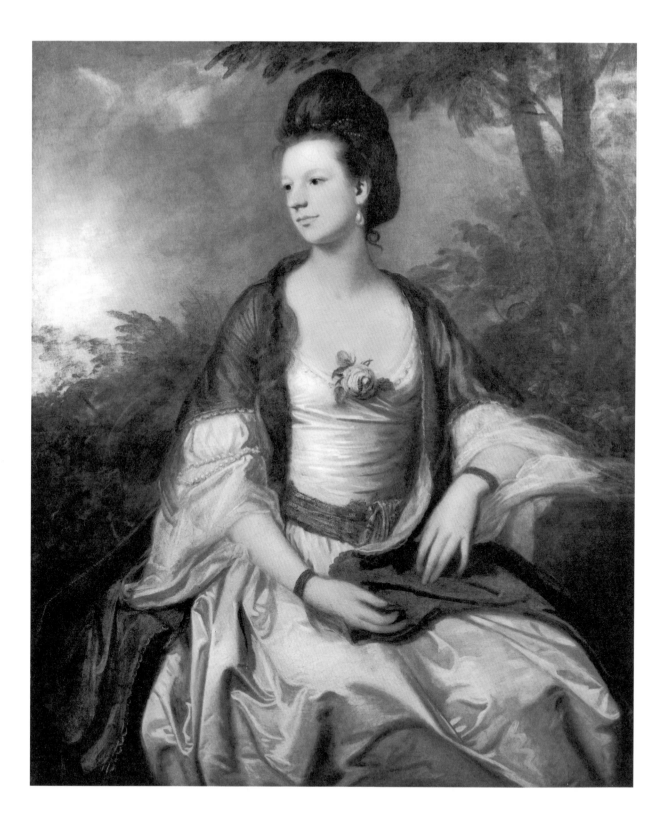

Privy Council. His widow became a peeress in her own right as Baroness Dynevor on her father's death in 1782, assuming the surname and arms of de Cardonnel.[2]

Lady Rice was twenty-nine years old when she posed for Reynolds in his studio in Leicester Fields. The artist's pocket book, in which he recorded his clients' visits, lists a "Mrs. Rice" in February 1762—one of thirteen sitters he scheduled that month.[3] He further recorded that he received 21 guineas for the portrait on April 12 that year.[4] This would have been less than half his normal rate for a portrait of this size, which he called a "half-length."[5]

<div align="right">E. M.</div>

EXHIBITED: Cambridge, Massachusetts, Fogg Art Museum, 1938–56, lent by Helen Clay Frick.

COLLECTIONS: Edward Rhys Wingfield, Barrington Park, Oxon.[6] Edward R. Bacon, New York, d. 1915.[7] W. Rathbone Bacon, New York. Henry Clay Frick, 1918. Helen Clay Frick, 1920. Mrs. I. Townsend Burden, Jr., Locust Valley, Long Island, New York. Mrs. J. Fife Symington, Jr., Lutherville, Maryland. Given by her to The Frick Collection in 1979.

NOTES

1. See M. K. Talley, Jr., "'All good pictures crack': Sir Joshua Reynolds's practice and studio," in *Reynolds*, ed. N. Penny, New York, 1986, pp. 65, 67.

2. *The Dictionary of National Biography*, London, 1917–, XVI, p. 988; *Burke's Peerage, Baronetage and Knightage*, London, 1931, p. 854.

3. C. R. Leslie and T. Taylor, *Life and Times of Sir Joshua Reynolds*, 1865, I, p. 218.

4. H. Graves and W. V. Cronin, *A History of the Works of Sir Joshua Reynolds, P.R.A.*, London, 1899, II, p. 821.

5. E. Waterhouse, *Reynolds*, London, 1973, p. 39; Talley, p. 58.

6. Graves and Cronin, *loc. cit.*

7. J. B. Townsend and W. S. Howard, *Memorial Catalogue of Paintings by Old and Modern Masters Collected by Edward R. Bacon*, New York, 1919, p. 18, No. 19.

ADDITIONAL REFERENCES

W. Armstrong, *Sir Joshua Reynolds*, London, 1900, p. 226.

E. Waterhouse, *Reynolds*, London, 1941, p. 51.

SIR HENRY RAEBURN

1756–1823

Born in the village of Stockbridge, outside Edinburgh, Raeburn was orphaned at the age of nine and raised by his elder brother William. Despite a lack of much formal training, Raeburn emerged in his twenties as a talented miniaturist and portrait painter. Marriage in 1780 to a wealthy widow, Ann Edgar, gave him financial independence. In 1784, Raeburn met Reynolds in London and followed his advice to visit Italy, where he remained until 1787. By the following decade he had become the leading Scottish painter. From 1810 on, he exhibited regularly with the Royal Academy, which elected him a full Academician in 1815. George IV, on a visit to Edinburgh in 1822, knighted Raeburn and the following year appointed him His Majesty's Limner for Scotland.

ALEXANDER ALLAN (92.1.174)

Painted about 1815. Oil, on canvas (lined), 81 × 57½ in. (207 × 146 cm).

DESCRIPTION: Allan has closely-cropped white hair and blue eyes. He is shown seated with his body turned three-quarters to the left, his left leg crossed over the right. His right arm extends across a table draped in red cloth; his left arm, resting on his thigh, holds a folded document. His armchair has a red leather seat. On the table rest a black box holding writing materials—a quill pen, a silver-topped ink container, a stick of red sealing wax—three volumes on top of a stack of papers, an open silver box, and more papers by Allan's hand. The subject wears a black suit with five brass buttons, a white stock, knee breeches, and black hose and shoes. Behind him, to the left, is a fluted column enveloped at the top in red drapery; a similar fabric is gathered up at the top right corner and falls behind Allan's chair. A green carpet fills the foreground.

CONDITION: The painting is in good condition, though a horizontal band across the canvas 12 in. from the top bears the impression of having been installed for many years under a wall panel that exerted pressure upon the canvas. There is evidence of darkening from bituminous pigment.

ALEXANDER Allan of Hillside (c. 1747–1825), with the unrelated Robert Allan, founded a bank in High Street, Edinburgh, in 1776—R. Allan and Son and Alexander Allan and Co. In 1803 he was in the Exchange in the same street. He owned property at Hillside, Edinburgh, and "The Glen," near Innerleithen, Peebles. Alexander Allan married Ann Losh, a native of Cumberland, at an unknown date.

Raeburn also painted a portrait of her, seated on a couch with her daughter Matilda,[1] as well as portraits of a Lieutenant-Colonel George Allan[2] and of Robert Allan.[3] Alexander Allan died on December 10 or 11, 1825, his wife on July 10, 1846.

In 1921, Alexander Allan's grandson of the same name was recorded as possessing a copy of Raeburn's portrait of his grandfather (and of his grandmother), painted by Edmund Thornton Crawford, R.S.A. (1806–85).[4]

E. M.

EXHIBITED: Edinburgh, 32 York Place, Raeburn Memorial Exhibition, 1824, No. 42. Edinburgh, Royal Scottish Academy, Exhibition of Works of Deceased and Living Scottish Artists, 1863, No. 96, as *The Late Alexander Allan*, lent by Alexander Allan. Edinburgh, National Galleries, Royal Scottish Academy, The Works of Sir Henry Raeburn, 1876, No. 15, lent by Lieutenant-Colonel William Allan. Cambridge, Massachusetts, Fogg Art Museum, 1932–35, lent by Helen Clay Frick.

COLLECTIONS: Alexander Allan, Edinburgh. His son, Colonel Alexander Allan, 1863. Lieutenant-Colonel William Allan, 41st (Welsh) Regiment, 1876. Major-General Allan of Hillside, Bidborough, Edinburgh, 1911. Edward R. Bacon, New York, d. 1915.[5] W. Rathbone Bacon, New York. Henry Clay Frick, New York, 1918. Helen Clay Frick, 1920. Mrs. Peter P. Blanchard (née Adelaide Childs Frick), Short Hills, New Jersey, 1951. Peter P. Blanchard, 1956. Given by him to The Frick Collection in 1992.

NOTES

1. J. Greig, *Sir Henry Raeburn, R.A.*, London, 1911, p. 37. After belonging to the Los Angeles County Museum of Art from 1960 until 1986, the painting was sold at Sotheby's, New York, January 17, 1986, Lot 14.

2. W. Raeburn Andrew, *Life of Sir Henry Raeburn, R.A.*, London, 1886, p. 100.

3. *Idem*; see also "Raeburn's Portrait of Mr. Allan," *Magazine of Art*, 1879, II, p. 268, repr.

4. Most of the information cited in this entry was taken from W. Roberts, *Alexander Allan by Sir Henry Raeburn, R.A.*, London, 1921, pp.

5–7, and D. A. T. Mackie, *Raeburn, Life and Art*, unpublished doctoral dissertation, Edinburgh University, June 1994, II, Catalogue A–F, No. 16. This material was kindly supplied the author by Helen Watson, Librarian of the Scottish National Portrait Gallery, Edinburgh, in September 1998.

5. J. B. Townsend and W. S. Howard, *Memorial Catalogue of Paintings by Old and Modern Masters Collected by Edward R. Bacon*, New York, 1919, p.12, No. 12.

ADDITIONAL REFERENCE

W. Armstrong, R. A. M. Stevenson, and J. L. Caw, *Sir Henry Raeburn*, London, 1901, p. 95.

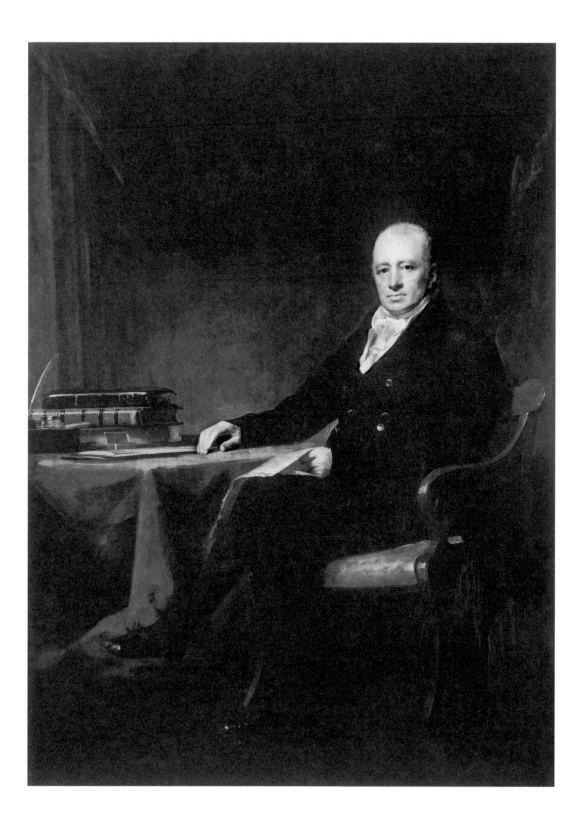

JOHN CONSTABLE

1776–1837

Constable was born in East Bergholt, Suffolk, and acquired his basic painting skills there, but his formal art training dates only from 1799, when he moved to London to study at the Royal Academy. In 1816 he married Maria Bicknell, and by the 1820s he was gaining wide recognition, although not until 1829 was he named a full Academician. Famed in his time for highly finished landscape canvases done in the studio, he is also admired today for the many drawings and oil sketches he executed directly on the site.

CLOUD STUDY (2001.3.133)

Painted probably about 1822. Oil, on paper, laid down on board, 11½ × 19 in. (29 × 48 cm).

INSCRIPTION: On verso: *28th July 12 o'clock noon, very fine day, showery and warm No West under the sun.*

DESCRIPTION: Bright blue patches of clear sky appear amid masses of white cumulus clouds with faint pink highlights. Deeper blues, dark grays, and deep pinks define the clouds looming above and at upper right, below which delicate vertical strokes suggest rain. The white clouds are built up with thick impasto, while in other areas the paint is so thinly applied that the pinkish-brown ground is visible.

CONDITION: Both this sketch and its companion are in good, stable condition, although the supports are now quite brittle and minor folds and creases appear in the paper. Constable seems to have used a coarse, tonal wove paper in each instance, a support he is known to have preferred for his oil sketches.[1] In both studies, the paper is attached to a board that appears to date from the nineteenth century but probably was not attached by Constable himself; short blue fibers on the versos of the sheets suggest that each had initially been laid down upon a different backing. There is foxing, and the inscription on No. 2001.3.133 is blurred, probably due to the addition of the backing.

CLOUD STUDY (2001.3.134)

Painted probably about 1822. Oil, on paper, laid down on board, 11½ × 19 in. (29 × 48 cm).

DESCRIPTION: At center, patches of blue sky appear amidst fleecy white clouds with subtle pink highlights. Encroaching from the sides are rain clouds composed of dark blue and gray with areas of pinkish-brown. As in the companion sketch, thick impasto in the white clouds contrasts with passages so thinly applied that the pinkish-brown ground is revealed.

CONDITION: The varnish has yellowed more obviously here than on No. 2001.3.133, especially over the whites of the clouds. Tacking holes along the edges of the sheet indicate where Constable attached it to a support during sketching. For further comment, see the condition report on the companion piece.

SEEKING respite from London and a therapeutic environment for his wife, Maria, and their children, in 1819 Constable rented a house in the village of Hampstead, near Hampstead Heath, north of the city, where the family would stay every summer for the next seven years excepting 1824. Hampstead Heath's elevation and unobstructed views encouraged Constable to observe and study the sky and its clouds—a process he called "skying." He recorded his observations in oil studies of clouds such as the two discussed here.

Between October 1820 and 1822, Constable made an estimated one hundred cloud studies, at various times of the day, and in changing weather. To many, he added the date and an inscription, often including the time, the direction he was facing, wind speed and direction, and other weather conditions.[2]

The two Frick oil sketches are pure cloud studies, with no landscape evident. Constable probably produced them in the summer of 1822. Unlike his earlier sketches, which were painted under late afternoon and evening skies, those of 1822 were done earlier in the day, mostly around noon. Whereas the sky studies from 1821 average about 10 × 12 in. (25 × 30 cm), the average sketch from 1822 measures 10 × 24 in. (25 × 61 cm), with three reaching 20 × 24 in. (51 × 61 cm).[3] Constable alluded to the size of his sky sketches in a letter to his friend John Fisher written from Hampstead on October 7, 1822: "I have made about 50 carefull studies of *skies* tolerably large, to be carefull."[4] Thornes assigned the partially dated Frick sketch No. 2001.3.133 to 1822 by comparison with contemporary meteorological records, noting that the weather recorded for July 28, 1822, was more in accord with Constable's inscription than that for the same day in 1821. Thornes also found it likely that Constable's notation "No West" on the verso referred not to the wind direction, but to the direction Constable was facing when he made the sketch, putting him at right angles to the wind and to the passing clouds.[5]

Cove's investigation of Constable's painting materials and techniques led her to propose that Constable began with sheets measuring 20 × 24 in., then either cut them in half to make them easier to carry during his skying excursions of 1822 or left them intact when he wanted to make his studies larger.[6] She also notes that

397

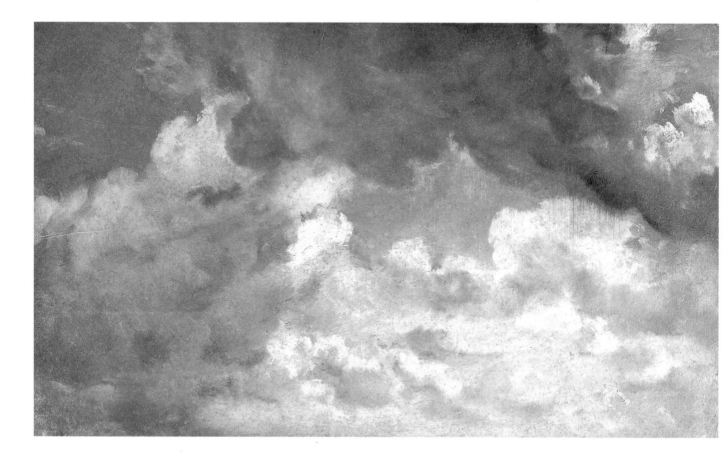

Constable used two types of paper support for his sketches: the coarse wove paper found in the two Frick works, and, less frequently, a smooth, white laid paper. During his most concentrated period of skying, Constable prepared batches of paper supports, laminating large sheets of wove paper and coating them with an opaque layer of color to serve as his ground. These grounds ranged from pink to dark purplish-brown and were probably composed of a water-based medium such as gum or size. The ground would seal the paper, preventing the oil from seeping into the sheet.[7]

Constable's correspondence and a surviving sketching box provide additional details about his sketching process. The lid of the box features a flat compartment separated from the rest by a removable wooden panel. This held the prepared paper while en route to the site, and also provided a receptacle for the wet sketches at the end of the day. Constable would rest the box on his knees during sketching, us-

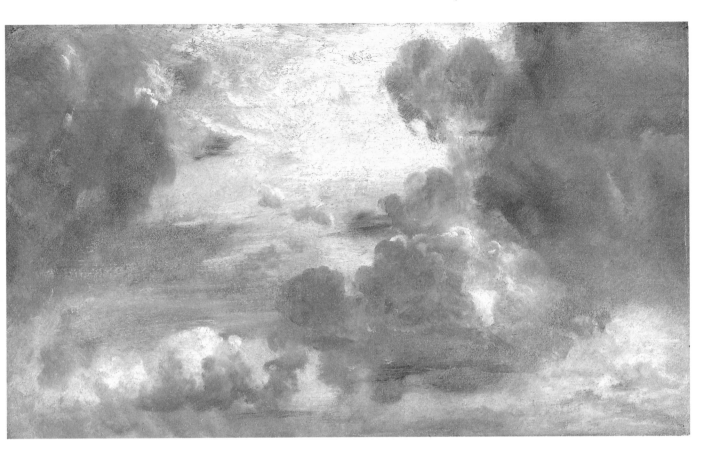

ing the lid as a support. To this lid he would tack the sheet on which he was working, as the tacking holes in Frick sketch No. 2001.3.134 confirm (see *Condition*).

The reason for Constable's extensive skying exercises is often debated. From the inscriptions they bear, Thornes infers: "They suggest that the single most important reason for the 'pure sky' studies was for Constable to perfect the noon skies of his six-footers."[8] Contemporary criticisms of the sky in *Stratford Mill*, made at Salisbury in 1821 and related to Constable by Fisher, may have encouraged the artist to rework his approach to rendering clouds.[9] In a famous letter written from Hampstead to Fisher on October 23, 1821, Constable responded to such criticism, stating: "I know very well what I am about, & that my skies have not been neglected though they often failed in execution—and often no doubt from over anxiety about them. ..."[10]

Additional motives for Constable's intense interest in skying might include the

publication of Luke Howard's system of cloud classification, which appeared in the *Philosophical Magazine* in 1803 and was published in more detail in *The Climate of London 1818–20*.[11] Hawes also pointed out the importance of Constable's early training as a windmiller, a profession requiring a thorough understanding of the wind and the ability to forecast weather.[12]

The cataloguing of the Constable family library by Parris and Shields in 1972 provided new insight into this debate, with the discovery of Constable's second-hand copy of Thomas Forster's book *Researches About Atmospheric Phenomena*. Entered in the margins were Constable's penciled annotations,[13] which included twice the term "cumulostrati," referring to clouds with large, dark, rounded masses. Various passages are marked, and occasional notes express Constable's doubt about certain statements.[14]

As an artist, Constable was deeply involved with the natural landscape from early on, declaring: "I associate my 'careless boyhood' to all that lies on the banks of the *Stour*. They made me a painter (& I am gratefull) that is I had often thought of pictures of them before I had ever touched a pencil. ..."[15] He began doing outdoor sketches early in his career,[16] inscribing some of them prior to the skyscapes of the early 1820s.[17]

In returning to the sky as a subject, Constable was also attentive to its treatment in the works of Old Masters and contemporary artists. The Dutchman Willem van de Velde the Younger's skies inspired him, and he may have been aware of van de Velde's supposed sky studies made at Hampstead in the early eighteenth century.[18] Constable found Ruysdael's skies particularly successful in creating a sense of mood.[19] His own preoccupation with rendering clouds effectively is further evidenced by the fact that he copied twenty skies in pencil from Alexander Cozens' treatise *A New Method of Assisting the Invention in Drawing Original Compositions of Landscape* (c. 1785).[20] In addition, Constable may have been aware of Turner's outdoor studies, particularly his sky sketches of 1817–19.[21] It should be noted, however, that, unlike Constable's sketches, Turner's, while influenced by his direct observation of nature, were probably made in the studio.[22]

Although none of Constable's cloud studies were ever used in his finished paintings, they played an important part in the evolution of his skies. Other than what can be discerned from his correspondence, Constable did not have the opportunity to propound his theories on representing clouds in a formal manner. In a letter of December 1836, he spoke of his intention to organize his notes for a

possible lecture in Hampstead the following summer, but he would die before accomplishing this.[23]

<div style="text-align: right">M. I.</div>

NOTES

1. S. Cove, "Constable's Oil Painting Materials and Techniques," in *Constable*, ed. L. Parris and I. Fleming-Williams, exhib. cat., London, 1991, p. 499. For their assistance in appraising the condition of both drawings, the author also acknowledges Marjorie Shelley of the Metropolitan Museum of Art and Barbara Roberts, Conservator at The Frick Collection.

2. Constable's earliest known oil landscape containing a weather inscription is dated October 17 of 1820. At least three other dated and inscribed studies from that year survive. The studies from 1820 differ from those of 1821–22 in that they are smaller, have briefer inscriptions, and capture only afternoon and evening views. For more about these early sketches, see J. Thornes, *John Constable's Skies*, Birmingham, 1999, p. 115.

3. It is primarily because the Frick oil sketches are executed in the larger format that various authorities have assigned them to 1822. For information on the dating of the sketches, see: R. B. Beckett, "Correspondence and Other Materials of John Constable, R.A.," unpublished typescript in the Victoria and Albert Museum Library, London, quoted by J. Thornes in "The Accurate Dating of Certain of John Constable's Cloud Studies 1821/22 Using Historical Weather Records," *Occasional Papers,* No. 34, Department of Geography, University College London, August 1978, p. 12; R. Hoozee, *L'opera completa di Constable,* Milan, 1979, Nos. 332, 350; G. Reynolds, *The Later Paintings and Drawings of John Constable,* New Haven–London, 1984, text vol., No. 22.11, p. 103, No. 22.54, p. 111, plate vol., pls. 341, 377; and E. Zafran, in P. C. Sutton *et al., Prized Possessions: European Paintings from Private Collections of Friends of the Museum of Fine Arts, Boston,* Boston, 1992, Nos. 133, 134.

4. *John Constable's Correspondence VI: The Fishers,* ed. R. B. Beckett, Ipswich, 1968, p. 98.

5. Thornes, 1999, p. 252, and letter to the author of August 30, 2001. Thornes also suggested that the two works might have been painted on the same day, and that they could be the first large cloud studies of 1822. The author gratefully acknowledges his assistance.

6. See Cove, p. 501. Thornes (1999, p. 121) surmises that Constable increased the size of his paper supports in 1822 to create sketches closer in scale to the skies in his six-foot canvases.

7. Cove, p. 499.

8. Thornes, 1999, p. 121. See also Thornes'

essay in *Constable's Clouds,* ed. E. Morris, Liverpool–Edinburgh, 2000, p. 157.

9. Parris and Fleming-Williams, p. 228.

10. Beckett, pp. 76–77.

11. K. Badt, *John Constable's Clouds,* trans. S. Godman, London, 1950, p. 51.

12. L. Hawes, "Constable's Sky Sketches," *Journal of the Warburg and Courtauld Institutes,* XXXII, 1969, pp. 344–65. Reynolds concurred with Hawes regarding Howard's influence, stating: "It is probable that in the formulation of this theory Luke Howard's book, *The Climate of London* played its part, conceivably not by suggesting considerations which had not previously occurred to him, but rather by crystallizing his ideas." See G. Reynolds, *Victoria and Albert Museum Catalogue of the Constable Collection,* 2nd ed., London, 1973, p. 27.

13. L. Parris and C. Shields, *John Constable: Further Documents and Correspondence,* London, 1975, pp. 43–44.

14. Thornes (1999, pp. 68–69) hypothesizes that Constable either purchased his copy secondhand before 1823 (the date of the final publication) or bought it in the late 1820s or early 1830s, when all editions were scarce. Constable was friendly with James Carpenter and his son William, booksellers on Old Bond Street, London, who supplied him for years. William also had an active interest in clouds.

15. See the letter of October 23, 1821, to John Fisher cited in note 10, above (Beckett, pp. 76–77).

16. Morris, in *Constable's Clouds,* p. 13.

17. His first sketch with weather notes is a watercolor inscribed "Nov. 4, 1805" and "Noon very fine day the Stour"; see Morris, p. 156. A series of watercolors produced during a visit to the Lake District in 1806 also is inscribed with weather descriptions, date, and time. It is from 1806 that Constable's earliest known pure sky study dates—a pastel on brown paper made inside the back cover of a sketchbook (Louvre, No. RF 08700). Two sky studies in crayon on blue paper, dated July 9, 1819, and several other drawings confirm Constable's interest in creating sky studies prior to his most celebrated examples. See Thornes, 1999, pp. 100, 113.

18. T. Wilcox, in *Constable's Clouds,* p. 59.

19. See *John Constable's Discourses,* ed. R. B. Beckett, Ipswich, 1970, p. 63: "Ruysdael ... delighted in, and has made delightful to our eyes, those solemn days, peculiar to his country and ours, when without storm, large rolling clouds scarcely permit a ray of sunlight to break the shades of the forest. By these effects he enveloped the most ordinary scenes in grandeur. ..."

20. Thornes, 1999, p. 80.

21. Hawes, p. 351.

22. See A. Lyles, in *Constable's Clouds,* pp. 135–50, in particular the discussion of Turner's cloud studies on pp. 144–46.

23. Letter to George Constable of Arundel, quoted by Beckett, 1968, p. 281.

24. There is some question concerning the early provenance of these sketches. The Boston Museum of Fine Arts lists Miss Isabel Constable as their first owner in its 1946 exhibition catalogue *Paintings, Drawings and Prints by J. M. W. Turner, John Constable and R. P. Bonington,* Boston, Nos. 133, 134, and Hoozee also lists them as once belonging to Isabel Constable in his 1979 catalogue (*loc. cit.*). However, Reynolds, in his 1984 catalogue raisonné (*loc. cit.*), proposes that earlier provenances listing Isabel Constable are incorrect, stating that Frith's sketches are all assumed to have been purchased from Leslie's sale of 1860. The Boston Museum apparently later concurred with Reynolds, as it lists Leslie's sale of 1860 in

the provenance for these sketches in its 1992 exhibition catalogue (Sutton *et al.*, Nos. 28, 29, pls. 96, 97). In his book on Constable (C. R. Leslie, *Memoirs of the Life of John Constable, Esq. R.A.,* 2nd ed., London, 1845, p. 102), Leslie discusses Constable's sky studies from the year 1822 and mentions a number of such sketches in his own collection, stating: "Twenty of Constable's studies of skies made during this season [1822], are in my possession, and there is but one among them in which a vestige of landscape is introduced. They are painted in oil, on large sheets of thick paper, and all dated, with the time of day, the direction of the wind, and other memoranda on their backs." If they were in fact "all dated" and inscribed as Leslie claims, this suggests that the Frick study No. 2001.3.134, which is not inscribed, was not in Leslie's possession. Unfortunately, the catalogue of the posthumous Leslie sale (London, Messrs. Foster, April 25 *et seq.*, 1860) provides only a limited description; listed as Lot 86, the sketches are described merely as "Seventeen Studies of Skies" by J. Constable, R.A.

JEAN·BAPTISTE·CAMILLE
COROT
1796–1875

Corot was born in Paris and studied there with the classicizing painters Michallon and Bertin before leaving in 1825 for the first of three visits he made to Italy. His many oil studies painted outdoors provided him with a library of landscape motifs that he often incorporated into canvases with traditional classical or religious subjects intended for exhibition. Corot traveled elsewhere in Europe and widely in France, working in the vicinity of Rouen, in the forest of Fontainebleau, and at Ville-d'Avray, near Paris, where his father had a house. He exhibited frequently in the Salons and won many honors.

THE ARCH OF CONSTANTINE and the Forum, Rome (94.1.175)

Painted in 1843.[1] Oil, on paper, mounted on canvas (lined), 10⅝ × 16½ in. (26.9 × 41.9 cm).

INSCRIPTION: In red, at bottom left: VENTE / COROT.[2]

DESCRIPTION: The site is viewed facing northwest along the main axis of the Roman Forum. The monuments include the Arch of Constantine, the Arch of Titus, the campanile of the Palazzo Senatorio on the Campidoglio, the tower of S. Francesca Romana, the ruins of the Temple of Venus and Rome, and, in the foreground, the remains of the Meta Sudans. Pale hues of green, blue, and buff suffuse the depopulated scene.

CONDITION: The original canvas has been relined with linen, using a glue paste adhesive. When the painting was cleaned in 1993, a slightly gray synthetic varnish was removed. It then became apparent that the artist made some changes after the paint had dried, glazing over his more brightly lit first sketch to subdue the tones. Some of these changes had darkened slightly over time, especially in the sky, and the most disturbing of them were adjusted by scumbling in dry pigments bound with PVA AYAB. The painting is in excellent condition.

IN 1826, during his first visit to Italy, Corot painted two large, panoramic vistas of the Forum as seen from above at a distance. Both of these paintings, now in the Louvre, are more composed, detailed, and finished than the Frick study, which the artist's friend Alfred Robaut assigned to 1843, when Corot made the last of his

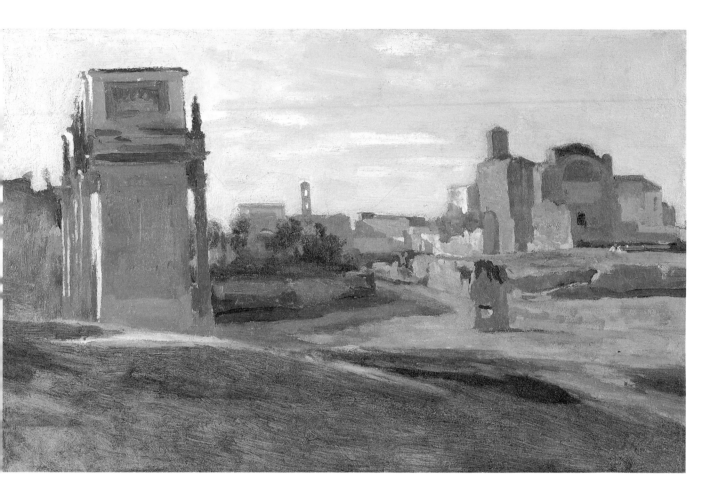

three Italian trips.³ This time, focusing his attention on Rome and its environs, Corot selected some of the most admired views to sketch. According to Moreau-Nélaton, he worked in and near Rome for several months, beginning in May.⁴ The gentle light and cool, pale coloring of his oil sketch of the Forum suggest that the season was indeed late spring or early summer. Corot has chosen the hour of late afternoon, when the light casts long diagonal shadows which echo the zigzag of the spatial recession from the right foreground back toward the silhouetted campanile on the horizon. The architectural shapes, the flowing rearward movement through space, the blocks of light and shadow are delicately balanced to arrive at a dynamic equilibrium of all the pictorial elements.

This view of the Forum, looking down the central road which leads to the Campidoglio, was the first of three oil studies of the same view, but the only one

evidently made on the site; the other two were executed about 1850, years after Corot had left Rome.[5] None of the sketches was intended as topographical reportage, and many passages were determined more by the demands of design, of shape and tone, space and mass, than by observed fact. As Corot himself wrote in his notebooks, "Je ne suis jamais pressé d'arriver au détail; les masses et le caractère d'un tableau m'intéresse avant tout."[6]

Perhaps the area in the sketches that most obviously illustrates Corot's disdain for details and his manipulation of "les masses" can be seen just to the right of center in the Frick painting, in the illegible cluster of architectural shapes dabbed in shades of brown and beige that huddle beneath the tower and walls of S. Francesca Romana. The appearance and proportions of these buildings as they are shown in other paintings, drawings, and photographs of this frequently portrayed view differ substantially from Corot's rendering. The main façade of the building, which Corot paints as a stripe of creamy beige with, above that, a darker brown ragged patch, indecipherable in architectural terms, was in reality a long, flat surface pierced by rows of small windows. Both of the 1850 oils appear to be based on the 1843 study but are variants, with the addition of figures and other changes in composition, in color, and even in the depiction of individual buildings. The painting in the collection of Wildenstein, New York, seems to suggest, for example, that the lower range of the long building façade beneath S. Francesca Romana is actually only a wall behind which grow gray-green bushy trees in place of the brown patch of the Frick sketch. The third version[7] portrays the façade with the rows of small windows found in views of the building by other nineteenth-century artists.[8] Corot must have made and preserved drawings of these buildings or borrowed from other artists' renderings of the site to combine with his earlier oil sketch in composing his later "souvenirs" of the Roman Forum.

<div align="right">B. F. D.</div>

EXHIBITED: New York, Pierpont Morgan Library, and Richmond, Virginia Museum of Fine Arts, Paintings and Art Objects from the Collection of Mr. and Mrs. Eugene Victor Thaw, 1985–86, No. 4. San Diego, Timken Art Gallery, and Williamstown, Sterling and Francine Clark Art Institute, J. B. C. Corot: View of Volterra, 1988.

COLLECTIONS: Henri Fantin-Latour, Paris.[9] McCormick family, Chicago. Stephen Hahn, New York. Mr. and Mrs. Eugene Victor Thaw, New York. Gift of Mr. and Mrs. Eugene Victor Thaw, 1994.

1. A. Robaut, *L'Oeuvre de Corot: Catalogue raisonné et illustré*, Paris, 1905, II, p. 160, No. 445.

2. Corot posthumous sale, May 26 *et seq.*, 1875, Hôtel Drouot, Paris, Lot 365.

3. Robaut, *loc. cit.*

4. É. Moreau-Nélaton, *Corot raconté par lui-même*, Paris, 1924, I, p. 57.

5. Robaut, II, p. 160, Nos. 446, 447.

6. Moreau-Nélaton, I, p. 66.

7. From the collection of Alain Delon, Hôtel Drouot, Paris, November 25, 1990, Lot 1. The Frick Collection is indebted to Martin Dieterle for information on the locations of the two 1850 versions.

8. See, for example: a watercolor by J. M. W. Turner in the Tate Gallery, London, drawn from almost the identical spot (Turner Bequest, D16367, dated 1819); a drawing by Hugh William Williams (Christie's, London, July 11, 1995, Lot 1); a watercolor by Antoine Ponthus-Cinier, *c.* 1845 (*Master Drawings*, W. M. Brady and Co., New York, 1995, No. 10); and a photograph of *c.* 1860–65 (M. R. Scherer, *Marvels of Ancient Rome*, New York, 1955, pl. 53).

9. Robaut, IV, p. 234, notes as buyer "250 f / M Fantin-Latour." See also note 2, above.

ADDITIONAL REFERENCE

P. Galassi, *Corot in Italy*, New Haven–London, 1991, p. 216.

ANTON MAUVE

1838 – 1888

Born in Zaandam, North Holland, Mauve first trained with Pieter Frederik van Os in the tradition of Dutch landscape and animal painters of the seventeenth century, but he was more deeply influenced by the contemporary work of Israëls, the Maris brothers, and, especially, Millet. Mauve established himself as an artist in Amsterdam in 1868. He married and moved in 1874 to The Hague and then in 1885 to Laren, where his wife's cousin Vincent van Gogh came to study with him. While Mauve exhibited widely in Europe and won numerous awards in Vienna, Antwerp, Paris, and Berlin, it was in America at the end of the nineteenth century that his most enthusiastic audience developed, especially in Pittsburgh among Henry Clay Frick and his collecting peers.[1]

EARLY MORNING PLOWING (77.1.170)

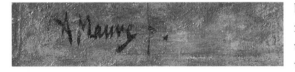

Signed, at lower left: *A. Mauve p.* Painted probably around 1875. Oil, on canvas, 16⅞ × 22⅞ in. (42.7 × 56.9 cm).

DESCRIPTION: Seen from behind, a man wearing a blue-gray blouse, brown pants, and a black cap is depicted manipulating a plow as he follows a dark brown horse heading to the left, toward the crest of a plain. A foggy sky is gray with a few pale pink clouds above and to the left of the horse. The earth is rendered in various tones of brown and gray, lightening at the bottom of the canvas.

CONDITION: Cleaned and relined in 1973, the painting is in good condition.

Early Morning Plowing is an archetypical work by Mauve, with its depiction of a lonely plowman and his horse seen from behind, in a chilly, bleak landscape under a silvery sky. Henry Clay Frick had a penchant for such pictures by Mauve and at one time owned five or six of them, both oils and watercolors. A sketchbook by the artist that includes a number of figural and compositional studies similar to *Early Morning Plowing* is preserved at the Frick Art Reference Library.[2]

E. M.

COLLECTIONS: Knoedler. Bought by Henry Clay Frick on September 14, 1896, for $1,500.[3] Helen Clay Frick, 1919. Given by her in 1957 to Mr. and Mrs. I. Townsend Burden, Jr.[4] Given to The Frick Collection by I. Townsend Burden, Jr., in 1977.

NOTES

1. See G. P. Weisberg, D. E. McIntosh, and A. McQueen, *Collecting in the Gilded Age: Art Patronage in Pittsburgh, 1890–1910*, Pittsburgh, 1997, pp. 60, 114, 169.

2. The album (F 313 M 449) was presented to Helen Clay Frick by A. Pryor on April 9, 1921.

3. *Paintings and Other Works of Art Owned by Henry Clay Frick ("The Red Book")*, f. 41.

4. Information from a photograph mount in the Frick Art Reference Library (317–3 C).

FRENCH

Probably Nineteenth Century

SET OF SIXTEEN MINIATURE PORTRAITS of French Eighteenth-Century Notables (66.1.166 A–P)

Painted probably in the nineteenth century. Watercolor and gouache, on ivory. For measurements, see below.

DESCRIPTION: The sixteen miniatures are individually mounted under glass in six horizontal rows on a velvet-covered wooden panel measuring 18⅛ × 12½ in. (45.8 × 31.7 cm). Beneath each miniature is a gilded wooden plate inscribed with the subject's name. For descriptions of the individual miniatures, see below.

CONDITION: The paintings are in good condition.

THE sixteen circular miniature portraits brought together here represent two generations of distinguished eighteenth-century men born between 1688 and 1750. Most are connected with the visual arts, among them painters, illustrators, and engravers. One is an actor, one is a scientist, and the identity of the man labeled only as "Port" remains uncertain. Although many are well known today, others are largely forgotten; in the latter category is the physicist and aeronautic pioneer Jacques-Alexandre-César Charles, the first person to ascend alone in a hydrogen-filled balloon.[1] All are French, including one Swedish-born artist who worked in Paris.

The subjects are as follows:

FIRST ROW

A. Jean-Baptiste Perronneau (1715–83), painter and engraver. D. 2 in. (5.1 cm). In right profile, wearing blue-gray jacket and white shirt with pleated collar, powdered hair tied with lavender ribbon, light gray background.

B. Jean-Baptiste Greuze (1725–1805), painter. D. 1⅞ in. (4.8 cm). In left profile, wearing rose jacket and white shirt with pleated collar, lightly powdered hair in loose curls tied with narrow gray ribbon, medium gray background.

C. Noël Hallé (1711–81), painter and engraver. D. 2 9/16 in. (5.8 cm). In left profile, wearing striped green jacket and white shirt, powdered hair (or wig) tied with a magenta ribbon, medium blue background.

D. François Boucher (1703–70), painter. D. 2 in. (5.1 cm). In three-quarter view toward right, wearing rose jacket and white shirt with rosette at neck, powdered hair tied with black hair ribbon, blue-gray background.

E. Hubert-François Gravelot (1699–1773), painter, illustrator, and engraver. D. 2⅛ in. (5.3 cm). In three-quarter view toward right, wearing rose jacket and white shirt with pleated collar, powdered hair (or wig) in sausage curls, medium gray background.

F. Jean-Michel Moreau *le jeune* (1741–1814), illustrator and engraver. D. 1⅞ in. (4.7 cm). In right profile, wearing rose jacket and white shirt with pleated collar, powdered hair tied with gray ribbon, blue background.

G. Carle Vanloo (1705–65), painter and engraver. D. 2¼ in. (5.7 cm). In three-quarter view toward right, wearing mauve jacket with lapels trimmed in fur and open white shirt with ruffled collar, powdered hair in loose rows of curls, blue background, darker to right.

H. Charles-Nicolas Cochin *le fils* (1715–90), engraver. D. 1¾ in. (4.5 cm). In left profile, wearing reddish-brown jacket and white shirt with pleated collar, powdered hair tied with black ribbon, light gray background, darker to right.

I. Gabriel de Saint-Aubin (1724–80), illustrator and engraver. D. 1⅞ in. (4.7 cm). In right profile, wearing turquoise jacket and white shirt with pleated collar, powdered hair tied with black ribbon, blue background.

J. Alexandre Roslin (1718–93), Swedish-born portrait painter, active in Paris. D. 1⅞ in. (4.8 cm). In right profile, wearing blue-gray jacket and white shirt with pleated collar, powdered hair tied with black ribbon, light gray background, darker to left.

K. Charles-Nicolas Cochin *père* (1688–1754), engraver. D. 1¹¹⁄₁₆ in. (4.2 cm). In left profile, wearing red jacket with yellow waistcoat and white shirt with

pleated collar, powdered hair in sausage curls, gray background, darker to right.

L. Charles-François-Nicolas-Racot de Grandval (1710–84), actor. D. 1¹³⁄₁₆ in. (4.6 cm). Head lifted in three-quarter view toward left, wearing blue, collarless jacket with two rows of buttons, buff waistcoat, rose scarf, and white shirt with pleated collar, powdered hair tied with gray ribbon, light gray background, darker to right.

M. Pierre-Henry de Valenciennes (1750–1819), landscape artist. D. 1⅝ in. (4.1 cm). In left profile, wearing brown jacket and white shirt, powdered hair or wig tied and wrapped with black ribbon, light gray background.

SIXTH ROW

N. Jacques Dumont, called *le Romain* (1701–81), history painter. D. 1⅝ in. (4.1 cm). In right profile, wearing blue-gray jacket and white shirt with pleated collar, powdered hair tied with dark gray ribbon, dark gray background.

O. "Port," possibly Jacques-André Portail (1695–1759), friend of Boucher, or Henri-Horace-Roland de la Porte (1724–93), painter of fruit, flowers, and still lifes. D. 1¹⁵⁄₁₆ in. (4.4 cm). In right profile, wearing maroon jacket with collar and white shirt, powdered hair tied with gray ribbon, blue background.

P. Jacques-Alexandre-César Charles (1746–1823), professor of physics and balloonist (see above). D. 1⅝ in. (4.2 cm). In left profile, wearing rose jacket trimmed in white, lace jabot, and cream waistcoat, powdered hair tied with light gray ribbon, light gray background, darker to right.

In twelve of the miniatures, the heads are represented in strict profile, six of them facing left and six right. The remaining four subjects are portrayed in three-quarter view. Almost all of the miniatures can be linked with sources in engravings done after paintings or drawings.

Six of the portraits are based on engravings after drawings by Charles-Nicolas Cochin *le fils*, all of them showing the subject bust-length in profile, in a circular frame or medallion. The miniature of Moreau *le jeune* is derived from an engraving of 1787 by Augustin de Saint-Aubin,[2] inscribed above the figure: "Société

Acad^{que} des Enfans d'Apollon."[3] The engraved portraits of Hallé and Roslin, dated 1775 and 1776 respectively, are by Bénédict-Alphonse Nicollet; in both, the subject is portrayed in a medallion hanging from a trompe l'oeil ribbon tied in a bow,[4] the sitter's name is inscribed below as if chiseled in stone, and his titles appear below that in script. The miniature of Perronneau also can be traced to an engraving after Cochin by Nicollet; in this undated print, the trompe l'oeil bow from which the portrait hangs is now untied.[5] In each of the last three portraits, the miniaturist followed his graphic models carefully, cropping the shoulder and upper body to focus on the head. The miniature of Cochin *le fils* himself is based on a self-portrait drawing of 1754 which was engraved by Jean Daullé.[6] Augustin de Saint-Aubin's engraved portrait of Cochin *père*, dated 1771, is likewise based on a drawing by Cochin *le fils*.[7] Augustin de Saint-Aubin also engraved portraits of Valenciennes (undated) and Jacques Dumont (1788)—both members of the Société Académique des Enfants d'Apollon—after drawings by Cochin *le fils*; these images have yet to be found to determine whether they might be the sources for the miniature portraits of the same.

Munhall has identified the sources for the two best-known artists in the group, Boucher and Greuze.[8] The Boucher miniature is based on Alexandre Roslin's portrait of 1760 in the Musée de Versailles. Exhibited at the Salon of 1761, the Roslin portrait was engraved the same year by Manuel-Salvador Carmona (1730–1807).[9] Roslin made a replica of the painting in which he focused only on the head and shoulders, turned the subject in the opposite direction, and changed the oval format to a circular one. The replica was engraved by Louis Bosse (active 1750–70); there the subject is again reversed, as is usual with engravings after paintings.[10] The slightly less refined nature of this image, its circular format, and the fact that the figure faces right as in the miniature suggest that it was the Bosse engraving from which the artist of the Frick portrait worked. The Greuze miniature is based on an engraving by Jean-Jacques Flipart of 1763 after a self-portrait drawing now at the Ashmolean Museum, Oxford.[11]

Grandval's image is based on Nicolas Lancret's *Portrait of the Actor Grandval* of 1742, a reduced variant of which is in the Indianapolis Museum of Art.[12] The miniaturist's source was most likely the engraving of 1755 after the painting by Jacques-Philippe Le Bas, which was exhibited in the Salon of the same year.[13]

The head and shoulders of the physicist Charles were excerpted by the miniaturist from an elaborate allegorical print by Simon-Charles Miger (1736–1820)

414

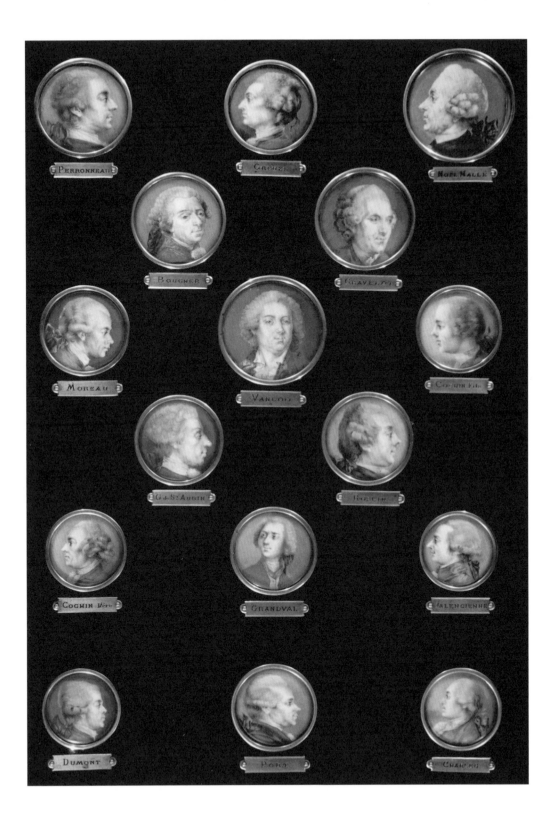

celebrating Charles' historic ascent in a hydrogen balloon.[14] The miniature of Gabriel de Saint-Aubin can be connected with an undated self-portrait medallion drawing,[15] an engraving after which was executed by Jules de Goncourt and published in the 1875 first edition of *L'Art du dix-huitième siècle*;[16] as the print is in the same direction as the minature, it is likely to have been its source. Gravelot's miniature depends from a pastel portrait of him by Maurice-Quentin de La Tour (1704–88) that inspired several prints.[17]

There is a very close connection between the miniature of Vanloo, the largest and most centrally placed on the panel, and a steel engraving reproduced in a book published in Paris in the nineteenth century, at some time after 1855;[18] the engraver is not identified, and whether the illustration is based on an earlier print has not yet been determined. The identity of the figure labeled "Port" remains uncertain, although, as noted above, a few candidates have been proposed.

While sources in engravings can be found for most of the miniatures, the issues of authorship and date and the question of why these particular eighteenth-century men were grouped together on a panel are open to speculation. The distinctive quasi-caricatural style of the miniatures is unfamiliar to experts who have examined them in the original or in photographs, and no similar works have thus far come to light. At the time of their acquisition in 1966, they were attributed—with no substantial evidence—to the painter Jean-François de Troy (1679–1752). However, Munhall dismissed that assumption, noting that de Troy was not known as a miniaturist and that he died before Greuze had executed the self-portrait drawing of 1763 on which his miniature is based.[19]

The miniatures have recently been examined by various experts. Katharine Baetjer, Curator of European Painting at the Metropolitan Museum of Art, New York, and Joseph Baillio, vice president of Wildenstein and Co., New York, were unable to connect them with any known miniaturist of the late eighteenth century, the period from which the works had been thought to date. Sarah Coffin placed them in the second half of the nineteenth century,[20] noting that while in the eighteenth century miniatures were made for lockets or small jewelry cases, the notion of arranging miniatures together on a panel for display on a wall—quite likely for a library—is a nineteenth-century conceit; of course the miniatures could have been executed earlier and assembled on a panel at a later time. Coffin also felt that the color was weak—more in keeping with mid nineteenth-century miniatures—and that the white, in particular, is definitely from that period. She believes the miniatures were

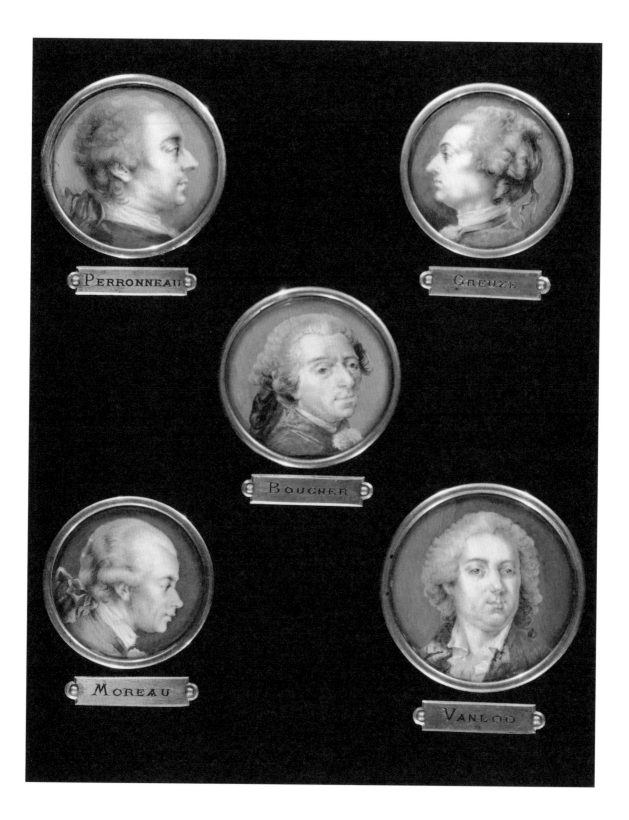

made by a French artist familiar with late eighteenth-century techniques, especially those of De Gault, Sauvage, Bouton, and others who worked in a grisaille tradition. Coffin noted that miniaturists such as these, many of whom catered to the Grand Tour visitor, although often skillful, usually did not sign their names.

Pierrette Jean-Richard of the Département des Arts Graphiques of the Louvre corroborated Coffin's opinion. She placed the miniatures in the nineteenth century on the basis of style and execution, which she found inconsistent and, in a number of cases, relatively weak.[21]

The miniatures, therefore, may be seen as part of a retrospective movement in the middle and late nineteenth century in France: the fascination on the part of writers, intellectuals, and artists with the age of the rococo, of which the Goncourt brothers were the leading exponents.

S. G. G.

COLLECTIONS: Charles E. Dunlap, New York and Newport. Possibly sold at Parke-Bernet, New York, around 1966. Helene Seiferheld.[22] Frank A. Partridge, Inc., New York, 1966. Frick, 1966.

NOTES

1. The Frick Collection is grateful to the miniature expert Pierrette Jean-Richard of the Département des Arts Graphiques, Musée du Louvre, for identifying this figure in a meeting with Susan Galassi at the Louvre in June 1997.

2. The engraving is reproduced in E. Boucher, *Jean-Michel Moreau le jeune,* Paris, 1882, frontispiece.

3. For information on the Société des Enfants d'Apollon, see C. Michel, *Charles-Nicolas Cochin et l'Art des Lumières,* Rome, 1993, p. 174, note 64, p. 471, note 17. A list of the members of this society, of which Cochin was probably president for a year, is on pp. 624–26.

4. The engraving of Roslin is reproduced in S. Rocheblave, *Les Cochins,* Paris, 1893, p. 113. An impression of the engraving of Hallé is in the Bibliothèque Nationale, Paris (photograph in the curatorial files of The Frick Collection).

5. See L. Vaillat, *J.-B. Perronneau, sa vie et son oeuvre,* Paris, 1909, pl. 1.

6. The engraving is reproduced in Rocheblave, frontispiece.

7. *Idem,* p. 137.

8. See curatorial files of The Frick Collection. Edgar Munhall laid the foundations for the research on the miniatures when they were acquired in 1966 and later guided work on them.

9. Dated 1761. See R. S. Slatkin, "Portraits of François Boucher," *Apollo,* October 1971, pp. 280–91, figs. 3, 5.

10. *Idem,* figs. 7, 8.

11. For the Flipart engraving, see R. Portalis and H. Beraldi, *Les Graveurs du dix-huitième siècle,* II, pt. 1, Paris, 1881, No. 24, p. 210. For

the drawing, see E. Munhall, *Jean-Baptiste Greuze, 1725–1805,* Hartford, 1976, No. 36, p. 89, repr.

12. The connection to this painting was made by Jean-Richard. The replica is illustrated in M. T. Holmes, *Nicolas Lancret,* New York, 1991, p. 94, No. 17, pl. 21.

13. See *Les Graveurs français du dix-huitième siècle,* Paris, 1875–82, No. 38, p. 31.

14. Jean-Richard linked the image to this print, which is in the Collection Vinck of the Bibliothèque Nationale, Paris. The undated engraving was announced for sale in the *Journal de Paris* on March 31, 1784. In the print, Charles is portrayed in a circular medallion bust-length, in profile, facing right. The medallion is suspended by three ropes from a balloon, of which only the lower part is seen, in a cloud-filled sky. Below the medallion, an eagle with spread wings, seen from behind, accompanies the medallion, carrying in its beak a rod to which a flowing banner is attached; on it is written: *Charles aux Thuilleries le 11 Decembre, M. DCCLXXXIII.* The miniaturist, however, may have worked from an anonymous copy of this famous print in which Charles faces in the opposite direction, as he does in the miniature. Thanks are due to Jean-Richard for providing this background information on the print from her files.

15. See É. Dacier, *Gabriel de Saint-Aubin, Peintre, Dessinateur et Graveur,* I, Paris, 1929, pl. I.

16. See É. Dacier, *L'Oeuvre gravé de Gabriel de Saint-Aubin,* Paris, 1914, p. 22. The engraving is undated. The drawing was in the collection of P. de Baudicour when Goncourt engraved it. No other engraving of this drawing is listed.

17. A likely print source is the engraving by J. Massard—probably Jean Massard (1740–1822)—engraver to the King. See E. and J. de Goncourt, *L'Art du dix-huitième siècle,* Paris, 1875, "Les Vignettistes," between pp. 12 and 13. The La Tour portrait is in the Musée des Beaux-Arts, Bordeaux.

18. See C. de Beaulieu, *Les Grands Artistes du XVIII Siècle, Peintres, Sculpteurs et Musiciens,* Paris (n.d.), facing p. 336.

19. See the curatorial files of The Frick Collection.

20. Coffin examined the miniatures at The Frick Collection in April 1996, for which visit several of them were removed from their frames. See the report on her visit in the curatorial files.

21. Jean-Richard examined photographs of the miniatures. Her conclusions are in the curatorial files of The Frick Collection.

22. Curatorial files.

SCULPTURE

FRANCESCO LAURANA

c. 1430–c. 1502

Francesco Laurana appears to have been born at Vrana, near the Dalmatian port of Zara. He is first documented in 1453, working in Naples for Alfonso I of Aragon. The reconstruction of Laurana's early work in Dalmatia, in Naples on the triumphal arch of the Castelnuovo, and elsewhere is in the main conjectural, and the first determinable point of his development is supplied by a group of medals executed in France for René of Anjou between 1461 and 1466. Thereafter he was in Sicily, where he executed sculpture for the Mastrantonio Chapel in S. Francesco at Palermo and statues of the Virgin and Child *at Palermo and Noto (both 1471). After some years in Naples, he returned to France, where he was documented in Avignon and Marseilles from 1476 through the 1490s.*

BEATRICE OF ARAGON (61.2.86)

Inscribed, on a rectangular tablet in the center at the base: DIVA BEATRIX / ARAGONIA. Marble: H. 16 in. (40.6 cm); W. 15⅞ in. (40.4 cm); D. at base 8 in. (20.3 cm).

DESCRIPTION: At the base the bust terminates in a line through the upper arms and chest. The sitter is posed frontally, with head inclined slightly to her left and eyes lowered. She wears a dress (*cotta*) decorated at the throat with a narrow horizontal band carved with two ermines (see below) and with three imperfectly legible devices on a punched ground. Over the dress she wears a loose tunic (*giornea*) cut low on the chest and rounded at the back. The tunic is decorated in front with bands bearing imitation Cufic designs, wider at the sleeve openings and narrower along the v-shaped opening at the neck; the ornament terminates at the shoulders and neck and does not continue in back. The sitter's head and forehead are covered with a cap (*cuffia*) with a roughened surface, through which the hairline can be seen. At the back the hair is pulled up from the neck into the cap, and at the sides it escapes from the headdress to fall in curls over the temples and cheeks.

CONDITION: The bust is in remarkably good condition, with no major breaks. Minor surface damage is confined to pitting on the nostrils, under the left eye, on the right upper eyelid, on the left jaw and chin, on the front of the throat, at four points on the left side of the neck, and at one point on the right shoulder. When the bust was lightly cleaned in 1988, overpaint and old repairs were removed and the pitted areas were refilled.

As indicated on the cartellino, the bust represents Beatrice of Aragon, who was the fourth daughter of Ferdinand I, King of Naples, and Isabella of Chiaromonte. Born in 1457, Beatrice was well educated at the Aragonese court, which nurtured her artistic and intellectual interests. After several prior attempts to arrange a marriage had failed (beginning when she was only six), Beatrice was affianced in 1474 to Matthias Corvinus, King of Hungary. Wars against the Turks delayed the wedding, but in September of 1476 she was married by proxy and symbolically crowned Queen of Hungary in the Incoronata, Naples; in December she celebrated her wedding at Buda. Matthias, an outstanding soldier and statesman with a keen enthusiasm for the arts and letters, established with his wife a court that became noted for its cultural climate. Beatrice also built considerable power, governing several cities and territories herself; but her inability to produce an heir brought discord to the marriage, and her inclination to favor Italians for positions at court made her unpopular in her adopted country. After Matthias' death in 1490, she remained in Hungary, but in 1501, daunted by escalating humiliations and loss of authority, Beatrice returned to Naples, where she died in 1508.[1]

Because the bust carries no reference to her title as Queen of Hungary it is presumed to have been carved before 1476. The portrait is variously dated to 1467 or 1472–75 by Burger,[2] to 1472–74 by Rolfs,[3] to 1473 by Valentiner,[4] d'Elia,[5] and Mognetti,[6] and to 1473–75 by Chiarini,[7] Seymour,[8] and Kruft.[9] The view that it was executed in the early 1470s is corroborated by the carving of the face, especially of the lower eyelids and lips, which finds close parallels in the head of the Virgin in the *Virgin and Child* at the Chapel of S. Barbara, Castelnuovo, Naples (documented 1474), and in the almost contemporary *Virgin and Child* in S. Maria Materdomini, Naples. R. W. Kennedy assumes that the bust formed part of an exchange of portraits before the marriage of Beatrice and Matthias, and adds the comment: "Fortunately [Laurana's] portrait of Beatrice survived the later Turkish depredations which despoiled the land Matthias had tried to modernize, and, after reaching Paris by an unknown path, it has now found its way to New York City."[10] There is no proof that the bust was made in connection with the marriage of Beatrice to Matthias, and no evidence that it was at any time in Hungary. It is equally possible that the portrait was prepared for one or another earlier prospective bridegroom.

The stylistic relation of the bust to others by Laurana in Vienna and the Louvre was first recognized in 1883 by Courajod, with no suggestion as to authorship.[11] Five years later Bode proposed an attribution for the busts to Laurana, on the

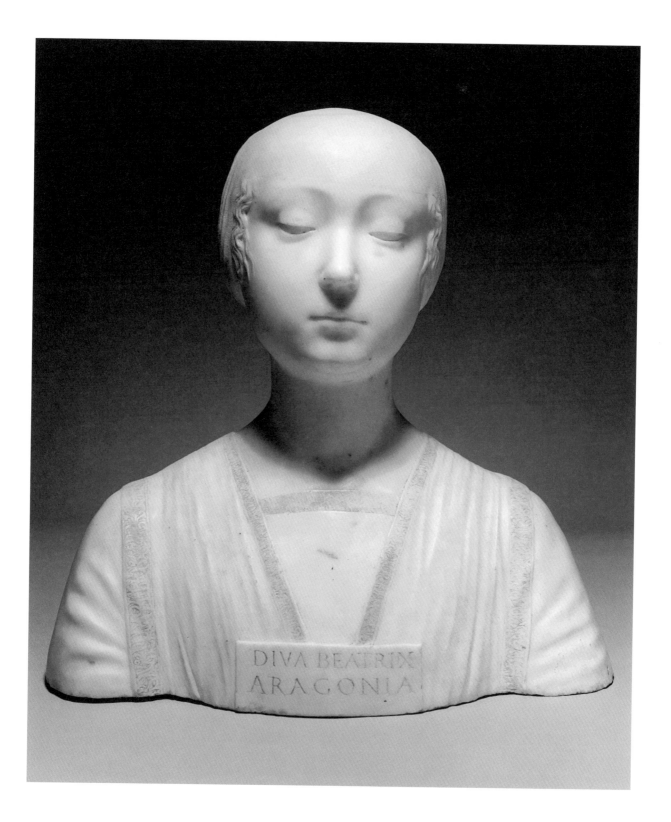

strength of analogies with this artist's signed or documented sculpture.[12] The ascription was contested by Reymond[13]—who regarded this and the related busts as "oeuvres faites par des artistes italiens, florentins sans doute ... si ces derniers bustes ne sont pas florentins, je crois qu'ils doivent être l'oeuvre de quelque maître lombard"—but it was accepted by Vitry[14] and by all later students of Italian sculpture.

On the cartellino the letters R I X appear a second time in diminished size beneath the present inscription; these are evidently the remains of an earlier inscription which was erased and superceded by the inscription legible today. It is correctly noted by Rolfs that the epigraphy of the present inscription conforms to that of the inscription on the base of Laurana's *Madonna* at Noto (1471).[15] As observed by Bode, the imitation Cufic decoration on the dress is related to that on the bust by Laurana formerly in the Kaiser Friedrich Museum, Berlin.[16]

The motifs on the horizontal band of the bodice are barely legible but apparently represent two ermines flanked at the ends by flowers, perhaps lilies, with clusters of three blooms.[17] Both of these motifs would symbolize purity, obviously appropriate to a young girl's costume, but additionally, the ermine was a device of Ferdinand I, Beatrice's father,[18] and corresponds in type with the ermines shown in illuminated volumes from the Aragonese library at Naples.[19]

J. P.-H. *and* B. F. D.

EXHIBITED: Paris, Palais Trocadéro, Exposition Universelle, 1878, lent by Gustave Dreyfus.[20] Princeton University, Art Museum, 1966–85, lent by The Frick Collection.

COLLECTIONS: Charles Timbal, Paris (said to have been bought in Florence *c.* 1855–60).[21] Gustave Dreyfus, Paris (bought for 3,000 francs from Timbal in 1871).[22] Purchased by Duveen with the remainder of the Dreyfus collection in 1930. John D. Rockefeller, Jr., New York. Bequeathed by him to The Frick Collection, 1961.

NOTES

1. For biographical information on Beatrice of Aragon, see: G. Cosenza, "La Chiesa e il Convento di S. Pietro Martire," *Napoli Nobilissima*, IX, 1900, pp. 104ff.; A. de Berzeviczy, "Les Fiançailles successives de Beatrice d'Aragon," *Revue de Hongrie*, IV, 1909, pp. 145ff. The Frick Collection is indebted to L. S. Domonkos, professor of history at Youngstown State University, Youngstown, Ohio, for correcting several errors in the literature.

2. F. Burger, *Francesco Laurana: Eine Studie zur italienischen Quattrocentoskulptur*, Strasbourg, 1907, p. 130.

3. W. Rolfs, *Franz Laurana*, Berlin, 1907, I, p. 336.

4. W. R. Valentiner, "Laurana's Portrait

Busts of Women," *Art Quarterly*, v, 1942, p. 284.

5. M. d'Elia, *Appunti per la ricostruzione dell'attività di Francesco Laurana*, Bari, 1959, p. 18.

6. E. Mognetti, *Le Roi René en son temps: Francesco Laurana Sculpteur du Roi René en Provence*, Musée Granet, Aix-en-Provence, 1981, p. 152.

7. M. Chiarini (*Francesco Laurana* [*I maestri della scultura, 47*], Milan, 1966, n.p.) believes it may be the earliest of a series of female portrait busts. For the eight related portrait busts by Laurana, see also J. Pope-Hennessy, in *The Frick Collection: An Illustrated Catalogue*, 1970, III, pp. 12 ff.

8. C. Seymour, Jr., *Sculpture in Italy: 1400 to 1500*, London, 1966, p. 165.

9. H.-W. Kruft, *Francesco Laurana: Ein Bildhauer der Frührenaissance*, Munich, 1995, p. 127.

10. R. W. Kennedy, *Four Portrait Busts by Francesco Laurana*, Northampton, Massachusetts, 1962, n.p.

11. L. Courajod, "Observations sur deux bustes du Musée de Sculpture de la Renaissance au Louvre," *Gazette des Beaux-Arts*, XXVIII, 1883, pp. 38 ff.

12. W. Bode, "Desiderio da Settignano und Francesco Laurana: Zwei italienische Frauenbüsten des Quattrocento im Berliner Museum," *Jahrbuch der Königlich Preuszischen Kunstsammlungen*, IX, 1888, pp. 209–27 (see p. 218 for the present bust). This attribution was contested by three French historians—A. Michel, E. Müntz,

and É. Molinier—in the pages of *Les Arts* (No. 4, May 1902, pp. 38 ff.) but then defended by an Italian writer, A. Salinas, in the same periodical (No. 12, December 1902, pp. 29–30).

13. M. Reymond, *La Sculpture florentine*, 1899, III, p. 75.

14. P. Vitry, "La Collection de M. Gustave Dreyfus," *Les Arts*, No. 72, 1907, pp. 27–28, repr. p. 23.

15. Rolfs, p. 340.

16. Bode, p. 219.

17. The relief may have been less abraded when described in 1907 by Rolfs (p. 340) as "zwei Iltisse oder Wiesel, die einen Hügel mit Vogel (?) zwischen sich haben, sowie zwei Lilien mit je drei Blütin."

18. G. de Tervarent, *Attributs et symboles dans l'art profane 1450–1600*, Geneva, 1958, I, col. 212.

19. Compare the manuscripts of Lorenzo Bonincontri, *Historia regni Siciliae*, in the University Library, Valencia, No. 859, and of Domizio Calderini, *Commentaria in Satyras Juvenalis*, in the Bibliothèque Nationale, Paris, ms. lat. 8078. Both are reproduced in T. de Marinis, *La biblioteca napoletana dei re d'Aragona*, Milan, 1947–52, III, pls. 39, 51.

20. *Livret-Guide du visiteur à l'Exposition Historique du Trocadéro*, comp. P. Breban, Paris, 1878, p. 40 (as "fin du XVᵉ siècle" but with no attribution). Illustrated as "marbre du XVᵉ siècle" in *L'Art ancien à l'exposition de 1878*, Paris, 1879, p. 153.

21. Rolfs, p. 339.

22. *Idem*.

ANDREA DEL VERROCCHIO

1435–1488

Born and buried in Florence, Verrocchio worked in his native city and nearby towns until his last years. Like many other Renaissance artists, he started his career as a goldsmith. Presumably he then served as assistant to some sculptor, but he also became equally successful as a painter. His shop provided training for numerous Florentine artists, from Botticelli to Leonardo da Vinci. First documented as a sculptor in 1461, Verrocchio soon became a favorite of the Medici, for whom he designed many of his greatest works: the tomb in S. Lorenzo for Piero and Giovanni (probably finished by 1472), the famous bronze figure of David, *now in the Bargello, and the* Eros Holding a Dolphin, *now in the Palazzo Vecchio. Among other important commissions were the bronze niche figures of* Christ and St. Thomas *for Orsanmichele (begun in 1468 but completed only in 1483) and the monumental bronze equestrian statue of* Bartolomeo Colleoni *in Venice, which Verrocchio was working on at the time of his death.*

BUST OF A YOUNG WOMAN (61.2.87)

Marble: H. 18⅝ in. (47.2 cm); W. 19³⁄₁₆ in. (48.7 cm); D. 9⅜ in. (23.8 cm).

DESCRIPTION: The sitter is posed frontally, with head turned slightly to her right. At the base the figure terminates in a line above the elbows and the waist. She wears a tunic (*giornea*) with strips of foliated ornament on its inner and outer edges, joined on the chest by a foliated clasp. Beneath is a bodice (*cotta*) fastened with double lacing. The sleeves are of figured velvet and are decorated with a bold pattern containing, on the outer surface of each arm, an impresa in the form of seven inverted heart-shaped motifs. Her hair is pulled back from the forehead and arranged in tight curls at each side. Two tresses on the crown and at the back, above the neck, are held in place with ribbons or bands. On the upper surface of the lower tresses are three flowers or flower-headed pins.

CONDITION: From damage the bust has suffered, it appears that the marble at some unknown date fell backward, shattering and flattening certain areas and snapping off the head, which may then have rolled, chipping the chin and severing the tip of the nose. Some of the locks of hair to the sides of the face may also have broken off. After the piece was repaired, a heavy oil paint was broadly applied to disguise these breaks and fills, and curls of hair were glued in place, possibly including new additions. When the bust was restored in 1987, the overpaint was removed mechanically, the surface was cleaned, and the old plaster repairs were extracted and replaced with a new resin compound.

428

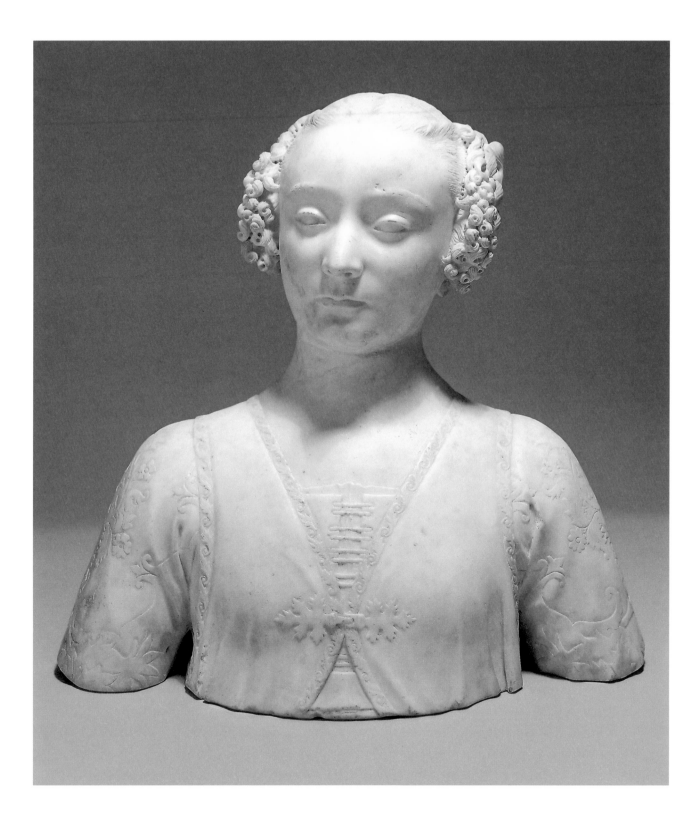

ACCORDING to Bode, the attribution of the present portrait to Verrocchio was first advanced in 1878 when it was exhibited in Paris at the Trocadéro.[1] A few years later, Bode seems to have concluded that the bust was more likely the work of a follower.[2] The attribution to Verrocchio has been accepted by Reymond,[3] Cruttwell,[4] Vitry,[5] Mayer,[6] Dussler,[7] Galassi,[8] Pope-Hennessy,[9] Bertini,[10] Adorno,[11] and Covi.[12] Seymour places it among attributed works, with a question mark.[13] Verrocchio's authorship is contested by Mackowsky,[14] and the bust is omitted from the monographs by Planiscig and Passavant.[15]

Though the portrait is nearly unanimously accepted as an autograph work by Verrocchio, there is less agreement about its date. Without external evidence, using only stylistic comparisons, it is difficult to construct a meaningful chronology in which to locate the bust. Some place it fairly early in Verrocchio's career, in the 1460s.[16] Others date it around 1470–75.[17] Comparison is inevitably made with the portrait of a *Lady with Primroses* in the Museo Nazionale, Florence, especially in the treatment of the hair, but that piece too is undocumented. In a more recent conclusion, Pope-Hennessy found parallels with the head of Faith on the Forteguerri monument in the Duomo, Pistoia, a late work of 1477–83, but subsequent cleaning of the monument has revealed fundamental divergences from the Frick bust.[18] The female faces of the monument are far more solid, heavy, and classicizing than the Frick portrait with its fine, linear, edgy carving of features. The delicate, almost tentative handling of her expression, form, and pose may in part reflect the character of the young sitter.[19] Yet these same qualities may well indicate an early stage in the sculptor's development and the influence of Desiderio da Settignano, who is sometimes proposed as Verrocchio's master.

The sole clue to the identity of the sitter is provided by the impresa on the sleeves, which has often been mistakenly connected with the arms of the Colleoni of Bergamo.[20] The association was accepted by Bode, who treated it with caution, refusing to specify the branch of the Colleoni family to which the impresa referred and rejecting the view that the portrait could represent Medea (d. 1470), daughter of the condottiere Bartolomeo Colleoni.[21] In his *Denkmäler*, however, Bode reproduced the work as "Marmorbüste einer Colleoni."[22] Vitry dismissed the possibility that the bust represents Tisbe, wife of Bartolomeo Colleoni, and assumed that Medea Colleoni is portrayed.[23] The identification as Medea Colleoni (whose features are known from an effigy by Amadeo in the Colleoni Chapel at Bergamo) was accepted by Middeldorf[24] but was properly denied by Cruttwell,[25] Dussler,[26] and Seymour.[27]

The portrait style is related by Pope-Hennessy to a classical portrait type represented by a Roman bust in the Uffizi, Florence.[28] The flower-headed pins may be compared with a similar ornament worn over the ear in the portrait of a girl from the workshop of Domenico Ghirlandaio in the National Gallery, London (No. 1230).

<div align="right">J. P.-H. <i>and</i> B. F. D.</div>

EXHIBITED: Paris, Palais Trocadéro, Exposition Universelle, 1878, lent by Gustave Dreyfus. Princeton University, Art Museum, 1966–85, lent by The Frick Collection.

COLLECTIONS: Charles Timbal, Paris (purchased in Venice through Eugène Piot).[29] Gustave Dreyfus, Paris (purchased from Timbal in 1870).[30] Purchased by Duveen with the remainder of the Dreyfus collection in 1930. John D. Rockefeller, Jr., New York. Bequeathed by him to The Frick Collection, 1961.

NOTES

1. *Livret-Guide du visiteur à l'Exposition Historique du Trocadéro*, comp. P. Breban, Paris, 1878 (p. 40, "portrait d'une Vénitienne, attribué à Verrocchio"); W. Bode, *Italienische Bildhauer der Renaissance*, Berlin, 1887, pp. 108–09, substantially reprinted from "Die italienischen Sculpturen der Renaissance in den Königlichen Museen—II: Bildwerke des Andrea del Verrocchio," *Jahrbuch der Königlich Preuszischen Kunstsammlungen*, III, 1882, pp. 103–04.

2. W. Bode, *Denkmäler der Renaissance-Sculptur Toscanas*, Munich, 1892–1905, p. 149.

3. M. Reymond, *La Sculpture florentine*, Paris, III, 1899, p. 215.

4. M. Cruttwell, *Verrocchio*, London–New York, 1904, pp. 110–11, 229.

5. P. Vitry, "La Collection de M. Gustave Dreyfus: I, La Sculpture," *Les Arts*, VI, No. 72, 1907, pp. 22–24.

6. A. L. Mayer, "Die Sammlung Gustave Dreyfus," *Pantheon*, VII, 1931, pp. 16–17.

7. L. Dussler, in Thieme-Becker, *Allgemeines Lexicon der bildenden Künstler*, XXXIV, Leipzig, 1940, p. 294.

8. G. Galassi, *La scultura fiorentina del quattrocento*, Milan, 1949, pp. 213–14, 220.

9. J. Pope-Hennessy, *Italian Renaissance Sculpture*, London, 1958, p. 312, and *The Portrait in the Renaissance*, New York, 1966, pp. 84, 313, note 33.

10. A. Bertini, *Verrocchio e la scultura fiorentina del '400*, Turin, 1964, p. 64.

11. P. Adorno, *Il Verrocchio*, Florence, 1991, pp. 62–63.

12. D. A. Covi, "The Current State of Verrocchio Study," in *Verrocchio and Late Quattrocento Italian Sculpture*, Florence, 1992, p. 11.

13. C. Seymour, Jr., *The Sculpture of Verrocchio*, Greenwich, Connecticut, 1971, p. 121, fig. 137.

14. H. Mackowsky, *Verrocchio*, Bielefeld, 1901, p. 46.

15. L. Planiscig, *Andrea del Verrocchio*, Vienna, 1941; G. Passavant, *Verrocchio*, trans. K. Watson, London, 1969.

16. Covi, *loc. cit.*; Andrew Butterfield, oral communication, February 27, 1997.

17. Mayer, *loc. cit.*; Dussler, *loc. cit.*; Pope-Hennessy, *Italian Renaissance Sculpture*, *loc. cit.*, and *The Portrait in the Renaissance*, p. 313, note 33.

18. J. Pope-Hennessy, "Deux Madones en marbre de Verrocchio," *Revue de l'art*, LXXX, 1988, p. 23. The Frick Collection is grateful to Andrew Butterfield for providing his photographs of the monument and sharing his ideas about its dating.

19. The subtle suggestion of an inner life conveyed by the subject's tilted head and alert gaze even prompted one writer to attribute the bust to Leonardo da Vinci (J. G. Phillips, "The Lady with the Primroses," *Metropolitan Museum of Art Bulletin*, XXVII, 1969, pp. 389, 391).

20. Instead of displaying seven inverted heart-shaped motifs as seen on the marble bust, the Colleoni arms consisted of three, only remotely similar, motifs (M. Bonavia, *Il Castello di Malpaga*, Bergamo, n.d., p. 28, note 5).

21. *Italienische Bildhauer*, *loc. cit.*

22. *Denkmäler*, *loc. cit.*

23. *Loc. cit.*

24. U. Middeldorf, "Statuen und Stoffe," *Pantheon*, XXXV, 1972, pp. 11–12.

25. P. 110.

26. *Loc. cit.*

27. *Loc. cit.*

28. *The Portrait in the Renaissance*, p. 84.

29. Mayer, *loc. cit.*

30. *Idem.*

ANTICO (PIER JACOPO ALARI BONACOLSI)

c. 1460–1528

Antico's life was centered in and around Mantua, where he worked for various members of the ruling Gonzaga family. Probably trained as a goldsmith, he earned a reputation for his knowledge of ancient art—and hence the nickname Antico—early in his career. He both restored antiques and purchased them for the Gonzagas, making more than one trip to Rome. But the chief justification for his agnomen derived from his numerous small, elegantly finished bronze figures inspired by ancient marble sculptures, with subjects from classical myth and history. He also produced bronze busts with classical subjects, roundel reliefs, and portrait medals. After Mantegna's death in 1506, Antico became artistic advisor to Isabella d'Este, the wife of Marchese Francesco I Gonzaga.

HERCULES (70.2.89)

Bronze, with gilding and silver inlay:[1] H. overall 15⅛ in. (38.2 cm); H. of figure 13¹¹⁄₁₆ in. (34.7 cm).

DESCRIPTION: The stocky figure of Hercules stands with his weight on the right leg, the left leg placed forward. He holds his right arm extended out from his side, the fingers of the hand curled slightly open. A lion skin wrapped about his hips is draped over his bent left arm, the head and paws hanging below. His left hand is held out, palm up (see below for objects missing from both hands). His bearded head, crowned by a wreath of grape leaves, is that of an aging man. Hair, wreath, and beard are fire gilded, as is the lion skin. Hercules' eyes are inlaid with silver.

CONDITION: The bronze was cleaned in 1971, following its acquisition. Portions of the figure had been coated at some undetermined date with a dark patina, most extensively throughout the gilded areas. The bronze was cleaned of superficial grime, but the dark patina was left untouched except for the gilded areas, which were partially cleaned mechanically. In 1975, a number of points of corrosion—the "bronze disease" found in other bronzes by Antico—were noted and treated on the back and in slighter amounts on the abdomen and to the right of the left knee. A few further outbreaks on the upper back were treated in 1980. The original patina—dark brown, almost black—is brittle and has worn thin in some areas, while it has flaked and chipped in others where it adhered poorly to the metal—flaws attributable to

433

Antico's methods of patination. These losses were disguised by what appears to be old oil paint. The surviving original portions of the patina, like those of other Antico bronzes, have a smooth, but not glossy, eggshell texture. The bronze base is original.

SEVERAL casts of the standing *Hercules* are known, but it is generally agreed that The Frick Collection's version is superior to all others. The refinement of detail and richness of finish—gold and silver glowing against the dark, smooth skin—are jewellike in their preciousness, creating an objet d'art of sumptuous luxury.

Sculptures representing Hercules are mentioned in documents referring to three members of the Gonzaga family of Mantua. An inventory of 1496, following the death of Gianfrancesco Gonzaga, lists in his estate: "Lo Hercules dal bastono de bronzo."[2] Another Hercules was commissioned by Ludovico Gonzaga, Bishop of Mantua, who in the spring of 1499 had difficulty getting Antico to deliver his Hercules.[3] Twenty years later, a third Hercules—though not specifically named—is thought to have been among eight bronzes ordered by Isabella d'Este from earlier models that Antico had made in preparing bronzes for Bishop Ludovico.[4]

A degree of consensus has been reached among scholars about which of the surviving bronzes corresponds to the third Hercules. It is believed that Isabella's version is the bronze in the Kunsthistorisches Museum, Vienna (No. 5773). In the same collection, with the same seventeenth-century provenance from Archduke Leopold Wilhelm, is Antico's *Hercules and Antaeus*, which was one of the subjects made for Isabella in 1519 and which bears an inscription with her name. The Vienna Hercules is presumed to be one of two "nudi dal bastone" listed in the 1542 inventory of Isabella's Grotto, which also includes an "Hercule et un Antheo."[5] Technically and stylistically, the two Vienna pieces are well matched. That Hercules, made with the aid of assistants, is neither partially gilded nor inlaid with silver.

There is less agreement about the date and quality of the *Hercules* in the Museo Arqueológico Nacional, Madrid (No. 52.991), which is embellished with gold and silver. Radcliffe, followed by others, believes that this bronze is the earliest of the three, the cast listed in the 1496 inventory of Gianfrancesco Gonzaga's estate.[6] Allison, on the other hand, judges it to be a later sixteenth-century cast based on the 1499 model for Bishop Ludovico.[7]

Both Radcliffe[8] and Allison[9] agree that the Frick *Hercules* probably was the bronze made for Bishop Ludovico. Other particularly fine examples of Antico's work are stylistically associated with the *Hercules* and may also have been made

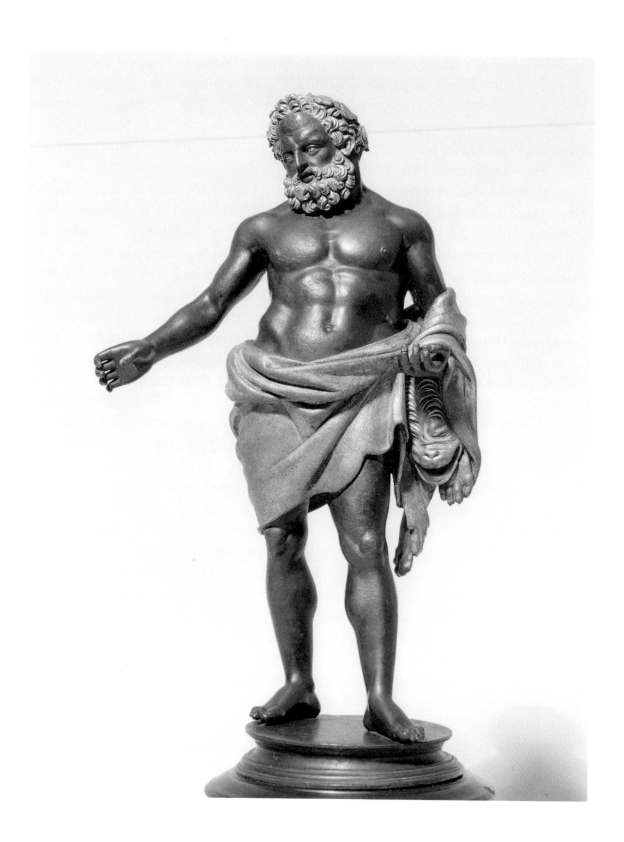

for the bishop, who was an enthusiastic collector. Included among them are the Vienna *Venus Felix*, the *Apollo* in the Ca' d'Oro, Venice, the *Meleager* in the Victoria and Albert Museum, London, and the *Paris* in the Metropolitan Museum of Art, New York. Raggio dates the group about 1498 to 1501, but she does not limit their possible patronage to the bishop alone.[10] Unfortunately, no inventory of his collection has been found.

Two more bronze figures of Hercules have been attributed to Antico. Allison has proposed that a statuette in the Louvre (No. OA 9134) is a late fifteenth-century North Italian work, probably the prototype for Antico.[11] Radcliffe and others have judged it to be a poor aftercast of Antico's model, made later in the sixteenth century.[12] It lacks gold or silver enrichments. Yet another version appeared at an auction of the Sylvia Phyllis Adams collection in London in 1996[13] and was acquired by a French dealer. The earlier provenance of that piece is unknown, but it is of considerably higher quality than the Louvre bronze; the hair and lion skin are gilded, though the eyes do not appear to have been silvered. The figure (34.5 cm tall) is slightly smaller than the Frick *Hercules* and differs in many details of anatomy and chasing.

The Frick *Hercules* is missing the club grasped in the right hand of the Madrid and Vienna models. The head of the club would have been propped on the base, resting inside the right foot. None of the versions actually holds in the left hand what are presumed to have been the golden apples of the Hesperides. The left palm of the Frick *Hercules* is in fact so delicately articulated with lines that it seems unlikely any object once was attached to it. Hercules stole the apples (or oranges)[14] from a tree guarded by a dragon at the western end of the world. This exploit is usually considered the last of his labors, and it sent Hercules beyond the geographic limits of the mortal world. Hercules Pomarius is often shown after this labor as aging and weary, yet as a symbol of hope, a mortal who achieved immortality. The grape leaves crowning his head refer to the hero's association with Bacchic mysteries.[15]

No single antique prototype for the *Hercules* has been identified. Monumental statues, such as the *Capitoline Hercules*, are not close enough to have provided Antico with his model. Similar figures, many of them small bronzes, have survived, but none with a lion skin wrapped across the loins.[16] A statuette of Hercules from the first century A.D. in the Museo Civico, Bologna (No. 1545), wears a himation draped across the hips and over the left arm, in a manner resembling the lion skin,

and holds apples in the left hand.[17] If Antico did not reproduce a specific antique model, now lost, he could easily have extrapolated his image of Hercules from existing antique sculptures.

<div align="right">B. F. D.</div>

EXHIBITED: London, Victoria and Albert Museum, 1907–12, lent by J. Pierpont Morgan. New York, Metropolitan Museum, Morgan Collection, 1914–16, No. 1482, lent by the J. Pierpont Morgan Estate.

COLLECTIONS: Charles Mannheim.[18] J. Pierpont Morgan.[19] Duveen. Henry Clay Frick, 1916. Gift of Miss Helen C. Frick, 1970.

NOTES

1. For a technical analysis of Antico's casting methods, see R. E. Stone, "Antico and the Development of Bronze Casting in Italy at the End of the Quattrocento," *Metropolitan Museum Journal*, XVI, 1982, pp. 87ff. Reports in The Frick Collection curatorial files written by Richard E. Stone, Jack Soultanian, and S. N. Hlopoff analyze in detail the composition of the bronze, gilding, and patination, the casting technique, and the conservation treatment of the *Hercules*.

2. The relevant documents are conveniently quoted in chronological sequence by A. H. Allison, "The Bronzes of Pier Jacopo Alari-Bonacolsi, called Antico," *Jahrbuch der Kunsthistorischen Sammlungen in Wien*, LXXXIX/XC, 1993/94, p. 277.

3. *Idem*.

4. *Idem*, pp. 291–92.

5. *Idem*, p. 302.

6. A. F. Radcliffe, in *Splendours of the Gonzaga*, ed. D. Chambers and J. Martineau, exhib. cat., Victoria and Albert Museum, London, 1981, p. 134. For others in agreement, see, for example: *Natur und Antike in der Renaissance*, exhib. cat., Liebieghaus Museum alter Plastik, Frankfurt am Main, 1985, p. 403; and M. Leithe-Jasper, *Renaissance Master Bronzes from the Collection of the Kunsthistorisches Museum, Vienna*, Washington, 1986, p. 74. J. Pope-Hennessy ("Cataloguing the Frick Bronzes," *Apollo*, XCIII, 1971, p. 371) suggested that the Frick *Hercules* might be identified with the earlier bronze listed in the 1496 inventory.

7. Allison, p. 159.

8. Radcliffe, p. 134.

9. Allison, p. 154.

10. O. Raggio, in *The Italian Heritage*, exhib. cat., Wildenstein, New York, 1967, No. 45. Allison dates the *Paris* later, *c.* 1522–28. See also: Leithe-Jasper, p. 74; Allison, p. 155.

11. Allison, p. 160.

12. Radcliffe, p. 134; H. J. Hermann, "Pier Jacopo Alari-Bonacolsi, genannt Antico," *Jahrbuch der Kunsthistorischen Sammlungen des Allerhöchsten Kaiserhauses*, XXVIII, 1910, p. 267.

13. Bonhams, London, May 23, 1996, Lot 27.

14. M. Levi d'Ancona, *The Garden of the Renaissance*, Florence, 1977, pp. 272–73.

15. *Natur und Antike in der Renaissance*, *loc. cit*.

16. *Lexicon Iconographicum Mythologiae Classicae*, IV, 2, Zurich, 1988, pp. 463–503.

17. *Idem*, No. 872.

18. É. Molinier, *Collection Charles Mannheim: Objets d'art,* Paris, 1898, p. 40, No. 136 (as "Italie, XVIᵉ siècle").

19. W. Bode, *Collection of J. Pierpont Morgan: Bronzes of the Renaissance and Subsequent Periods*, Paris, 1910, I, p. 26, No. 92 (as Antico).

SEVERO DA RAVENNA

Before 1496–1525/38

The father of Severo di Domenico Calzetta da Ravenna came from Ferrara, but the son evidently was born in Ravenna and named after St. Severus, a fourth-century bishop of that city. In the first known mention of Severo, in 1496, he is already referred to as "magistro." By 1500, when he received the commission for a marble statue of St. John the Baptist for the basilica of S. Antonio in Padua, he had settled in that city. Documents of 1505, 1507, and 1509, referring to his marriage and to real estate transactions, indicate continued residence in Padua. But by 1511, Severo was recorded back in Ravenna, where he apparently remained until his death sometime between 1525 and 1538.

SEA-MONSTER (97.2.103)

Signed, on the upper ring of a socket set into the sea-monster's back beneath the seashell: O[PUS]·SEV·ERI·RA·. Bronze: H. 4½ in. (11.4 cm); L. 9¾ in. (24.7 cm).

DESCRIPTION: The sea-monster is a fantasy composite of fish, reptile, and amphibian parts, with an anthropoid face framed in acanthus leaves and a seashell fastened to its back (see also below). The scaly creature lies on its belly, legs splayed outward, tail coiled, head twisted to turn upward and to its right. The brow over the wide eyes is furrowed, and the gaping mouth reveals the tongue. The chasing of the surface is very finely executed, with the individual scales given relief by a curved punch, the pupils of the eyes expressively modeled, and the locks of hair contrasted in texture with the smooth finish of the face.[1]

CONDITION: The *Sea-Monster* is composed of two separate parts: the monster itself; and the seashell, which is screwed into a socket in its back. The bronze is in excellent condition, apart from minor damage to the wax model that occurred in the casting (the right ear is folded over) and a flaw that was corrected probably immediately after casting, when the nose, the upper lip, and part of the right cheek were evidently found to be unsatisfactory. These features were cut away, remodeled in wax, and directly "cast-in" on the bronze. A transparent brown lacquer was at some point applied, perhaps to minimize worn areas of the original blackish patina.

439

As sometimes happens, written evidence testified to the existence of an important artist—in this case a sculptor known as Severo da Ravenna—before any body of work could be associated with his name. He was described by Pomponio Gaurico, a writer who knew him, as an excellent sculptor, highly skilled at working in bronze, marble, wood, or modeling, and equally noted as a painter.[2] But apart from the signed marble statue of *St. John* in the basilica of S. Antonio, Padua, Severo's oeuvre had not been identified until a bronze *Sea-Monster* inscribed with his signature—the present piece—was published by Planiscig in 1935.[3] It then gradually became apparent that a great number of bronzes, including a series formerly attributed to the mysterious "Master of the Dragons," were by Severo. The masterpiece of this series of bronzes is The Frick Collection's *Neptune on a Sea-Monster*.[4] Like so many other bronzes by Severo, that work had previously been attributed both to Bartolomeo Bellano and to Andrea Riccio, sculptors also active in Padua.

Severo appears to have been very well known in his time and a highly successful entrepreneur.[5] His small bronzes—often utilitarian objects of fanciful design inspired by the antique—were so much in vogue that to meet the demand he established a large workshop, which even after his death continued prolific production. Among these small bronzes, his most popular items seem to have been sea-monsters, several dozen of which have survived. They vary greatly in quality of execution. Some were intended to carry inkwells, candlesticks, or lamps; these functional elements, like the seashell on the Frick sea-monster, usually screw into the creature's back. Since the screws and sockets in many of Severo's bronzes match precisely, the sculptor could interchange parts, permitting the same sea-monster to be fitted with some form of lighting fixture or inkwell from a prefabricated supply, according to the client's desire. Of course, later collectors could do the same, and it has been suggested that the Frick sea-monster may once have carried some object larger than a seashell, such as a candlestick.[6]

The shell borne by the monster, identical to that attached to many bronzes by Severo and his shop, is a realistic portrait of a common Mediterranean mollusk, the Prickly Helmet (*Galeodea echinophora*).[7] The sea-monster itself, however, is an imaginary beast. The tip of the tail and the scales resemble those of fish, yet the long torso seems more reptilian. The four-toed feet derive from those of frogs, and the limbs are joined to the body in a fashion more doglike than either reptilian or amphibian.[8] Unlike the fierce dragonlike head of the Frick sea-monster ridden by Neptune, the head of this curious beast displays broad, coarse human features resem-

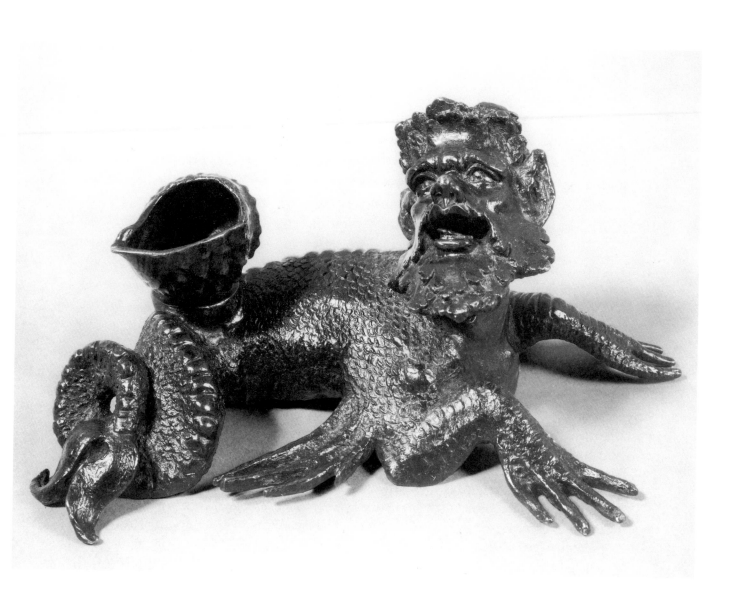

bling a satyr's, though it lacks a satyr's horns. The expression seems more anxious than menacing, and there is something helpless about the creature's flattened posture and splayed legs.

Both the quality of the chasing and the nuances of expression in face and bodily movement seem to the present author superior to the multitudes of sea-monsters more or less closely dependent upon the signed example.[9] Few even approach the distinction of the Frick piece; with rare exceptions, most of the others are

441

wretchedly debased specimens, often late shop productions or perhaps mere imitations. By signing the Frick *Sea-Monster*—an act highly unusual in his career—Severo proclaimed his pride in the work, which very likely was the first finished model of the type and the progenitor of a fecund, longlived breed of monsters.

Avery and Radcliffe have suggested that the finest Severo bronzes, such as the Frick *Neptune on a Sea-Monster* and the signed *Sea-Monster*, date from the sculptor's Paduan sojourn and probably from the earlier years, before 1504, when Pomponio Gaurico wrote so admiringly of Severo's work.[10] However, since Gaurico disapproved of sculptors who wasted their time making satyrs, hydras, chimeras, and monsters never seen on earth,[11] and since satyrs and sea-monsters comprised such a large portion of Severo's work, the question of their dating—before or after 1504—must remain unresolved.

B. F. D.

EXHIBITED: Vienna, Kunsthistorisches Museum, Kleinkunst der italienischen Frührenaissance, 1936, No. 19, lent by Robert Mayer. Northhampton, Massachusetts, Smith College Museum of Art, Renaissance Bronzes in American Collections, 1964, No. 8, lent by Blumka to this and subsequent exhibitions. New York, Metropolitan Museum, Early Renaissance Sculpture from Northern Italy, 1440–1550, 1973, No. 29. New York, Frick Collection, Severo Calzetta, Called Severo da Ravenna, 1978, No. 11. New York, Rosenberg and Stiebel, A Bronze Bestiary, 1985, No. 8. Frankfurt am Main, Liebieghaus Museum alter Plastik, Natur und Antike in der Renaissance, 1985–86, No. 233. Pittsburgh, Frick Art & Historical Center, Renaissance and Baroque Bronzes in the Frick Art Museum, 1993–94.

COLLECTIONS: English private collection.[12] Robert Mayer, Vienna. Ruth and Leopold Blumka, New York.[13] Estate of Ruth Blumka. Anthony E. Blumka. Frick, 1997, gift of Eugene and Clare Thaw in honor of Charles Ryskamp and in memory of Ruth Blumka.

NOTES

1. For an analysis of Severo's casting methods and a more complete report on the condition of the present bronze, see R. E. Stone, "Technical Note," pp. 29–31, in B. Davidson, *Severo and the Sea-Monsters*, New York, 1997. This booklet also includes more comprehensive information than can be provided here on the background, sources, and significance of the *Sea-Monster*.

2. Pomponio Gaurico, *De sculptura*, Padua, 1504, tr. and ed. A. Chastel and R. Klein, Paris, 1969, p. 262. Archival notices about Severo are few and generally unrevealing, rarely relevant to his artistic activities.

3. L. Planiscig, "Severo da Ravenna (der 'Meister des Drachens')," *Jahrbuch der Kunsthistorischen Sammlungen in Wien*, IX, 1935, p. 75.

One other bronze by Severo, a kneeling satyr sold at Christie's, London, July 8, 1981, bears what appears to be a partial signature.

4. See J. Pope-Hennessy and A. F. Radcliffe, in *The Frick Collection: An Illustrated Catalogue*, New York, 1970, III, pp. 126–35. The Frick Collection had hoped to acquire the signed *Sea-Monster* and expresses deep gratitude to Mr. and Mrs. Thaw (see *Collections*) for fulfilling this wish.

5. For the few documents found relating to Severo, see: A. Sartori, *Documenti per la storia dell'arte a Padova*, Vicenza, 1976, pp. 36–37; and U. Middeldorf, "Glosses on Thieme-Becker," in *Festschrift für Otto von Simson zum 65. Geburtstag*, Frankfurt am Main, 1977, p. 290 (notes, p. 293, with references to earlier sources). More extensive discussions of Severo's work and career, including documents and bibliography, can be found in: C. Avery and A. Radcliffe, "Severo Calzetto da Ravenna: New Discoveries," *Studien zum europäischen Kunsthandwerk: Festschrift Yvonne Hackenbroch*, Munich, 1983, pp. 107ff.; and P. M. de Winter, "Recent Accessions of Italian Decorative Arts," *Bulletin of the Cleveland Museum of Art*, LXXIII, 1986, pp. 89ff.

6. Stone, p. 30.

7. The shell was identified by William K. Emerson, Curator of the Department of Fossil and Living Vertebrates, American Museum of Natural History, New York.

8. David Dickey, Department of Herpetology, American Museum of Natural History, provided helpful guidance on the monster's anatomy.

9. Bronze sea-monsters are so numerous, and previously unrecorded examples appear so often on the art market, that no one could hope to make a comprehensive accounting of them. De Winter (p. 132, note 43) provides one of the more exhaustive published lists.

10. *De sculptura*, pp. 116–17.

11. *Idem*, p. 60.

12. Planiscig, p. 75.

13. It is not known when or from whom the Blumkas bought the bronze. If the sea-monster illustrated in the Chastel-Klein 1969 edition of P. Gaurico (pl. 52) is the signed bronze, it would seem to have been at some date in the Grassi collection, according to the caption. However, the text (p. 247, note 3) claims the illustration was borrowed from a 1963 catalogue of the Cramer gallery in The Hague. Hans Cramer does not find any record that the piece passed through the gallery, though the gallery did have other versions (letter of January 27, 1997). And Marco Grassi, who has kindly examined his family's records, reports that the sea-monster owned by his grandfather was a different version of the bronze.

JACQUES JONGHELINCK

1530–1606

Born in Antwerp to a family of mint-masters, Jonghelinck became one of the leading medalists and sculptors of the Spanish Netherlands in the sixteenth century. His training in medal-making probably began with his father, and he may have studied with the sculptor Cornelis Floris. In 1552 he worked in Milan as an assistant to the sculptor and medalist Leone Leoni, and a year later he was in Brussels, where he designed a silver florin. Most of his career, however, was spent in Antwerp; there he carried out sculptural commissions for such patrons as Margaret of Parma and Fernando de Toledo, Duke of Alba (see below). Jonghelinck was appointed official sculptor, metal-caster, and seal-engraver to the Spanish King in 1556, and was named mint-warden of Antwerp in 1572. He devoted his last thirty years to making medals, working primarily in precious metals.[1] By merging the refined style of his Milanese master with his own penchant for powerful characterization of his subjects, Jonghelinck rose to the summit of his art in a period that has come to be known as the golden age of medal-making.

PORTRAIT MEDAL OF THE DUKE OF ALBA (94.2.100)

Dated, on the truncation of the obverse: 1571. Silver (cast): D. 1⁹⁄₁₆ in. (3.95 cm).

DESCRIPTION: On the obverse, the subject is depicted in profile, looking right. He is bareheaded, has a long, flowing beard, and wears a cuirass, cloak, ruff, and the pendant of the Order of the Golden Fleece. Encircling his head is the legend: FE [or FF] RDIN[andus]· TOLET[anus]·ALBAE DVX·BELG[ii]· PRAEF [ectus] (Ferdinand de Toledo, Duke of Alba, Governor General of Belgium). On the reverse,

a burning candle rests on a base supported by a recumbent lion. A crane stands in profile on either side, that at left holding a stone in its upraised claw. The legend reads, in raised letters above: DEO ET REGI; and engraved in the exergue: VITAE VSVS (The purpose of life [is service] to God and the King). The border on both faces is pearled.

CONDITION: The medal is in excellent condition.

THE Frick medal dates from the year in which Jonghelinck executed two bronze sculptures of Don Fernando Álvarez de Toledo, third Duke of Alba (1508–82). Following successful military campaigns in Germany and Hungary under the Emperor Charles V and King Philip II of Spain against the Turks and the Protestants, the

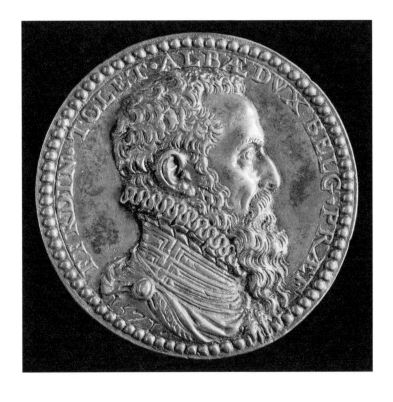

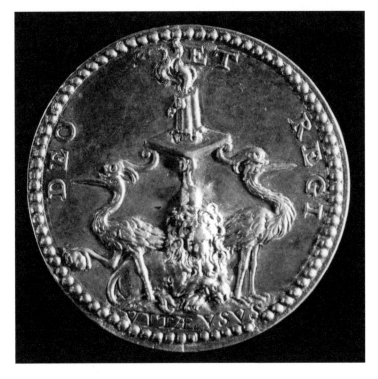

Duke was appointed by Philip as Governor General of the Spanish Netherlands in 1567; a medal made by Jonghelinck pairing the King and the Duke was issued that same year.[2]

The Duke is remembered largely for his fanatical loyalty to the Catholic Church and to Spain, and for the tyrannical measures he used to repress the growing spirit of religious toleration in the Low Countries and resistance to Spanish rule. In 1568 he set up the Council of Troubles, popularly known as the Court of Blood, which was responsible for the execution of some eighteen thousand accused of heresy and the forced exile from the country of countless others.[3] The Duke's extreme cruelty and the added injustice of increased taxation levied on the decimated population brought about a revolt in 1572; he was recalled to Madrid in disgrace a year later.

At the height of his reign of terror, the Duke commissioned from Jonghelinck (who remained loyal to Spanish rule) a life-sized statue of himself made from captured cannon and had it set up at the entrance of the citadel of Antwerp. (It was quietly disposed of by his successor.) In 1571, the sculptor presented the Duke with a bust-length version of the statue. The bust, which is now in The Frick Collection, may have been intended as a model for the larger figure and then developed into an independent work, or was perhaps a replica after it, though it is not an exact copy.[4] The Frick bust and medal conform closely to contemporary descriptions of the Duke and are considered the most life-like representations of this notorious figure.[5]

The profile portrait of the Duke on the obverse of the medal captures the haughty and resolute personality of the sitter, and displays the artist's gift for forceful characterization. The high forehead, hollow cheeks, prominent cheekbones, and long, thin nose are identical to those in the bust, although less elongated—undoubtedly a concession to the circular format of the medal.

On the reverse, an allegory drawn from familiar emblems alludes to the Duke's accomplishments. A burning candle, representing his life consumed in service to God and King, is supported on the back of a recumbent lion (symbol of might). The lion is flanked by two cranes (vigilance), that at left holding a stone in its upraised claw; according to an ancient belief, the crane dozed on one leg while carrying a stone in the other as a precaution, so that if it fell asleep the stone would drop and wake it.[6]

The Frick medal is one of four contemporary versions. Examples of the other

three are in the medal cabinets of the Rijksmuseum het koninklijk Penningkabinet in Leyden, the Bibilothèque Nationale in Paris, and the Kunsthistorisches Museum, Vienna.[7] There are also versions executed after the Jonghelinck medal, as well as numerous variants.[8]

S. G. G.

EXHIBITED: New York, Frick Collection, The Currency of Fame, 1994, No. 163, lent by Stephen K. and Janie Woo Scher. New York, Frick Collection, The Proud Republic: Dutch Medals of the Golden Age, 1997, No. 6.

COLLECTIONS: Henry Oppenheimer. His sale, Christie's, London, July 27, 1936, Lot 392. Private collection, Holland. Sotheby's, London, July 5, 1994, Lot 164. Stephen K. and Janie Woo Scher. Given by them to The Frick Collection, 1994.

NOTES

1. L. Smolderen, in *The Currency of Fame: Portrait Medals of the Renaissance*, ed. S. K. Scher, New York, 1994, p. 350.

2. C. Lawrence, in *The Dictionary of Art*, London, XVII, 1996, p. 643.

3. *The Columbia Encyclopedia*, 15th ed., New York, 1993, p. 49.

4. See: J. Pope-Hennessy and A. F. Radcliffe, in *The Frick Collection: An Illustrated Catalogue*, New York, IV, 1970, pp. 28–33; L. Smolderen, *Jacques Jonghelinck, Sculpteur, médailleur et graveur de sceaux (1530–1606)*, Louvaine-la-Neuve, 1996, pp. 117–46.

5. Smolderen, 1994, p. 357.

6. *Idem.*

7. See: Smolderen, 1996, No. 77, p. 315, and 1994, No. 163, p. 357; S. K. Scher, *The Proud Republic: Dutch Medals of the Golden Age*, New York, 1997, No. 6, p. 17.

8. Smolderen, 1996, pp. 316–22.

ADDITIONAL REFERENCES

P. Bizot, *Histoire métallique de la République d'Holland*, Amsterdam, 1688–90, I, p. 14.

J. Simonis, *L'Art du médailleur en Belgique, Nouvelles Contributions à l'étude de son histoire*, Brussels, II, 1904, p. 143, pl. XV, No. 1.

J. Taelman, *De Penningkunst in de Nederlanden*, Brugge, 1989, p. 18.

G. van Loon, *Histoire métallique des XVII provinces des Pays-Bas*, The Hague, 1732, No. 1, p. 134.

ALESSANDRO ALGARDI

1598–1654

Born in Bologna, Algardi studied there at the academy of the Carracci and with minor local sculptors, learning particularly the art of modeling in terracotta, a Bolognese specialty. At about the age of twenty he entered the service of Ferdinando Gonzaga in Mantua, but he stayed only a few years. Following a brief detour to Venice, he moved in 1625 to Rome, where he remained for the rest of his highly successful career. Like his rival Gian Lorenzo Bernini, who was born in the same year as he, Algardi sought commissions from churches and the nobility, soon winning a roster of illustrious patrons for his religious subjects and portrait busts, both in marble and in bronze. After Bernini's champion Pope Urban VIII was succeeded by Innocent X in 1644, Algardi received important papal commissions—including the tomb of Leo XI in St. Peter's—and was knighted by the pope in 1649. His sculpture, especially the many large scenes in relief that he produced for Roman tombs and altars, retained pictorial qualities imprinted by his early Bolognese experience.

PIETÀ (92.2.99)

Bronze, octagonal. Including flange: H. 12¾ in. (32.4 cm); W. 12⅛ in. (30.8 cm); relief alone, excluding flange: H. 11⁹⁄₁₆ in. (29.4 cm); W. 11⅝ in. (29.5 cm).

DESCRIPTION: The Virgin bends toward the body of Christ lying before her. With her left hand she lifts a shroud from his face, while her right arm and hand, which are modeled in the round, fling out and upward in a gesture of horror and despair. Great swathes of the shroud drapery, finely tooled and fringed, flow around the figure of Christ. The Virgin's billowing cloak is textured by delicate punchwork. Behind her right hand rises the upright of the cross, and below the cross a hill is suggested by a few rocks and sparse vegetation. The background is roughened by punching to contrast with and give relief to the wave-like silhouette of figures and drapery.

CONDITION: The relief is in excellent condition. A few minor patches and reinforcements are visible from the rear, most of them made probably at the time the bronze was cast. A hole in the drapery, caused by a casting flaw, is hidden behind Christ's right knee.

VIRTUALLY all the information available on Algardi's *Pietà* was discovered and published by Montagu, whose years of research on the artist and his contempo-

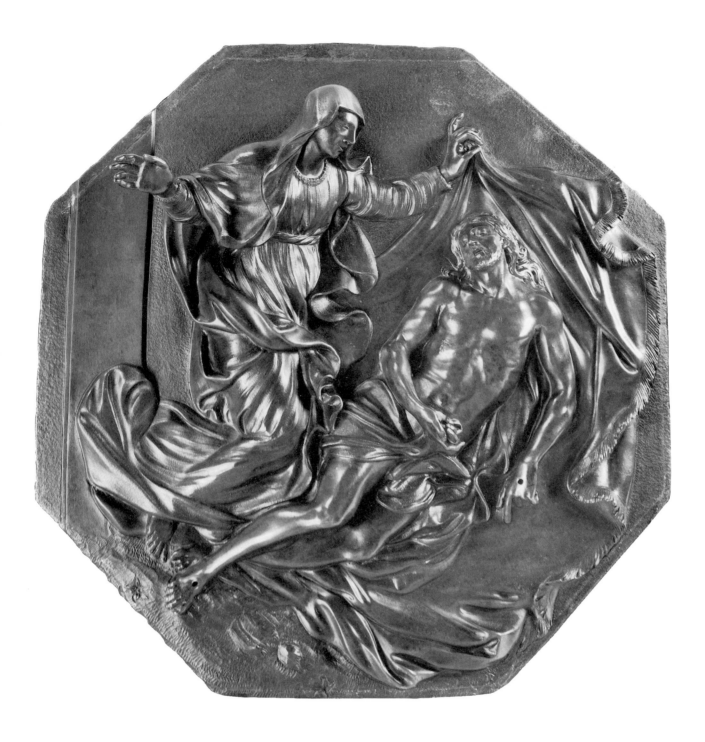

raries have provided much important material.[1] Still unresolved, however, are basic questions about the commission: the patron, date, and initial destination of the *Pietà*, and Algardi's role in its execution. Unless hitherto unknown archives emerge, only educated guesses can span some of the voids.

According to Montagu, the Frick relief "is the work of Algardi," a design of the mid 1630s, and distinctly superior to the three other known surviving versions: one in the Palazzo Pallavicini-Rospigliosi, Rome;[2] a second formerly in Schloss Ottenstein, Czechoslovakia;[3] and a variant, in pewter, in the collection of Carlo Bertelli, Milan.[4] The only documented *Pietà* ascribed to Algardi is lost. This was a copper relief, seemingly of the figure group alone, gilded and mounted in an elaborate octagonal frame for Cardinal Francesco Barberini in 1657 (after the sculptor's death).[5] The Pallavicini-Rospigliosi *Pietà* is one of three identically framed octagonal reliefs in that collection, none of them documented but all believed by Montagu to be fine late seventeenth-century Florentine casts of Algardi models from the middle and late 1630s.

The attribution of the Frick *Pietà* to Algardi, based on strong stylistic grounds, is therefore indirectly reinforced by inferred association with two of the above-mentioned repetitions of this composition: the record of an octagonal relief of the same subject said to be by him, once in Cardinal Barberini's collection, and the version included in the set of three octagonal reliefs from the Pallavicini-Rospigliosi collection. In addition to the *Pietà*, this set includes another generally acknowledged work of Algardi, the popular *Rest on the Flight*, known through several examples, as well as a third relief depicting the *Rest on the Return from Egypt*. To the best of current knowledge, these are the only three octagonal bronze reliefs by Algardi. Indeed, they appear to be among the very few independent small bronze reliefs by him; no evidence suggests that the reliefs formed part of some larger project.[6]

No drawing directly associated with the *Pietà* has been found, though there is a related study for a plaster relief of *The Trinity*, now in SS. Luca e Martina, Rome. In this drawing, God the Father bends over the dead Christ, his arms flung wide in a gesture similar to that of the Virgin in the bronze relief. Montagu suggests a date shortly after 1635 for the *Trinity* composition.[7]

Algardi made many models for sculpture, but, as was the custom, the actual bronze casting would have been entrusted to a foundry specializing in such time-consuming technical procedures. The highly skillful artisans who cast the *Pietà*

seem to have preserved all the subtle refinements of the sculptor's model. The bronze conveys the differentiation among textures, the graceful elegance of line, and the intricate rhythms of movement that are characteristic of Algardi's work in terracotta.

The relief does not illustrate a historical event from Biblical narrative, but is a devotional image intended to inspire meditation on Christ's sacrifice.

B. F. D.

COLLECTIONS: Victor D. Spark, New York. Sale, January 14, 1992, Christie's, New York, Lot 145. Colnaghi USA, Ltd. Frick, 1992, purchased with funds from the bequest of Arthemise Redpath.

NOTES

1. J. Montagu, *Alessandro Algardi*, New Haven–London, 1985, II, p. 342, No. 31.C.1 (see also index under Algardi, *Pietà*).

2. *Idem*, p. 343, No. 31.C.3.

3. *Idem*, No. 31.L.C.4. The executant of this cast (which has disappeared) misunderstood elements of the setting, transforming, for ex-ample, the upright of the cross into a brick wall.

4. *Idem*, p. 343, No. 32.

5. *Idem*, p. 342, No. 31.L.C.2.

6. Letter from Jennifer Montagu, June 5, 1996.

7. Montagu, 1985, p. 346, No. 36.

GIAN LORENZO BERNINI

1598–1680

The quintessential maestro of baroque Rome was born in Naples, but the family soon moved to Rome, where Bernini remained except for a five-month visit to France late in life. A child prodigy, trained by his sculptor father, and a worker of immense energy and creativity, Bernini dominated artistic activity in Rome during his long career as architect, sculptor, painter, writer, and designer of theatrical productions. His talent, charm, wit, and diplomatic skills won him a series of important patrons, including three popes, Louis XIV of France, and Cardinal Scipione Borghese, for whom he made some of his best-known works. His architecture and sculpture changed the face of Rome, including the colonnades he built for St. Peter's, his baldacchino, throne, tombs, and statues within the basilica, the fountains in the Piazza Navona and Piazza di Spagna, his churches and church chapels, his marble portrait busts and figure groups. Bernini's large shop at times consisted of up to three dozen sculptors (including foreign artists who helped disseminate his style), enabling him to pursue several complex commissions simultaneously. Marble was Bernini's preferred medium for sculpture, but in his chapels and such works as the throne in St. Peter's, which combine with dramatic effect many media, including natural light sources, he created unprecedented visual and spiritual sensations that are his most original contributions.

HEAD OF AN ANGEL (96.2.104)

Terracotta, coated with dark brown paint flaked with copper (see *Condition*): H. 9¼ in. (23.5 cm); W. 8½ in. (21.6 cm).

DESCRIPTION: Above the sloping shoulders, the angel's head turns slightly to the viewer's right, the thick locks and curls of hair seemingly tossed by that movement over the left shoulder. The face tilts slightly downward, the lowered lids directing the gaze to something below the head and to the right. The full lips, curving in a faint smile, are cushioned between plump cheeks. The hair parts over the brow in two swinging waves and falls behind in cascades of curls. At the sides the bust terminates just beneath the shoulders in a line that dips lower toward the middle over the chest. In back, the terracotta, hollowed out beneath the shoulders, is supported on a roughly modeled central trunk of clay.

CONDITION: There are losses to the terracotta, notably in part of the curl above the right eye and in the highpoint of the right cheek. The

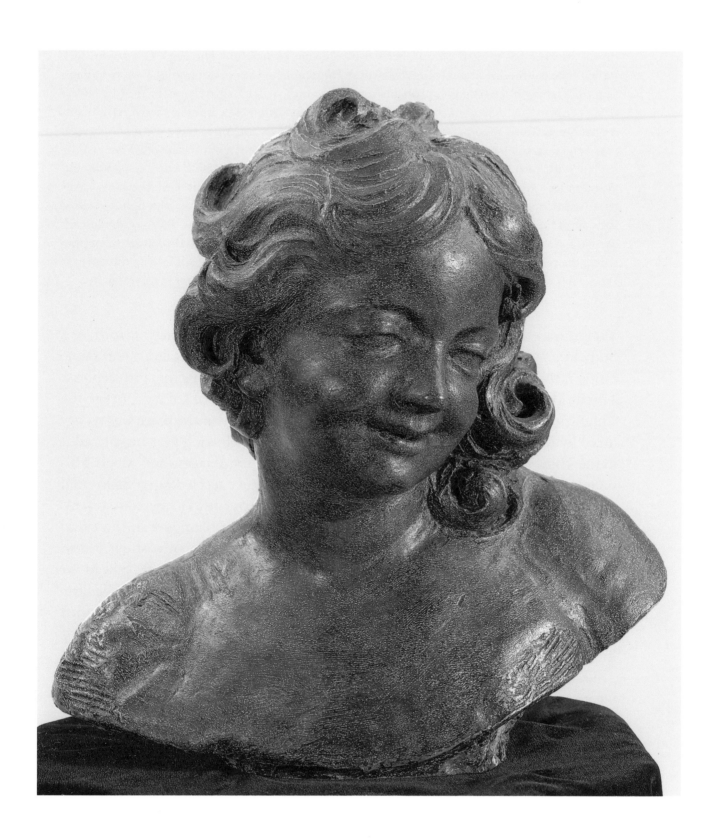

tip of the nose has broken off and been reattached. The entire surface was formerly covered by a thick, shiny black oil paint, probably nineteenth-century in date, which obscured the modeling. Beneath this overpaint were found two other layers of paint that are contemporary in date with each other: a ground layer composed of lead white, and over it a dark brown paint with copper flakes. These two layers are seen on all the surfaces save for the underside at the back and at the bottom, beneath the base, where the terracotta was left in its raw state. In 1994, after consultation with Eugene Thaw, the current owner, and The Frick Collection, Jack Soultanian, Conservator at the Metropolitan Museum of Art, began removing the black overpaint from the surface, but he preserved the paint layers beneath it, since these were of historical importance (see below).[1] The few losses to the modeling were filled with salt-free plaster, and losses to the brown paint with its copper flakes were inpainted to simulate the light-reflective qualities of the copper. Thermoluminescent tests made in 1988 produced a date between 1627 and 1840, with the probability that the clay was fired earlier rather than later in this range.[2]

THE terracotta bust of an angel emerged from centuries of obscurity in 1961, at a Sotheby's sale in London.[3] The sculpture was catalogued for the sale as: "An interesting terracotta Bozzetto of an angel's head after Bernini. ... Rome, 17th century. This head closely resembles that of Bernini's angel lifting Habakkuk by a lock in the Chigi Chapel, S. Maria del Popolo, Rome. ..." The quality of the piece was recognized by Ronald A. Lee, who bought it for £100. The following year Lee placed it in the Third International Art Treasures Exhibition at the Victoria and Albert Museum, where it was described as: "A Seventeenth-century terracotta modello head of a girl, by Giovanni Lorenzo Bernini (1598–1680). Terracotta lacquered to resemble bronze. The model is associated with the finished marble figure in the Chigi Chapel, Rome. ..."[4] J. M. Trusted, to whom Lee sold the terracotta, showed it to Rudolf Wittkower, who in a letter of 1965 wrote to Trusted that it was a head for the Habakkuk marble and that the bronze coating signified that there "can be little doubt" the piece came from the Chigi palace in Rome.[5] Wittkower then included the sculpture in the 1966 edition of his monograph on Bernini, describing it as "a hitherto unpublished beautiful bozzetto for the angel of the Habakkuk group. ..."[6]

Bernini made the marble group of *Habakkuk and the Angel* for one of two vacant niches in the Chigi chapel in S. Maria del Popolo, Rome. The two other niches had been furnished with statues by Raphael and his assistants, but only in 1652, when Cardinal Fabio Chigi began to take an interest in the family mausoleum, did work resume on the chapel. In 1655, upon his election to the papacy as Alexander VII, he began major redecoration, not only of the chapel but also of the church, with

Bernini in charge and Don Flavio Chigi, the pope's nephew, supervising. The first niche statue Bernini began was the figure of *Daniel*, finished in 1657. Though the *Habakkuk* was not installed in the chapel until 1661, the project must have been well underway before August 9, 1656, when Alexander noted in his diary that Don Flavio went "dal Bernino a veder il Daniel, a dimandar dell'Abacuc."[7]

Drawings by Bernini for the *Daniel* survive, but none for the *Habakkuk* is known. A terracotta modello for each of Bernini's niche statues was presented—along with other clay sketches—by the Italian State to the Vatican in 1923, as a part of the great Chigi family library where the sculptures had previously been displayed.[8] Wittkower, as noted above, was convinced that the angel head had also belonged to the Chigi, a not unreasonable conclusion since it was related to a Chigi commission and had a surface—a thin dark-brown layer simulating bronze covered at a much more recent date with heavy black paint (see *Condition*)—which resembled the coating on the Chigi terracottas given to the Vatican.[9] As Raggio has reported, Don Flavio Chigi (1631–93), named cardinal in 1657, was a voracious collector, of terracottas among other works.[10] Inventories exist of his collection, which, after the sale of his Casino alle Quattro Fontane, merged with the family holdings in the palace at the Piazza Colonna. The terracottas in the Vatican can all be identified in one or another of the many Chigi inventories now in the Biblioteca Apostolica, which date from the seventeenth to the twentieth century. However, no inventories examined by the present writer include any item that might refer to a terracotta head.[11] There appears to be no evidence that it ever belonged to the Chigi.

Bernini made terracotta studies as a way to sketch out ideas—"drawings" in three dimensions—or in order to guide assistants, or, in a more completed form, to show a patron what he proposed to make. Though he must have produced thousands of them, only about forty survive, not only because they were fragile but also because they were seen as a means to an end and valued less than sculpture made of such precious materials as bronze or marble. Rough bozzetti probably were prized chiefly by other sculptors, who preserved them for study.[12] Highly finished pieces and presentation modelli were considered more desirable for display and often were coated to simulate bronze, silver, gold, or porphyry. Bernini himself had in his house a terracotta head of Goliath tinted "color di bronzo."[13] The simulated bronze surface of the angel's head, though it resembles that of the Vatican terracottas, does not, therefore, offer any indication of its provenance.

The angel is executed with great freshness and dash, conveying a strong sense of the act of creation, the pinching and pushing of thumbs and fingers, the scoring from various rasps and claw chisels. It is more finished than the usual clay sketch by Bernini, but not as polished or refined as the typical presentation modello. The terracotta is very close to the marble in all respects. The sweep and pattern of the locks of hair are nearly identical, though there are differences in details of the individual locks, and they blow away from the left shoulder in freer waves in the marble than in the terracotta. The hair of the marble is far more roughly carved on top and at the back. The face of the marble angel seems to twist slightly inward toward Habakkuk, the nose is more curvaceous, and the lips part more distinctly. None of these differences provides conclusive evidence of the relation between the two—whether the terracotta is a preparatory study or was made for some other purpose.

In one essential, the terracotta differs from other bozzetti or modelli made in preparation for a larger sculpture. Because the clay was cleanly sliced off below, as for a portrait bust, and because it is supported on a flat-bottomed base, the head appears to have been designed as an independent piece. Other surviving terracotta heads by Bernini are clearly fragments of bigger projects and were never intended for display as discrete works of sculpture.[14]

The angel head does not then appear to fall into any of the familiar categories of Bernini terracottas. It seems more like a ricordo made for someone who particularly admired the angel's beatific face, or a modello for a small reproduction of the head. A market for small busts had already been established by such sculptors as Hendrick de Keyser (1565–1621) and François Duquesnoy (1597–1643). Small bronzes seldom were produced by Bernini's shop, but many copies of his sculptures were made by others.[15] Though no direct copy of the terracotta angel head has yet been found, the terracotta itself or some now-lost replica of it must have been known and greatly admired, for a seemingly endless stream of busts, of approximately the same size, based on a model derived from it can be cited. They appear chiefly in bronze but also in terracotta, marble, ceramic, and plaster, and they turn up all over the globe, under a bewildering miscellany of dates and attributions, but usually as anonymous. In this series of similar heads, Bernini's energy and subtlety are lost. The face turns upward rather than down, the tender smile spreads into a broad grin, and the thick, springy curls of hair lose their richness and vigor. The eyeballs, unlike those of Bernini's marble and terracotta, are inscribed with iris and pupil. Often the smiling child is paired with a grieving companion.[16]

Unquestionably, Bernini's angel head found a broad appeal and led to diverse replicas and imitations. A marble version, based not on the terracotta but evidently derived from the Chigi marble, was once on the London art market,[17] and a 1733 inventory of a Sienese sculptor's studio recorded not one but two copies of the head ("Due teste di gesso replicate, che sono la testa del Angelo del Abaccucco, fatto in marmo dal Bernino nella Madonna de Popolo in Roma").[18] Other inventories referring to an angel head by Bernini are not specific enough to identify.[19]

Comparison of all the known derivations from The Frick Collection's terracotta model of the angel head only serve to bring out its exceptional quality, which the mystery of its purpose does nothing to alter. Perhaps some answers will come from a major study of terracottas by Bernini and his contemporaries launched in 1997 by the Harvard University Art Museums. Its goal is to investigate the medium and working methods of these artists through technical analyses of the clay and examination of such physical evidence as tool marks and fingerprints. The Frick Collection, like many other museums, has cooperated with the team conducting the project. Eventually, more information about the angel head should emerge from this investigation.

<div style="text-align: right">B. F. D.</div>

EXHIBITED: London, Victoria and Albert Museum, Third International Art Treasures Exhibition, 1962, No. 432, lent by Ronald A. Lee.
COLLECTIONS: F. de Luc. Sold by him, Sotheby's, London, August 3, 1961, Lot 143, bought by Ronald A. Lee for £100. J. M. Trusted, Hoewyck Farm, Fernhurst, Sussex. John Gaines, Lexington, Kentucky. Peter Jay Sharp, New York. His sale, Sotheby's, New York, January 13, 1994, Lot 56. Eugene Victor Thaw, New York. Frick, 1996, gift of Mr. and Mrs. Eugene Victor Thaw.

NOTES

1. These notes on condition are based on the more comprehensive report of his conservation work submitted by Jack Soultanian in March 1997.

2. Analysis conducted and reported by V. J. Bortolot, Daybreak Nuclear and Medical Systems, Inc., dated November 17, 1988. The date range cited by Sotheby's in the Peter Jay Sharp sale catalogue (see *Collections*) was based on an erroneous reading of the same report.

3. See *Collections*.

4. Third International Art Treasures Exhibition, Victoria and Albert Museum, London, March 2–April 29, 1962, p. 55, No. 432.

5. Letter dated November 9, 1965, Wittkower papers, Rare Book Collection, Columbia University, New York.

6. R. Wittkower, *Gian Lorenzo Bernini*, London, 1966, p. 234. The attribution is endorsed by Anthony Radcliffe and Olga Raggio; Jennifer Montagu, judging from photographs, considers the attribution to be "plausible" (oral communication, April 28, 1997).

7. R. Krautheimer and R. B. S. Jones, "The Diary of Alexander VII," *Römisches Jahrbuch für Kunstgeschichte*, XV, 1975, p. 203; G. Morello, "Bernini e i lavori a S. Pietro nel 'diario' di Alessandro VII," *Bernini in Vaticano*, Rome, 1981, p. 322. For the iconography of the subject and of the chapel in general, see: Wittkower, 1966, p. 9; W. Messerer, "Zu Berninis Daniel und Habakuk," *Römische Quartalschrift*, LVIII, 1962, pp. 292–96; and M. Hesse, "Berninis Umgestaltung der Chigi-Kapelle an S. Maria del Popolo in Rom," *Pantheon*, XLI, 1983, pp. 109 ff.

8. A set of photographs of interiors of the Chigi palace on the Piazza Colonna, undated but probably early twentieth-century, is in the Biblioteca Apostolica Vaticano (Archivio Chigi 25175). The terracottas may be seen crammed on a circular stand in the library. Not all are visible, but Habakkuk and a few others can be identified. Doubtless, therefore, these sculptures came to the Vatican simply because they were considered a part of the library when it was given to the Biblioteca Apostolica. The views of other rooms in the palace show some sculpture but none of the terracottas.

9. For the condition of the Vatican terracottas, see: *Bernini in Vaticano*, pp. 108–09, 126–28; and M. T. De Lotto, "Mostra restauri in Vaticano," *Bollettino, Monumenti Musei e Gallerie Pontificie*, IV, 1983, pp. 277 ff.

10. O. Raggio, "Bernini and the Collection of Cardinal Flavio Chigi," *Apollo*, CXVII, 1983, pp. 368 ff. See also the exhibition catalogues: *Bernini in Vaticano*, pp. 126–28; *The Vatican Collections*, New York, 1983, pp. 89–90; and *Vatican Splendour*, Ottawa, 1986, pp. 21–22.

11. The author is greatly indebted to Dr. Giovanni Morello and Dr. Luigi Fiorani for generous assistance in navigating the Chigi archives.

12. Ercole Ferrata had an important collection, which included many terracottas (V. Golzio, "Lo 'Studio' di Ercole Ferrata," *Archivi*, II, 1935, pp. 64 ff.). Even so minor a sculptor as Francesco Antonio Fontana had bozzetti by Bernini and Algardi (E. Bianca Di Gioia, "Casa e bottega del Cav. Francesco Antonio Fontana: materiali dallo studio di uno scultore romano della seconda metà del '600," in *Archeologia nel centro storico*, Rome, 1986, pp. 151 ff.).

13. *Gian Lorenzo Bernini: Il testamento, la casa, la raccolta dei beni*, ed. F. Borsi, C. A. Luchinat, and F. Quinterio, Florence, 1981, p. 107.

14. A terracotta female head, evidently similarly finished off at the base as an independent bust, was published by A. E. Brinkmann (*Barock-Bozzetti*, II, Frankfurt, 1924, p. 48, pl. 24) as a study for Bernini's *Veritas*. Wittkower (1966, p. 235) associated it instead with the figure of St. Barbara in the cathedral of Rieti, though it is unclear whether he had actually examined the head, which in Brinkmann's day was in a Roman private collection and appears not to have been seen since by Bernini scholars. Its quality is difficult to judge from the Brinkmann illustration.

15. See J. Montagu, "Two Small Bronzes from the Studio of Bernini," *Burlington Magazine*, CIX, 1967, pp. 566 ff.

16. M. Baker ("The Production and Viewing

of Bronze Sculpture in Eighteenth-Century England," *Antologia di Belle Arti: La Scultura*, 1996, p. 151) has suggested that many of these pieces appear to be English, and he has very tentatively proposed Louis-François Roubiliac (*c.* 1705–62) as their author. In his review of Nicholas Penny's catalogue of sculpture in the Ashmolean Museum (*Burlington Magazine*, CXXXVI, 1994, p. 851), Baker listed several versions of the laughing child in diverse media. Others have appeared on the art market (Sotheby's, New York, January 9–10, 1990, Lot 102; Sir Michael Sobell sale, Christie's, London, June 23, 1994, Lot 156) and in private collections. The catalogue entry on a bronze version in Frankfurt (B. von Götz-Mohr, *Nachantike Kleinplastische Bildwerke*, II, 1988, p. 207, No. 82) points out a connection with Roubiliac and with the Bernini terracotta.

17. In 1968 Cyril Humphris sent photographs of this head to Rudolf Wittkower (Wittkower papers, Department of Art and Archaeology, Columbia University). Wittkower replied that he knew of two other marble heads related to the angel and that he believed Humphris' version to be the work of some Bernini collaborator.

18. M. Butzek, "Die Modellsammlung der Mazzuoli in Siena," *Pantheon*, XLVI, 1988, p. 88. The present author is much indebted to Dean Walker for this reference and that in note 19.

19. See, for example, the inventory of a French sculptor active in Rome, Pierre-Étienne Monnot (1657–1733), who owned "Due testine di creta cotta bozzate dal Bernini uno rapp.ᵃ Longino e l'altro un Angelo" (P. Fusco, "Pierre-Etienne Monot's Inventory after Death," *Antologia di Belle Arti*, XXXIV/V, 1988, p. 75).

ANTOINE COYSEVOX

1640–1720

Born at Lyon, Coysevox studied in Paris under Louis Lerambert and by the age of twenty-six had attained the rank of Sculpteur du Roi. *After serving four years with the Bishop of Strasbourg and another four in Paris, he returned to Lyon, but from 1677 onward he worked chiefly in and around the capital, notably at Versailles, Marly, and Saint-Cloud. He produced many portraits of his contemporaries, including several celebrated representations of Louis XIV. Coysevox' bronze bust of Robert de Cotte, Louis' chief architect, is in The Frick Collection, as is a bust of Maréchal Turenne attributed to him.*

LOUIS XV AS A CHILD OF SIX (90.2.98)

Signed and dated, on the back of the base: A. / COYZEVOX F. / 1716. Marble: H. 23⅛ in. (59 cm).

DESCRIPTION: The young King looks to his right, his eyes alert, his lips parted as though about to speak. He wears a flowing wig with curls that fall over both shoulders, an elaborately decorated tunic with the top three buttons undone, and a soft stock tied around the neck. The bust terminates in the swelling folds of a fringed cloak that falls over the left shoulder and billows out from a bow at the right. The back of the bust forms a concave shell whose surface has been uniformly chiseled.

CONDITION: The tip of the nose has been repaired and overpainted. There are two small chips in the lower right area of the hair on the back and small pitted losses above and below the right eyebrow. The drapery, where it billows out from the bow on the side, has been repaired. The cross of the Order of the Saint-Esprit has been removed from over the left breast (see below). The pedestal has been restored and overpainted.

LOUIS XV (1710–74) succeeded his great-grandfather, Louis XIV (1638–1715), as King of France in 1715, at the age of five. The child had become next in line for the throne when his father, Louis, Duc de Bourgogne, died in 1712; the Duke, in turn,

460

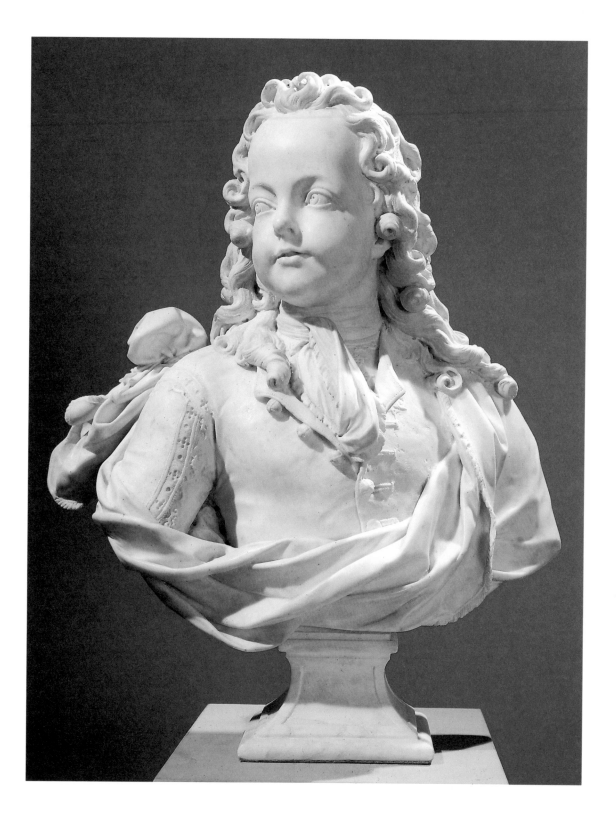

had survived his father, Louis, the Grand Dauphin (1661–1711), by only one year. To celebrate the new monarch, numerous childhood portraits of Louis XV were produced; between 1715 and 1717 Rigaud painted a full-length portrait of the young King on the throne,[1] and countless other paintings, engravings, and medals of Louis exist from this time.[2] Saint-Simon, whose *Mémoires* record life under Louis XIV and Louis XV, described the eight-year-old King during an official ceremony in the Tuileries as: "sérieux, majestueux, et en même temps le plus joli qu'il fût possible, grave avec grâce dans tout son maintien, l'air attentif et point du tout ennuyé, représentant très bien et sans aucun embarras."[3] The Frick bust reinforces this vision of the young Louis, demonstrating how Coysevox was able successfully to capture the charm of childhood combined with the grandeur suitable to a King.

According to an anonymous contemporary biography of Coysevox in the *Mémoires inédits … des membres de l'Académie royale* first published in 1854,[4] the sculptor executed four busts of Louis XV between the death of Louis XIV in 1715 and 1718, the date of the memoir. The four busts then belonged to the King; to the Regent, the Duc d'Orléans; to the King's governess, Madame de Ventadour; and to the *avocat-général du grand conseil*, Dupuy.[5] The Frick bust is considered the earliest of the group, and probably corresponds to that "portrait du Roy" which in September of 1716 Coysevox asked the Académie Royale to register in order to prevent molded copies of it from being sold, a process prohibited by a decree of the Council in June of 1676.[6]

Nine other known versions of this portrait, including a late nineteenth-century imitation, are as follows:

1. Marble bust in a private collection, inscribed A. COYSEVOX F. This undated bust, probably executed in 1716, was acquired by Madame de Cormis from the antiquarian Kraemer[7] and in 1920 entered the collection of Wildenstein, who in turn sold it to the Baron Maurice de Rothschild in 1931.

2. Marble bust in a private collection, inscribed A. COYSEVAUX 1717.[8] Acquired by Madame Burat in 1931, this bust appeared in a sale catalogue of items from her collection in 1937.[9] The King is shown wearing the star and ribbon of the Order of the Saint-Esprit.

3. Marble bust of about 1718 in the Musée de Versailles, not inscribed. This version, which was at Fontainebleau during the Restoration,[10] shows the sitter with the emblem of the Order of the Saint-Esprit.

4. Terracotta bust in a private collection, with the worn inscription CO...OX. This smaller bust probably attests to an early stage of Coysevox' creative process; it is likely that it was a preliminary model that preceded the more fully rendered terracotta bust in the Musée du Louvre (see below).[11]

5. Terracotta bust in the Musée du Louvre, inscribed COYSEVOX 1719. This piece was acquired by the Louvre from a private collection in 1982. Analyses of the bust, done at the Laboratoire de Recherche des Musées de France, reveal that it served as a model, most probably for the marble bust at Versailles.[12]

6. Terracotta bust, signed and dated 1719. This piece appears in the 1987 sale catalogue of Étienne Libert and Alain Castor, Paris.[13]

7. Wax bust in a private collection, formerly at Azay-le-Rideau, inscribed in a manner similar to the Louvre bust.[14] Souchal suggests that this version was the maquette of the marble bust at Versailles.[15]

8. Stone bust mentioned only by Souchal, who suggests that it may be identical with a bust in the museum at Valenciennes.[16]

9. Bust in the Nasjonalgalleriet, Oslo, inscribed COYSEVOX 1779 [*sic*]. This bust was executed by an able imitator who adapted it to suit the dominant taste of the late nineteenth century by heightening the agitation in the King's expression.[17]

A comparison of the surviving busts of the young King reveals how Coysevox retained the same pose throughout, making only minor adjustments to the costume and features to record the passage of time. The above-mentioned analyses of the terracotta Louvre bust have provided insight into how Coysevox worked, revealing that he sculpted busts in terracotta before executing the final marble versions. Artists were rarely granted the favor of a royal sitting, and not only did Coysevox have to work from his early busts, but these also served as model for some of the later medals of Louis XV done by Jean Le Blanc and Jean Duvivier.[18]

The signed but undated marble in a private collection is assigned to 1716 by both Souchal and Keller-Dorian.[19] However, the King's slightly younger appearance and the less elaborate frogging on his coat in the dated Frick version, and the fact that the signature on the Frick bust is not perfectly centered (suggesting a miscalculation not uncommon in a first version), make it probable that the present bust, rather than the undated one, is indeed the original registered by the artist with the

Académie Royale. The present bust is further distinguished from the other examples by the elaborate flow of drapery caught up in a ribbon at the right shoulder, a feature that is less exaggerated in the undated version, has broken off of the 1717 bust formerly in the collection of Madame Burat,[20] and is missing in the other versions.

The cross and ribbon of the Order of the Saint-Esprit apparent on a number of the surviving busts of the young monarch once decorated the left side of the King's tunic in the Frick bust as well, but was effaced, probably during the Revolution, in order to mask the identity of the bust at a time when royal images were subject to destruction. Though Louis was not formally invested with the order until his coronation in 1722, he wore the emblem by courtesy from the day of his birth.[21]

S. S.

EXHIBITED: London, Heim Gallery, French Paintings and Sculptures of the 17th and 18th Century, 1979. New York, Stair Sainty Matthiesen, An Aspect of Collecting Taste, 1986.

COLLECTIONS: Royal house of Bourbon-Naples, traditionally said to have been a gift of the Duc de Berry (1778–1820). Francesco I, King of the Two Sicilies (1777–1830). Luigi, Prince of Bourbon-Sicily, Conte d'Aquila (1823–97). His granddaughter, Mrs. Freeman (née Bourbon-Sicily). Marquise de Préaulx (née Sophie Freeman). By inheritance, private collection, Rio de Janeiro. Heim Gallery, London, 1979. Stair Sainty Matthiesen, New York, 1986. Dr. and Mrs. Ira H. Kaufman, New York. Frick, 1990, gift of Dr. and Mrs. Ira Kaufman.

NOTES

1. C. Maumené and L. d'Harcourt, *Iconographie des Rois de France*, Paris, 1931, II, pp. 295–97, pl. XX.

2. *Idem,* pp. 294–307. For a discussion of medals depicting Louis XV, see *Louis XV, un moment de perfection de l'Art français,* Hôtel de la Monnaie, Paris, 1974, pp. 524–27.

3. Quoted in M. Antoine, *Louis XV*, Paris, 1989, p. 21.

4. *Mémoires inédits sur la vie et les ouvrages des membres de l'Académie royale de peinture et de sculpture*, ed. L. Dussieux *et al.*, Paris, 1854, II, p. 38.

5. *Idem.*

6. *Procès-Verbaux de l'Académie Royale*, Paris, 1881, IV, p. 231.

7. Maumené and d'Harcourt, p. 300, No. 21a. This version is also discussed by: F. Souchal, *French Sculptors of the 17th and 18th centuries: The reign of Louis XIV*, I, Paris, 1981, p. 218, No. 99a, fig. 99a; G. Bresc-Bautier, "Louis XV, à l'âge de 9 ans," in *Musée du Louvre: Nouvelles acquisitions du Département des Sculptures (1980–1983)*, Paris, 1984, p. 57; and G. Keller-Dorian, *Antoine Coysevox (1640–1720)*, II, Paris, 1920, p. 77, No. 95.

8. Souchal (*loc. cit.*) questions this signature. Keller-Dorian (II, p. 78, No. 95*bis*) records the inscription as "COYSEAUX 1717." This version is further discussed by Bresc-Bautier (*loc. cit.*) and Maumené and d'Harcourt (p. 301, No. 22b, pl. XXI).

9. Her sale, June 17–18, 1937, Galerie Charpentier, Paris.

10. See Bresc-Bautier, *loc. cit.* Souchal dates this portrait to 1719 (I, p. 219, No. 103a), while Maumené and d'Harcourt indicate "vers 1718" (p. 301, No. 23c). This version is illustrated in Keller-Dorian (II, p. 79, pl. 146).

11. See Bresc-Bautier, pp. 56–58.

12. *Idem*, p. 57.

13. Their sale, July 1, 1987, Hôtel Drouot, Paris.

14. Bresc-Bautier (p. 58) describes the wax bust as "analogue à notre terre cuite, signé et daté 1719."

15. Souchal, I, p. 218. Souchal does not include in his study the Louvre terracotta which Bresc-Bautier suggests was the model for the Versailles bust. For an illustration of the wax bust, see *Connaissance des Arts*, No. 59, 1957, p. 11.

16. Souchal, I, p. 218, No. 99b.

17. Bresc-Bautier, p. 58.

18. *Louis XV, un moment de perfection*, pp. 524–27.

19. Souchal, I, pp. 218–19, No. 99a, fig. 99a; Keller-Dorian, II, p. 77, No. 95.

20. Keller-Dorian, II, p. 78.

21. Antoine, *loc. cit.*

DECORATIVE ART

TUSCAN *or* UMBRIAN
Last Third of the Sixteenth Century

SMALL CREDENZA with Terms in Relief (55.5.112)

Carved walnut, with interior and back of poplar and pine; mounts of cast yellow-metal and wrought iron. H. 39¾ in. (101 cm); W. 35¼ in. (89.5 cm); D. 15½ in. (39.4 cm).

MARKS & INSCRIPTIONS: Stamped twice on the back of the cupboard and once on the bottom of the drawer: *27786*, probably a Duveen stock number. Inscribed under the drawer in pencil and orange wax crayon: *42270/28*, probably a stock number of French & Company.

CONSTRUCTION: The rectangular cabinet consists of a slightly recessed central cupboard enclosed by two doors; a wider, deeper supporting structure; and a wider, deeper drawer-case under a cornice. The projecting top is made up of three boards running laterally, the sides are fitted with recessed vertical panels, and the back consists of four tenoned boards running horizontally. Each door is a single board with decorative moldings attached to give the appearance of mitered and tenoned paneling. The cabinet rests on affixed carved front feet and bracket-shaped back feet.

CARVED ORNAMENT: The front feet are treated as lions' paws with fur above. At the base of the cabinet proper is a convex molding carved with truncated heavy flutes that curve outward from the center on the front and curve forward from the rear at the sides; surmounting these is a recessed band of stopped flutes. Applied to the front stiles are a male term at left and a female term at right, each dressed only in a palmette apron above a fluted shaft framed by drapery; below the shaft is a plain horizontal molding over a tall volute with rosettes and drapery. The doors are carved with an outer band of laurel leaves. The entablature has a stepped architrave molding, a convex drawer-frieze with deeply carved rustication, and a projecting cornice comprising a row of dentils, two stepped moldings, and a row of truncated tongues. A plain convex molding relieves the three exposed edges of the top.

MOUNTS: The cabinet is mounted on the doors with two cast yellow-metal disk knobs and on the drawer with two cast yellow-metal oval ring handles with a profiled grip and a round backplate. The doors are hinged with bent nails to the corner stile panels. The right-hand door is mounted with a single-throw, spring-loaded iron lock, and the left-hand door has an iron ring at the back that engages with a hook mounted under the single shelf inside.

CONDITION: The piece shows extensive repairs carefully executed. Parts of the top and of the rusticated frieze have been replaced, the fluted base has undergone extensive renewal, and the entire dentiled molding appears to be later. The lower molding of each door frame

and the upper molding of the left-hand door are replacements, and the term-supporting volutes and narrow draperies under the palmette aprons are of later date. The feet are partly renewed and strengthened. There is old insect damage throughout.

THE frequent occurrence of similar credenze (sideboards) in Italian inventories of the fifteenth century, as well as their depiction in contemporary paintings of domestic interiors, documents that the form with two doors was fully developed by that time.[1] The type derived from simple trestle tables that were set against a wall and often supported a stepped superstructure; such temporary arrangements were covered with sumptuous textiles to form an appropriate backdrop for the ostentatious display of choice objects and fine plate. As Thornton has noted, in the *sala*, a formal room where one dined, a "family's most precious vessels were placed on show … on important occasions."[2] In keeping with this prestigious function, the sideboard, like the cassone (chest), soon became highly fashionable and a suitable vehicle for the art of elaborate carving and supreme craftsmanship. In the course of the sixteenth century, the powerful and wealthy sought greater privacy and would retreat into a smaller dining parlor, using the large hall only on formal occasions. Now a more compact sideboard was needed, one that would not occupy much space but still conjure up the elegance of its antecedents. With the spread of mannerism, its decor became richer, often with strongly three-dimensional sculptural ornamentation, as modestly reflected in the present example.[3]

It is important to note that similar small sideboards (also called *armaretti*, or small cupboards) were sometimes placed in bedchambers. A decorative linen cover transformed them into dressing-tables holding toilet utensils and the obligatory ewer and basin for performing morning ablutions. In the households of the old aristocracy and the new moneyed nobility, such items were often made of precious metal and were regarded as part of the owner's treasury.[4] Like the chest, this lockable two-door cabinet could be used to store valuables securely. Placed not far from the bed, it was immediately accessible for removal of its contents in case of fire, always a potential hazard in those days.[5]

The expressionistic, boldly-carved rustication of the drawer on the present example is unusual. Renaissance architectural theory traditionally located such a motif at the base; in a building, the surface of each story would gradually receive a lighter appearance advancing toward the crowning cornice in the antique style. Here, the designer applied the rustication self-consciously and probably deliber-

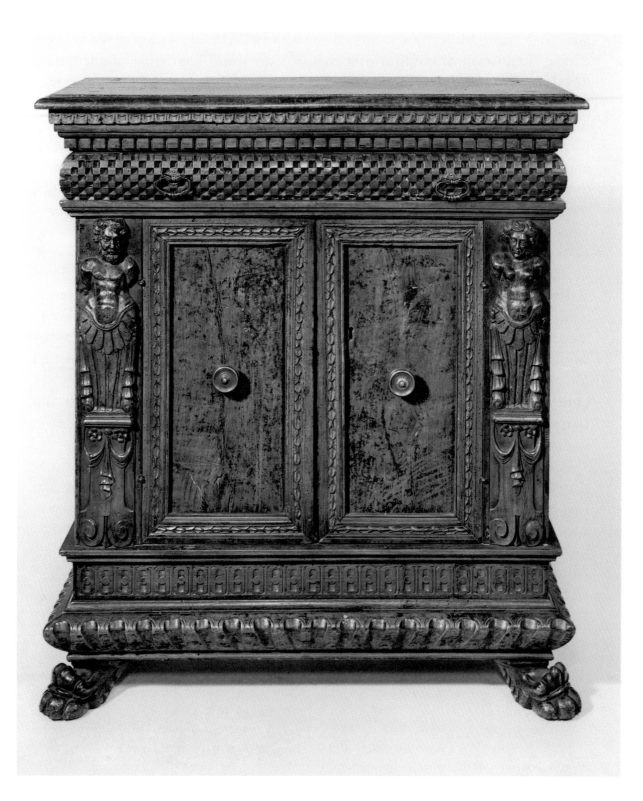

ately to the prominent frieze section. The motif could be an allusion to the heraldic checky, a variation of the field of a coat-of-arms shield consisting of alternating metal (or fur) and tincture. Even on a piece of furniture, learned contemporaries would not have overlooked such a symbolic detail. Often incorporated into an overall interior design of heraldic decoration, similar motifs could be found on fireplace frames, overdoors, and wall paneling. *In situ*, they formed an inseparable part of the whole, an undertaking in the service of the patron's aristocratic splendor.[6] Detached from such a context, the Frick credenza can no longer be identified with a specific patron, as the heraldic checky was relatively widespread in Renaissance Italy.[7]

This small credenza represents a form that was typical and fairly common in nearly all of Upper and Central Italy in the sixteenth century. The grotesque figural decoration combined with the more austere sarcophagus-shaped base and severe antique cornice suggest an origin in Tuscany or Umbria and a probable dating in the last third of the sixteenth century. The compact rendering of the human bodies seems to evoke the influence of architectural figure inventions by Agostino Veneziano (*c.* 1490–*c.* 1540). His printed designs were widespread and easily obtainable, and offered a wealth of possibilities for local craftsmen to borrow and adapt elements to their own requirements.[8] The Frick piece can be compared with various credenze of similar quality.[9]

The carefully executed restoration of the Frick credenza suggests that heavily damaged parts were replaced by closely matching the corresponding sixteenth-century model. It can be assumed that the sideboard as it appears today is very near in appearance to the original piece.

W. K.

COLLECTIONS: Duveen (?). French & Company, New York (?). Frick, 1955.

NOTES

1. P. Thornton, *The Italian Renaissance Interior 1400–1600*, New York, 1991, pp. 205–29, figs. 220, 243, 248.

2. *Idem*, p. 207.

3. The present piece was mentioned (but not reproduced) by W. Koeppe in his review of vols. V and VI of *The Frick Collection: An Illustrated Catalogue* in *Studies in the Decorative Arts*, Fall 1994, p. 116.

4. Compare a drawing by Jacopo Ligozzi showing a credenza serving as a dressing table (Thornton, fig. 249).

5. For the bedroom see W. Koeppe, "The Chest in the Italian and Central European Bedchamber from the 15th to the 17th century," in *The Bedroom from the Renaissance to Art Deco*, ed. M. Chilton (lectures of the Decorative Arts Institute held at the Royal Ontario Museum, Toronto, in 1993), Toronto, 1995, pp. 13–24.

6. For example the famous Strozzi *sgabello* (see W. Koeppe, "French and Italian Renaissance furniture in the Metropolitan Museum," *Apollo*, June 1994, p. 29, figs. 7–9).

7. It was employed, for example, on the coat-of-arms of the poet Jacopo Sannazaro (see J. Pope-Hennessy, *Italian High Renaissance and Baroque Sculpture*, 2nd ed., London–New York, 1970, text vol., fig. 63). For an example on majolica, see J. Rasmussen, *Italian Majolica: The Robert Lehman Collection*, x, New York–Princeton, 1989, No. 121.

8. Bartsch, xiv, 230.

9. Compare: F. Schottmüller, *Wohnungskultur und Möbel der italienischen Renaissance*, Stuttgart, 1921, figs. 210–12, 214, 219–20; E. Baccheschi, *Mobili italiani del rinascimento*, Milan, 1964, pp. 97–98; sale catalogue, Christie's, London, October 1, 1998, Lots 278, 282.

FLEMISH (BRUSSELS?)

c. 1580–1620

TAPESTRY Showing Deer Hunt with Archer (35.10.13)

Woven in weft-faced tapestry technique with wefts of dyed wool and silk on warps of undyed wool, 95 × 74 in. (241.3 × 187.9 cm).

DESCRIPTION: To the sound of ringing horns, spear-bearing hunters run through woodland in search of game, though the only animals visible are a rabbit crouching in the underbrush of the foreground and a doe pursued by a pair of hounds in the middle ground. Undisturbed by this commotion is an archer who stands at right, drawing an arrow as he sights an unseen target. He is dressed in classical attire, his cape billowing in the wind. Nestled in the woods beyond are a village with a walled monastery and a church and, at far right, part of a garden by a stream. Wooded mountain slopes rise in the distance. The tapestry is without borders.

WEAVE: The hanging is assembled from four pieces of tapestry in weft-faced weave, each section with 16 to 18 warps per in. (7 warps per cm) and 48 to 72 wefts per in. (18 to 40 wefts per cm). The warps are undyed wool, z spun, s ply (3), while the wool and silk wefts are usually z spun, s ply (2); some wool wefts are three-ply, thereby making a thicker yarn and lowering the count of wefts.

CONDITION: The tapestry is in fair condition, with the section joins secure, though visible. Two seams traverse the entire vertical length, marking the insertion or addition of the section containing the archer. At the top of this section is a square patch, the joins of which were carefully camouflaged by the matching of foliage. There are many repairs (both reweaving and darning) to the right edge, particularly to the archer's left hand and bow. The left half of the tapestry is intact, but a dark brown or black dye has degraded and destroyed the wool wefts that were used as contour lines. Two treatments were attempted to cover the warps exposed by this loss of weft: repairs made with dyed yarns, which have now faded and no longer match the original, and the application of pigment to the exposed warps in order to disguise their undyed wool. The tapestry has been cut on all four sides and bound, by machine stitching, with a blue replacement galoon. The tapestry has an interface support, through which repairs have been made, and an outer lining of crimson silk damask that has been closely stitched along all perimeters.

TAPESTRIES depicting hunt scenes were very popular across Europe, and a great many survive from the period spanning the sixteenth and early seventeenth centuries. Lush with greenery, these woven portrayals of the sport appealed both to princely patrons, who commissioned specific weavings, and to other wealthy

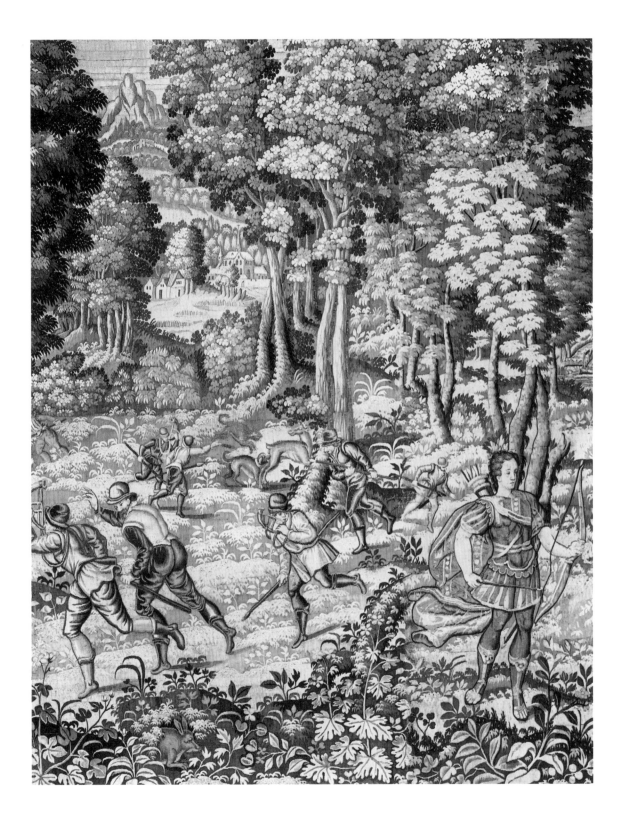

customers, who were content to purchase stock models. Flanders—especially Brussels—was a particularly active region of production.

Flemish hunt scenes of this date usually follow a common composition in which there is a broad, receding landscape. The foreground is filled with a variety of low-growing plants whose various leaf forms and trailing tendrils may hide creatures such as rabbits, weasels, or birds. The details of the plants and animals are brought into crisp focus by their large scale at the bottom edge of the tapestry. This foreground shortly gives way to the middle ground, a clearing in the woods, where the principal action takes place. Hunters spy prey and give chase, accompanied by packs of hounds. Spatial recession is conveyed by the diminishing size of the figures and by the change in color balance towards the yellows and muted greens of meadow grasses. Forests with tall trees surround the clearing and the hunting activity but offer, through their dense foliage, glimpses of villages, gardens, châteaux, waterways, and distant hills. Leafy branches of the tallest trees, rocky outcrops of faraway mountains, and blue sky occupy the uppermost stretches of the hangings. Distance and atmosphere are suggested by a predominance of blue tones, a device that parallels contemporary landscape painting.

A wide border commonly surrounded Flemish hunting tapestries of this type. Surviving borders typically consist of compartmentalized sections—vignettes of classical landscapes or harvesting scenes, strolling couples, vases of flowers or fruits—against a light ground color of cream or yellow. Figurative reserves representing the Seasons or Elements alternate with bouquets of flowers or baskets of fruit and strapwork or grotesques. Allegorical figures (Peace, Justice, Prudence, Abundance) or mythological divinities (Minerva, Juno, Diana, Apollo), often woven in larger scale, fill the corners.

Because *Deer Hunt with Archer* is pieced together, it combines the more common Flemish hunt scene with an insert from an unidentified classical tale. The left half of the tapestry is intact and shows hunters in contemporary costumes, but the large figure of the archer on the right is garbed in attire inspired by the ancient world. He wears a cuirass, a short leather skirt, open-toed boots, a flowing cape, and a sword with its hilt and scabbard point just visible. While the helmeted hunters all run with their spears ready, the classically dressed figure stands still, poised in the act of putting an arrow to his bow. His back is turned to the pursuit.

Numerous tapestries are known in which a hunting scene serves as the backdrop for a classical myth, such as the stories of Diana and Actaeon, Diana and Procris,

Diana and Callisto, or Meleager and Atalanta. The closest parallel to the archer in the Frick example is found in a bear hunt tapestry portraying the meeting of Venus and Adonis.[1] Though that figure of Adonis differs in pose, other aspects offer a compelling comparison to the classical figure seen here: the handling of the hair, the costume and its dual bands around the cuirass, the puffed and twisting sleeves, the billowing cape and its patterning, the shape of the sword hilt, and the bow and quiver. But as the figure in *Deer Hunt with Archer* stands alone, it is not possible to identify him precisely.

<div align="right">C. B. D.</div>

COLLECTIONS: Frick, 1904.[2] Gift of Miss Helen C. Frick, 1935.

NOTES

1. A borderless tapestry sold in Berlin, February 27, 1936, Lot 65; recorded in the Marillier file deposited in the Department of Textiles and Dress, Victoria and Albert Museum, London, T.37.Y–1946, p. 76.

2. The tapestry is believed to have served as a portière at Clayton, the Frick family home in Pittsburgh.

TAPESTRY Showing Bear Hunt (35.10.12)

Woven in weft-faced tapestry technique with wefts of dyed wool and silk on warps of undyed wool, 94⅛ × 73⅝ in. (239 × 187 cm).

DESCRIPTION: The tapestry portrays a bear hunt in a forest clearing. Just beyond the undergrowth that comprises the foreground, a bear raised on its haunches defends itself against a pack of hounds and three spearmen. One hound is dead, crushed beneath the bear, while another lies limply within the bear's grasp. The bear extends its left paw to swipe away the spear of an advancing hunter, but the beast is surrounded as two other spearmen approach from behind. Mounted hunters charge in from the right in pursuit of a second bear, which attempts to climb the base of a tree in order to evade additional hounds and spear-bearers on foot. A little farther into the woods, a third bear turns to face its share of the dogs. The woodland opens beyond to show vignettes of a village with a church spire, the walled grounds of a manse, and the forested slopes of a mountain. Crouching among brambles in the foreground are two reptilian creatures, perhaps lizards or toads, that hiss at each other. The tapestry is without borders.

WEAVE: The hanging is constructed in weft-faced tapestry weave, with 16 to 18 warps per in. (6 to 7 warps per cm) and 60 to 92 wefts per in. (28 to 40 wefts per cm). The warps are undyed wool, z spun, s ply (3), while both the wool and silk wefts are z spun, s ply (2), though sometimes the green wool weft consists of a single yarn. Occasionally there is plying of two silk yarns of different colors into one weft.

CONDITION: Comparison of the reverse of the hanging with the face reveals significant color loss overall and fading of the yellow tones, so that the color balance has shifted toward blue. The pink tones have also been affected and are nearly gone altogether. The tapestry is in poor condition, with loss of both silk and wool wefts, leaving the undyed warps exposed in numerous places. Wool wefts dyed dark brown or black have especially degraded. The yellow-colored leaves woven of silk, now brittle, have also deteriorated. The *Bear Hunt* has been extensively repaired and patched over time. The largest patch, about 20 in. long, was taken from another hanging and inserted in the left side of this one, stretching from the raised hand of the left spearman upward along the tree above the bear. The tapestry has been cut on all four sides and bound, by machine stitching, with a replacement blue galoon of wool. An old partial lining of linen, through which many repairs have been worked, exists under a modern linen lining.

HUNTING, both as a princely sport and as a common necessity, was among the earliest recorded tapestry subjects. In woven form, the theme was popular across Europe from the fifteenth century, and Flanders was a particularly active center of production. Such hangings both recorded the activity and testified to its significance in daily life. The subject was rich in variety (hawking, snaring, trapping, chasing, riding with hounds) and appealed to a wide audience. In addition to sets expressly commissioned, it seems that many workshops produced hunting scenes as stock.

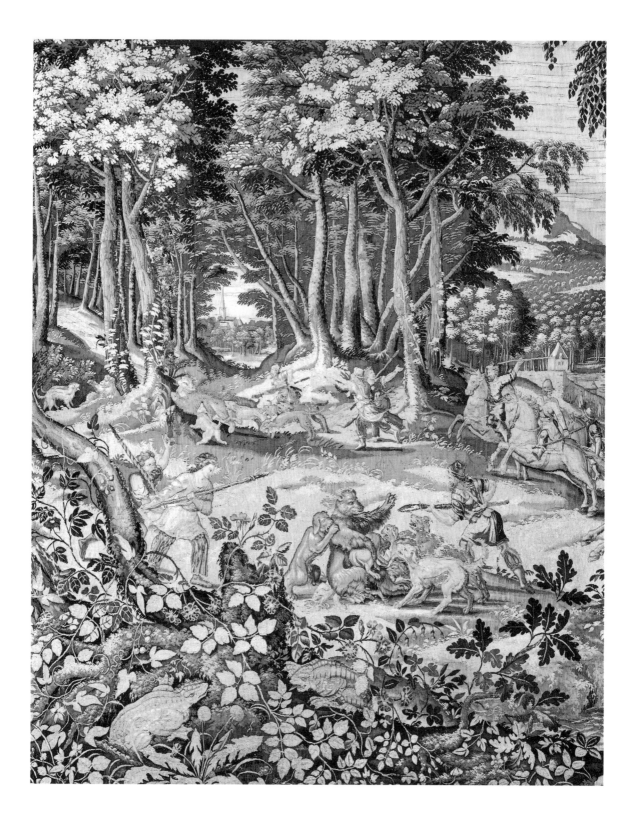

Though deer hunts appear to have been most common, bear hunts such as seen in this tapestry were not rare. Several examples survive, woven in Brussels or other Flemish workshops during the last quarter of the sixteenth century and the first quarter of the seventeenth. Generally, these bear hunts occur in a wooded landscape that often includes a view of a château, garden, village, or church and distant mountains. Typically, the hunt scenes were surrounded by wide borders that were compartmentalized into vignettes of classical landscapes, harvesting scenes, and the like, as noted in the preceding entry.

The visual source for two of the bears in the present tapestry—the one seated upright grasping a dog in one paw and that turning its snarling head towards the pursuing hounds—derives ultimately from prints by the Nuremberg engraver Virgil Solis (1514–62). Solis and his workshop produced series of hunts and, specifically, several scenes portraying bears in similar positions fending off both hounds and spear-bearing hunters on foot.[1] It is likely that the Solis prints circulated among several tapestry workshops in and around Brussels over the span of some fifty years. Slight variations of the seated bear are known from other examples: a bear crushing an outstretched hunter underneath,[2] and a bear with neither hunter nor dog beneath.[3] These differences indicate either artistic license on the part of the weavers or deterioration of the tapestry cartoon over the years, requiring touch-ups and alterations to the composition. None of the surviving tapestries that incorporate this bear are identical; each varies in scale, landscape, and number of figures, and it may be concluded that the portion of the hunt scene shown here was only one of many components that were interchangeably positioned to achieve variety.[4]

C. B. D.

COLLECTIONS: Frick, 1904.[5] Gift of Miss Helen C. Frick, 1935.

NOTES

1. See *The Illustrated Bartsch 19 (Part 1): German Masters of the Sixteenth Century, Virgil Solis: Intaglio Prints and Woodcuts,* ed. J. S. Peters, New York, 1987, Nos. 366–70, 373, pp. 169–71.

2. One version, complete with borders, is in the Fine Arts Museum of San Francisco (Acc. No. 44.27, gift of Mr. and Mrs. Mortimer Fleischhacker). See A. G. Bennett, *Five Centuries of Tapestry from the Fine Arts Museums of San Francisco,* San Francisco, 1992, No. 41, pp. 149–51, repr. After it was sold at the Galerie Georges Petit, Paris, December 4, 1925, Lot 105, this piece and a second example passed through French & Company, New York (neg.

480

No. 13488 and stock No. 41422 respectively; Getty Research Institute, Research Library, Los Angeles).

3. Two examples passed through French & Company (stock No. 18702 and perhaps H482; Getty Research Institute, Research Library, Los Angeles).

4. One tapestry with the same bear actually portrays the meeting of Venus and Adonis. The two mythological characters, along with Cupid, occupy the foreground and are disproportionately large; they are indifferent to the hunting activities behind them. This borderless tapestry was sold in Berlin, February 27, 1936, Lot 65 (recorded in the Marillier file deposited in the Department of Textiles and Dress, Victoria and Albert Museum, London, T.37.Y–1946, p. 76).

5. The tapestry is believed to have served as a portière at Clayton, the Frick family home in Pittsburgh.

FLEMISH (BRUSSELS?)

c. 1620

TAPESTRY Showing Deer Hunt with Diana (35.10.14)

Woven in weft-faced tapestry technique with wefts of dyed wool and silk on warps of undyed wool, 95 × 64 in. (241.3 × 162.5 cm).

DESCRIPTION: In a lush vale, a pack of hounds and a party of spear-bearing hunters attack a deer. The men and hounds converge upon the animal from all sides—from woodland at left and from meadows before a château and its walled parterre. Oblivious to the hunt are two female figures standing in the left foreground: the goddess Diana, crowned with a crescent moon, who embraces her companion and clasps her hand. Their heads are inclined towards each other, as in greeting or parting, and each carries a full quiver over one shoulder. At their feet, two birds with speckled feathers and pointed beaks search the undergrowth. In the background, beyond the château, rise gentle tree-shrouded slopes and rocky peaks. The tapestry is without borders.

WEAVE: The hanging is constructed in weft-faced tapestry weave, with 16 to 18 warps per in. (7 warps per cm) and 48 to 60 wefts per in. (20 to 32 wefts per cm). The warps are undyed wool, z spun, s ply (3), while the wool wefts are z spun, s ply (2), and the silk wefts are z spun, s ply (3 or 4); four-ply wefts, combining silk yarns of different colors, are thicker and thus account for the lower count of wefts.

CONDITION: The tapestry is in fair condition, though the silk wefts are generally dry and brittle. The loss of weft and the exposure of undyed wool warps have been extensively repaired over time with yarns whose color has faded at a different rate than has the original tapestry. The application of pigment to exposed warps has also been used to mask the loss of weft. Traces of pigment can generally be found where a dark brown wool yarn (now degraded) was woven to outline figures and trees. The tapestry has been cut on all four sides and bound, by machine stitching, with a replacement blue galoon. It has an interface support, through which repairs have been made, and an outer lining of crimson silk damask that has been closely stitched along all perimeters.

TOWARD the end of the sixteenth century, it was not uncommon for Flemish and Dutch tapestry workshops to portray episodes from classical mythology, particularly as related by Ovid, against the background of a Northern European landscape. Many hangings are known in which one or more scenes of a classical narrative unfold within a forest, garden, or game park. Generally, the tale is enacted by prominent figures in the foreground while other activities, such as hunting or promenading, fill the middle ground, though other chapters in the story are sometimes placed

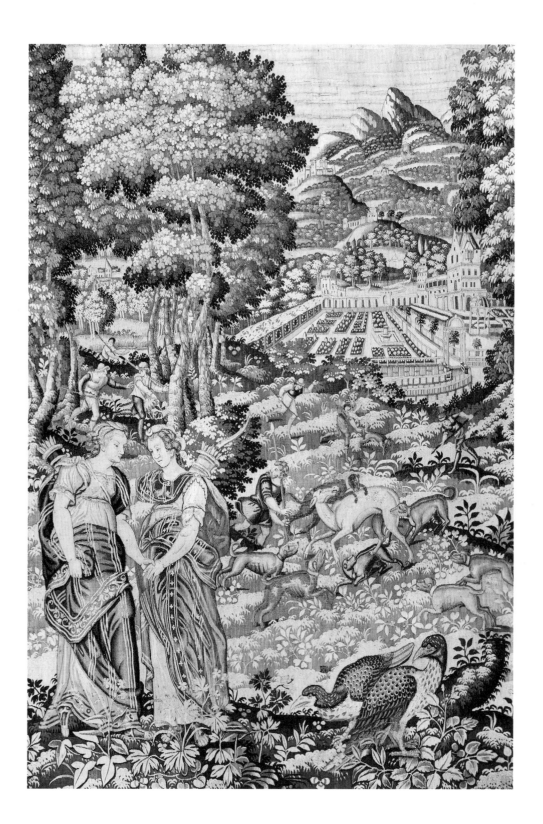

as vignettes in the same field. The main protagonists, in classically inspired attire, are distinguished readily from the secondary figures, who wear contemporary dress and inhabit the nearby villages and châteaux.

Landscapes and game parks as settings for hunting activities were especially suited to tales relating to Diana, goddess of the hunt. The Minneapolis Institute of Arts conserves a tapestry from this period[1] in which two such themes intertwine: the hunt of deer by spear-bearing men dressed in late sixteenth-century fashion, and the myth of Diana and Actaeon portrayed by figures in antique garments. The border of that tapestry survives intact and typifies the wide surround that usually framed Flemish hunt hangings of this date.

In the Frick *Deer Hunt with Diana*, the goddess is clearly identified by the attributes of the crescent moon on her forehead and the full quiver hanging from her shoulder. The companion she embraces also carries a quiver of arrows but bears no other distinguishing object. It is doubtful that she is Callisto, the attendant of Diana who was seduced by Jupiter in disguise, as the pair of birds in the foreground are not eagles.[2] When the workshop of François Spiering (1549/51–1631) wove a hunt tapestry portraying Diana and Callisto, the figures were flanked by an eagle gripping lightning bolts in its beak.[3]

It is probable that the two female figures in *Deer Hunt with Diana* derive from a portrayal of Diana and Procris that was woven in Delft about 1610 by the Spiering workshop after a design by Karel van Mander I (1548–1606).[4] The wide tapestry that survives in the Rijksmuseum, Amsterdam,[5] sets Ovid's tale of Cephalus and Procris in a broad landscape. The central figures of Diana and Procris part in farewell, the goddess clasping one of Procris' hands while Procris' other hand holds the drapery of her dress. In the Frick tapestry, the two figures reverse positions, and Diana extends an arm around the shoulder of her companion.

The attack of the doe by hounds seen here in the middle ground is known in other hunting tapestries.[6] The image of this deer, bitten in the flank, must have circulated among the Flemish workshops originally as a print. Lifted from its source, it became one of the many interchangeable components that filled the woven field of stock hunting tapestries.

C. B. D.

484

COLLECTIONS: Frick, 1904.[7] Gift of Miss Helen C. Frick, 1935.

NOTES

1. Acc. No. 15.208. See C. J. Adelson, *European Tapestry in the Minneapolis Institute of Arts*, Minneapolis, 1994, No. 13, pp. 138–46, repr. Neither the cartoon artist nor the weaver has been identified, but the hanging is attributed to a Flemish workshop.

2. The birds derive from an earlier prototype of waterfowl with speckled feathers, webbed feet, and a duck's bill. See, for instance, the bird in the foreground of a bear hunt tapestry sold at the Galerie Georges Petit, Paris, May 17, 1926, Lot 101.

3. See the Diana and Callisto tapestry, woven with the signature *Franciscus Spiringius Fecit* and the mark for the city of Brussels, sold from the collection of François Coty, Galerie Jean Charpentier, Paris, November 30–December 1, 1936, Lot 115. It later passed through French & Company, New York, stock No. 27193 (Getty Research Institute, Research Library, Los Angeles).

4. See the exhibition catalogue *Dawn of the Golden Age, Northern Netherlands Art 1580–1620*, Rijksmuseum, Amsterdam, 1993, No. 78, pp. 420–21, repr. p. 239 and p. 310. The present author thanks Ebeltje Hartkamp-Jonxis of the Rijksmuseum for bringing this citation to her attention.

5. Acc. No. RBK 1954–69B.

6. See for example French & Company, New York, neg. No. 13489 (Getty Research Institute, Research Library, Los Angeles).

7. The tapestry is believed to have served as a portière at Clayton, the Frick family home in Pittsburgh.

PETER VAN DEN HECKE

d. 1752

Peter van den Hecke was a tapestry weaver and head of an active workshop in Brussels, principal city of the Austrian Netherlands (modern-day Belgium). He was the fourth generation, at least, in a family of weavers whose production spanned the seventeenth and eighteenth centuries. On November 15, 1710, he was licensed (privilégié) *by the city of Brussels, and in 1711 he attained the influential post of dean* (doyen) *of the powerful weavers' guild. His workshop specialized in subjects that were mythological (The Story of Psyche) and allegorical (The Seasons and The Elements), as well as in contemporary genre scenes inspired by literature (The Story of Don Quixote) and painting (scenes with peasants after David Teniers the Younger). Peter van den Hecke, though twice married, was not survived by sons. After his death in February 1752, an inventory of the estate was made; all goods, tools, and tapestry cartoons of the workshop were auctioned, and the business was dissolved.*

TWO TAPESTRIES WITH SCENES FROM THE STORY OF DON QUIXOTE

THE ARRIVAL OF DANCERS AT THE WEDDING OF CAMACHO (65.10.20)

Signed, at lower right: P.VAN.DEN.HECKE (with both *N*'s in reverse). Woven in weft-faced tapestry technique with wefts of dyed wool and silk on warps of undyed wool, 123¼ × 218⅝ in. (313 × 555.2 cm).

MARKS & INSCRIPTIONS: Woven in red at the bottom of the field, well to the right of center: a shield flanked by two *B*'s, the mark for Brussels; woven still further to the right, under flowering plants: the above-mentioned signature for Peter van den Hecke in yellow and red; woven in the right vertical length of brown galoon, about 3 ft. from the bottom: an unmarked crimson-colored shield. Inscribed in ink on a section of the original lining (see *Condition*): *No. 222: Don Quichotte / 7: P. sur 2: au 7/12 / 3e. P. Entrée de L'Hymen 4: au 7/8.* Stamped on the outer face of the original lining (now removed): VISITTE / DE·MOR / TAGNE / 1755 in a circle under a crown, and the number *66* within a separate circle.

DESCRIPTION: In a clearing by the wood-

486

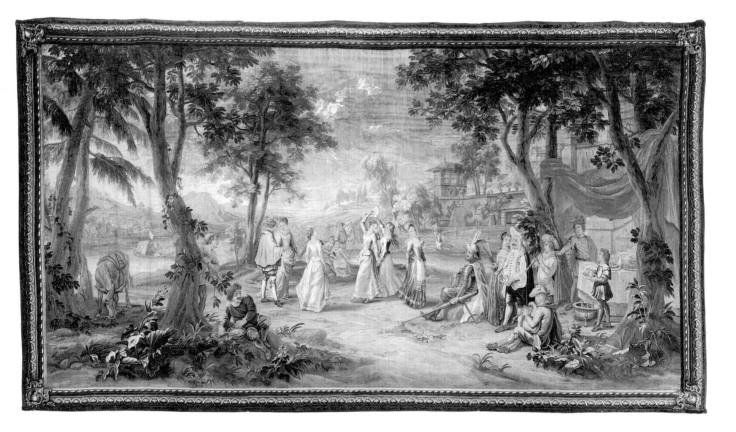

ed banks of a river, guests celebrating the marriage of Camacho and Quiteria gather to watch a dancing troupe of country maidens. Two central dancers grasp hands and pass a tambourine overhead, while two others take a few steps forward and back. An armored knight, Don Quixote, sits on a rock just to the right, beside a richly dressed lady holding a large fan who turns her head toward a mustached gentleman wearing a broad-brimmed hat. A standing flutist and seated piper provide musical accompaniment, and behind them a steward and a young boy with a serving tray stand by a refreshment table. Across the clearing, Sancho Panza reclines under a tree, enjoying the gener-

ous provisions of the host. Dapple the donkey, never far from his master, chomps on grass behind the tree. The river sweeps by in the middle ground, and the countryside recedes beyond the far bank. The scene is surrounded by a border simulating a carved and gilded frame comprising a thin inner scroll and a wider outer band of guilloche; a large fleuron of scrolling acanthus leaves occupies each corner.

WEAVE: The hanging is constructed in weft-faced tapestry weave, with 20 to 22 warps per in. (9 warps per cm) and 56 to 88 wefts per in. (20 to 34 wefts per cm). The warps are undyed wool, z spun, s ply (3), while both the wool and silk wefts are z spun, s ply (2). There is frequent

use of two, sometimes three, yarns of wool and silk plied as one weft, thereby making a thicker yarn and lowering the count of wefts.

CONDITION: Overall, the tapestry is in good condition. The original olive brown galoon, which survives in a damaged state, is now encased by netting and covered by a modern woven edge. Comparison of the reverse of the tapestry with the face reveals an overall fading of the yellow tones, resulting in a subtle shift of the color balance toward blue. The brown, red, and crimson dyes have lost very little of their intensity. The tapestry is backed by a modern cotton sateen lining supported by straps of cotton herringbone 3 in. wide, positioned about every 10 to 12 in. A section of the original linen backing survives and is attached to the new dust band in the lower left corner of the back (see *Marks*).

SANCHO PANZA'S DEPARTURE FOR THE ISLE OF BARATARIA (65.10.21)

Signed, at lower right: P.VAN.DEN.HECKE (with both *N*'s in reverse). Woven in weft-faced tapestry technique with wefts of dyed wool and silk on warps of undyed wool, 123⅞ × 232¾ in. (314.3 × 591.1 cm).

MARKS & INSCRIPTIONS: Woven in red at the bottom of the field, well to the right of center: a shield flanked by two *B*'s, the mark for Brussels; woven at far right, beneath three broad-leafed plants: the above-mentioned signature for Peter van den Hecke in red. Inscribed in ink on a fragment of the original backing (see *Condition*): *No. 222 Don Quichotte / 7: P. sur: 2 au 7/12 / se. P. Départ de Sancho: 5 au.* Stamped on both the inner and outer faces of the original lining (now removed): VISITTE / DE·MOR / TAGNE / 1755 in a circle under a crown and, within a separate circle on the outer face only, the number *66*.

DESCRIPTION: In a tree-lined space between the entrance portico of a palace at left and a stone fountain jetting water at right, a group of courtiers gathers round the armored figure of Don Quixote, who bids his companion, Sancho Panza, farewell. Dressed as an attorney in an overcoat and holding a white turban in his left hand, Sancho accepts an embrace from his master. A young groom attends the white mule Sancho will ride in ceremony, as two mounted trumpeters signal Sancho's departure. By a tree at right, two more stable boys groom Sancho's favored donkey, Dapple, which will follow Sancho's cortege. At far right, a maid holds a small red-and-gold casket. A pavilion is visible beyond the fountain, its waterfront parterre filling the middle ground. The distant sea alludes to Sancho's crossing to the island of Barataria, where he will preside as

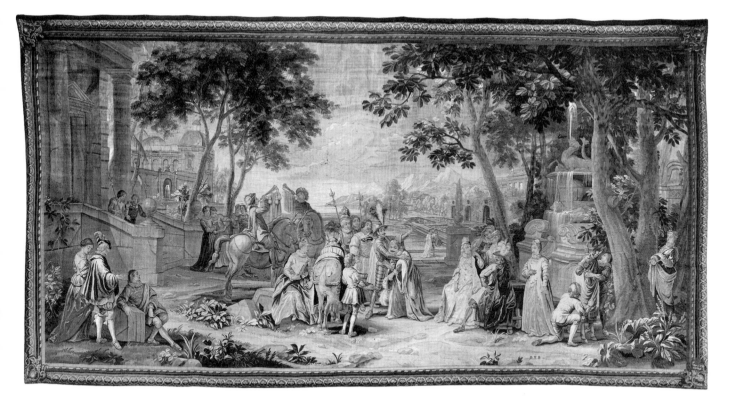

governor. The scene is again surrounded by a border simulating a carved and gilded frame made up of a thin inner scroll and a wider outer band of guilloche, with a single large fleuron of scrolling acanthus at each corner.

WEAVE: The hanging is constructed in weft-faced tapestry weave, with 20 to 22 warps per in. (8 to 9 warps per cm) and 64 to 80 wefts per in. (26 to 34 wefts per cm). The warps are undyed wool, z spun, s ply (3), while both the wool and silk wefts are z spun, s ply (2). There is frequent use of two yarns, sometimes one of wool and one of silk, plied as one weft.

CONDITION: Overall, the hanging is in fair to good condition. Sections of its original olive brown galoon survive in a damaged state, now encased by netting and covered by a modern woven edge. Comparison of the reverse with the face reveals noticeable fading in the yellow and orange tones. The green-colored fibers are still strong, but both the dark blue and the dark brown yarns have lost some of their intensity. The tapestry has suffered water damage in the upper left corner that left stains visible on the face; these were mitigated by cleaning during conservation treatment in 2000. The tapestry is backed by a modern cotton sateen lining and supported by straps of cotton herringbone 3 in. wide, positioned about 10 to 12 in. apart. A section of the original linen backing survives and is attached to the newer dust band in the lower left corner of the back (see *Marks*).

THE novel *Don Quixote de la Mancha*, published in two parts in 1605 and 1615 by Miguel de Cervantes Saavedra (1547–1616) and illustrated as early as 1640,[1] was a literary source for the major European tapestry manufactories during the eighteenth century. Workshops in Paris, Beauvais, Aubusson, Lille, Oudenaarde, Brussels, Naples, and Madrid wove hangings illustrating the escapades of Don Quixote and his companion, Sancho Panza. Artists employed by the various manufactories created tapestry cartoons that proved to be immensely popular across the Continent. The most influential of these were painted by Charles-Antoine Coypel (1694–1752), who supplied a total of twenty-eight scenes to the Gobelins manufactory in Paris beginning in 1714 (the last delivered in 1751, shortly before his death).[2] Twenty-four of Coypel's subjects were engraved from 1723 to 1734 and were widely disseminated throughout the eighteenth century.

The Brussels workshop of Peter van den Hecke produced a series of tapestries illustrating the story of Don Quixote comprising eight scenes, six of them inspired by engravings after Coypel. A sales list from van den Hecke's workshop[3] described the subjects: Don Quixote being knighted;[4] the arrival of dancers at the wedding of Camacho;[5] Don Quixote served by the ladies of the Duchess;[6] Sancho's departure for the Isle of Barataria;[7] Sancho's arrival on Barataria;[8] and Sancho's feast on Barataria.[9] The remaining two subjects in van den Hecke's set—Sancho tossed in a blanket[10] and Don Quixote locked into a cage[11]—do not derive from Coypel, who did not prepare cartoons for these titles. Rather, they seem to have been inspired by designs provided before 1715 by Jan van Orley (1665–1735) and Augustin Coppens (1668–1740) for a Don Quixote tapestry series, including those two scenes, woven by the Brussels workshops of Reydams-Leyniers (active 1712–19) and the Leyniers family (active 1719–68).[12]

The cartoons for the van den Hecke Don Quixote tapestries have been tentatively attributed to the painter Nicolas De Haen (master 1725), active in Brussels.[13] Whether prepared by De Haen or another artist, they borrow from, but do not directly copy, the Coypel models. The Flemish painter broadened the scenes, placing his characters in panoramic landscapes rather than the constrained stage settings of Coypel and increasing the size of the cast.

Unlike the other Don Quixote scenes produced by the van den Hecke workshop, *The Arrival of Dancers at the Wedding of Camacho* is not one of pivotal action or high humor. Rather it depicts the festivities taking place before the arrival of the groom, Camacho, and his bride, Quiteria, at their country wedding. The serenity

of the scene does not suggest the tumultuous sequence of events that immediately followed, wherein Quiteria's betrothed Basilio feigned suicide before all assembled and persuaded her to forgo her marriage to the wealthy Camacho.

The artist who provided cartoons for van den Hecke actually combined figures from two separate Coypel scenes in *The Arrival of Dancers at the Wedding of Camacho*. The wedding guests and the young girls dancing to the music of a Zamora bagpipe derive from Coypel's *Entrée de Bergeres*, while the seated figures of Don Quixote and Sancho are borrowed from Coypel's second illustration of the same chapter, *Entrée de l'Amour et de la Richesse*. But the cartoonist working for van den Hecke significantly expanded the setting and cast. He placed the figures in a landscape that is both broad and deep, creating an illusion of wide space by employing the sweeping river that flows through the middle ground and by using blue tones to imply an infinitely receding distance. The artist must also have been familiar with the text, since he added vignettes to the scene that correctly illustrate the chapter: the well-stocked table of food and bottles of good wine, the attentive servants, and the proximity of Dapple, Sancho's donkey. It is clear that not everyone found the scene easy to identify, as attested by the inked title *Entrée de L'Hymen* inscribed on the eighteenth-century label tagged to the tapestry's reverse (see *Marks*).[14]

In *Sancho Panza's Departure for the Isle of Barataria*, eight figures can be traced back to Coypel, once again from two different scenes. From Coypel's *Departure* come the central characters of Don Quixote embracing Sancho and the secondary figures of two stable hands tending Dapple to the right. The seated Duke and Duchess, with two ladies-in-waiting standing behind, derive from Coypel's rendering of a different subject, *La Doloride ou les Magiciens*.[15]

It is not known if the artist who executed van den Hecke's cartoons designed the eight tapestries simultaneously or serially, as did Coypel, nor whether he drew inspiration directly from the Gobelins tapestries or from the intermediary engravings. If he knew the tapestries directly, then the two subjects in The Frick Collection could date from about 1720, since the first Gobelins set woven in 1717–18 included all the relevant Coypel figures.[16] If he used engravings, then the weavings could not predate 1724, the year following the publication of the first engravings after Coypel. It is also feasible that the tapestry cartoons were not designed as a group until 1734, when the entire suite of engravings after Coypel was complete.[17] None of the van den Hecke tapestries date later than 1752, the year of the weaver's death.

Despite their French prototypes, the Brussels tapestries are distinctively Flemish in their outdoor settings. The cartoonist was working within Flemish tradition, taking inspiration from the paintings of village scenes by David Teniers the Younger (1610–90). Flemish tapestry workshops, including that of van den Hecke, produced other figured landscapes, particularly scenes inspired after David Teniers, contemporaneously with the Don Quixote subjects.[18]

A set of seven—not eight—of the van den Hecke Don Quixote tapestries, including the two now in The Frick Collection, was inventoried in 1775 among the possessions of the French Garde-Meuble de la Couronne, along with eight hangings after Teniers from the same workshop.[19] Though the inventory itself dates from 1775, the tapestries must have entered the Garde-Meuble prior to 1758, since their record precedes the set of Gobelins Don Quixote tapestries with yellow mosaic alentours delivered by that date for Louis XV's use at the Château de Marly.[20] It is not known if the other five hangings from the royal Don Quixote van den Hecke set survive.[21]

Aside from the Frick *Arrival of Dancers at the Wedding of Camacho* and *Sancho Panza's Departure for the Isle of Barataria*, only one signed example of a Don Quixote tapestry woven by the manufactory of Peter van den Hecke is known, a narrow version of *Don Quixote Being Knighted* in the Cagnola collection, Italy.[22] The Kunsthistorisches Museum, Vienna, conserves six Don Quixote tapestries attributed to the workshop of Peter van den Hecke, including both of the Frick subjects.[23] Although the *Sancho's Departure* in the Vienna set follows the same cartoon as the Frick example, it lacks the woman at far right who carries a small red casket. Another example of *Sancho's Departure*, also lacking the maid with the casket, was sold from the collection of the Countess of Craven at Combe Abbey in 1922,[24] and a version of *The Arrival of Dancers at the Wedding of Camacho* from the collection of Prince Galicyn, Petrograd, was auctioned in London in 1923.[25] A set of seven Don Quixote hangings, possibly by van den Hecke, was in the Abbey of St. Peter, Ghent, at the end of the eighteenth century.[26]

<div align="right">C. B. D.</div>

COLLECTIONS: French royal collection, Paris, recorded in 1775. Possibly collection of the Vicomte de Fontarce, Paris, *c.* 1900.[27] Hubert Mersmann, Los Martines, Granada, Spain.[28] Henry Clay Frick, 1909. Childs Frick, Rosalyn, Long Island.[29] Bequeathed by him in 1965.

These Don Quixote tapestries were first studied by Adolph S. Cavallo, whose unpublished report of 1974, which cited the labels affixed to the backs of the tapestries and related them to the corresponding entries in the Garde-Meuble inventory of 1775, is available to researchers in the curatorial files of The Frick Collection. The same information on the labels and the 1775 inventory was discovered independently by the writer of the present entry in the preparation of this text.

1. See J. Seznec, "Don Quixote and His French Illustrators," *Gazette des Beaux-Arts*, September 1948, pp. 173–92.

2. See M. Fenaille, *État général des tapisseries de la Manufacture des Gobelins depuis son origine jusqu'à nos jours 1600–1900*, Paris, III, 1904, pp. 157–282.

3. "Histoire de Don Quixote de la Manche en petites figures commes le Teniers à 4½ aunes de hauter …," in A. Wauters, *Essai historique sur les Tapisseries de haute et de basse lisse de Bruxelles*, Brussels, 1878, pp. 357–58. A Flemish *aune* equaled 69.5 cm or 27⅜ in., and this measurement corresponds with the heights of the Frick tapestries. Van den Hecke also offered his customers this series woven to the alternative height of 4¼ *aunes*. All eight subjects, end-to-end, measured 51¾ running *aunes*, but their lengths could be adjusted to accomodate a specific interior.

4. M. de Cervantes Saavedra, *The Adventures of Don Quixote*, trans. J. M. Cohen, London, 1950, part I, chapter 3. Coypel's illustration was engraved in 1724 by Charles-Nicolas Cochin (1688–1754). Coypel's cartoons survive at the Château de Compiègne. See T. Lefrançois,

Charles Coypel, Peintre du Roi (1694–1752), Paris, 1994.

5. Part 2, chapter 20. Coypel's cartoon was completed in 1718, and on August 18, 1719, the Gobelins manufactory paid him 550 livres. The scene was engraved by Louise-Madeleine Hortemels Cochin (1686–1767).

6. Part 2, chapter 31. Coypel's illustration was engraved in 1724 by Louis de Surugue (1686–1762).

7. Part 2, chapter 44. Coypel's cartoon was prepared by 1717, though he did not receive payment of 440 livres until January 15, 1718. It too was engraved by Louis de Surugue. A workshop copy of Coypel's cartoon for *Sancho's Departure* was offered for sale at Drouot Richelieu, Paris, June 14, 1995, Lot 21, and again at the same auction house on April 10, 1996, Lot 9.

8. Part 2, chapter 45. Coypel's scene was engraved by Nicolas-Henri Tardieu (1674–1749).

9. Part 2, chapter 47. Coypel's illustration was engraved by D. Beauvais, who is perhaps identical with Nicolas-Dauphin de Beauvais (1687–1763).

10. Part 1, chapter 17.

11. Part 1, chapter 46.

12. H. Göbel, *Wandteppiche, Die Niederlande*, Leipzig, 1923, I, pp. 342, 361–63. Jan van Orley may have collaborated with his elder brother, Richard, on this series. See K. Brosens and G. Delmarcel, "Les Aventures de Don Quichotte, Tapisseries bruxelloises de l'Atelier Leyniers-Reydams," in *Revue belge d'Archéologie et d'Histoire de l'Art*, LXVII, 1998, pp. 55–92.

13. G. Delmarcel, *Flemish Tapestry*, New York, 2000, p. 331.

14. Gobelins weavings of the same subject bore the title *Entrée de bergeres qui dancent aux*

nopces de Gamache [sic] and *Entrée de l'Amour et de la Richesse*. Both were engraved by Louise-Madeleine Hortemels Cochin.

15. The Gobelins weavings of this subject (part 2, chapter 39) were accompanied by the title *La Doloride Affligée de sa Barbe prie dom Guichot de la Vanger de L'Enchanteur*. Coypel's cartoon was engraved by Louis de Surugue in 1724.

16. See Fenaille, III, pp. 190–94, and "The Duc d'Antin Don Quixote Tapestries," Christie's, London, June 10, 1993.

17. As proposed by I. de Meûter, in *Tapisseries d'Audenarde du XVIᵉ au XVIIIᵉ Siècle*, Tielt, 1999, p. 262.

18. Tapestries after Teniers framed by borders of the same design as those on the Frick hangings were produced by the manufactory of Peter van den Hecke. See J. Boccara, *Ames de laine et de soie*, Saint-Just-en-Chaussée, 1988, repr. pp. 234–35.

19. O¹ 3345 Inventaire Général des Meubles de la Couronne, IV, fol. 174, vo.: "Dom Quichotte. 222. Une tenture de Tapisserie laine et soie fabrique de Bruxelles Manufacture de Vandenhecke représentant quelques sujets de l'histoire de Don Quichotte, dans une bordure couleur de bronze ayant aux coins un petit cartouche fleuronne. La Tenture en sept pieces contenant vingt huit [French] aunes de cours, sur deux [French] aunes sept douze de haut. Cye … 28 au. sur 2 aun. ⁷/₁₂." The inscribed patch of original linen backing that survives attached to the reverse of *The Arrival of Dancers at the Wedding of Camacho* identifies it as the third tapestry in this set of seven, and that on *Sancho Panza's Departure for the Isle of Barataria* identifies it as the fifth. In 1789 these Don Quixote hangings were in the Château de Compiègne, divided between the bedroom of Monsieur and the Cabinet de Conseil. The set of van den Hecke tapestries after Teniers appears as No. 223 on the same folio, described as "Verdure de Teniers" representing the Four Seasons and "divers sujets flamands."

20. Fenaille, III, 1904, pp. 206–17, and O¹ 3345 Inventaire Général des Meubles de la Couronne, IV, fol. 174, ro.: "Dom quichotte. 225."

21. Five Don Quixote tapestries bearing the signature of P. van den Hecke were recorded by Wauters (p. 358) as having been sold by the Dubus family of Tournai at the Hôtel Drouot, Paris, in 1877. The present author has not been able to trace the 1877 Hôtel Drouot sale.

22. See N. Forti Grazzini, in *La Collezione Cagnola, II: Arazzi, sculture, mobili, ceramiche*, Busto Arsizio, 1999, pp. 54–55. The author thanks Nello Forti Grazzini for this information.

23. Kunsthistorisches Museum, Vienna, Inv. Nos. T LII 1–6. R. Bauer, in the exhibition catalogue *Wohnen im Schloss, Tapisserien, Möbel, Porzellan und Kleider aus drei Jahrhunderten*, Schloss Halbturn, 1991, convincingly attributes the set to the van den Hecke manufactory, even though their borders repeat a design found on Don Quixote tapestries woven with the signature of Urban Leyniers. For an example of the Leyniers hangings, see Christie's, New York, September 25, 1997, Lot 379.

24. Christie's, London, April 25, 1922, Lot 7. Recorded in the Marillier file deposited in the Department of Textiles and Dress, Victoria and Albert Museum, London, T. 37.P–1946, p. 41.

25. Now in the Museo di Arti Decorative della Fondazione Pietro Accorsi, Turin, it previously sold at Puttick and Simpson, London, December 7, 1923, Lot 81 (sale postponed to December 10). The same hanging appeared again

at Puttick and Simpson on November 28, 1924. Recorded in the Marillier file in the Department of Textiles and Dress, Victoria and Albert Museum, *loc. cit.* Forti Grazzini (p. 55) mentions a cut version of this subject that appeared on the art market in 1969, sold at the Palazzo Internazionale delle Aste ed Esposizioni, Florence, October 16–24, 1969, Lot 292, repr.

26. Wauters, note 1, p. 359, and E. de Busscher, "L'Abbaye de Saint Pierre, à Gand, 1781 et 1847," *Annales de la Société royale des Beaux-Arts et de Littérature de Gand*, Ghent, 1846–47, p. 308.

27. Fenaille, III, pp. 279–80.

28. Recorded in the Marillier file in the Department of Textiles and Dress, Victoria and Albert Museum, T. 37.P–1946, p. 35.

29. The tapestries are shown *in situ* in M. F. S. Sanger, *The Henry Clay Frick Houses*, New York, 2001, pp. 235, 237, 246–47.

SÈVRES MANUFACTORY
Middle of the Eighteenth Century

BISCUIT PORCELAIN BUST OF LOUIS XV, after Jean-Baptiste Lemoyne, on a Glazed Pedestal, *c.* 1760 (90.9.52)

Porcelain, soft paste. H. overall 10⁷⁄₁₆ in. (26.3 cm); H. of bust 4⁷⁄₁₆ in. (11 cm); maximum w. of bust 3⁹⁄₁₆ in. (9.1 cm); w. of pedestal at base 3³⁄₁₆ in. (8.1 cm).

DESCRIPTION: The biscuit bust and its tapering quadrangular socle are fired in one. The subject is shown bareheaded, his flowing locks knotted at the back of the neck. He looks up and slightly to his left. The monarch is garbed as a Roman emperor, wearing an embossed cuirass beneath a fringed cloak affixed with a circular brooch on the left shoulder. The four sides of the hollow, tapering, green-ground pedestal swell out slightly at top and bottom; they are decorated with gilded and tooled trophies symbolizing war, architecture, music, and painting. The sloping sides of the base are decorated with floral sprays, as are the centers of the bracket feet. The upper and lower edges of the pedestal as well as the side panels are banded with gilding. The flat upper surface of the pedestal is notched to receive a flange that is normally part of the circular base of such busts but is missing here.

CONDITION: The head has been broken off and reattached. There are small chips in the porcelain at the top and bottom of the pedestal, and the gilding is slightly worn and chipped. Firing cracks run up one inner wall of the pedestal, across the chest of the bust, and on the outer side of the base.

BOTH the miniature portrait bust of Louis XV (1710–74) and the ornamental pedestal on which it stands were produced at the Sèvres porcelain manufactory around 1760, probably as an homage to the King, who had assumed total financial responsibility for Sèvres the year before.[1] Records indicate that busts of Louis and his Queen, Marie Leczinska, were produced in some quantity at that time, but very few have survived; these include a pair of the King and the Queen in the Boston Museum of Fine Arts; one of the King in the British Museum; and a few isolated busts without pedestals.[2] Sales records of 1760 list busts and pedestals as having been sold to Madame Louise, the King's daughter; to Madame de Pompadour; to Bachelier, then the artistic director of Sèvres; and to the dealers Poirier and Sprot.[3]

Despite the lack of any evidence at Sèvres of his participation in the production of the bust, it has traditionally been associated with Jean-Baptiste Lemoyne (1704–

497

78). Of his many portrait sculptures of Louis XV, Lemoyne's lost equestrian monument inaugurated at Bordeaux in 1743 corresponds most clearly to the present miniature portrait; Nicolas-Gabriel Dupuis' engraving after Charles-Nicolas Cochin's drawing of that sculpture may have served as a model for the unidentified sculptor at Sèvres.[4] The head of the equestrian monument and that of the Sèvres bust are strikingly similar in their renderings of the signs of age in the royal visage: the sagging lower eyelids, the heavy jowls, and the receding hairline.[5]

A possible alternative model is a miniature terracotta bust of Louis XV inscribed *Lemoine*. Apparently an autograph reduction of the head and torso of Lemoyne's monument to the monarch inaugurated at Rennes in 1754, the terracotta differs from the Sèvres bust too greatly to be regarded as a direct source; however, its similar size (10.2 cm) provides evidence of a type of model the unknown sculptor at Sèvres might have utilized.[6]

The tapered pedestal of glazed apple-green porcelain on which the portrait bust rests is unique for its gilded and exquisitely tooled trophies; the Boston pedestals are solid blue with gilded borders, and the British Museum example is ornamented with colorfully painted designs. The compositions on the Frick pedestal are difficult to decipher completely; however, they correspond in a general way to symbolic trophies painted on numerous examples of Sèvres porcelain, notably on the related pedestal in the British Museum.[7] Both pedestals show trophies of war and architecture; but where the British Museum example evokes sculpture and geography, the corresponding designs on the Frick pedestal allude to painting and music. All of the trophies share backgrounds formed by billowing clouds. The British Museum trophy of sculpture helps interpret the Frick trophy of painting, as both include a representation of François-Jacques-Joseph Saly's familiar *Bust of a Young Girl* of about 1750 (a version of which is in The Frick Collection[8]).

<div align="right">S. S.</div>

EXHIBITED: London, Deborah Gage, Ltd., Vincennes / Sèvres, 1990, No. 23, lent by John Whitehead.

COLLECTIONS: Sale (pedestal only), Sothe- by's, New York, October 16, 1987, Lot 161. Hector Binney, London, until 1987 (bust only). John Whitehead, London (bust and pedestal). Frick, 1990.

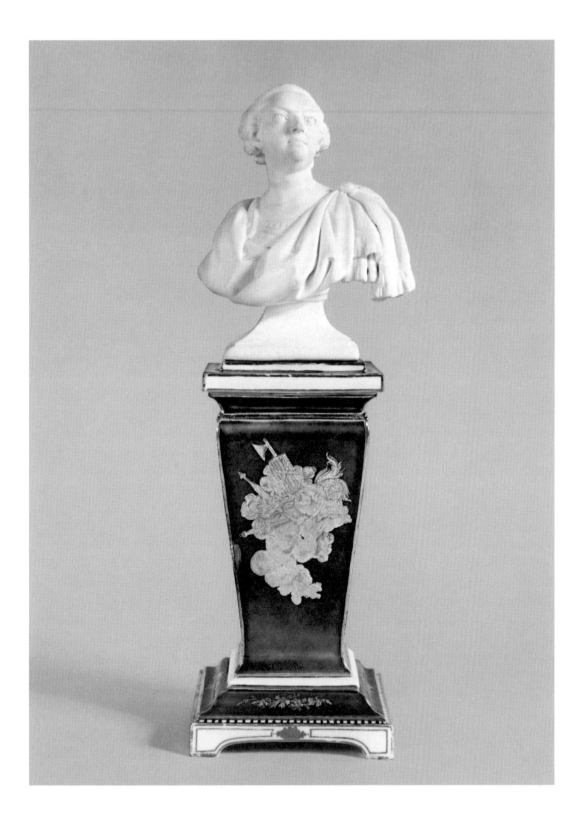

1. See R. Savill, *The Wallace Collection, Catalogue of Sèvres Porcelain*, London, 1988, I, pp. 117–26.

2. Boston, Museum of Fine Arts, Inv. No. 53.54.1964, bequest of R. Thornton Wilson, in memory of Florence Ellsworth Wilson; London, British Museum, Reg. No. 1948.12–3,5, bequest of Sir B. Eckstein, Bt., 1948; Sèvres, Musée National de la Céramique, MNC 10058; St. Petersburg, Hermitage, Inv. No. 26512. Derivative examples of the bust alone in other mediums are discussed by A. Dawson in the forthcoming *French Porcelain in the British Museum*. A second model of the bust of Louis XV, in which he is shown wearing armor and a cloak bearing the Order of the Saint-Esprit, exists; examples include one at the Musée National de Versailles et de Trianon, another at the Musée Lambinet, Versailles (No. 647), and a third, formerly in the Elizabeth Parke Firestone collection, sold at Christie's, New York, March 21, 1991, Lot 148.

3. See E. Munhall, "A Sèvres Biscuit Bust of Louis XV Acquired by The Frick Collection in Memory of Guy Bauman," *Metropolitan Museum Journal*, 1992, No. 27, pp. 121–28. According to Munhall (pp. 121, 124), "On the basis of summary eighteenth-century descriptions, it is difficult to identify extant examples as those recorded in the Sèvres sales records. However … it is tempting to associate the pedestal of the Frick bust with one of a pair of 'pieds d'es-taux en gaine' with green ground and gilding, which were sold for 72 *livres* each to Poirier in 1760, and in turn with a pair of busts referred to in a letter by the Parisian banker Bonnet, dated April 15, 1760. This letter concerned porcelain that Poirier had sent from Paris to the chief minister of the ducal court of Parma, Guillaume Dutillot, including 'le portrait du Roi et de la Reine aussi en biscuit sur des petits piedsdestaux qui servent a mettre des fleurs lorsque l'on n'y met pas les petites bustes.'"

4. *Idem*, p. 126.

5. For the history of Dupuis' and Cochin's engraving, see: P. Courteault, *La Place Royale de Bordeaux*, Paris–Bordeaux, 1923, pp. 387–91; M. Marionneau, "Correspondance de J.-B. Lemoyne et de l'Intendant de Tourny au sujet de la gravure de la statue équestre de Louis XV, érigée en 1743, sur la place Royale de Bordeaux," in *Réunion des Sociétés des Beaux-Arts des départements*, Paris, 1882, pp. 154–55; M. Roux, *Bibliothèque Nationale, Département des Estampes, Inventaire du fonds français: Graveurs du XVIII^ème siècle*, Paris, 1955, VIII, p. 398, No. 155.

6. Munhall, p. 126.

7. For a more detailed discussion of the trophies on the Frick and British Museum pedestals, see Munhall, p. 124.

8. See T. W. I. Hodgkinson, in *The Frick Collection: An Illustrated Catalogue,* IV, 1970, pp. 92–94.

FRENCH

Last Quarter of the Eighteenth Century

GILT-BRONZE MANTEL CLOCK with Attributes of Ceres, Venus, and Bacchus (79.6.15)

Signed, on the dial: *Guydamour* / A · PARIS. Made probably about 1790. Case and figures of gilt bronze; plinth of white marble. H. 17¾ in. (45 cm); W. 13¾ in. (35 cm); D. 6 in. (15 cm).

INSCRIPTIONS: Enameled on the dial: the above-mentioned signature *Guydamour* / A · PARIS; and at the base of the dial: faint traces of a second signature, almost certainly that of the *émailleur*.

CONSTRUCTION: The clock rests on a molded, bow-ended, rectangular white statuary marble plinth supported by six gilt-bronze feet. A similarly shaped gilt-bronze plinth is bolted to the marble plinth, and to its concave middle band are applied separately cast reliefs. Bolted to the top of this platform is a central rectangular pedestal decorated in front with three panels of applied reliefs and around the base with separately cast moldings. Flanking the central pedestal are two gilt-bronze putti, their arms and wings cast separately and brazed together. Above the putti is a third bow-ended plinth, atop which are a central drum, housing the dial and movement of the clock, and two separately cast rearing goats screwed to separate bases. Atop a stepped cresting between the goats is mounted an overflowing basket. The reverses of the base and pedestal are brazed to the sides of the case. Access to the dial and movement is by means of glazed doors hinged to the front and back.

BRONZES: The feet of the clock are of peg-top form with milled collars, and the reliefs set within the recessed panels on the front and sides of the gilt-bronze plinth consist of ribbon-tied garlands of fruit and flowers. The reverse-curve molding at the foot of the central pedestal is composed of alternating acanthus and stiff leaves. Mounted above it are three further reliefs. The largest, middle relief centers on a flaming urn supported by a tapering beaded stem and flanked by acanthus scrolls that end below in *pieds-de-biche* and at their centers in sunflowers. From each scroll rises a spirally-fluted cornucopia overflowing with fruiting vines, pomegranates, and roses. To the flanking panels are applied further fruit and floral garlands suspended from a patera. The winged putti, swathed in delicate drapery, are shown with the right foot forward and their raised hands appearing to support the uppermost plinth. The frieze below the clock-case is fluted, two milled bands circle the sides of the case, and the bezel of the glazed doors is pearled and milled on the front of the case and bears plain moldings on the reverse. Pierced, stylized fleurs-de-lis form the hour and minute hands. The clock-case is flanked by rearing goats that devour grapes which spill from a basket of fruit, vines, and flowers atop the cresting. The reverse of the clock is plain. The figures and goats are skillfully hatched to diffuse light and give a soft

501

appearance to both skin and fur. This contrast is greatly heightened by the exceptionally rich contrast of chased and burnished areas, enhanced further still by the use of two tones of gilding: the architectural elements and reverse are all surfaced in rose-gold, while the figures, feet, applied moldings, goats, and cresting are all of yellow-gold. The chasing is well done, with soft touches and rich contrasts; this is particularly visible on the goats, which are fully chased in front and simply cast and gilded, as originally modeled, on the reverse.

MOVEMENT: The eight-day movement is fitted with a recoil anchor escapement and a silk-suspended pendulum. A single steel bell mounted on the backplate strikes the hour and the half-hour. The slightly asymmetrical placing of the winding-holes—that at right for the time train, that at left for the striking chain—is a legacy from the Louis XV period, although far more restrained. The hours on the enameled dial are marked in Roman numerals, the min-utes in Arabic numerals at the quarter hour. A small hole at the top of the dial allows for the adjustment of the pendulum.

CONDITION: The case is in very good condition, although there is some rubbing to the gilding, particularly on the burnished areas of the plinth and the back of the drum. Only the two rear feet are original; the two front and two end feet were replaced probably in the nineteenth century and are of slightly different profile and color. The goats are each drilled on the underside, suggesting that further vines may have originally emerged around their hind legs. Two additional drilled holes, probably to secure the goats' beards, are visible in the bunches of grapes. The enameled dial has minor chips around the winding-holes. The central pinecone finial on the cresting has a flattened top and may possibly have originally supported a further foliate finial. There is a small knock to the panel of the back. The movement, which was cleaned in 1995, is in nearly pristine condition.

THE iconography of this clock is almost certainly derived from a saying of classical antiquity, preserved by Terence in *Eunuchus*: "sine cerere et libero friget Venus" (Venus is ice without Ceres and Bacchus).[1] Ceres, or Abundance, is represented by the overflowing cornucopias that flank the flaming urn, as well as by the basket of fruit and flowers; Bacchus by the goats and trailing vines; and Venus by the attendant Cupids. Such an iconographical scheme would have been most appropriate for a dining room or other room of entertainment.

The present model can be dated with some certainty, as an identical clock, now at Broadlands, Hampshire, together with a flanking pair of candelabra, was acquired by Lord Palmerston for £41 16s from the *marchand-mercier* Dominique Daguerre in 1791.[2] Its movement, however, is by Jean-Antoine Lépine, and its base is of patinated bronze. The heir to Simon-Philippe Poirier's workshop, Daguerrre specialized in supplying *objets de luxe* to the French court and, following the Revolution, particularly to the English nobility. Established in the Rue Saint-Honoré, as his trade label reveals he "Tient magazin de Porcelaines, Bronzes, Ebénisterie,

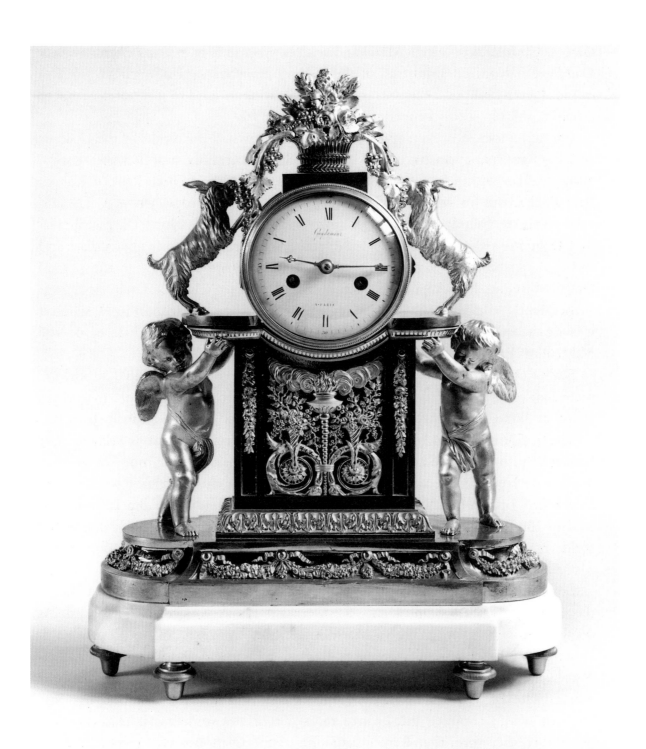

Glaces, Curiosités et autres Marchandises." In his capacity as a *marchand-mercier* Daguerre patronized almost all of the leading *bronziers*—including François Ré-mond, Pierre-Philippe Thomire, and Pierre Gouthière—and so it is not possible to attribute this clock conclusively to a specific *bronzier*.

Daguerre does, however, appear to have either owned the model of the clock or perhaps have had exclusive use of it, as he almost certainly supplied an identical example, also with a movement by Guydamour, to Grand Duke Paul of Russia, later Paul I, and his wife, Maria Feodorovna. Touring Europe between 1781 and 1785 under the pseudonyms of the Comte and Comtesse du Nord, the couple vis-ited Daguerre's shop on May 25, 1782, and purchased numerous objets d'art and furniture, including a Sèvres porcelain-mounted *bureau plat* now in the J. Paul Getty Museum, Los Angeles, which retains Daguerre's label.[3] Their clock was subsequently sold from the Russian imperial collections in Berlin in 1928, when it was described as coming from the Hermitage, the Gatschina Palace, or the Mikhailloff Palace.[4]

Four further clocks of this model, also with movements by Guydamour, are recorded: one sold in Paris in 1861;[5] one sold in Paris in 1921;[6] one sold in Paris in 1956;[7] and one, possibly the same as the last-mentioned, sold in Paris in 1990.[8]

The sculptural motif of two putti flanking a central element is seen on gilt bronzes throughout the Louis XV and Louis XVI periods. The motif of grazing goats, however, is more unusual, and is perhaps most closely related to the goats that adorn a pair of andirons supplied to the Garde-Meuble for the Trianon and sold by the Revolutionary government at Versailles in 1793;[9] variously attributed to Pierre Gouthière or to Pierre-Philippe Thomire, those andirons are now in the Museum of Fine Arts, Boston.[10]

Edme-Philibert Guydamour (1752–98), elected *maître* on August 14, 1784, is recorded in the Rue Saint Denis–St. Germain l'Auxerrois from 1788 until his death. Through his marriage to Marie-Angélique-Anne Baudin on November 1, 1776, he was a nephew of the *ébéniste* Balthazar Lieutaud. Apprenticed to Louis-Nicolas Delaunay in 1766 and to Jean-François Colon in 1772, Guydamour worked closely with the *bronziers* François Rémond and the Osmond dynasty, both of whom supplied gilt-bronze cases for his movements; it is certainly a possibility, therefore, that Rémond or one of the Osmonds was responsible for the execution of this model.[11]

<div align="right">O. R.</div>

COLLECTIONS: Mrs. J. Fife Symington, Jr. Given by her to The Frick Collection, 1979.

NOTES

1. *Eunuchus*, 4, 5, 731–32. See *Dawn of the Golden Age: Northern Netherlandish Art, 1580–1620*, ed. G. Luijten *et al.,* exhib. cat., Rijksmuseum, Amsterdam, 1993, No. 26, p. 367.

2. P. Verlet, *Les Bronzes dorés français du XVIIIᵉ siècle*, Paris, 1987, p. 349, fig. 368.

3. C. Bremer David *et al., Decorative Arts: An Illustrated Catalogue of the Collections of the J. Paul Getty Museum*, Malibu, 1993, pp. 58–59, No. 79.

4. Lepke, Berlin, November 6, 1928, Lot 169. The clock was subsequently sold at Galerie Charpentier, Paris, Collection M.D., December 9, 1952, Lot 45, and was advertised by Pascal Izarn on the French art market in 1994.

5. Strauss sale, Paris, April 18, 1861, Lot 25.

6. Hôtel Drouot, Paris, May 26–27, 1921, Lot 90.

7. Charpentier sale, Ader, Paris, March 15, 1956, Lot 38.

8. Arcole sale, Hôtel Drouot, Paris, December 12, 1990, Lot 157.

9. September 30, 1793, Lot 2354.

10. Verlet, p. 44, fig. 36.

11. For further information on the *horloger* Guydamour, see J. D. Augarde, *Les Ouvriers du temps*, Geneva, 1996, p. 330; for Delaunay, see p. 302.

INDICES

INDEX
of Artists Represented

509

SELECTED CHECKLIST
of Works not Discussed

PRINTS

ANONYMOUS, *Eighteenth Century*
 Thomas Cromwell

RICHARD EARLOM
 Sermon on the Mount, after Claude
 Lorrain

HENRI-CHARLES GUÉRARD
 Count Robert de Montesquiou, after
 James McNeill Whistler

JACOBUS HOUBRAKEN
 Sir Thomas Cromwell, after Hans
 Holbein the Younger
 Sir Thomas More, after Hans Holbein
 the Younger

AUGUSTE LEPÈRE
 Crépuscule
 Route de la Houssaye, Crèvecoeur
 La Route de Saint-Gilles
 Sous-bois à la Rigonette

DAVID LUCAS
 The White Horse, River Stour, after
 John Constable

C. HARBORD MORANT
 Lady Skipwith, after Sir Joshua Reynolds

GEORGE H. PHILLIPS
 Miss Murray, after Sir Thomas
 Lawrence

JOSEPH B. PRATT
 The Countess of Warwick and Her Chil-
 dren, after George Romney

PIERRE-SALVY-FRÉDÉRIC TEYSSO-
NIERES
 Comtesse d'Haussonville, after Jean-
 Auguste-Dominique Ingres

WILLIAM THORNLEY
 The Rehearsal, after Edgar Degas

BERNHARDT WALL
 Maréchal Joffre

WILLIAM WARD
 Thoughts on Marriage, after John
 Raphael Smith

SCULPTURE

ANDREA DELLA ROBBIA, *Manner of*
 Madonna and Child

FREDERIC S. REMINGTON
 Bronco Buster

DECORATIVE ART

ENGLISH, *Late Seventeenth or Early
Eighteenth Century*
 *Ten Side Chairs with Needlepoint
 Covers Depicting Figures, Birds,
 and Animals in Landscapes*

ENGLISH, *Eighteenth Century*
 *Four Splat-Backed Side Chairs with
 Panels of Painted Glass*
SÈVRES, *Eighteenth Century*
 Sugar Bowl with Floral Decoration

512

THIS EDITION OF 1,500 COPIES
WAS PRINTED UNDER THE SUPERVISION OF
MARTINO MARDERSTEIG BY STAMPERIA VALDONEGA
ARBIZZANO DI VERONA, ITALY
ON MUNKEN PURE PAPER, MANUFACTURED IN MUNKEDAL, SWEDEN
TEXT COMPOSED BY STAMPERIA VALDONEGA IN GALLIARD
DESIGNED BY MATTHEW CARTER IN 1978 AFTER THE
SIXTEENTH-CENTURY ORIGINALS BY
ROBERT GRANJON
BOUND IN SCHOLCO BRILLIANTA CLOTH BY
LEGATORIA TORRIANI, COLOGNO
MONZESE, MILAN
DESIGNED BY
MARK ARGETSINGER
ROCHESTER, NEW YORK